ONE PLANET

ONE

The *Fondation Nicolas Hulot pour la Nature et l'Homme* (Nicolas Hulot Foundation for Nature and Humanity) was founded in 1990. Its mission is to help modify our behavior as individuals in order to preserve the Earth. Dedicated to promoting education about the environment, and recognized by the French government as being of public benefit, it raises awareness among young people and adults of the richness and vulnerability of nature. To find out more visit www.fnh.org.

PLANET

A Celebration of Biodiversity

NICOLAS HULOT
FOUNDATION

Abrams, New York

INTRODUCTION

By Niles Eldredge, Curator, Division of Paleontology,
The American Museum of Natural History

It is difficult to truly comprehend the living planet. Humans are the only species with the awareness that Earth even exists; yet we are just one of millions of species found in every conceivable environment—from oases to desert sands, from ice caps to steamy jungles, from briny hot springs to the coldest cracks in the crust of seafloors. That is our advantage over other species—our consciousness. We know we are alive, and that knowledge has allowed us to understand that birds, trees, mushrooms, and bacteria are alive as well.

Although consciousness has been an advantage for us, it has also put us at a disadvantage when it comes to grasping in a fundamental, emotional sense what it truly means to be alive. For we have used our intellect to declare our independence from the ecosystems from which we sprang—the ecosystems that, until recently, were still occupied by remnant bands of hunter-gathering peoples. The positive side of providing our own food and other life necessities rather than living off the fruits of natural systems has been the diversification of cultural systems: the flourishing of arts and sciences, the gathering and dissemination of knowledge—much of it about the natural world.

But there has been a negative side to the abandonment of our ancestral, primordial ecosystems: Our population has exploded. There were probably no more than one million people on our planet 10,000 years ago, the era when agriculture dawned and civilization began to rise. Today, in the early years of the 21st century, there are more than 6 billion people in the world, and for a long time we have noticed the devastating effects that population is having on the rocks, soil, water, and atmosphere of our planet. Not the least of these devastating effects of our destructive presence is the rampant loss of biodiversity—as many as 30,000 species a year are disappearing due to habitat destruction, pollution, overharvesting, and the introduction of alien species around the globe. While there have been natural mass extinction events in the past, our current "biodiversity crisis"—this human-caused "sixth extinction" in which we now find ourselves—is the only such devastation of life caused by a single species. And that species, of course, is humans.

But life is tough and resilient. I have hope that we will wake up before it is too late and learn to curb our population growth and our collective despoliation of the planet before we have truly trashed every vestige of our intricately varied ecosystems. That can only happen, however, if we do a better job of sharing our concern for our planet among our 6 billion brethren. For that is the other more subtle side effect of our having lived life outside the confines of local ecosystems for the past 10,000 years: No longer a functional part of ecosystems, we have no urgent sense of their necessity for our lives. We are no longer like the Ba Mbuti people of the African Ituri forest, who the anthropologist Colin Turnbull once recorded as having softly chanted as they entered the forest to hunt and gather up vegetables: "Hello Mother Forest, hello Father Forest…we are here to take only what we need…." These hunter-gatherers had a profound sense of being part of their local ecosystem; they knew that they relied on it, and its continued health, if they were to survive.

Their sense of place and belonging is a luxury that the vast majority of us—who rely on farming and fishing, and who buy our food at the supermarket—simply no longer have. For the most part, we have lost our emotional, visceral, life-and-death connection to the natural world, and that is why we have, collectively, allowed the destruction of the world to accelerate. It is as if the loss of species and the destruction of ecosystems no longer matters.

But of course it does. Our fisheries are almost depleted, and our atmosphere, oceans, and soil have become so polluted that we will soon realize that our existence depends on the collective health of the world's total ecosystem, our "biosphere," rather than one particular ecosystem.

We need to emotionally reconnect with the living world before we can fully understand on a conscious level how seriously damaged our living planet has already become. Most of us can't actually leave our cities or small towns—even our farms—to spend quality time just experiencing the natural world. Even during the times when we can visit the natural world, we are still inexorably tied to our cars, bottled water, and prepackaged foods. It is as if we need these items to brave what is left of the natural world.

This is why I am so glad that we have the work of visual artists—painters and in our modern age, photographers. This book alone will not save the life of our planet. But if it inspires its readers—even if it helps a single child to develop a sense of awe at the sheer beauty of natural ecosystems—it will have done its job; this reconnection with the living world is something that we so desperately need. The intelligence and emotional power that is evoked by the photographs and text in this book are what will help us to forge that reconnection.

CONTENTS

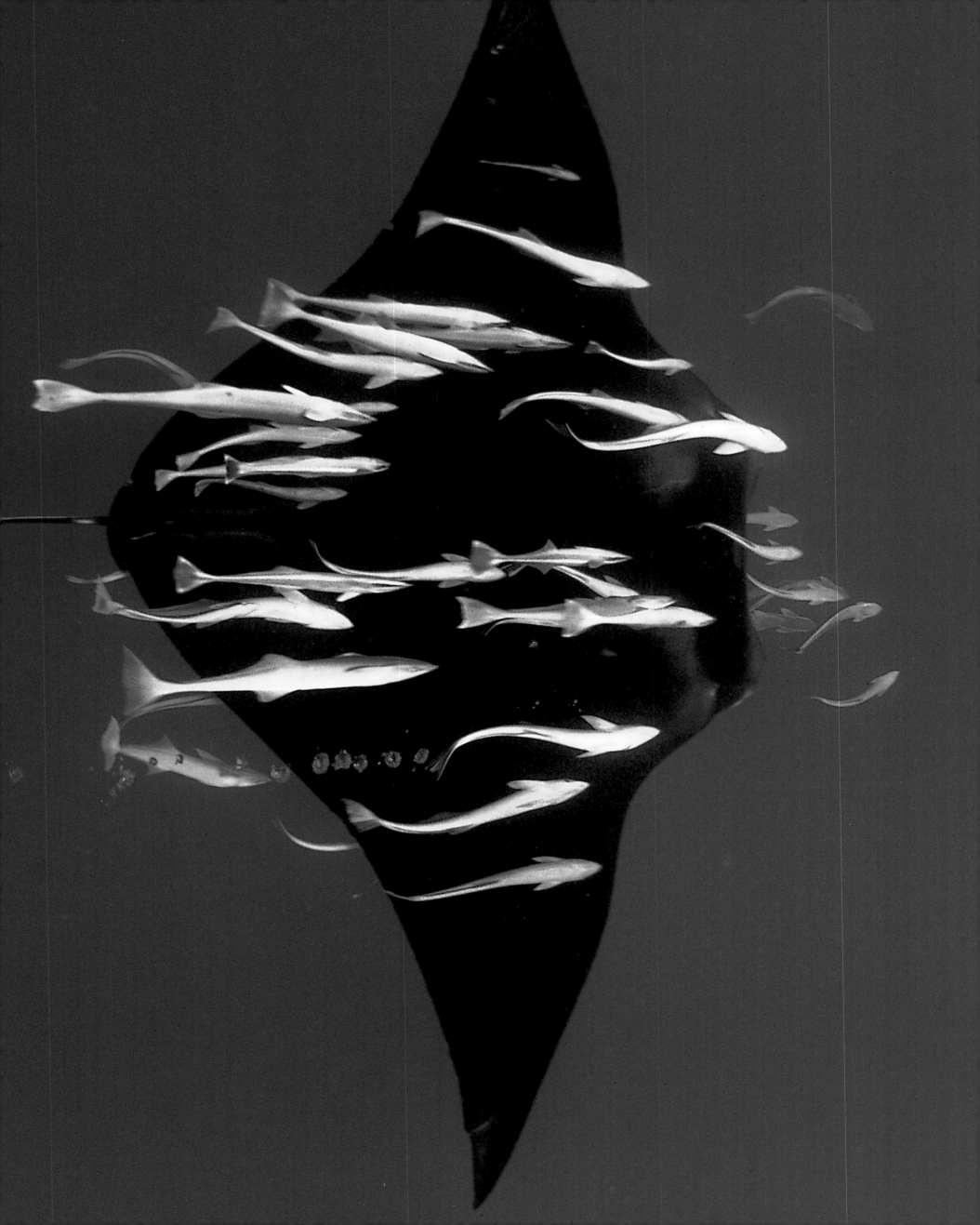

Oceans

Unquestionably, the sea is the last great ecosystem that still remains to be discovered. Although we often just focus on what takes place on *top* of the water, there is also teeming, diverse, and unknown life *beneath* the water's surface. In essence, these are two worlds that are adjacent, yet foreign to each other. Sailors do not like to put their heads underwater, while divers do not really appreciate the joys of navigation. It is disturbing to think that it is possible to spend a lifetime sailing the seas while remaining unaware of what is happening just a few feet beneath the surface.

Left: A manta ray and its escort of fish cruise off Rangiroa, French Polynesia, making an abstract design in the water. The fish are remoras, and they remove the parasites that live on the skin of manta rays and sharks. When too many of the fish congregate around a manta ray, it may leap out of the water to rid itself of them.

On the water's surface, it is easy to see what is happening not only with the most terrestrial aspects of the marine environment (such as birds and marine mammals) but also with man-made disasters, such as oil slicks. Beneath the surface, however, lies the unknown. Here we find what is intimate, secret, and how the marine environment functions. The great interplay of the seas and oceans takes place beneath the surface. Because much of what happens occurs out of our sight, we see the seas and oceans in a rather superficial way; we need to understand what happens within them.

I have been fortunate enough to visit this submerged world—always an intense experience—in many locations all over our planet. When we explore this world we don't just throw ourselves into the water, we slip into it. We enter this environment in the same way we might enter a cathedral. It is not a world that can be treated roughly; it is a world where we must be self-effacing. We may observe, but we must do our best not to touch anything. Thanks to some scientist friends, I have also discovered that in these vast oceans it is not necessarily the largest creatures that are the most spectacular. There are a multitude of small living things that we must strive to see. It's difficult to train our eyes to look at the underwater world, but it's essential if we want to understand how the oceans function.

A recent scientific study of the sea suggests that 99 percent of marine species have yet to be discovered, and that most of the planet's biodiversity is in the sea. According to current estimates, about 250,000 marine species are known; the World Conservation Union estimates that perhaps between 500,000 and 1 million species live under the sea.

North America is home to four of the world's 25 biodiversity "hot spots": the California Floristic Province, the Madrean Pine-Oak Woodlands in Mexico, the Meso-american Forests in Central America, and the Caribbean Islands. North America possesses an unparalleled marine heritage, extraordinarily diverse and representative. For example, according to Conservation International, the Caribbean Islands have more than 160 species of freshwater fish, about 65 of which are endemic to one or a few islands, and many of these to just a single lake or springhead. There are two distinct groups of freshwater fishes in the Caribbean: on smaller and younger islands, most fish are species that are widespread in marine waters but also enter freshwater, while on the larger and older islands of the Greater Antilles, there are several groups that occupy inland waters, including gars, killifishes, silversides, and cichlids.

Naturally, an encounter with a cetacean is unforgettable. Sometimes we're impressed by the sheer abundance of life; sometimes we're impressed by the relationship that exists between us (feeble human beings) and whales (huge marine creatures). I experienced this abundance of life one day in British Columbia, as we were flying at a low altitude over an immense school of dolphins on the move. It took at least 10 minutes to fly from the back of the school to the front; it was as wide as it was long. The hundreds of thousands of dolphins in the school formed a vast white expanse, stretching for miles—as far as the eye could see. Where had they come from? Where were they going? What force drove them? How could there be so many? Such encounters remind us of our place in nature.

Another similar experience was when I swam among humpback whales off the coast of Madagascar. There were three below me and two alongside me less than 10 yards away. They appeared to be moving in slow motion, as if in a universe of their own—so deep was the blue of the water. At the same time, they sang their songs, which are on par with the music of the world's greatest symphony orchestras. Indeed, underwater, whales are often heard long before they are seen. At times like these, our little earthly pleasures seem insignificant.

Unfortunately, these rather idyllic images may soon be a thing of the past. Humans are annihilating underwater life, just like they are in all the earth's other ecosystems. Where once there was a profusion of life, now I see only scarcity.

Coastal and marine habitats are especially in danger. A coastline is a narrow, unique space; its richness depends upon a fragile equilibrium, particularly in estuaries, bays, and lagoons. This richness is clearly visible in the intertidal zone, which

> Because much of what happens occurs out of our sight, we see the seas and oceans in a rather superficial way; we need to understand what happens within them.

is home to the tiny organisms on which migratory birds feed. Coastal areas are also where the densest growths of seaweed are found, as well as vast underwater prairies of Posidonia and eelgrass. Along with retaining sediment, and thus being of enormous value in helping to prevent coastal erosion, these plants provide spawning grounds and a haven for the young of many marine species. Most of what the seas produce comes from coastal regions; almost 90 percent of the organisms that live in the sea breed there.

In tropical regions, mangroves are indispensable for the reproduction of marine species; they are veritable reserves of fry and young for fisheries. Coral reefs, too, are an important habitat for marine fauna.

The problem is that we do not see what goes on beneath the water's surface, and fish and marine life are suffering. The cod fish is an excellent example. This was one of the most abundant fish in the North Atlantic, yet now some scientists predict it will just about vanish before the end of this century. How can this be? The cod has become so rare that most Northern European countries cannot catch their full quotas. In Canada, there hasn't been any cod fishing since the 1990s to allow the species to recover; it has not resumed because stocks have not returned to the required level.

Of course, the cod is not the only species to have suffered such a fate. It is estimated that world fish stocks are no more than one-sixth of what they were in 1990. Over the same period, 1990 to 2005, fishing has increased eightfold in order to achieve the same quotas as in the past. With 94 million tons of fish being caught every year, three quarters of marine fish stocks suffer from overfishing. And yet commercial fishing vessels still ply the oceans, trailing lines with baited hooks or nets that sometimes measure 25 miles long. These nets scoop up everything in their path; nothing is spared: pelagic fish, young fish, sharks, or albatrosses. Most species of the latter two are now in danger of extinction, as are many species of marine mammals such as dolphins, seals, and sea lions, along with six of the seven species of turtle. When the nets become tangled, unscrupulous fishermen cut them and leave them to drift—a veritable sinking death trap. This slaughter embodies our failure to carefully manage the marine environment, which covers more than 70 percent of the earth's surface.

> It is estimated that world fish stocks are no more than one-sixth of what they were in 1990. Over the same period, 1990 to 2005, fishing has increased eightfold in order to achieve the same quotas as in the past.

The exploitation of natural resources is not the only source of the ills affecting oceans. The disappearance of coastal habitats, invasive species, pollution by hydrocarbons, and, most of all, pollution coming from land and human activity alter all ecosystems with which they come in contact.

As the world's temperature rises, ocean temperatures follow suit, causing a rise in sea levels (higher temperatures cause the volume of water in the oceans to increase). Sea levels are forecast to rise between 3.5 and 35 inches between now and the year 2100. The effects on the millions of people living in coastal regions can be imagined: warmer waters will disrupt the cycle of oceanic life. In many places, plankton will decrease or migrate. From Scotland to Alaska, chain reactions will lead to the disappearance of birds or marine mammals. In tropical regions, coral reefs are increasingly threatened. For example, on the Great Barrier Reef in Australia the coral is dying, and so too is the reef's entire ecosystem.

The conclusion is a bleak one. As modern man accomplishes one technological achievement after the other, he has broken his solidarity with all other living things in an act of supreme vanity. His relationship with the oceans, as well as with the rest of nature, is distant and unilateral. He is exhausting the ocean's vast resources, forgetting that only the passage of time has allowed them to be built up. Man is going astray, and every day getting a little deeper into a planetary impasse. He turns his power against the earth, and yet—just like during the sinking of the *Titanic*—the orchestra continues to play at full volume, drowning out the inaudible murmur of reason.

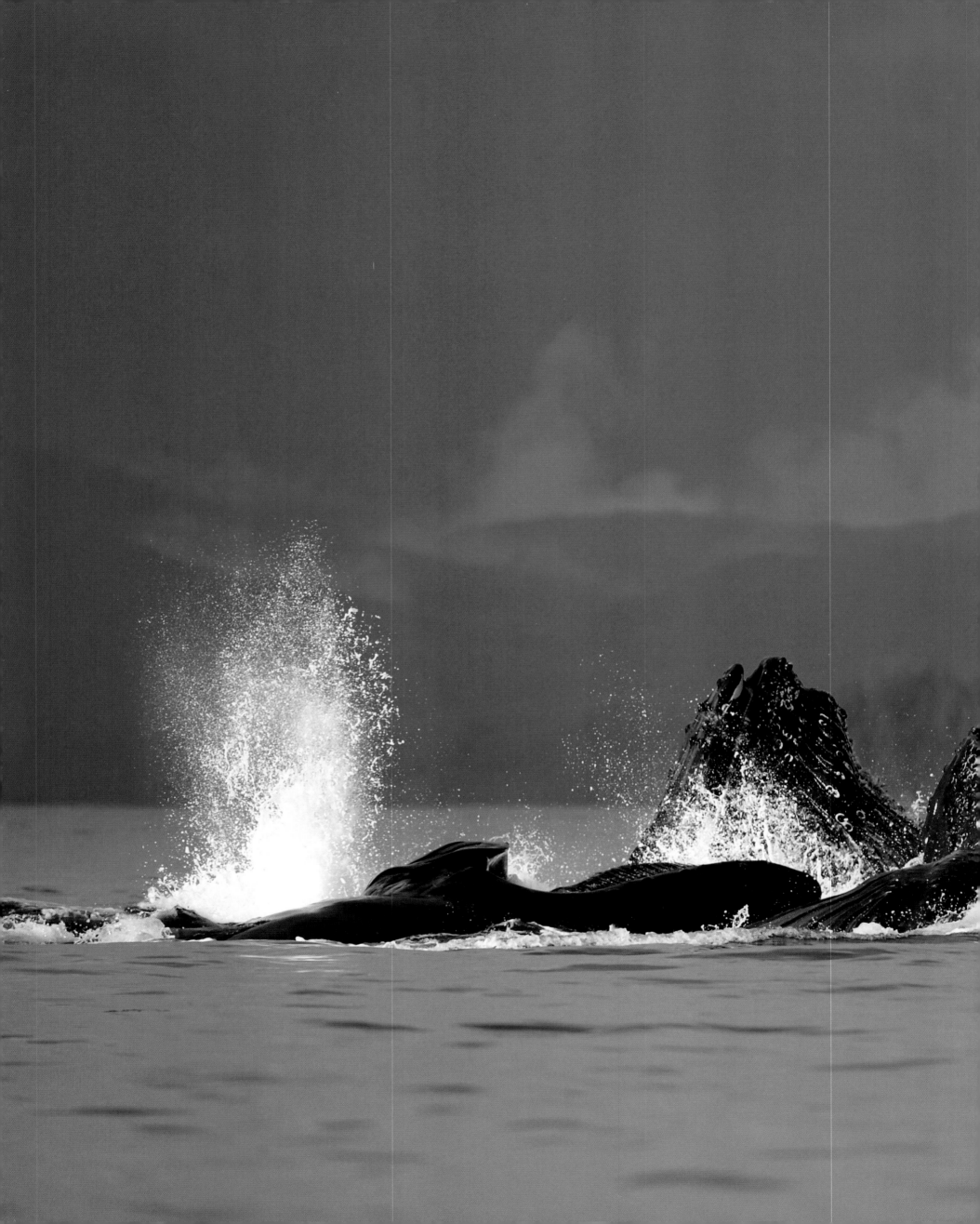

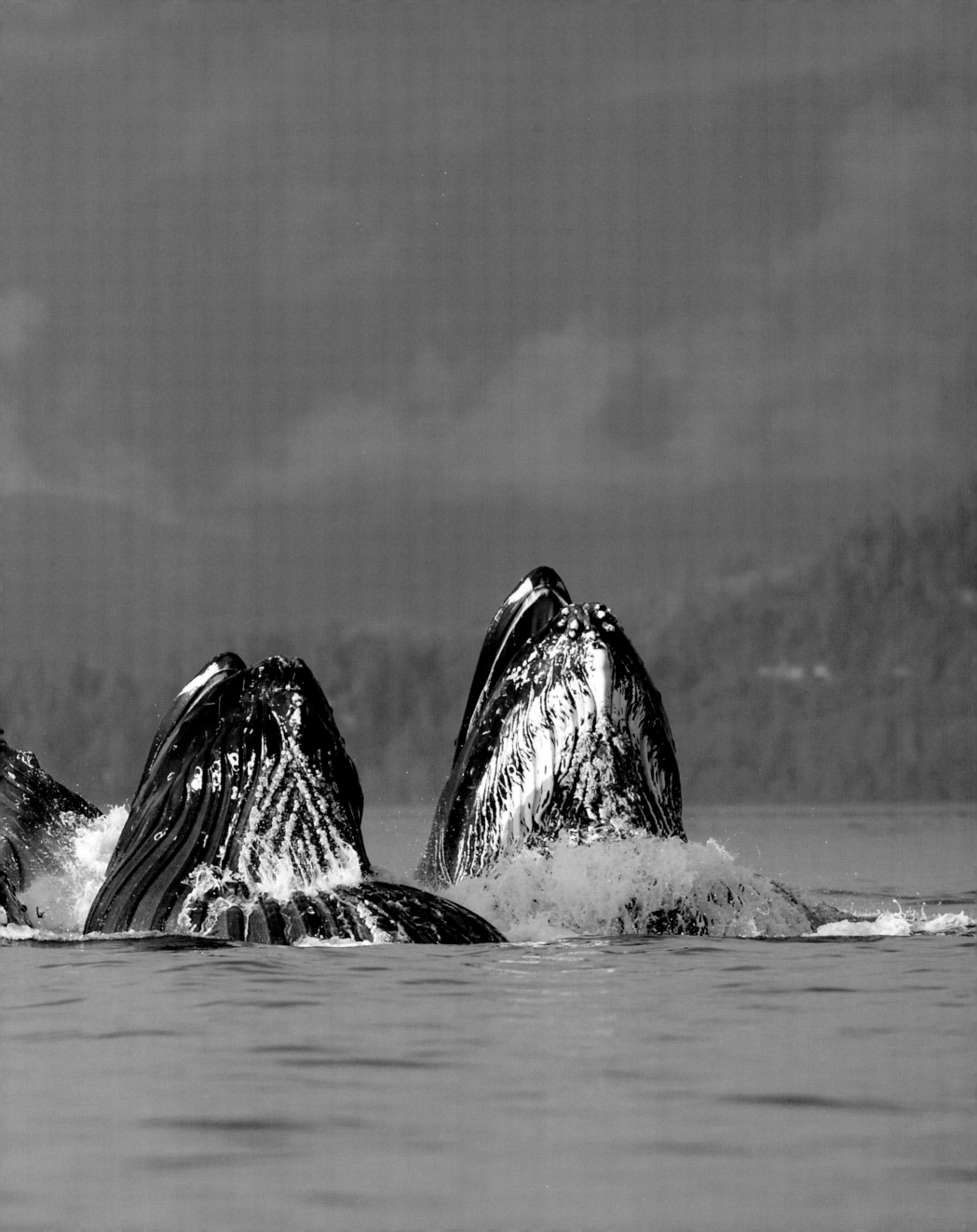

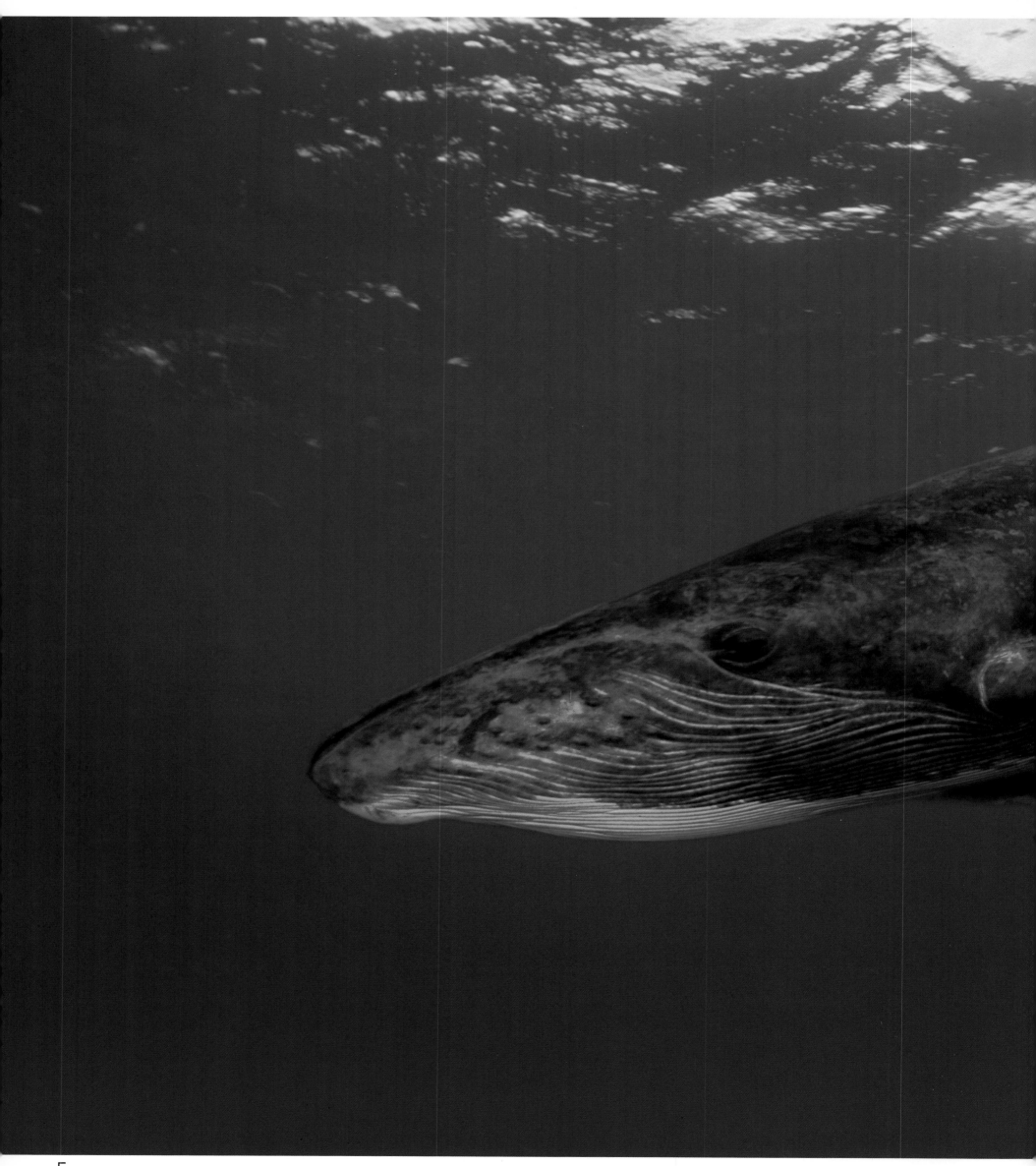

Preceding pages: The numbers of most ocean cetaceans have been reduced because they don't breed every year. Female humpback whales (above) produce a calf every two years. They have long been hunted (at least 100,000 were killed during the 20th century), and their population has dwindled everywhere in the world. Some of the approximate 10 humpback whale species found in different regions are more endangered than others. This whale, above, belongs to just such an endangered group found off the coast of Alaska.

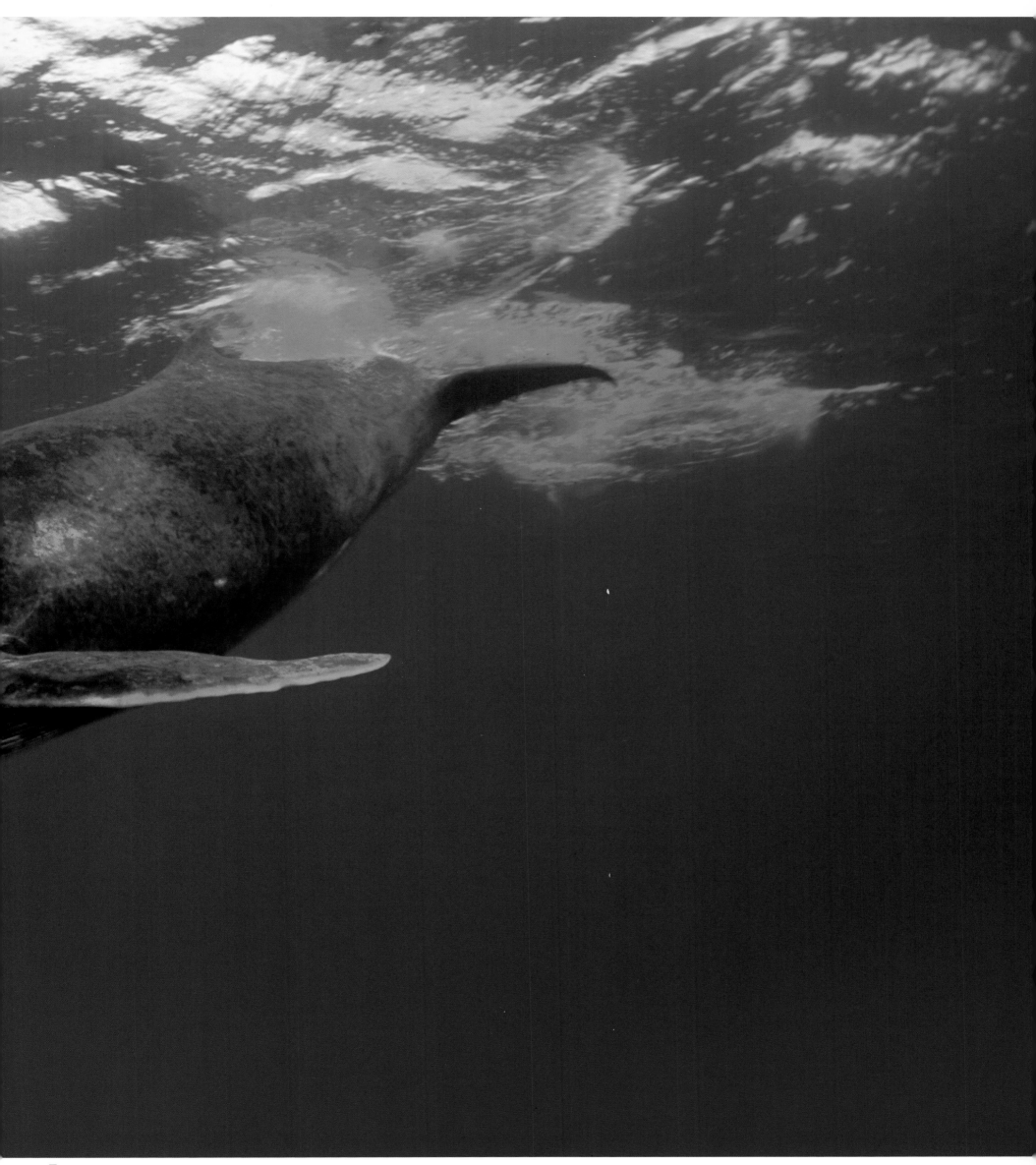

Above: Does this young humpback whale have a better chance of survival now than it would have had 50 or 60 years ago? Although it is less likely to be hunted now (only three countries still hunt whales), it still has to contend with a diminished food supply and the danger of being tangled in drifting nets.

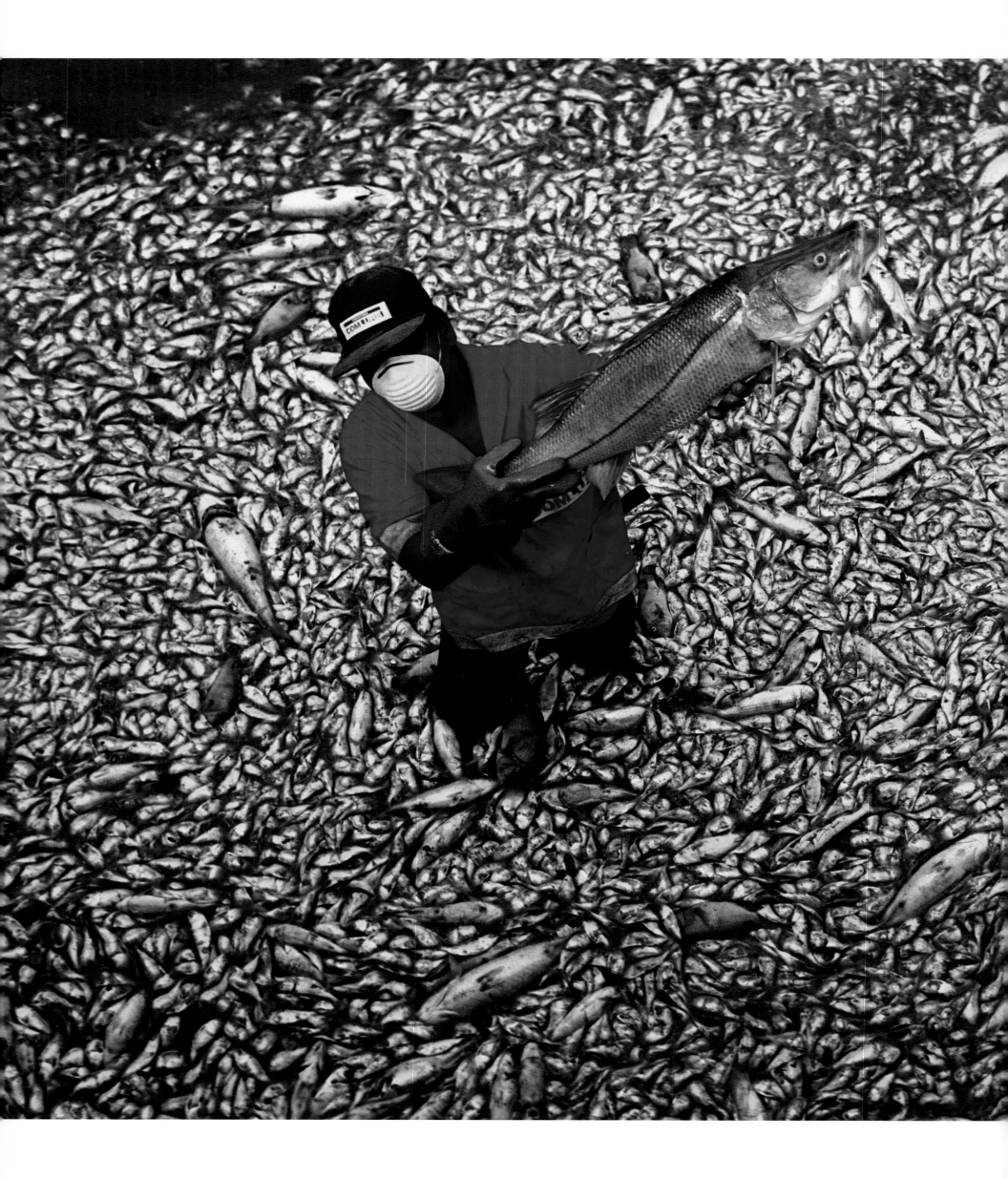

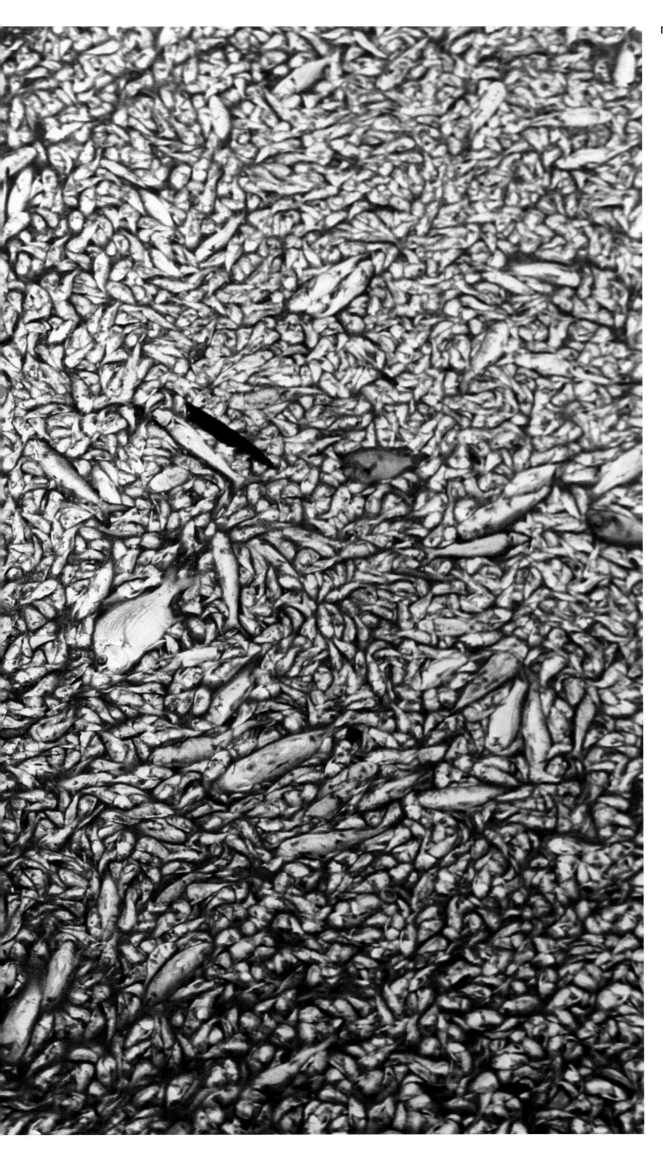

A sewage spill in a coastal city in Brazil caused the mass death of all fish in the surrounding waters. A few years ago in central Europe, vast numbers of freshwater fish were killed as a result of mercury pollution in rivers. Moreover, hot, dry summers have led to increased fish mortality worldwide, especially in rivers.

This pointed cowrie blends in perfectly with the surrounding gorgonians (coral). Cowries are sea snails (gastropods), and in some species the color and structure of their outer covering perfectly mimic those of their host.

Right: Less than an inch long, the pygmy seahorse is one of the smallest species. It was discovered in 1970 and lives only in the western Pacific Ocean among gorgonians (corals) of the genus *Muricella*, against which it is perfectly camouflaged.

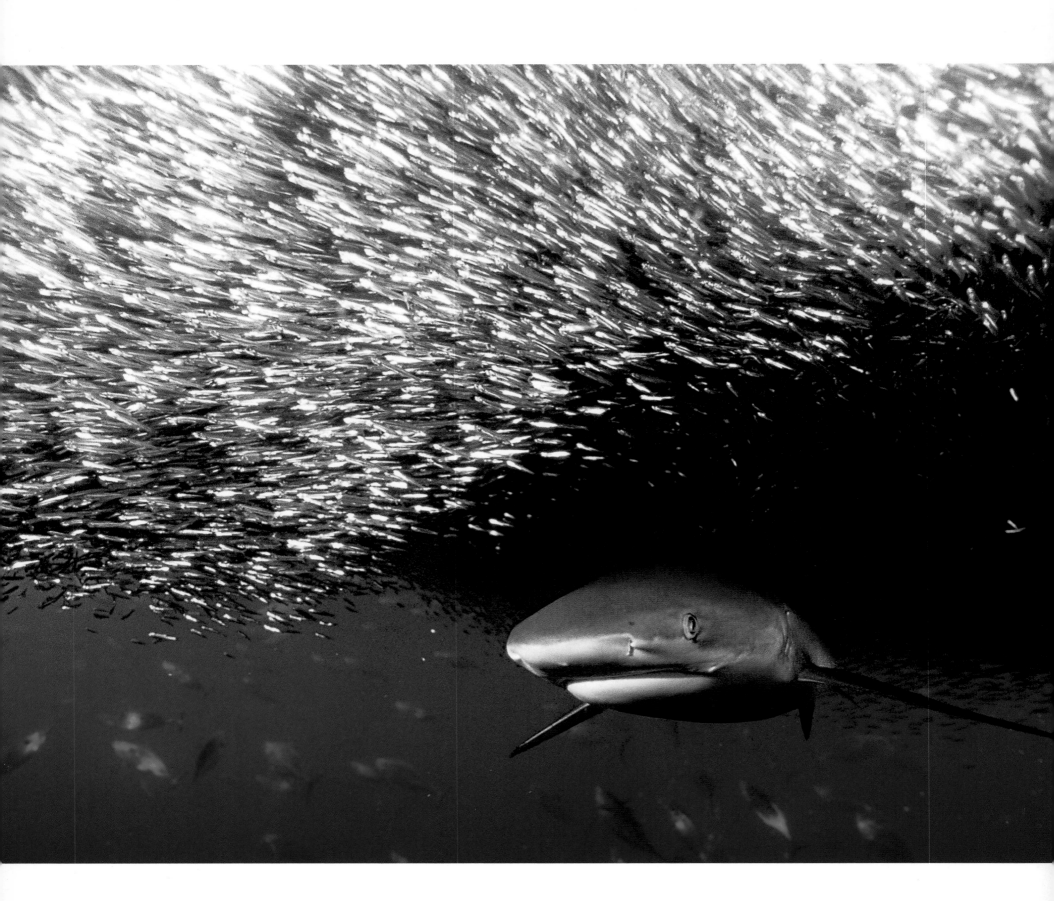

Above: By congregating in tight groups, these fish are better able to escape the jaws of this gray reef shark off the Solomon Islands. Many shark species are increasingly under threat. Treated mercilessly by fishermen, some species have diminished by an estimated 70 to 90 percent since the middle of the 20th century.

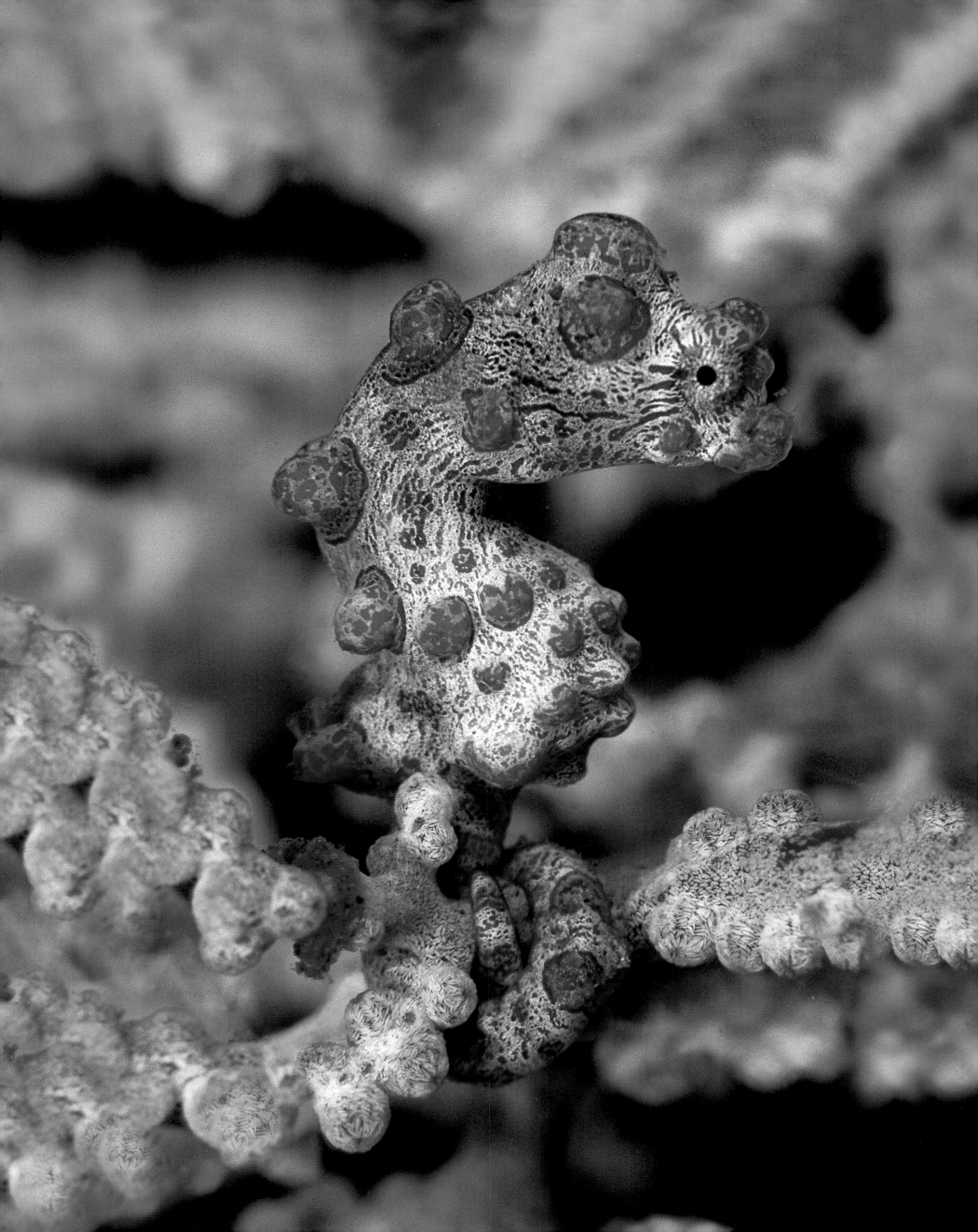

Throughout the world coral reefs, such as this mushroom coral, are threatened. Unscrupulous tourism and, especially, the harvesting of coral seriously damage and deplete reefs. In addition, an increase in water temperatures, partly due to climate change, is causing thousands of acres of coral to bleach and eventually die—one example of such a depletion is with the Great Barrier Reef in Australia. In the long term, this process may be irreversible.

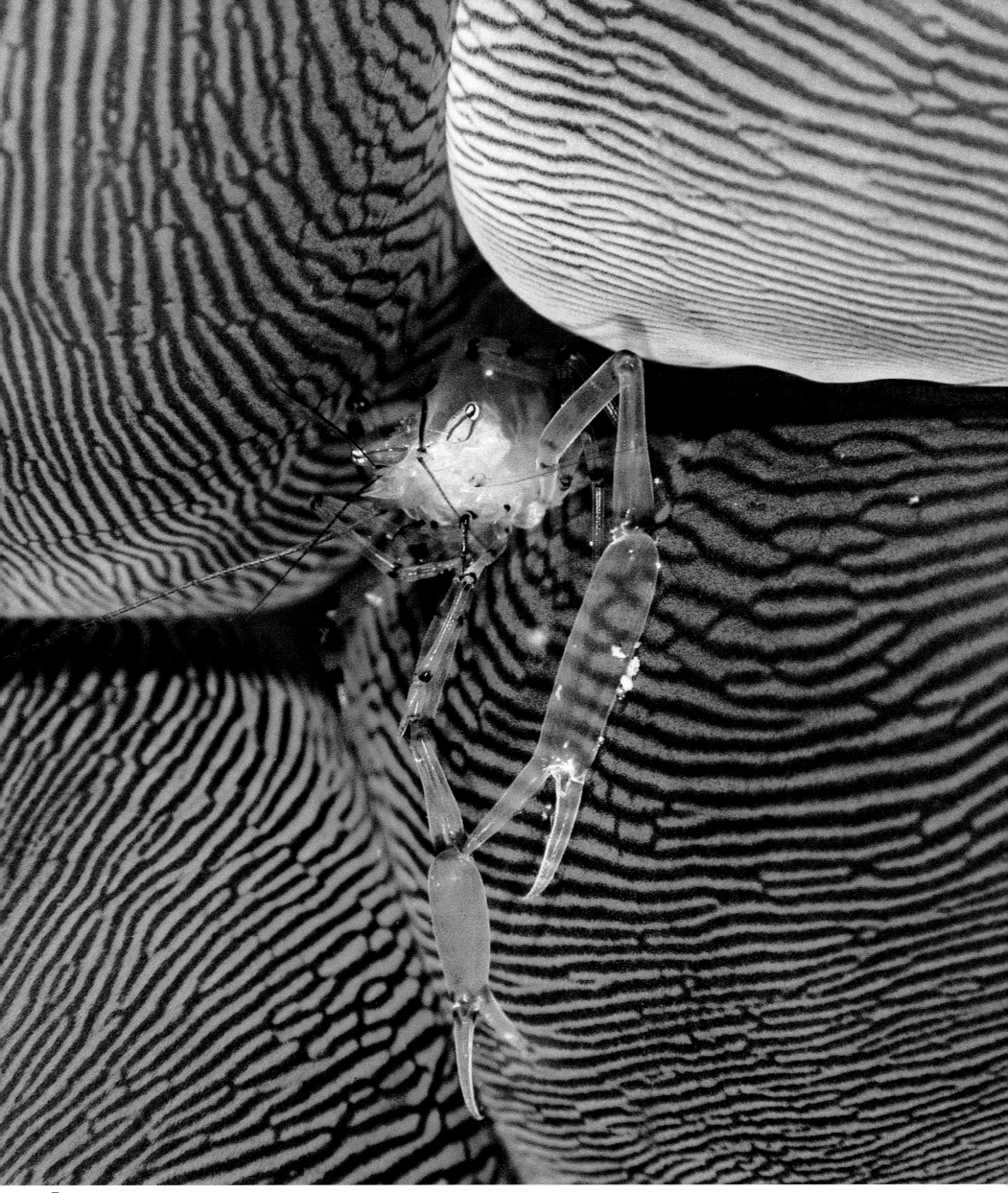

Like many other species, the bubble coral shrimp (*Vir philippinensis*) lives exclusively on certain madrepores (bubble coral). It can be found from the Andaman Sea to the China Sea and as far south as Australia.

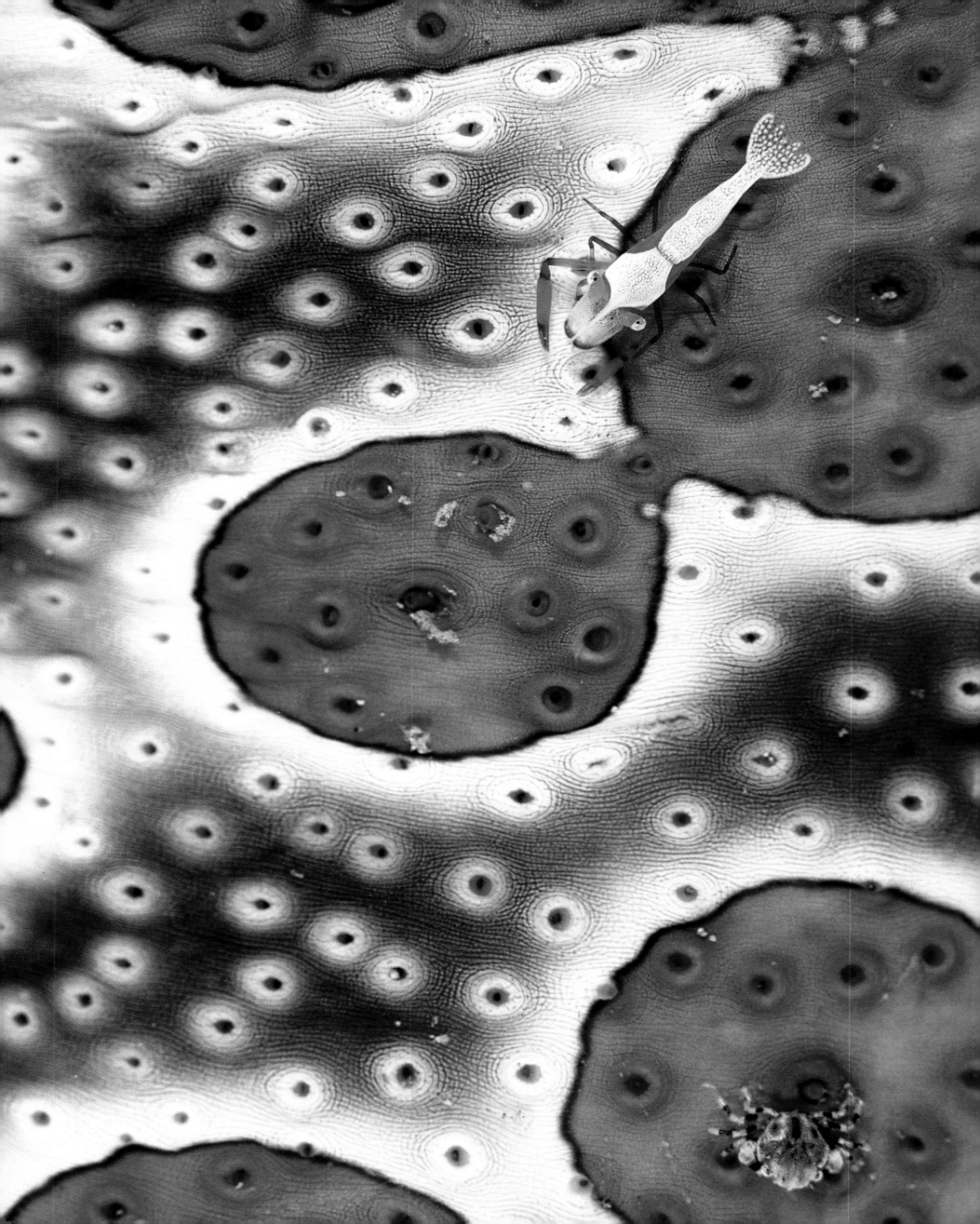

Left: What immediately strikes us is this pleasing blend of colors—orange, brown, and creamy white predominate. This is a detail of a sea cucumber (or holothurian), an echinoderm that produces toxic substances, which are dangerous to many species. If we look closer, however, we see a kuruma shrimp whose colors are identical to those of its host. This shrimp has a sort of commensal relationship with the sea cucumber, ridding it of its waste (on which it feeds); the sea cucumber gives shelter to and protects the shrimp from predators. Looking even closer, we can discern a tiny harlequin crab, or sea cucumber crab, which lives on the sea cucumber but does not interact with it.

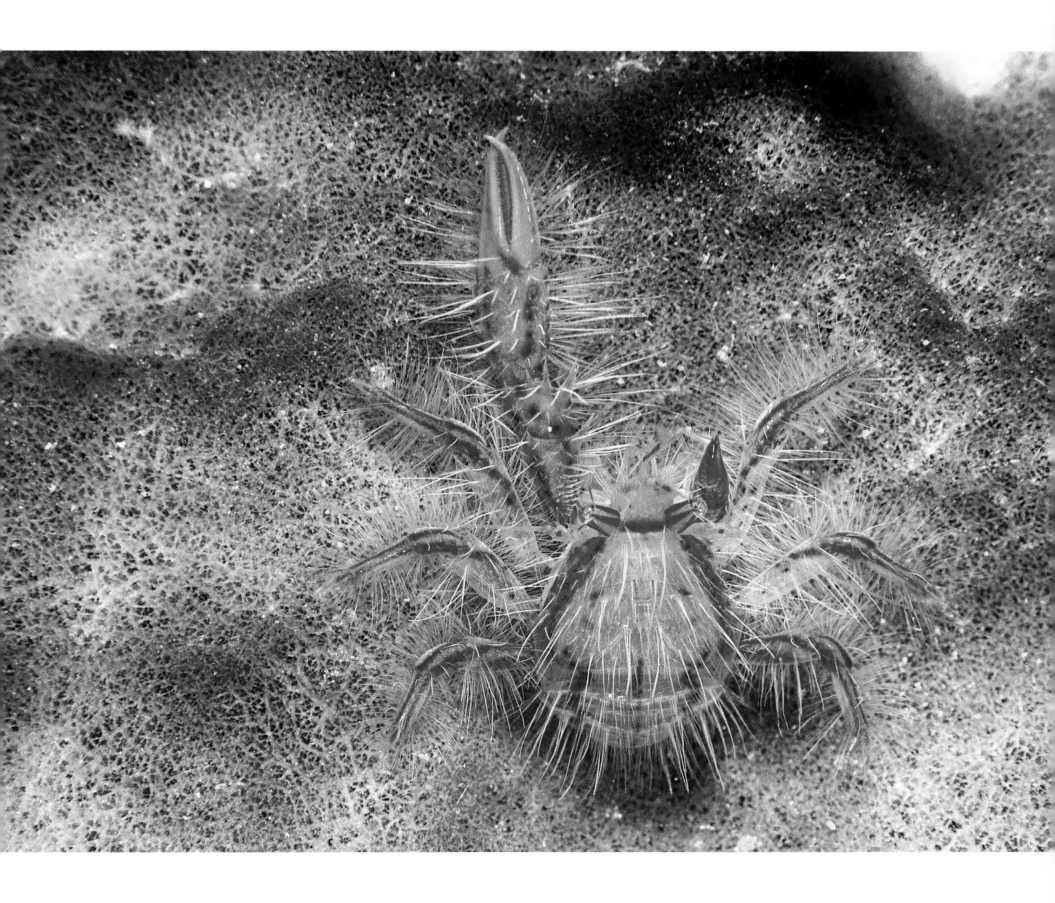

Above: The squat lobster is a tiny crustacean (a sort of small crayfish) that lives on barrel sponges of the *Xestospongia* genus. Its bristlelike hairs can detect movement in the water. When a predator approaches, the squat lobster takes refuge in one of the sponge's cavities.

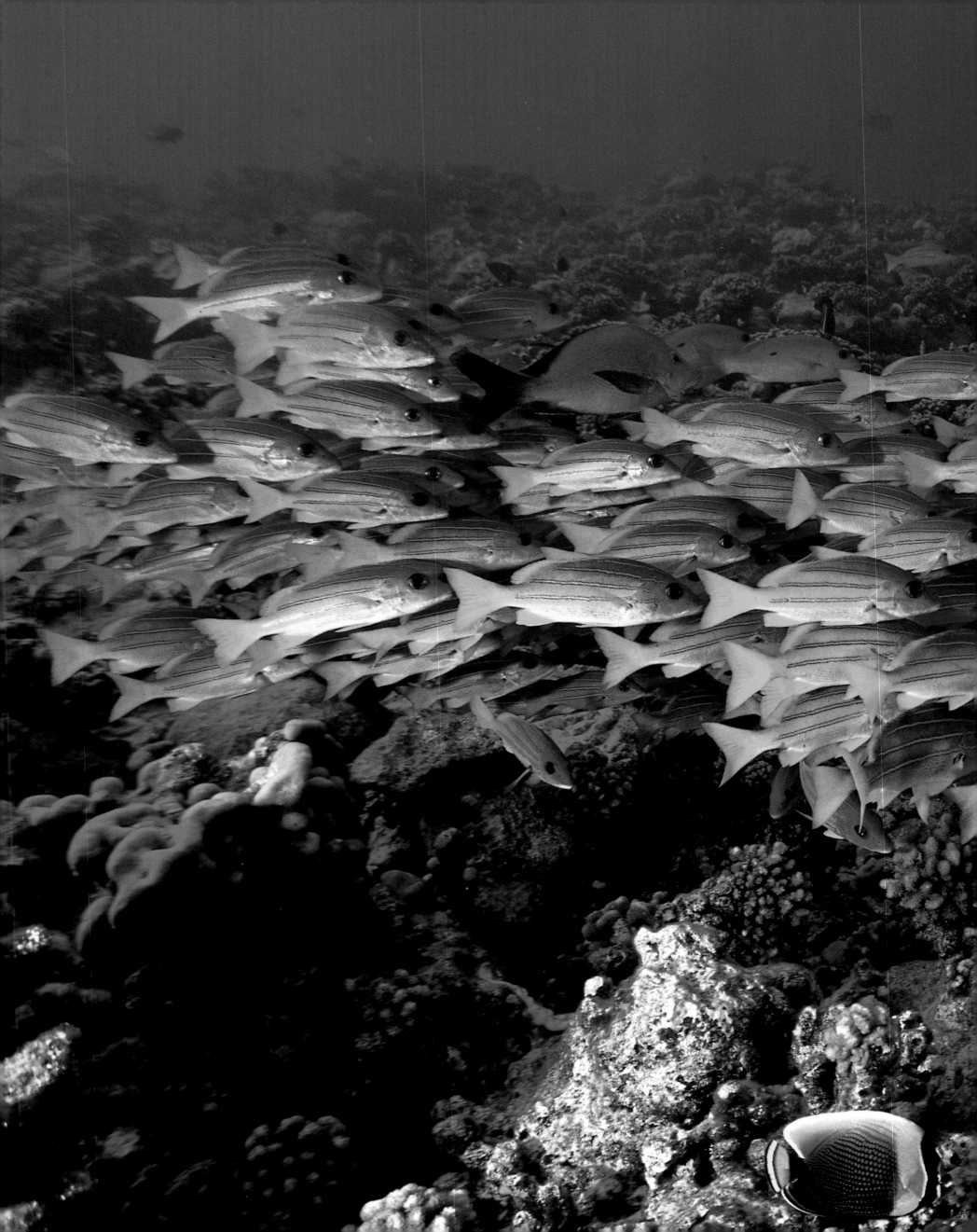

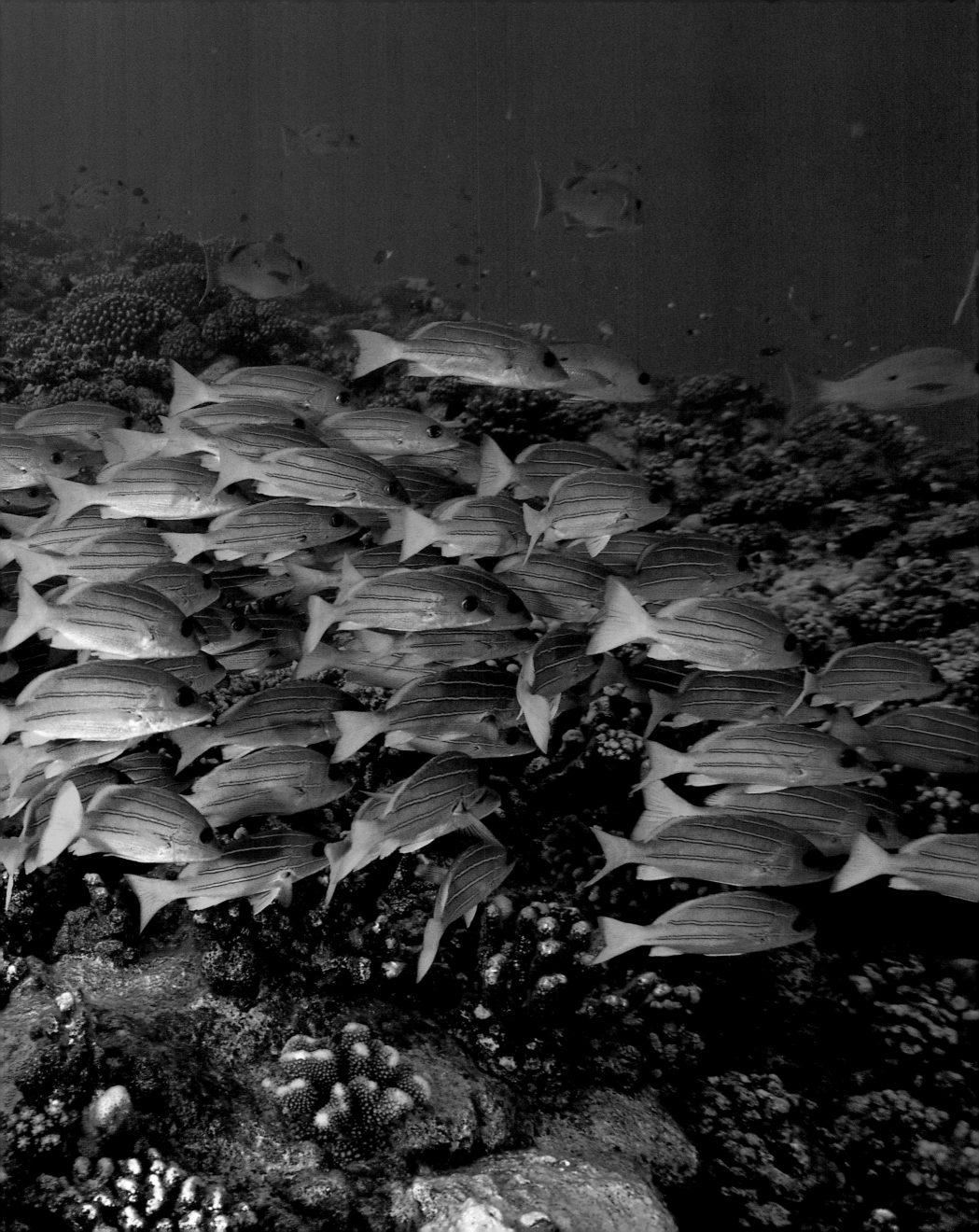

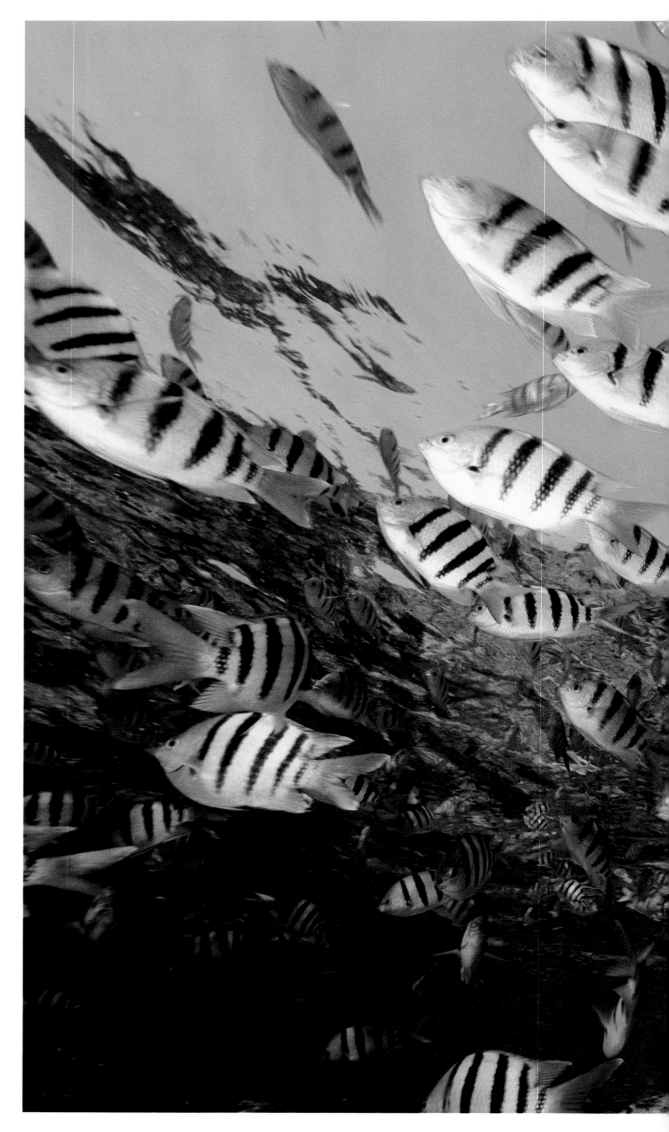

Preceding pages: The blue-striped snapper also live in shoals but only during the day. At night the fish disperse, each going its own way to hunt for small fish and crustaceans.

Right: The fish that haunt coral reefs are often highly gregarious, living in shoals, like these sergeant major fish of the Red Sea and Indo-Pacific tropics; they feed exclusively on plankton.

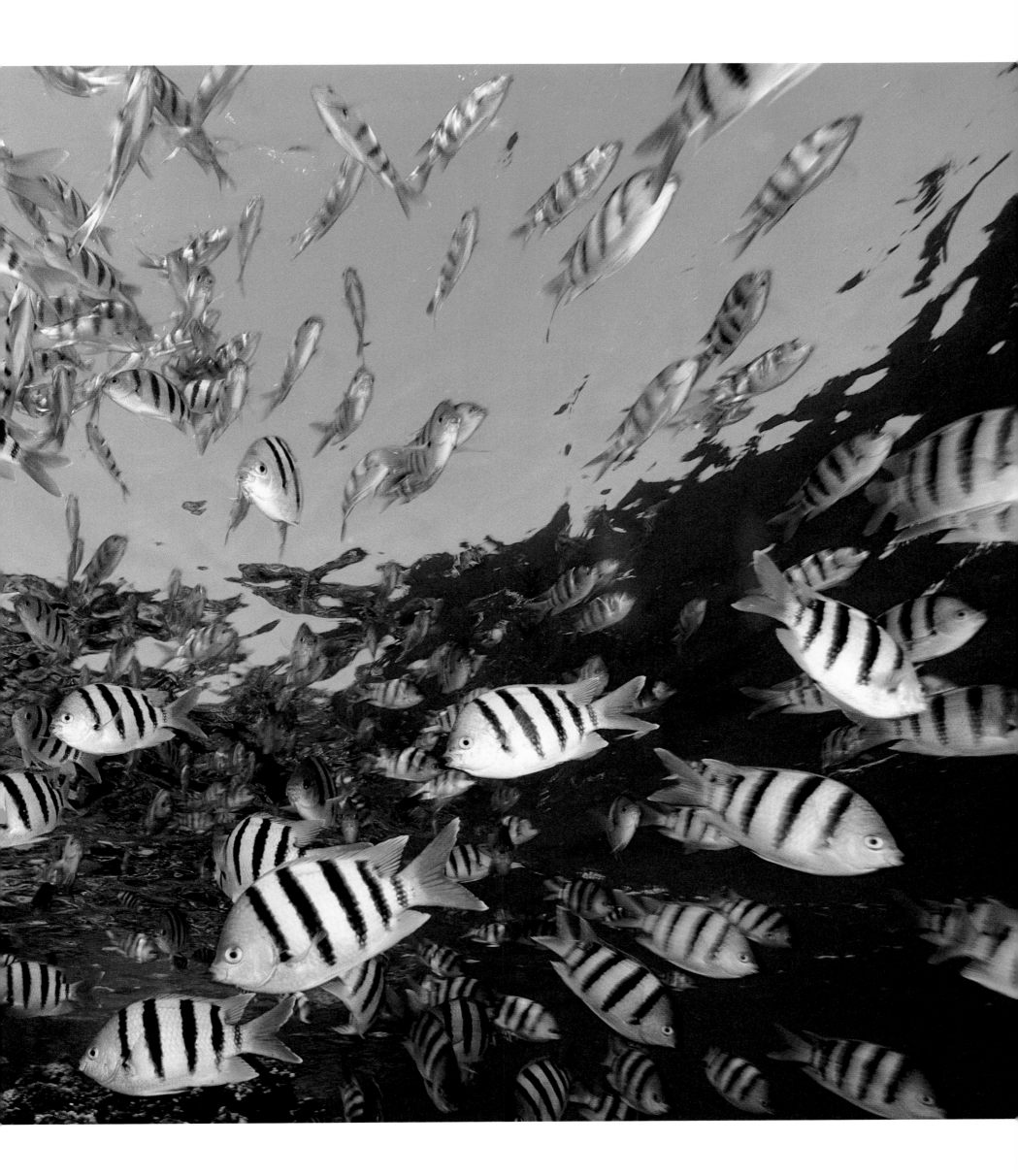

The relationship between the clownfish and the sea anemone is a perfect example of symbiosis. Although the anemone is toxic, it poses no danger to the clownfish, which secretes a protective mucus. Therefore, in the event of danger it can take refuge in the anemone's tentacles. In return, the clownfish protects the anemone: as it feeds, it prevents its host from being smothered.

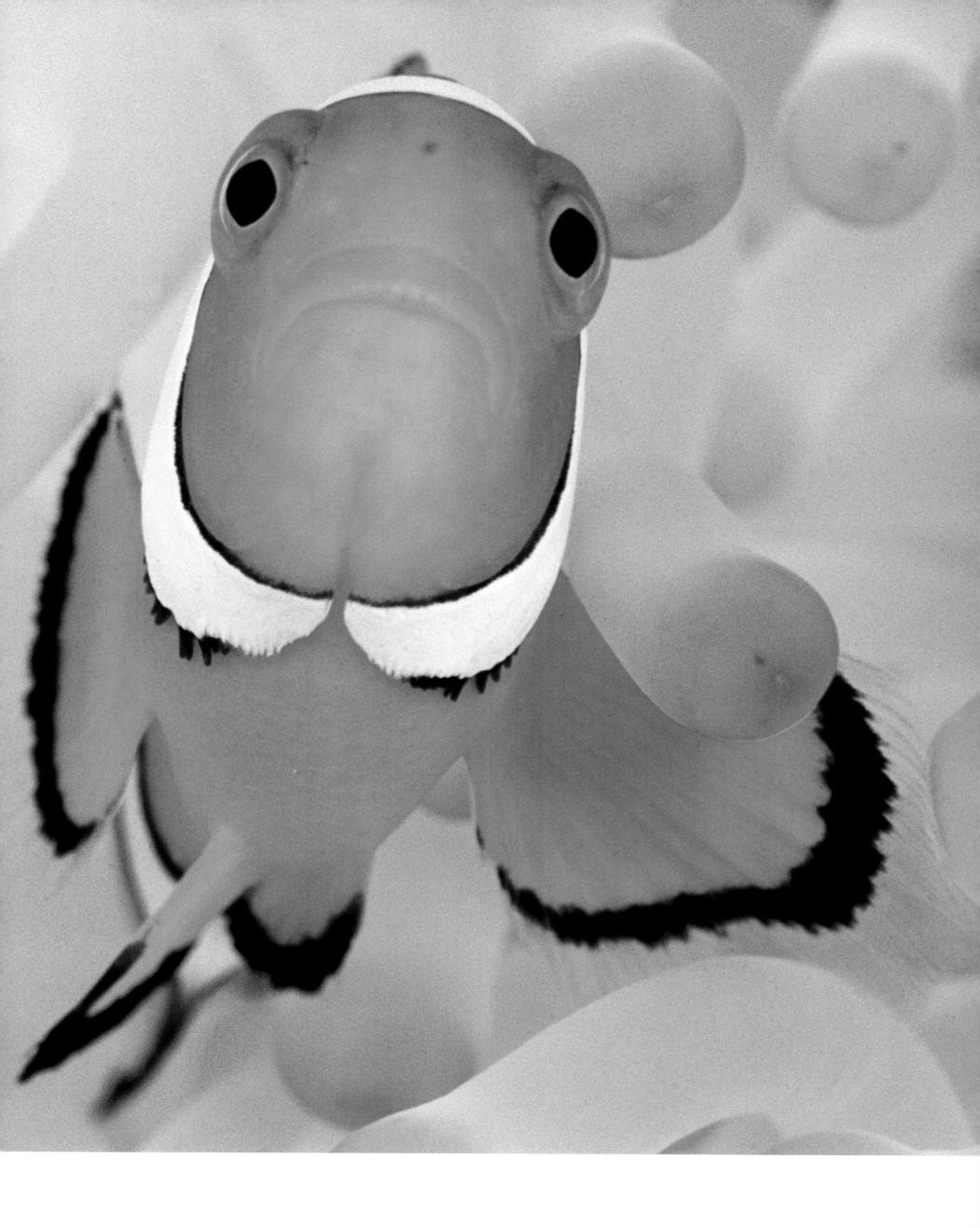

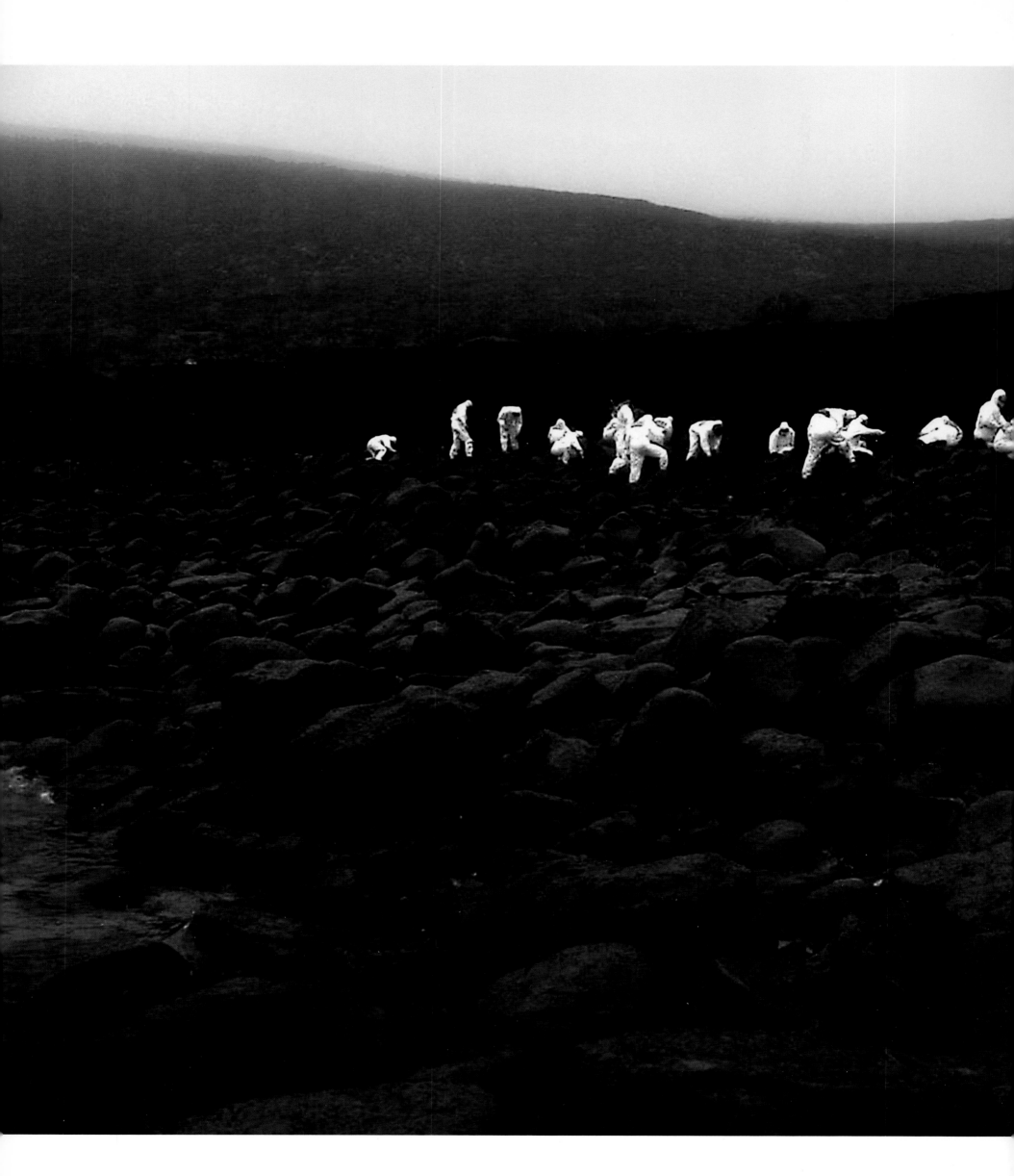

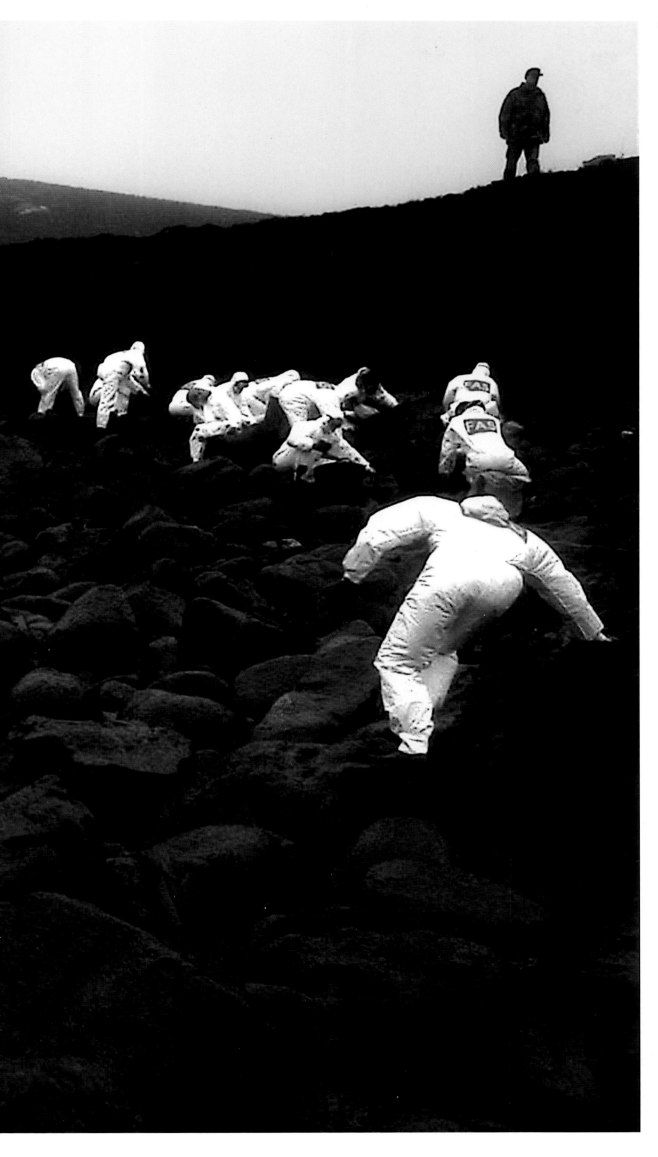

Looking at this image, you could imagine these are astronauts taking samples from the surface of the moon! In fact, they are Spanish soldiers who, on a gray morning in January 2003, were trying to clean up oil that leaked from the tanker *Prestige.* This disastrous spill, which washed ashore in Galicia, was the biggest ever to hit Spain: 85,000 tons of crude were washed up on its shores. However, oil spills account for only a small percentage of marine pollution—most pollution comes in the form of waste expelled from the ballast tanks of numerous ships.

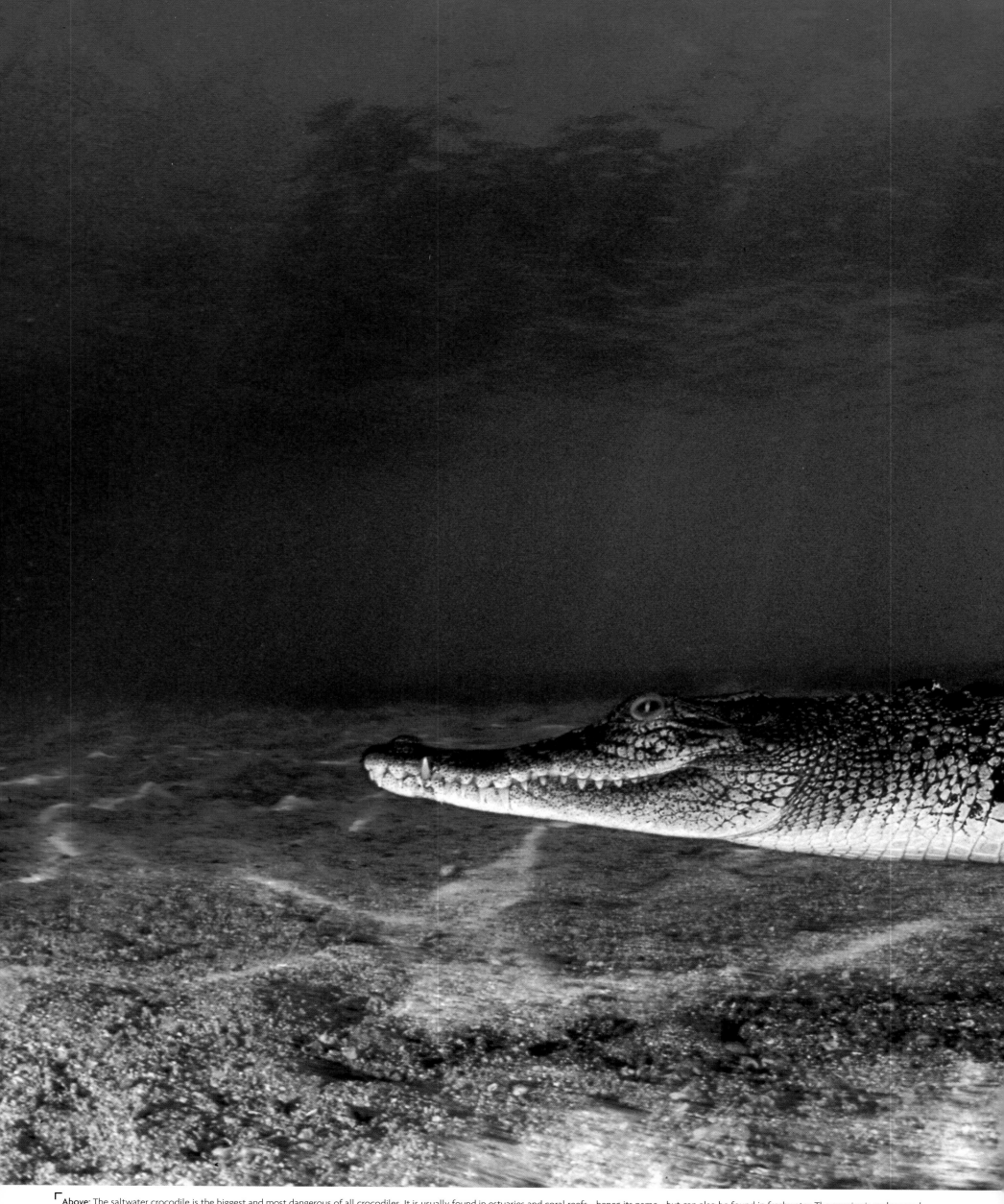

Above: The saltwater crocodile is the biggest and most dangerous of all crocodiles. It is usually found in estuaries and coral reefs—hence its name—but can also be found in freshwater. The species is endangered worldwide; its populations are threatened in Australia, Indonesia, and Papua New Guinea.

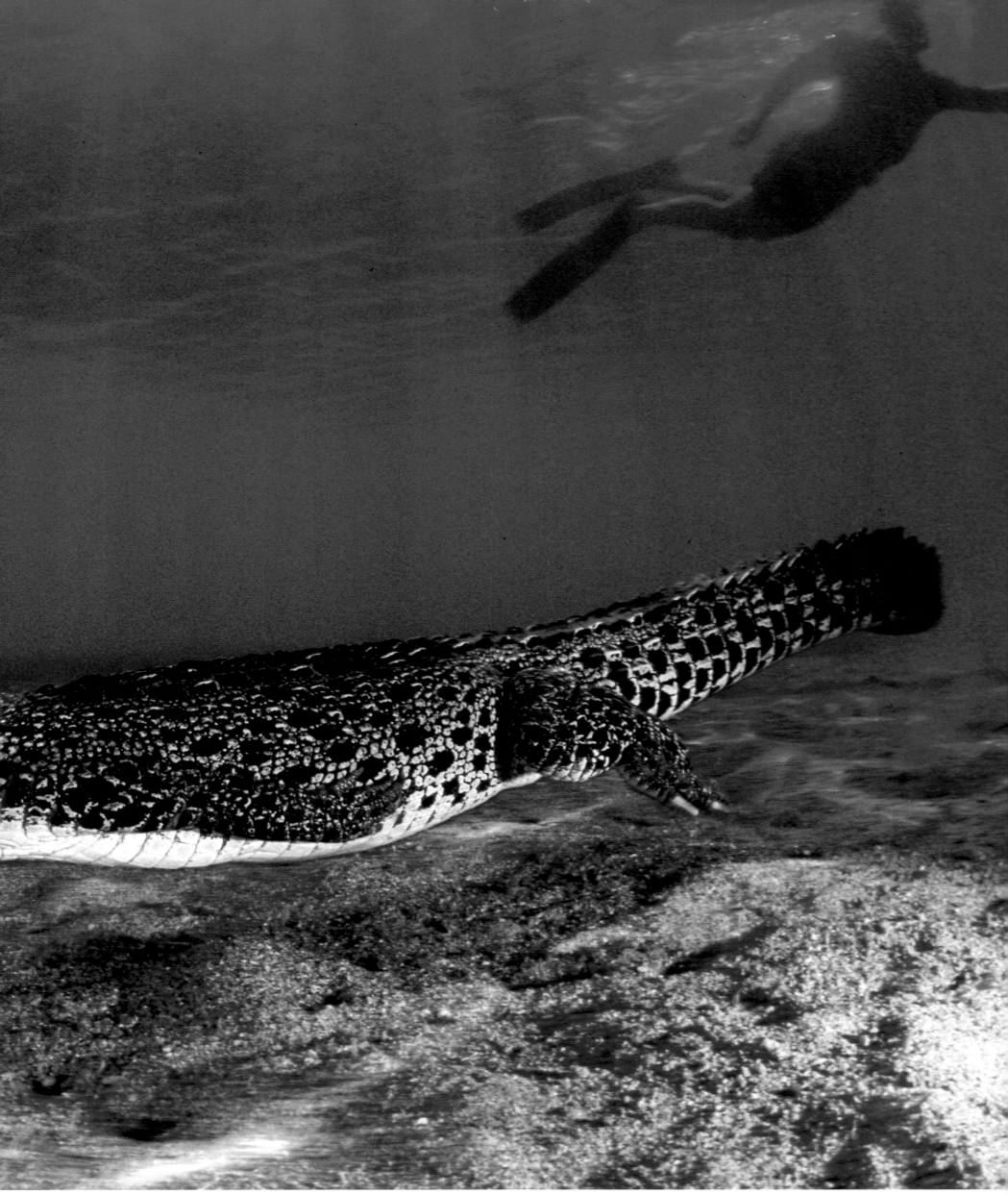

Following pages: The diversity peculiar to coral reefs is also among the most extensive in nature: thousands of species live side by side in a complex and fragile equilibrium. Here, in the Solomon Islands, coral is home to a crinoid (*Oxycomanthus bennetti*), left, that resembles a dwarf palm tree growing on the rock. As with sea anemones, some shrimp live in symbiosis with crinoids.

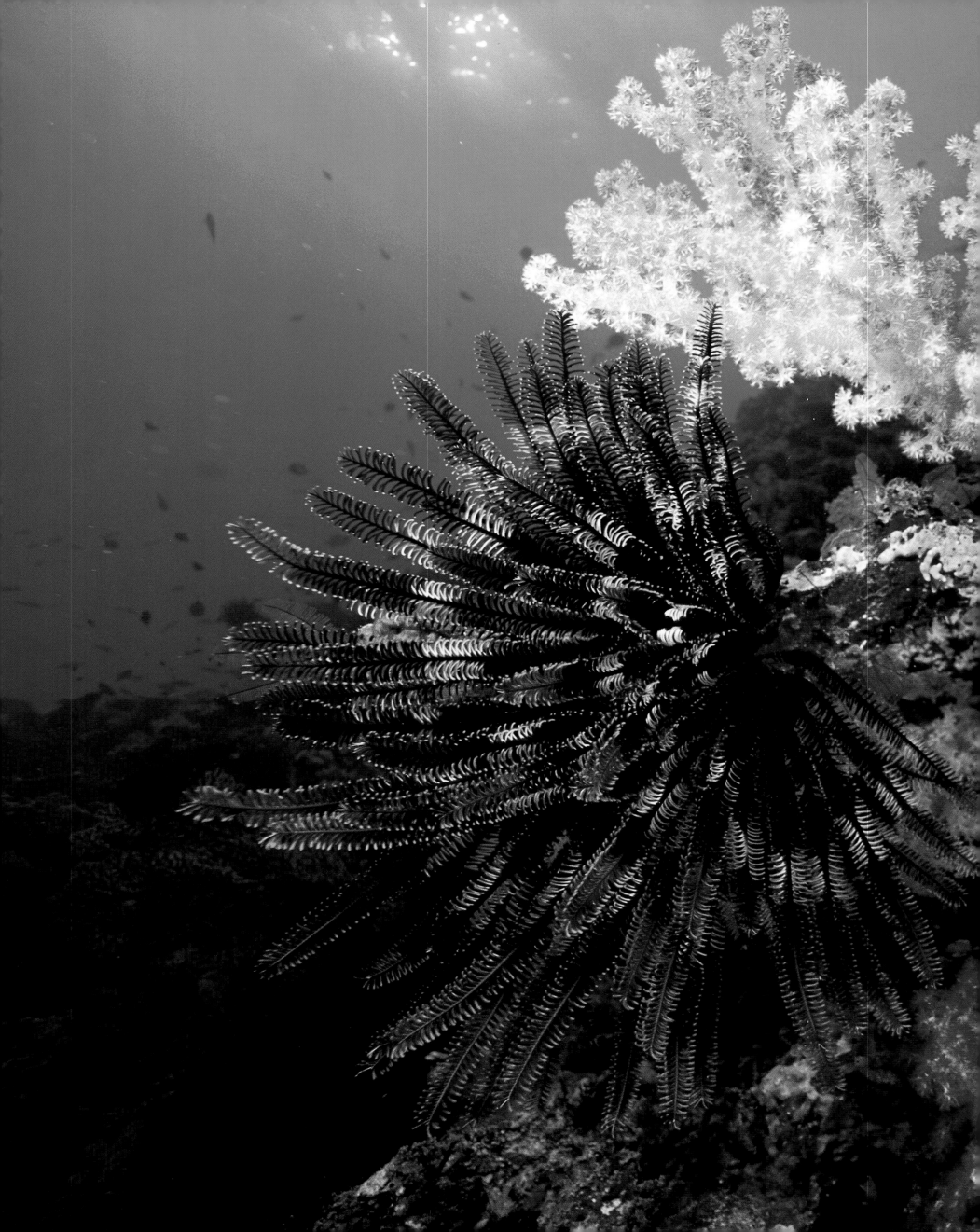

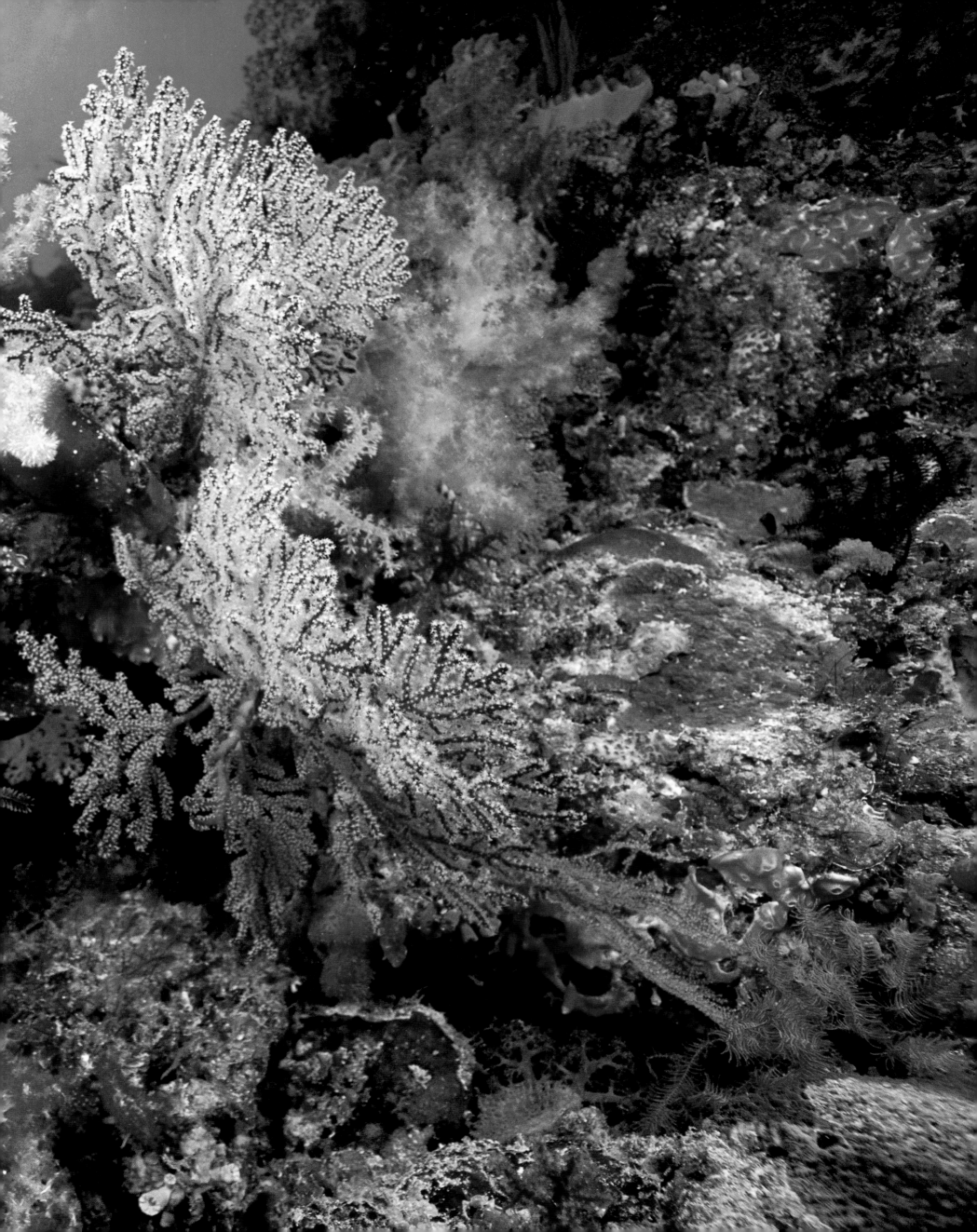

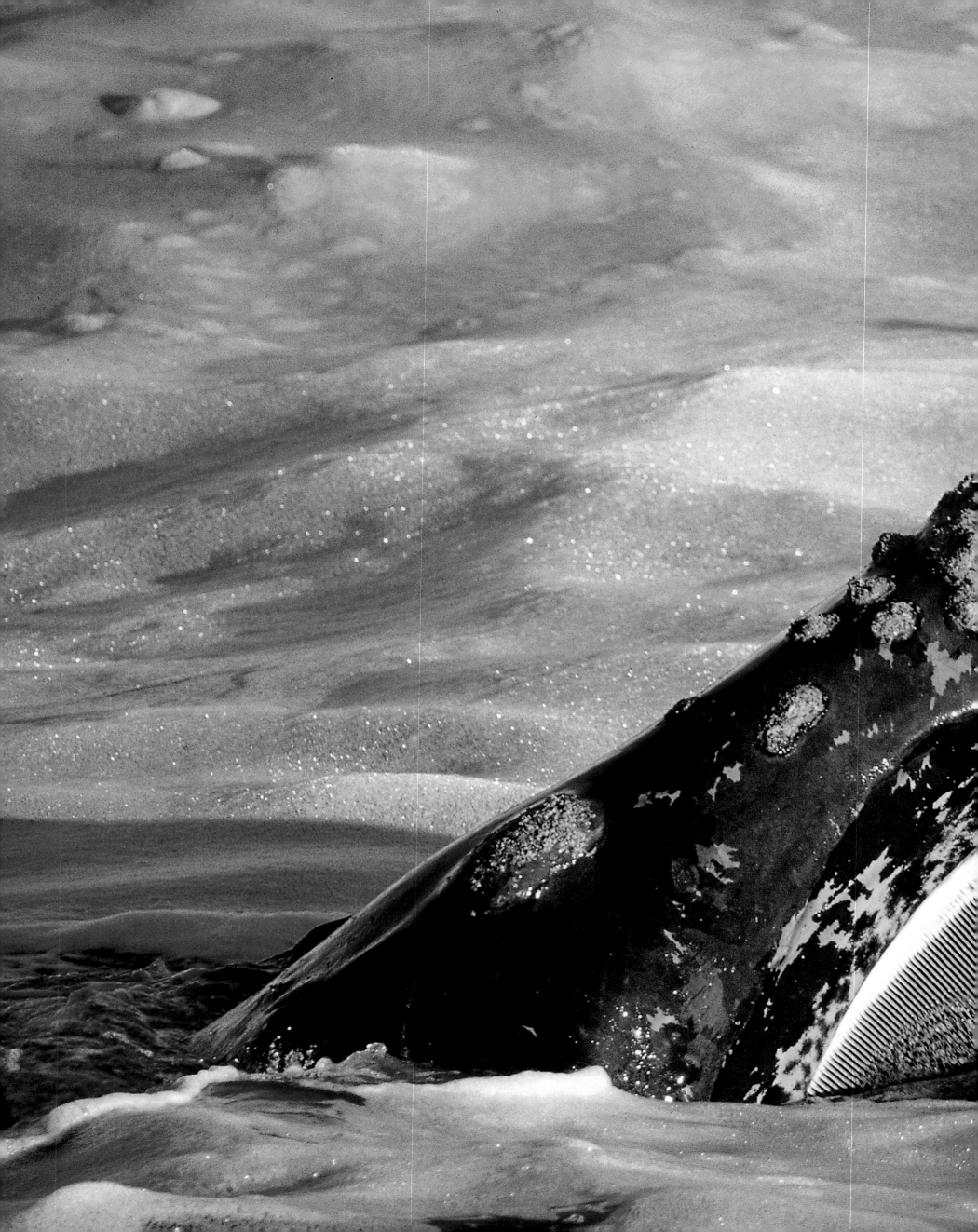

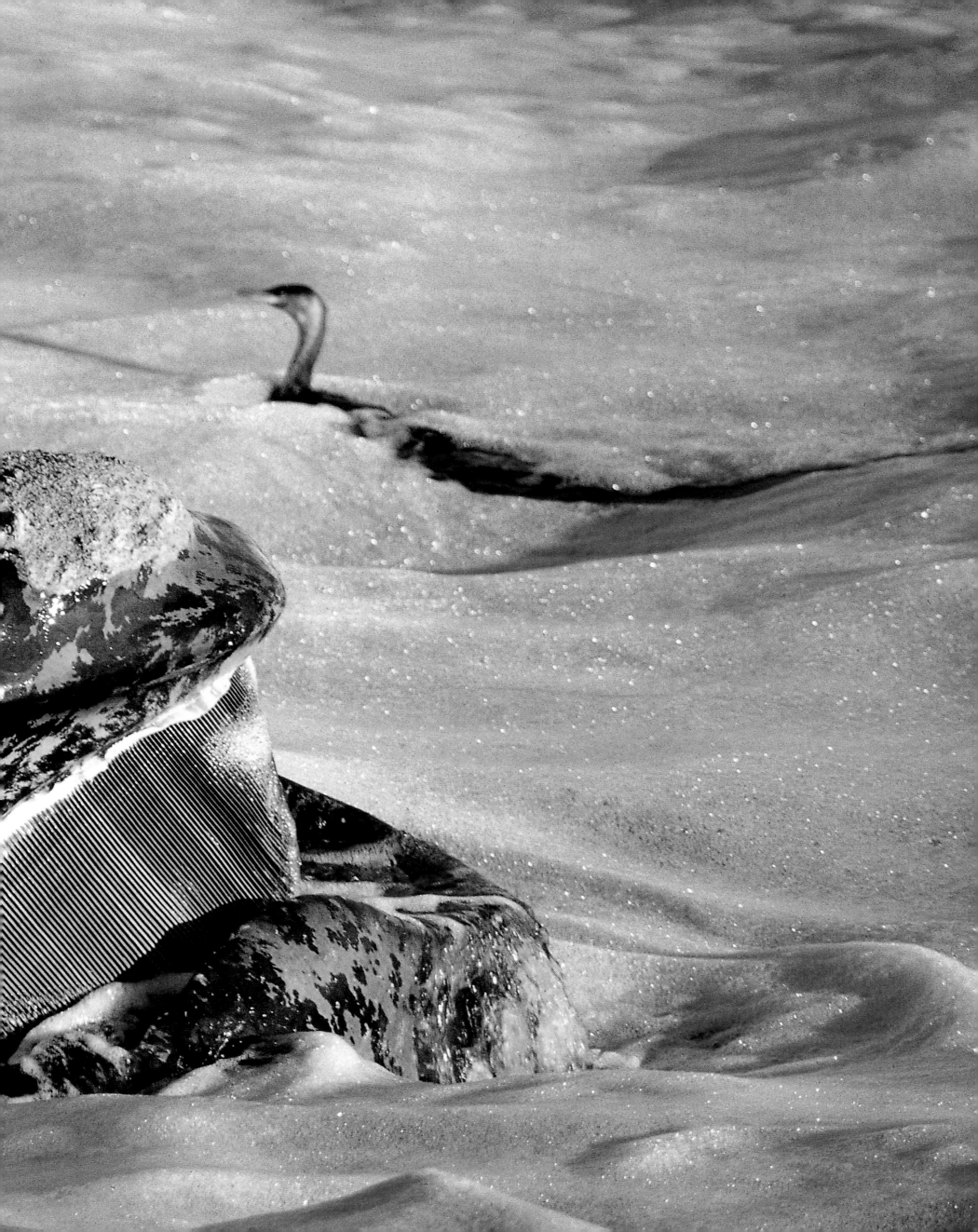

Preceding pages: Amid the sea foam off the coast of South Africa, a southern right whale, a few yards away from a cormorant, surfaces briefly to breathe. The cormorant has nothing to fear. The right whale is endowed with baleen plates and feeds chiefly on krill (tiny shrimp), which it gathers by straining water.

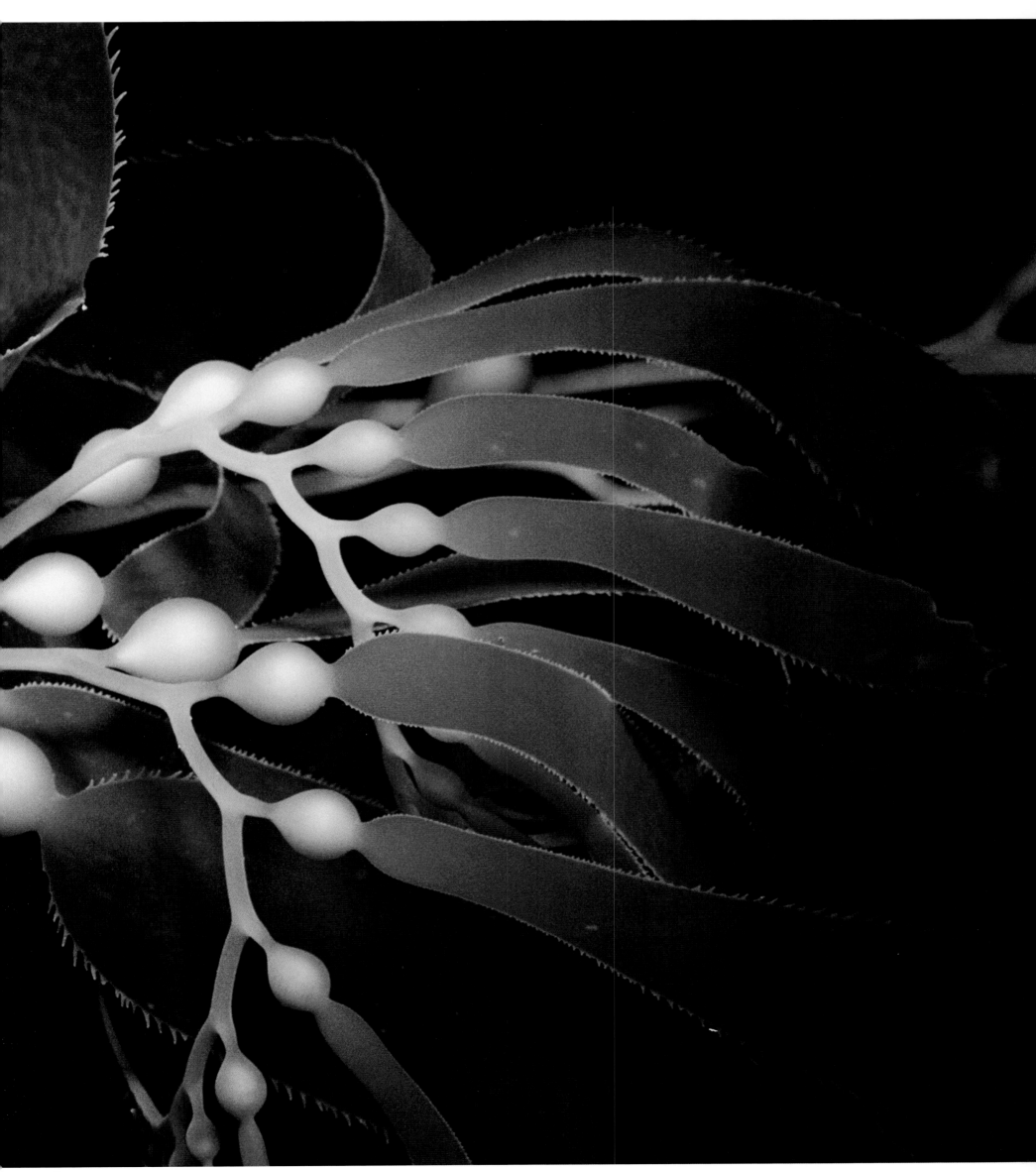

Above: This beautiful seaweed, called kelp (*Macrocystis pyrifera*), is certainly the largest marine organism in the world: it can grow to a length of almost 300 feet, at the rate of more than one foot per day. It is found mainly in the waters off the coast of California. Many fish and invertebrates live and breed in these kelp "forests." Introduced elsewhere in the world—for example, in Brittany in the 1970s—to develop the alginate industry, this seaweed spreads rapidly, though today it seems to have been brought under control.

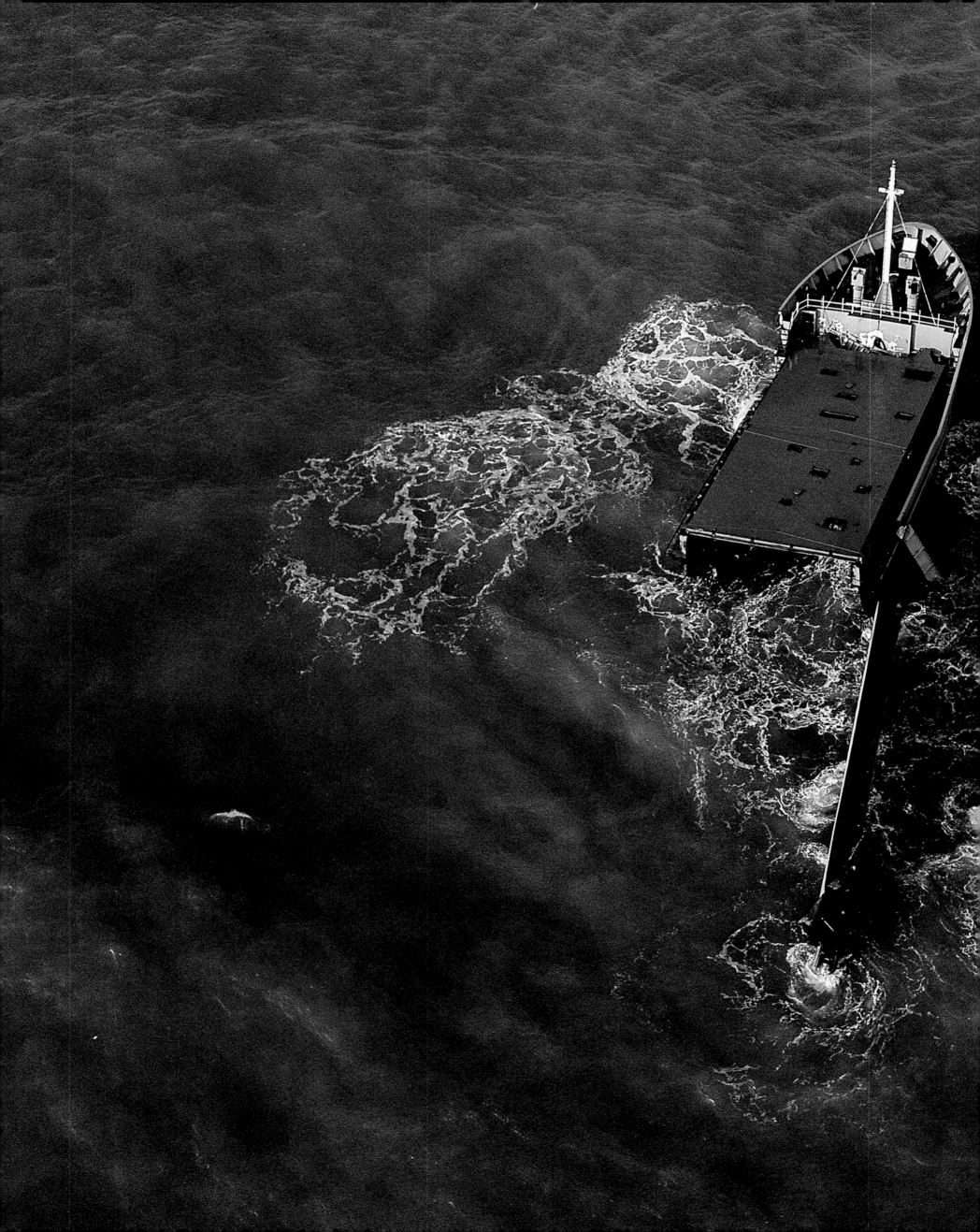

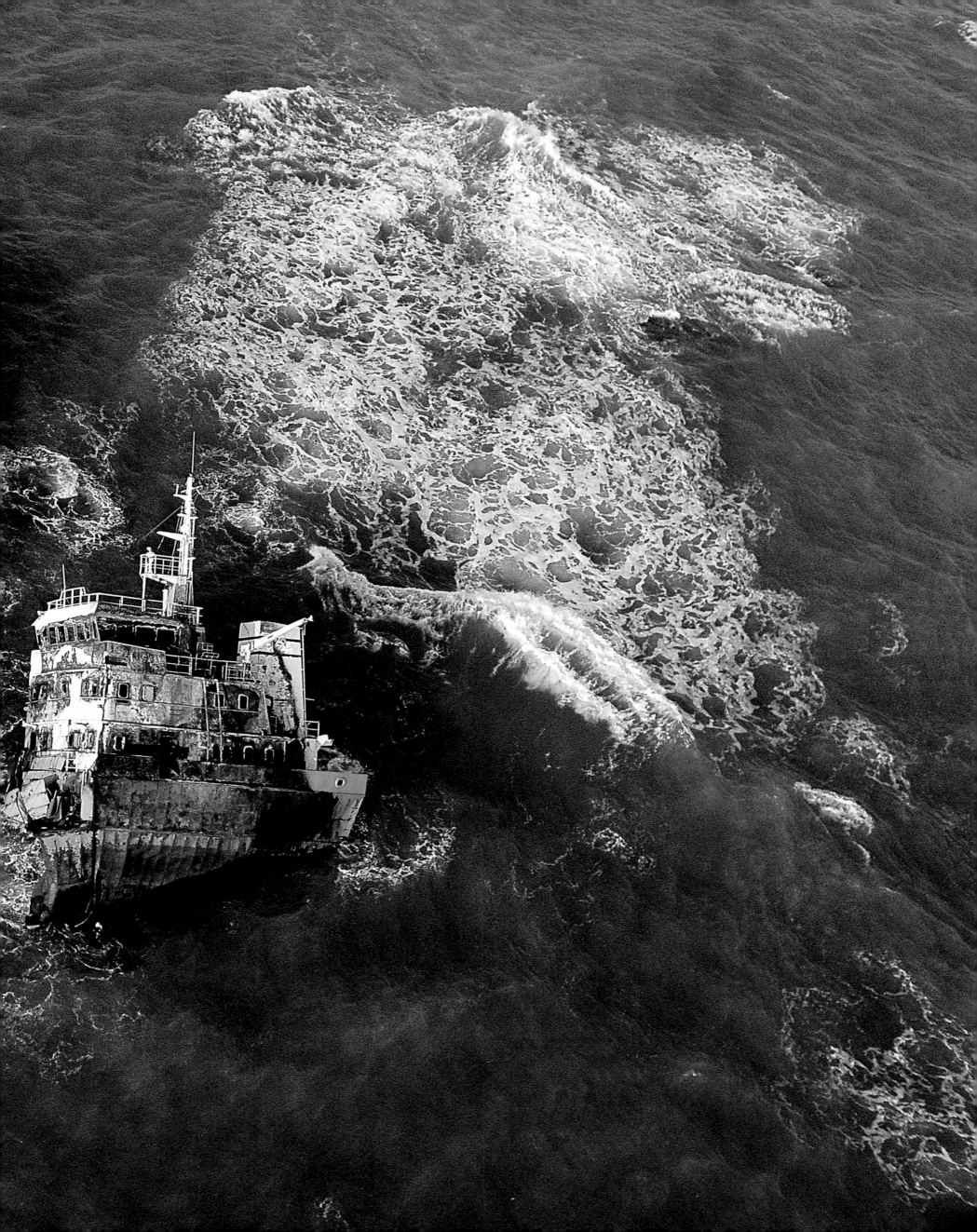

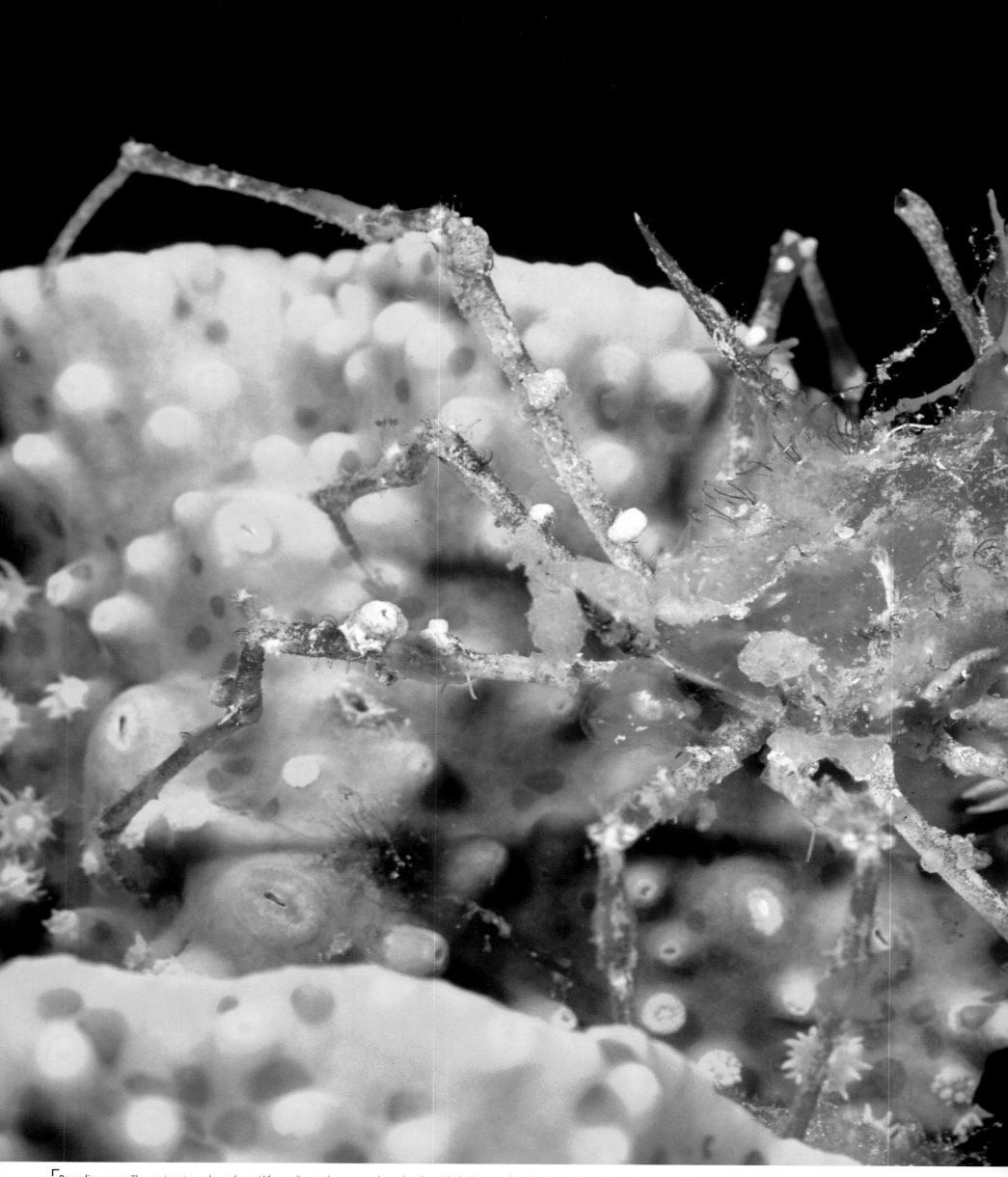

Preceding pages: The sea is not a garbage dump. When a disaster happens and an oil tanker sinks (as happened to the ships *Erika* and *Prestige*), it is very difficult to recover its hull; it sinks to the sea floor, where it acts as an artificial reef. It becomes home to a multitude of fish and invertebrates.

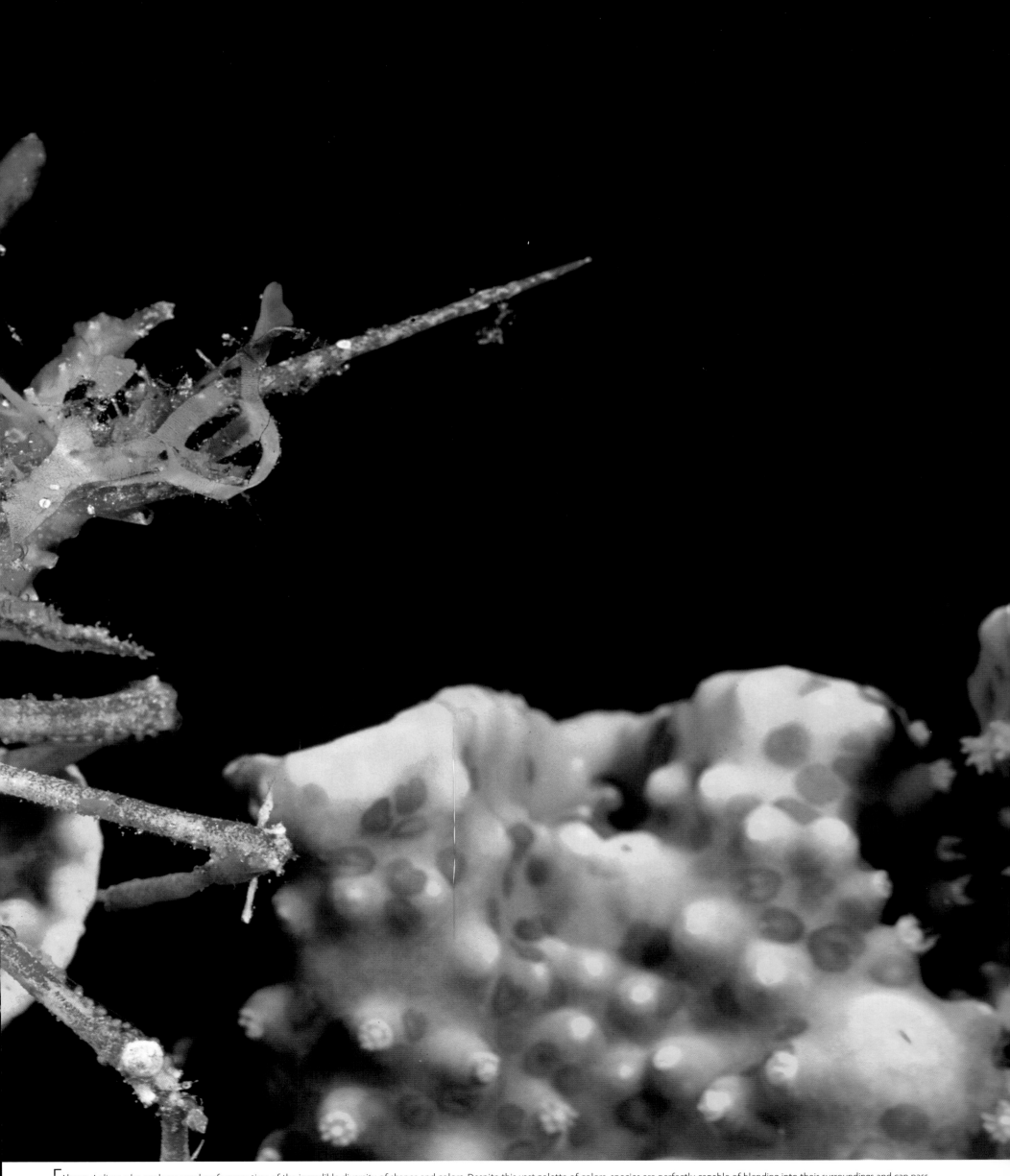

Above: A diver who explores coral reefs never tires of the incredible diversity of shapes and colors. Despite this vast palette of colors, species are perfectly capable of blending into their surroundings and can pass completely unnoticed. Here, this small, motionless spider crab is completely invisible against the coral's craggy surface.

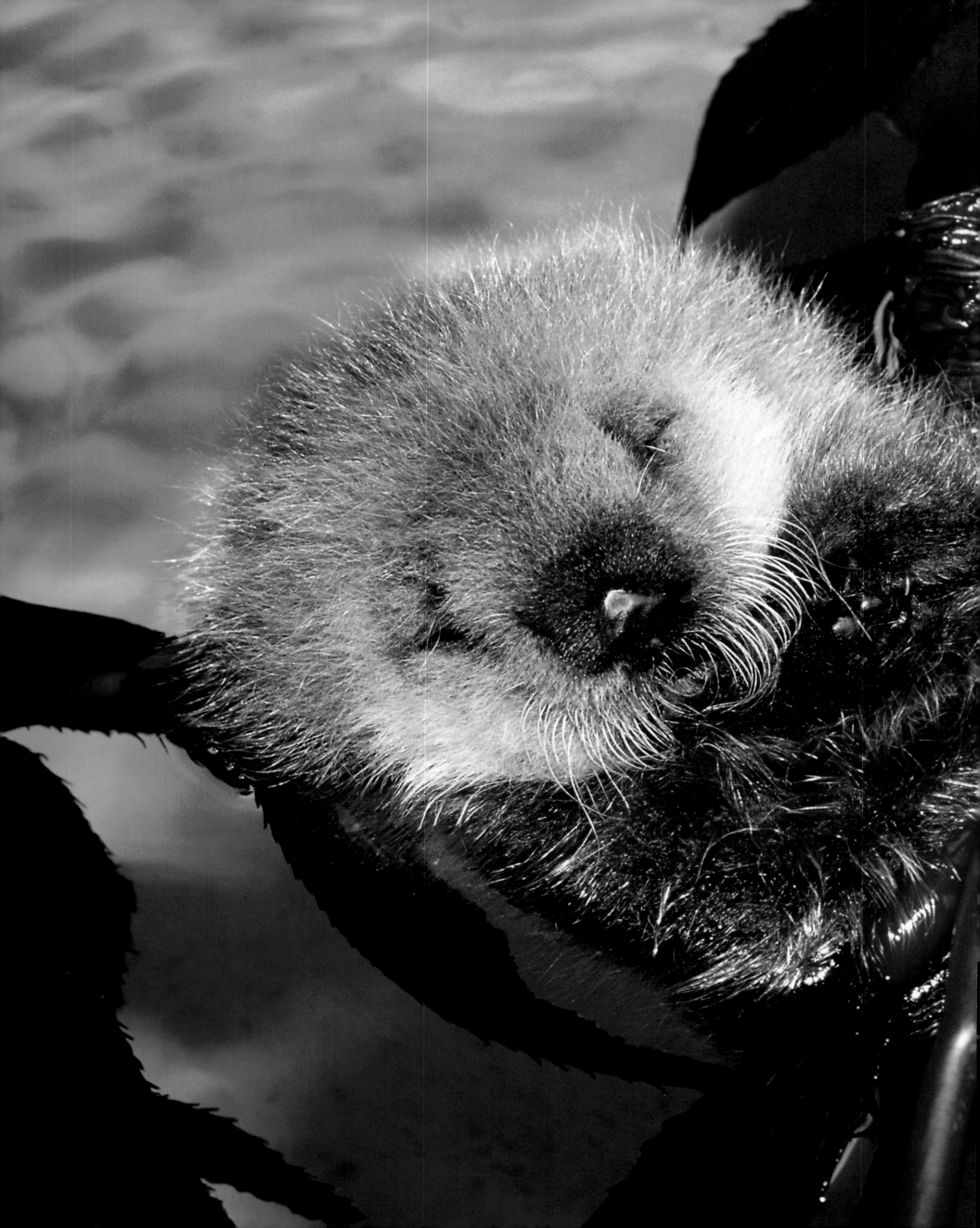

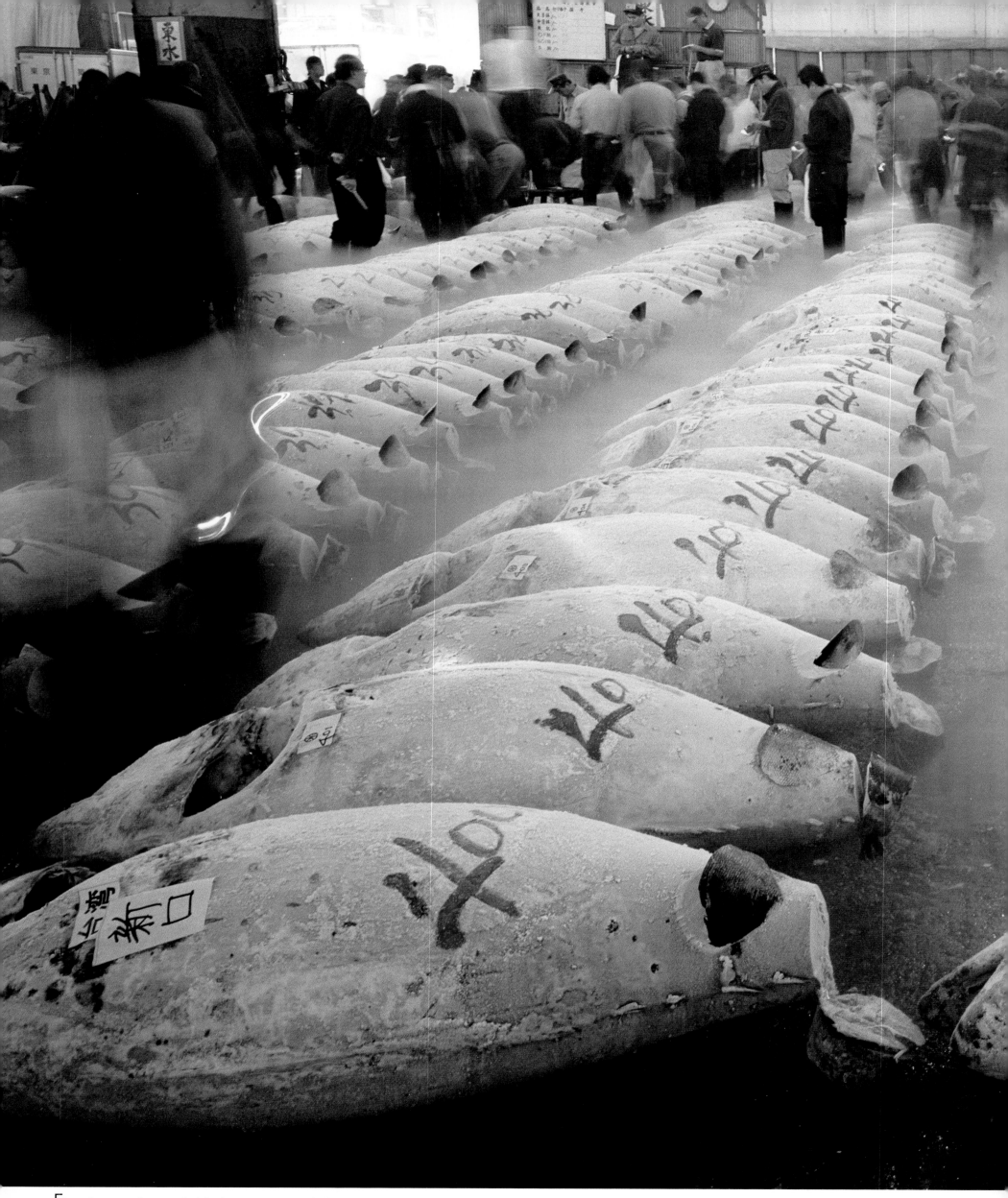

Preceding pages: Clinging to the kelp, this sea otter seems to be leading a perfectly happy life in the port at Monterey, California, where the species is common. However, the truth belies this rosy scenario. Throughout California waters, north to Alaska, the sea otter faces many threats: water pollution and pathogenic viruses in California, and disruption of the food chain in areas of Alaska. In the latter region, a sharp decline in the numbers of fish species have led killer whales to feed instead on sea otters, decimating entire colonies.

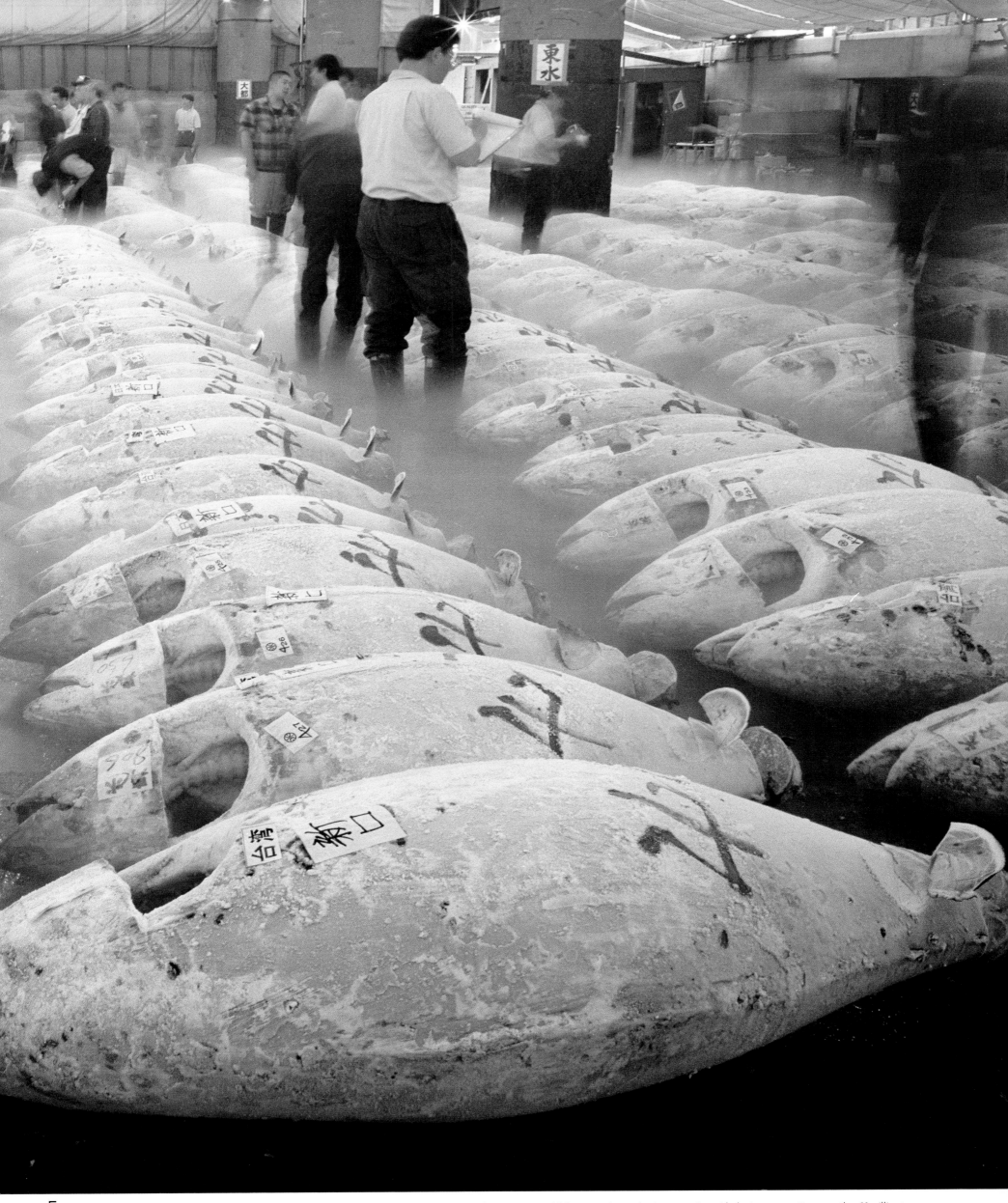

Above: The Tsukiji Ichiba fish market in Tokyo is the biggest in the world, with a daily turnover of more than 2,700 tons of fish. Tuna is the predominant species, with the Japanese eating more than 1.1 million tons every year. However, for several years catches have dwindled as tuna stocks have diminished; the national catch is now less than 330,000 tons. Because of this, Japan must now import most of its tuna.

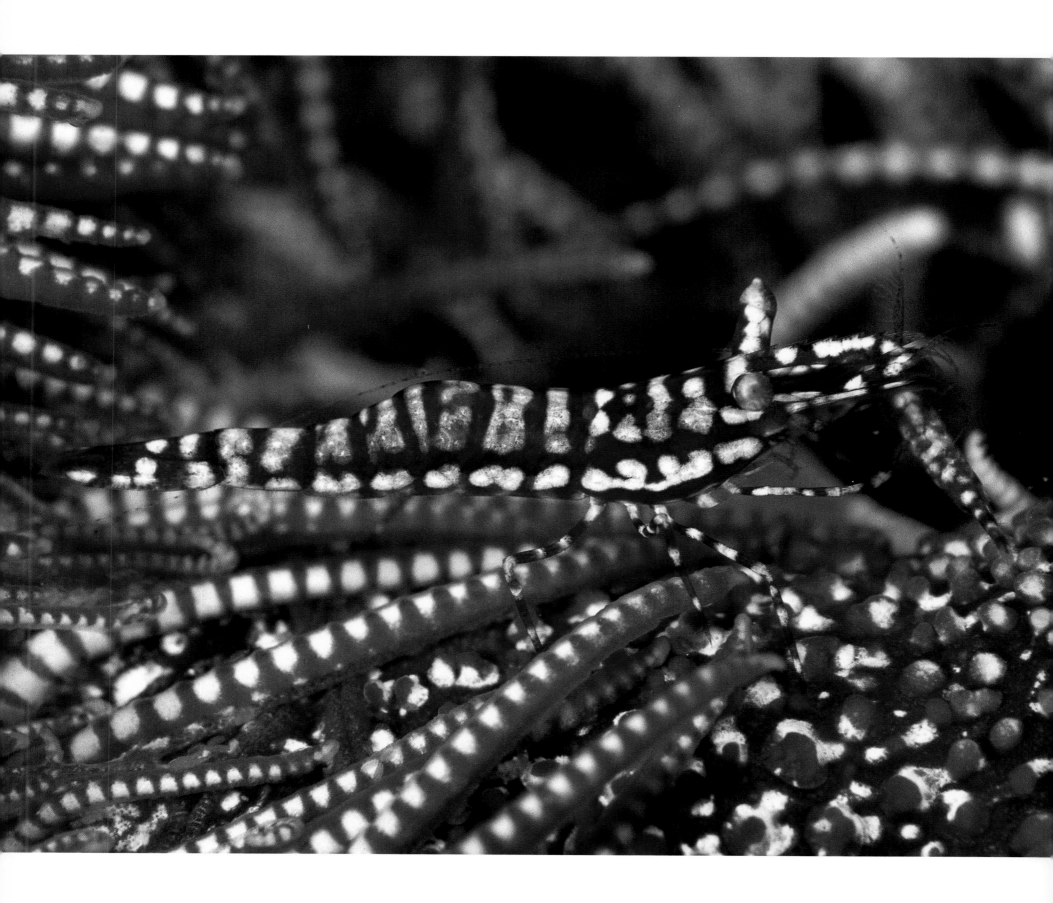

Above and right: One might be forgiven for thinking these were two different species of shrimp, but in fact the crinoid shrimp (*Periclimenes commensalis*) is able to flaunt a whole palette of colors, much like a chameleon. It takes on the color of its hosts—comatulids (crinoids closely related to starfish)—with which it lives in a perfect commensalism. This species is found in warm seas, from East Africa to the Great Barrier Reef in Australia, and as far north as Japan and New Caledonia.

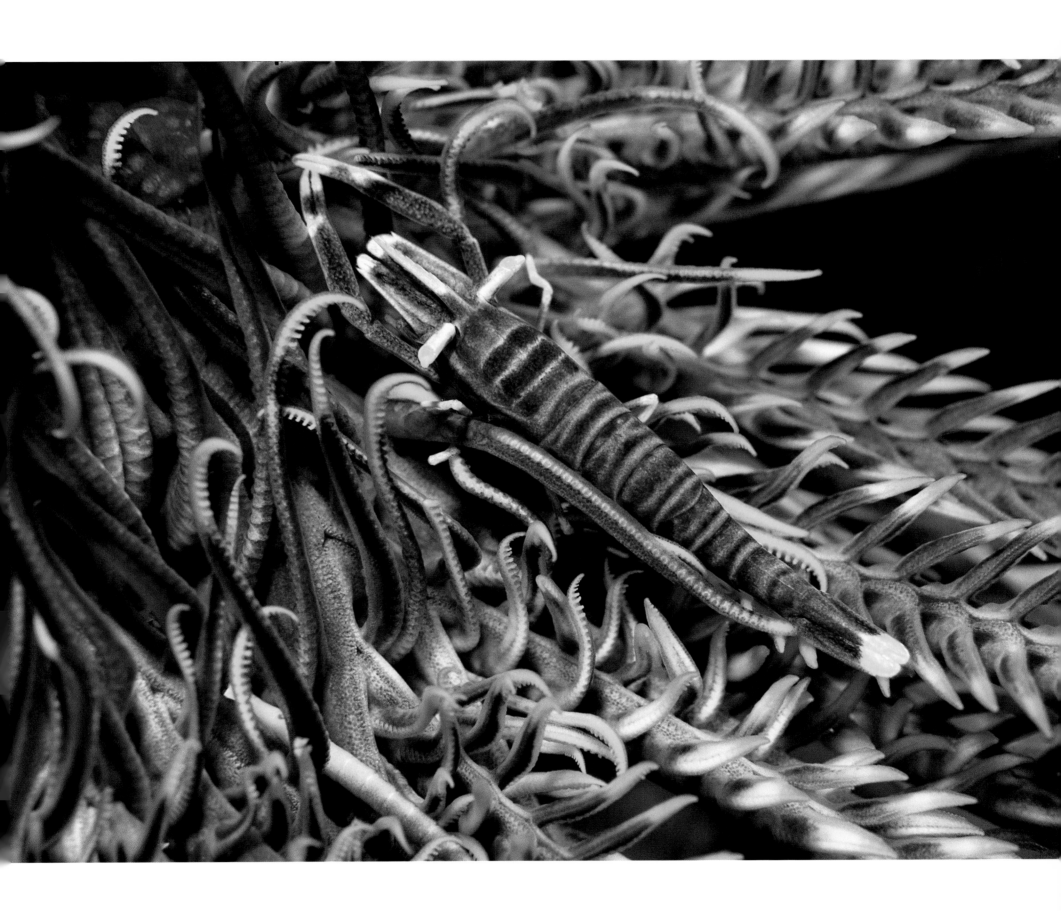

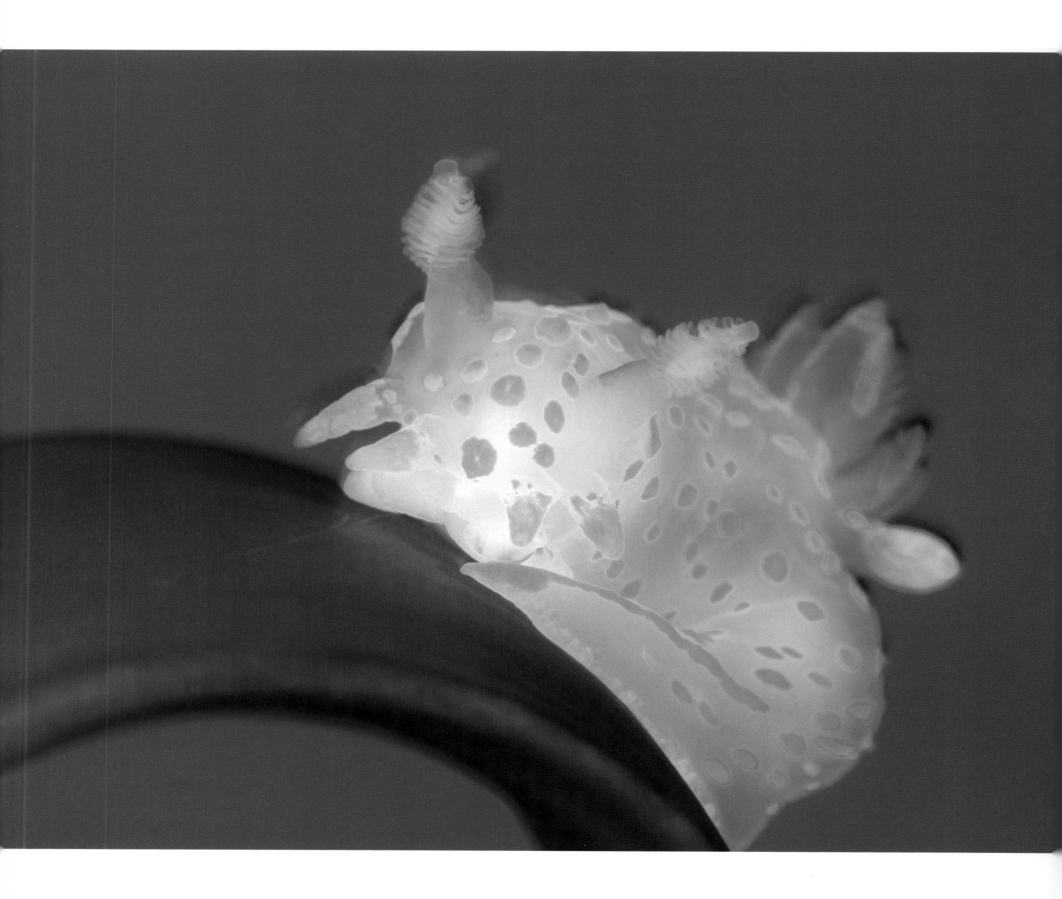

This marine mollusk, which faintly resembles a slug, is a nudibranch. Given its beautiful coloring, one might think that it lives in the tropical waters of the Pacific or Indian oceans. But in fact this particular mollusk, attached to a laminaria (seaweed), was photographed in Norway. The species, *Polycera quadrilineata,* is found in waters from the Arctic Ocean to the Mediterranean.

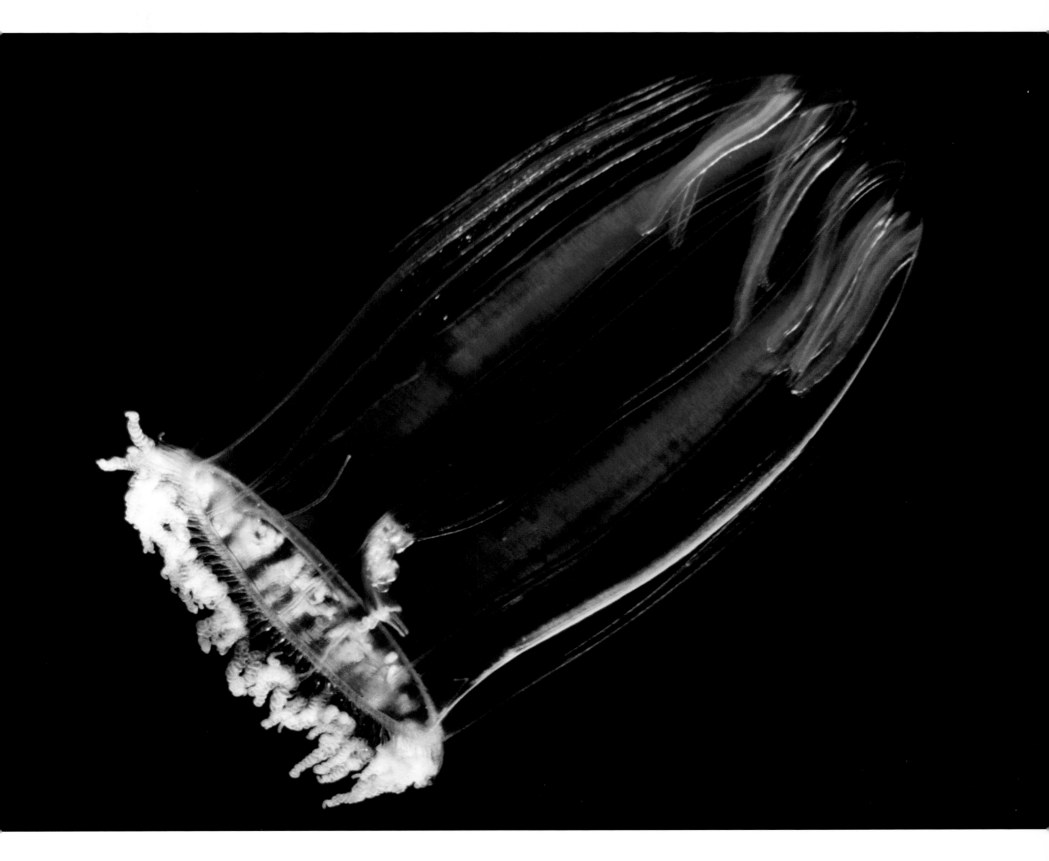

This luminescent zooplankton was photographed in the Arctic Ocean. Often at sea, as a ship churns up the water, it leaves behind a brilliant wake of billions of tiny invertebrates. Bioluminescence is the production of light by living things. Although fireflies (glow-worms) use it on land to attract a mate, we know little of its function among these marine organisms.

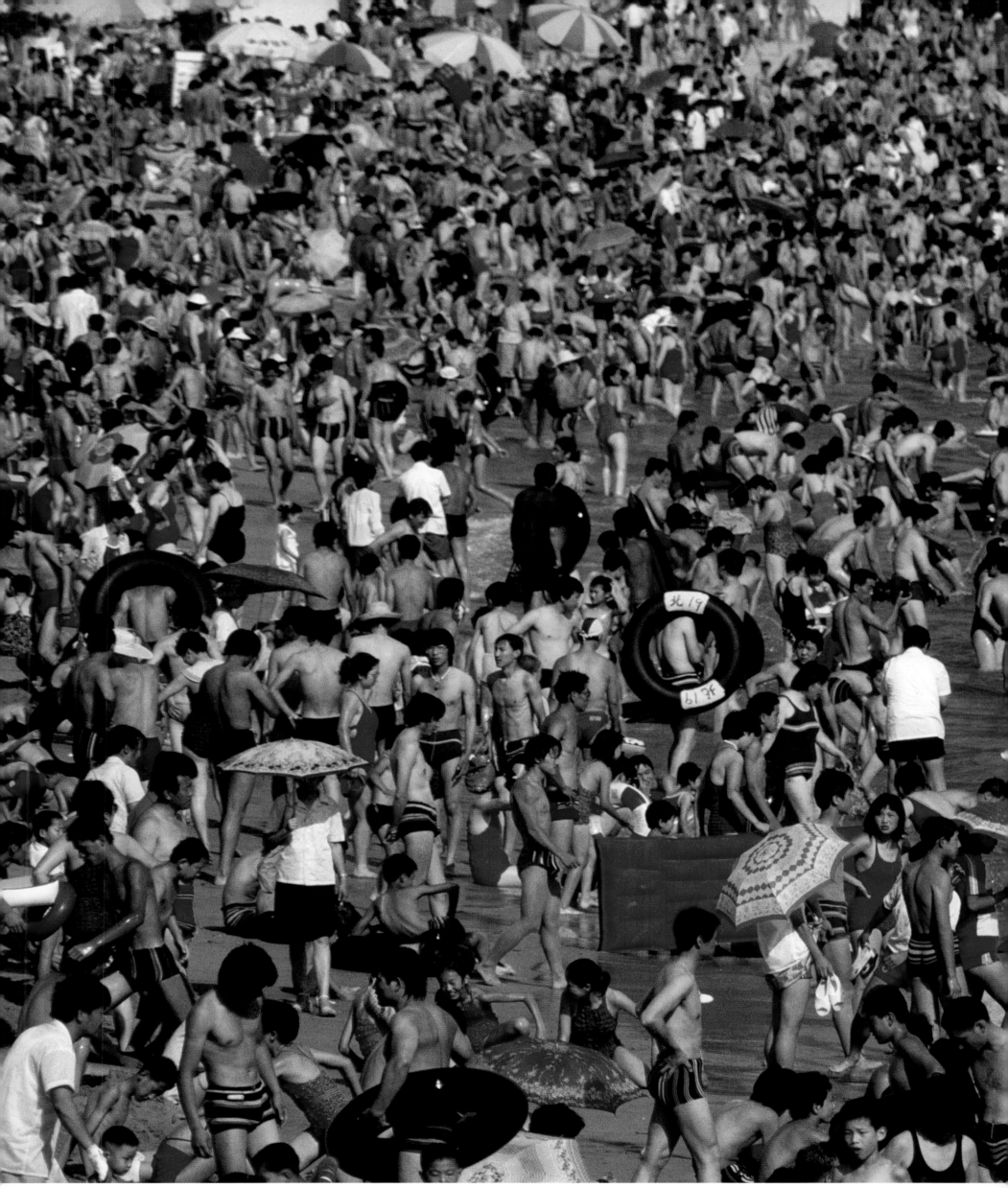

Above: Today in China, beaches are overrun at holiday time. The leisure industry, which is rapidly becoming a global phenomenon, will soon have to take into account the environmental consequences of its expansion, to avoid wiping out fragile coastal ecosystems.

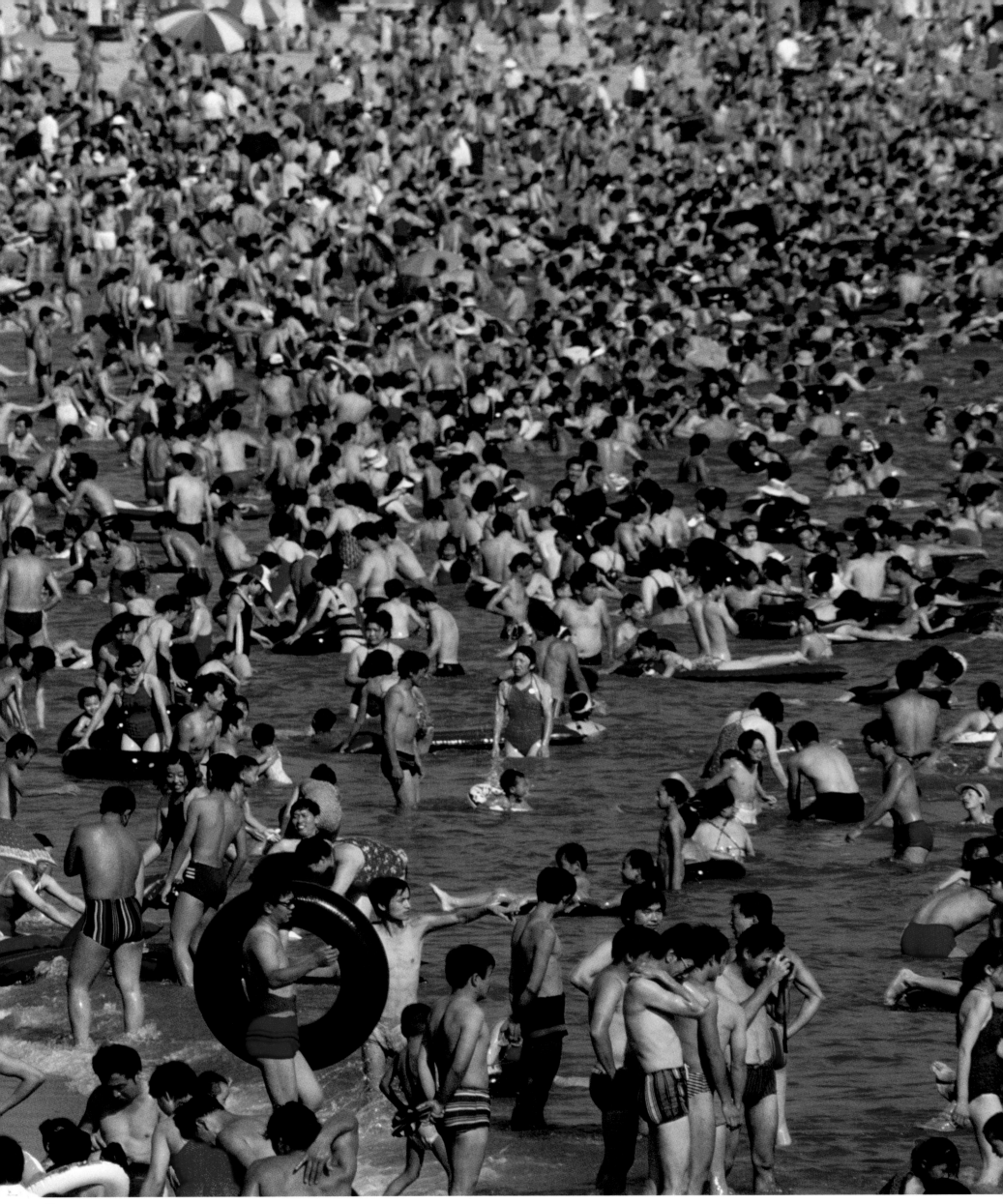

Following pages: When great storms rage, like those of October 1987 and December 1999, and the ocean whips itself into a frenzy, pleasure boats are tossed about like straws, as happened here in the port of La Rochelle. Storms remind us of our fragility in the face of the elements.

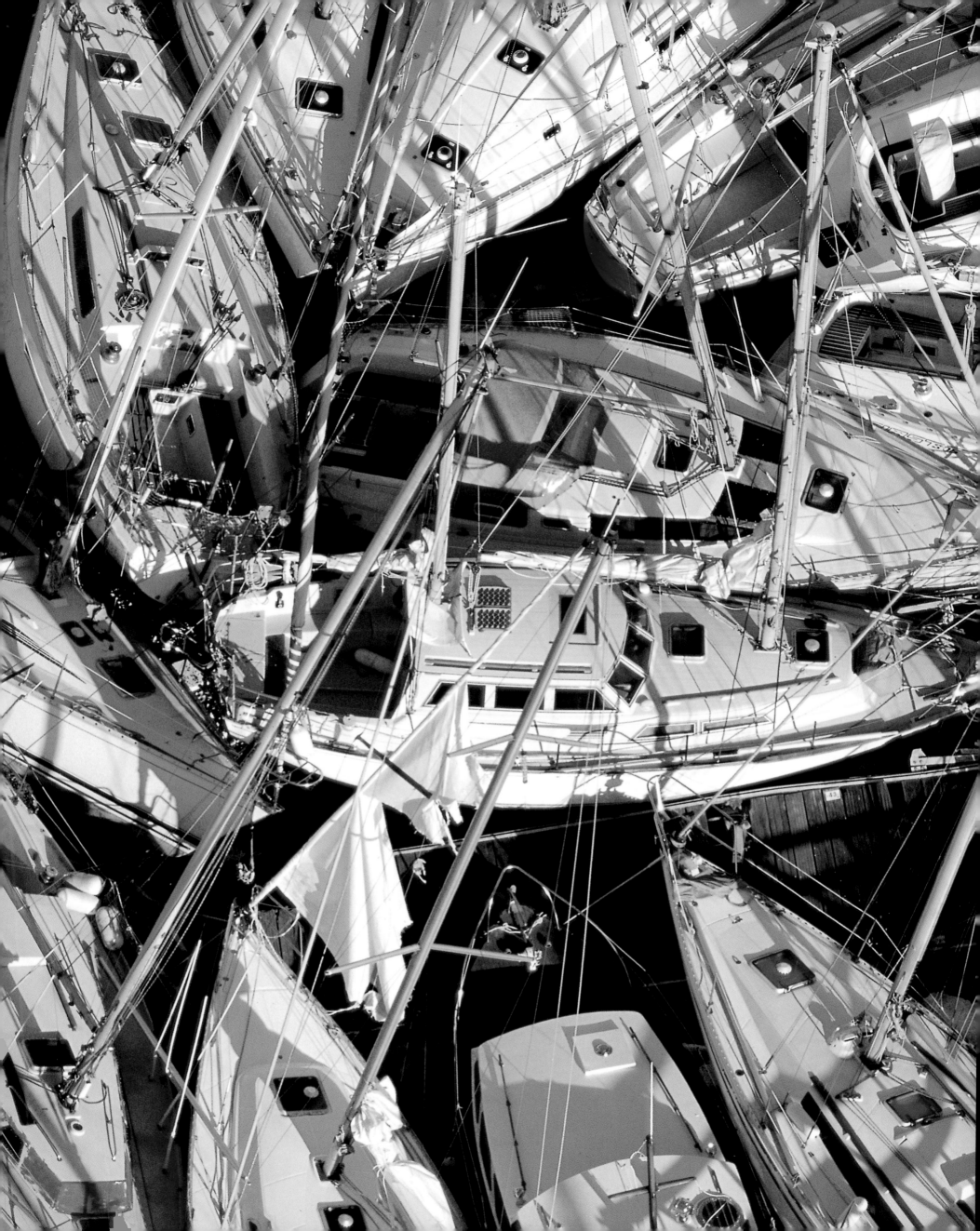

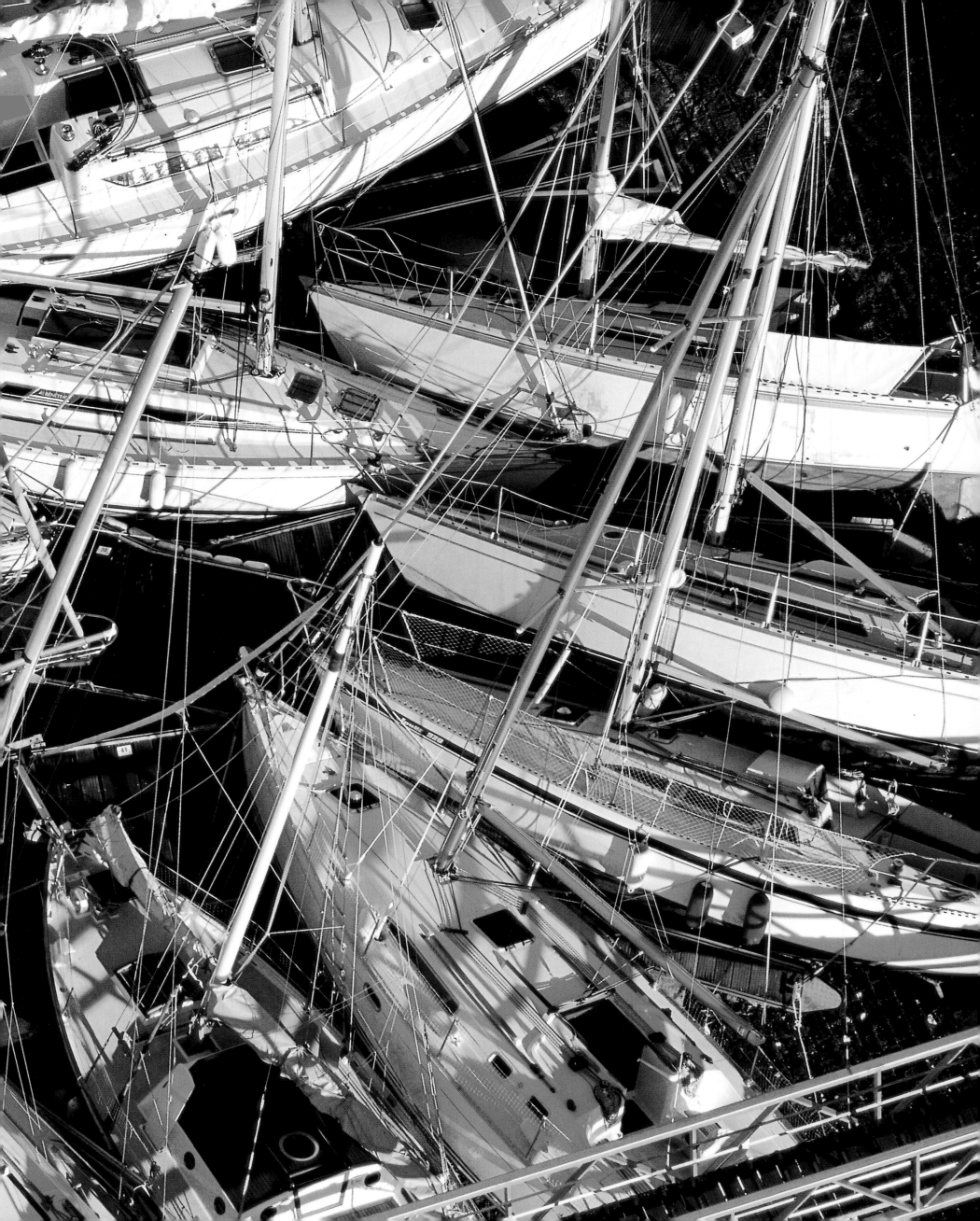

Deserts

Whether they are great stony plains or veritable oceans of dunes, all deserts have something of the divine. Winds and sand sculpt rocks into astonishing, unreal shapes. The materials and colors are indescribable and sublime. When the air is clear, the horizon seems to vanish into the edges of the world. Just before daybreak everything is bathed in a gray tint; then, suddenly, colors appear as if by magic. Light floods the contours of the land as the interplay of shadows reveals and heightens.

Left: Some places, such as Monument Valley, Arizona, have been spared from human interference. We should not be deceived by the fascination that the desert exerts on humans: whatever we claim it expresses or embodies is nothing more than a projection of our personal expectations. The desert merely reveals, acting as a mirror, reflecting the souls of those who love it or live there.

Deserts

I once had the extraordinary good fortune to spend a few days in the desert with the legendary biologist and environmentalist Théodore Monod. I would not trade those moments for all the riches in the world. They were wonderful.

In fact, the most beautiful remark about deserts came from Monod himself. Monod, who undertook long expeditions in the Sahara Desert to study its flora and fauna, said, "Deserts are like a subtraction." This is an extraordinary assertion. It marvelously illustrates what it is about the desert that fosters purity. He also said, "Here, a king becomes the slave of reality." It is true that, in contrast to the world we are accustomed to (which offers all sorts of distractions, where we lose ourselves and flee from the truth), deserts bring us back to reality, to the very essence of life. In this sense they are providential. We all should have the opportunity, some day, to spend time in the desert. It is a spiritual ecosystem, where we are forced to face ourselves.

The desolation of the Sahara or the Atacama deserts has a sublime, purified quality that brings us into contact with what is essential. Life in the desert means economizing scarce resources, the antithesis of today's civilization of waste. In a sense, life inside and life outside the desert are two extremes. If our society were to get to know the desert, it might find the correct balance to ensure humanity's survival.

In Niger, in the Aïr region, I flew in a tiny glider over the world's biggest sand dunes—those of the Temet. We flew like a shadow, borne along on the warm air, which allowed us to skim the ridges with a sensation of incredible softness. Above these dunes, very close to the sand and its heat, among these voluptuous, soft hills, we caressed the belly of the world. It is an almost fetal pleasure—the remembrance of absolute well-being.

Farther south in Africa, the Namib Desert is one of the most affecting, because it combines two climates: warm, which comes from the land, and icy, which comes from the ocean's cold currents. Animals from these two extremes come together in an unreal way at the spot where the climates meet—on the beaches. Quite often, elephant seals rub shoulders with elephants.

With their infinite, majestic spaces, deserts appear to be uninhabited. Yet they conceal precious life in places called oases—tiny patches of green, teeming with life. They may have a spring or well—water here is both precious and plentiful. But in the great bare spaces there is life, too, both unexpected and inconspicuous. In these extreme environments, desert plants and animals demonstrate some of the extraordinary adaptations of which living things are capable. Each species, from microscopic life forms to large mammals, displays ingenious strategies—using their shapes, colors, ways of life, or survival instincts—to survive in these arid, unforgiving places. How can we not be astounded by the flowering of the desert after a rain—a miracle of life, proof of ubiquitous biodiversity? Here, life takes advantage of fog and the slightest trace of available water in order to survive. Deserts receive less than four inches of rainfall per year. And yet an extraordinary fauna lives in the *regs* (vast plains covered with sand and pebbles) and the *ergs* (immense massifs of dunes); the fauna has been able to adapt to the extreme constraints of an arid climate.

Life and water are inseparable. In these vast spaces, where this blue gold may appear only in the shape of a fine, fleeting mist, you'll find that life has developed a precious inventiveness in the forms it takes and in its modes of behavior.

Life and water are inseparable. In these vast spaces, where this blue gold may appear only in the shape of a fine, fleeting mist, you'll find that life has developed a precious inventiveness in the forms it takes and in its modes of behavior.

Plants capture the smallest drop of water within their reach and reduce loss to a minimum by using their spines or leaves covered with a waxy layer to minimize evaporation. Animals, for their part, can survive without drinking. Herbivores seek out succulent plants that are rich in water, as well as juicy roots, tubers, and bulbs. The metabolism of herbivores enables them to extract the water contained in this vegetation, retaining as much as possible. They sometimes eliminate sweating and pass highly concentrated urine and dry droppings, excreting the minimum.

Carnivores, too, can survive without drinking, using the water found in the bodies of their prey. The moloch (also known as the mountain devil or spiny lizard) of Australia is a reptile that can absorb moisture from sand. It gathers droplets of water through fine grooves in its skin and takes them to its mouth.

Under the sand, in deep burrows, small rodents and other mammals take refuge from the heat. Some of them become torpid during the hot months. In order to avoid the sun, animals often look for food at night, dawn, or dusk.

> The imposing size of deserts should not blind us to the fact that they are extremely vulnerable. Veritable colossi with feet of clay, deserts today are imperiled by new threats on an unprecedented scale.

From the microscopic to the largest, plants and animals have succeeded in surviving in these extreme environments. But life is balanced on a tightrope. In these expanses that seem infinite on a human scale, which have been the cradle of astonishing life forms for thousands of years, remarkable biodiversity has been forced to endure ever more extreme conditions. Fauna and flora have been able to adapt to these demanding environments by incredible ingenuity.

However, the imposing size of deserts should not blind us to the fact that they are extremely vulnerable. Veritable colossi with feet of clay, deserts today are imperiled by new threats on an unprecedented scale.

The exciting majesty of these great open spaces poses a challenge. Destructive auto races are organized every year that show a total lack of respect for the environment and for the plants and animals that live there. I personally regret having taken part in one of these when I was young and passionate about competitive sport: the Paris–Dakar rally. Since then, however, I have traveled through many deserts and discovered the secrets of life that lie hidden within them: deserts command the utmost respect.

What lies beneath the deserts also spurs greed. Humans have imposed themselves here, without constraints or precautions, to extract oil and nonrenewable reserves of ancient ground water.

The fauna of the desert—birds, ungulates, and large carnivores—are victims of greed, trafficking, and hunting for sport, which kills them in vast numbers and endangers their survival. One example is with the bustard, a desert bird that used to be caught using falcons. Today, hunters drive SUVs and carry out veritable massacres in the Sahara every year, putting the entire species in peril.

Some men have made an impression on me in my encounters with these very special milieus, but all one needs to do is travel to these environments to understand that the life forms that have developed there command admiration and respect. This miraculous biodiversity has made the deserts the ambassadors of living ingenuity. If we are not careful, ignorance and idiotic greed may turn these majestic spaces from havens for life into dead expanses, where man will have annihilated life without even noticing.

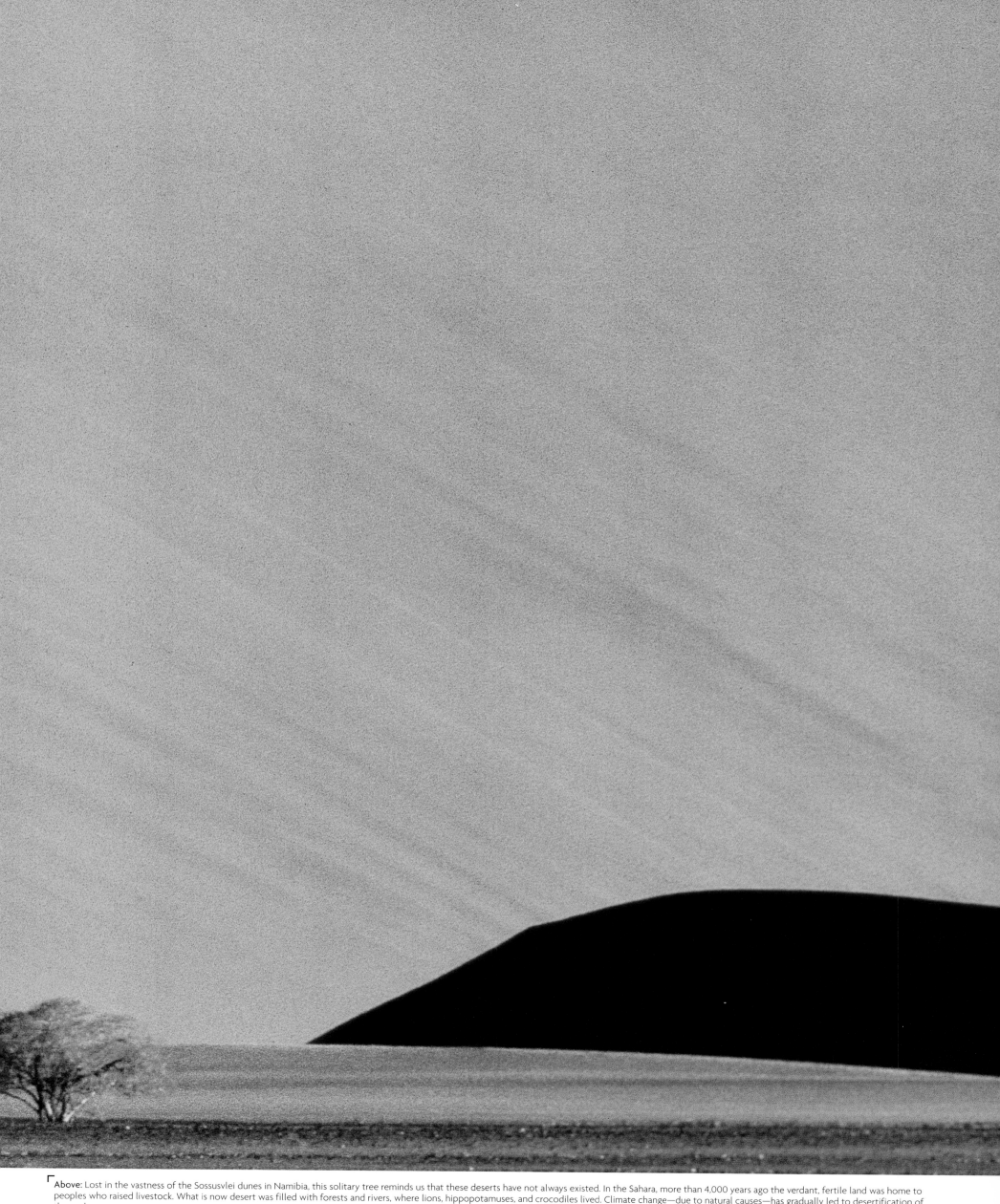

Above: Lost in the vastness of the Sossusvlei dunes in Namibia, this solitary tree reminds us that these deserts have not always existed. In the Sahara, more than 4,000 years ago the verdant, fertile land was home to peoples who raised livestock. What is now desert was filled with forests and rivers, where lions, hippopotamuses, and crocodiles lived. Climate change—due to natural causes—has gradually led to desertification of these places.

Right: Life in the desert demands extraordinary adaptation to heat and lack of water. For this reason, the animal and plant species that live there are neither numerous nor diverse. However, those that have succeeded in adapting can endure extreme climatic conditions, like this little Namibian web-footed gecko (*Palmatogecko rangei*), which has found a solution: it is nocturnal.

66

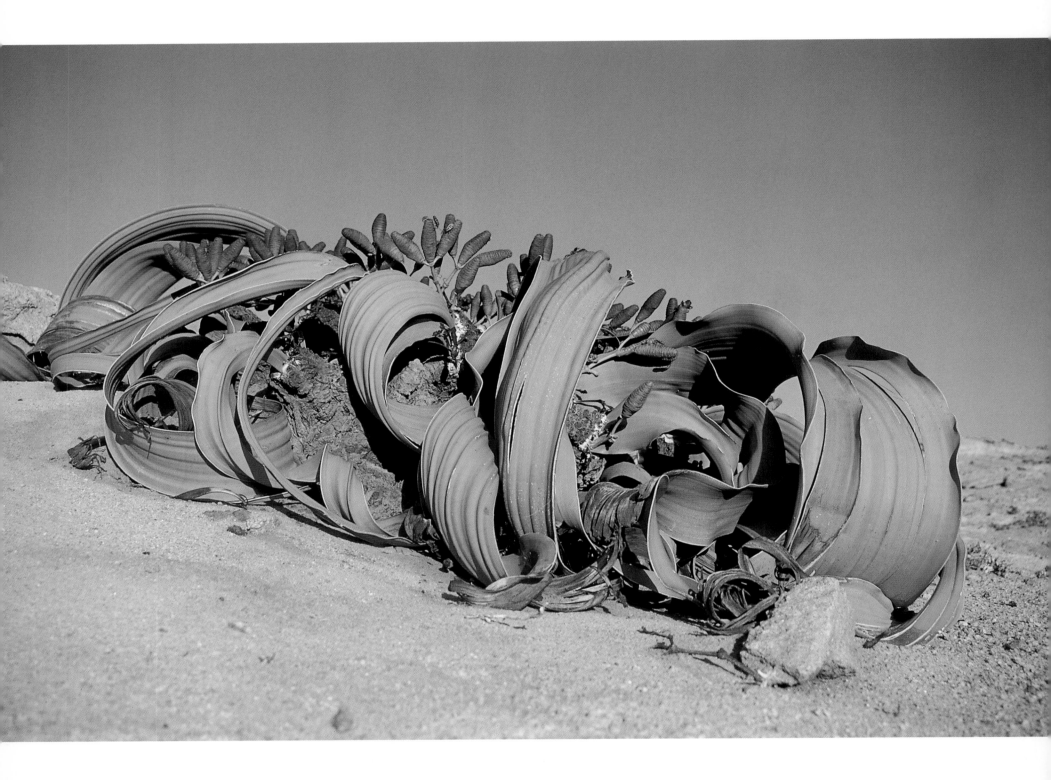

Above: Welwitschia is certainly one of the most extraordinary plants in the world. Discovered only in 1929, this native of the Namib and Kalahari deserts is distantly related to conifers and can live up to 2,000 years. It possesses two leaves, growing opposite each other, that can reach a length of 20 feet. These leaves continue growing indefinitely, curling in on themselves while their ends wither. To gather water deposited by morning mists, the plant's roots form a network in the ground that stretches out laterally.

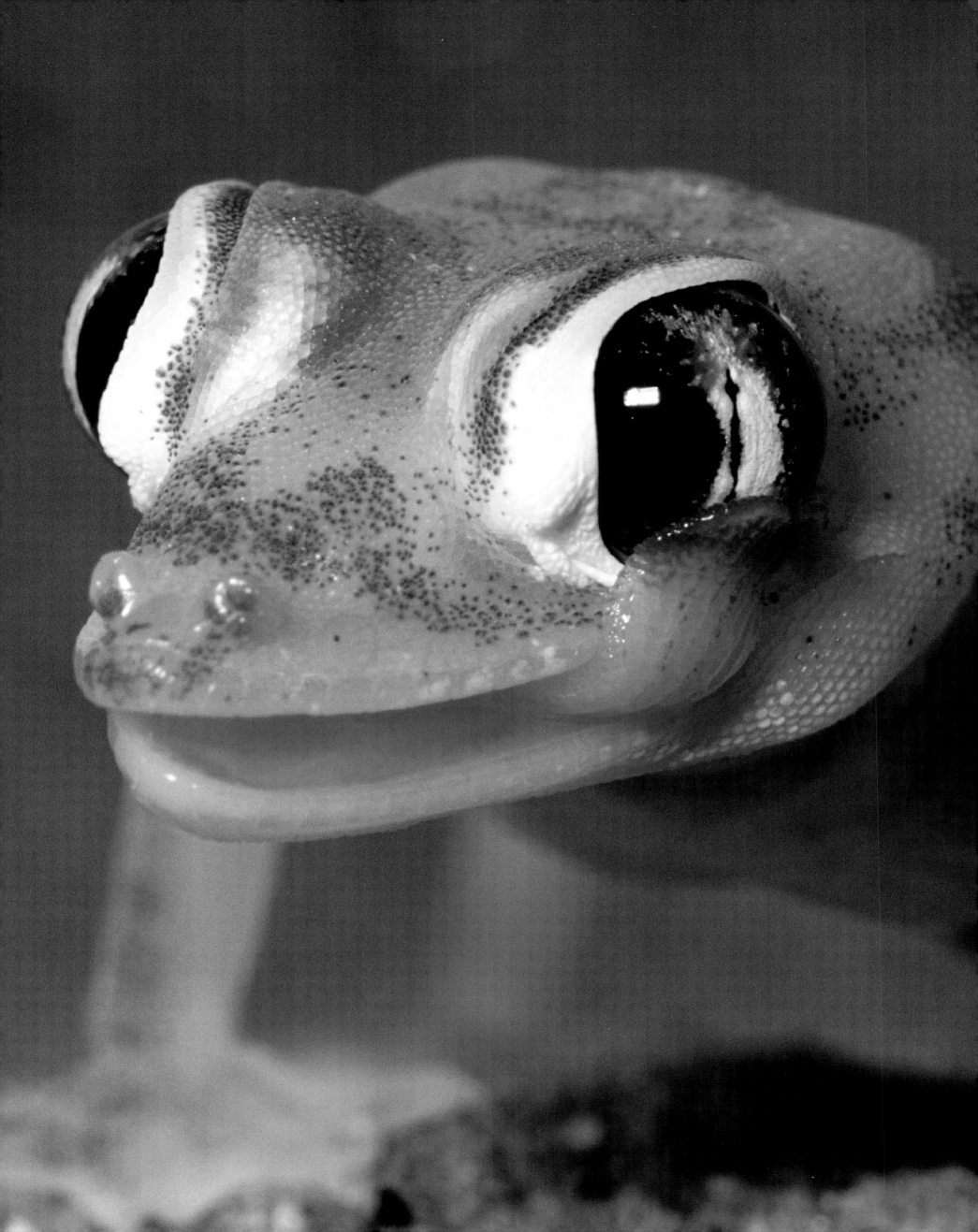

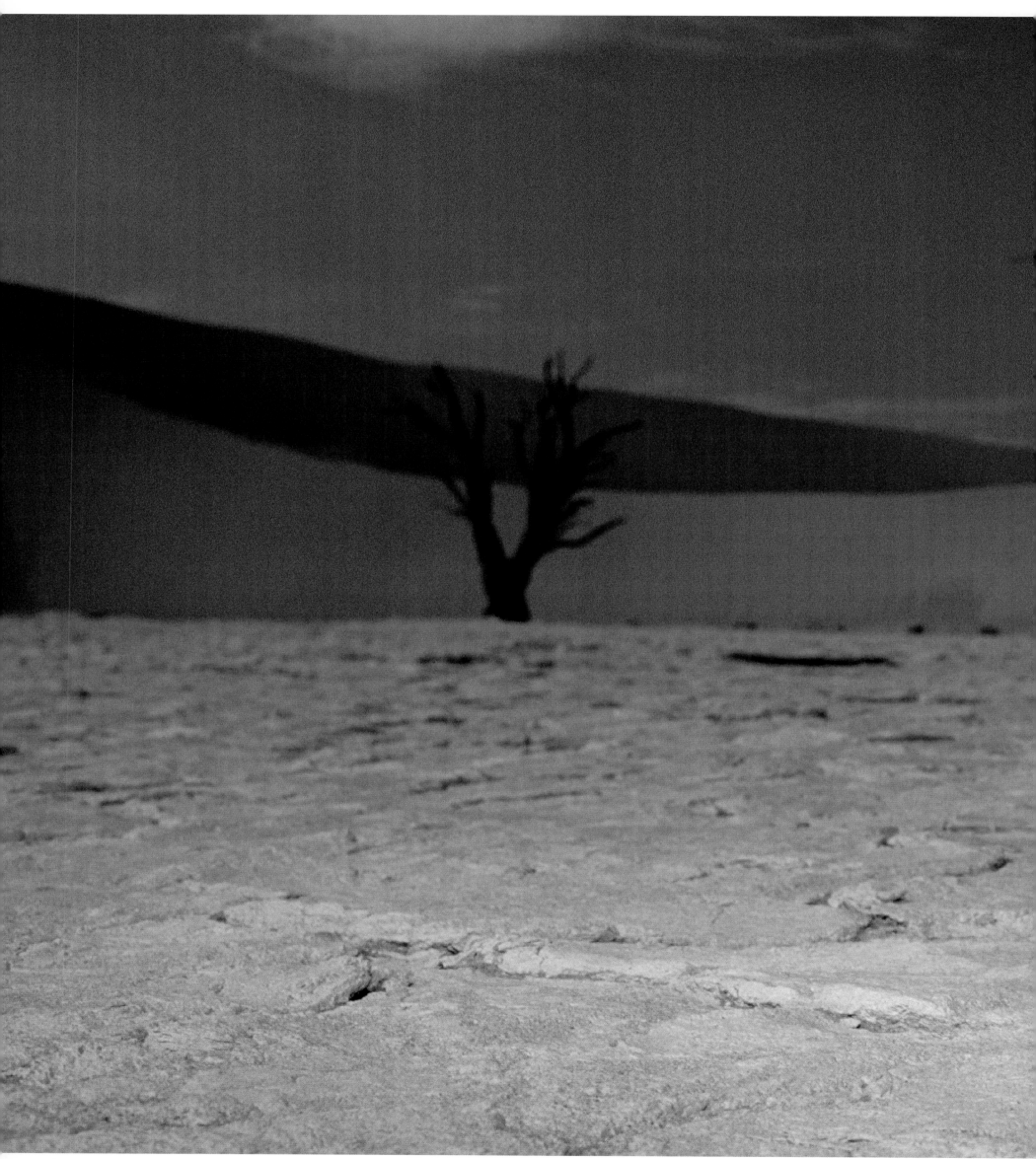

Above: Most chameleons live in trees, forests, or savannah. The Namaqua chameleon, however, adapts well to life in the desert and has no hesitation in coming down to the blisteringly hot ground to look for prey (flies and other insects). Because of its ground-living habits, it is one of the fastest-moving chameleon species. When it gets too hot, it digs burrows or finds the burrows of small rodents to shield itself from the burning sun. Like other desert species, it excretes salt through its nasal glands.

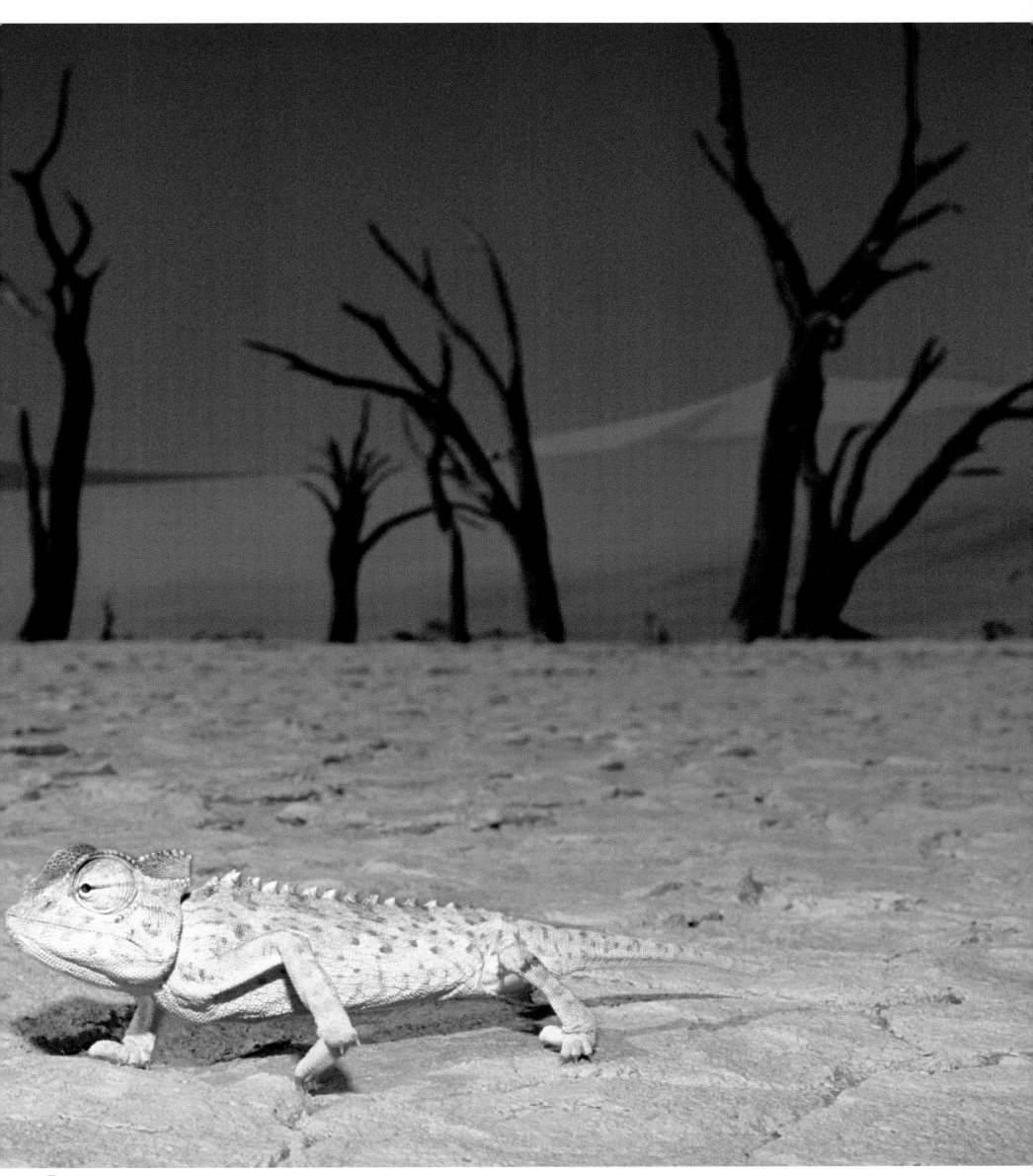

Following pages: The moloch of Australia is one of the most astonishing lizards on earth. Its hard spine and skin make it look as if it belongs to another era (it almost looks like a dinosaur). These traits not only provide it with camouflage but also keep away predators, which can neither seize nor swallow it and are likely afraid of it. It is a voracious eater of ants, consuming between 2,000 and 3,000 at a time. Like other reptiles, it buries itself completely in the sand when conditions become too hot.

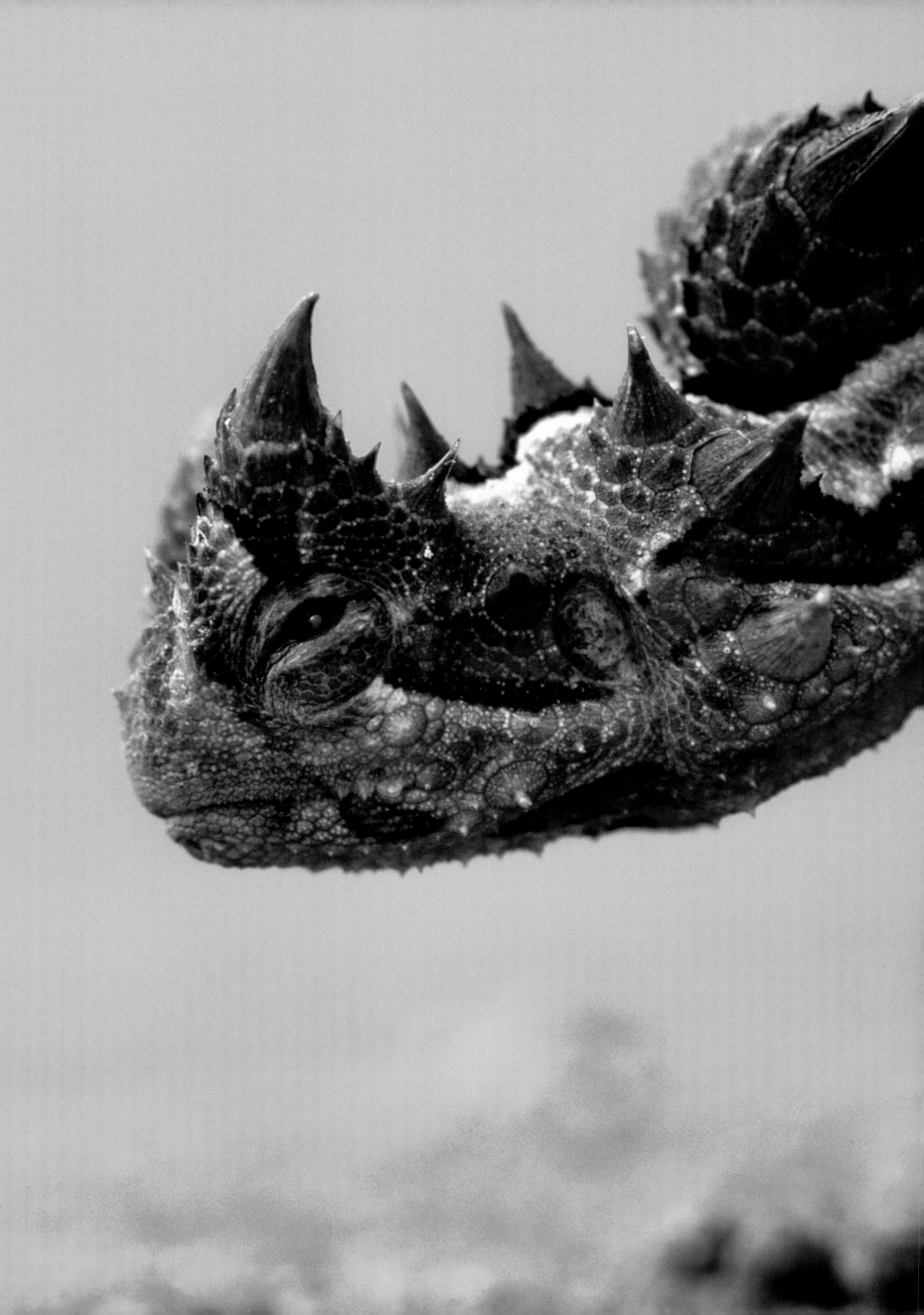

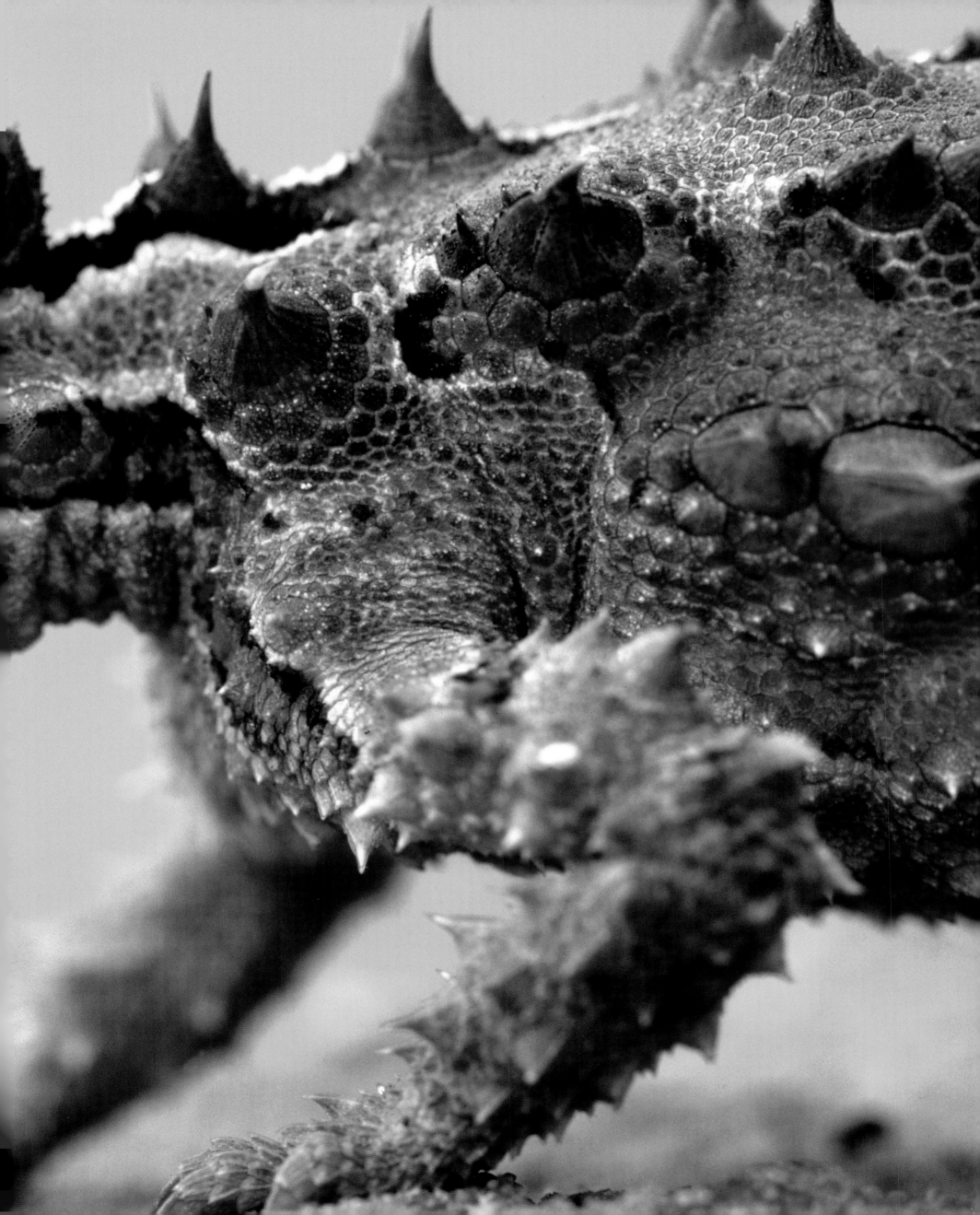

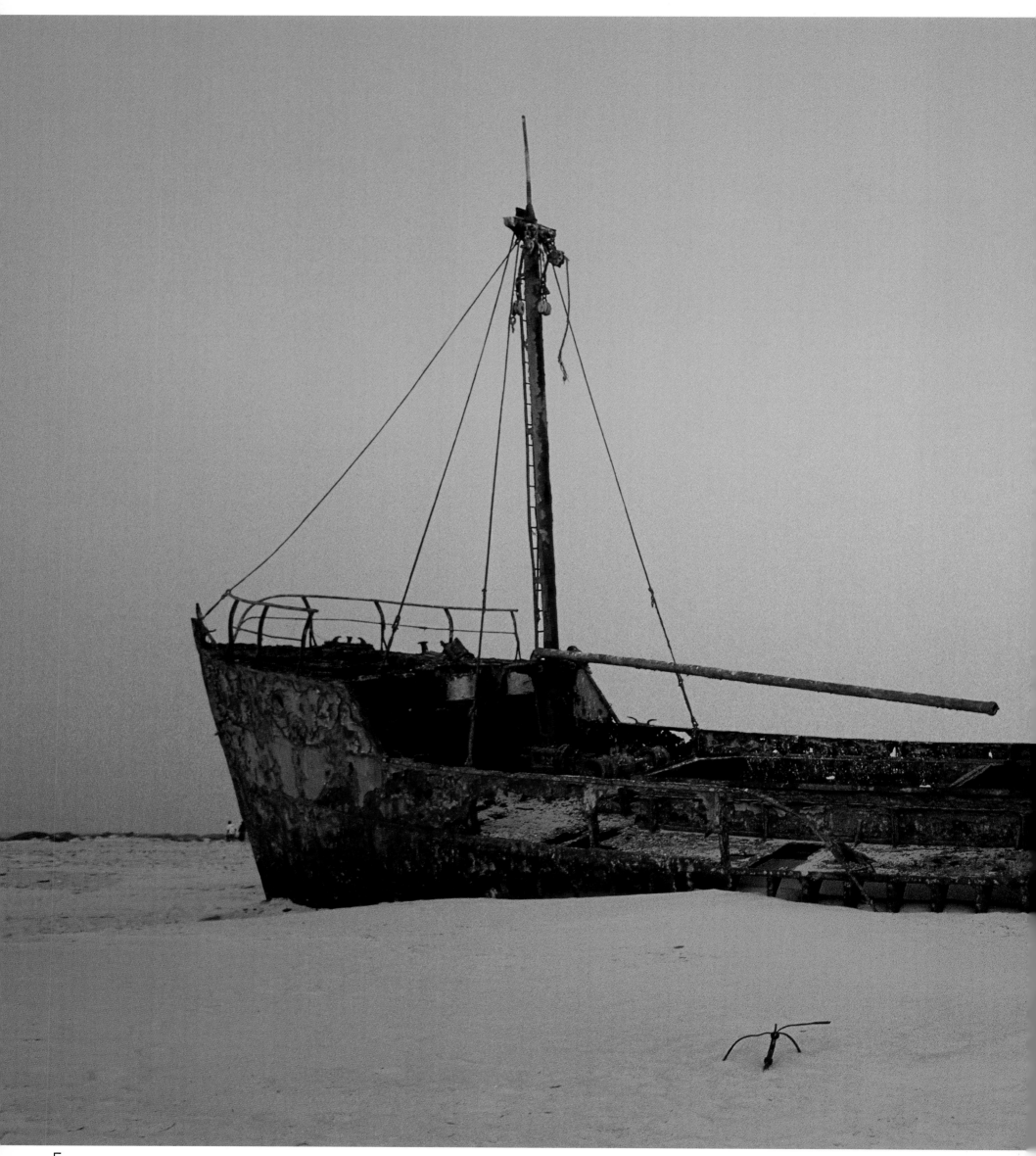

Along the Mauritanian coast, the desert advances toward the sea. Contrary to popular belief, this phenomenon is very localized worldwide. Driven by the trade winds, the sand drifts toward the ocean; for this reason, hulks of ships are now found several hundred feet inland.

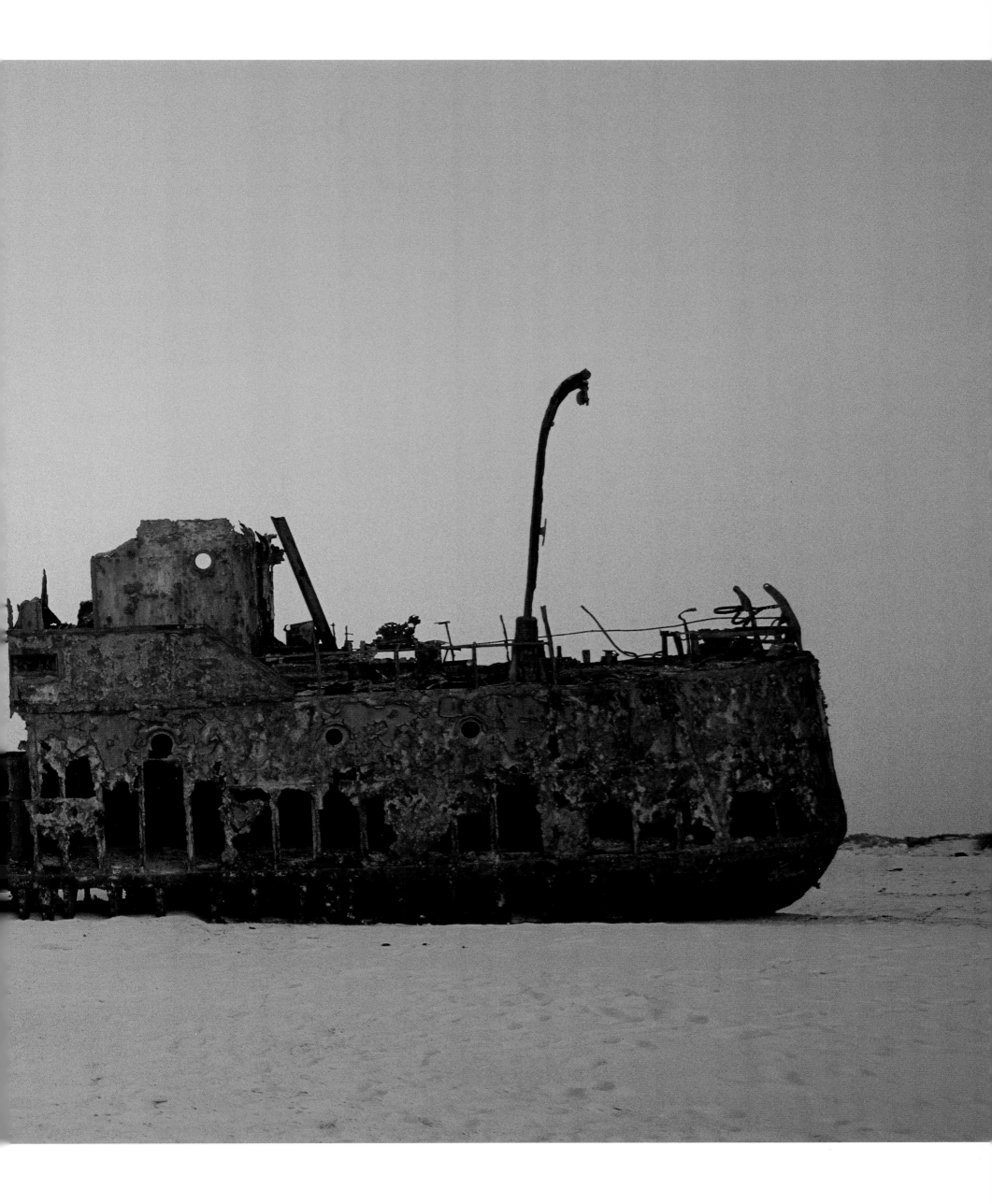

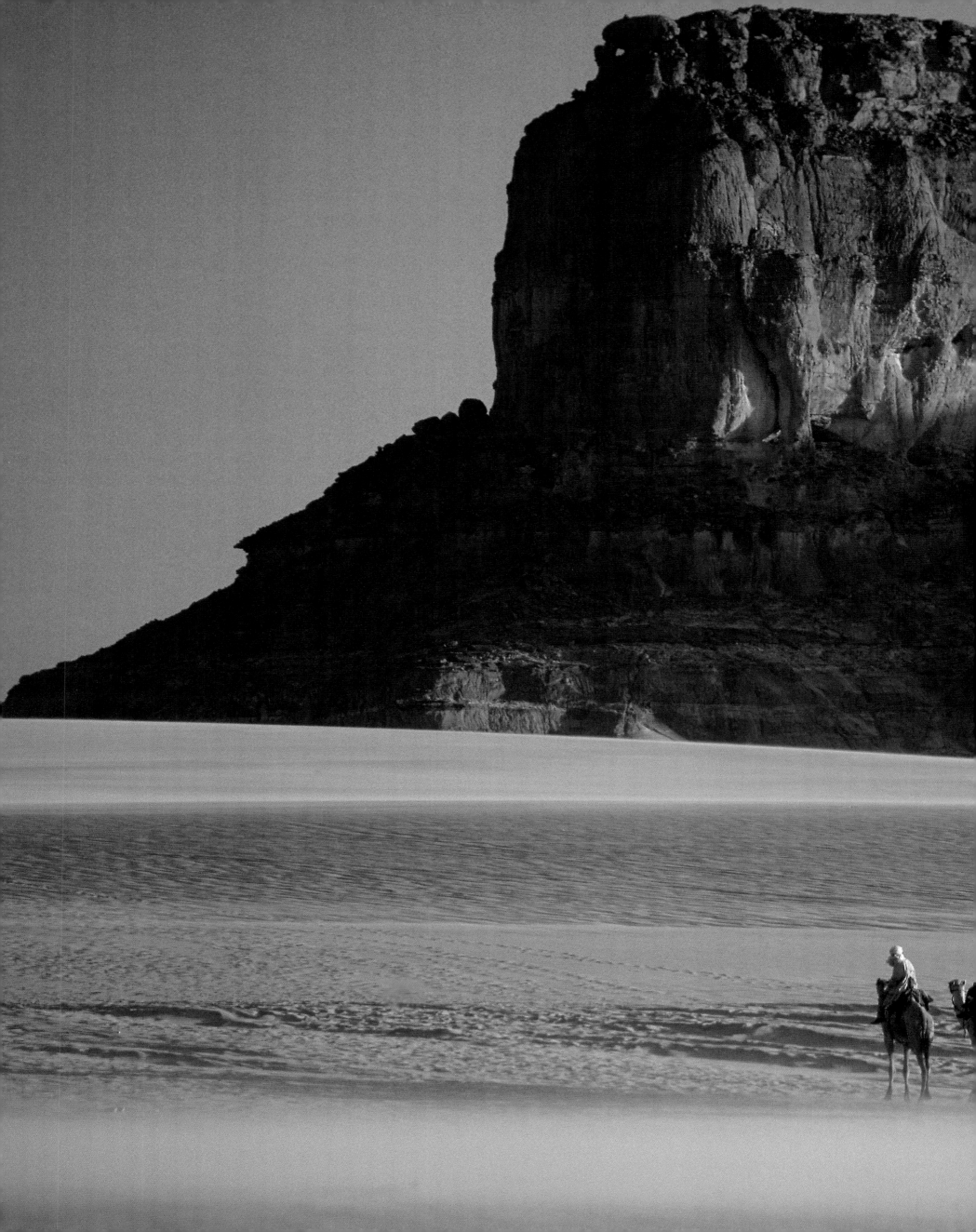

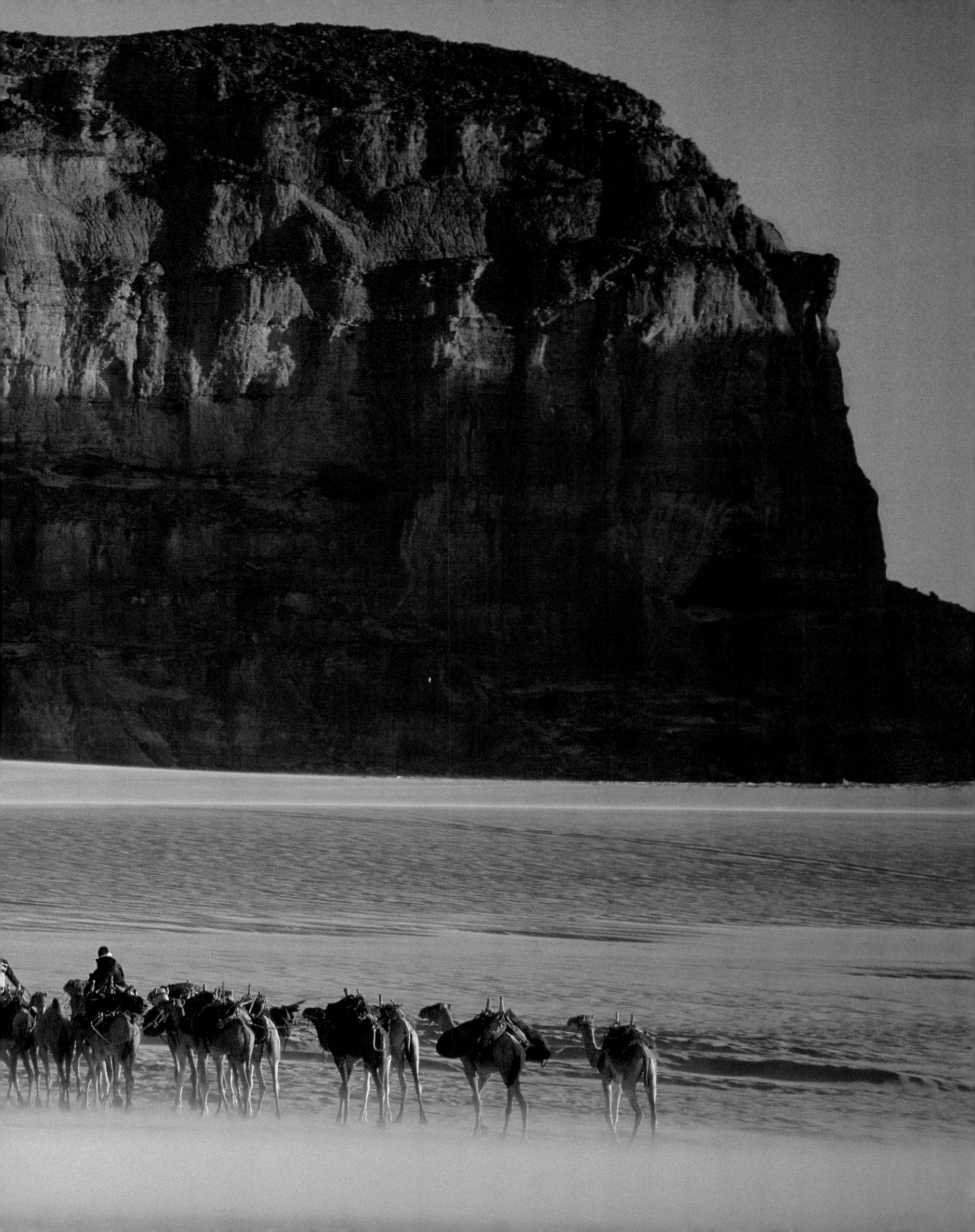

Preceding pages: This caravan of Toubous traveling through the Mourdi depression in Chad is carrying salt and dates. These people are perfectly adapted to the heat and vastness of the desert. They have no map by which to find their way and few landmarks to prevent them getting lost—just an ancestral, instinctive knowledge of the route to follow and a way of life in harmony with the demanding, austere conditions of this place. They have adapted as their environment has gradually turned to desert.

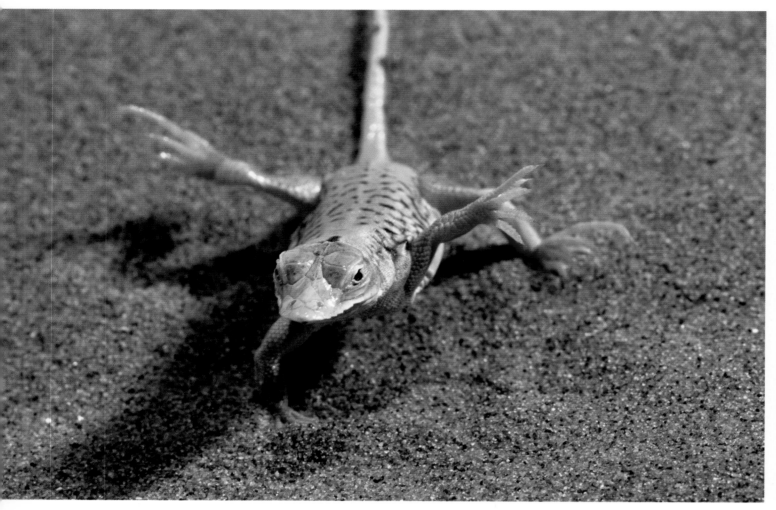

Above: The Namibian lizard (Aporosaura anchietae) is highly specialized. During the hottest time of the day, it lifts its legs. This allows them to cool off for a few seconds and reduce the temperature of the blood flowing through their legs. When the lizard moves over the sand, it does so on tiptoe, thus keeping its feet away from the burning heat. Like other Namib Desert species, it licks morning dew off the ground. Its pointed, wedge-shaped snout is perfect for burrowing into the sand to take refuge.

Below: Most vipers of the *Bitis* genus live in desert habitats, like this Peringuey's Adder viper of the Namib Desert and Angola. It emerges from its hiding place only at dusk or during the night, to hunt lizards and insects. Generally, all that is seen of it is the trail left by its sideways creeping, typical of desert vipers.

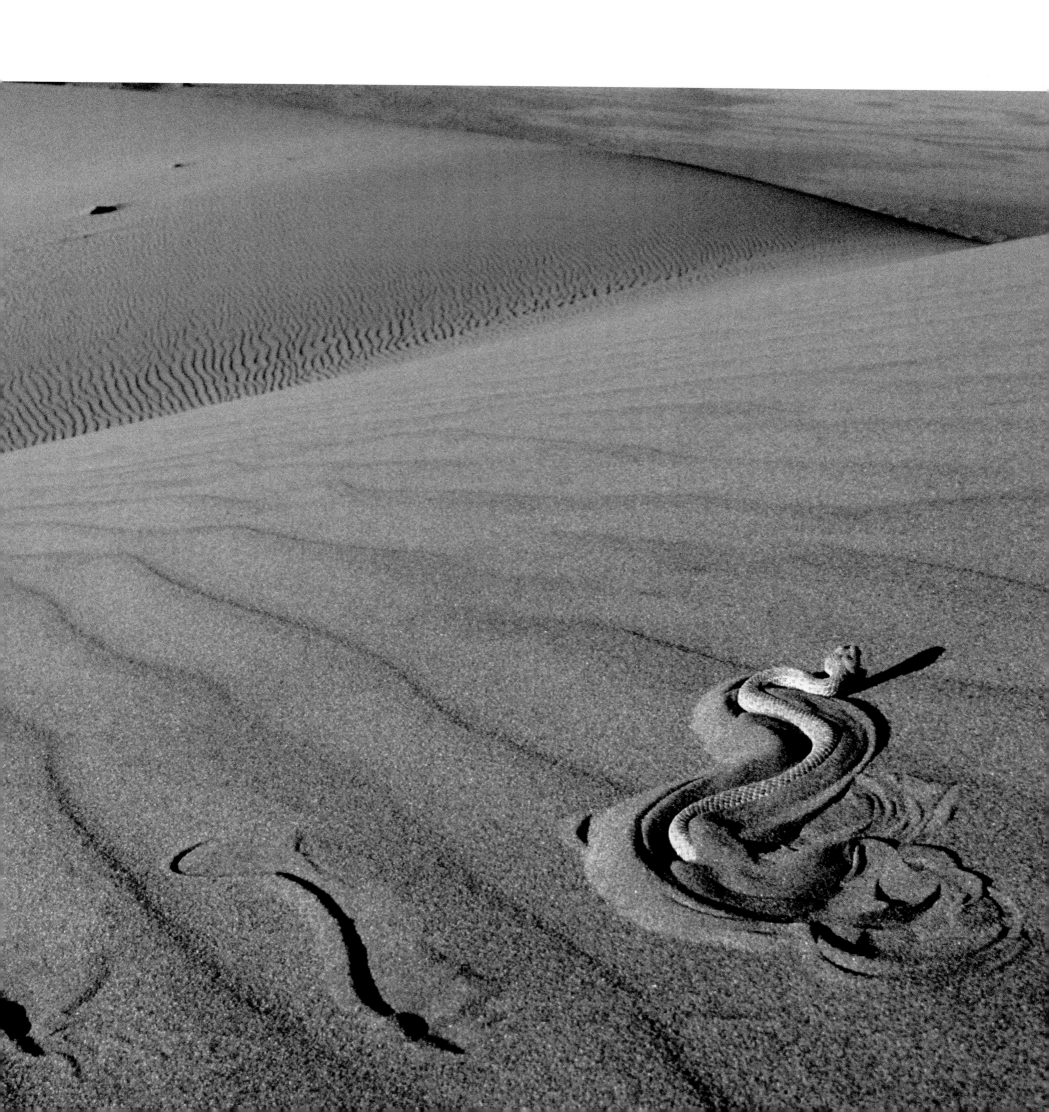

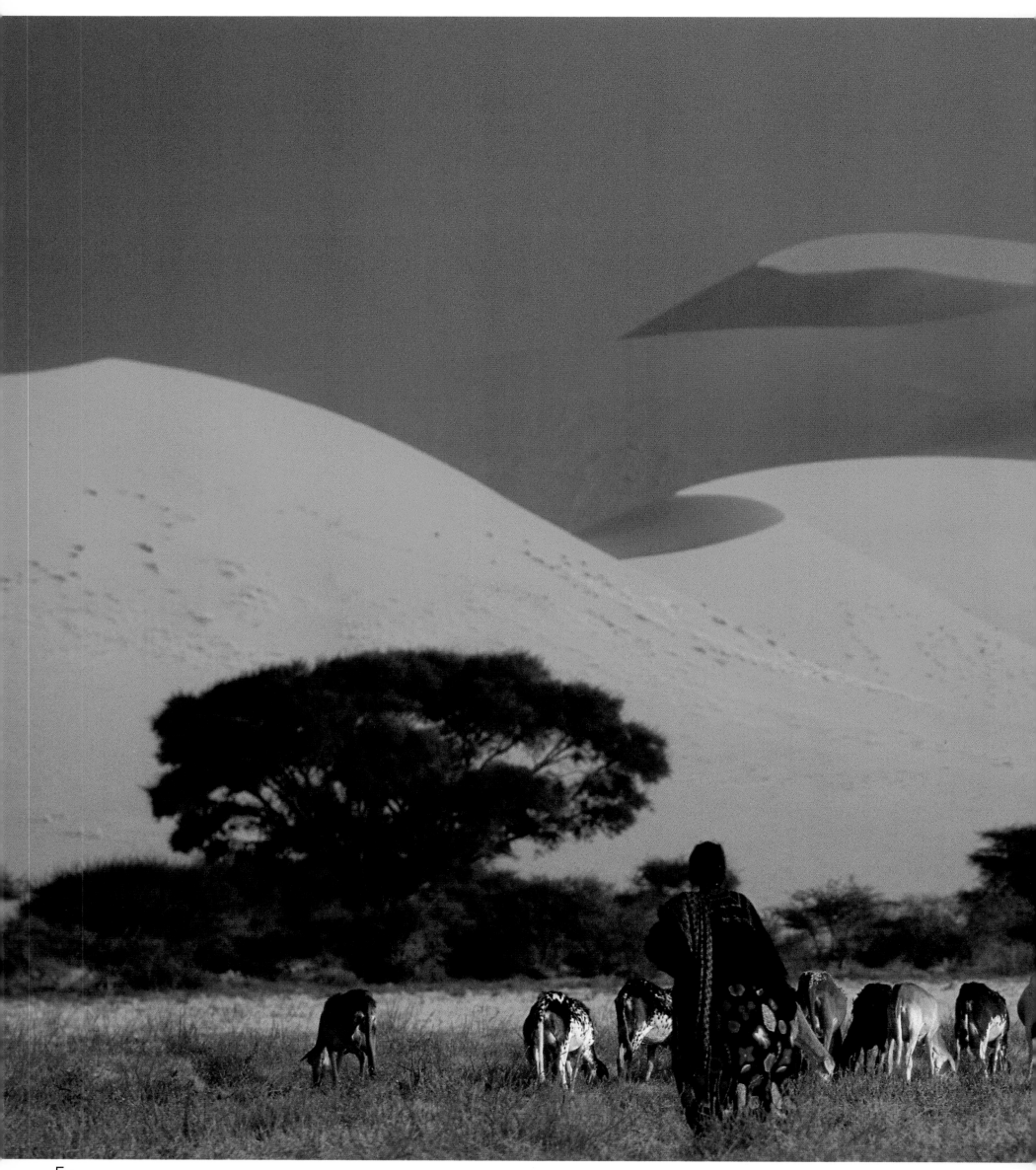

Above: In the Ténéré, in Niger, the rainy season—if it happens at all—is extremely short. For a few days, herds of livestock graze on lush grass. Herders move about, looking for the best spots for the animals to graze.

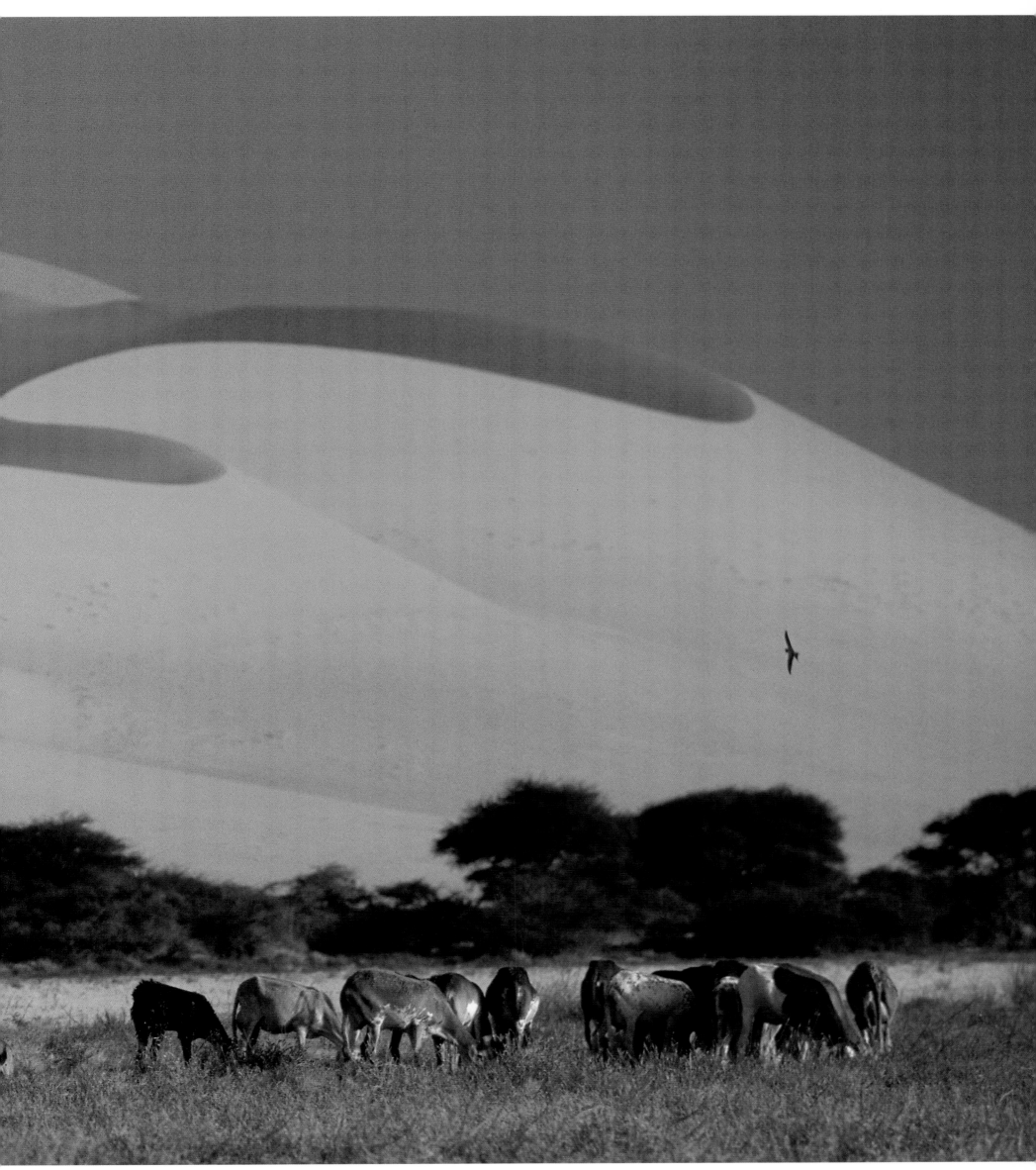

Following pages: The oryx is one of the few large mammals tied to a desert habitat. It is perfectly adapted: its body absorbs a large amount of heat during the day and then loses it at night. Its brain is protected from sunstroke by a highly efficient system of capillary vessels. It survives on little food, preferring the succulent plants, roots, tubers, and bulbs that contain the most water. When the oryx is in the Namib Desert, it settles for receiving water from the dew that forms on the grass.

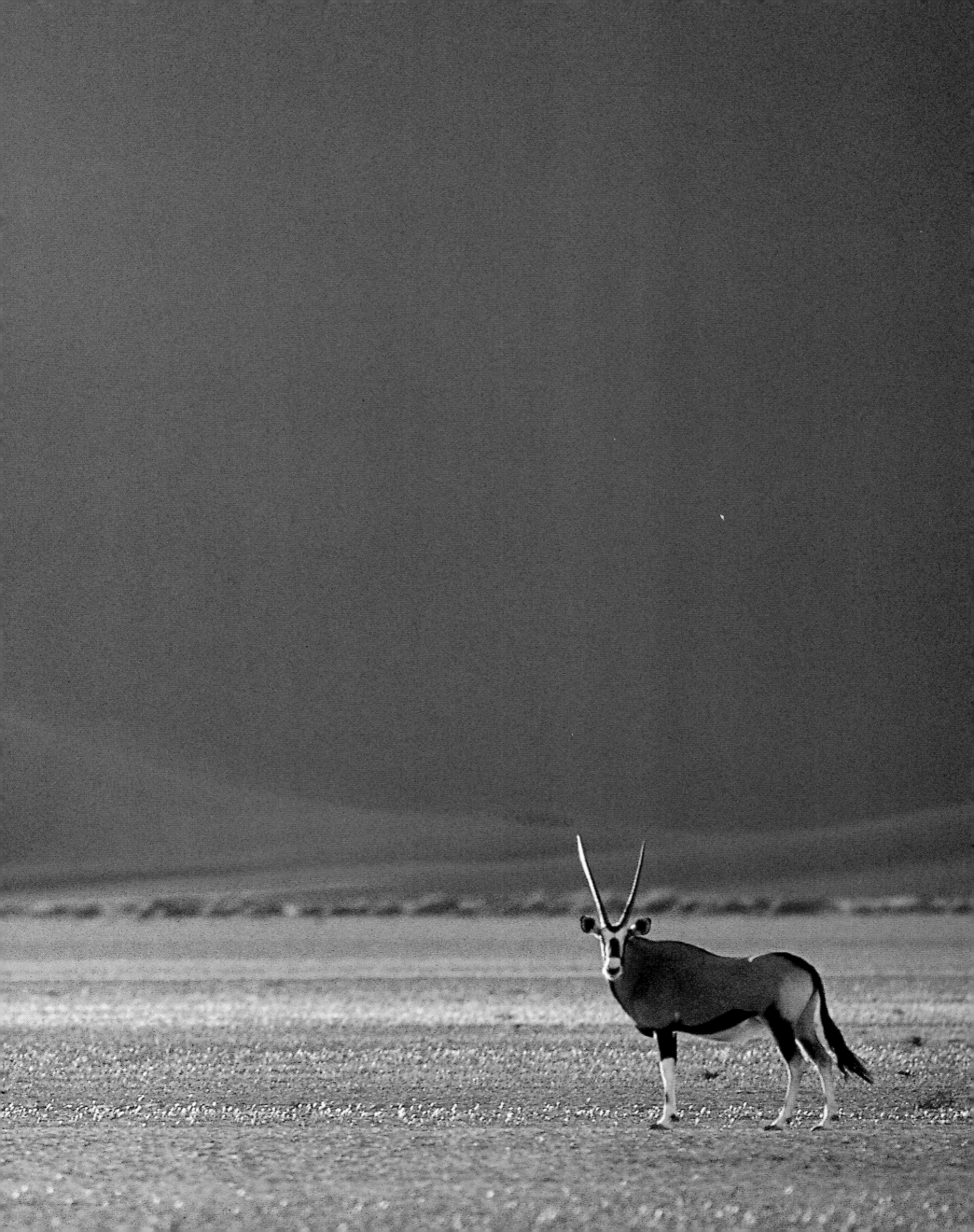

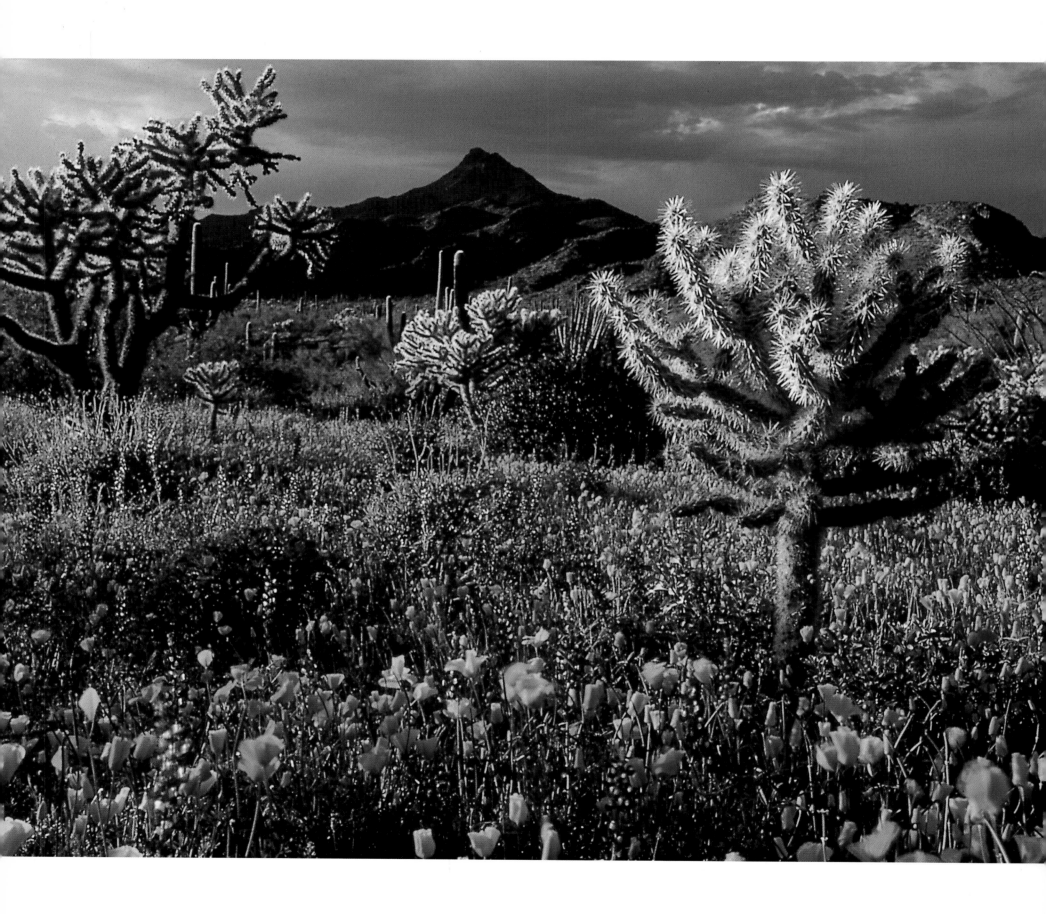

In the Organ Pipe Cactus National Monument in Arizona, plants flower briefly and dazzlingly. In a matter of days the ground becomes covered by plants in a multitude of colors, like these lupines and poppies that have sprouted among the cacti. This flowering coincides with the time when many birds and mammals raise their young. Within a few weeks, however, the landscape will have regained its usual austere appearance.

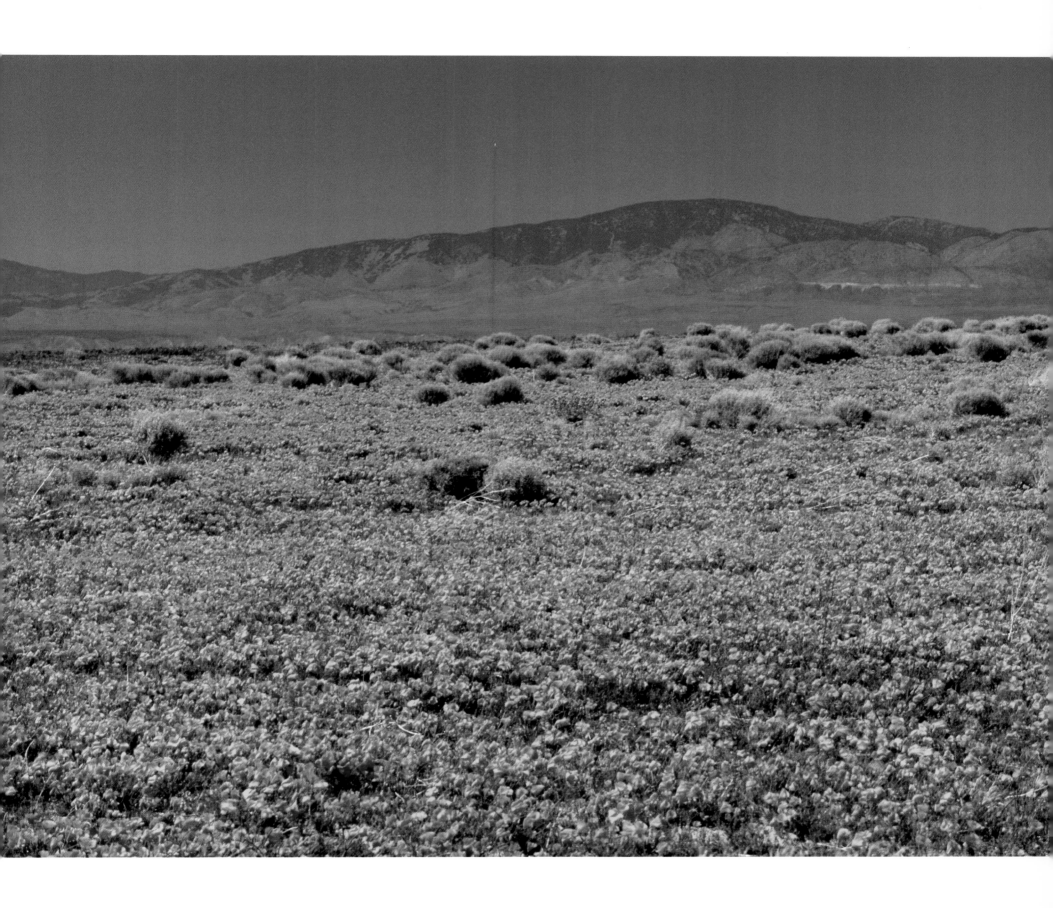

In spring, the deserts of Arizona and California are clothed in myriad colors. The dominant color is the orange of the California poppy, the official state flower of Calfornia. Here it's seen in bloom in the Antelope Valley California Poppy Reserve. When it's cold or very cloudy, or when dusk sets in, the flowers close, only to reopen when the sun's rays return.

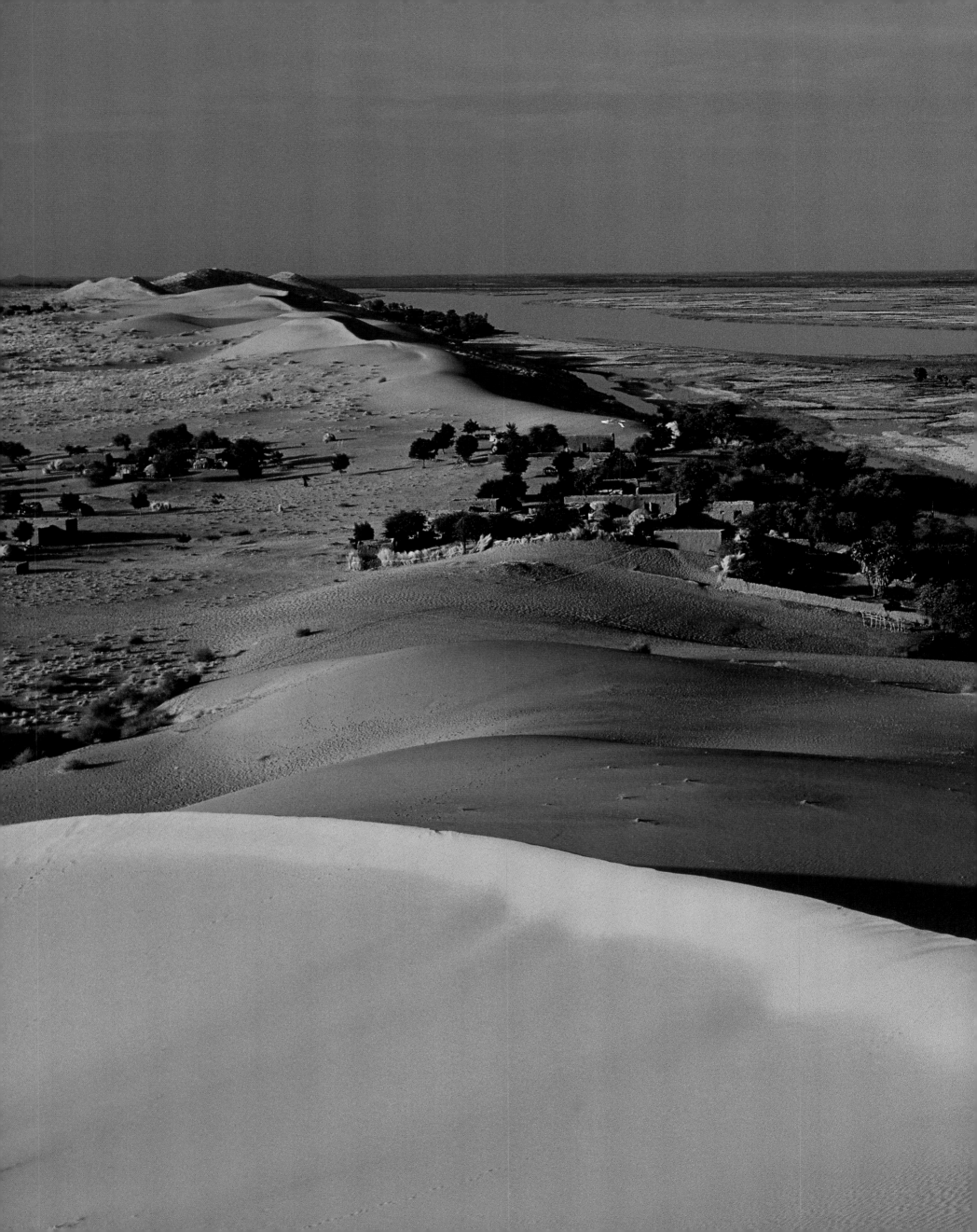

Preceding pages: The pink dune at Gao, in Mali, brushes the shore of the Niger River. In the heart of the Sahel region, the river is a veritable lifeblood for humans and all the organisms living alongside them. Bourgou, a water plant used as fodder for livestock, is gathered along its banks. Farther downstream the river becomes a delta—one of very few inland deltas in the world. It is a hotbed of biodiversity, where hundreds of thousands of water birds from Europe, Siberia, and even tropical Africa come to spend the winter.

Above: Not long ago there was a road here, with a power line running alongside it—a rather unremarkable landscape, close to the oasis of El Khârga, Egypt. Then, imperceptibly at first but with increasing volume, sand came to cover the road and the thorn bushes. This "flood" of sand is continuing its work of slowly smothering the landscape: tomorrow, no one will even be able to tell that there were telephone poles here. In many regions of the world, the desert is advancing.

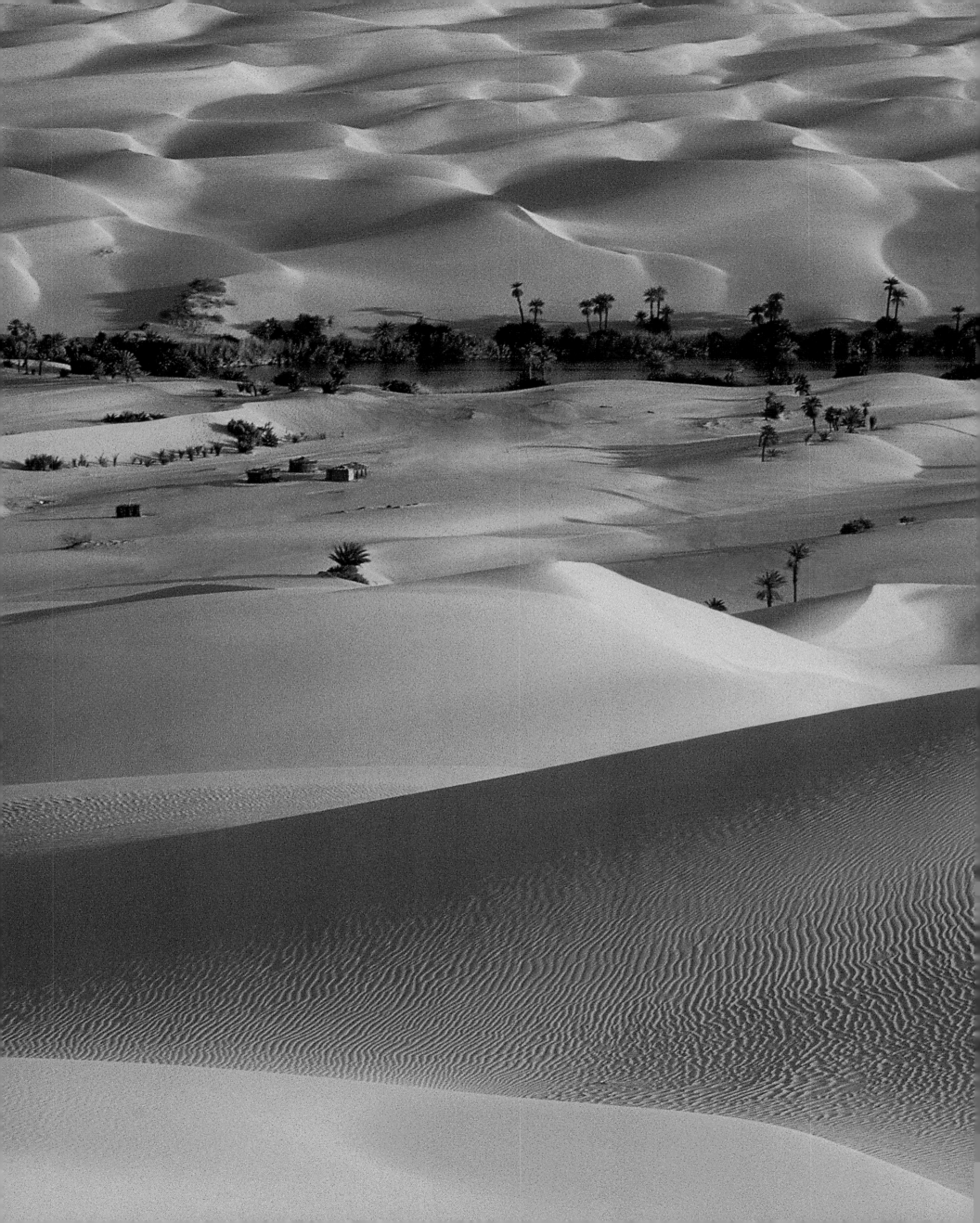

Left: The lake of Oum-el-Ma in Libya is no mirage, but a real lake, lying at the foot of the great dunes of Akakous. These scarce watering points are sometimes an extraordinary blessing for migratory birds, which make the journey twice a year, between Europe and Africa. Some birds owe their lives to these providential spots, but many die in the open desert because their energy reserves prove inadequate to reach the water.

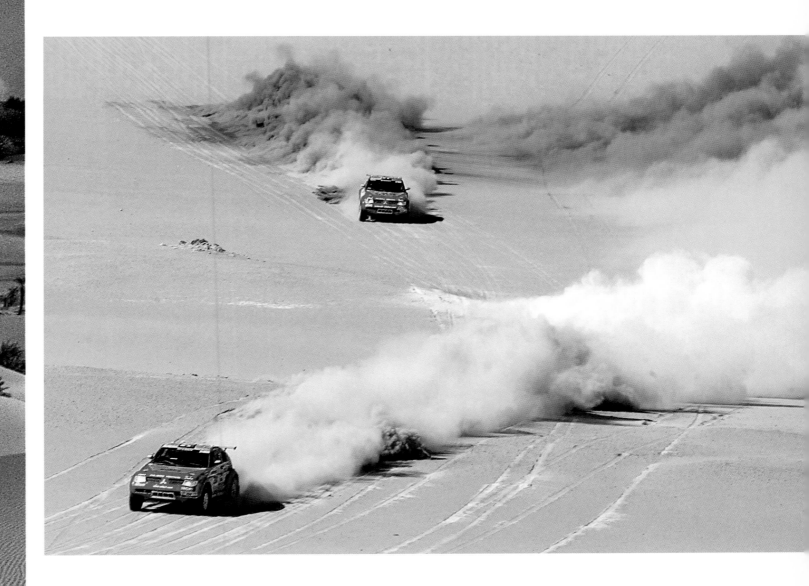

Above: The majesty of deserts excites human desire and is seen as a challenge. Destructive auto races are organized every year, with a total lack of respect for the environment and for the plants and animals that live there. This is one such race, where cars hurtle at full speed along the dunes and trails of the Sahara.

Above: These hollows, deep in the desert at Teguidda-n-Tessoumt, in the Ingal region of Niger, intrigue travelers. They are used for collecting salt. The basins are regularly refilled with water, which then evaporates, leaving a thin film of salt. It is carefully gathered, made into bars, and sold to local livestock herders for use as a supplement in their animals' diet.

Following pages: Early morning in the Namib Desert, this beetle of the *Tenebrio* carries dew droplets on its legs, as there is no water on the dune's surface. Salvation for the beetle comes in the form of the morning mist as it deposits a few beads of dew on the thin vegetation. This proves a godsend for the beetle—it's a way for it to get its daily water ration.

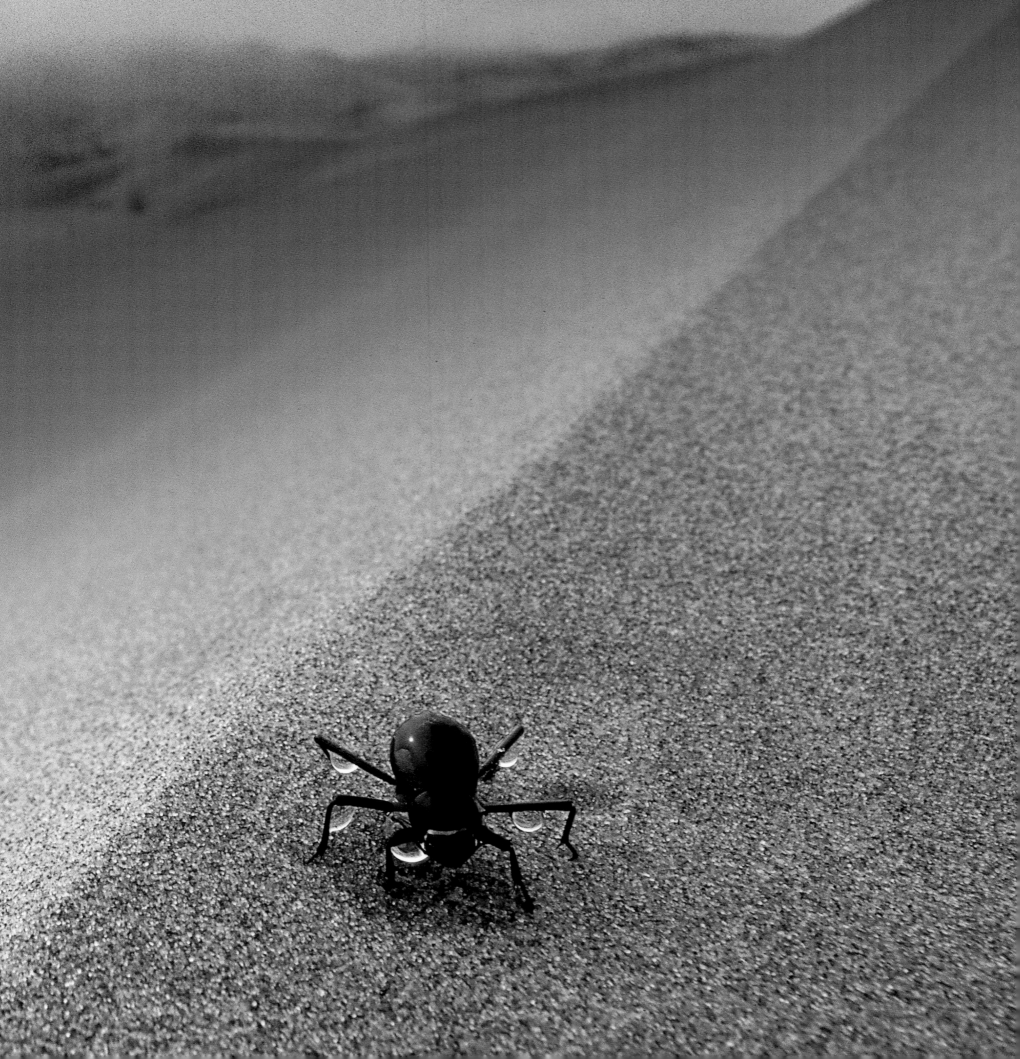

Left: During the day, horned vipers bury themselves completely in the ground, leaving only their eyes and nostrils exposed. Since they are completely invisible, one could easily step on them inadvertently. Legend has it that this is the reason the shoes worn by the men of the desert have turned-up toes!

Below: Sometimes microclimatic conditions (such as sun, moisture, or exposure) are enough to allow a tree or plant to grow in a completely unexpected place.

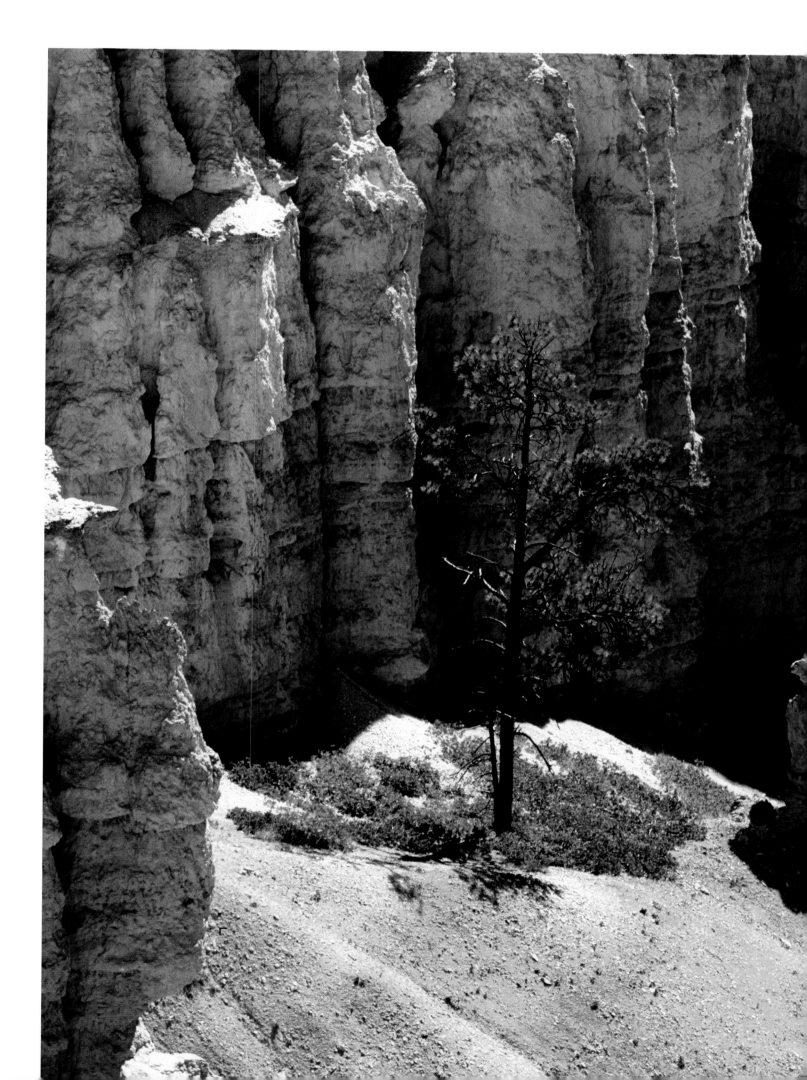

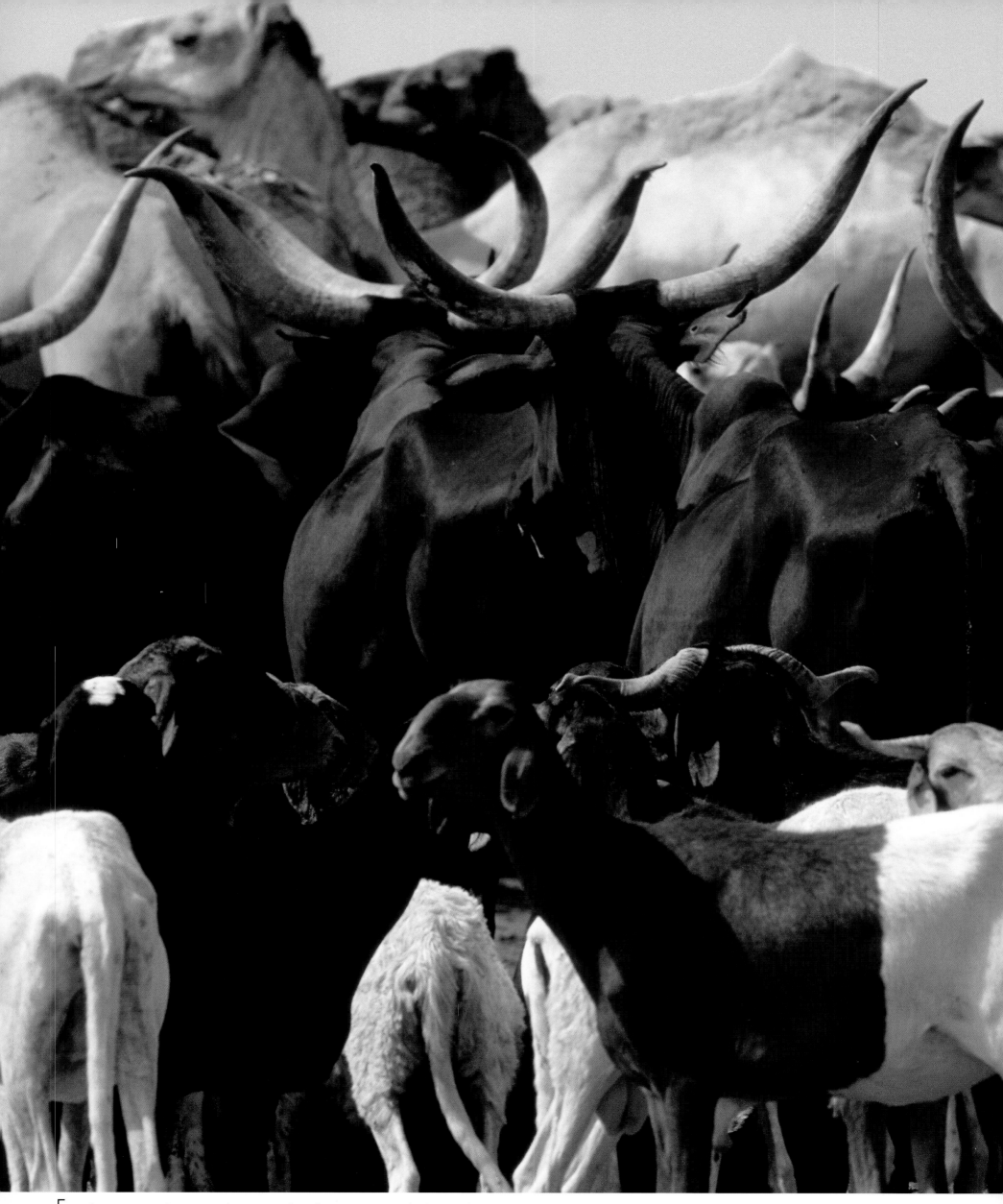

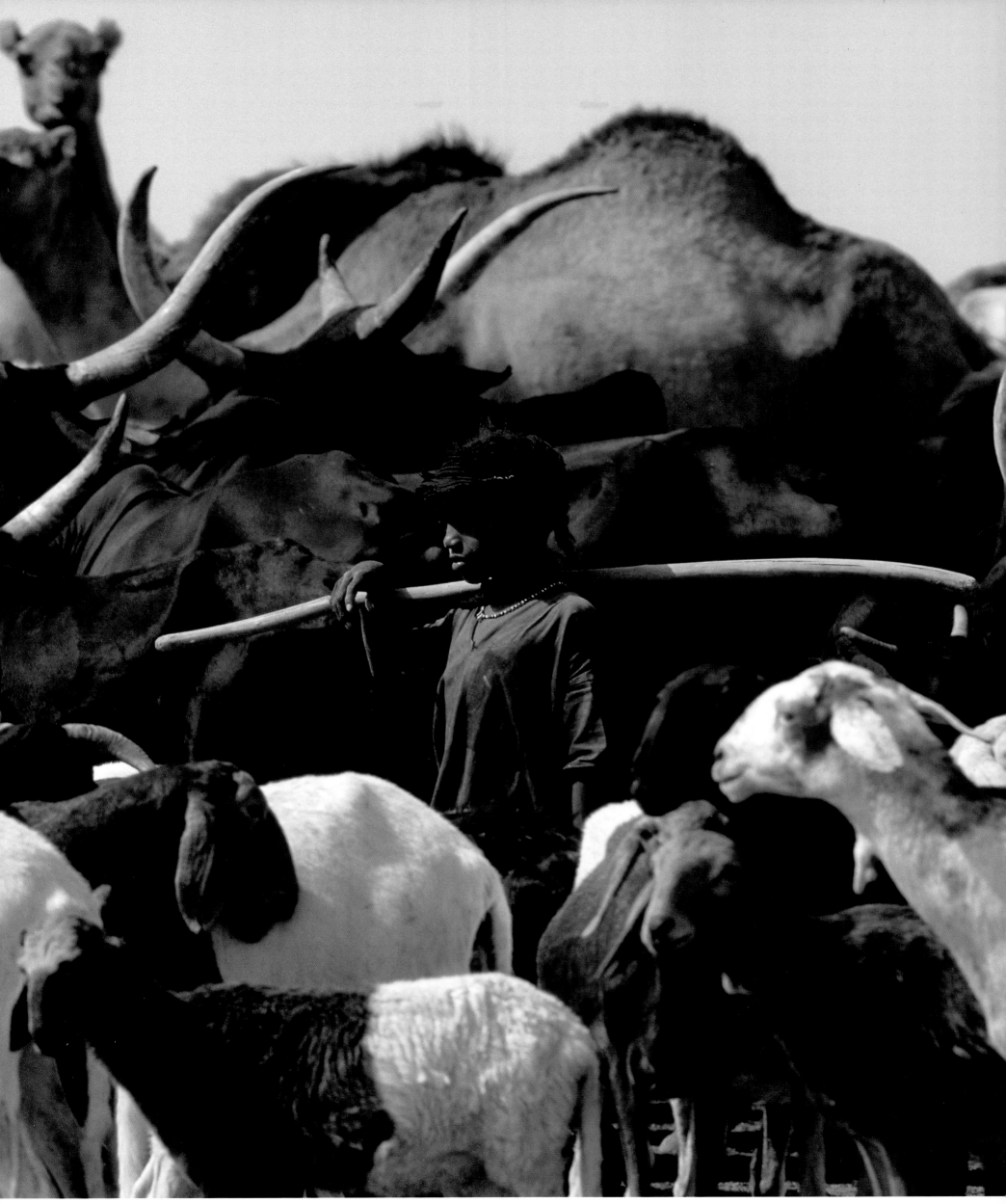

Above: This Peul herder and his animals visit the watering hole closest to Teguidda-n-Tessoumt, Niger. His entire wealth is gathered here: dromedaries, magnificent bororodji oxen, and sheep. He's trying to find water at the well or pool, along with a thin grazing for his animals. It has been a long time since the Sahara was verdant, and humans have mirrored the retreat of the plant world, making do with essentials and dispensing with the superfluous. These regions of the Sahel can teach a lesson to Westerners who always seek immediate gratification of their consumer desires.

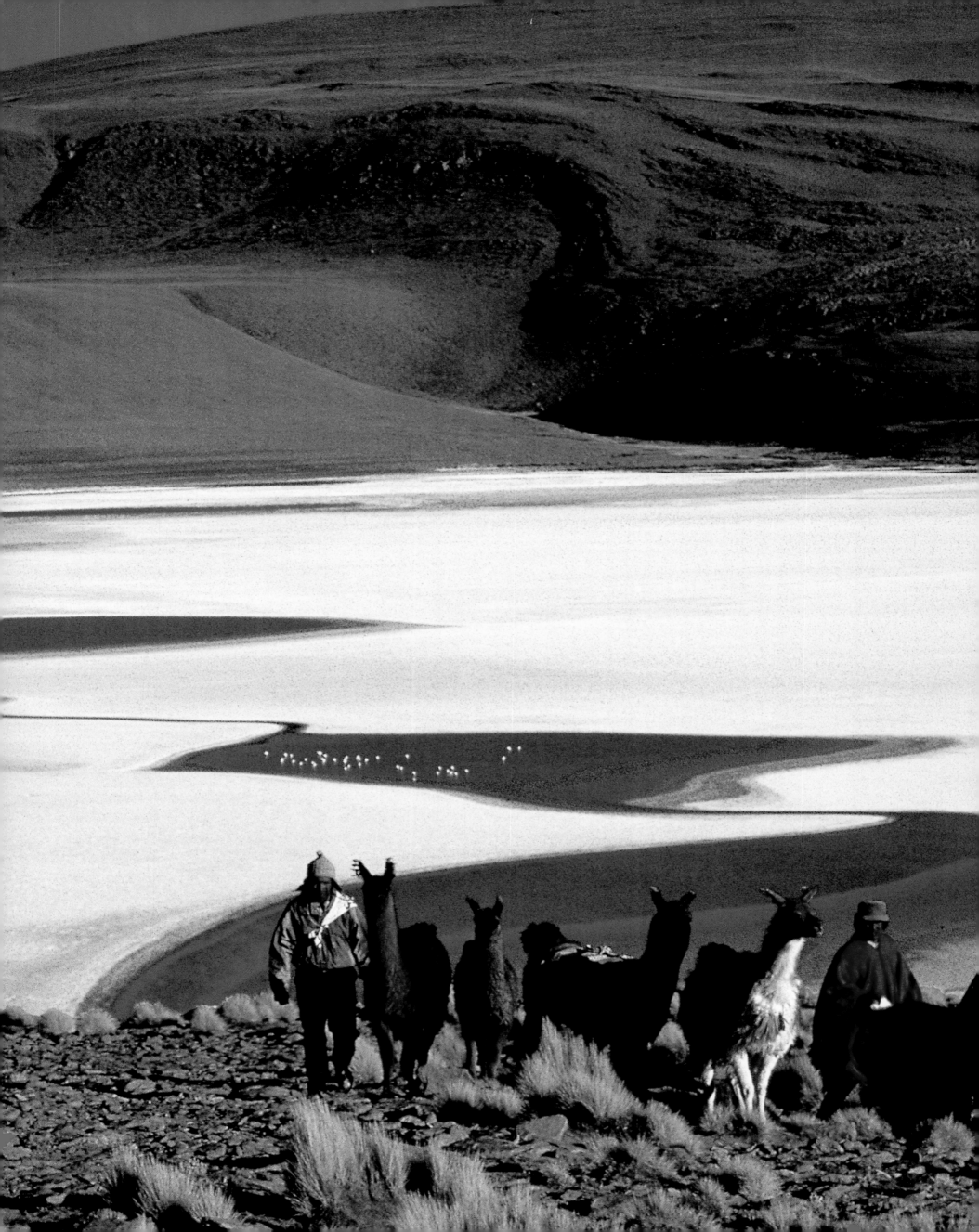

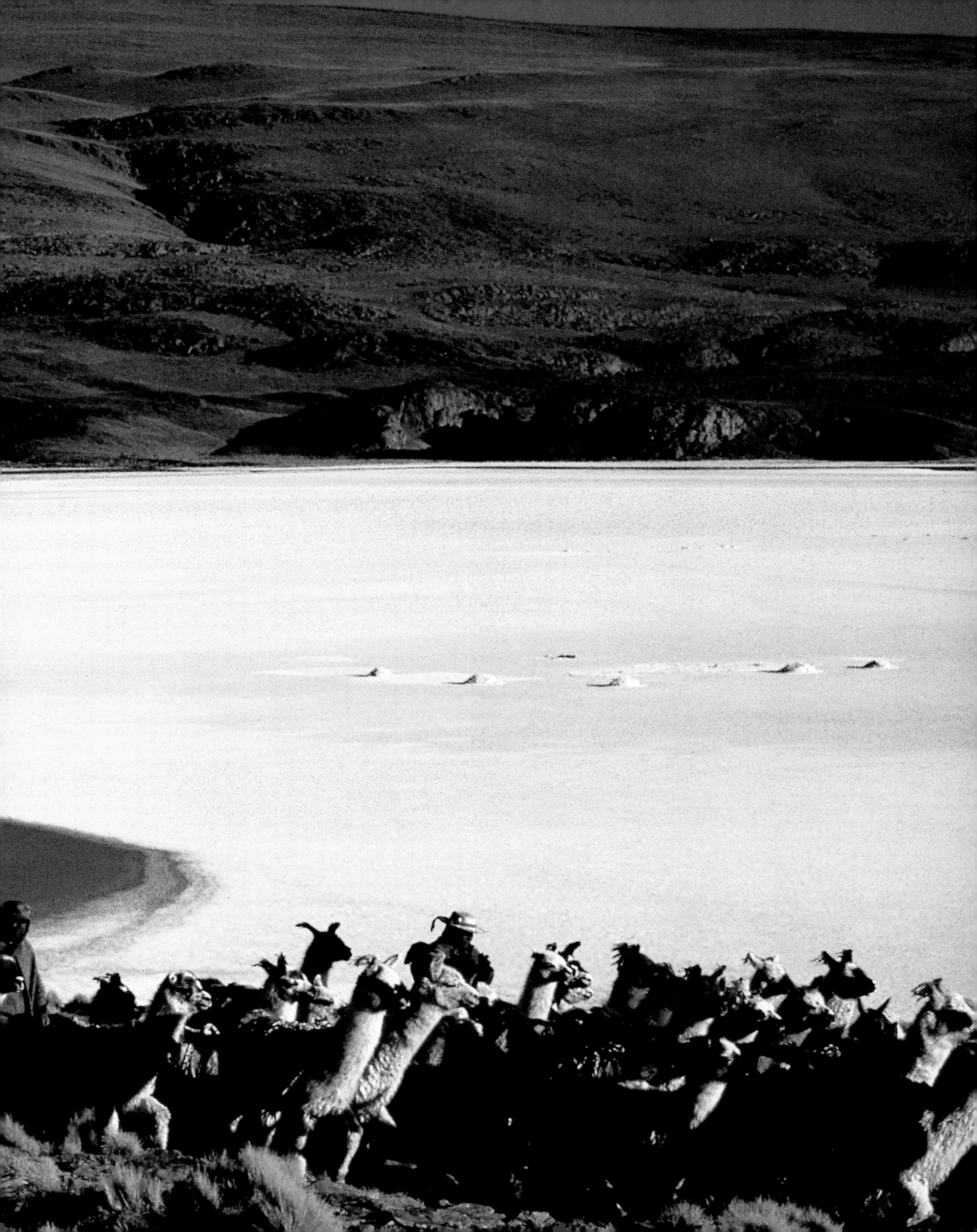

Preceding pages: At about 12,000 feet above sea level, the Altiplano in Bolivia is probably one of the highest inhabited regions on the planet. The wind sweeps unceasingly across the space of this immense plateau, in a region which contains the most ancient remains of America's pre-Columbian civilization. Agriculture, which essentially consists of raising llamas, is a testament to the Quechua and Aymara peoples' exceptional empathy with and knowledge of the species and functioning of these habitats.

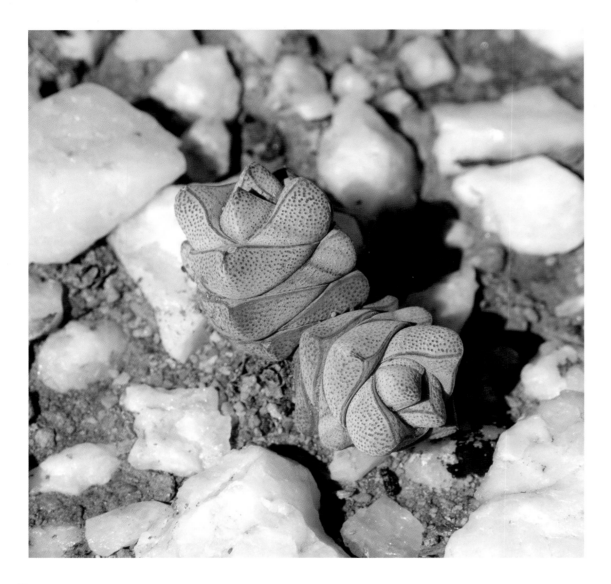

Above: Plants of the *Crassulaceae* family, known as succulent plants, can retain water due to the thick skin on their stems and their fleshy leaves.

Right: This jerboa has scratched its way into the sand of the dune, digging a small burrow to seek some shade during the hottest hours of the day as well as safety from predators. The species is nocturnal and feeds on thin grasses. It does not drink, rather, it obtains its necessary water from the plants it eats. It also produces extremely dry feces, because its intestine reabsorbs the water contained within it. When it exhales, it expels water vapor, which helps to maintain moisture inside the burrow.

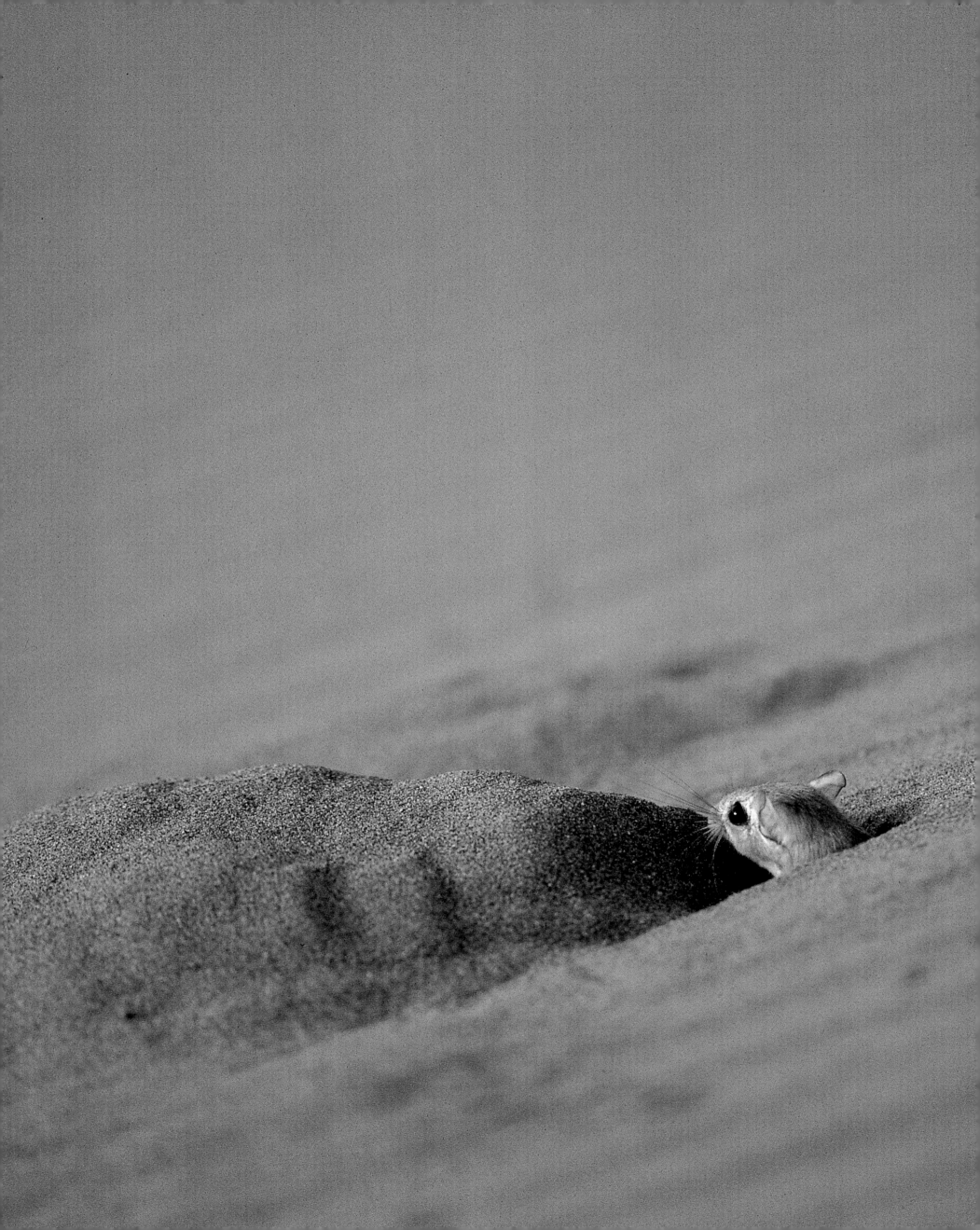

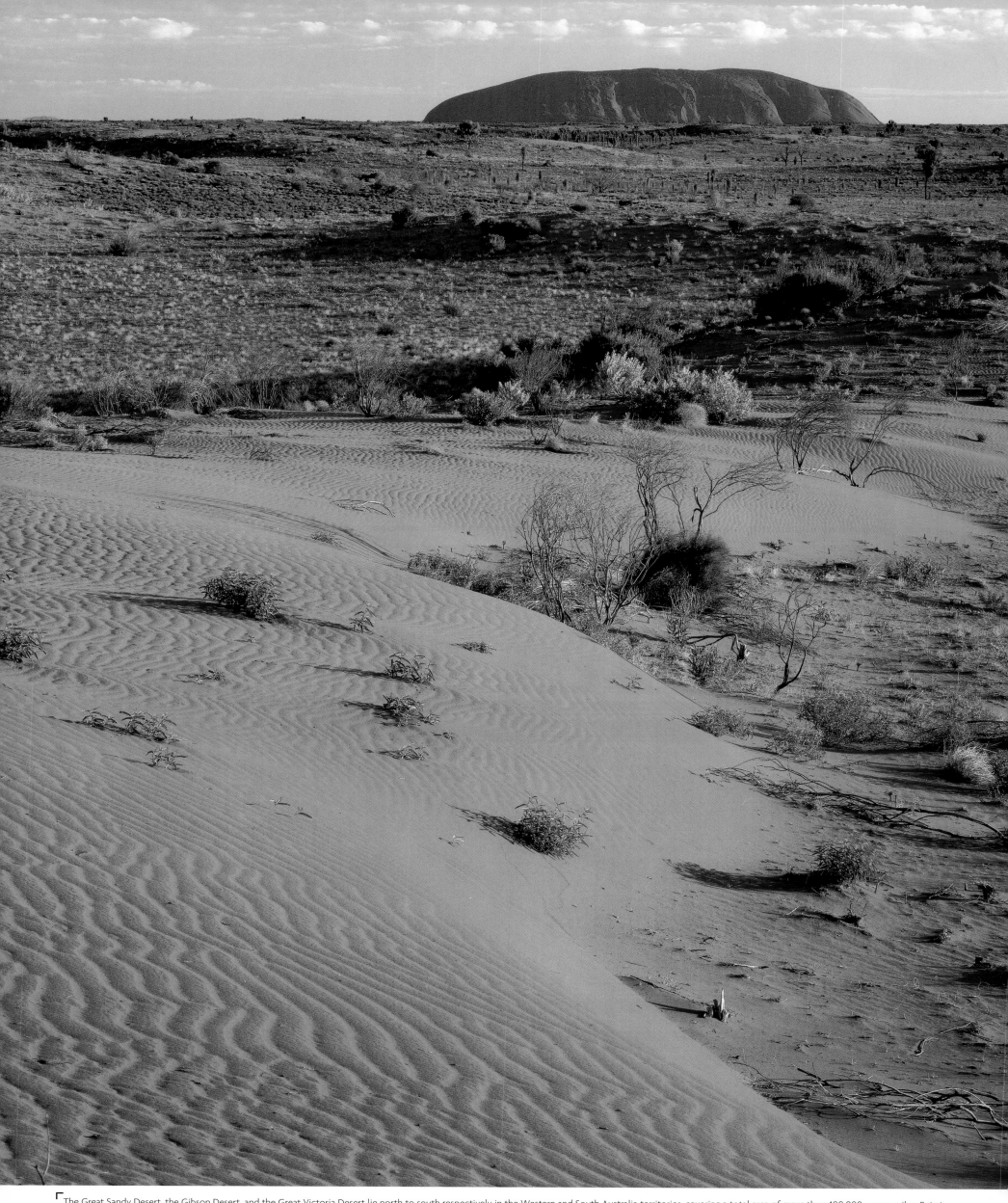

The Great Sandy Desert, the Gibson Desert, and the Great Victoria Desert lie north to south respectively in the Western and South Australia territories, covering a total area of more than 400,000 square miles. Rain is an exceptional event here. Many animal and plant species here are ephemeral, proliferating only during the very short favorable periods. Ayers Rock, seen here in the background, is an important place in the culture of Aborigines, nomadic hunter-gatherers who were the first inhabitants of the Australian continent.

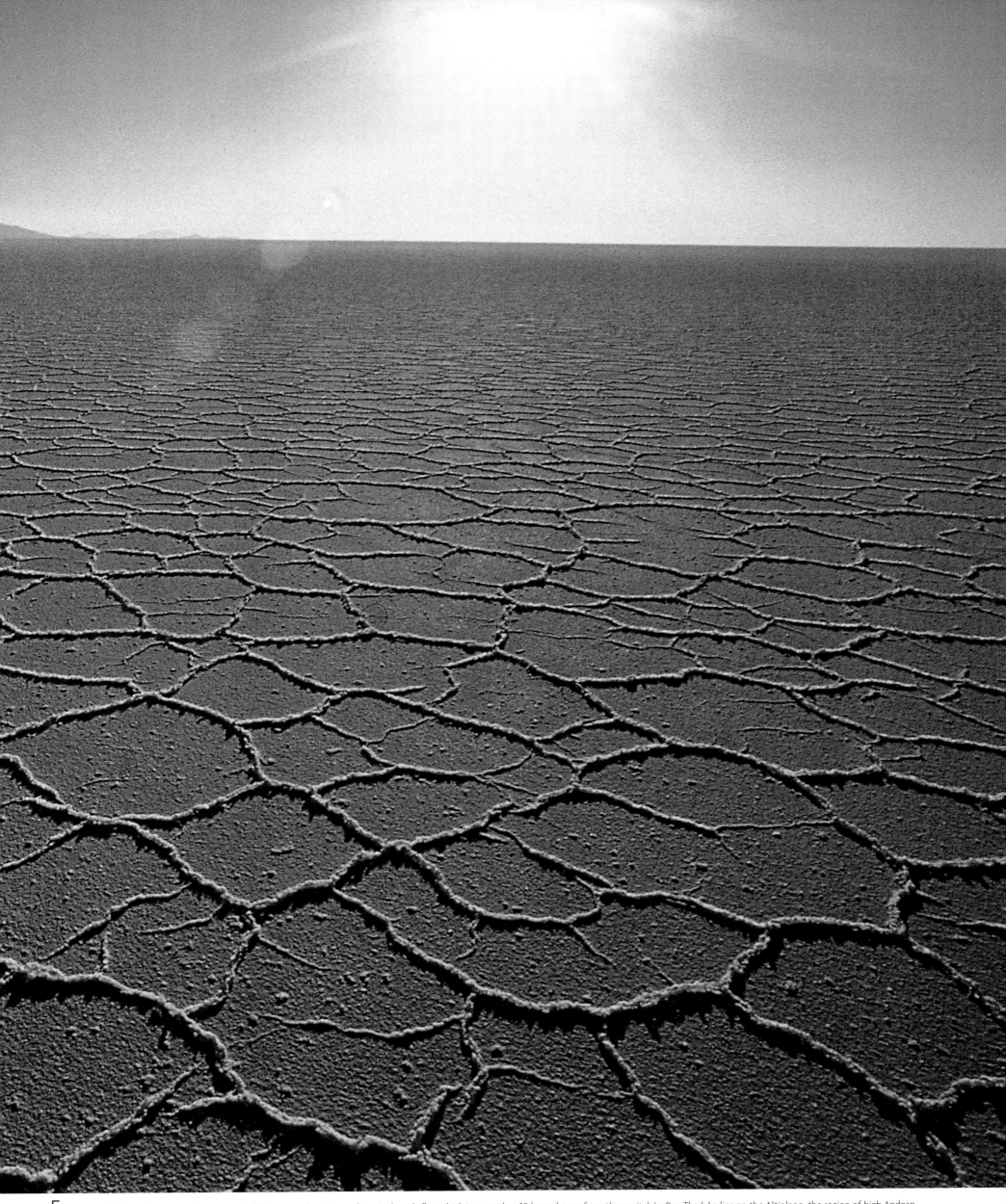

The dried salt lake of Uyuni in Bolivia covers 4,600 square miles. No one lives in the salt flat, which is more than 10 hours by car from the capital, La Paz. The lake lies on the Altiplano, the region of high Andean plateaux hemmed in by the Western and Royal cordilleras, at an average altitude of more than 12,000 feet.

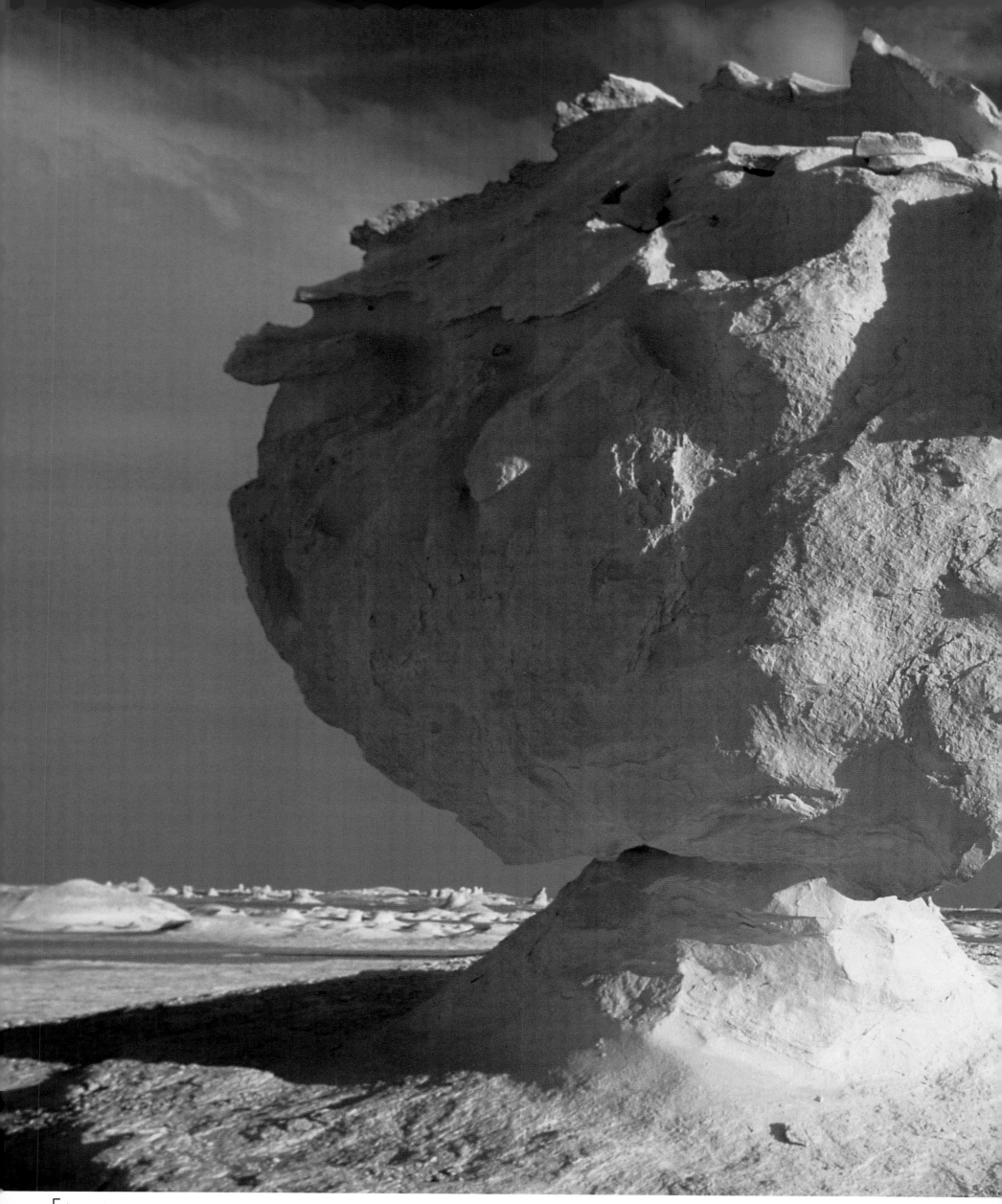

Above: Is this a universe made of sand or salt? Or are these mushroom clouds from a nuclear blast frozen in front of the photographer's eyes, or snowmen melting in the sun? None of the above. It is in the White Desert, in Egypt. There is no trace of animal or plant life, only a world of limestone and chalk, where the wind, over time, has sculpted the rocks into improbable shapes: statues in which the eye imagines more than is actually there. Perhaps this is also a glimpse of what our planet might look like one day in the future.

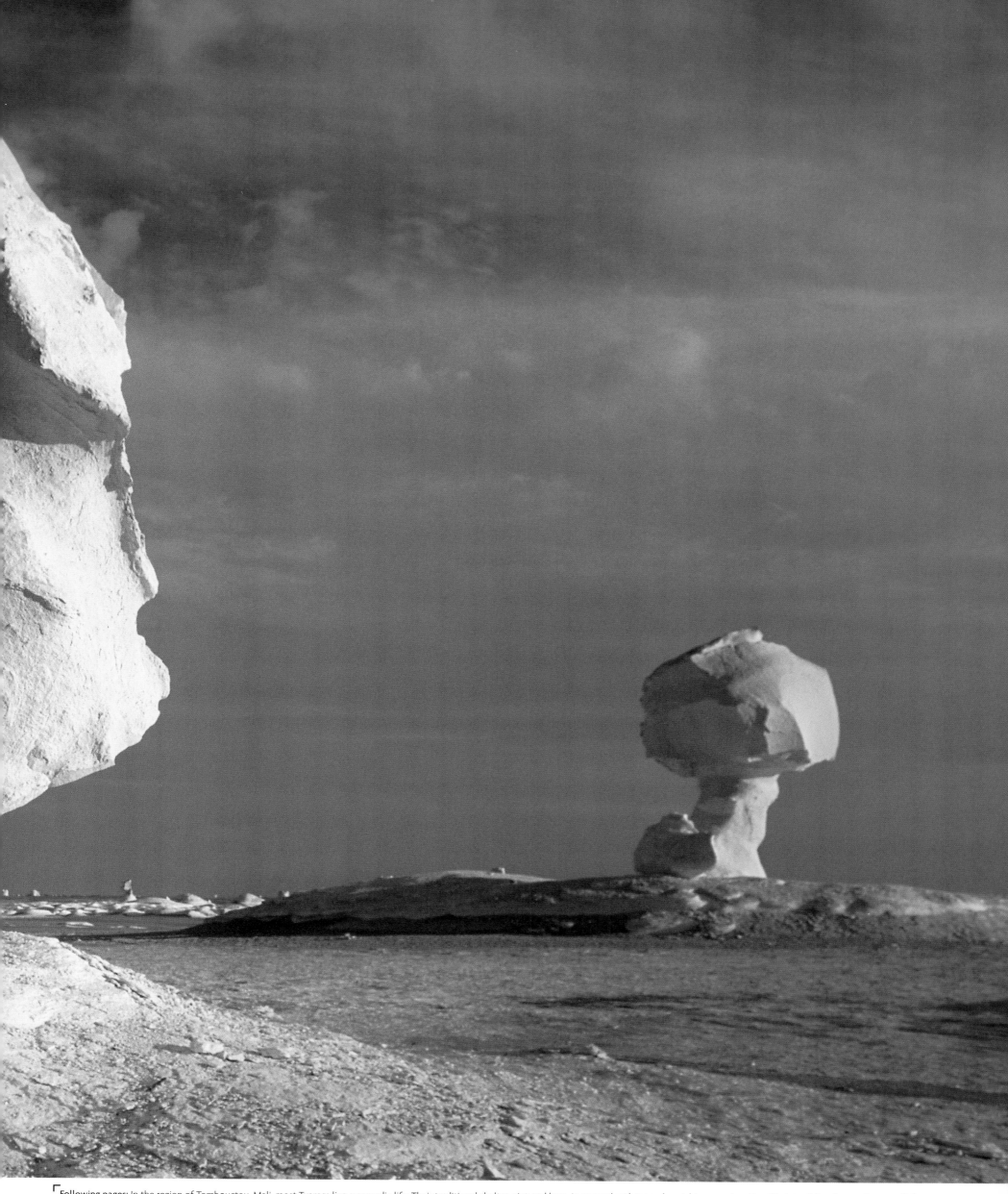

Following pages: In the region of Tombouctou, Mali, most Tuaregs live a nomadic life. Their traditional shelter, pictured here, is covered with tanned goatskins sewn together. Their traditional nomadic way of life, however, is now threatened, replaced with a largely urban lifestyle that offers them no real prospects.

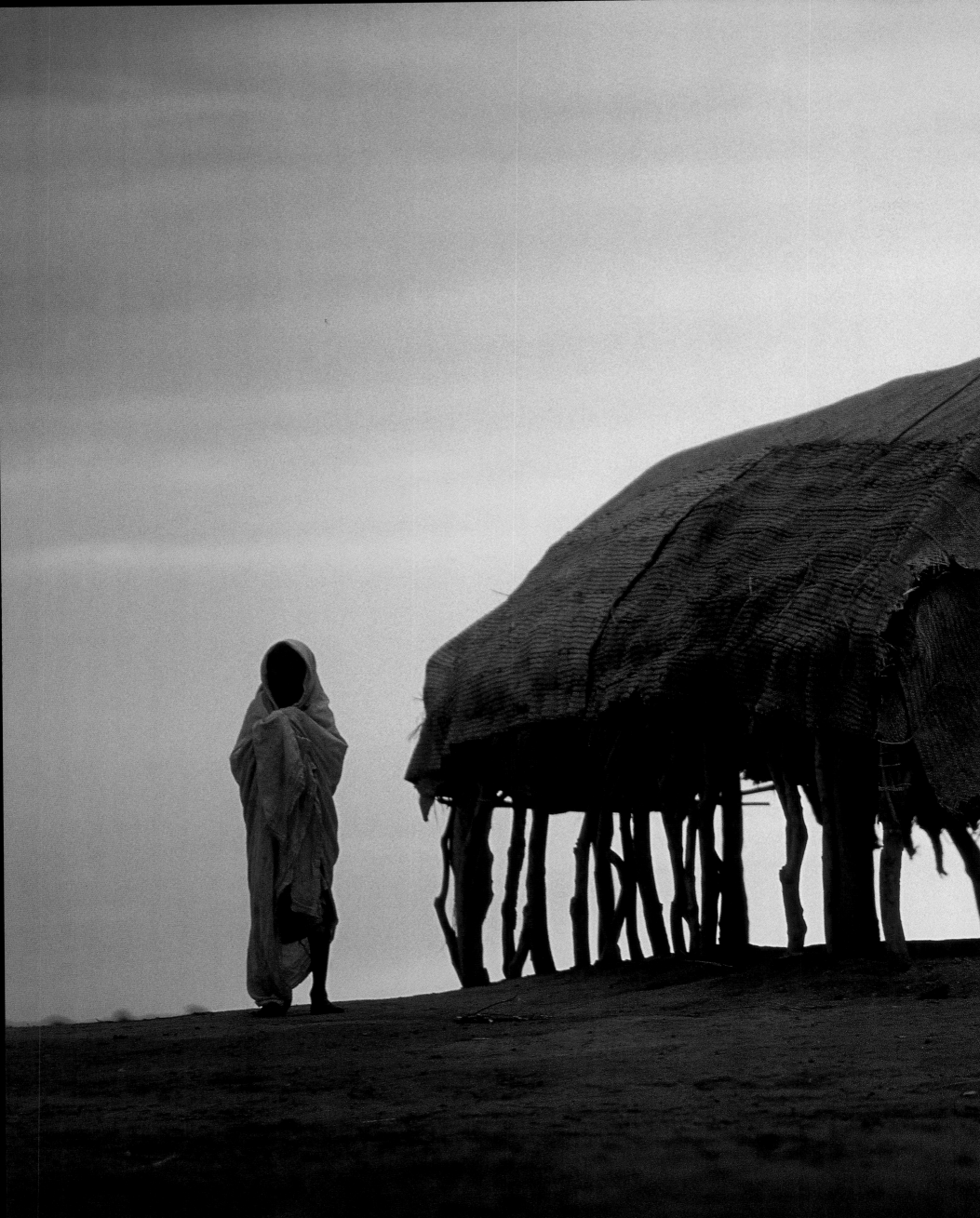

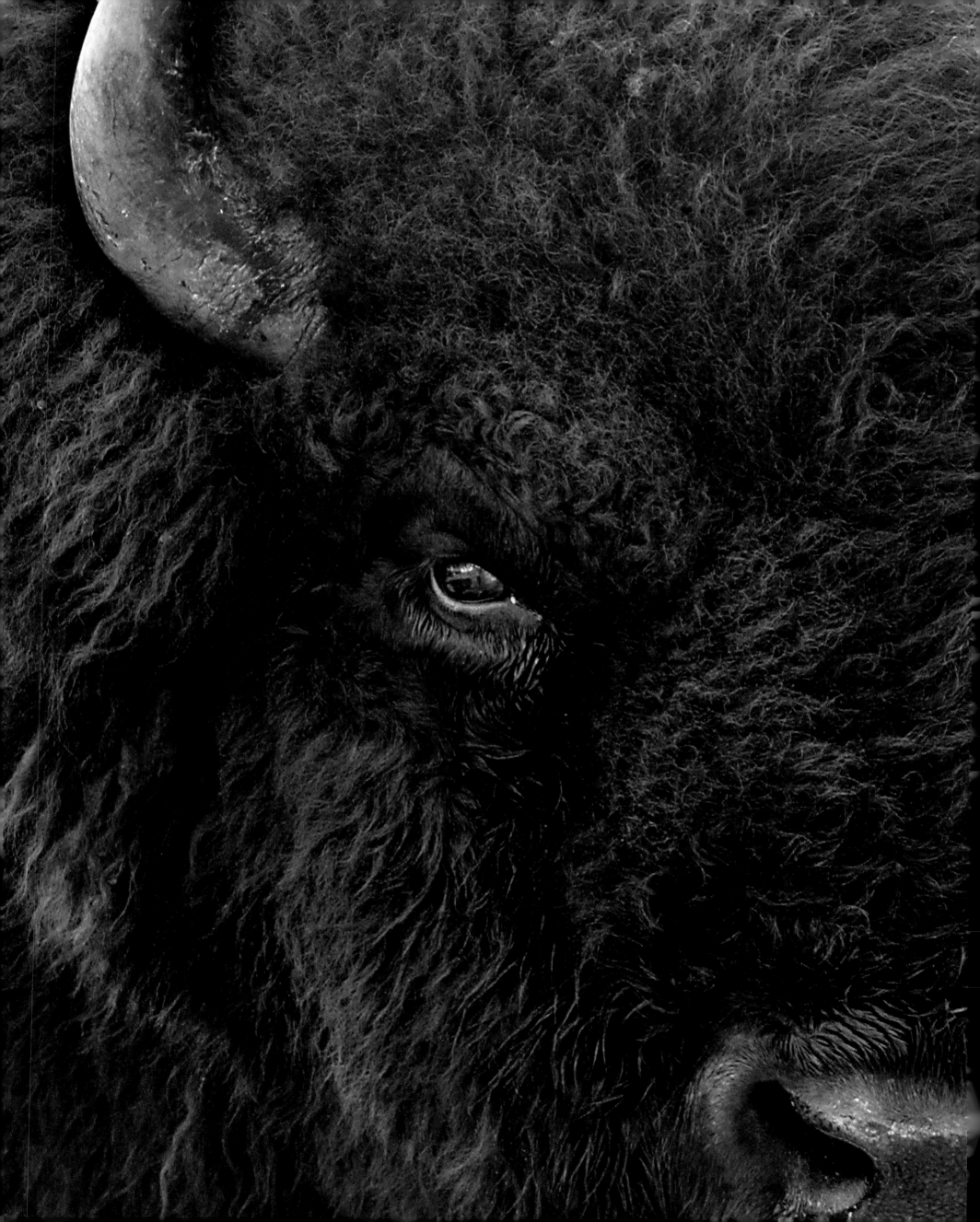

Grasslands

Whenever someone mentions grasslands—those vast, luminous expanses to which the eye is drawn—my first thought is of the African savannah, especially that of East Africa. Everyone can picture those great plains, with their processions of animals, tall grasses, and the imposing, proud outline of acacia trees. Their fauna is abundant and varied.

Left: The eye of a bison: What species better embodies the great open spaces of North America? Before the white man arrived, prairies covered a considerable area of what is now the central United States and were probably home to millions of bison. In the space of a few decades, the species has almost disappeared, and the prairie is now reduced to fragments contained within protected areas.

Grasslands

Giraffes, elephants, zebras, gnus, lions, hyenas, and many other species, familiar even to children who live in our cities, are superb examples of the diversity and inventiveness of nature. These large mammals are just a small part of the biodiversity found in grasslands. Large herbivores, especially antelopes and elephants, find the vegetation they need here, but they are also the architects of this landscape. Their numbers and diversity ensure these tall grasses reproduce. Each animal species has its own diet, choosing different plants, or parts of plants, to eat, giving little chance for the fragile shoots of bushes and trees to grow wild. If these herbivores were not here, the terrain would become overrun with bushes and eventually trees; this open country would slowly become wooded.

The diet of these animals, however, is not the only thing that alters the vegetation; fire plays a role as well. This element and these great expanses are inseparable, so much so that, for example, certain herbaceous plants can germinate only after the ground temperature has risen due to fires. The reason the world's open plains remain open is because of these minor disturbances produced by herbivores and fires, and are thus classified as "young" environments, rich in biodiversity. Sadly, savannah has become a rare habitat today, existing only in national wildlife reserves, frozen in time like an old postcard.

In other latitudes, open plains are known as prairies, and the American bison that grazed on prairies were chiefly responsible for their existence. These large herbivores were hunted mercilessly and are now found only in wildlife refuges. The wild prairies, once so rich in life, have almost disappeared from the United States.

Humans have been changing their environment for 10,000 years. The development of agriculture and the raising of livestock enabled them to master the natural environment, and the natural landscapes gave way to those shaped by humans.

Very quickly, the domestication of livestock—goats, sheep, donkeys, aurochs, reindeer—between 10,000 and 6,000 B.C. allowed humans to attain the civilization we know today. Pastoral nomadism developed in all continents, bringing economic activity to regions with a harsh climate or poor soil unsuited to agriculture, while preserving the diversity of species. This human presence is an essential component of these harsh ecosystems. Pastoral nomadism is also the way of life through which humans have colonized the planet. It became widespread after the horse and the dromedary were domesticated, which allowed travel over long distances in Asia and North Africa during the first millennium B.C. A few nomadic groups are Tuaregs and Peuls in West Africa; Lapps, Nenets, and Tsaatans in Scandinavia, Siberia, and Mongolia, respectively; and the Bedouins, Kurds, Kirghiz, and Mongols in the Middle East and Asia.

Zebus, dromedaries, goats, sheep, reindeer, horses, Bactrian camels, and yaks descended from undomesticated species that were able to adapt well to local environmental conditions. The shifting of the steppes and tundra reflected the needs of the environment, climate, vegetation, and game as well as the herders. Contrary to what is often believed, what was new about the way of life of these "global societies" was not their mobility (even though this enabled different areas of pasture to be used alternately) but the dispersion of people into small groups or clusters. This dispersion reflected the demands of human survival within geographical areas with limited resources, which were used parsimoniously and lastingly.

In Europe, agriculture and livestock farming led to the disappearance of large herbivores and predators. Farmers who settled there began to burn down forests in order to sow crops in the clearings, or to turn them into pasture for their herds to graze. This led to the destruction of natural open habitats such as marshes, peat bogs, and grasslands. This gradual change allowed most species to adapt to the new conditions and to continue living in the areas left free of human activity. Specific, varied flora and fauna endured in regions where livestock farming retained its extensive nature. When industrial agriculture intensified (over the last 50 years or so) the course of events were forever changed.

Until recently, the steppes of central Asia were open land managed by natural grazing. Today, in Kazakhstan, the disintegration of traditional agriculture has led to entire regions being overgrown with bushes; plantations of poplars have completed the afforestation of this habitat, favoring the return of predators and contributing to the disappearance of local

> In Europe, agriculture and livestock farming led to the disappearance of large herbivores and predators.

species. In Mongolia, by contrast, the intensification of small herders' grazing has endangered not only wild herbivore species such as the saiga but also the survival of vegetation itself.

Today, it is no longer a question of taming nature so we can live in harmony with it, but rather of subjugating it to our Promethean illusions. By ignoring the power of nature, we are drastically changing the landscape and with it the functioning of ecosystems, endangering biodiversity in the process.

The uniform vegetation of crops does not trap rainwater—it runs off in large quantities, carrying with it soil, nutrients, and artificial substances such as fertilizers and pesticides. The water cycle is disrupted, and water quality is jeopardized. In these vast expanses, wild plants and animals are seen as undesirable—"weeds" or "pests." These kinds of word choices show how humans have declared war on the biodiversity of these open spaces.

As great quantities of herbicides and pesticides are used, crops—as well as the land itself—are sterilized, and flora and fauna disappear: a hellish, vicious circle. Invertebrates and insects vanish and, with them, the chief nourishment of birds, such as the shrike, which is fond of large beetles. Now a silent spring has descended on many agricultural regions of Western countries. Have we forgotten how much wild plants and trees, such as those that we cultivate, owe to pollination—especially pollination by insects? Wild plants and soil-dwelling invertebrates are all part of the food chain, including birds and mammals, which are threatened in turn. The few remaining havens of this diversity of life of the plains are found in the last areas of rough pasture mixed with woodland, and in the few hedges that still grow along roadsides and in other infrastructure. Confined to these fragile islets of "wild country," species are reduced to very small numbers and prevented from moving about or mingling with others of their kind. As a result, they are threatened with extinction.

> Confined to these fragile islets of "wild country," species are reduced to very small numbers and prevented from moving about or mingling with others of their kind. As a result, they are threatened with extinction.

Agriculture's excessively powerful hold over the land prevents ecosystems from working, sterilizes the environment, and reduces the diversity of crops—as well as of livestock varieties—to the minimum. And yet, not long ago, agriculture relied on a very wide variety of plant and animal species. It involved mixed farming and raising livestock, a wide range of crops, small field sizes, and many races of domestic herbivores.

Grizzlies hunting salmons; mixed herds of elk, deer, and antelope grazing in pastures; cougars peering down from above. Although this scene sounds as if it took place in a remote, undisturbed land, it actually happened around the shores of San Francisco Bay only 150 years ago. The only species that still wander in this region are the deer and cougar, and they're far removed from the Bay. The cause for the reduction of these species is clear: artificial urban habitats push out the indigenous species. Today, the numbers of plant and animal varieties have been dangerously reduced. This reduction in the diversity of living things—due to the use of insecticides and herbicides that favor the development of more aggressive pathogens—renders crops more fragile and endangers the health of the food supply.

Western agriculture is an important cause of the erosion of biodiversity and ecosystem degradation, changing the quality and quantity of renewable resources that are indispensable to people's health and well-being. A society that claims to be concerned about the environment, and which has the ability to stop degrading the ecosystem, cannot be at ease with this. What used to be acceptable when priorities were different is no longer acceptable.

In the present agricultural ecosystem, biodiversity is in danger. When humans grow only the kinds of crops and plant life that are the most productive, they are behaving in a terrifying manner that can have dangerous repercussions. How far down this road will they travel? Respect for nature can never be born out of these selfish actions.

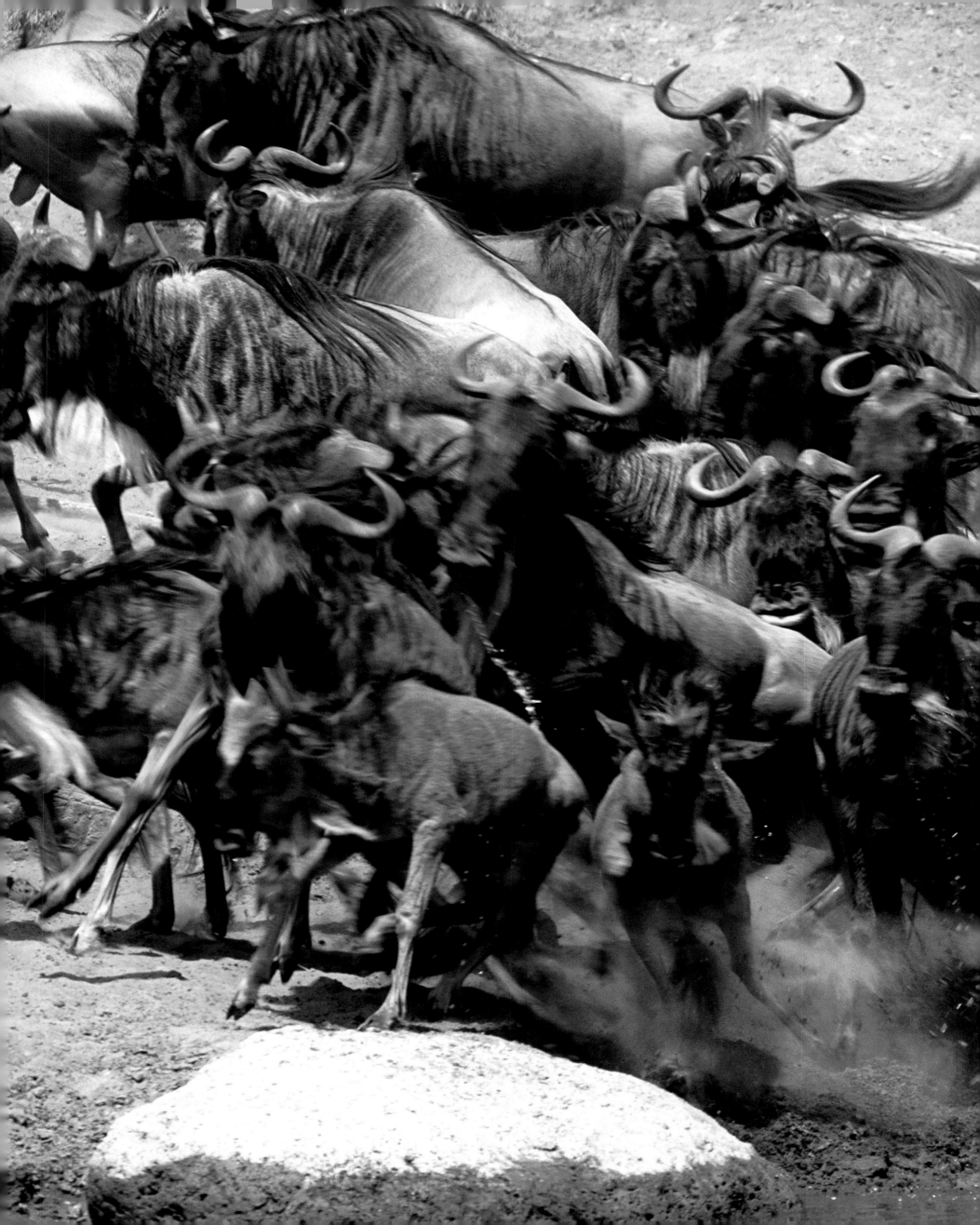

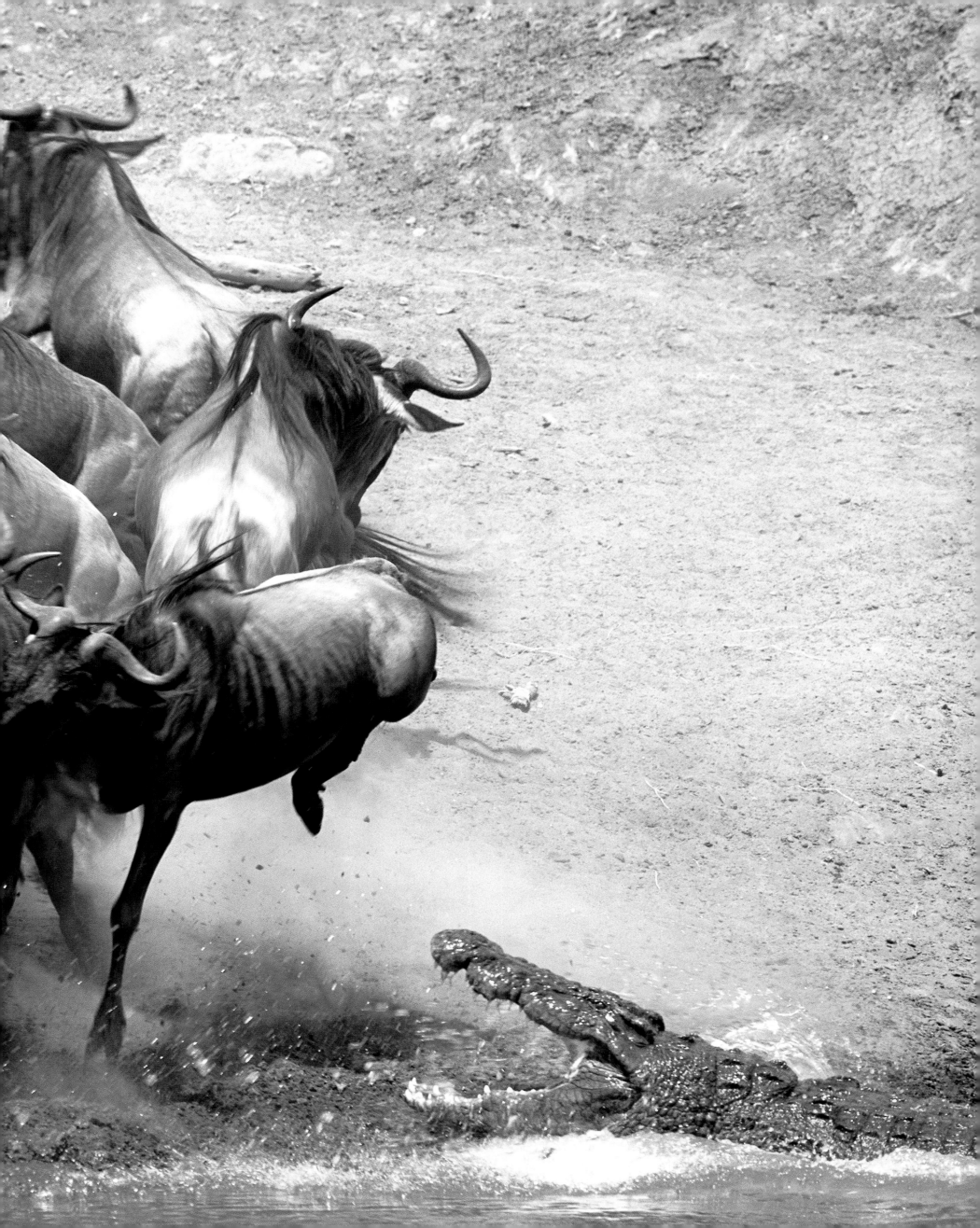

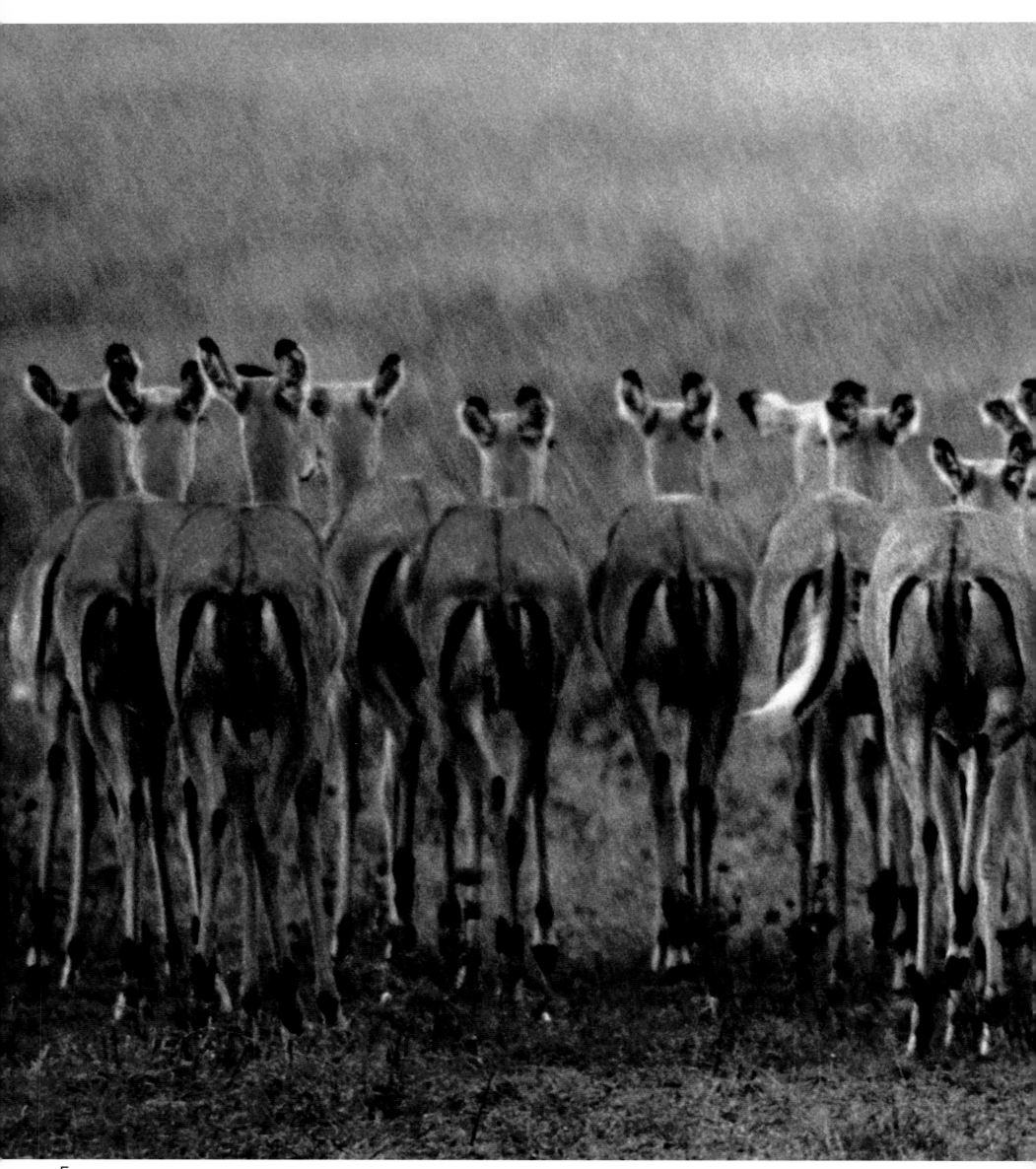

Preceding pages: The gnu's journey is not always a peaceful one. To reach some grass-rich pastures, it must sometimes cross rivers swollen by the rains, such as the Mara River in the Masai Mara Reserve in Kenya. Many gnus drown, carried away by the current, while near the banks of the river, crocodiles, attracted by this unbelievable bounty, wait their turn to attack the weaker gnus.

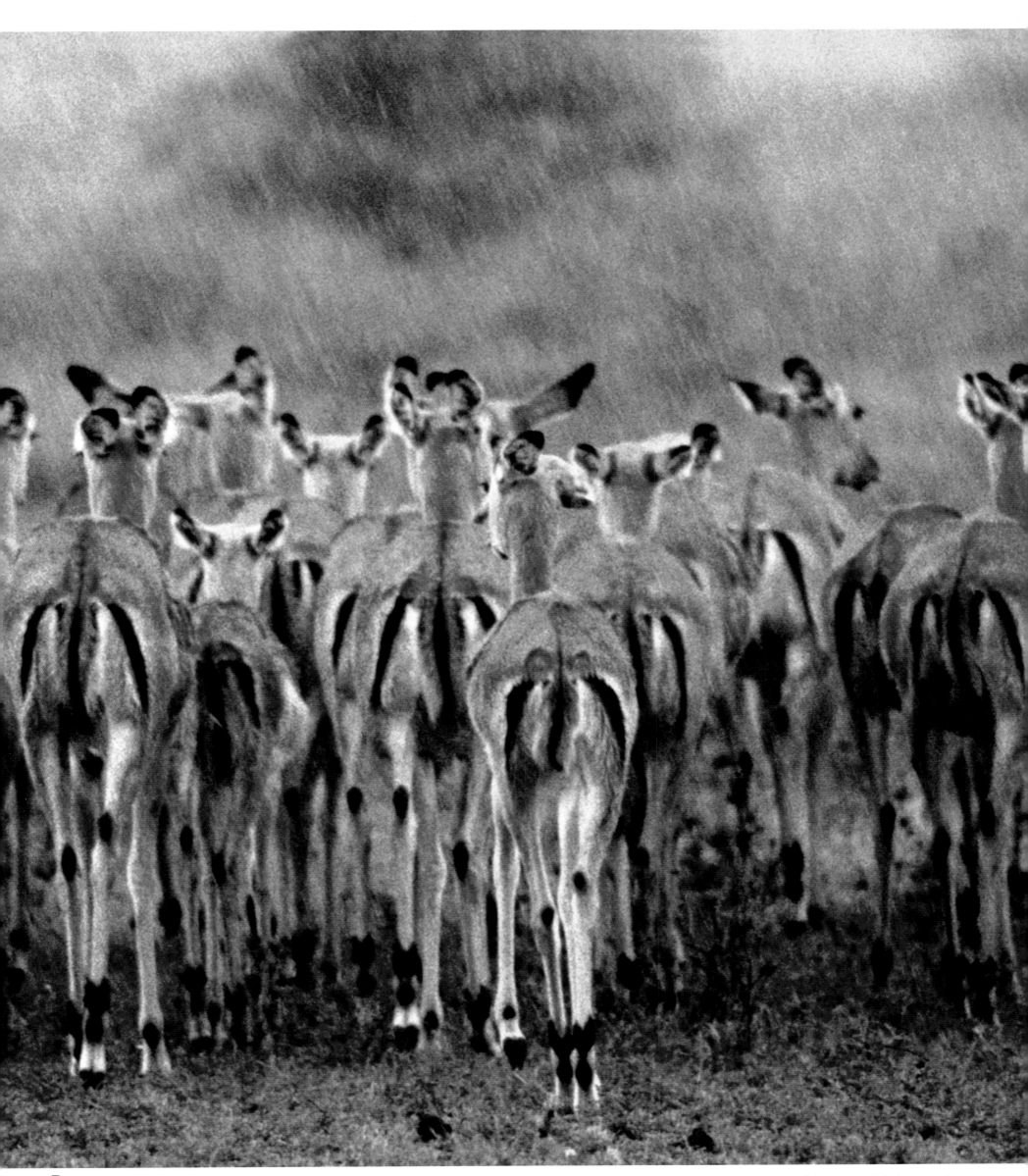

Above: Like other antelopes, these impalas are dependent on the rains and the vegetation that follows. Like gazelles, impalas are frequently the victims of predators. It is estimated that more than half the young of this species ends up in the jaws of large carnivores.

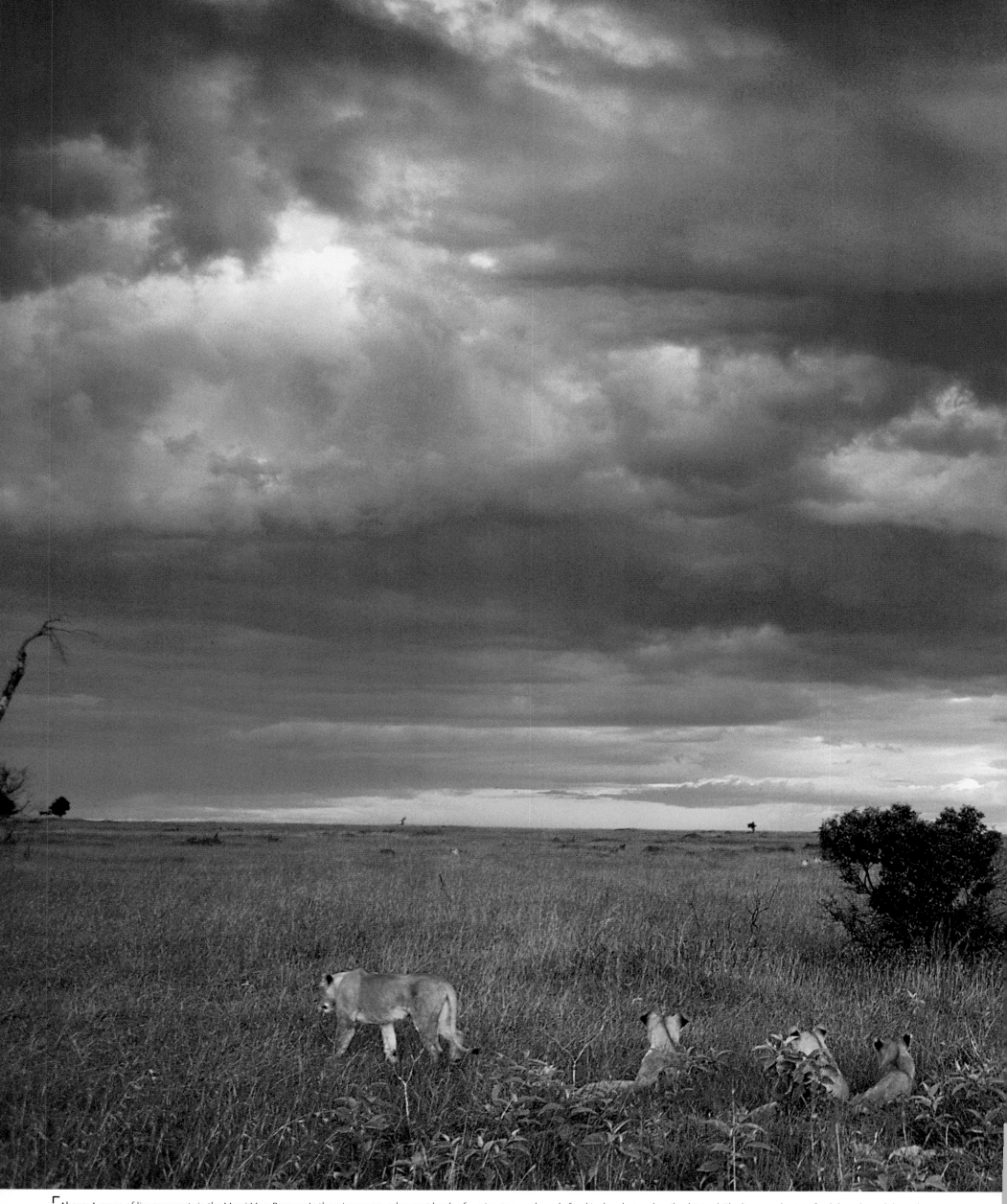

Above: A group of lionesses rests in the Masai Mara Reserve. In the rainy season, when vast herds of ruminants pass through, food is abundant and easily obtained. The lionesses hunt to feed the cubs and the male lions, which are the first to eat once prey has been killed. Lionesses live together for their entire lives.

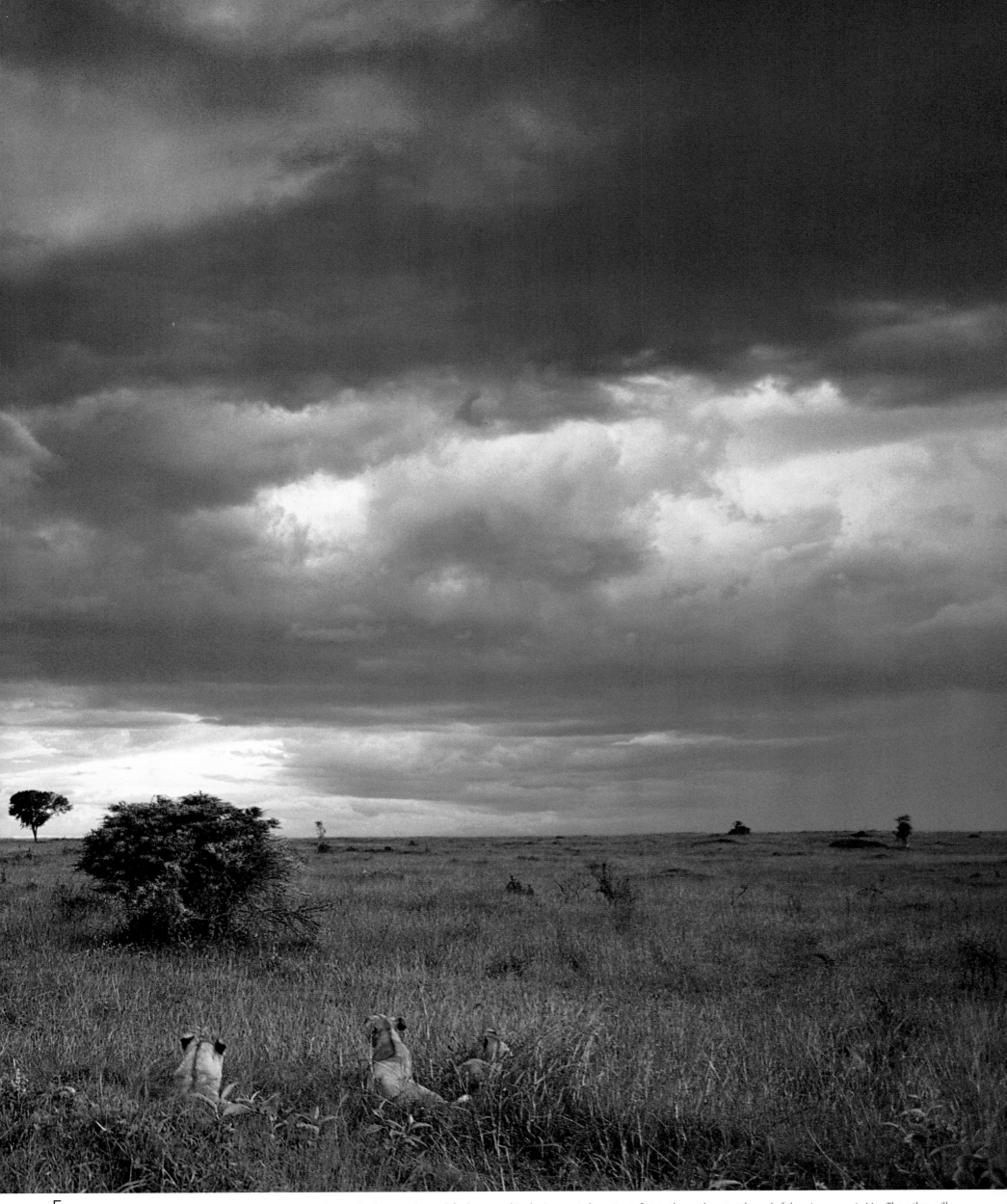

Following pages: Burchell's zebras move about in the company of gnus. Like the gnus, they seek fresh grass and, in the Serengeti, they migrate first to the northwest at the end of the rainy season in May. There they will find the dampest areas, where the grass has not yet been burned by the sun. The distance traveled depends on the abundance of the rain: the less it rains, the farther north the animals go.

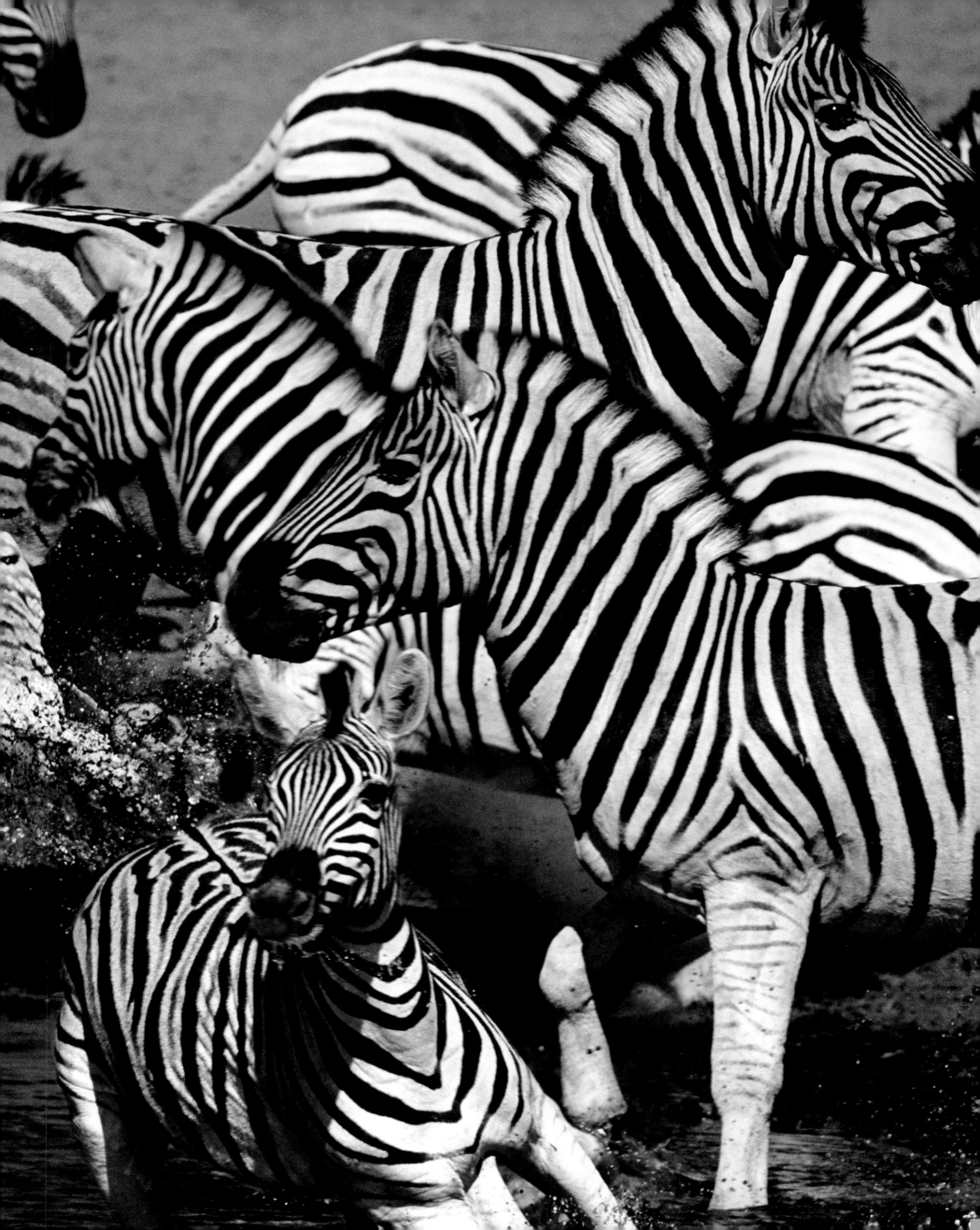

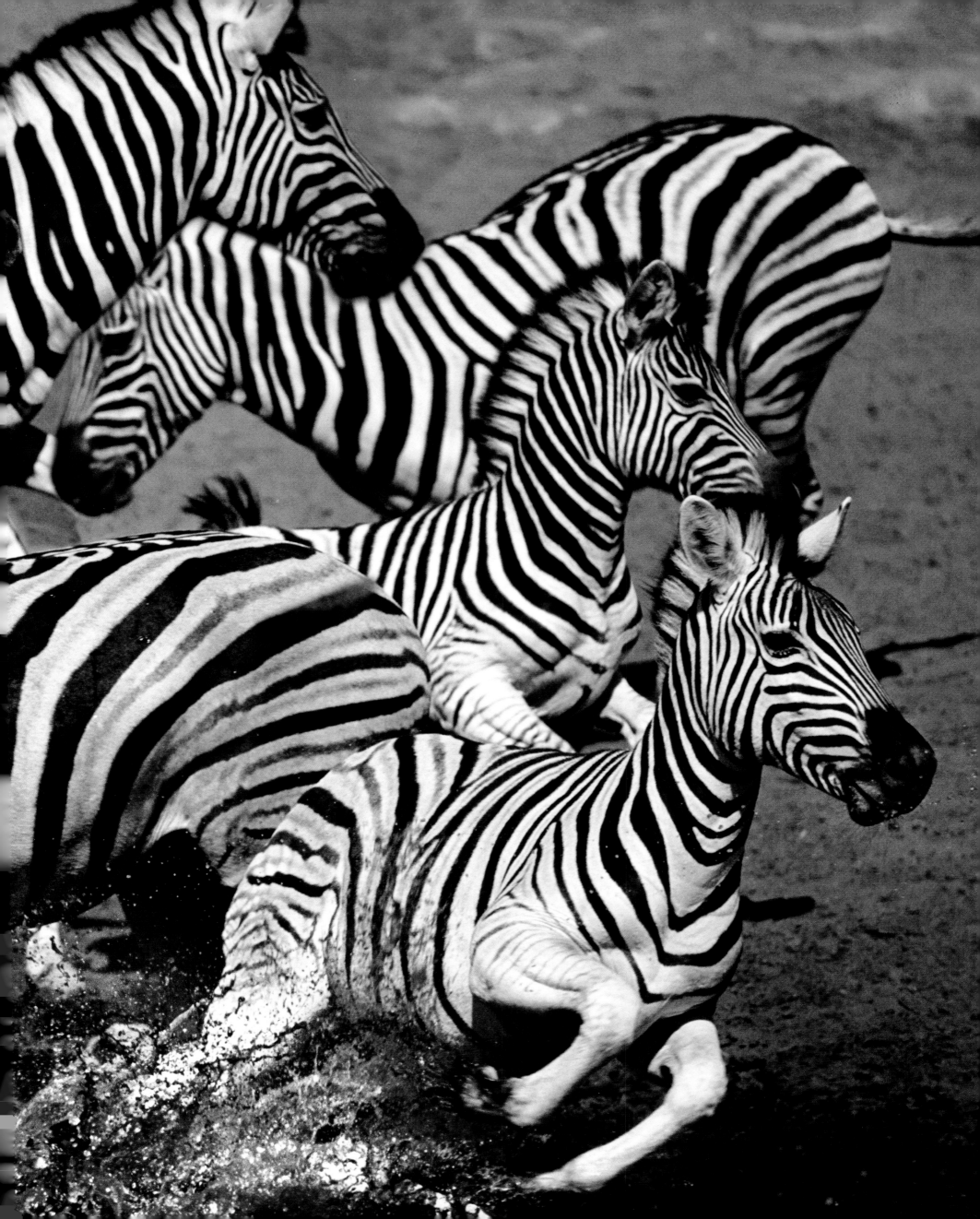

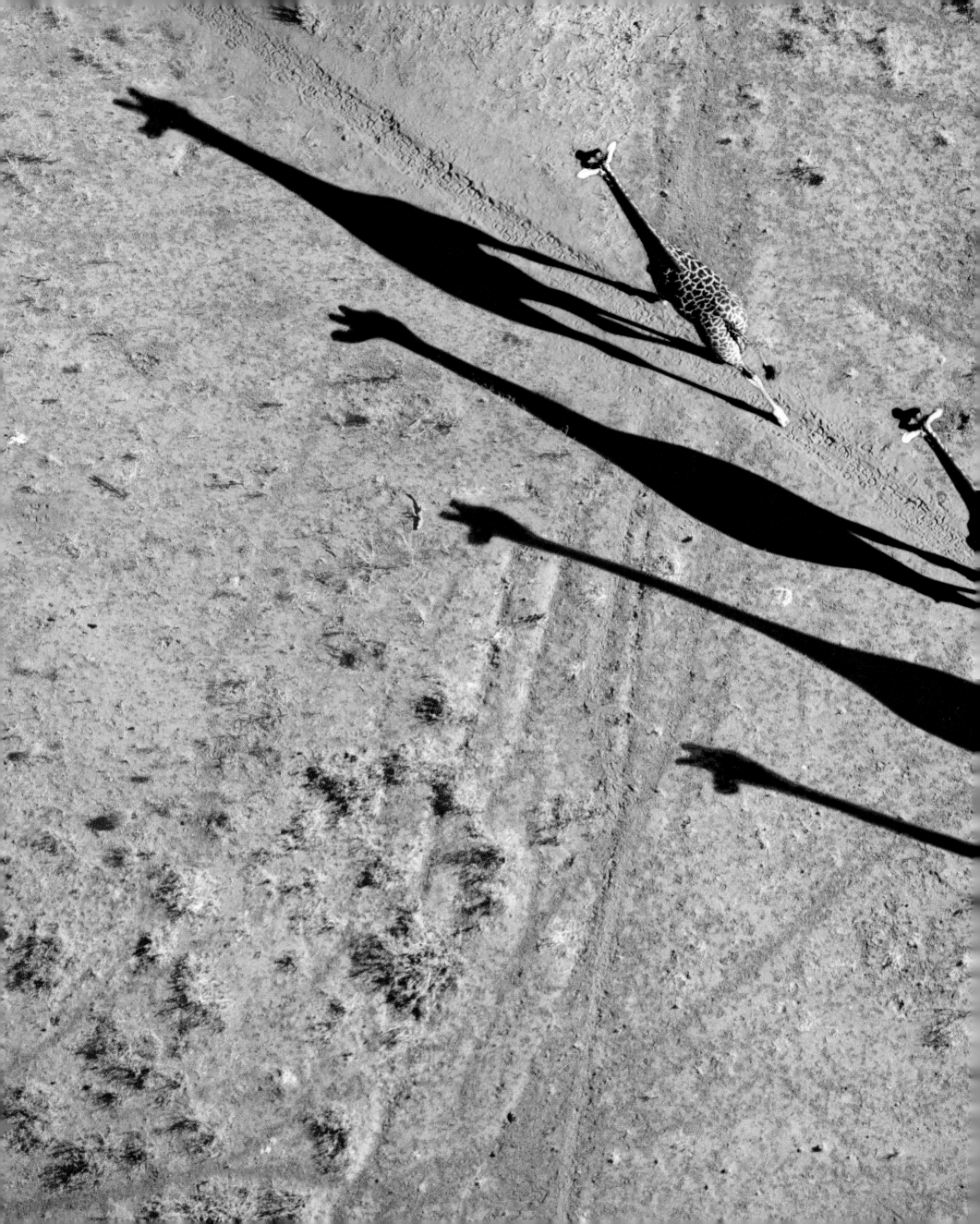

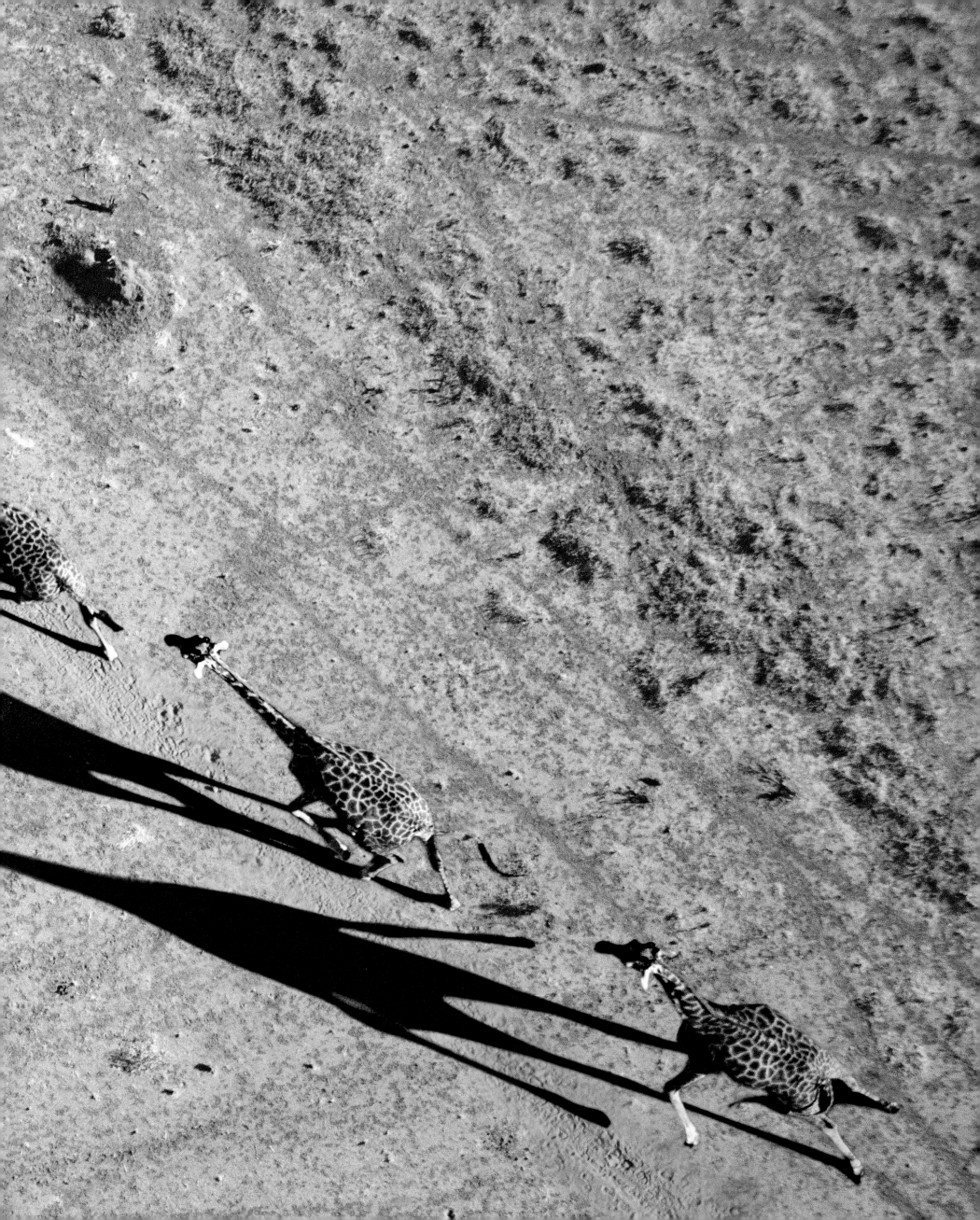

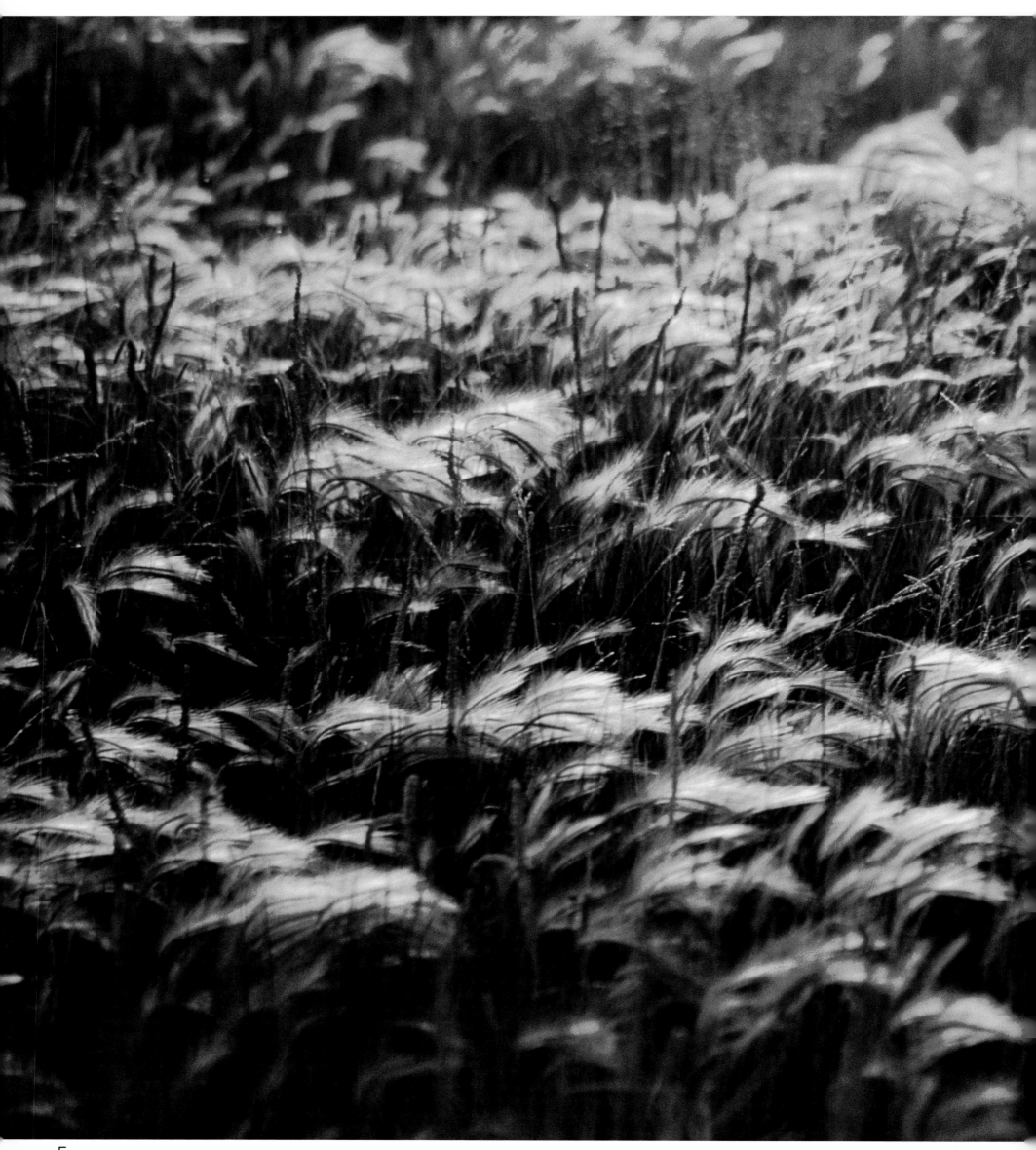

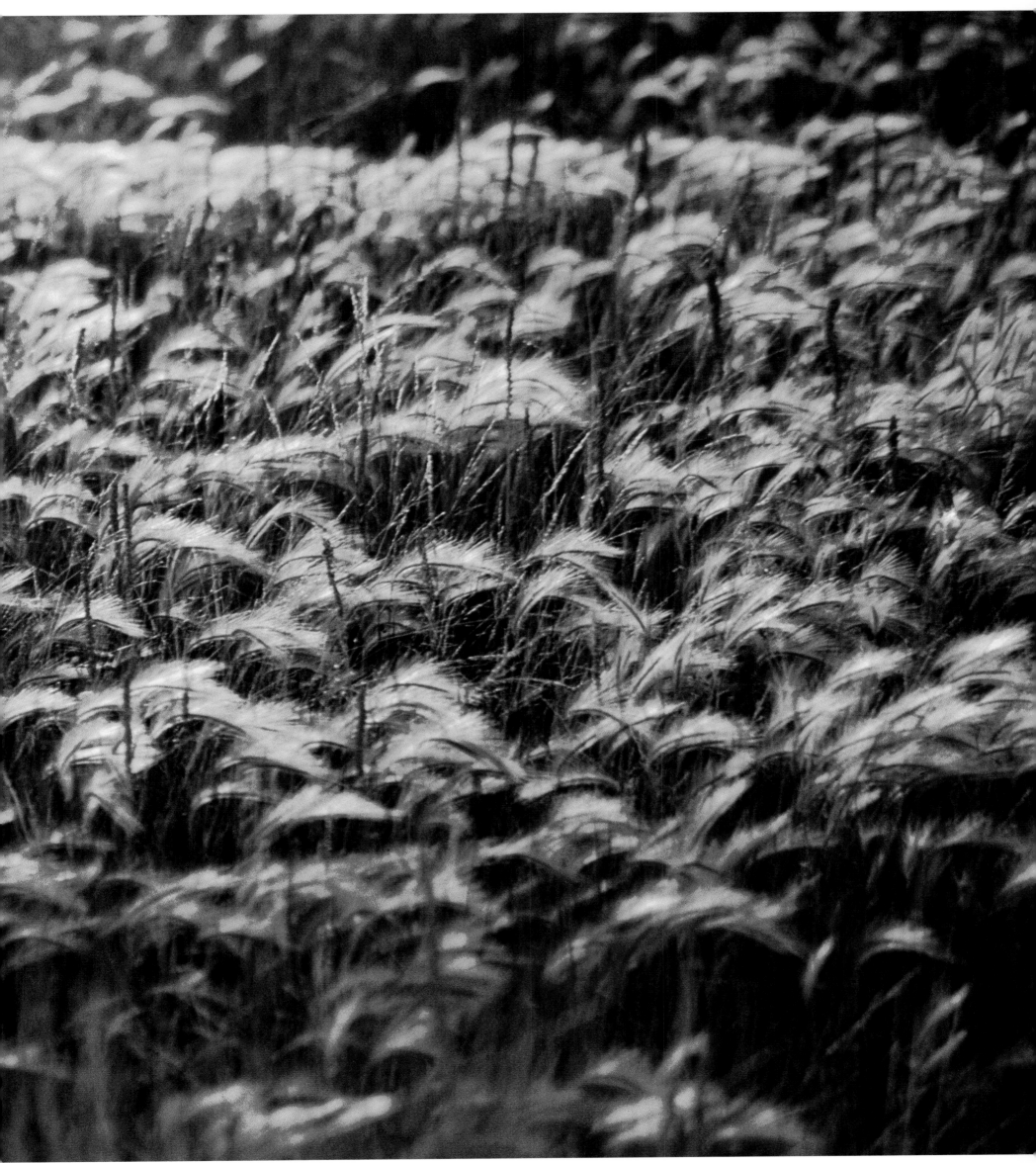

Above: In North America today, vast prairies where many grass species and abundant flowering plants grow can only be seen in reserves—as here, in the Seedskadee National Wildlife Reserve in Wyoming. Elsewhere on the continent, prairie has given way to the monoculture of various cereal products. This has caused considerable damage to biodiversity, leading to the decline and even the disappearance of animal species tied to this habitat, such as prairie dogs, prairie chickens, meadowlarks, and buntings.

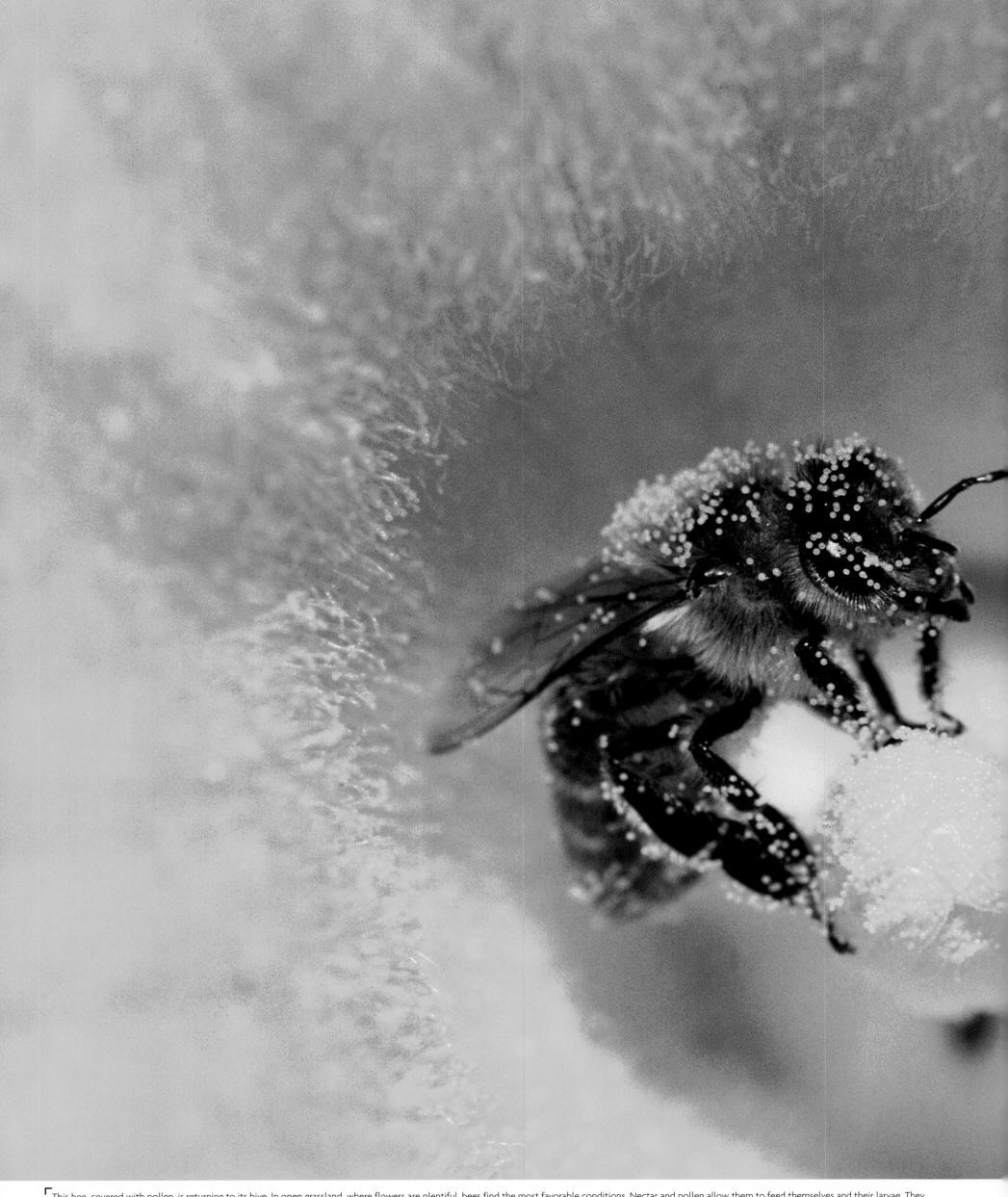

This bee, covered with pollen, is returning to its hive. In open grassland, where flowers are plentiful, bees find the most favorable conditions. Nectar and pollen allow them to feed themselves and their larvae. They collect nectar with their tongue and store it in the crop. The hairs that cover a bee's body trap pollen grains, which are later stored in balls on the bee's hind legs.

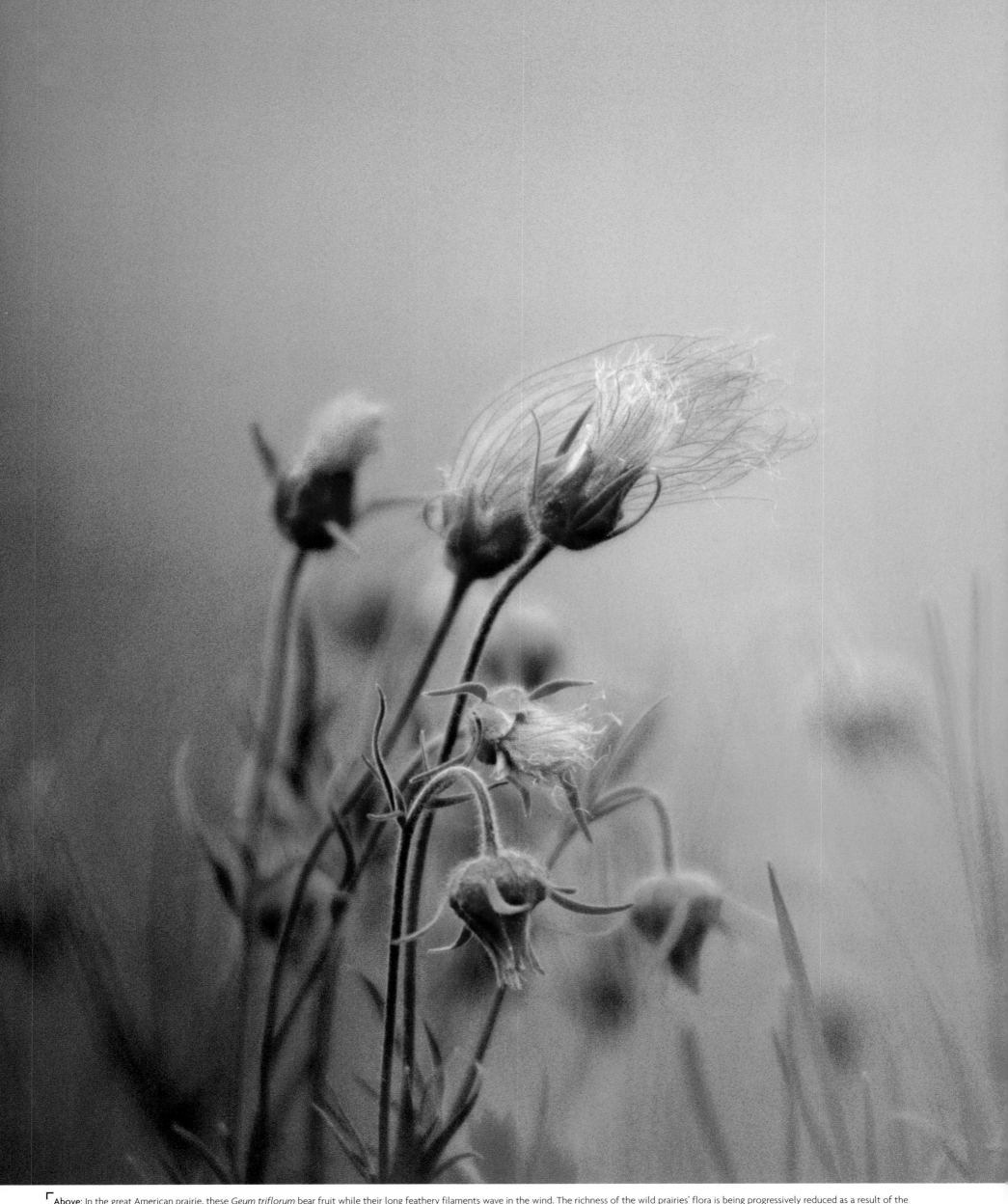

Above: In the great American prairie, these *Geum triflorum* bear fruit while their long feathery filaments wave in the wind. The richness of the wild prairies' flora is being progressively reduced as a result of the irreversible decline of this type of habitat, which has been replaced by cereal monoculture (corn, wheat, and the like). What will be left of these flower-strewn prairies at the end of the 21st century?

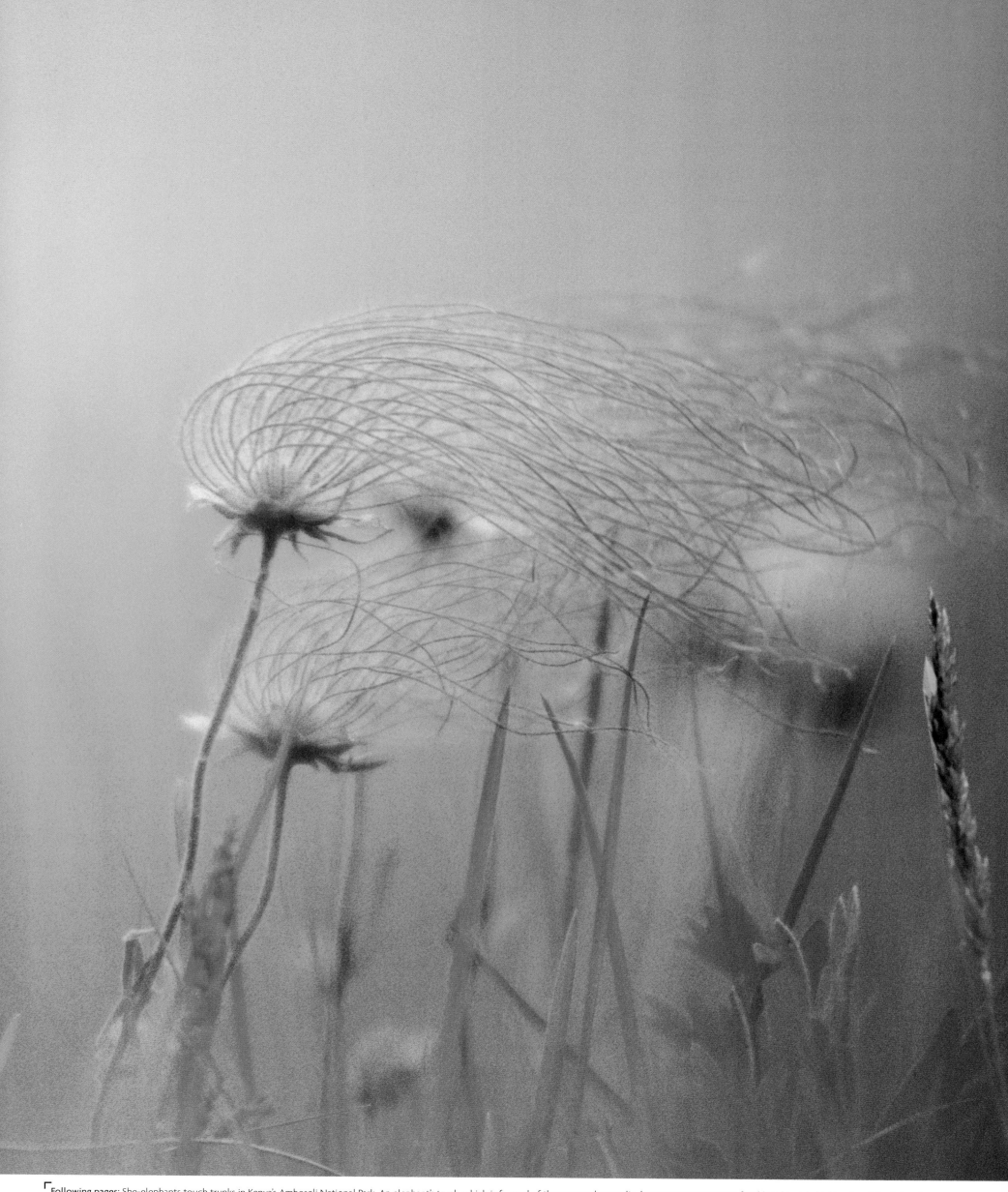

Following pages: She-elephants touch trunks in Kenya's Amboseli National Park. An elephant's trunk, which is formed of the nose and upper lip, has many uses: grasping food (or objects), drinking, breathing (when in water, the elephant can use it as a snorkel), and smelling. The eldest female leads female and young elephants.

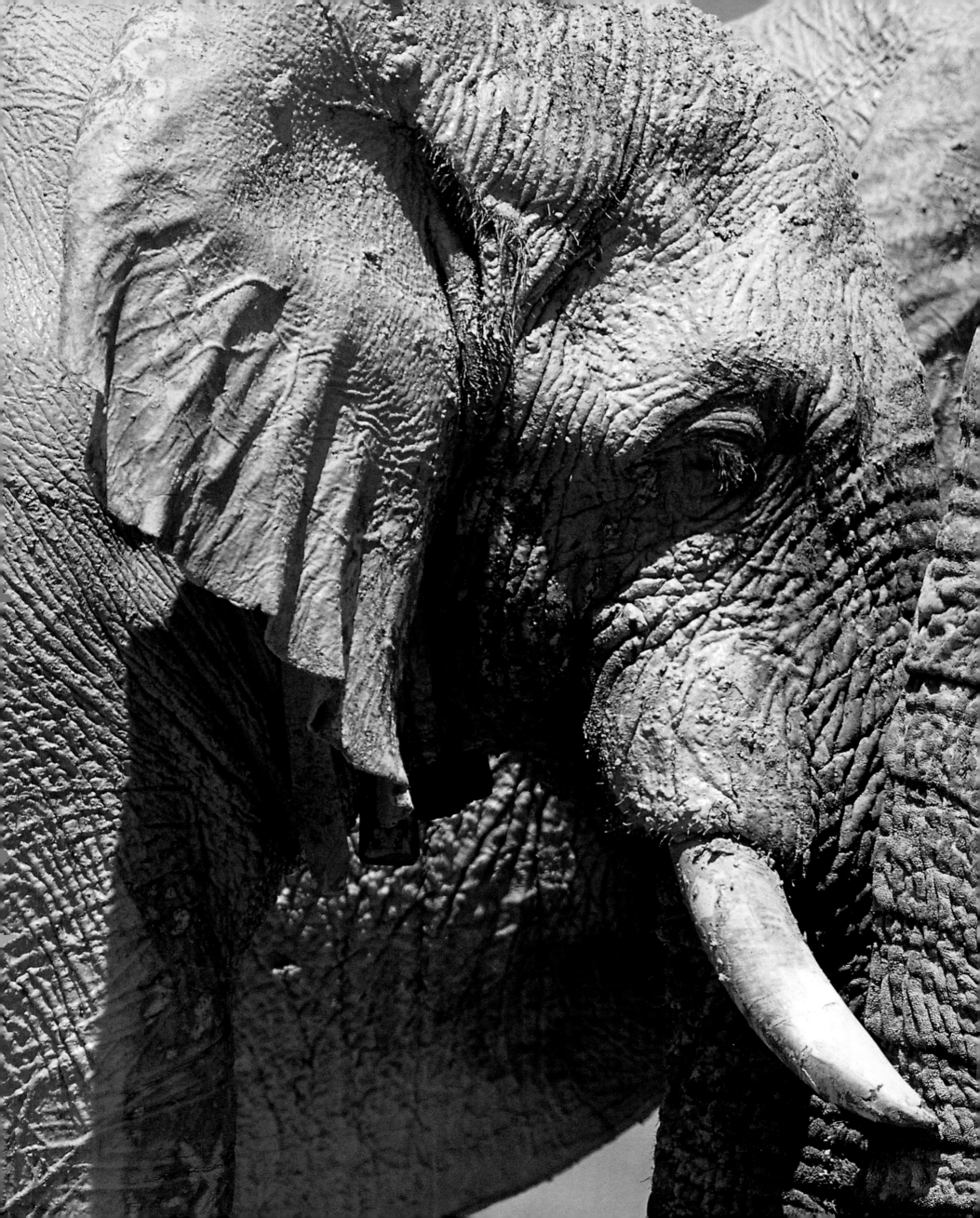

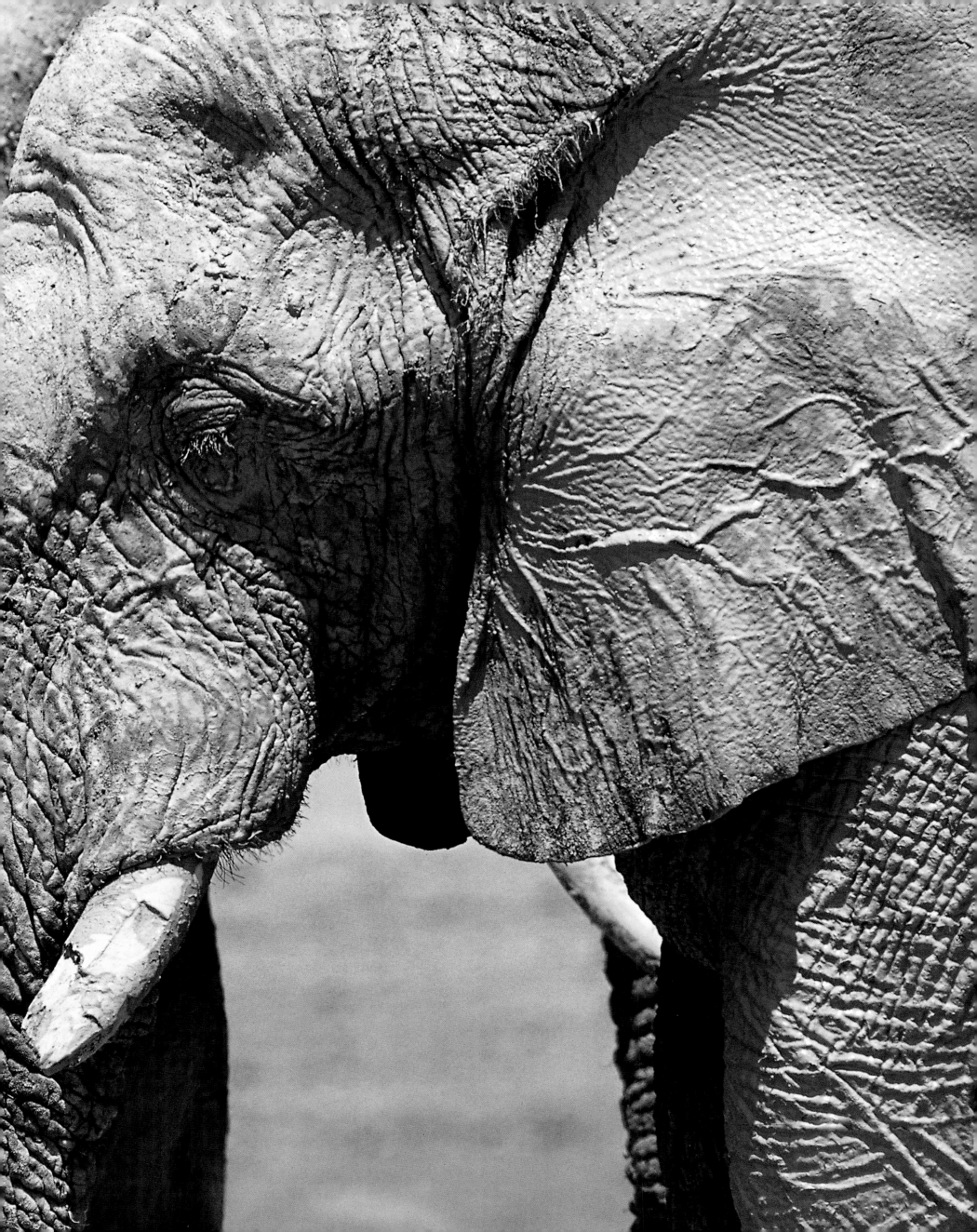

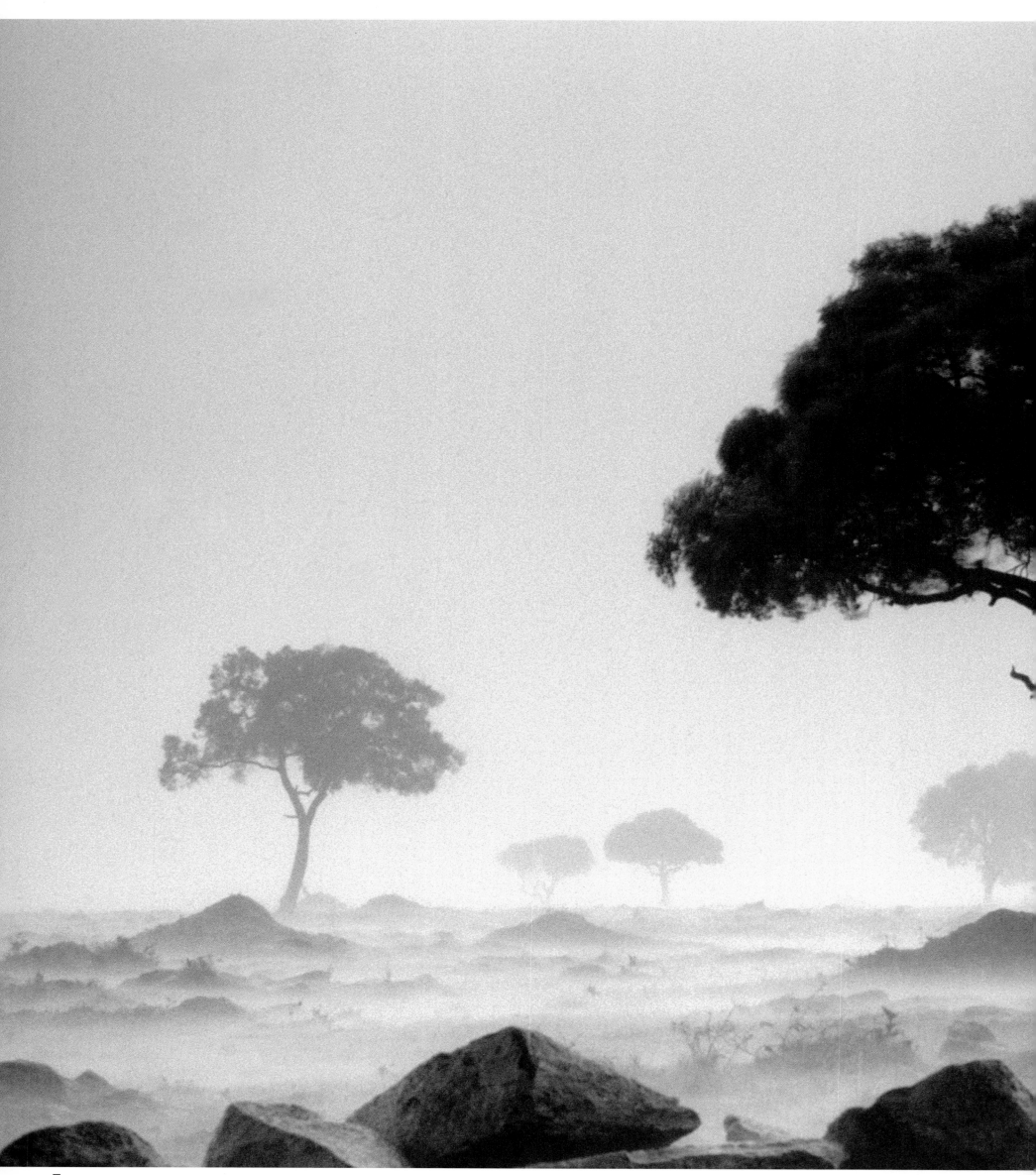

⌐**Above:** Suddenly, on a morning in November on the Serengeti Plain in Kenya, the rains arrive. In the space of a few days, grass will sprout and turn the cracked earth green. This is the long-awaited moment for the great herds of ruminants—zebras, gnus, and gazelles—to begin the greatest movement of mammals on the planet. Previously confined to the northern part of the Serengeti National Park in Kenya, more than 1 million gnus and 800,000 zebras will head southward, their movements dictated by grass growth in this park, whose name means "infinite plain" in Masai.

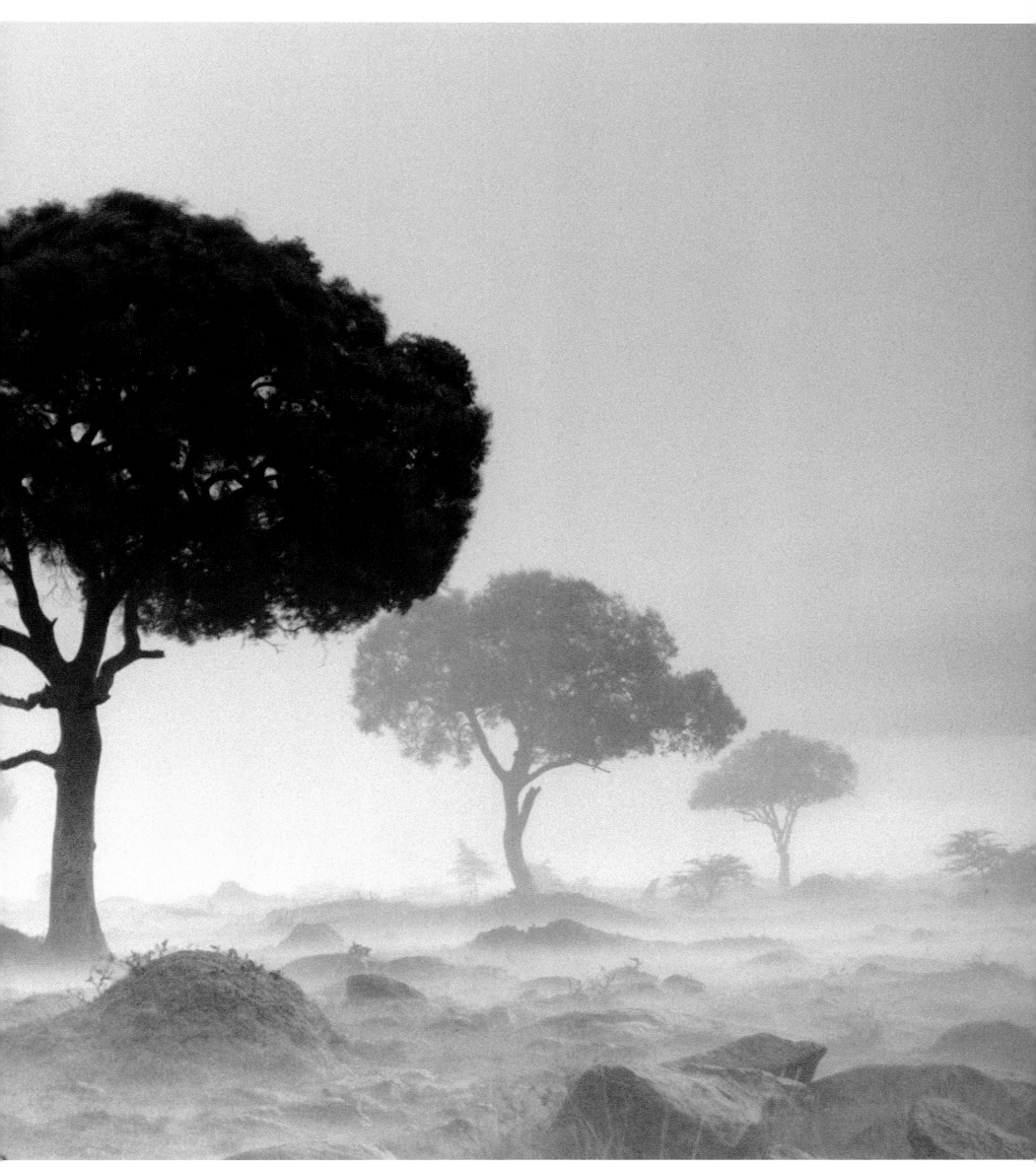

Following pages: At the foot of their sacred mountain, the Ol Doinyo Lengai volcano in Tanzania, Masai herders graze their cattle on the savannah. Their use of the natural habitat is modest and does not damage the ecosystem. Wild and domestic animals exist in harmony, side by side.

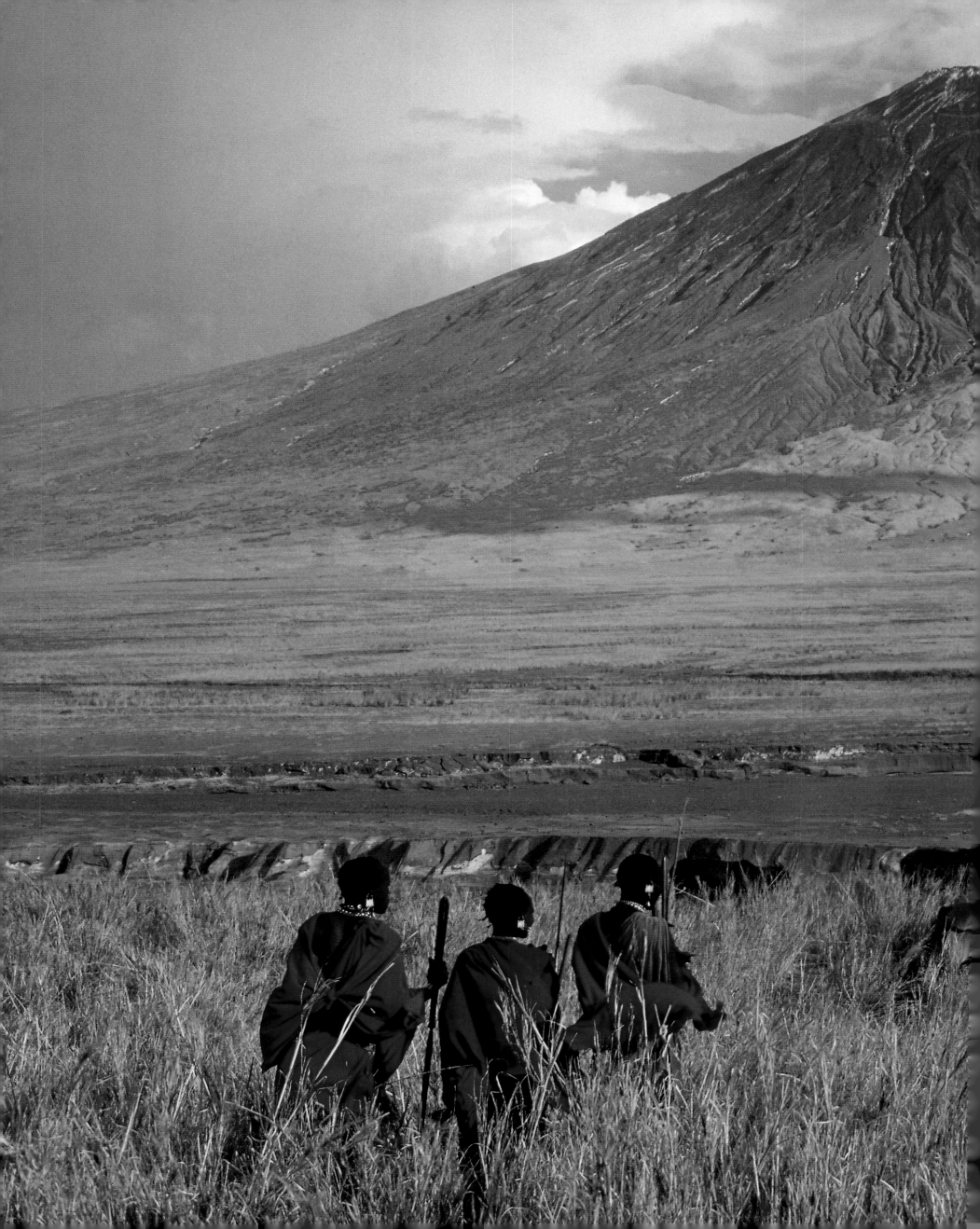

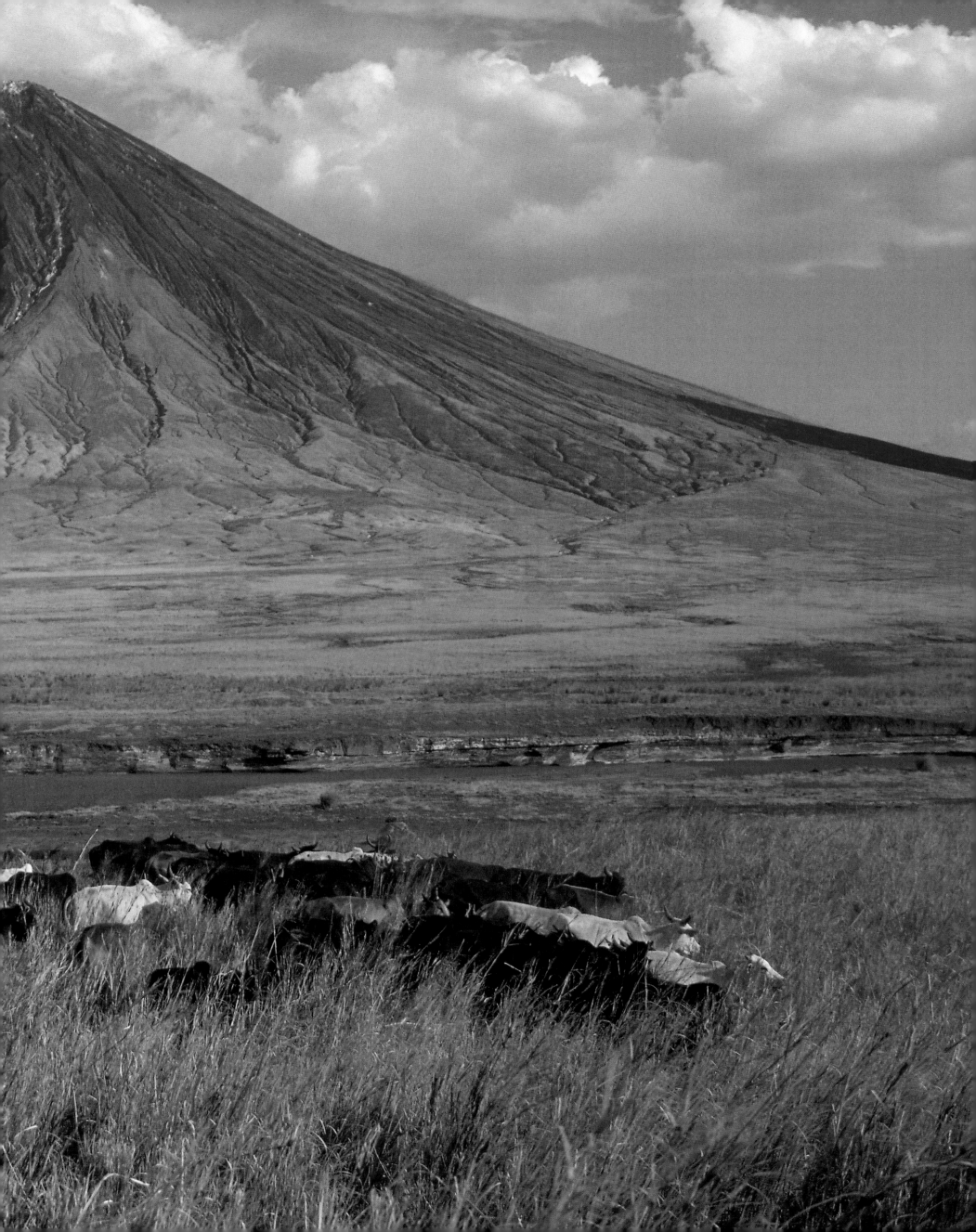

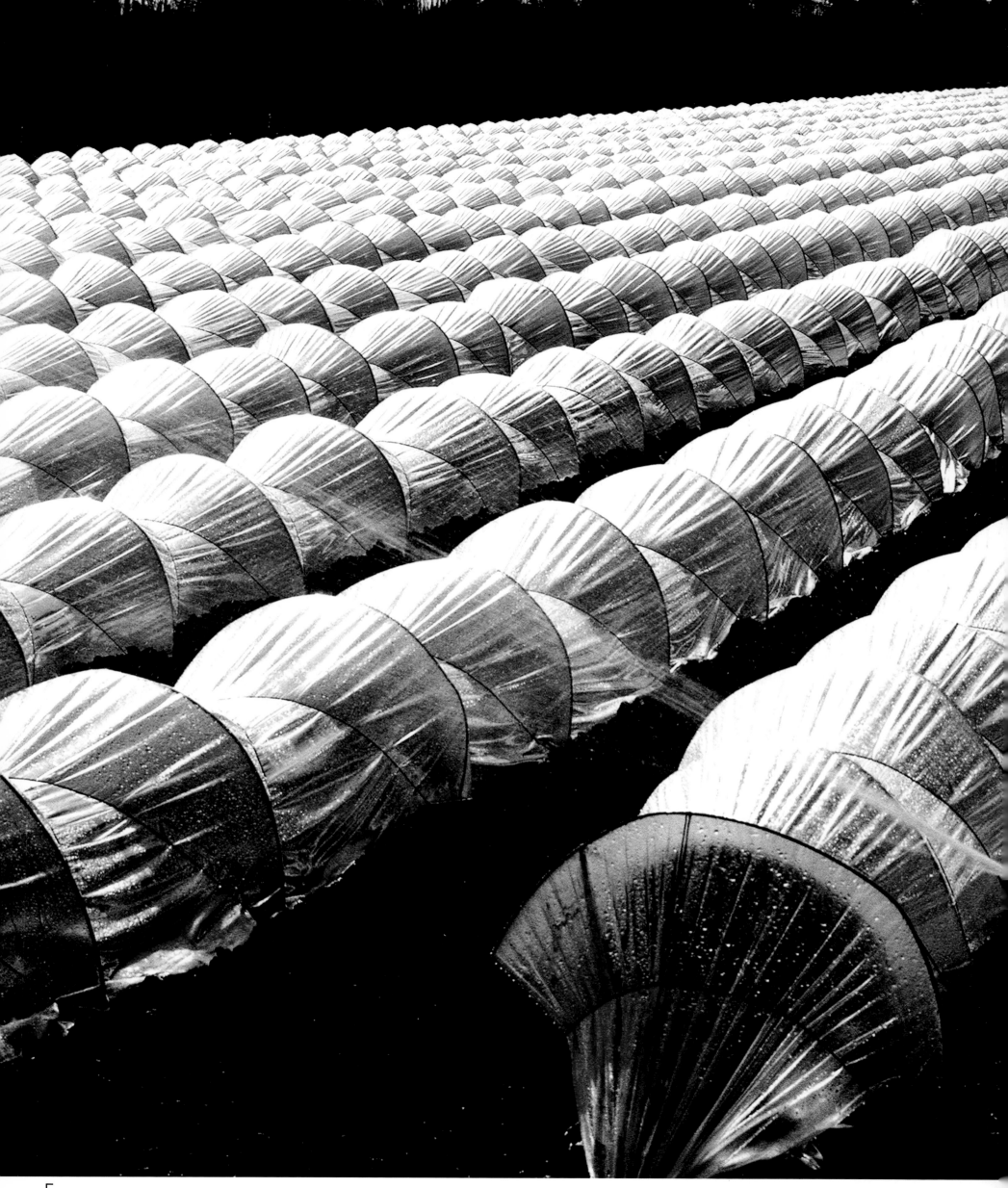

Above: Increasingly, crops are being grown under plastic coverings, as here in the Vaucluse department of France, where the system is used to produce strawberries and tomatoes more rapidly than was possible previously. These plastic covers create a microclimate that speeds growth. The plants underneath the coverings do not see much fresh air, wind, sun, or insects.

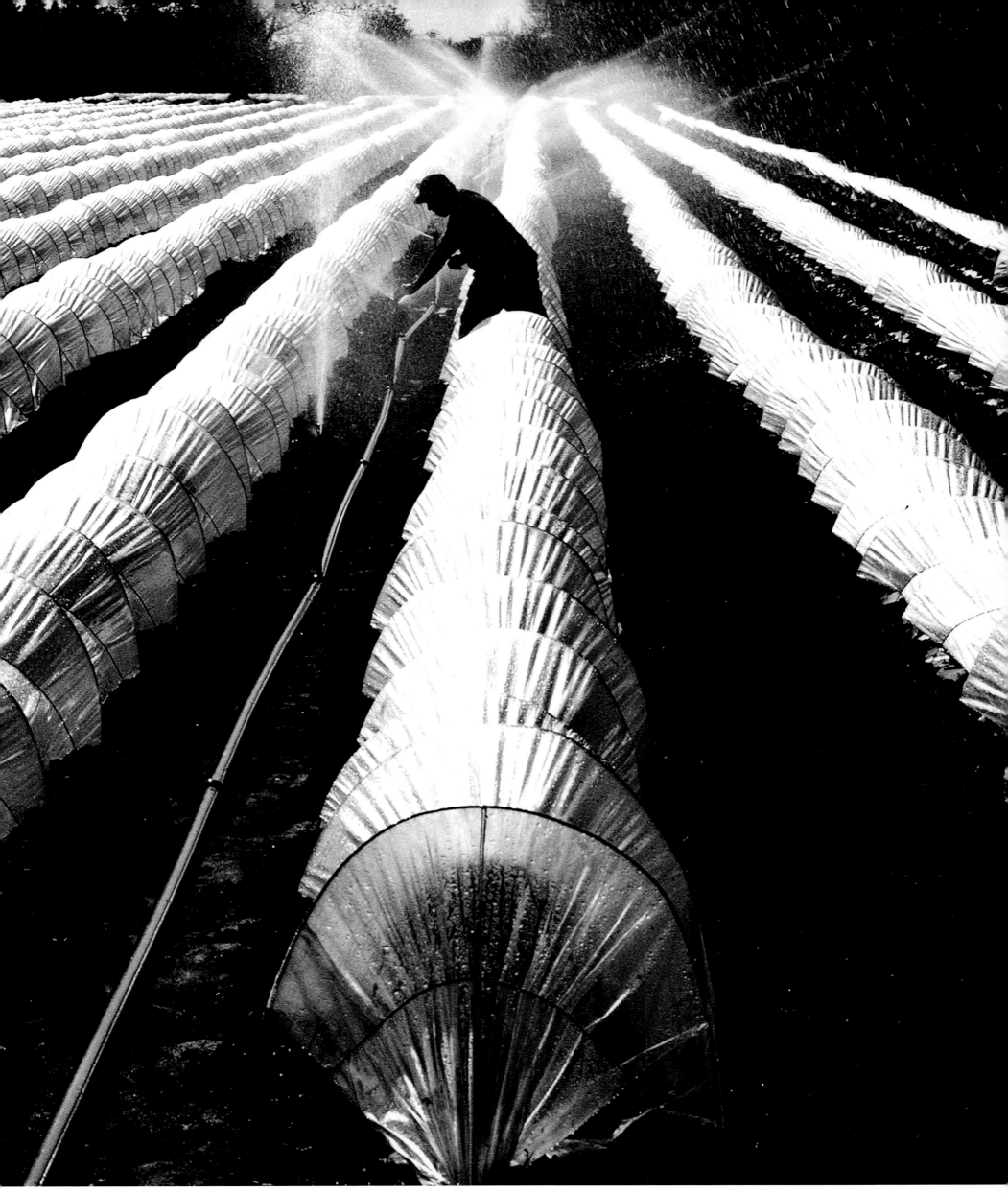

Following pages: In Brazil, intensive cattle raising has taken on another dimension. Today, the destruction of the Amazon rain forest is largely due to this activity. Here there once stood a forest that contained about 90 percent of the planet's biodiversity, but humans are destroying it, preferring to practice intensive agriculture (of questionable profitability) in a habitat ill-suited to this type of activity.

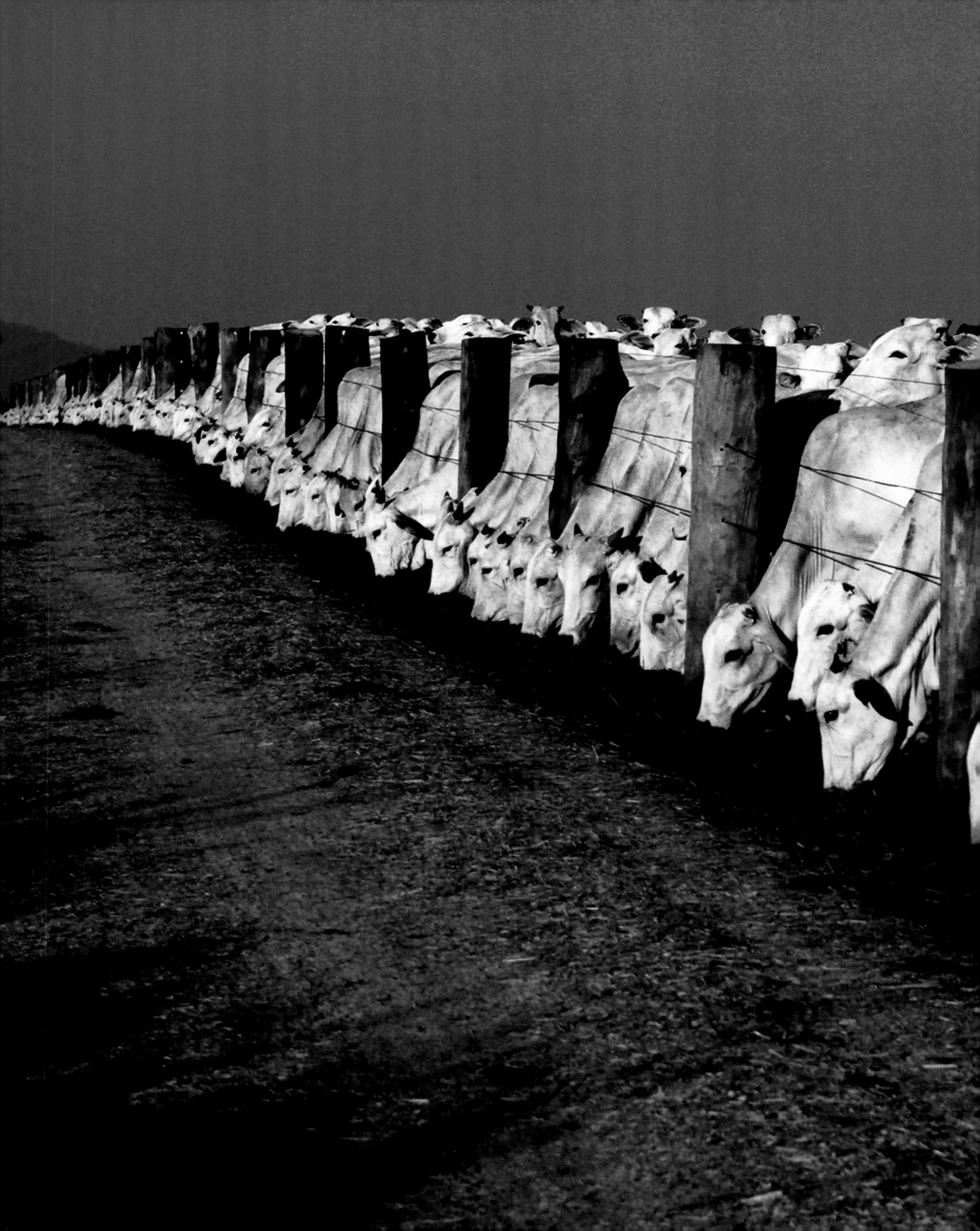

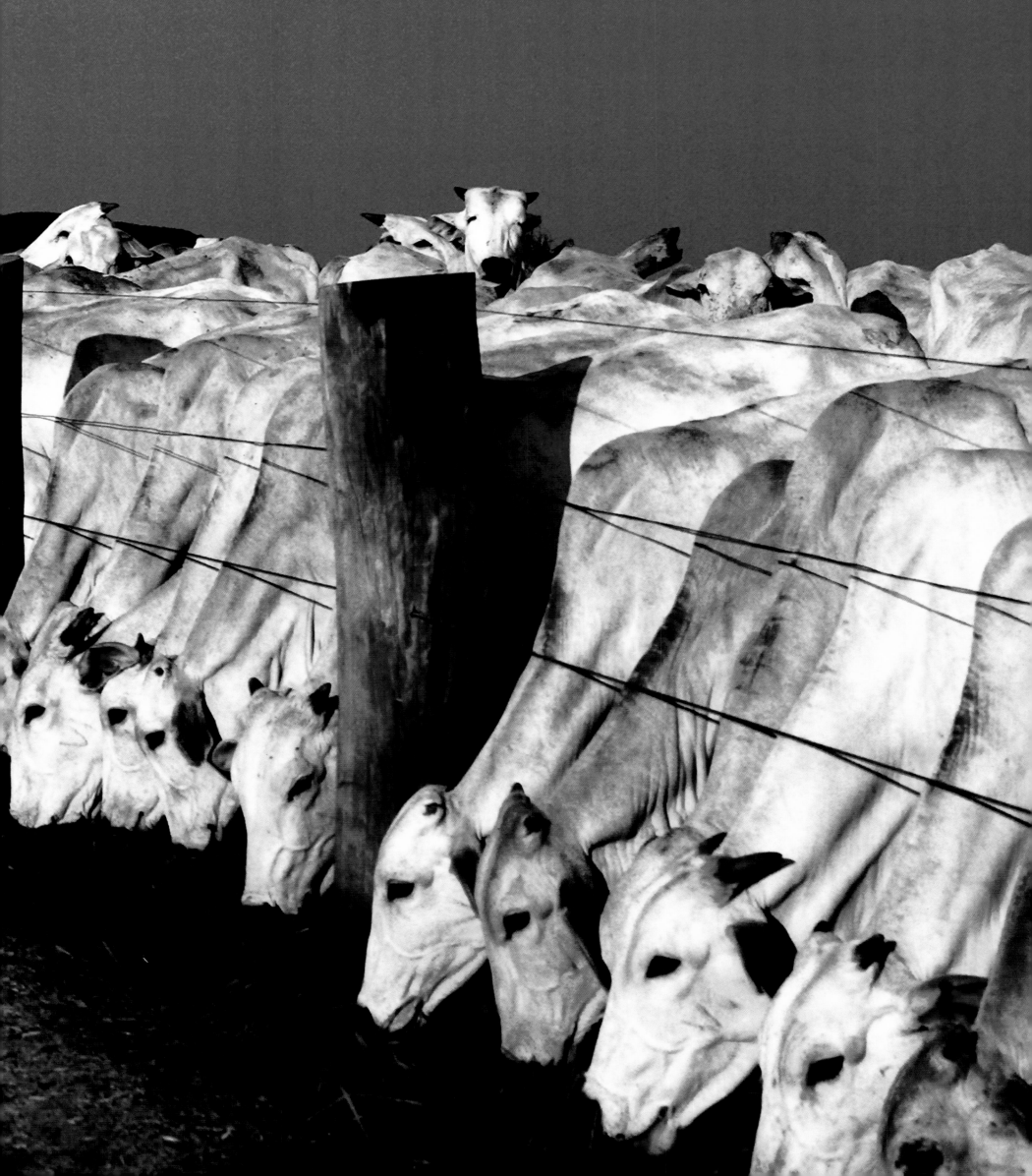

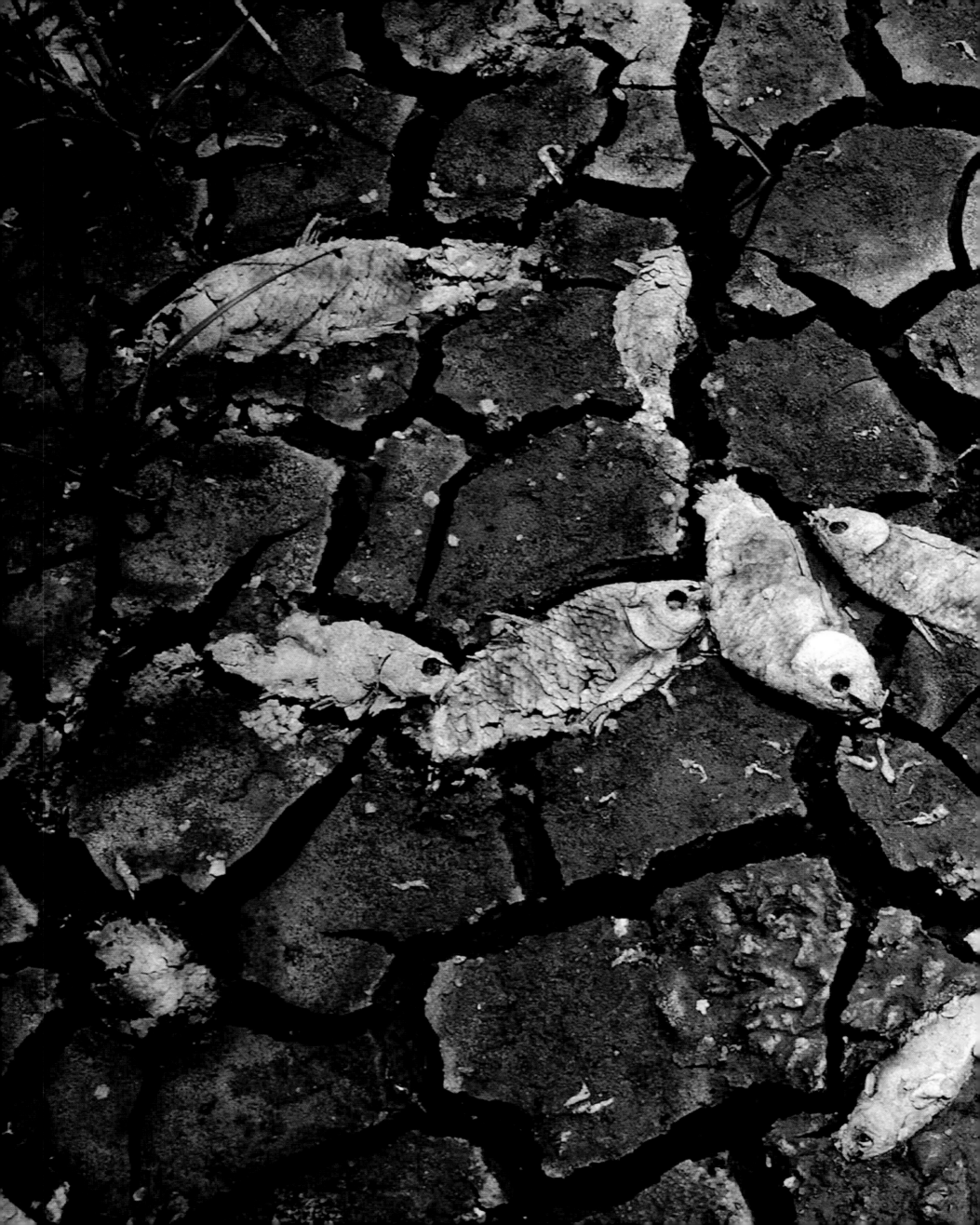

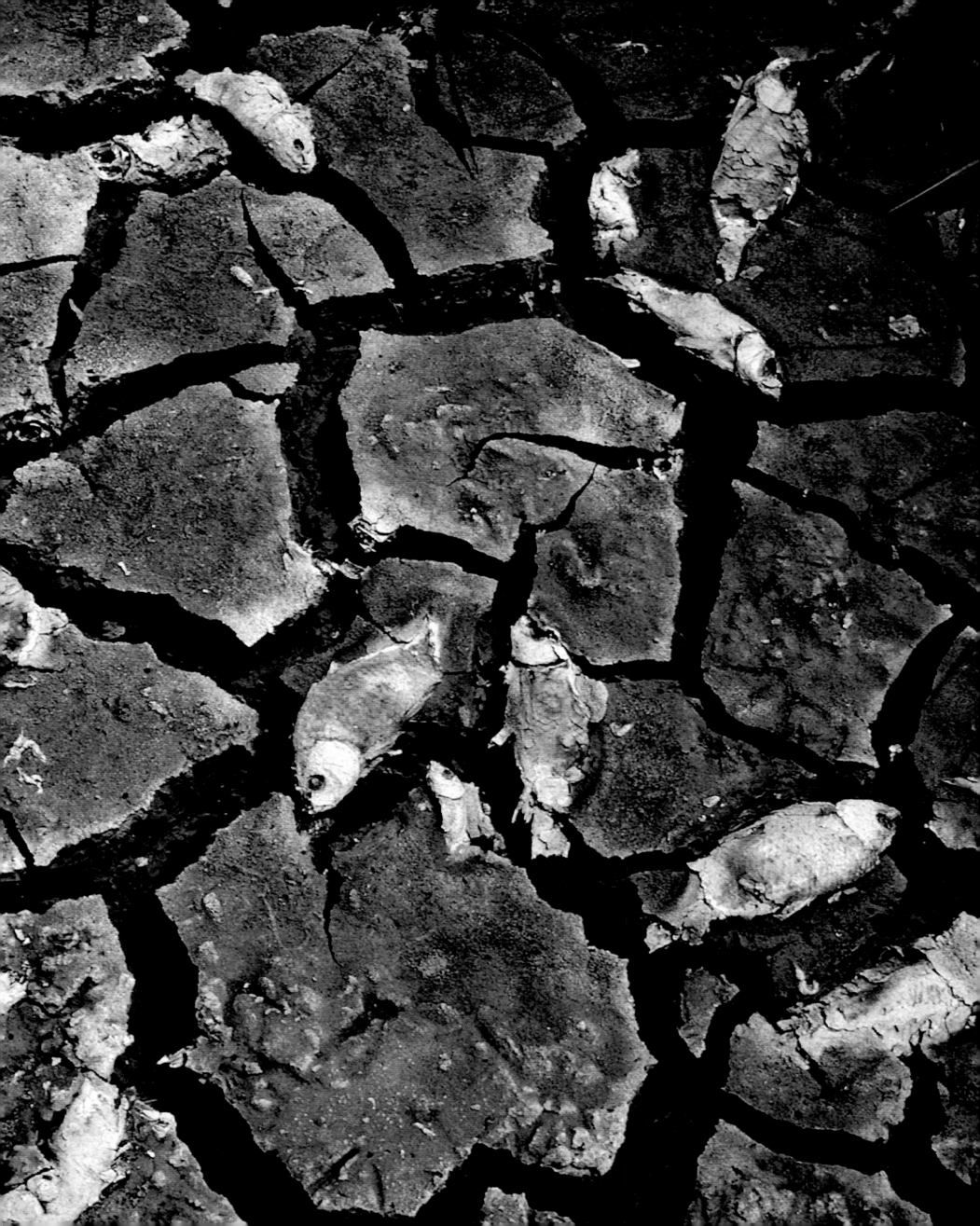

Above: In the Zanskar region in India, agriculture is far from intensive. Under harsh climatic conditions peasant farmers grow peas, wheat, and barley. Livestock act as threshers, trampling the wheat. In the autumn, the peasants harvest the barley, which is their staple food. A small pool allows a reasonable amount of crop irrigation.

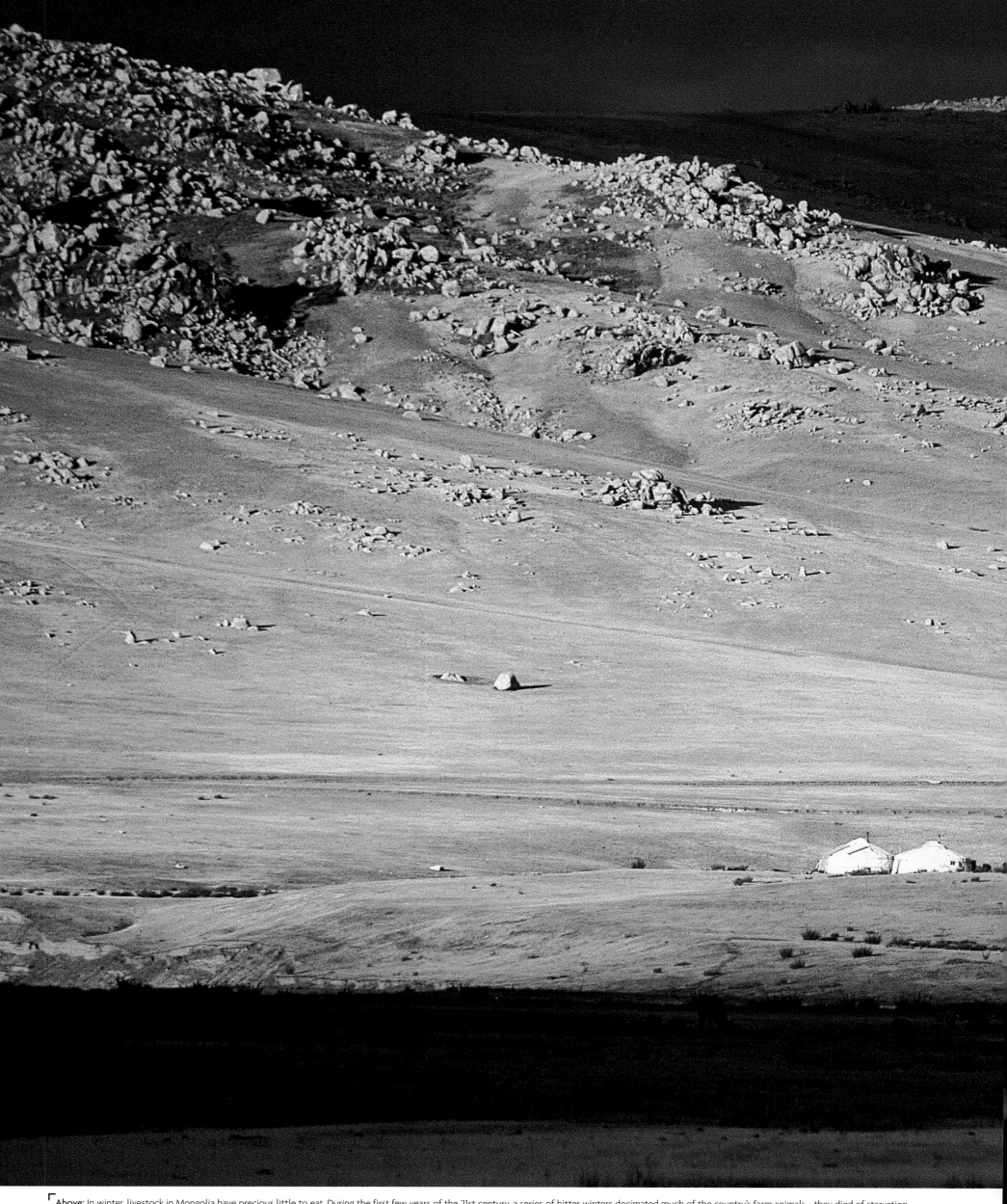

Above: In winter, livestock in Mongolia have precious little to eat. During the first few years of the 21st century, a series of bitter winters decimated much of the country's farm animals—they died of starvation. Ironically, an overall increase in the number of livestock in the country has led to overgrazing of the steppe—detrimental to both grassland plants and wild animals (notably gazelles and saiga), which find themselves in direct competition with domestic animals.

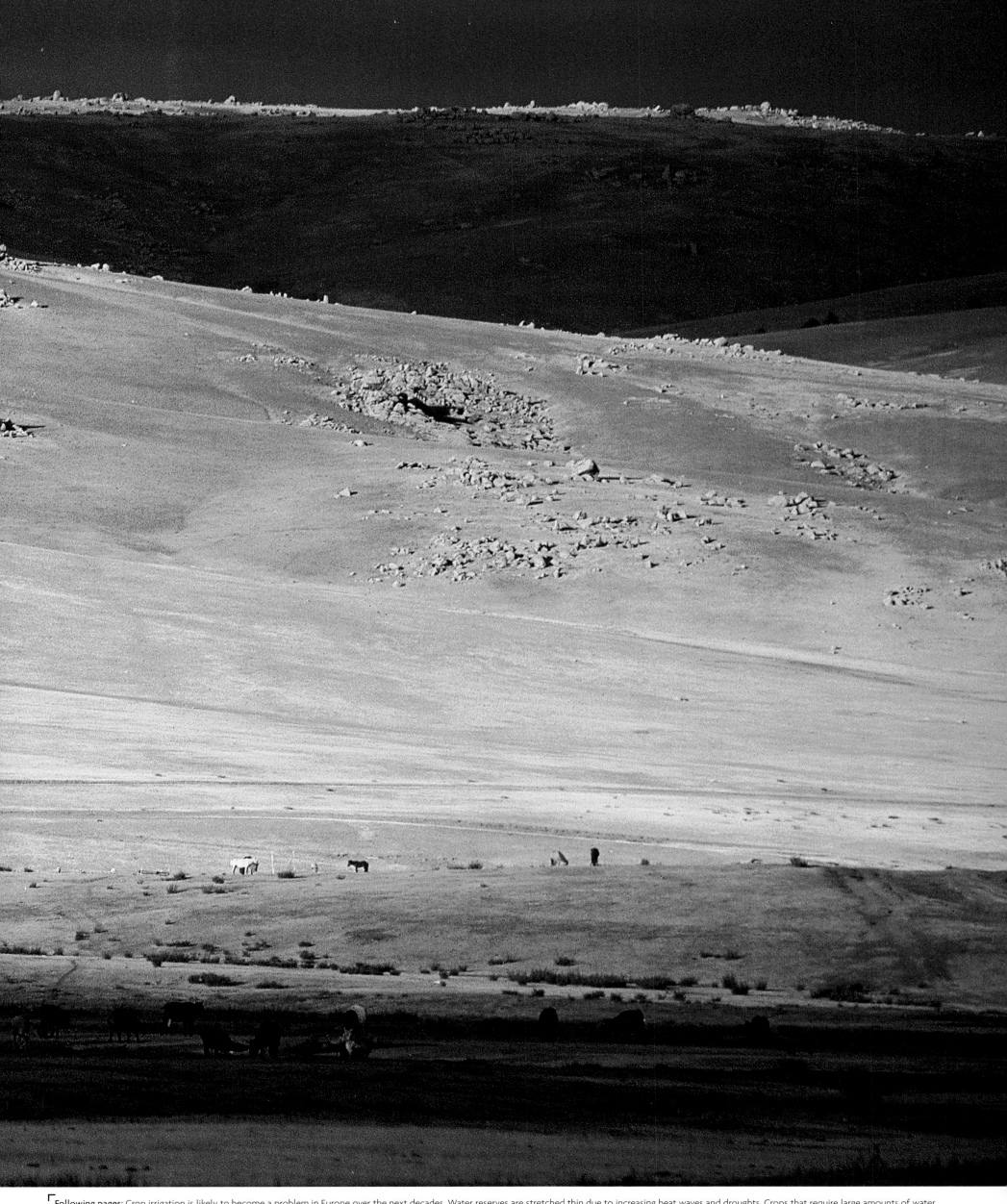

Following pages: Crop irrigation is likely to become a problem in Europe over the next decades. Water reserves are stretched thin due to increasing heat waves and droughts. Crops that require large amounts of water, such as maize, are likely to suffer. It will therefore become necessary to urgently rethink the types of crops that are grown in countries grappling with these new climatic conditions.

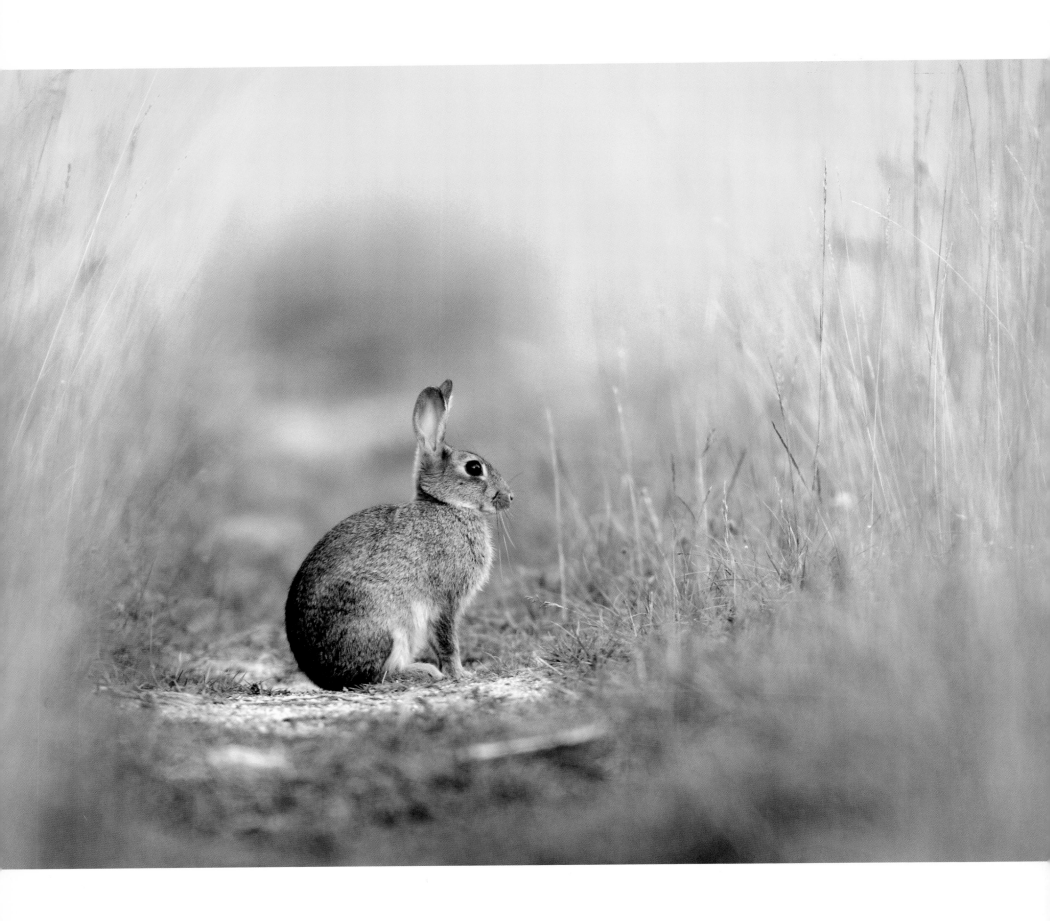

The wild rabbit, a victim of diseases such as myxomatosis and VHD, which have killed large numbers, has had mixed
fortunes in Europe. Its original habitats (such as dunes and grassland) are disappearing or being increasingly broken up.
The islands of rabbits that are left, ever more isolated, no longer communicate with each other; the genetic flux, which
is essential to maintaining the population, is impaired, making the animals more vulnerable. In France, the number of
wild rabbits killed by hunters has fallen from more than 13 million in 1974–75 to little more than 3 million in 1998–99.
This is due in part to fewer wild rabbits to hunt.

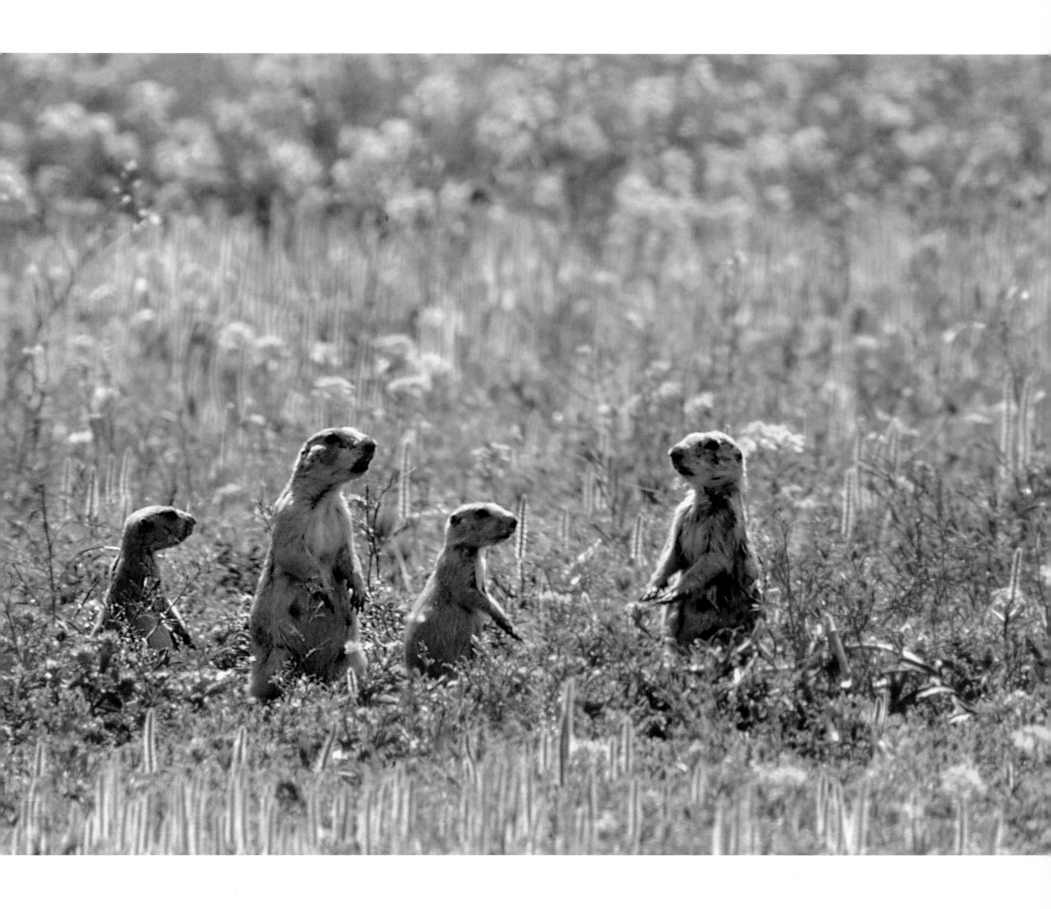

Always on the alert, the prairie dogs of North America live in groups. It must be said that they are the favorite prey of many predators—first and foremost wolves, coyotes, and lynxes, but also a number of diurnal birds of prey. Of the five species, the Mexican prairie dog is in danger of extinction.

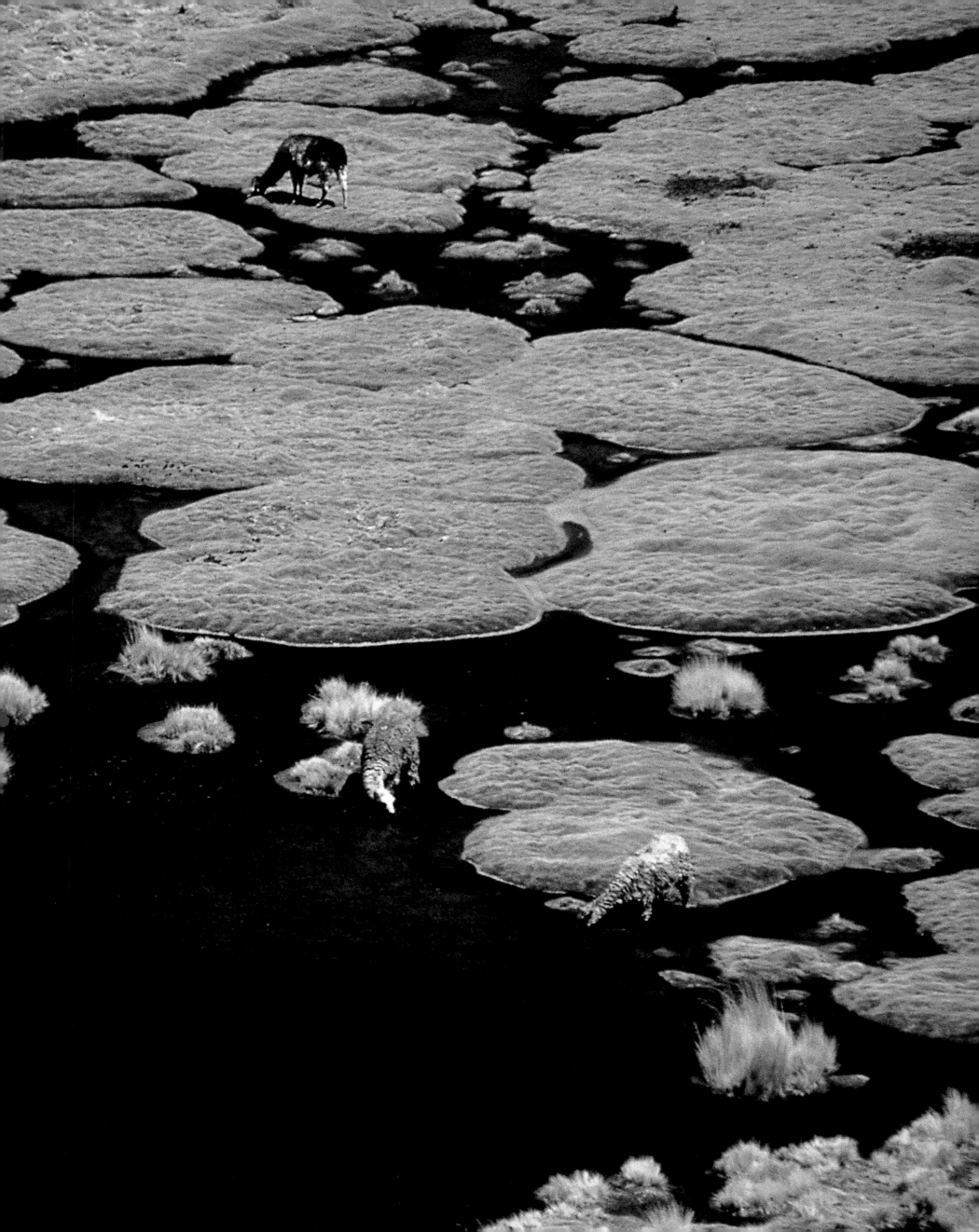

Left: On the valley floors of the high Andes—as here, in Bolivia—peat bogs form in the streambeds up to an altitude of 16,000 feet. However, this remarkable ecosystem is fairly poor in animal and plant diversity because of the harsh conditions.

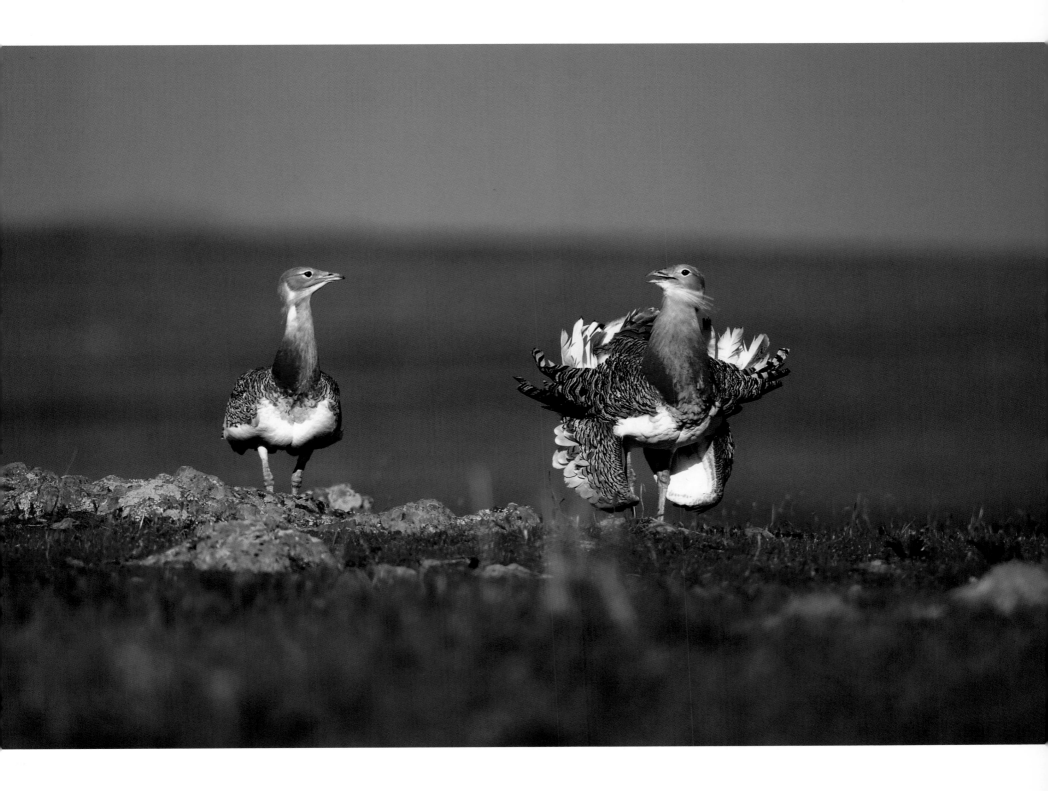

Above: These magnificent great bustards, performing a mating display among the crops of northern Extremadura, Spain, are without doubt the remnants of a declining biodiversity. As recently as a few years ago these enormous birds lived in flocks among the mixed crops of the northern Iberian Peninsula and central Europe. Today, the few thousand survivors are actively protected, and desperate efforts are being made to preserve a few shreds of their original habitat.

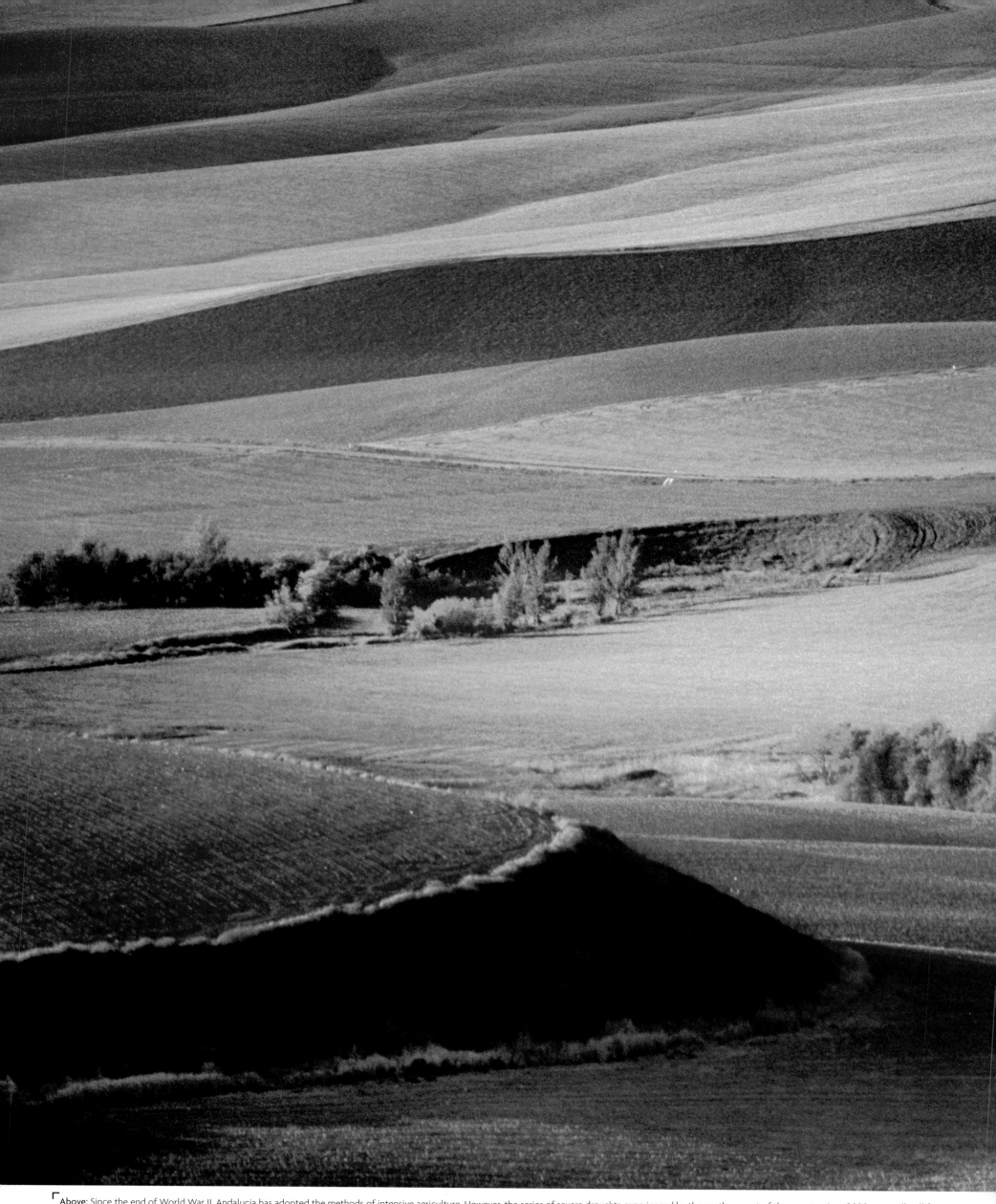

Above: Since the end of World War II, Andalucia has adopted the methods of intensive agriculture. However, the series of severe droughts experienced by the southern part of the country since 2000 may well nullify all the Spanish government's efforts and transform this region into a vast area of semidesert.

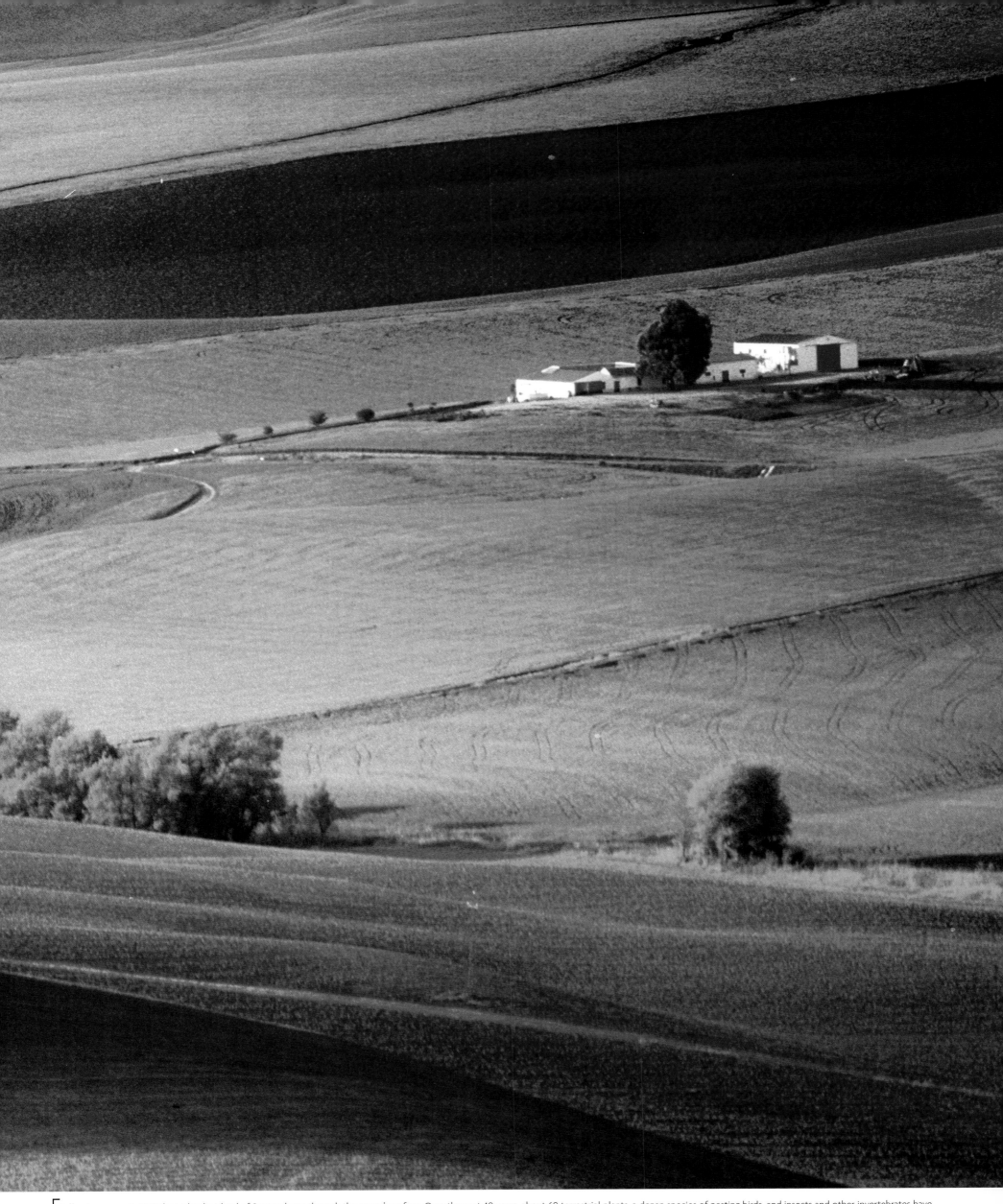

Following pages: In 1963 the Icelandic island of Surtsey burst through the ocean's surface. Over the past 40 years, about 60 terrestrial plants, a dozen species of nesting birds, and insects and other invertebrates have colonized the island. This type of habitat is a godsend for scientists, who can study the history of the colonization of a totally "new" habitat.

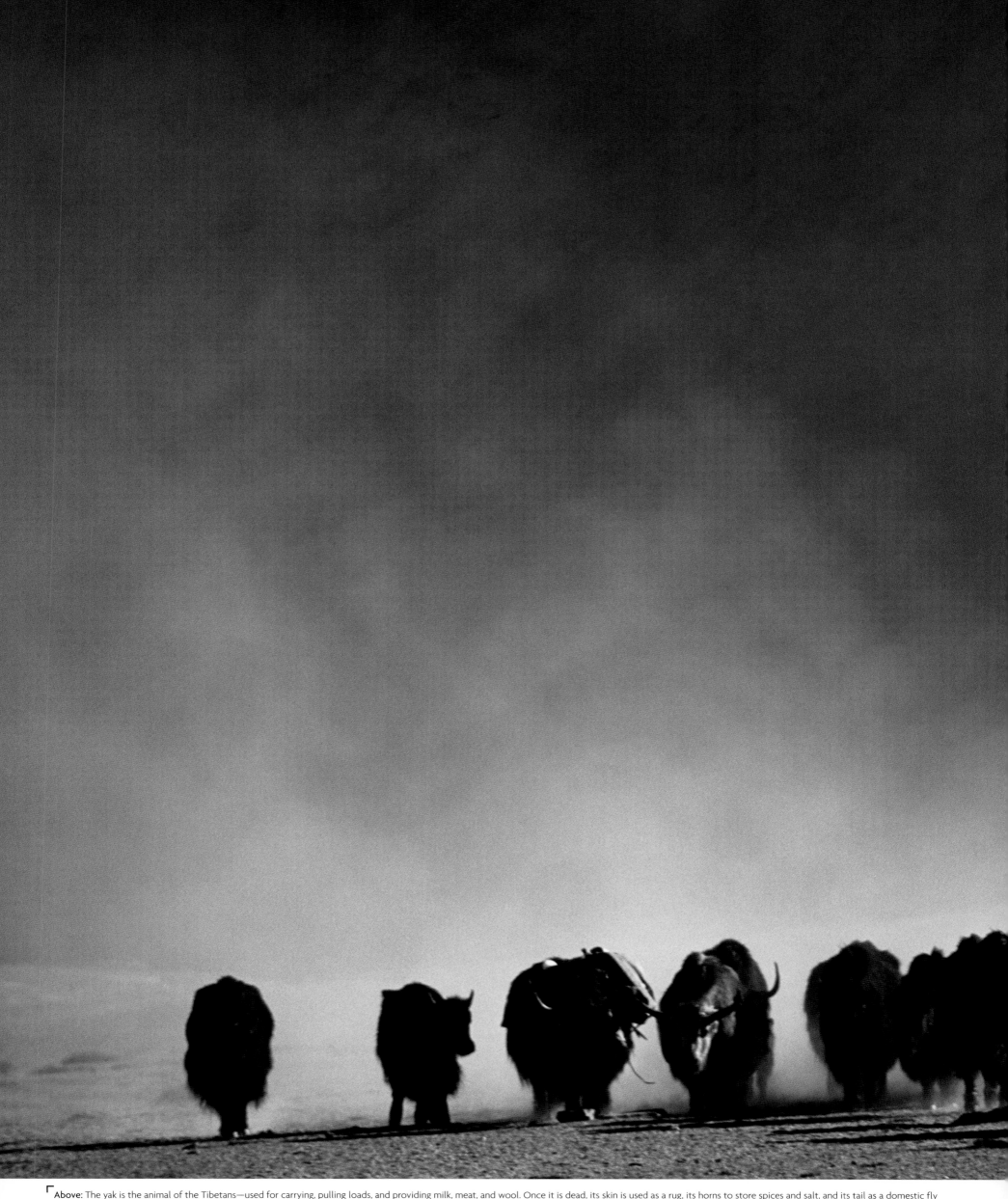

Above: The yak is the animal of the Tibetans—used for carrying, pulling loads, and providing milk, meat, and wool. Once it is dead, its skin is used as a rug, its horns to store spices and salt, and its tail as a domestic fly swatter. Wild yak populations, however, have become extremely rare and are found only in India and China.

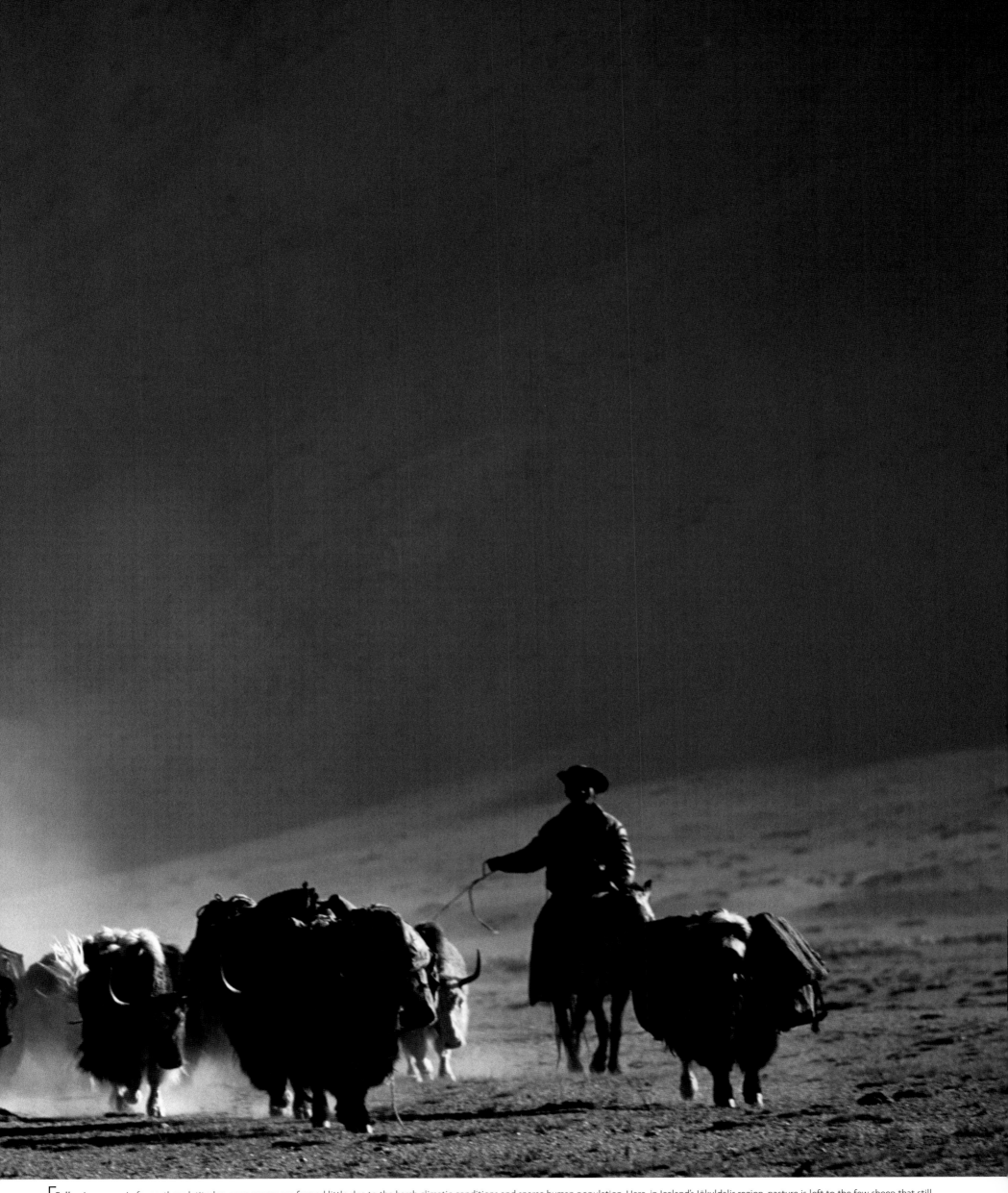

Following pages: In far northern latitudes, open spaces are farmed little due to the harsh climatic conditions and sparse human population. Here, in Iceland's Jökuldalir region, pasture is left to the few sheep that still live there.

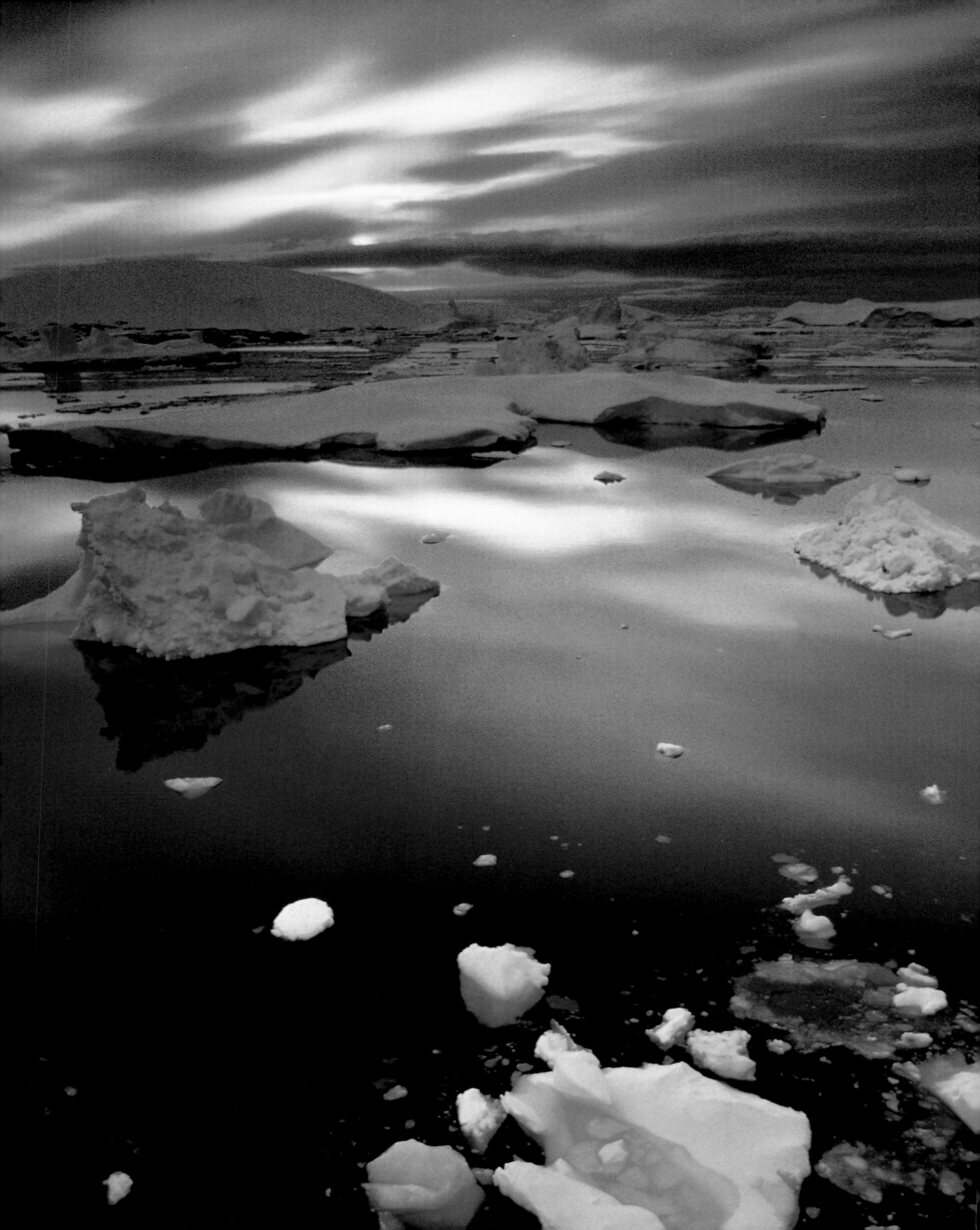

Polar Regions

We are born with the power of sight, but we remain blind for a long time, as if screens interpose, hiding the truth and reality of things before us. Then, one by one, something happens that makes these screens drop off; one day, a form of truth appears—at least our own personal truth.

Left: Over the last two or three decades, sea ice has been thawing earlier in the spring as a result of rising global temperatures. How long before it disappears completely?

While my experiences in the Antarctic are limited, my first experiences in the Arctic played an important role in shaping my perception of nature. It is there where I understood the place humans occupy in nature and the role we play in it. Being there was like being struck with wonder, a purifying wave that swept away the miasma of our technological, urban society.

My Arctic expeditions were veritable journeys of initiation: a way of testing myself. Indeed, these polar regions made me aware of certain truths about man's place in nature. Simply sleeping in the icy cold of the geographic North Pole resets your body—you become aware of your own fragility.

In this environment where all things superfluous are stripped away, the Arctic light confers on the place an unparalleled enchantment. All night long in high summer, this dying light, between one day and the next, produces a magical sensation. The alternation of day and night loses its meaning. Time is not subdivided as it is in our Western society. We lose our bearings, time becomes an abstract, and we see a strange palette of colors—whites, blues, grays. At this point, we need to reset our senses once again.

There is life here, unsuspected but omnipresent. Just like in the desert, is it difficult to imagine that there are living things in the Arctic, but if we look closer, life teems, especially under the sea ice. In the silence of this night that is not night, the furtive shadow of an Arctic fox, the breath of a band of white whales, or the distant call of a flock of wild geese give one the feeling of being close to the essential nature of life. Arctic regions speak to the soul.

Beyond these impressions, there are also ecological facts. It cannot be stressed too much: summer sea ice in the Arctic has been thinning at an alarming rate; in about 50 years it may disappear altogether. This sea ice, we must remember, plays a fundamental role in the equilibrium of the planet for many reasons. First, its white surface reflects energy, sending it back into the atmosphere and thus acting as a temperature control. If this white surface were to disappear, however, the dark surface of the ocean would replace it, and a large amount of heat would be absorbed. As for Antarctica, its progressive melting exposes naked, dark land, which also absorbs solar energy.

As ice melts in the Arctic, enormous amounts of fresh water mix into the oceans' salt water. Salt water is denser and tends to sink toward the bottom of the ocean. This influx of fresh water leads to a disruption of the main ocean currents, which safeguard, together with currents in the earth's atmosphere, the planet's climatic equilibrium. This isn't just a hypothetical scenario—it's happening. The increase in greenhouse gases in the atmosphere contributes to a rise in surface and ocean temperatures. Current predictions are quite clear: the greatest rises in temperature will take place in the Arctic—a rise of between 37°F and 43°F by the year 2100 is very likely. When this warming occurs, the taiga (northern forest) will extend northward, at the expense of the tundra (a vast treeless expanse and a gigantic reservoir of biodiversity). Sea levels will also rise, and the "conveyor belt" of ocean currents will slow, affecting winter temperatures in the West that cannot yet be predicted.

The whole of nature will suffer from these changes. The polar bear is a good example of the disruption happening in the Arctic regions. The shrinking of sea ice and the earlier spring thaw (between two and three weeks earlier, depending on the area) have reduced the period of time during which polar bears can hunt seals. This is the period in which the bears need to build up their fat reserves; once summer arrives, large prey such as seals are no longer accessible. However, because the ice breaks up earlier, the seals return to the ocean sooner and the bears catch fewer of them. The result is that the weight of polar bears has been decreasing for some decades; the less well-fed females, which give birth to their young at this time, have been producing less milk. Cub mortality has increased. To make matters worse, it has also been discovered that female bears are experiencing hormonal troubles due to the pollution from heavy metals—a clear demonstration of how our behavior affects the entire planet. At this rate, polar bears in the wild may well disappear by the end of the 21st century.

> All night long in high summer, this dying light, between one day and the next, produces a magical sensation.

Humans, too, live in the heart of the Arctic—peoples belonging to the group described as "aboriginal," who once lived a nomadic life and who have been forcibly settled. One example is the Siberian peoples, who became sedentary because, according to Soviet leader Nikita Khrushchev, nomadism was incompatible with socialism. Nevertheless, some peoples have managed to retain their traditional lifestyle. A notable example is the Nenets, who even today still practice transhumance with their reindeer in far northeastern Siberia. On the opposite side of the Arctic, the promise of Western consumer goods was used to persuade the Inuit to settle.

> And then there is the magic of the polar regions themselves— these universal, improbable spots where one remains only for a few seconds because of the rotation of the earth.

All of these peoples have a relationship with nature that deserves notice: they take only what they need from nature and consider nature a common good, not something with which resources can be extracted indefinitely, without concern for the future or for other people. They do not feel that anything is theirs by right, and thus, for them, nature has retained its sacred side. In fact, they feel indebted to nature, and this indebtedness indirectly leads to shamanism. I believe that regardless of people's religious beliefs, nature and living things are sacred realms. To me, the excessive spirituality of shamanism, coupled with their fealty toward nature, is far more palatable than living in a society that pollutes.

If there is any place on earth where we can survey the planet, it is at the polar regions. Although this may be nothing more than personal impression, not based on fact, when you're at the poles you feel as if you're on top of the world. And then there is the magic of the polar regions themselves—these universal, improbable spots where one remains only for a few seconds because of the rotation of the earth. I remember looking at the GPS readout at the North Pole. It read "90°00'00" N" only for an instant, because here, more than anyplace else, we are at the very center of the earth's rotation. A moment later, however, we moved. During those few seconds, in whichever direction we walked, we were going south. The reason for this is that when you're on the North Pole, you're standing on a floating ice cap seven feet thick. The GPS measurement changes as the currents move the ice cap, unlike what would happen if you were to stand on the South Pole (a continent, solid ground). This is why the North Pole is so magical.

The Arctic is also a symbolic place, and it is no coincidence that it is the point where all the meridians meet. It is also the crossroads of humanity, as if humanity had put down all its roots there. There, everything is in play. If we are incapable of protecting the Arctic, of keeping it free from human activity, then we are also incapable of protecting the rest of the planet. The North Pole, like the South Pole, is the place where all our irresponsibilities converge. Although they are far from large centers of human population and industrial activities, they are the victims of all the outrages of which we are guilty.

We should ask ourselves what has brought this pass. In the words of author Barry Lopez: "How does the Arctic landscape affect the human imagination? How does the desire to make use of this landscape influence the way we evaluate it? And finally, what happens to our sense of what constitutes wealth when we are confronted by a landscape unknown to us? What does it mean to become wealthy? Does it mean to retain our capacity to be overawed and to continue to seek what is authentic? Does it mean to live ethically and at peace with the universe?"

It is clearly impossible to answer these questions. Is it possible, as Lopez asks, "to discern with new eyes the way to attain security for the soul and heart, and to integrate ourselves with the flow of time that we call History, our history and that of the world, this dream common to both ordinary people and great men"?

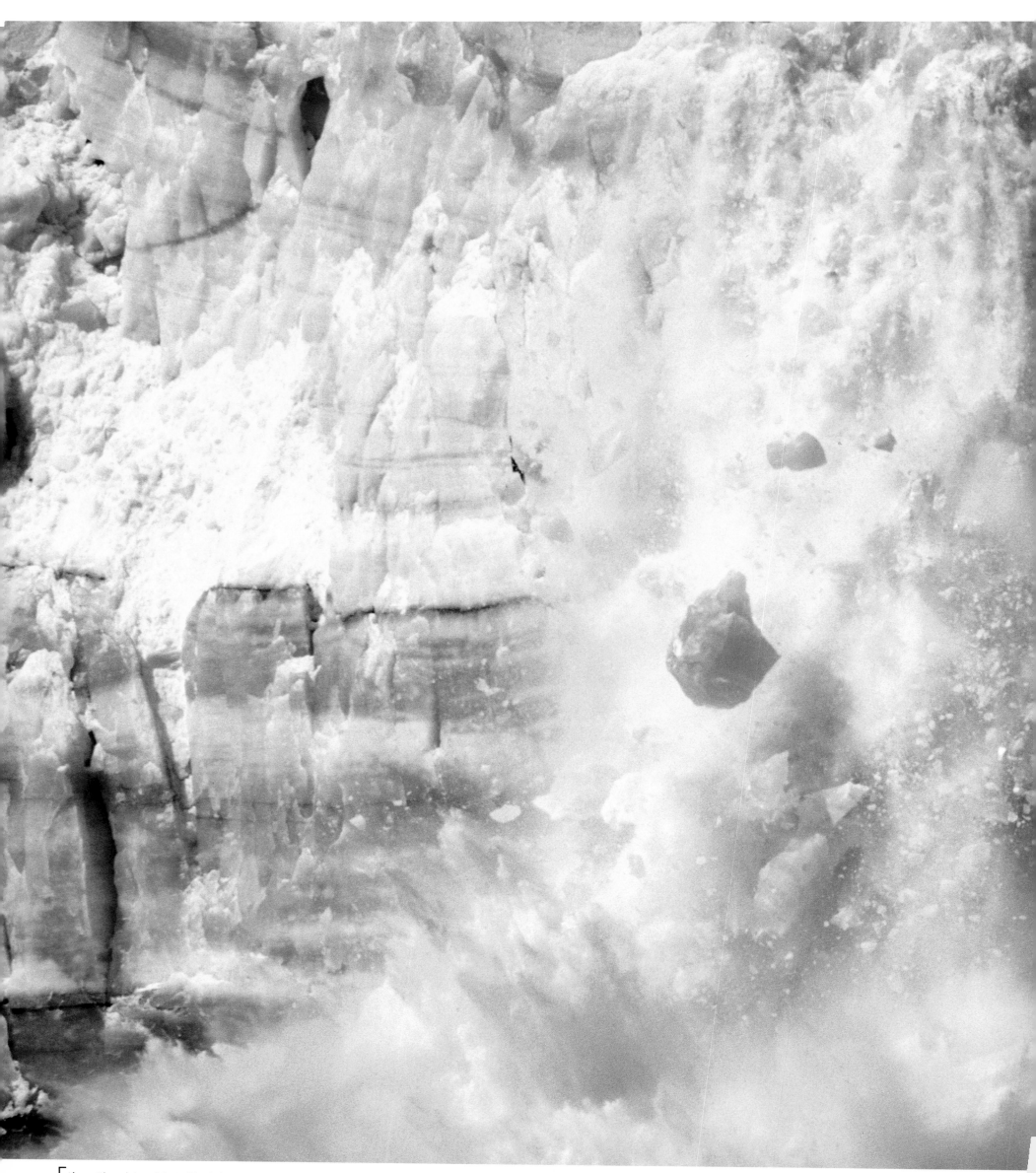

Above: The calving of the Hubbard glacier in Alaska is staggering to witness. Blocks of ice weighing dozens of tons routinely crash into the sea, making a fearsome roar. Unfortunately, this is happening at an ever-faster rate. Climate change is causing glaciers to melt at the polar regions and in the mountainous regions. In Alaska, 80 percent of glaciers have shrunk. However, climate change is not necessarily the only cause of melting glaciers—glacier shrinkage is also due to a natural cycle.

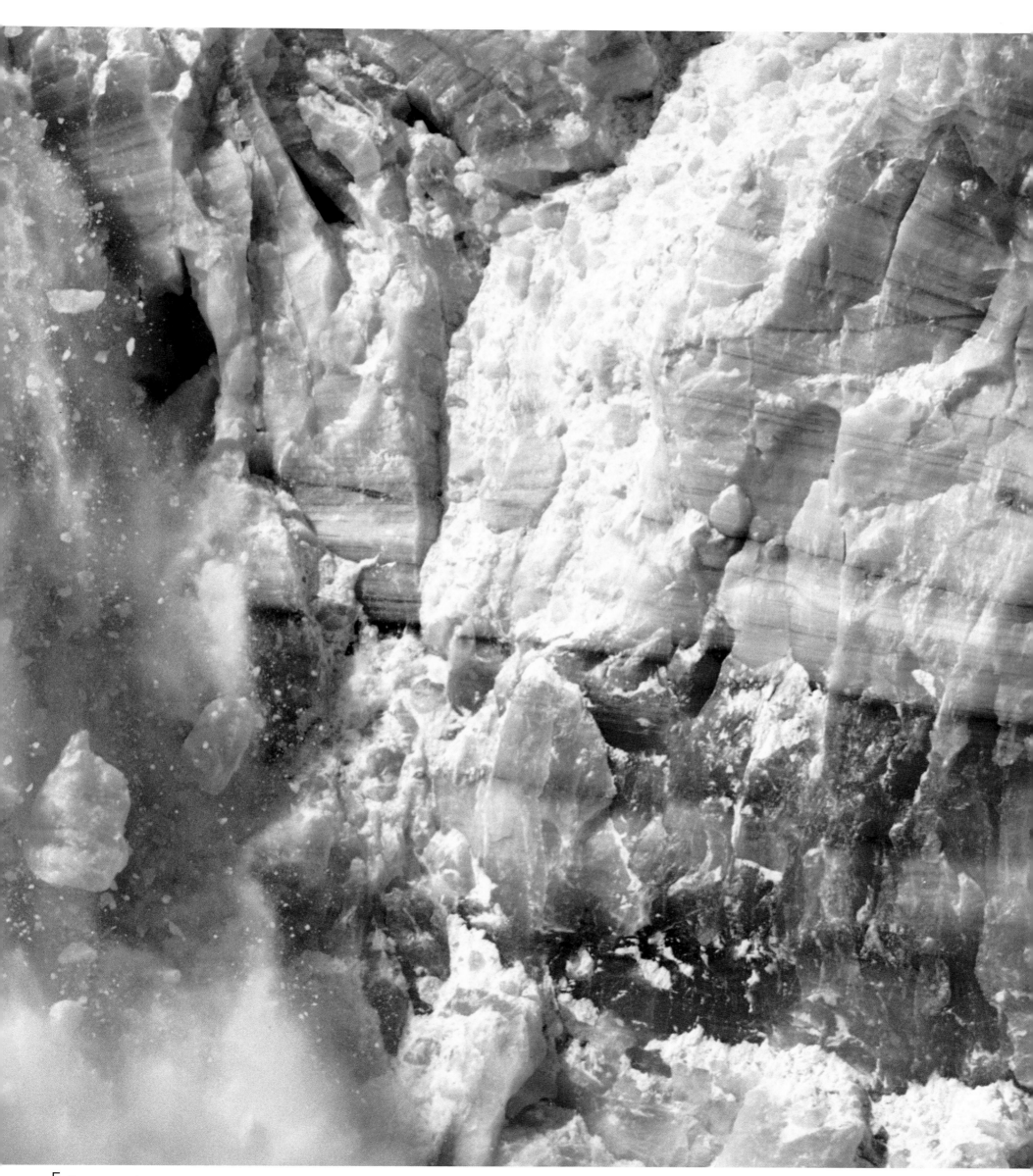

Following pages: This emperor penguin rookery, on the shores of the Weddell Sea in the Antarctic, is one of the largest in the world. Older chicks have gathered together in a nursery, waiting for their parents to come to feed them. The adult will be able to find its own chick because each bird gives a unique call. It will only feed its own offspring, even if other hungry chicks crowd round it, demanding food.

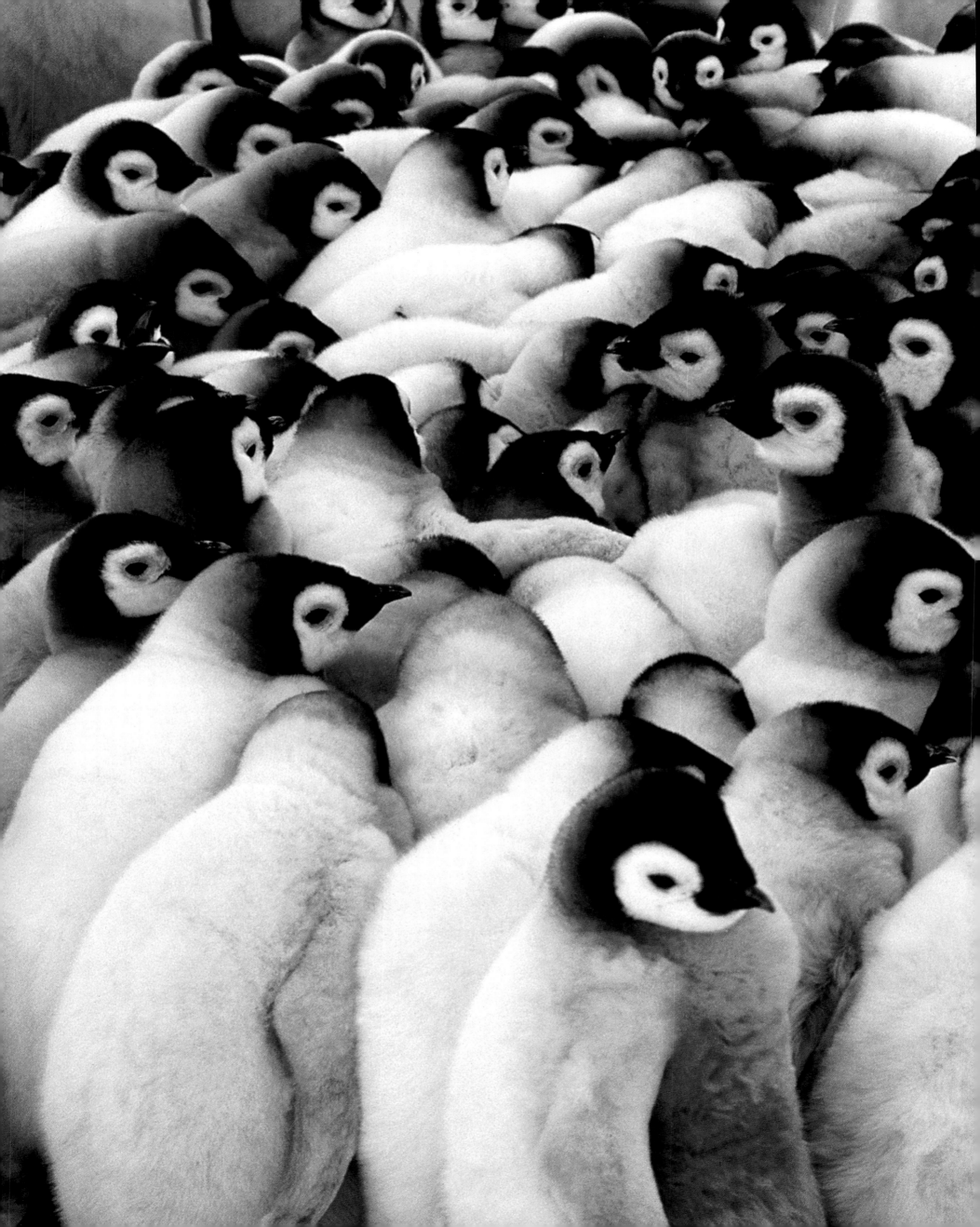

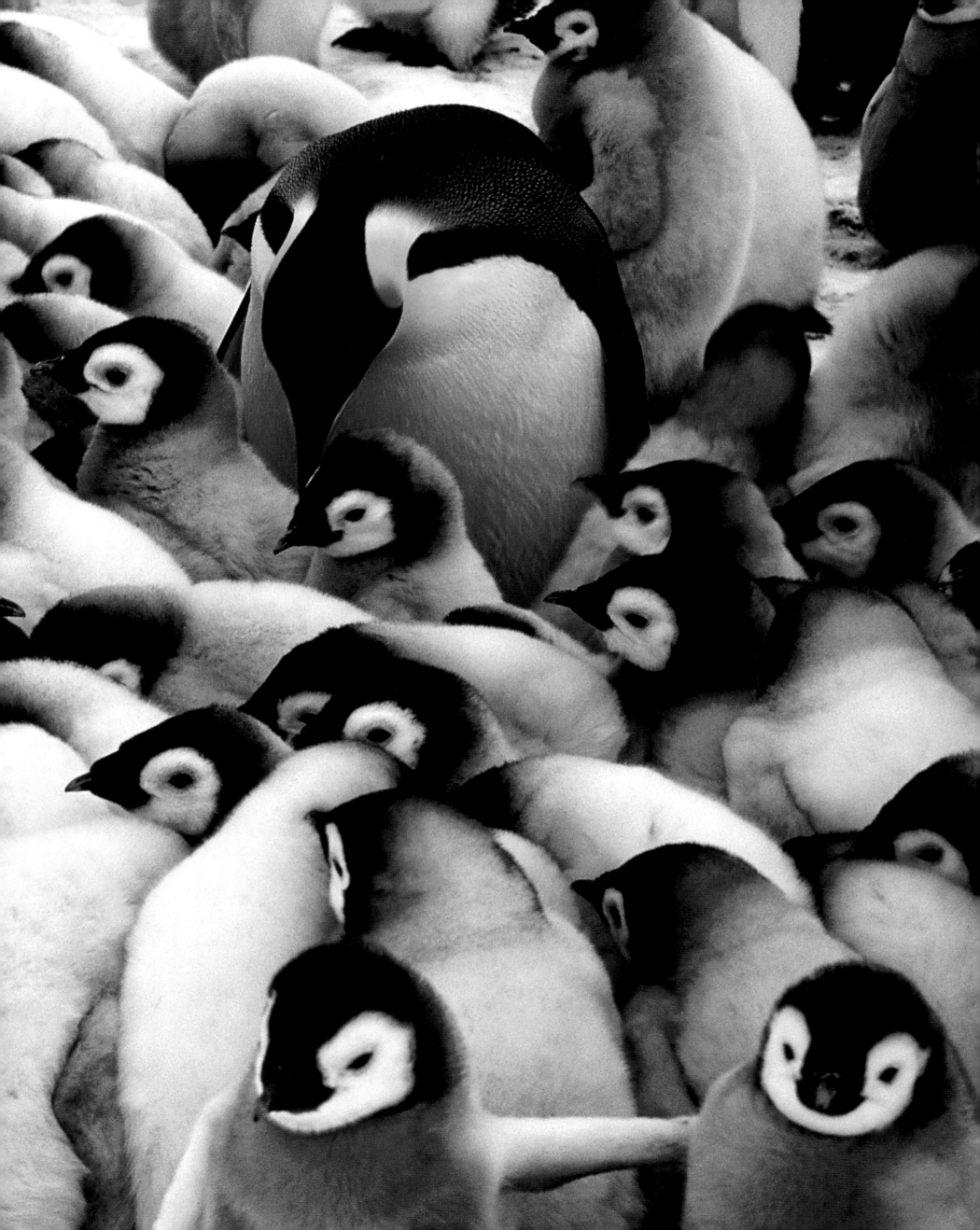

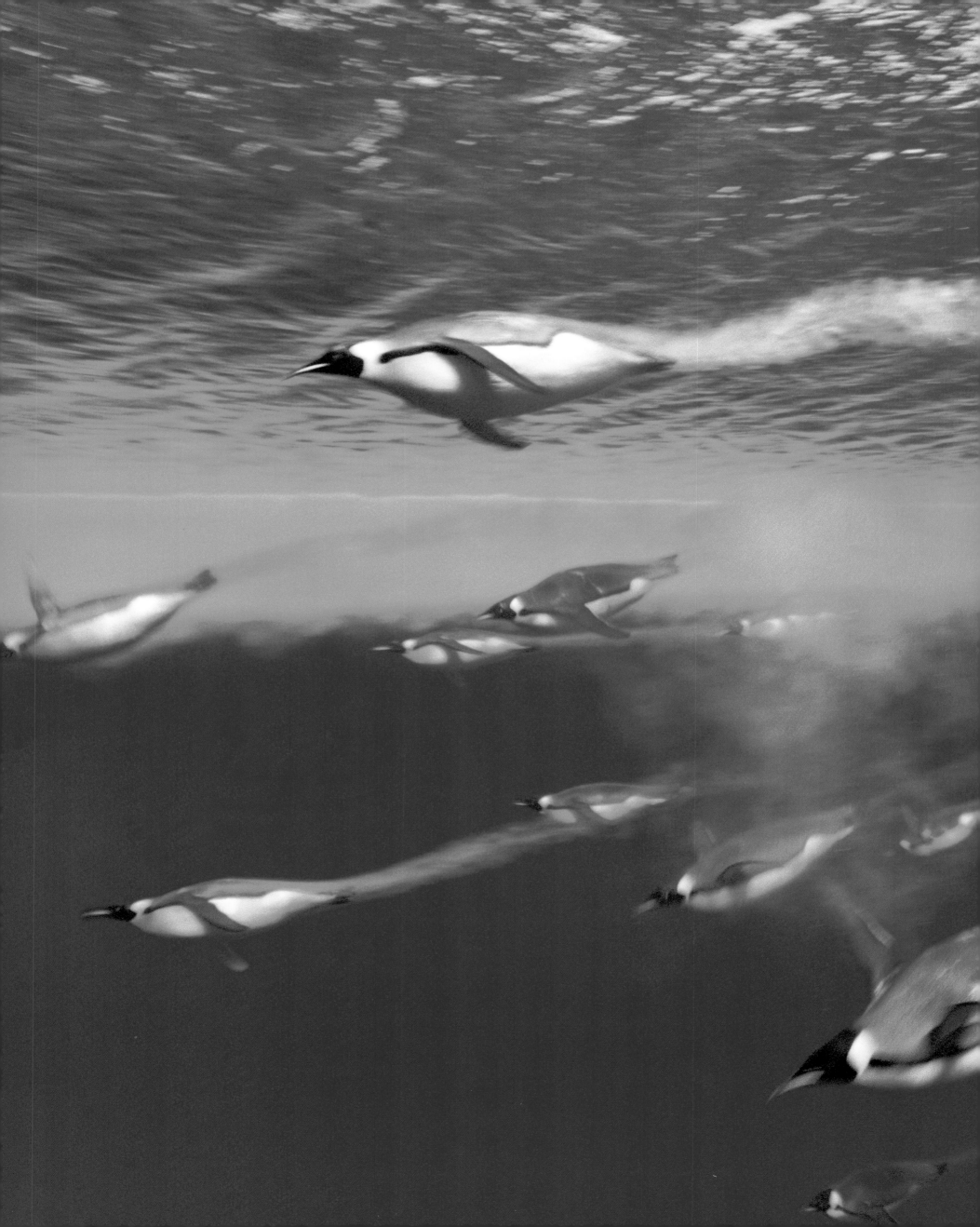

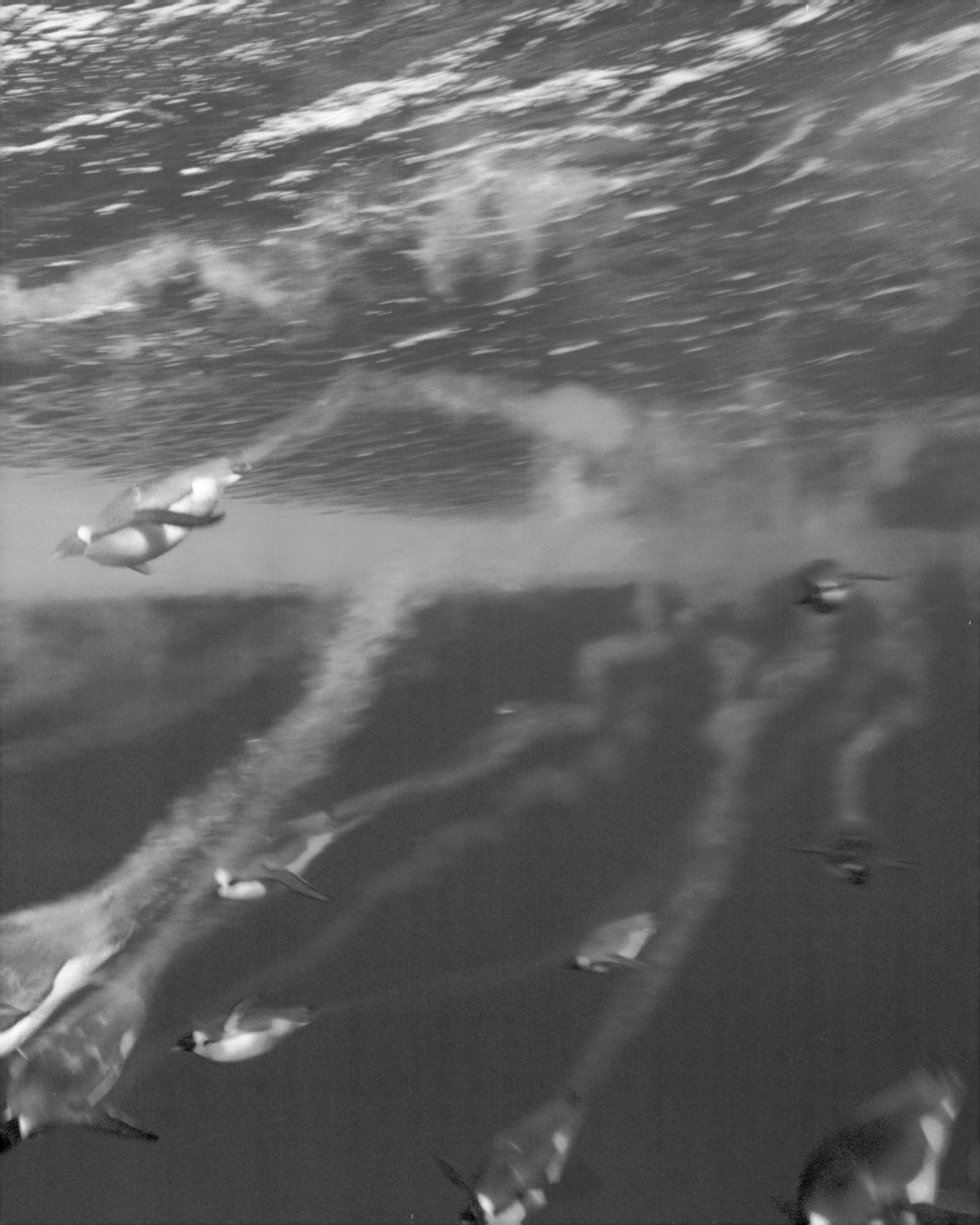

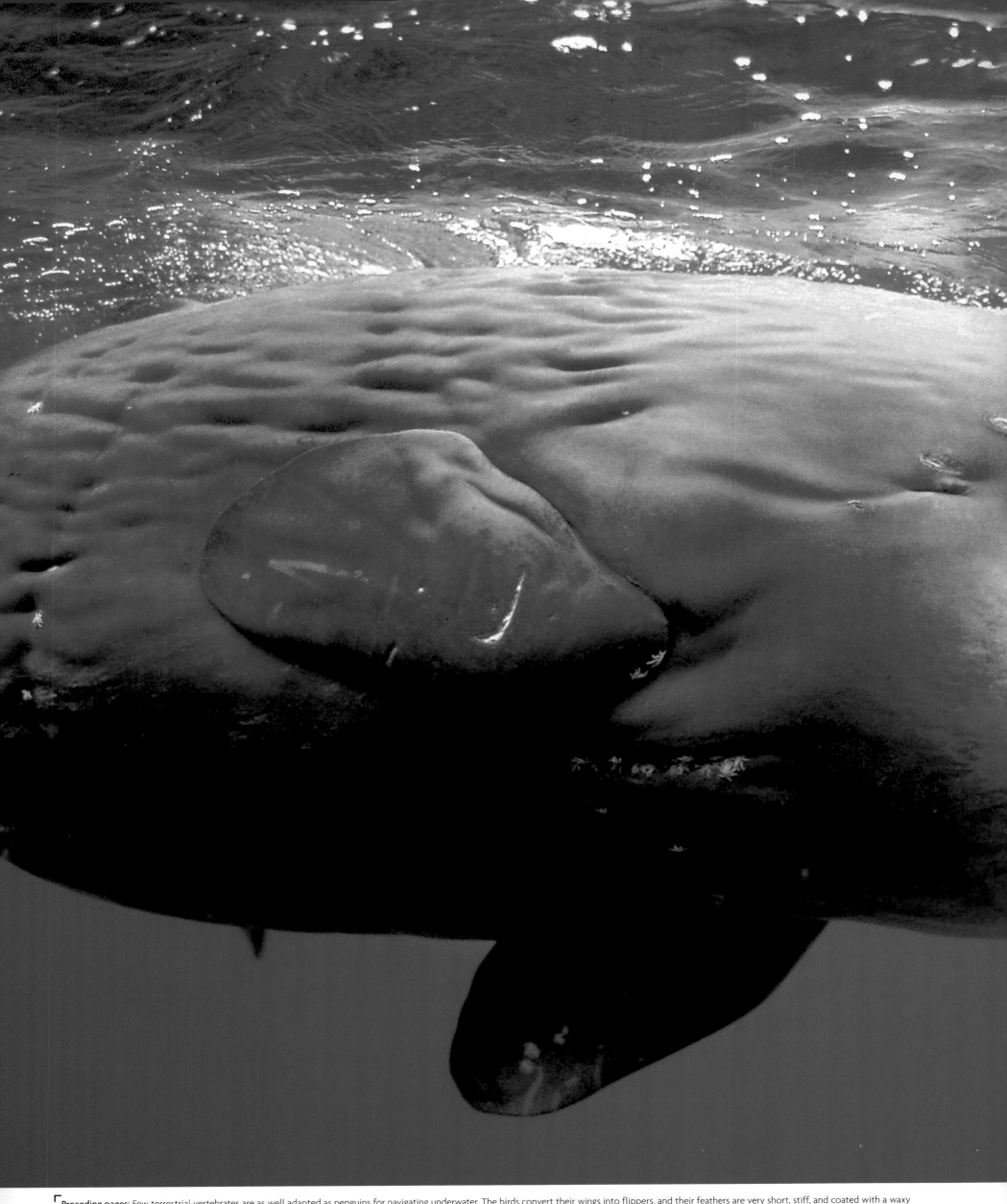

Preceding pages: Few terrestrial vertebrates are as well adapted as penguins for navigating underwater. The birds convert their wings into flippers, and their feathers are very short, stiff, and coated with a waxy secretion that makes them waterproof. Feeding on marine invertebrates (crustaceans known as krill), squid, and small fish, penguins are capable of deep dives, sometimes going as deep as 1,600 feet. They can remain underwater up to a quarter of an hour and sometimes even longer.

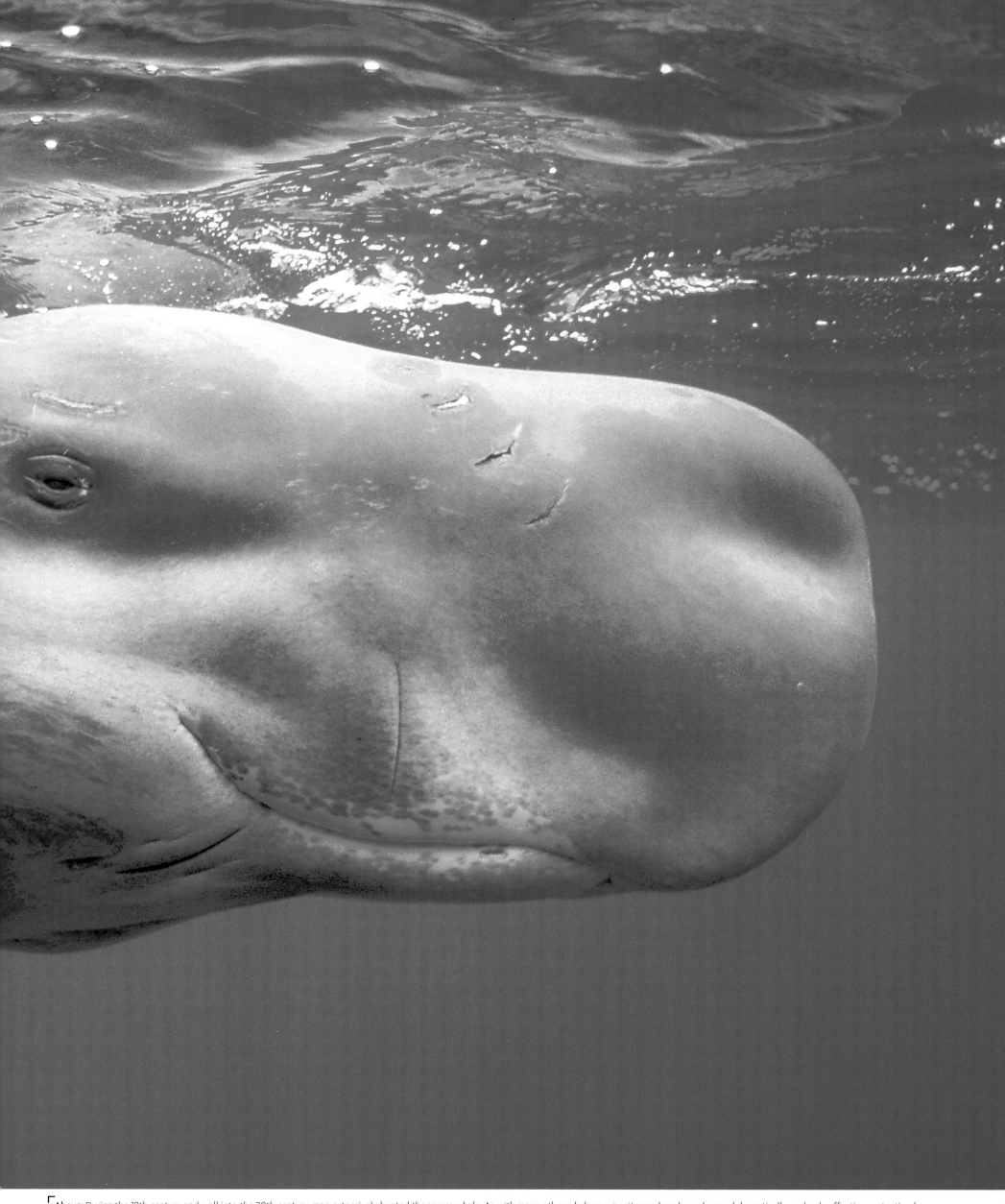

Above: During the 19th century and well into the 20th century, man extensively hunted the sperm whale. As with many other whale species, its numbers have dropped dramatically, and only effective protection has prevented it from joining the ranks of extinct species. The sperm whale is one of the toothed whales, an odontocete. It feeds primarily on mollusks but also on fish. It is found in all Arctic and Antarctic seas.

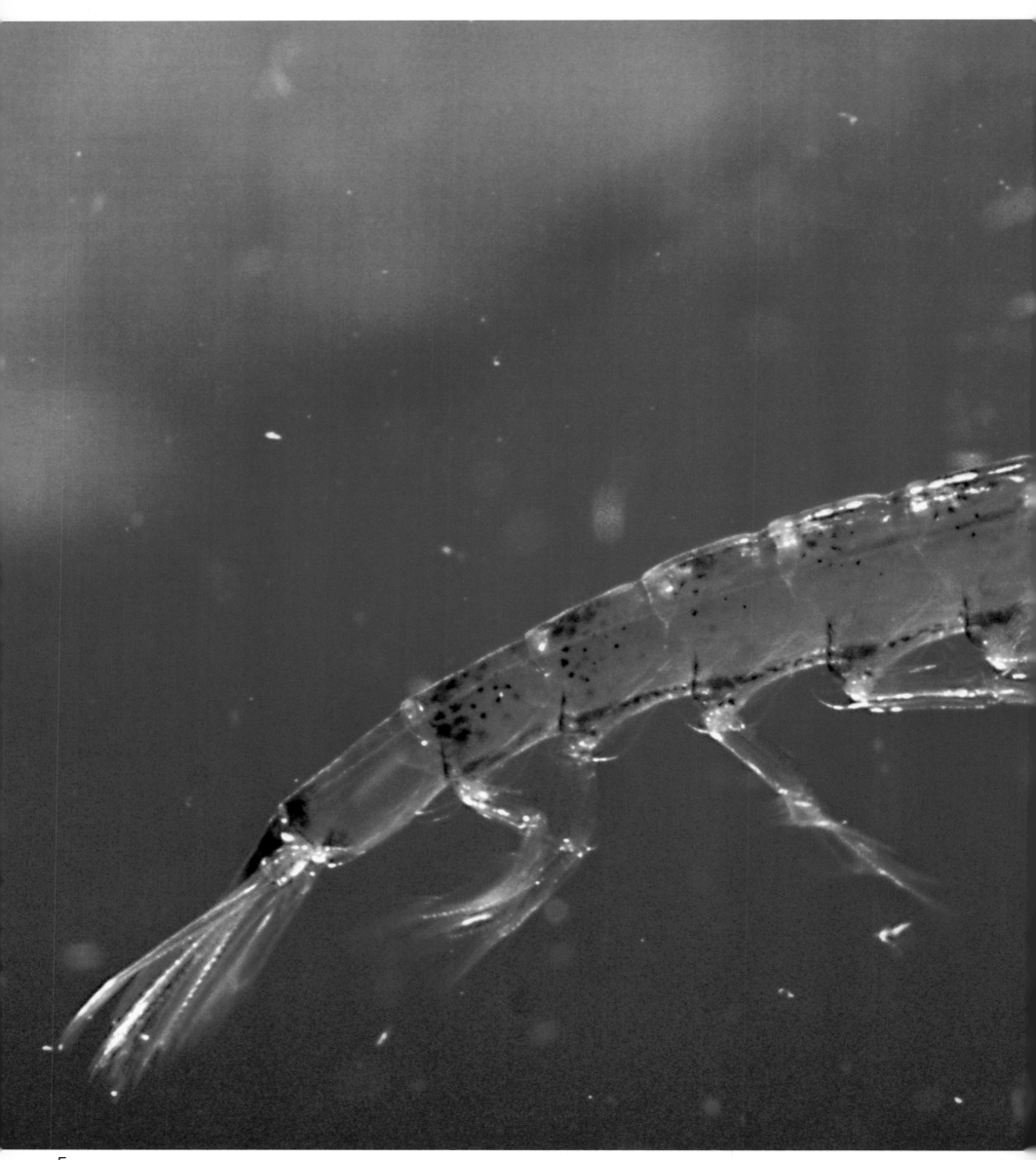

Krill: a strange name for a strange creature. The term refers to minute animals, most of which are shrimp belonging to the *Euphausia* genus. These gregarious animals, which are rich in protein, constitute zooplankton. Baleen whales (belonging to the suborder mysticeti), penguins, and other sea birds feed on krill, which form huge shoals. However, the rising ocean temperature, near the polar regions and other areas, may have an adverse effect on krill—and therefore on all the species that feed on them.

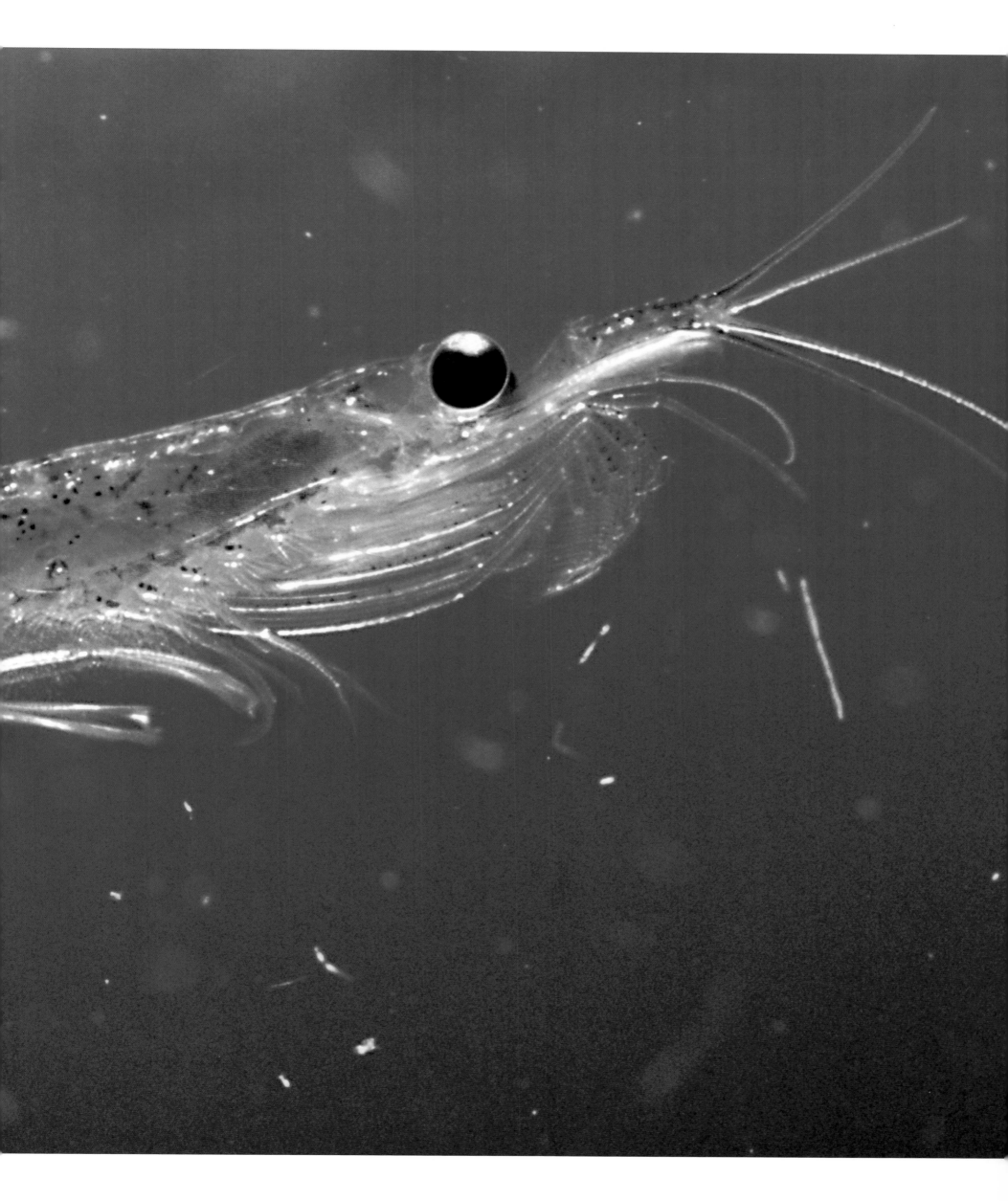

Right: Reindeer (known as caribou) feed on lichen. In winter they scrape away the snow to reach their food. As temperatures rise, however, snow turns to rain, and it freezes when it touches the ground. This thick layer of ice makes it extremely difficult for the reindeer to access food, and thus, they risk dying of starvation.

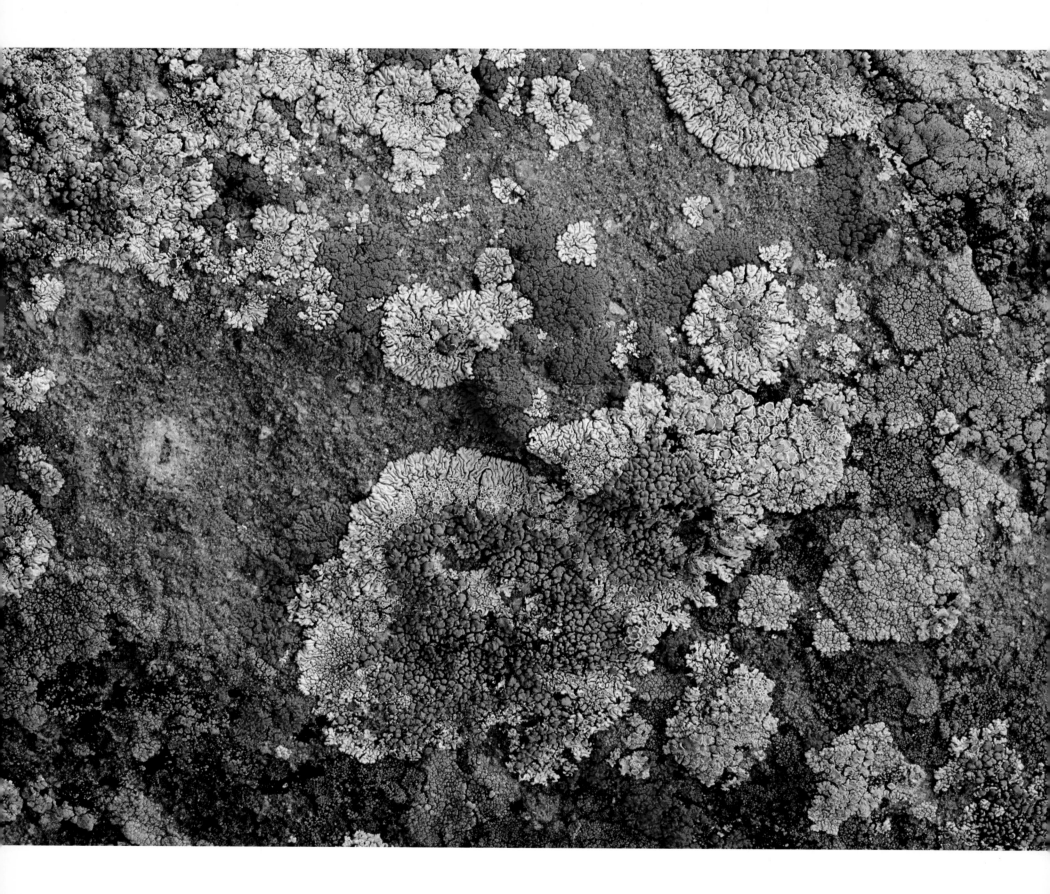

Above: Each type of lichen consists of two species: a fungus and an alga, which are totally dependent on each other—that is, they live in symbiosis. Lichen adapts perfectly to the harsh polar conditions, but it is sensitive to pollution.

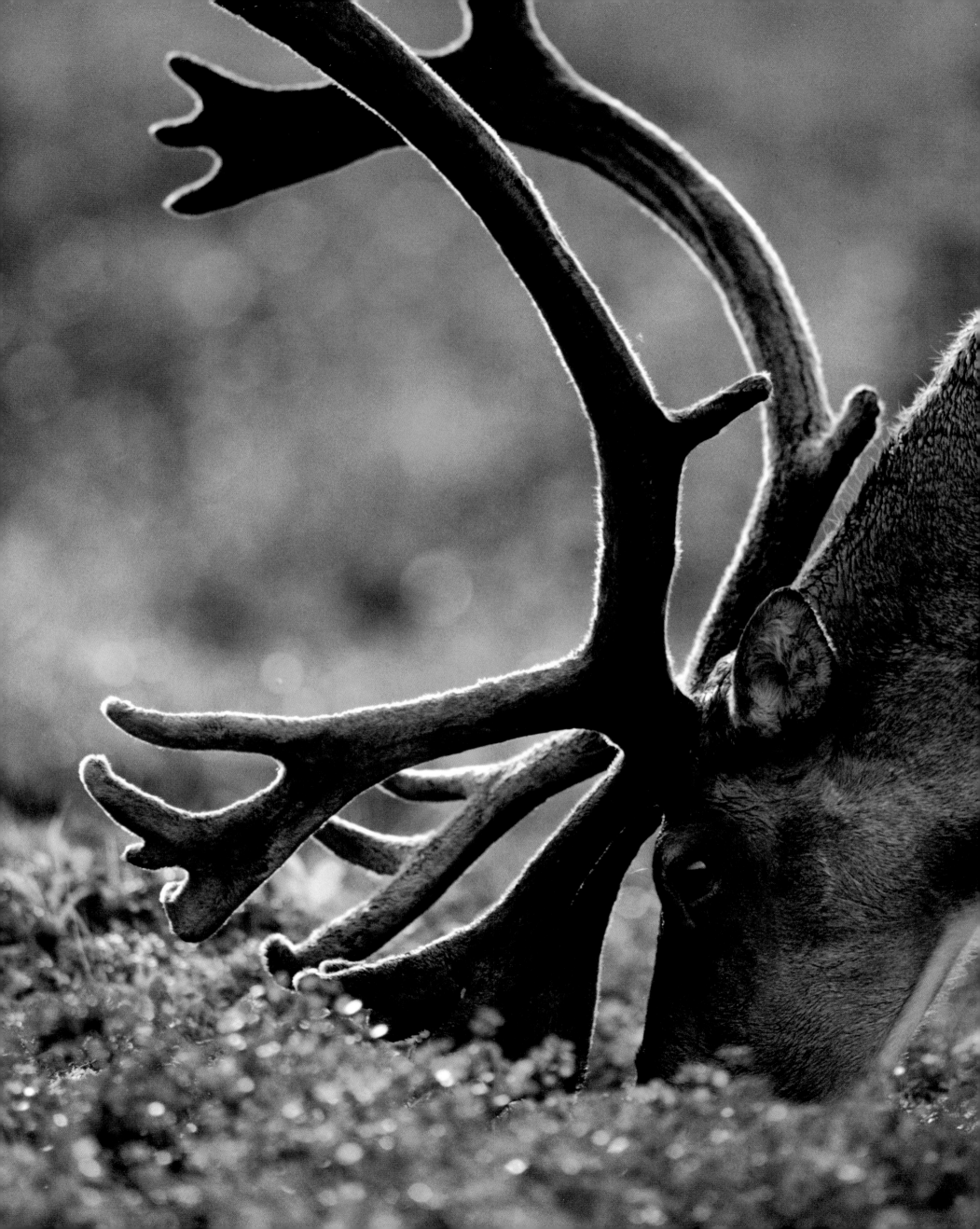

Above: These dark, feather-covered shapes amid the vastness of the tundra are young snowy owls, born just 10 days prior in Alaska's Arctic National Wildlife Refuge. Their parents are large, white owls, which feed principally on lemmings. The latter go through regular population cycles, which have repercussions on the population density of predators such as snowy owls, Arctic foxes, and other birds of prey. If there aren't enough lemmings, these young owls are condemned to death.

Following pages: To describe the environment of the tundra as harsh is an understatement: weather conditions are often appalling. The period during which nature blossoms is barely two months long; during this time there is an explosion of animal and plant life. By the end of July, cold holds sway once more. Snow and fog may cover the tundra from August onward. By this time, flowers have already faded, and birds have departed for warmer climates.

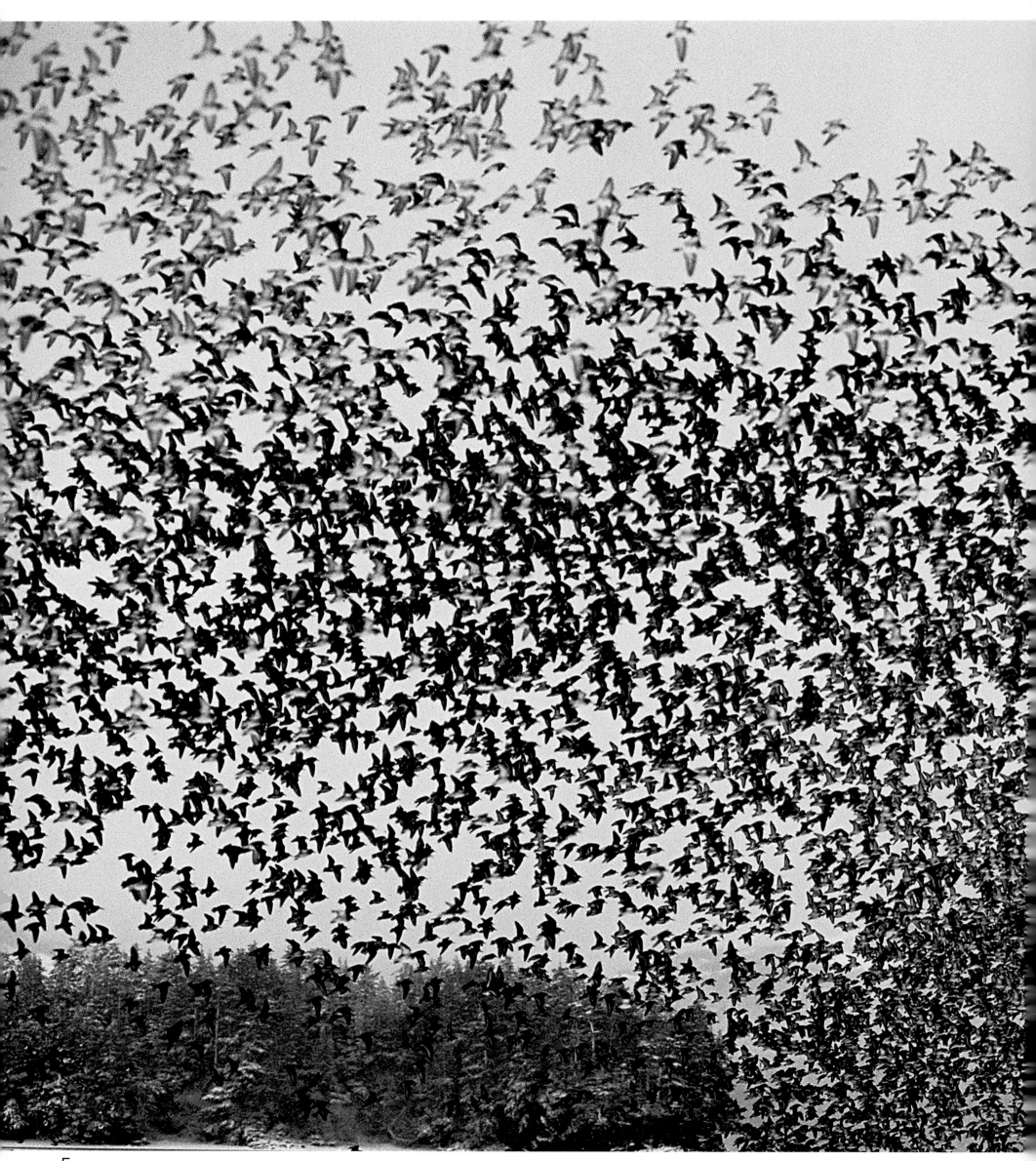

Above: During May, the mudflats of the Copper River delta in Alaska see millions of small waders passing through on their way to the north tundra. It is an important stopping point for these western sandpipers, which, like many other species, are on their way back from South America. They must replenish their fat reserves to finish their long voyage and, more importantly, to be able to breed in a harsh environment where ice and snow await them. Hence the importance of this break in their journey. The rise in sea levels forecast between now and the year 2100 will have a disastrous effect on these immense mudflats, which are threatened with permanent submersion.

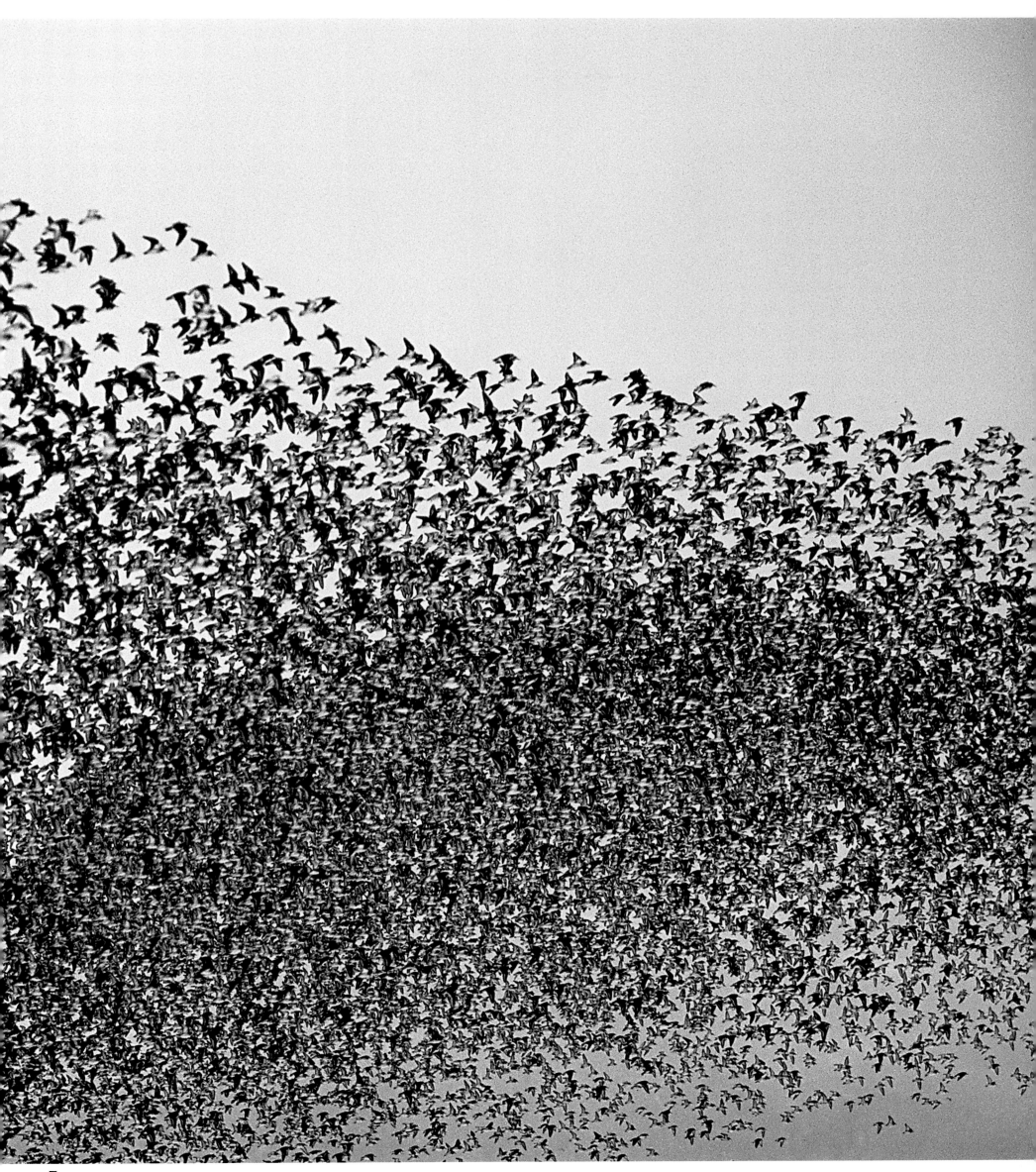

Following pages: Like other mammals, the Arctic fox is perfectly adapted to the tundra environment. Its thick fur and short ears protect it from the cold and wind. The fox has two coats: gray for the summer and white for the winter. The latter allows it to pass unnoticed—especially by its prey—in the snow-covered landscape that predominates at this time of year.

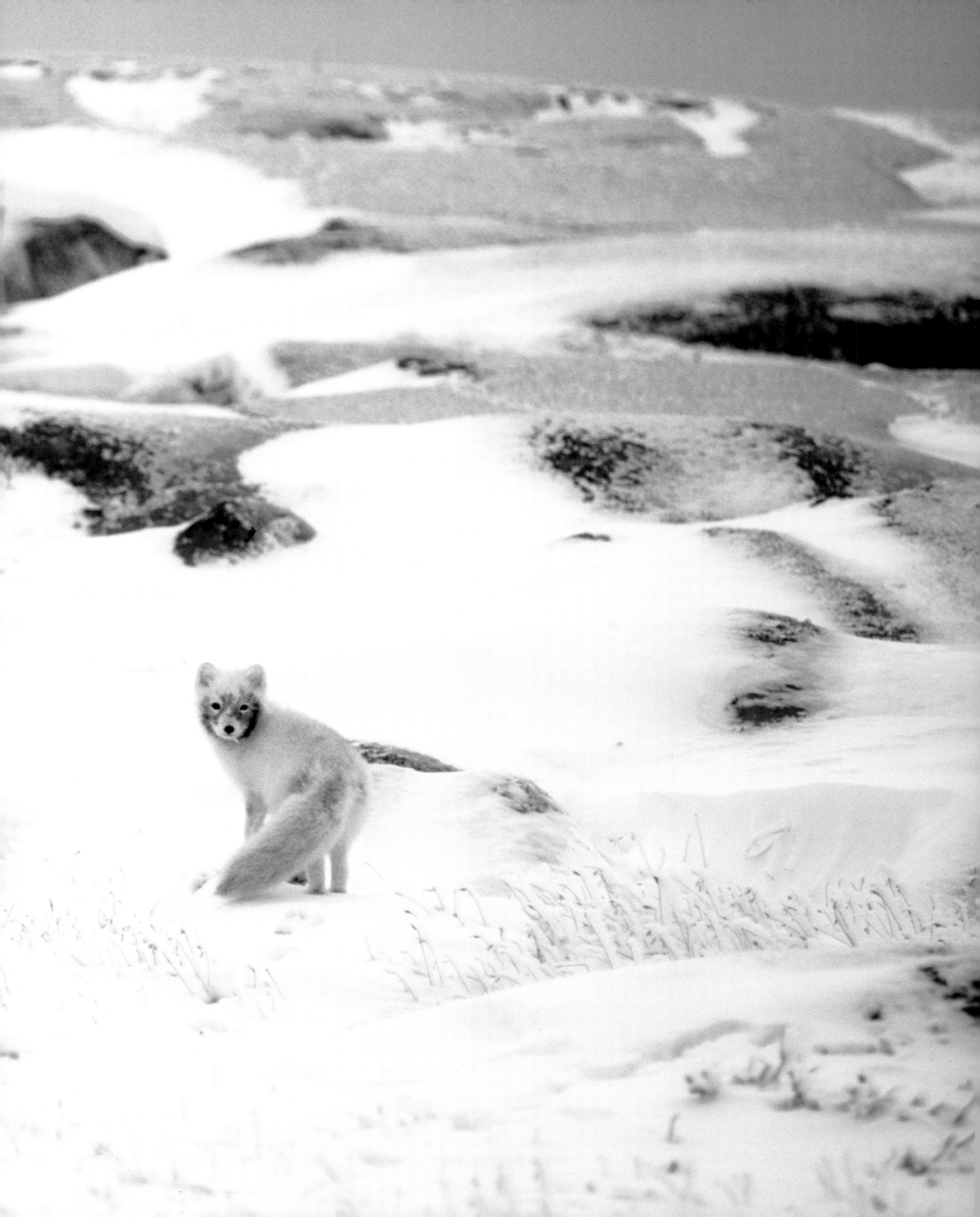

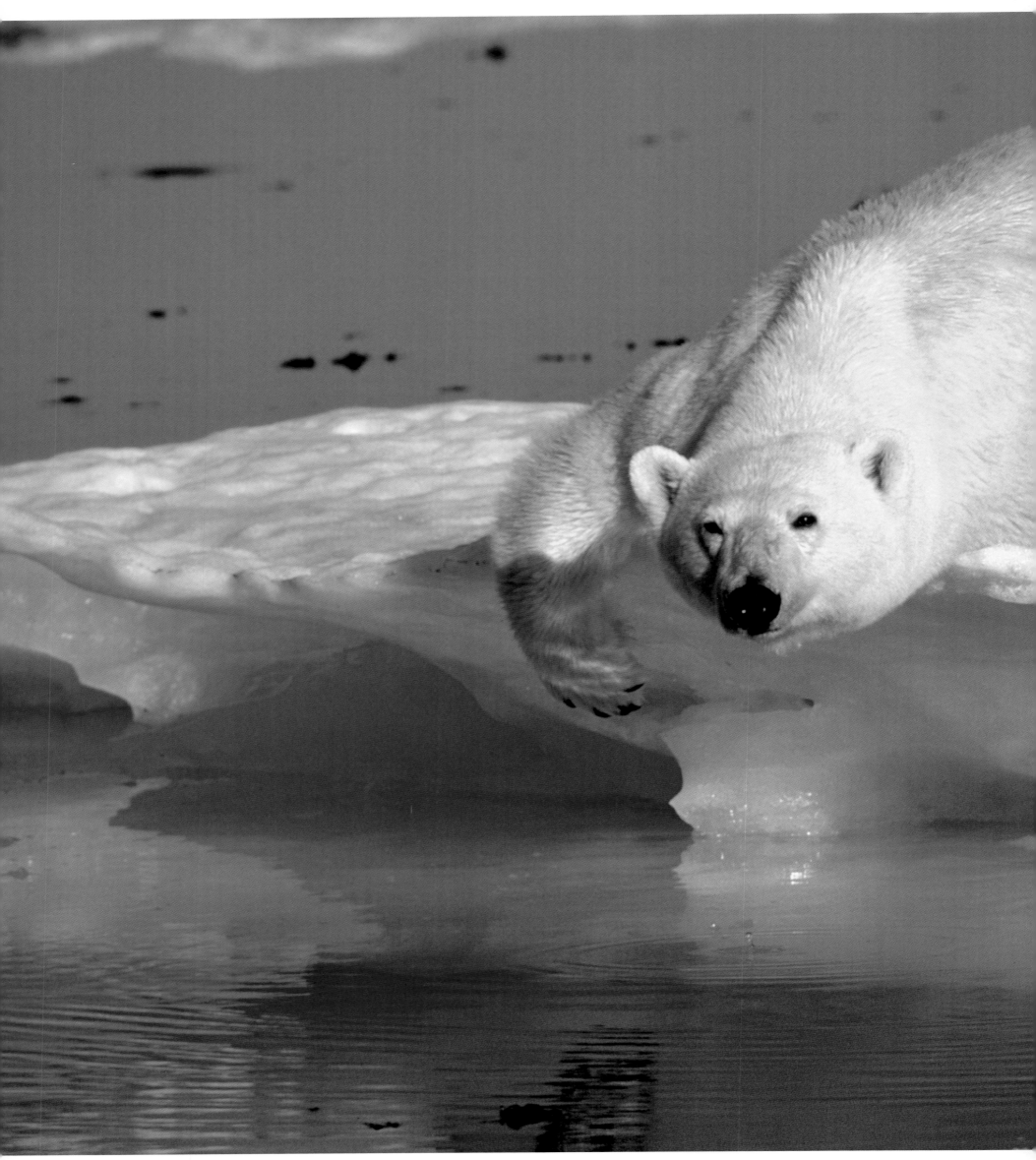

Above and following pages: Will the sight of a polar bear lazing on floating ice soon be nothing more than a memory? This is the fear today of biologists who are studying the species. In the span of 30 years, sea ice has melted more rapidly, especially in the spring, when the ice now breaks up a couple of weeks earlier than in the past. As a result, seals—the bears' chief and vital prey at this time of year—head for open water earlier than they used to, which in turn makes it harder for the bears to catch them. At this time female bears give birth to and suckle their cubs; however, because the bears don't build up enough fat reserves (they are 15 percent lighter on average than 25 years ago) and produce less milk, they feed the cubs less efficiently. Cub mortality has increased markedly. It's possible the species could disappear altogether by the end of this century.

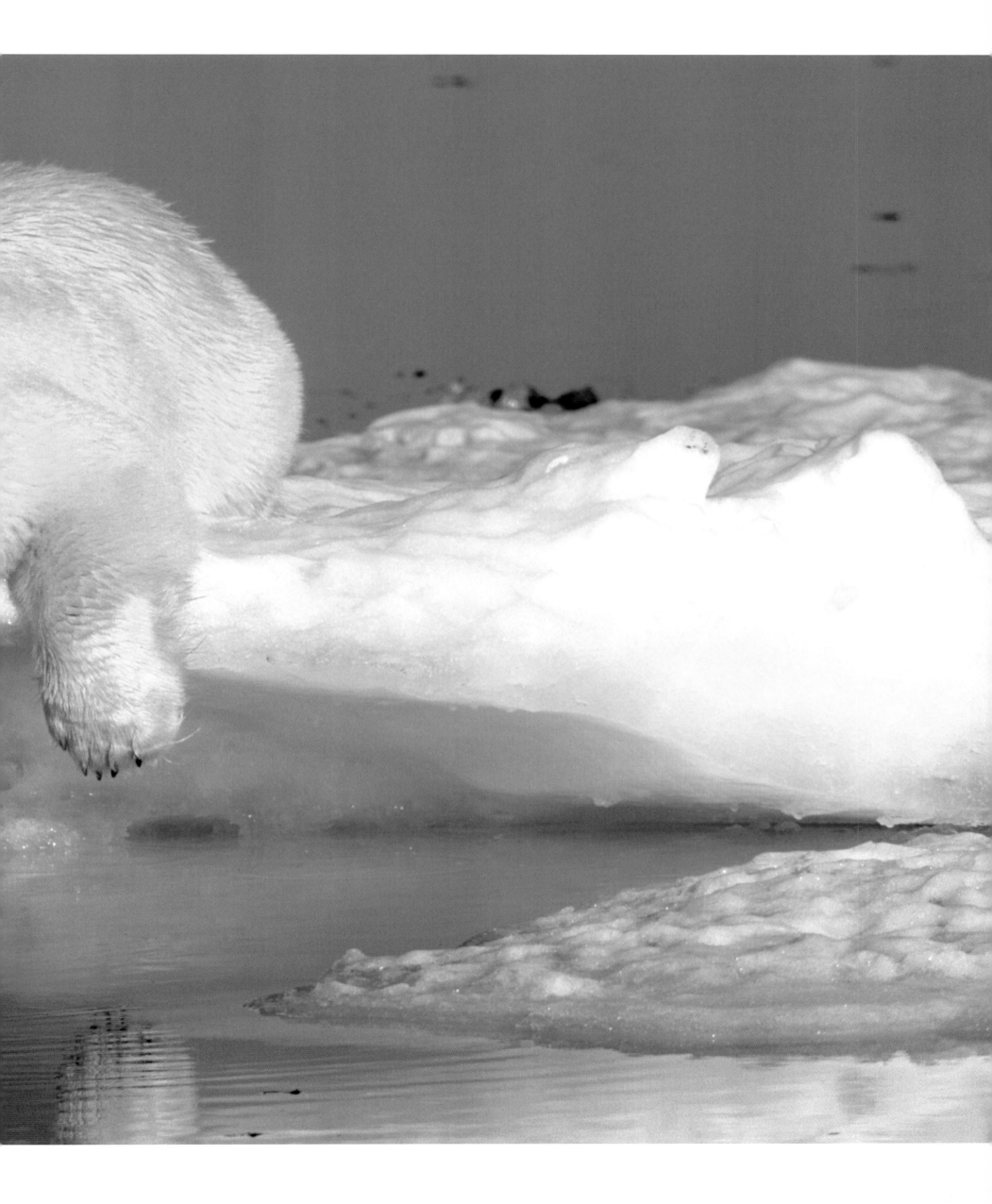

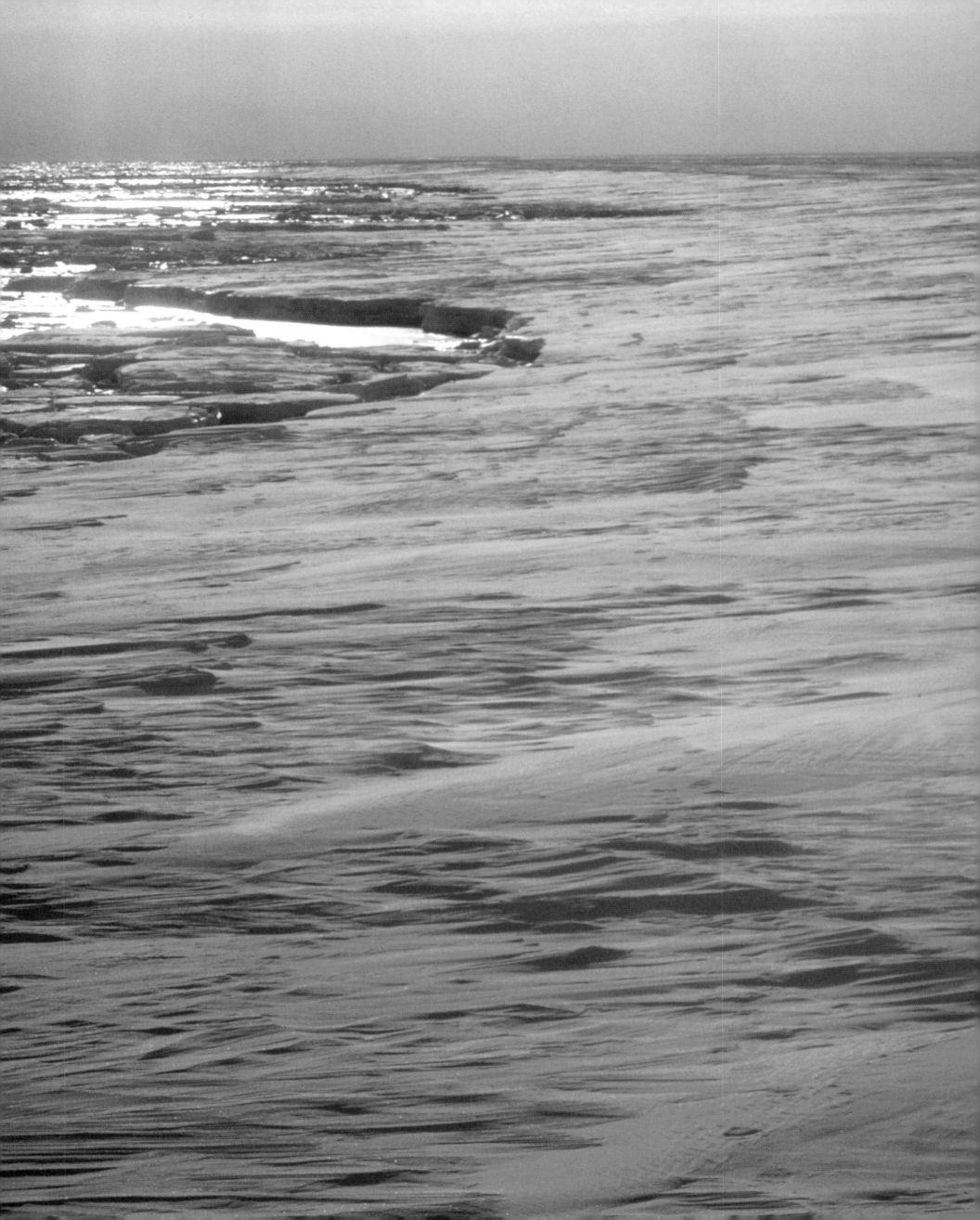

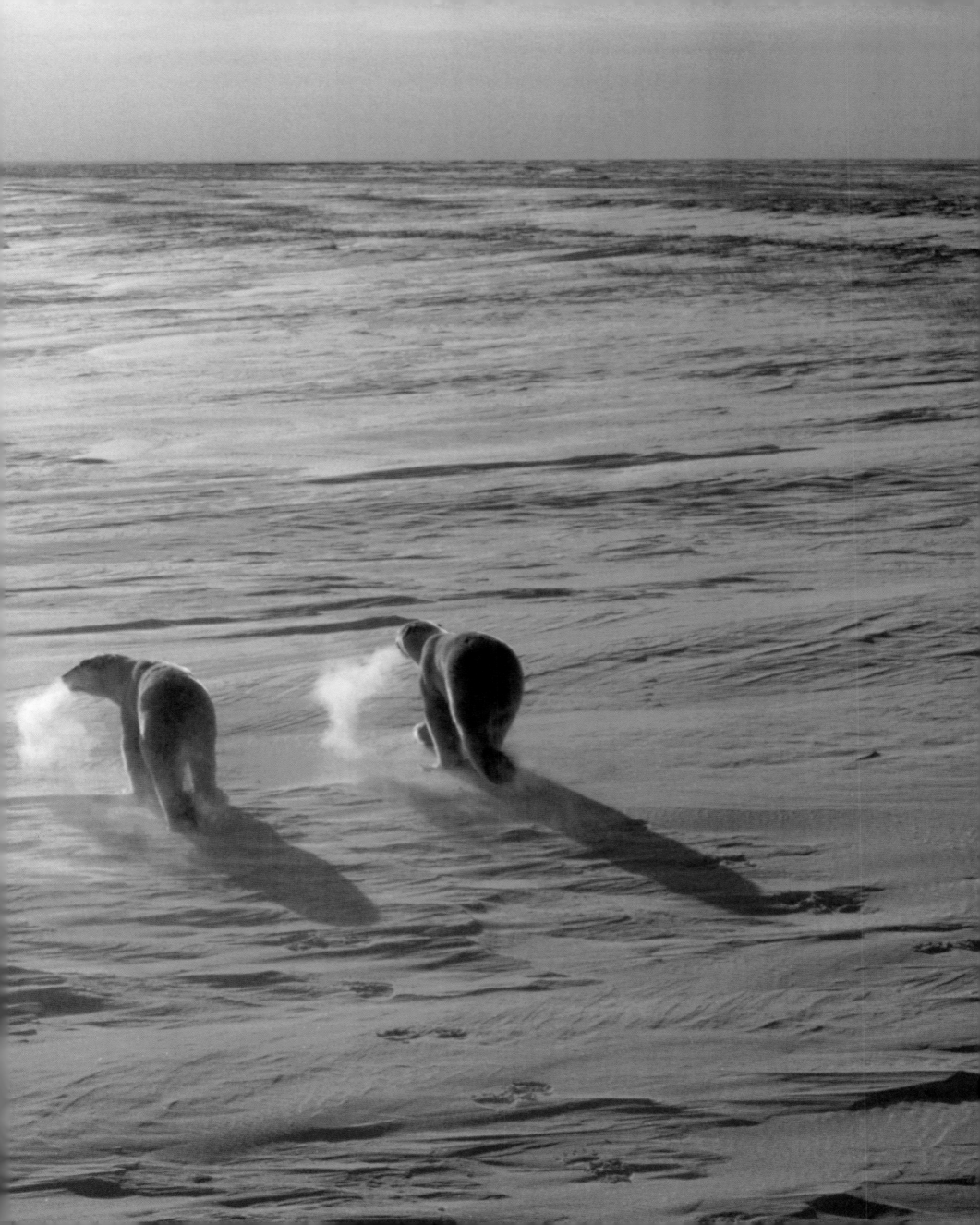

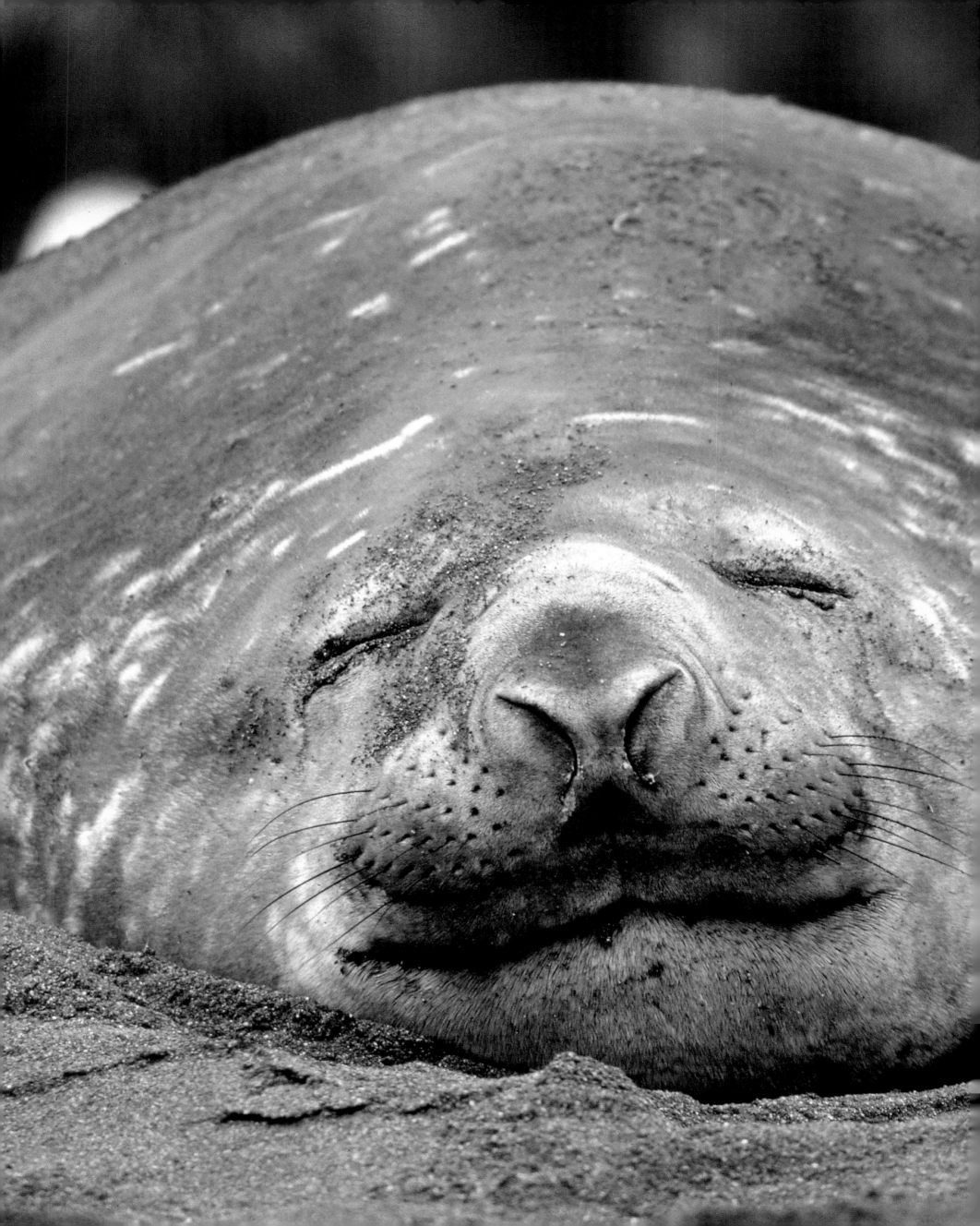

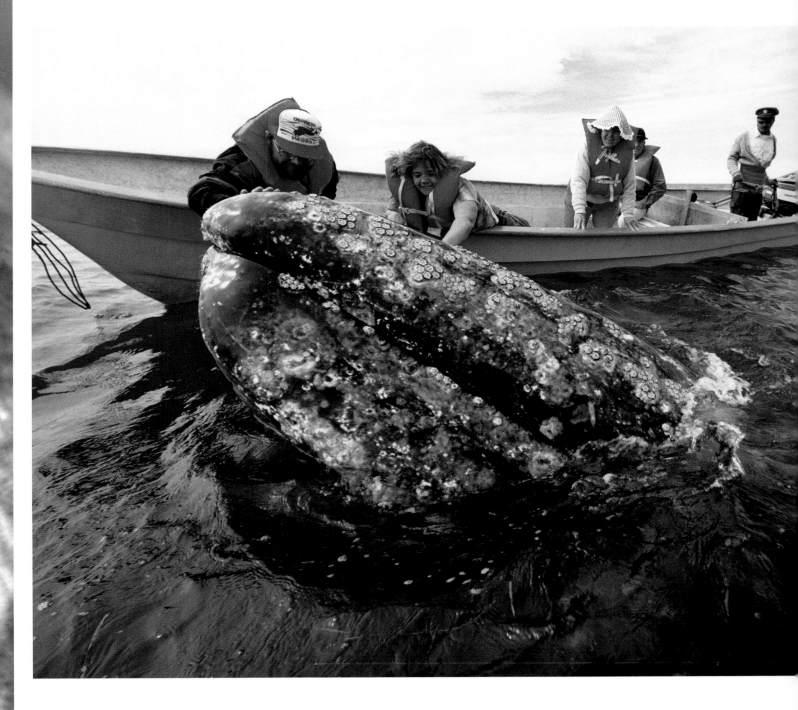

Above: Whale-watching indirectly helps to protect whales. Here, in the San Ignacio Lagoon in Baja California, Mexico, tourists get as close as possible to these gray whales. Certain rules need to be followed, however: do not get too close to the animals or pester them by chasing them in motorboats.

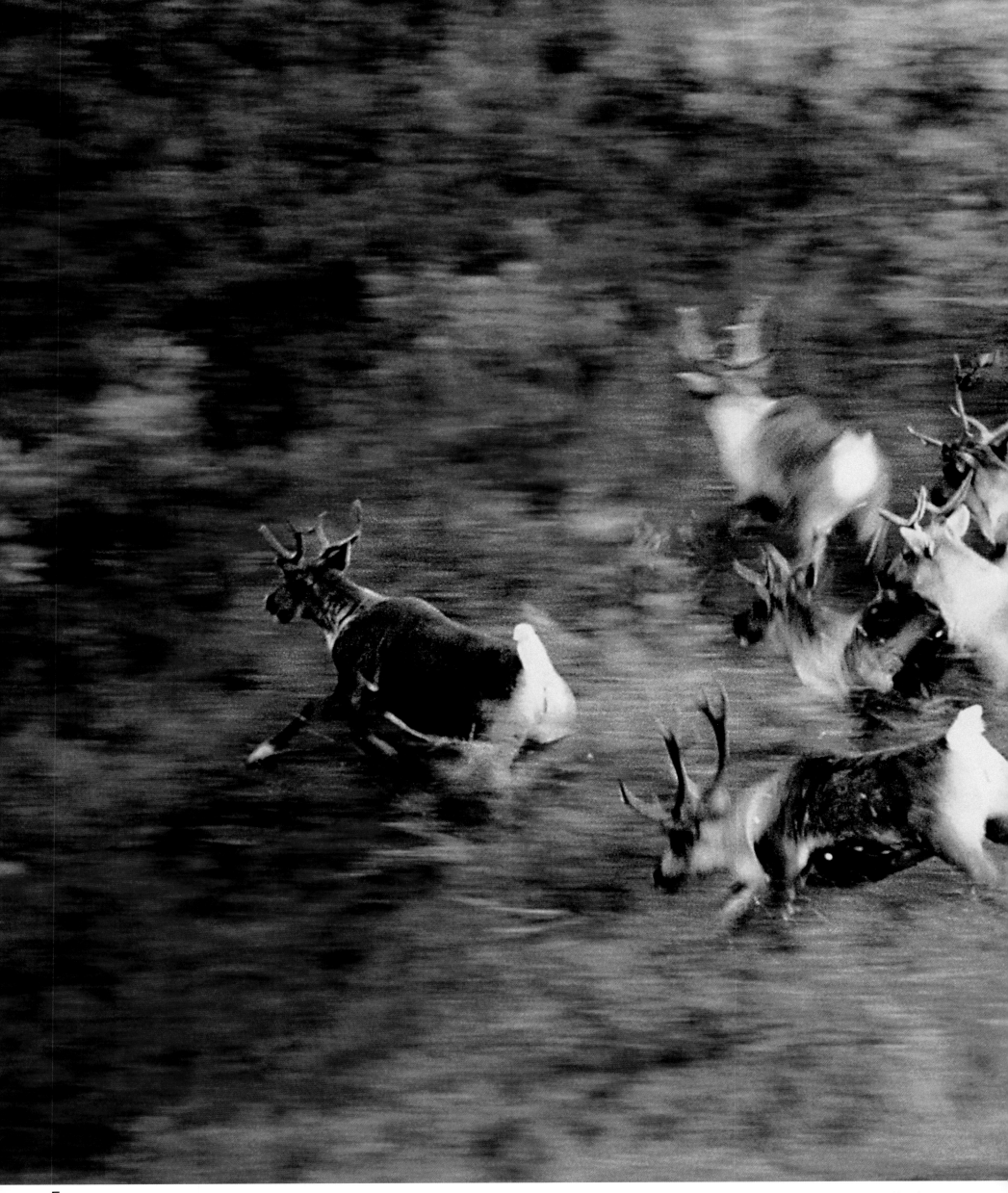

The effects of climate change on the caribou of North America, which migrate over long distances every year, are as yet unclear. As temperatures rise, the grass in the tundra grows earlier in the season and lasts longer. This improves the females' lactation, leading to a better survival rate among the young. Nevertheless, it has been observed that the numbers of the largest caribou population living in this part of the world—the Porcupine herd, which numbers 100,000—have not increased, and may in fact be decreasing. No one yet knows why.

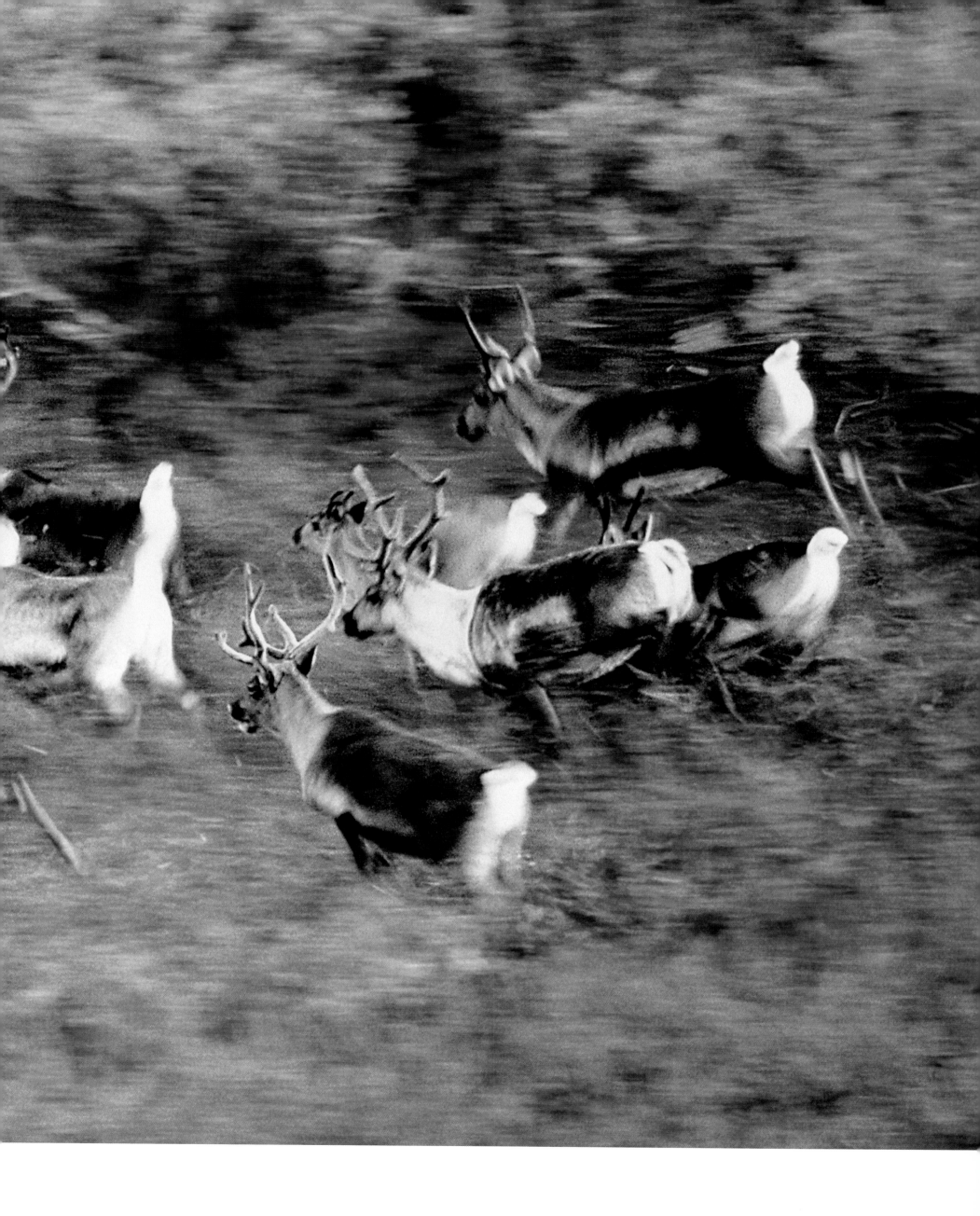

Right: In the space of a few days, the tundra becomes covered with flowers. The Arctic poppy and the moss campion are just two of these species, whose lifespan is particularly short. It is remarkable the way that they have adapted to Arctic conditions. Since there's very little rainfall in the summer, these plants minimize water loss by reducing the size of their leaves. They also develop a layer of hairs on their stems, which help them absorb heat. At this time of the year, daylight lasts almost 24 hours, but the summer is brief: the plants' growth is therefore short but rapid.

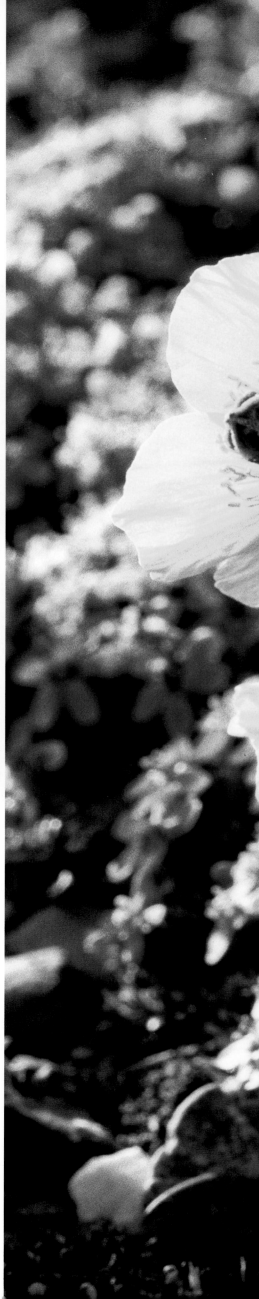

Above: Do you know *Echiniscoides sigismundi*? Or the tardigrades, a species that does not exceed 1 millimeter in length? These incredible creatures defy all laws of nature. They are found in the sea and in fresh water, from the warmest waters to the coldest. Faced with the vicissitudes of their environment, they can desiccate themselves and endure temperatures as low as −458°F. They also can withstand extreme heat and radioactivity. Tardigrades can be carried by the wind and cover considerable distances in hope of one day regaining their normal appearance, assuming environmental conditions will allow. This might not happen for a century!

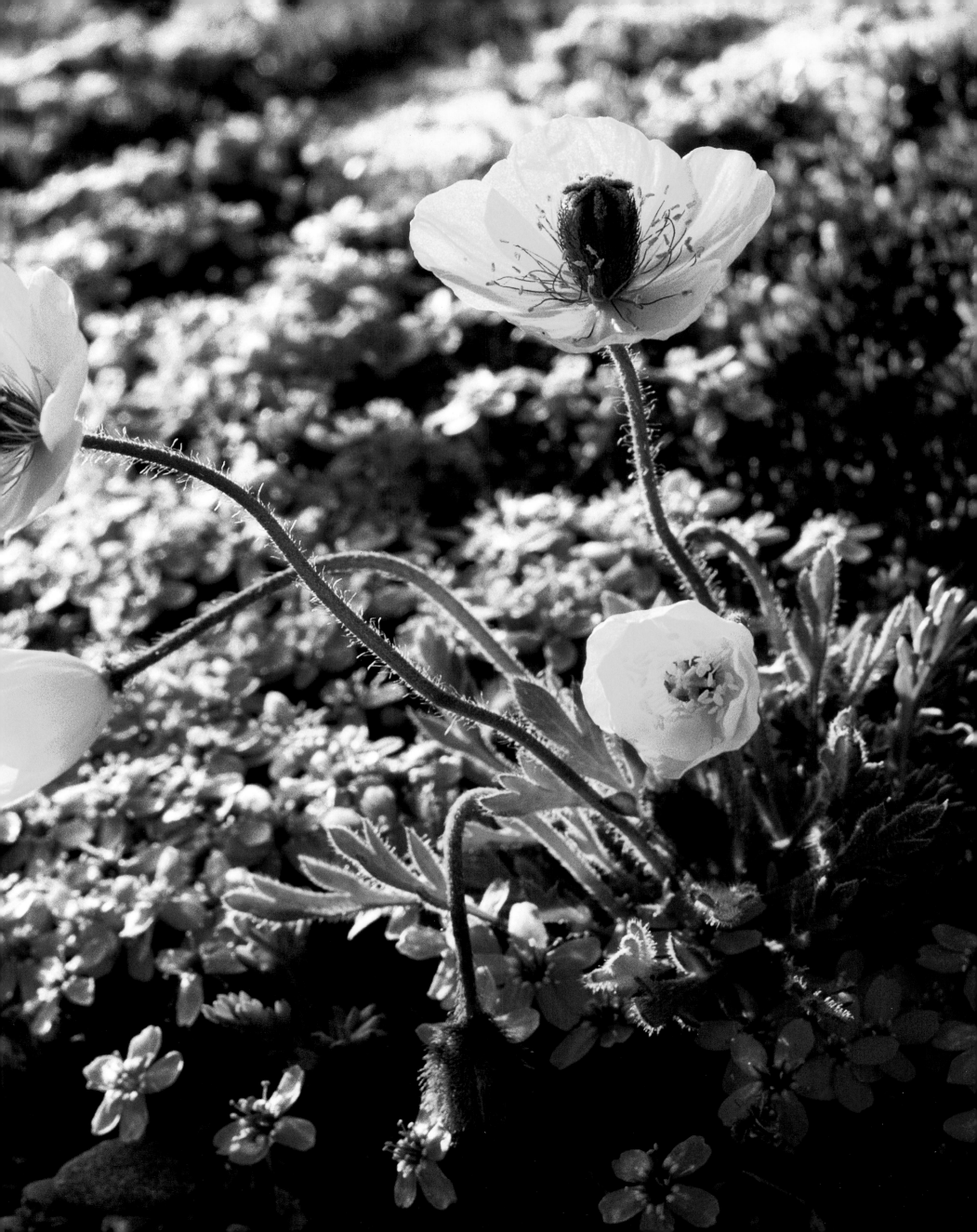

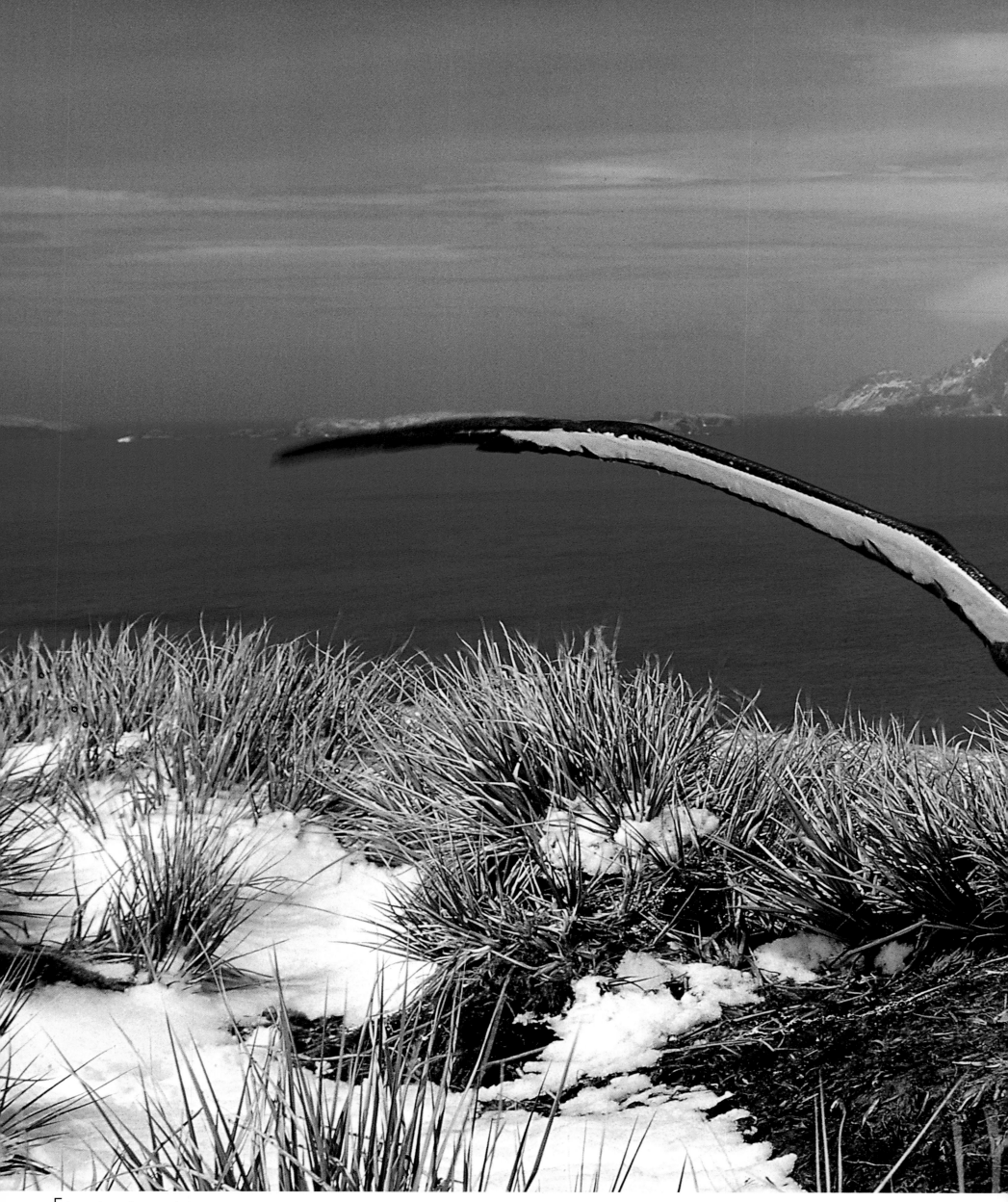

The wandering albatross is the largest seabird in existence. Its immense, narrow wings, which can have a span of up to 11 feet, are perfectly adapted to "dynamic soaring" above the surface of the Southern Ocean, its usual habitat. It returns to land (on subantarctic islands) once every two years only to breed. It covers vast distances each year—between 93,000 and 186,000 miles—to feed and gather food for its young. Sadly, the species is endangered due to drifting baited fishing lines, a threat to the birds and fish of these regions.

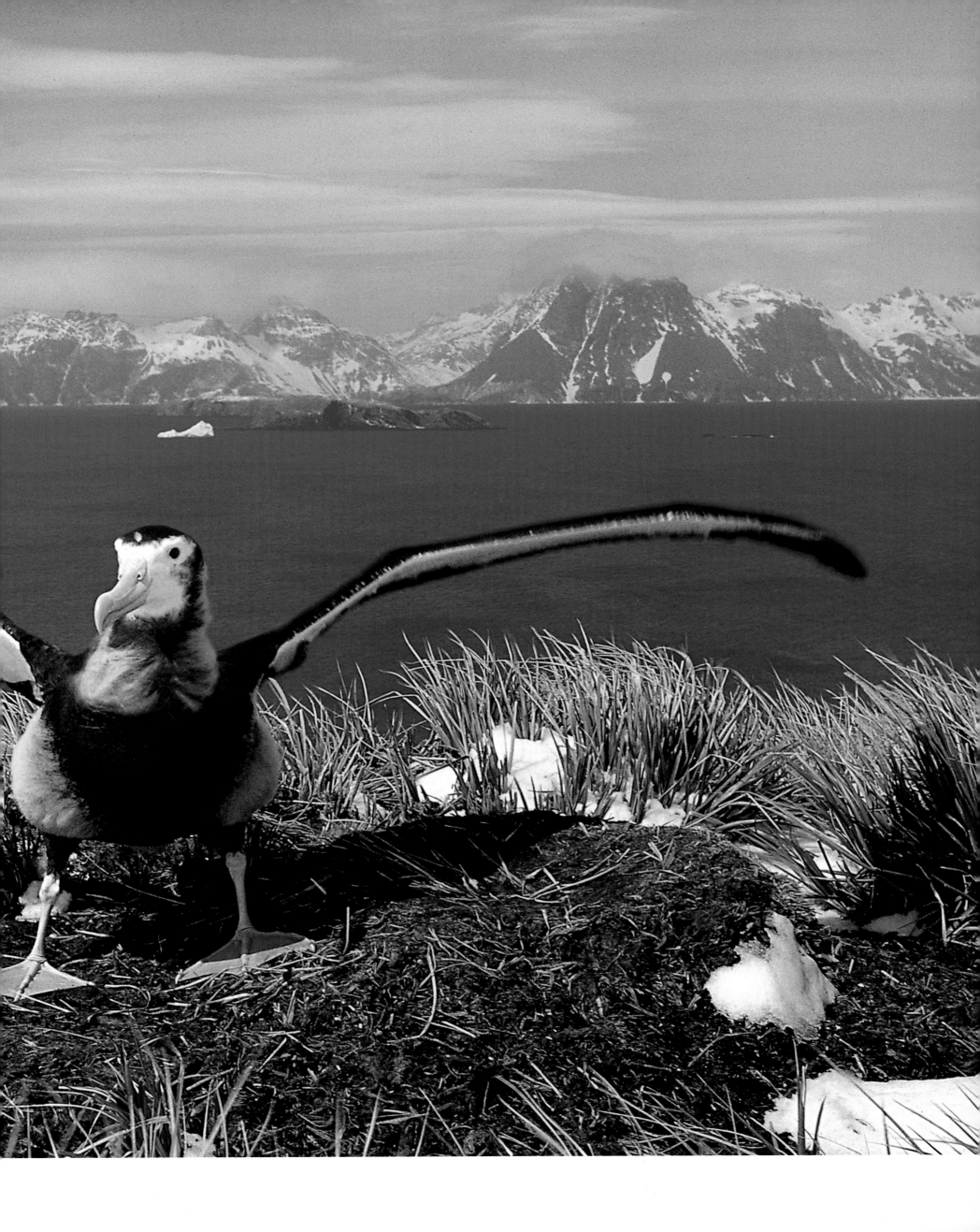

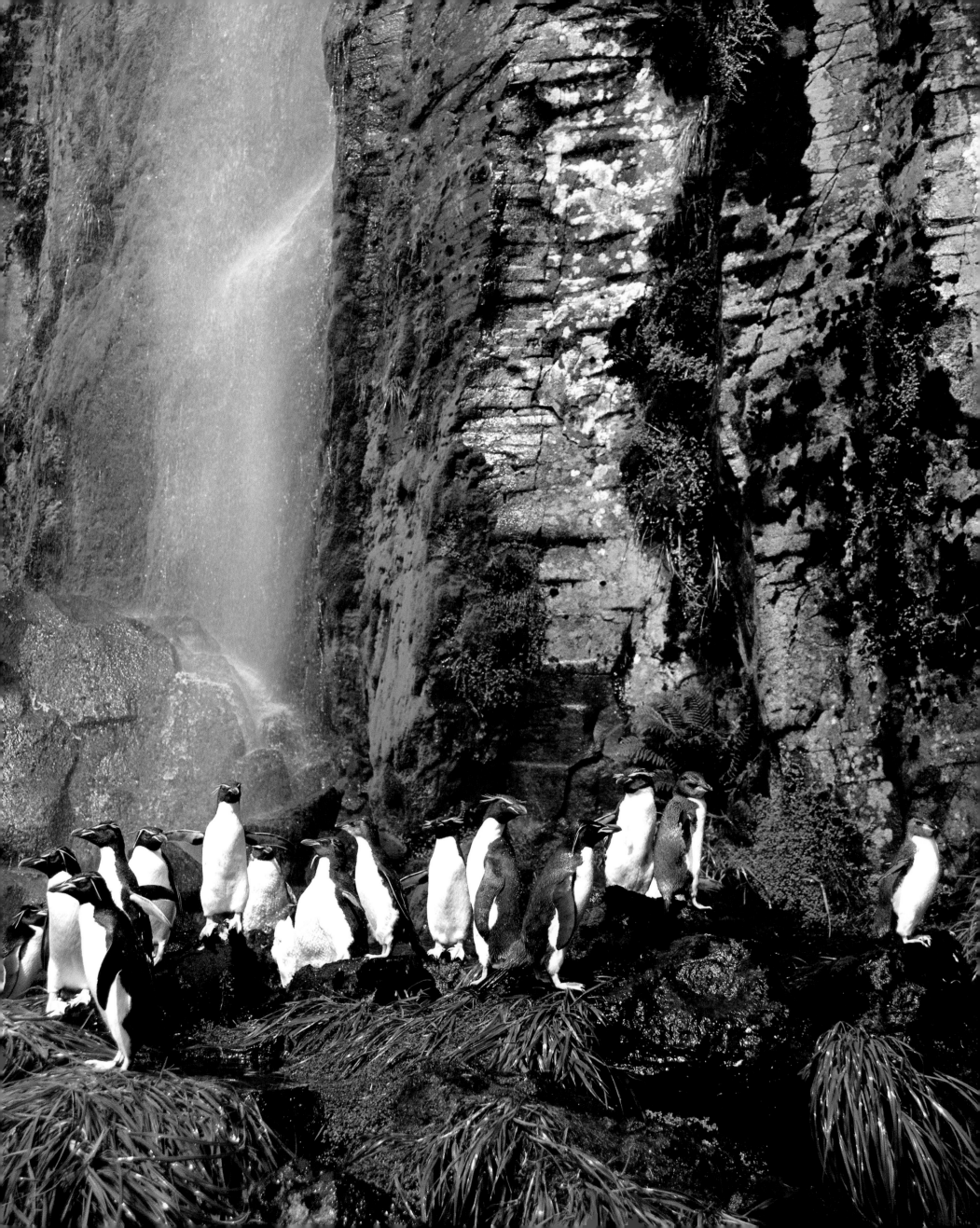

Left: Like most other penguins, these rockhoppers, standing in front of a waterfall on Campbell Island, New Zealand, are simultaneously threatened by the melting of the polar ice caps, the warming of ocean waters, depletion of their prey, and overfishing (of which they are sometimes indirect victims).

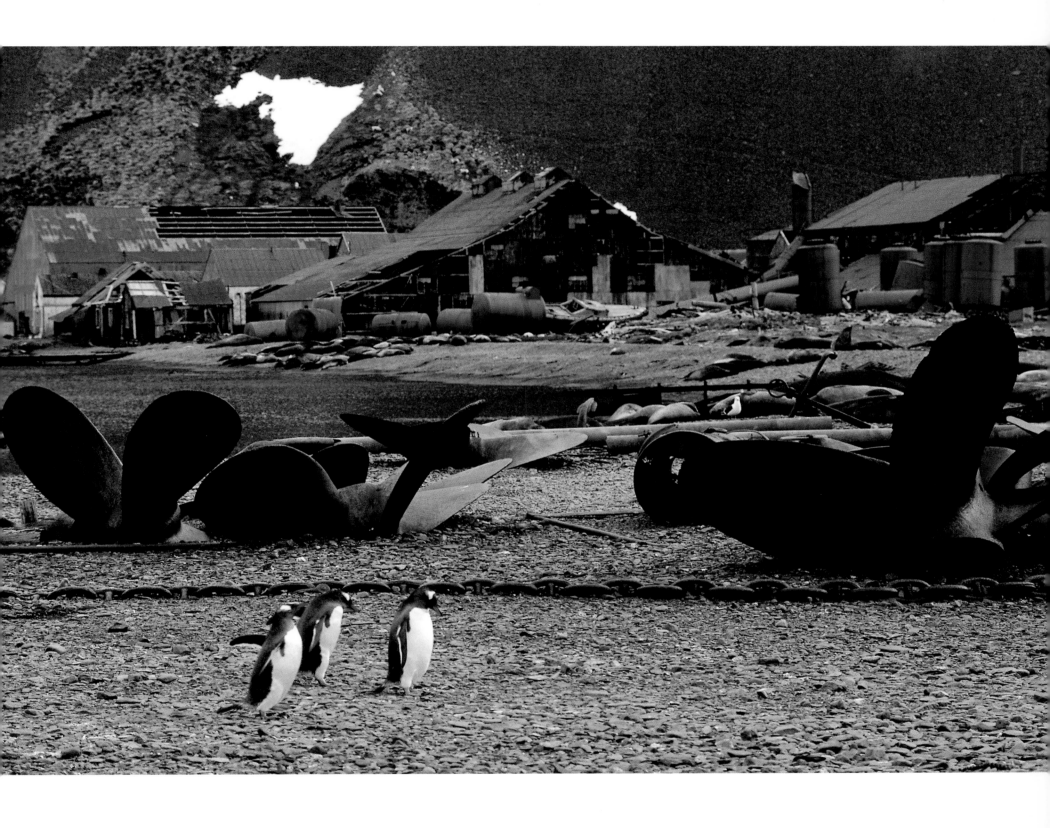

Above: Shortly after World War II, certain subantarctic islands, such as South Georgia Island here, became strategic military bases and also were used for commercial purposes and to explore the South Pole. Dwellings were erected on the island, but soon, for various reasons, many bases were abandoned. Within a few years, as the relics of human presence rusted away, the islands once again became the haunt only of seabirds, such as these gentoo penguins, which nest there in large numbers.

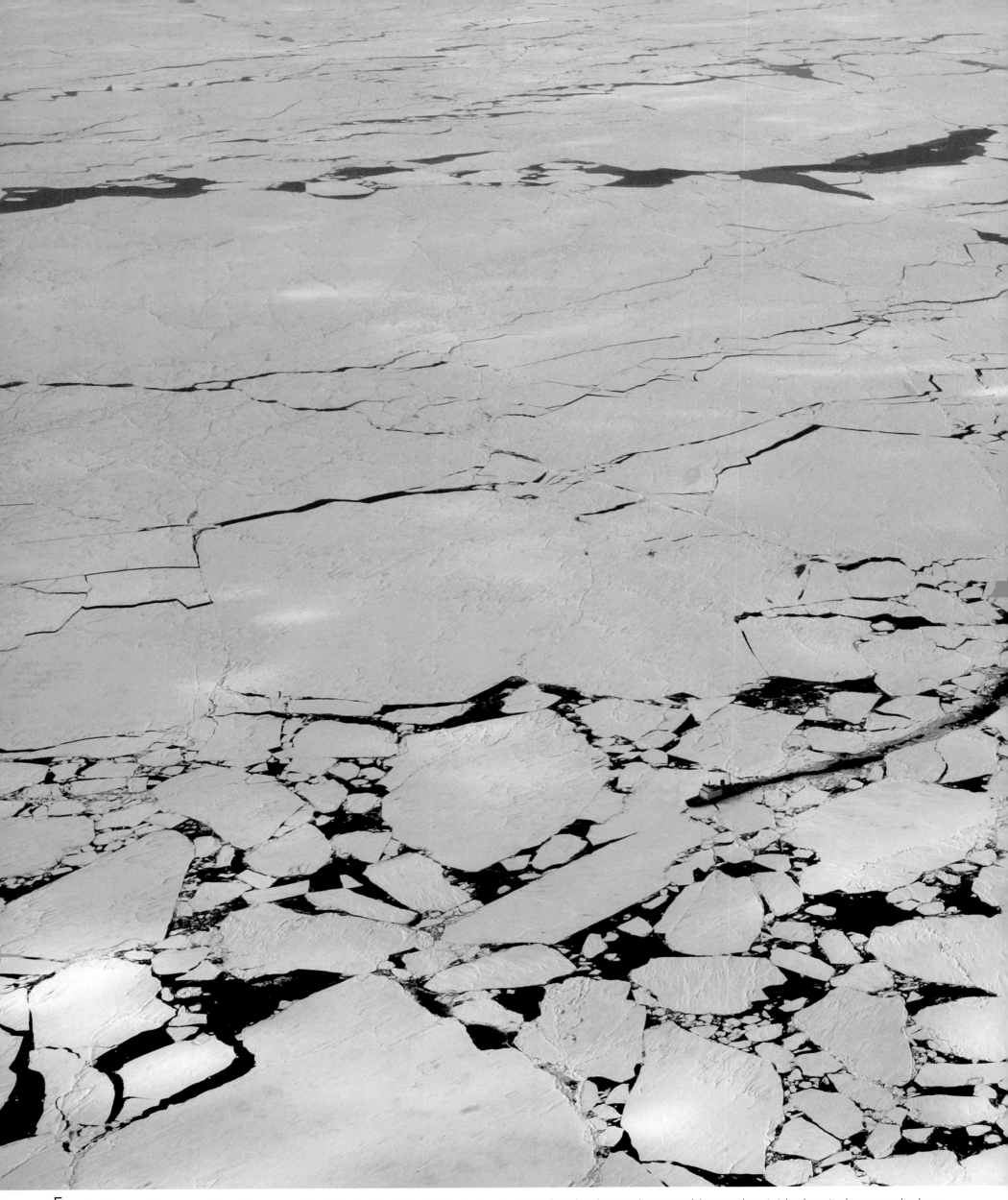

An icebreaker moves, like a tiny ant, through the vastness of the thickening Antarctic ice. The floating ice acts as an insulating layer between the ocean and the atmosphere. As it breaks up, it releases very salty, dense water, which sinks to the bottom of the ocean. By modifying the salinity, and therefore the density of seawater, sea ice plays a key role in the circulation of ocean currents, in marine life, and in the earth's climate.

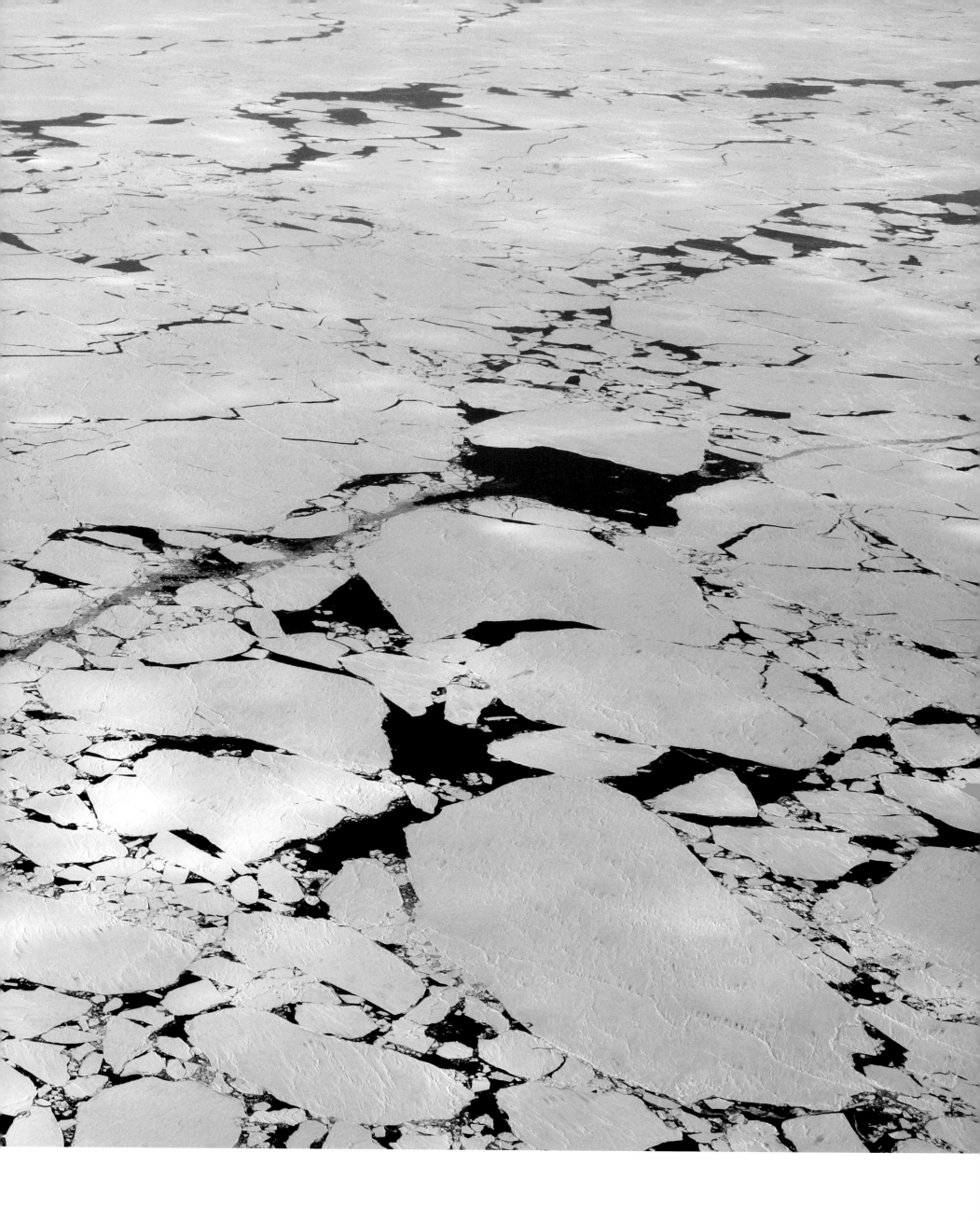

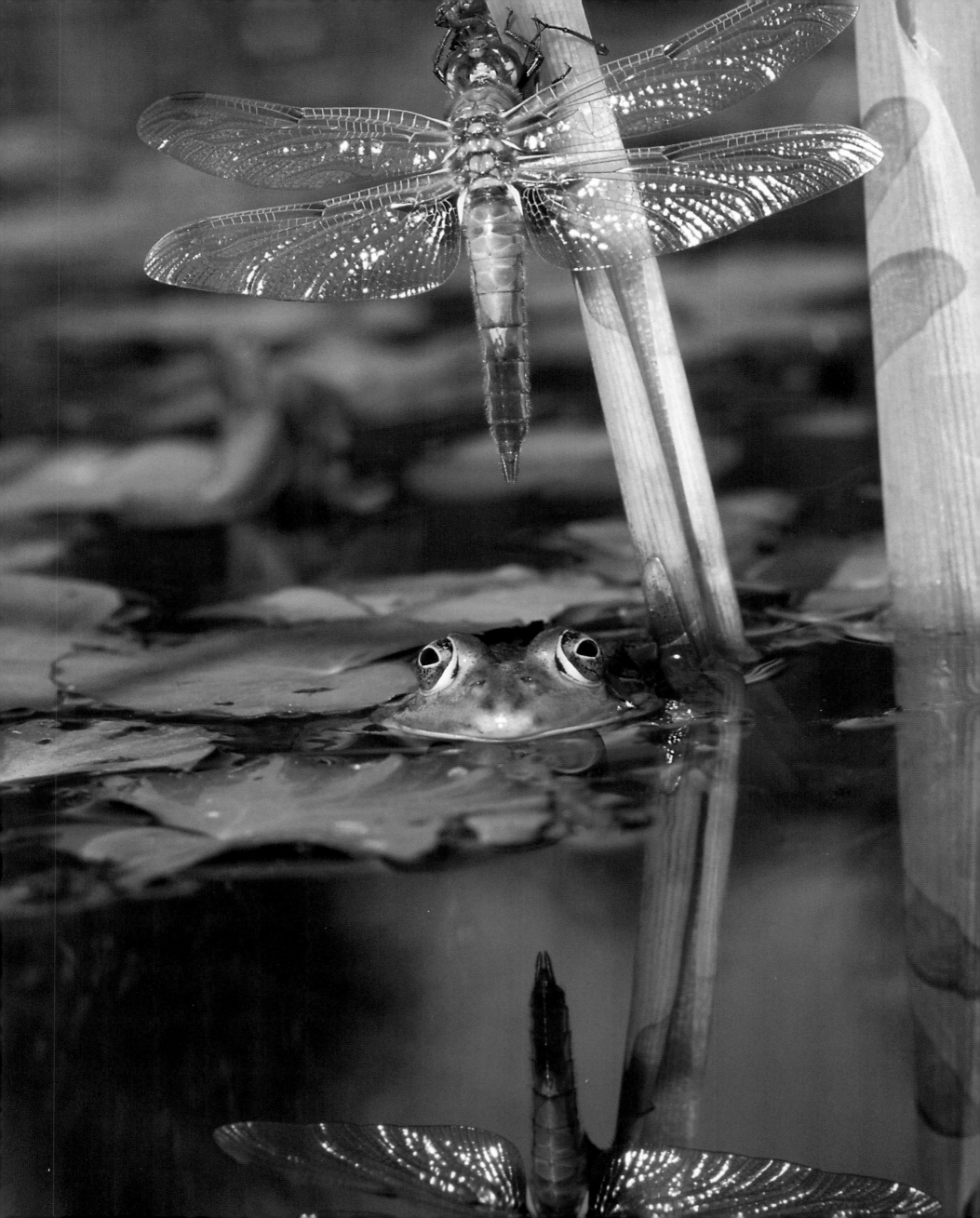

Wetlands

The Okavango was a great revelation. This region of southern Africa reminds us not only of nature, but of the fundamental role nature plays in life, on earth, and for mankind. What wonder! The Okavango is a veritable purifying wave, which wakes anyone who has come from an urban, technological society. Some places are like an initiation, and the Okavango is one of them. It is there I realized the essential truth: nature contains all the elements needed to give moments of happiness and fulfillment.

Left: A drama waiting to happen down at the pond: the green frog has caught sight of the dragonfly, as it rests on the stem of an aquatic plant. Within seconds, the insect will vanish in the amphibian's mouth. Wetlands are areas of extraordinary diversity of fauna and flora. Many animal species visit wetlands to reproduce, even if they do not spend the entire year there. In terms of the quantity of animal and vegetable matter (biomass) they produce, wetlands are among the most prolific habitats on the planet.

It is one of the few inland deltas on the planet. The Okavango River's source is in Angola, near the Atlantic Ocean. Because of the region's geology, it doesn't flow toward the ocean, but southeast, to meet the sands of the Kalahari Desert, where it vanishes, dispersed in a thousand channels. The meeting of the water and the warm land produces a luxuriant garden that covers a vast area, where all the animals in the region converge. Famously, it is one of the world's most populous bird sanctuaries.

When I discovered it, the Okavango was the embodiment of Eden. It was a paradise swarming with life, shimmering with extraordinary colors. The water color ranges from cobalt blue to navy blue to turquoise; there are tobacco-colored sandbanks and sand cliffs, in a fantastic palette of ochers. Vegetation, varied and luxuriant, is thick with astonishing trees and water lilies, whose magnificent flowers perfume the air: here is water, land, and life.

Much of the beauty of Okavango is due to the water. There are so many mirrors, and hues—and there is a coolness that makes gliding over the water a sensual pleasure. I leaned on a pole we used to transverse the Okavango, slipping through the parting water lilies. We were accompanied by a quiet lapping, a reminder of vigorous life beneath the water's surface. One might almost forget to traverse with prudence, were it not that these sometimes shallow watercourses are home to many hippopotami. Small wading birds frolic about, and fish eagles watch for their prey. There are buffalo and elephants near by. Not a moment passes when the eye is not fascinated by this place—it is so full of life and excitement.

After the rains come to Angola, the waters of the swollen river percolate down into the delta. The water advances at a walking pace, and the whole animal tribe follows it: insects, birds, and mammals. It is an amazing sight.

I came to know this paradise—which I believe to be untouchable—long before it, too, was placed in jeopardy. The Morocos, the local people in the Okavango Delta, have fished and hunted without ever endangering the land. However, as the surrounding population increases, the land is now being used for intensive livestock farming, drainage, and hydraulic works. These dangers have come from outside. Since this has been happening, I have realized that no place—not even where human population is sparse, as in the Okavango—escapes greed in one form or another.

This paradise, where human presence was never a threat, is now endangered and damaged by national and international economic activity. Today the Okavango, the pearl of inland wetlands, is being progressively and irreversibly dried up. Upstream, the river's waters are being drained and exploited by the diamond industry. When a fence running east to west was put in place to protect livestock from wild animals, it caused overgrazing and has prevented natural migration. This, along with hunting for sport (more lucrative than ordinary tourism), has lead to death among wildlife.

How much longer will the Okavango remain one of the world's most important sites for biodiversity? In collaboration with the Preserve organization, I am trying to have it listed as a World Heritage Site. It is a true race against the clock.

> Today the Okavango, the pearl of inland wetlands, is being progressively and irreversibly dried up.

Wetlands and marshes are the richest and most prolific ecosystems. They cover more than 3 million square miles worldwide. Invertebrates, the staple diet of many bird and fish species, are plentiful in saltwater areas. Marshes are poorly drained areas of land. In areas where the soil is poor, peat bogs form out of dead vegetation. In the Northern Hemisphere, at high latitudes and in mountains, low temperatures slow the decomposition of dead matter, and mosses and sphagnum invade the vegetation. In areas with richer soil (inland or at the mouths of large rivers), grass grows and produces marshes. Along coasts, river deltas form tidal brackish zones or nontidal lagoons.

In the United States there are other areas where water and land come together to produce teeming life: the Bolsa Chica wetland in California is one example. In addition to these great wetlands, life can also be found in and around lakes, pools, ponds, streams, and rivers—all these places are cradles of life. Water, grass, and floods have long coexisted harmoniously, allowing societies to develop river transport and fisheries, as well as farming based chiefly on extensive livestock raising. In such regions, biodiversity is rich.

Whether in calm or turbulent waters, the vegetation found both in it (seaweed, water lilies, and the like) and on its banks reveals the stupendous diversity of these habitats. Water is home to many fish and invertebrates specific to each habitat. Near the water, pink flamingoes, pelicans, ducks, and other water birds—both migratory and sedentary—find favorable places to breed and migrate. Fresh water provides spawning grounds for fish, including such sea fish as salmon, that swim up rivers to lay their eggs. By contrast, eels swim downstream and move from rivers to oceans, setting off to breed in the Sargasso Sea. It's there where the elvers will make the return journey to fresh water, where they will grow to maturity.

These areas rich in biodiversity, which are so essential to controlling and maintaining the quality of water resources, provide vital ecological services to the planet—and in turn to humans. Yet humans deprive themselves of these areas by destroying them. In Europe and the United States about half of all wetlands have been drained to make way for urban development or agriculture. Indeed, agriculture is the main cause of the loss of these areas, which are drained to increase the size areas of arable land. Dams built across rivers to generate electricity change the water habitats downstream, obstructing the movements of migratory fish toward their spawning grounds. All inland wetlands, especially marshes, are threatened with drainage. Marshes were long seen as inaccessible, mysterious, and unhealthy places that were dangerous to humans. They were incompatible with human activity and, above all, harbored many species of insects that bore disease. For a long time their insalubrity was the justification for draining these places.

Watercourses were carefully tamed. Dykes were built to prevent flooding in some places and to aid navigation or the abstraction of water in other places. This domestication or removal of fresh water was driven as much by the illusion of mastering nature as by ignorance of the wealth that such habitats constituted for humans. Even so, there have been many accidents that remind us that water reclaims its rights—and resumes its previous course—after heavy rain. Peat bogs and other marshes play a vital role in controlling freshwater flows. They act as veritable sponges during floods and filter surface water, thus directly helping to keep water pure.

These areas—cradles of biodiversity—are vitally important to ecological balance. Draining these habitats, "reclaiming" land from water, and overfishing in degraded aquatic environments have drastically reduced all life forms that depended on them and which make up an integral part of their ecosystems.

> Agriculture is the main cause of the loss of these areas, which are drained to increase the size areas of arable land.

The sturgeon, whose eggs are so greatly valued for caviar, once lived in large estuaries. A victim of fishing, poaching, and the channeling of watercourses, this fish survives in very small numbers worldwide. One breed, the lake sturgeon, is found primarily in freshwater lakes and large rivers in northeastern North America. At one time, lake sturgeon were incredibly abundant, but since they are prized for their caviar, skin (for leather), and swim bladders (for isinglass), population levels plummeted within a relatively short period of time. Since sturgeon reach breeding age at only 12 years old, the rebuilding of stocks—and the fish's very survival—are so precarious that the species is considered to be in danger of extinction.

Although the destruction and the thoughtless misuse of wetland areas occurs in developed countries, it's even more commonplace in developing ones. This destruction is symptomatic of a shortsighted approach that favors the nonsustainable use of renewable resources to meet immediate needs. However, wetlands play a role in the health of ecosystems and in the good condition of water resources. Humans easily forget the invisible services that nature provides, or only become aware of them when deprived of them. In the latter case, attempts are sometimes made to restore them: building storm water detention basins and lagooning pools for purifying water, and building "replacement" pools for storing winter rain water to be used for irrigation in spring. But if we can somehow try to restore what we have destroyed, is it not time to preserve what already exists? Can't we render sustainable the benefits that these ecosystems have for individuals, societies, and all humanity—today and tomorrow?

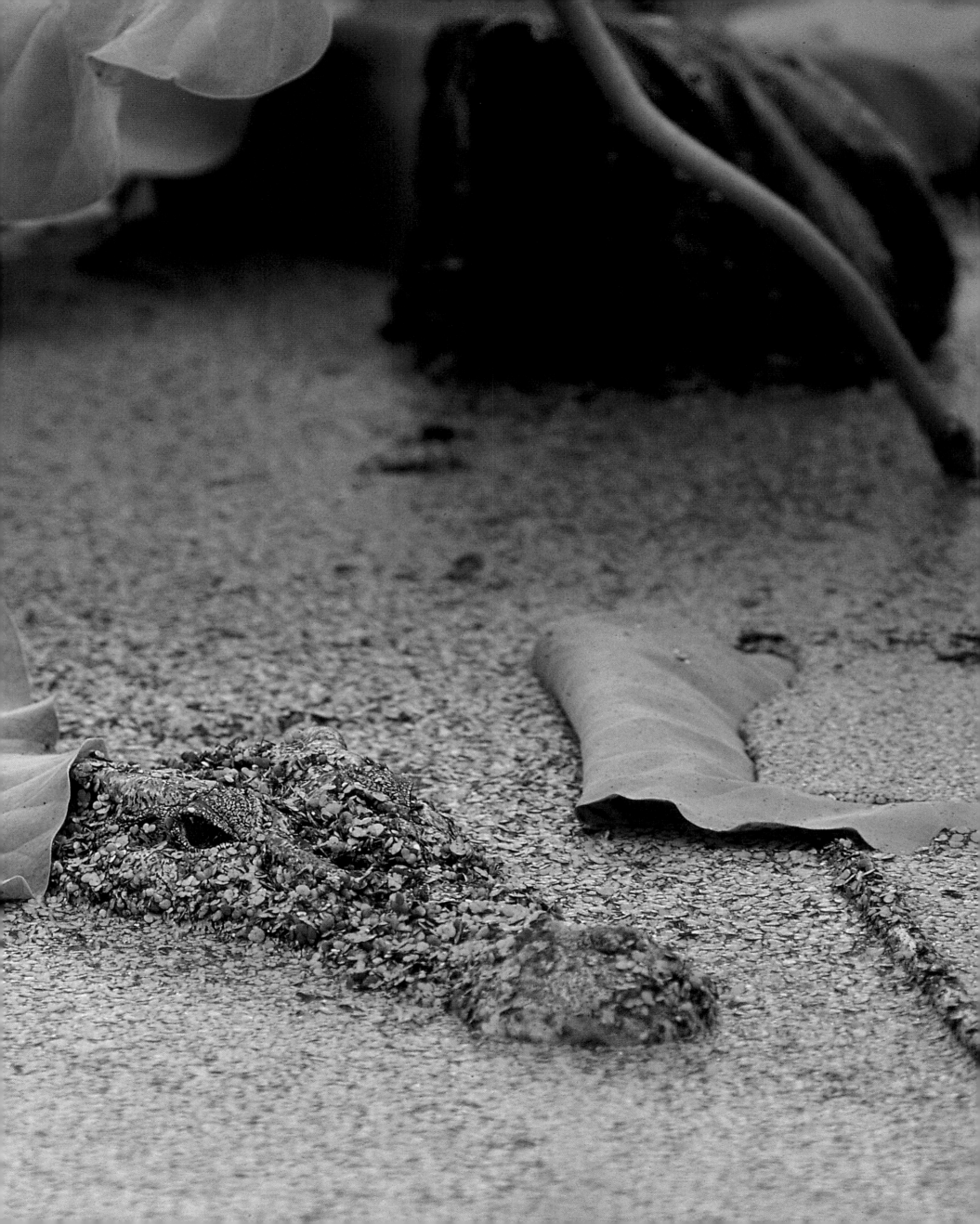

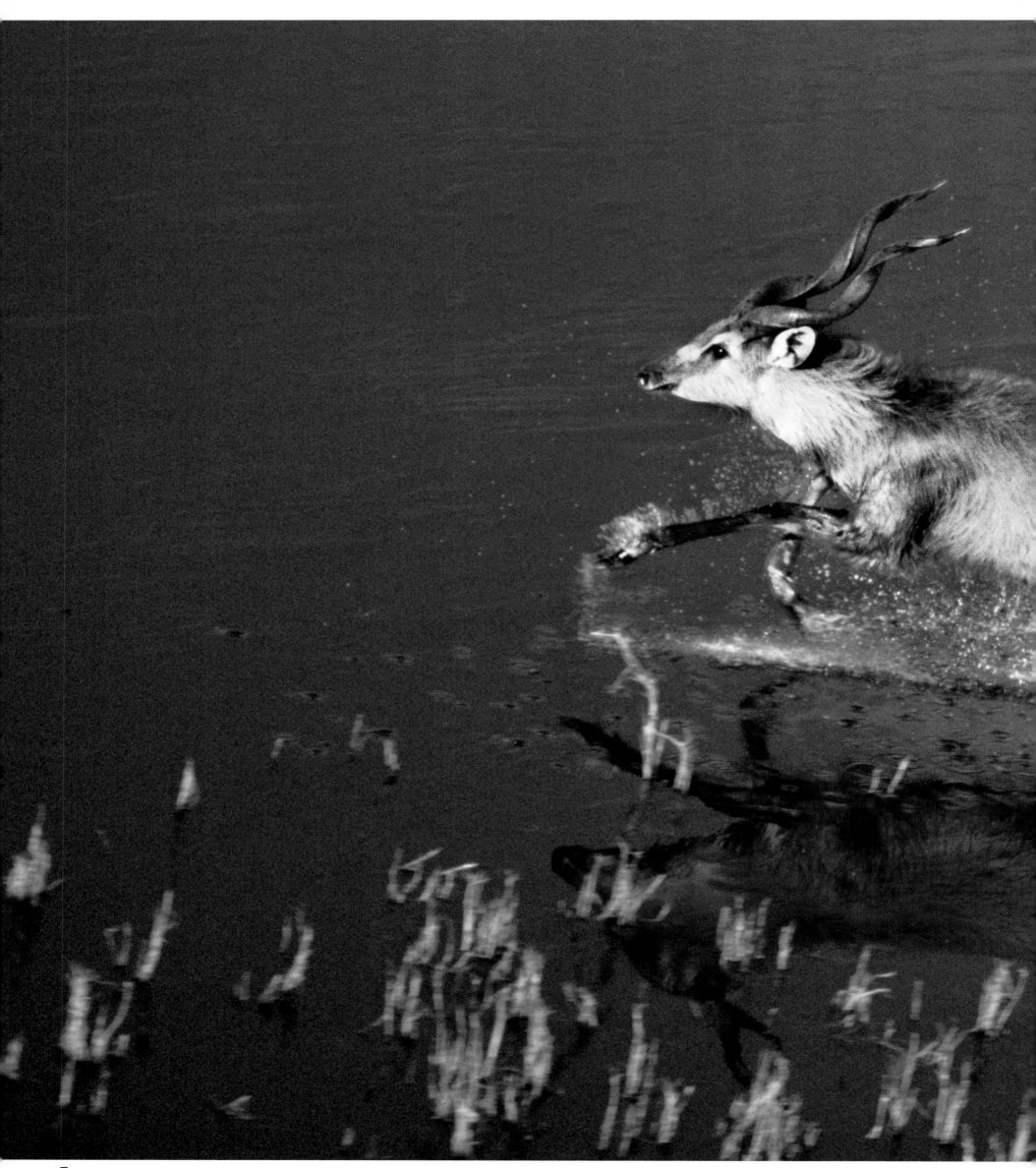

Above: The sitatunga (or marshbuck) is one of the few African antelopes that live in wetlands. It feeds chiefly on papyrus and reeds, sometimes completely submerging itself in its quest for water plants. It may do the same when pursued by a predator, leaving only its nostrils above the surface. Here is a male in the Okavango Delta.

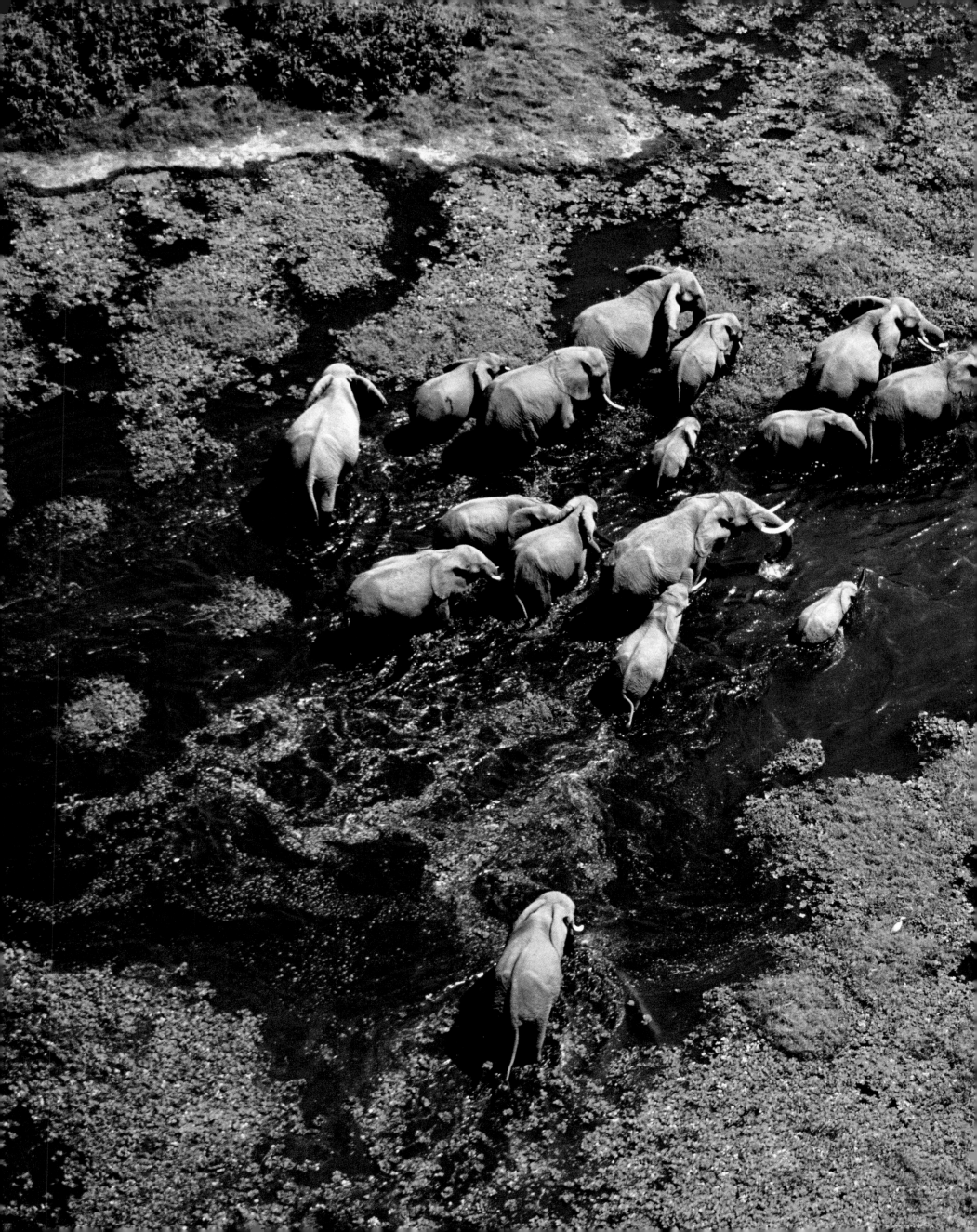

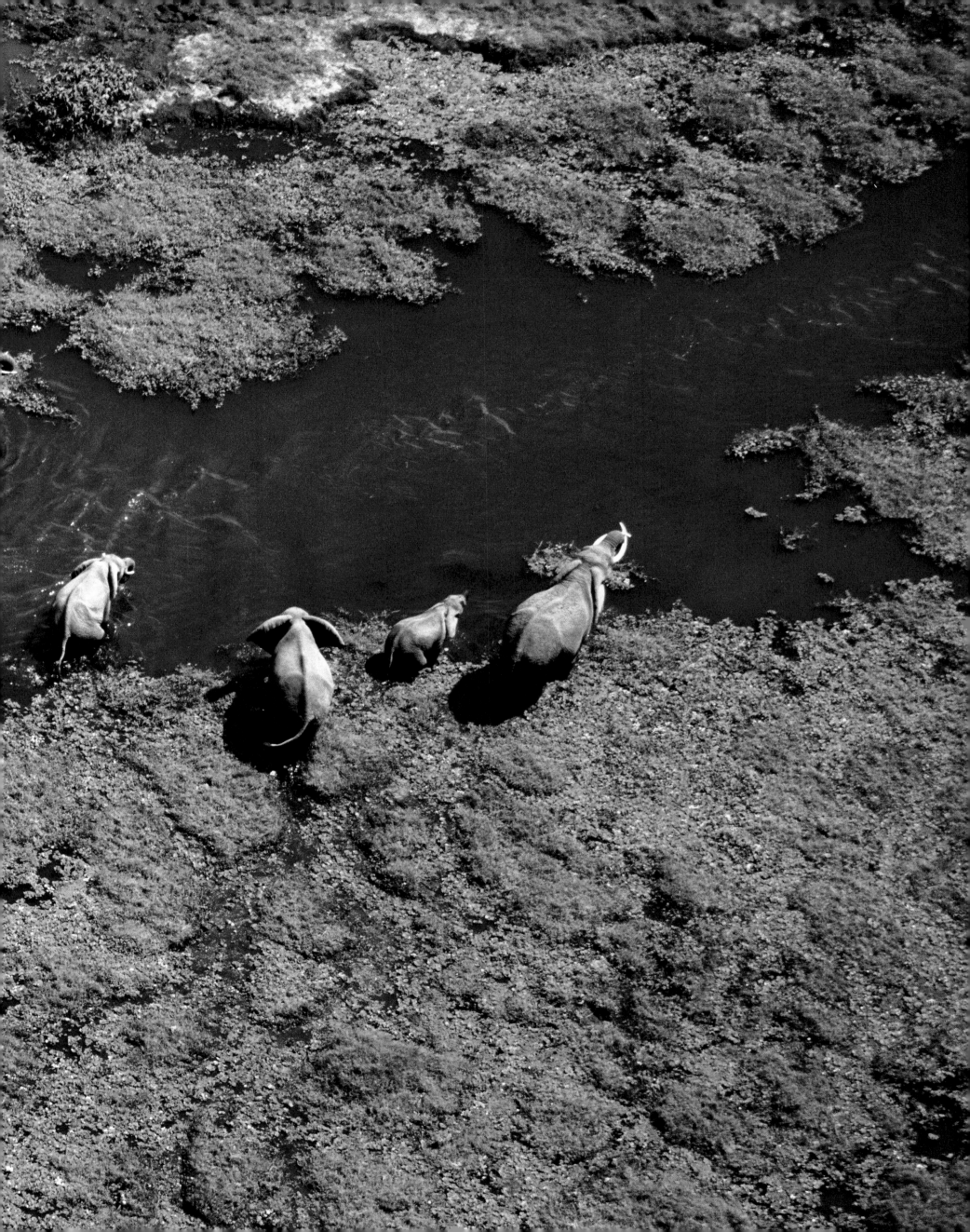

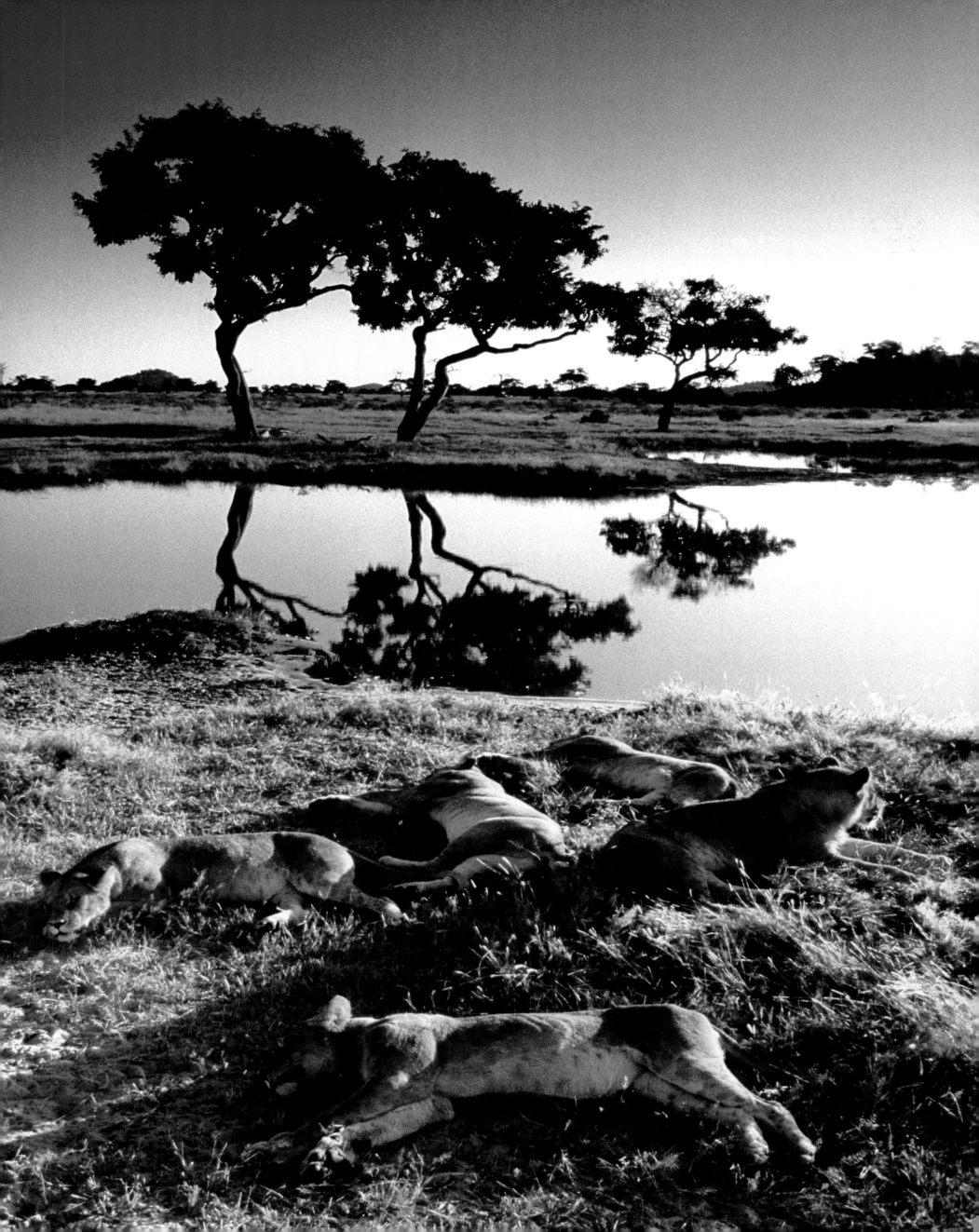

Preceding pages: In some regions of Africa, such as the Okavango, elephants live chiefly in wetland areas. This is in contrast with other African regions, where the species frequents mostly dry savannah. Nevertheless, elephants may still travel long distances in search of a watering hole. The versatile African elephant finds abundant food in the marshes, a task that might not occur in East Africa.

Left: Contrary to popular belief, lions are not very numerous in Africa. Their numbers have been depleted locally, and epidemics have almost wiped them out in parts of East Africa. These epidemics are due in part to large tourist populations in certain wildlife parks; tourists transmit diseases. The western subspecies of the African lion—the male of which has no mane—is doing especially badly. Fewer than about 1,000 are thought to survive.

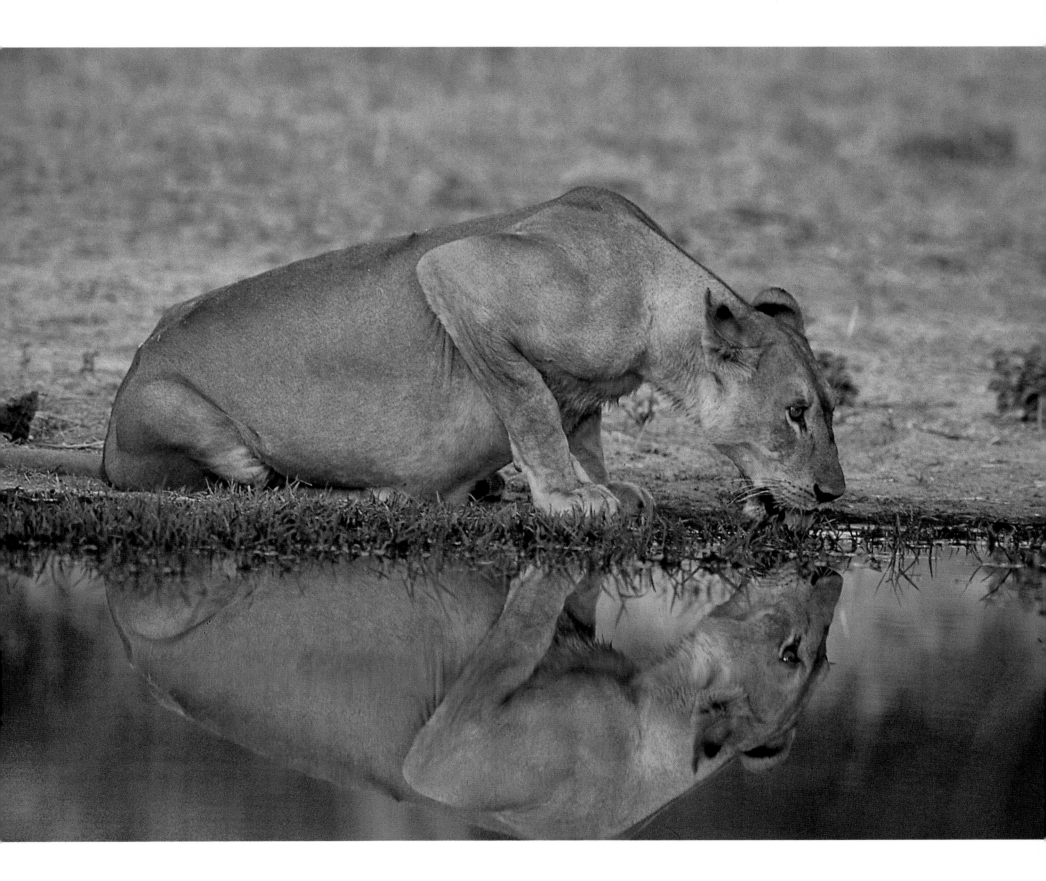

Above: In the Okavango Delta, it appears as if all the wildlife traditionally associated with the African savannah has moved en masse. Even the lions have followed their aquatic prey and frequent the fringe of the marsh.

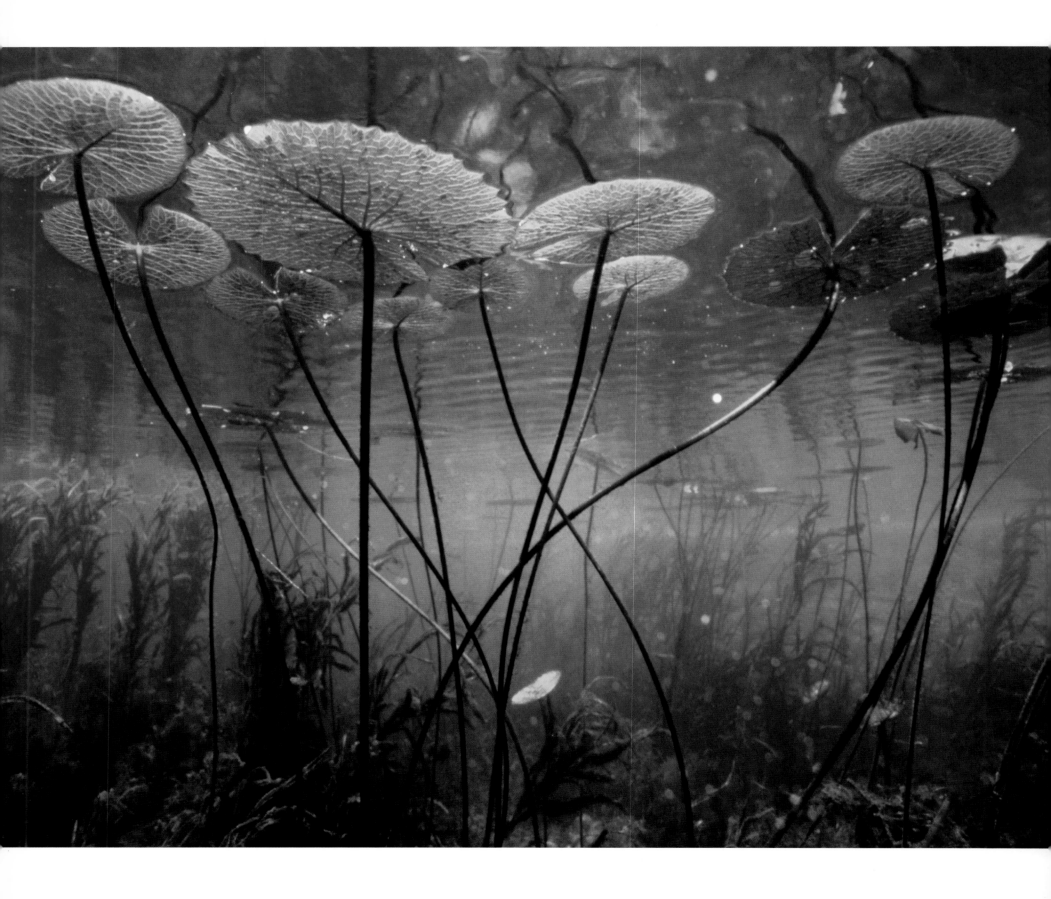

Water plants play an essential role in the interaction between aerial and aquatic habitats. This vegetation interface is involved primarily in the exchange of gases necessary to maintain life—such as these water lilies in the Okavango Delta, Botswana. The introduction of invasive species, which is increasingly common, can severely destabilize such ecological balances.

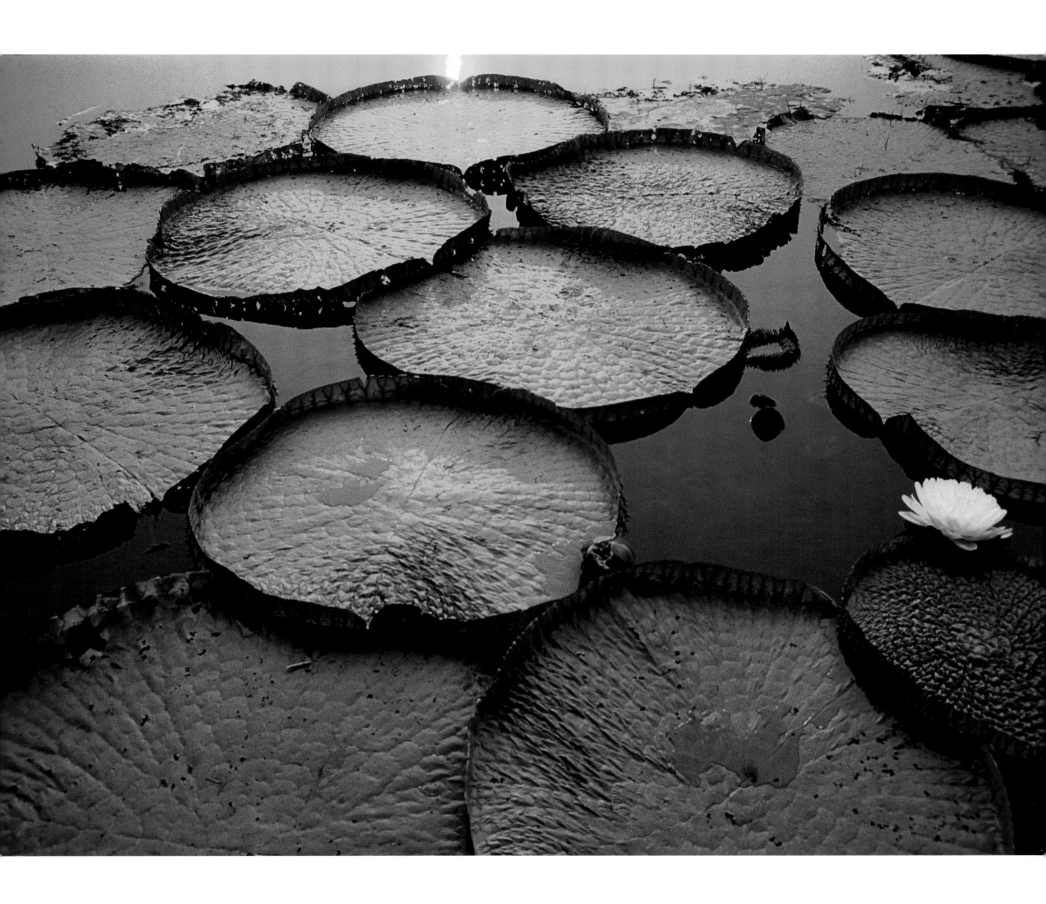

The giant water lilies of the Pantanal in Brazil are as large as tea trays. They can bear the weight of water birds, which make them useful when stalking prey in the ponds and marshes of this region.

Above: Wetlands have a bad reputation, no doubt because they are home to insects that carry serious diseases, such as this mosquito, on a water lily in Guyana. During the 17th and 18th centuries, extensive marsh drainage was undertaken in many places in Europe to eradicate malaria.

Following pages: In spring, male green frogs sing their hearts out in the ponds and marshes of temperate Europe. Swelling their vocal sacs, they croak in unison to attract females. The depletion of aquatic environments that has continued uninterrupted since the beginning of the 20th century has led to a sharp drop in the numbers of amphibians all over the world. They also face an increasing number of diseases caused by viruses, parasites, and fungi.

Left: They look like single-cell organisms photographed under an electron microscope. The truth is rather different, however. They are hippopotamuses, gathered together to take a mud bath in the Rwindi National Reserve in the Democratic Republic of the Congo. Not only does this bath protect them from the fierce sun, it also protects them from parasites, flies, and other biting insects.

Above: The Congo basin is still home to healthy populations of hippopotamuses—animals extremely partial to mud baths. Although like species is doing well throughout its range, the same cannot be said of its close cousin, the pygmy hippopotamus of West Africa, whose numbers have fallen sharply in recent decades. This species, which tends to be more forest-dwelling, lives primarily in Liberia. A fierce civil war there has affected wildlife.

Above: Ingenuity has allowed humans to produce staple foods in the most improbable places. In China, growing rice in terraces allows the production of a cereal that demands large quantities of water. It's grown in a mountain environment where access is difficult.

Following pages: Water in all its splendor! Pictured is a waterfall near Paro Taksang, Bhutan. Between its source and the sea, the river crosses and waters a great variety of habitats. Water is the starting point for animal and plant life, and human life as well. As we face uncertainty over tomorrow's climate, our planet's surface water should be increasingly protected—at least as much as our natural environments.

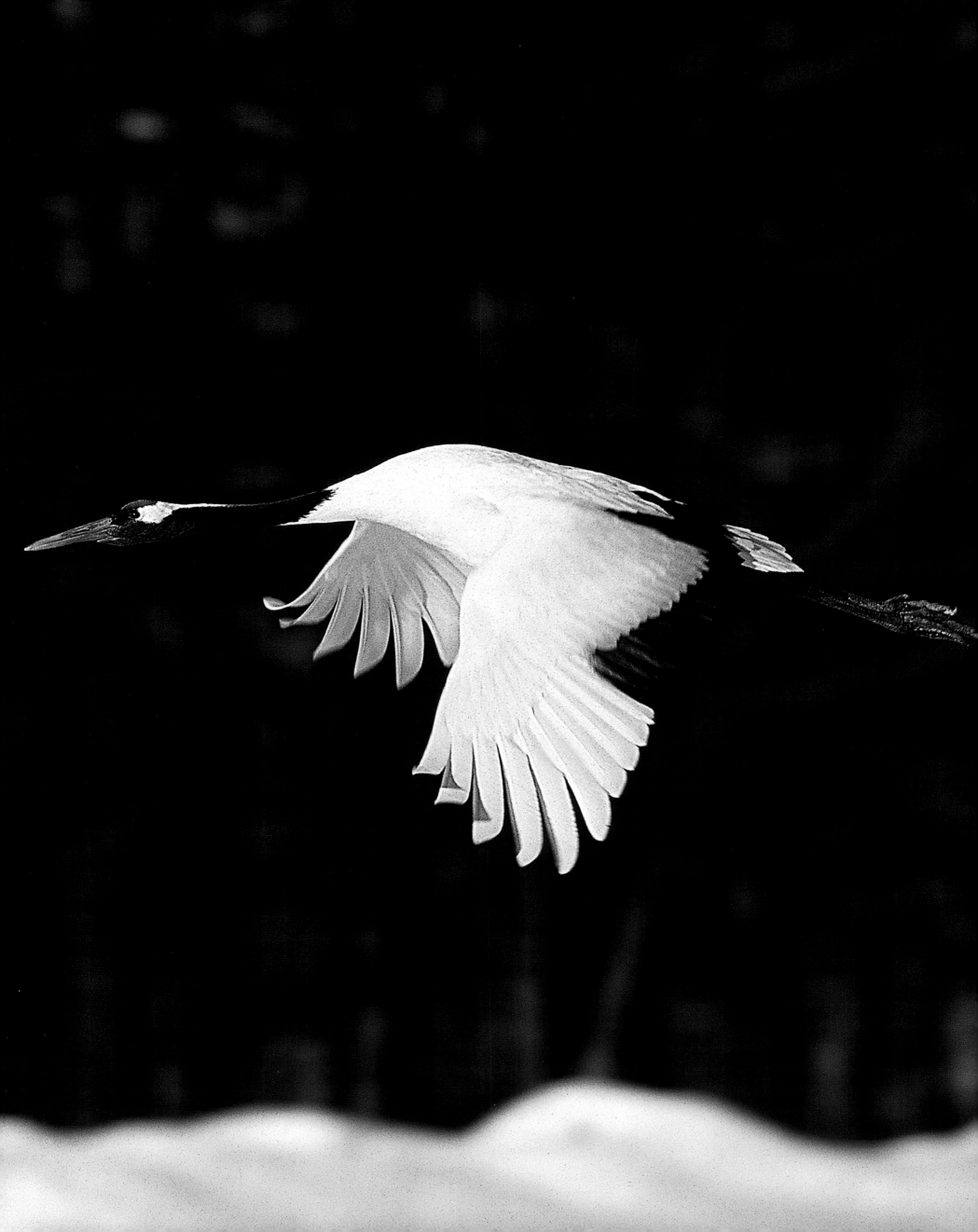

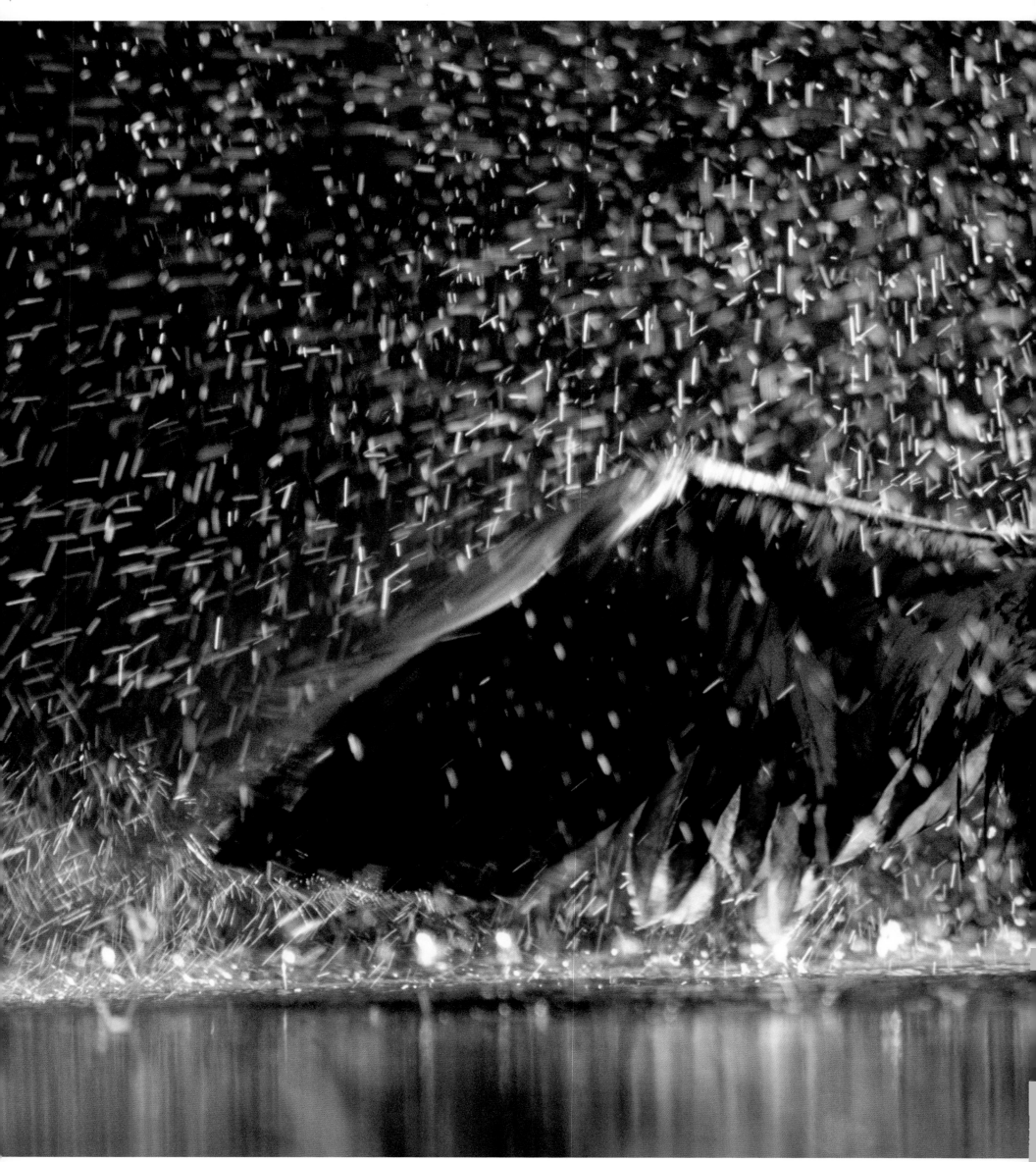

Preceding pages: Each winter the island of Hokkaido, in northern Japan, is visited by thousands of cranes belonging to several species, most of them from China and eastern Siberia. The Japanese crane is certainly the most remarkable of these, and its mating display is one of the most beautiful sights in the bird world.

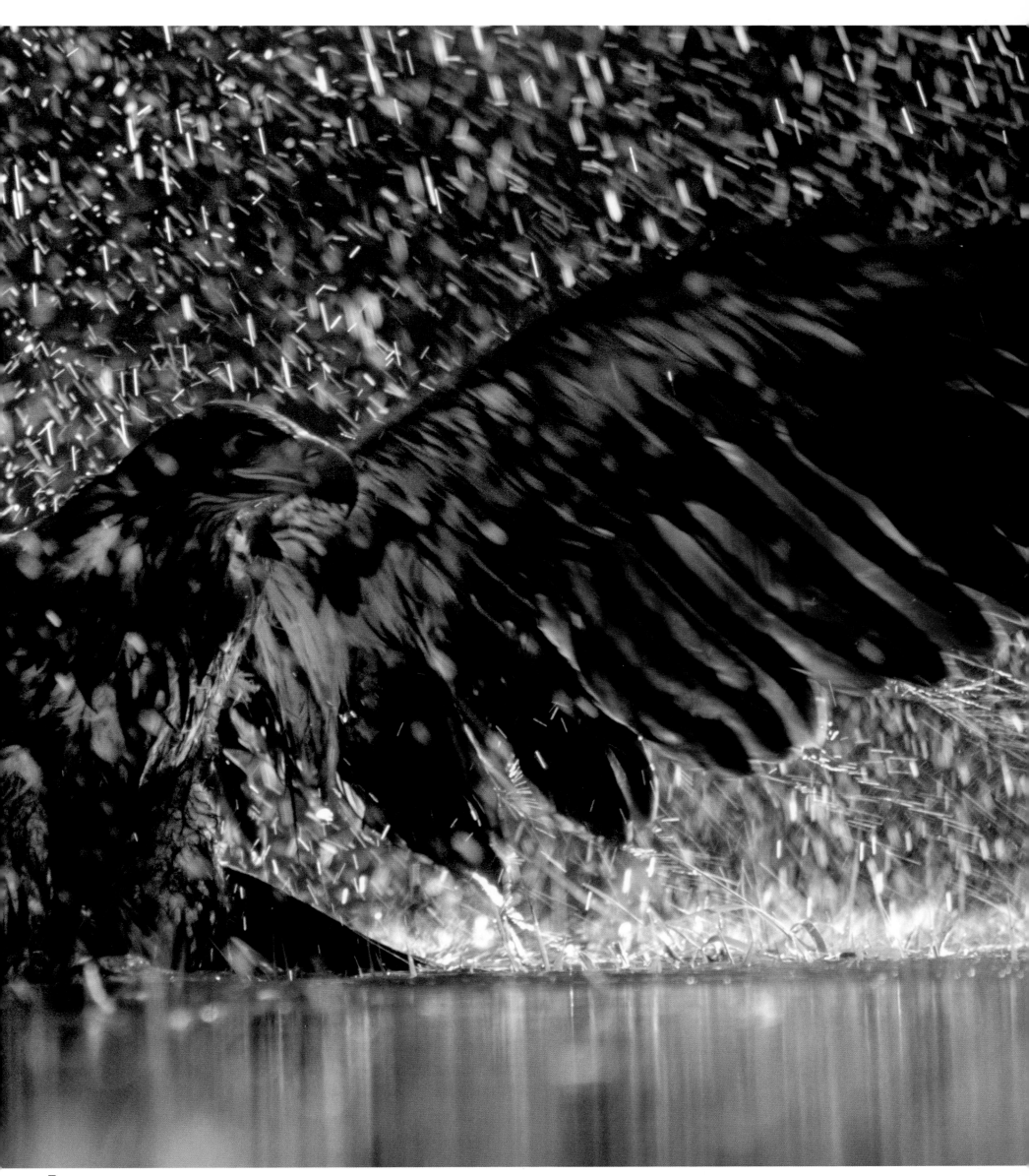

Above: The bald eagle, the emblem of the United States, was very nearly wiped out. It was persecuted for a long time, but the worst damage was done by the use of pesticides such as DDT. Since the late 1960s, when American authorities became aware that the species was close to extinction, effective protection measures have been taken. Today, the bald eagle has recovered and is no longer threatened. This young bird is taking a winter bath in a marsh in British Columbia.

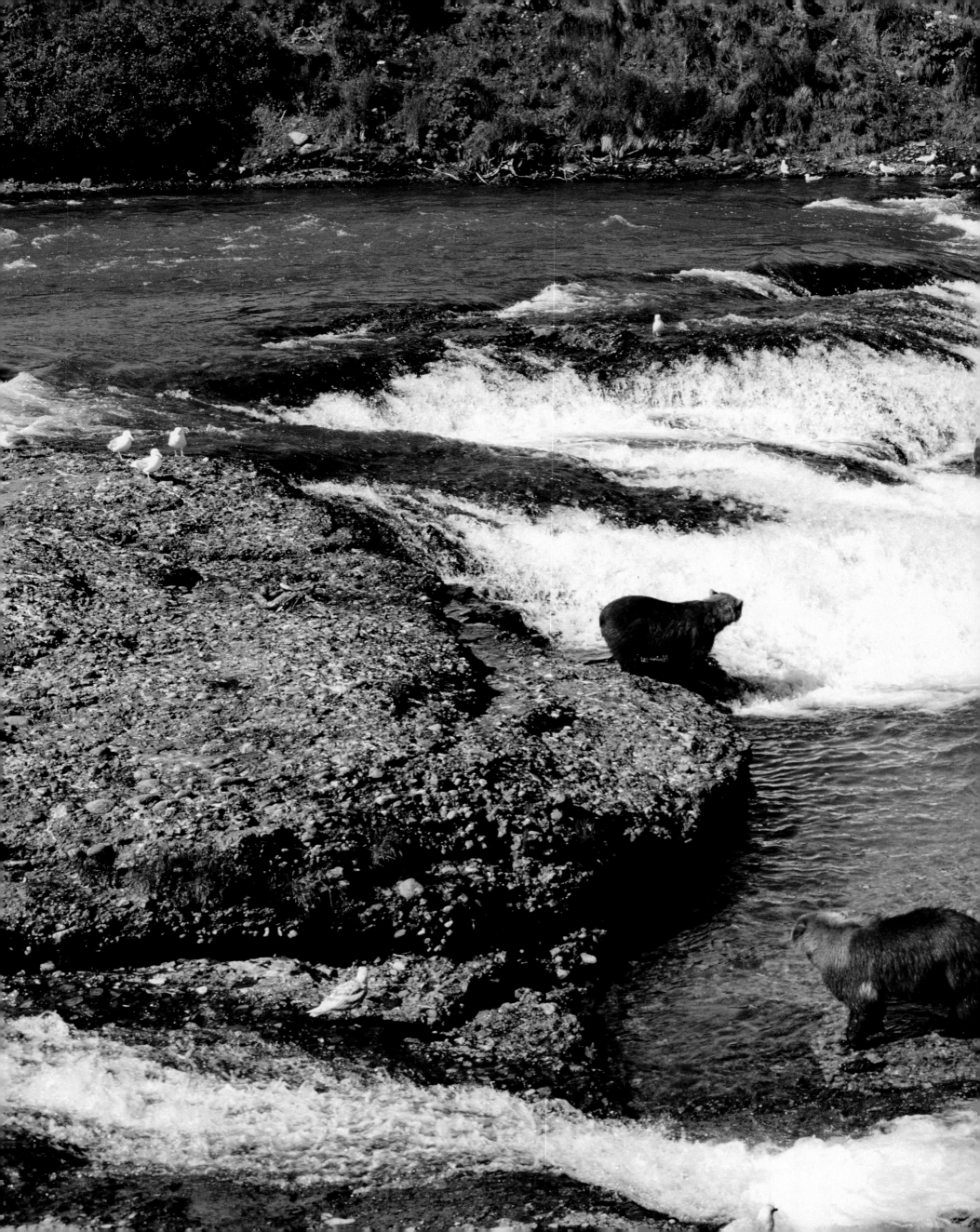

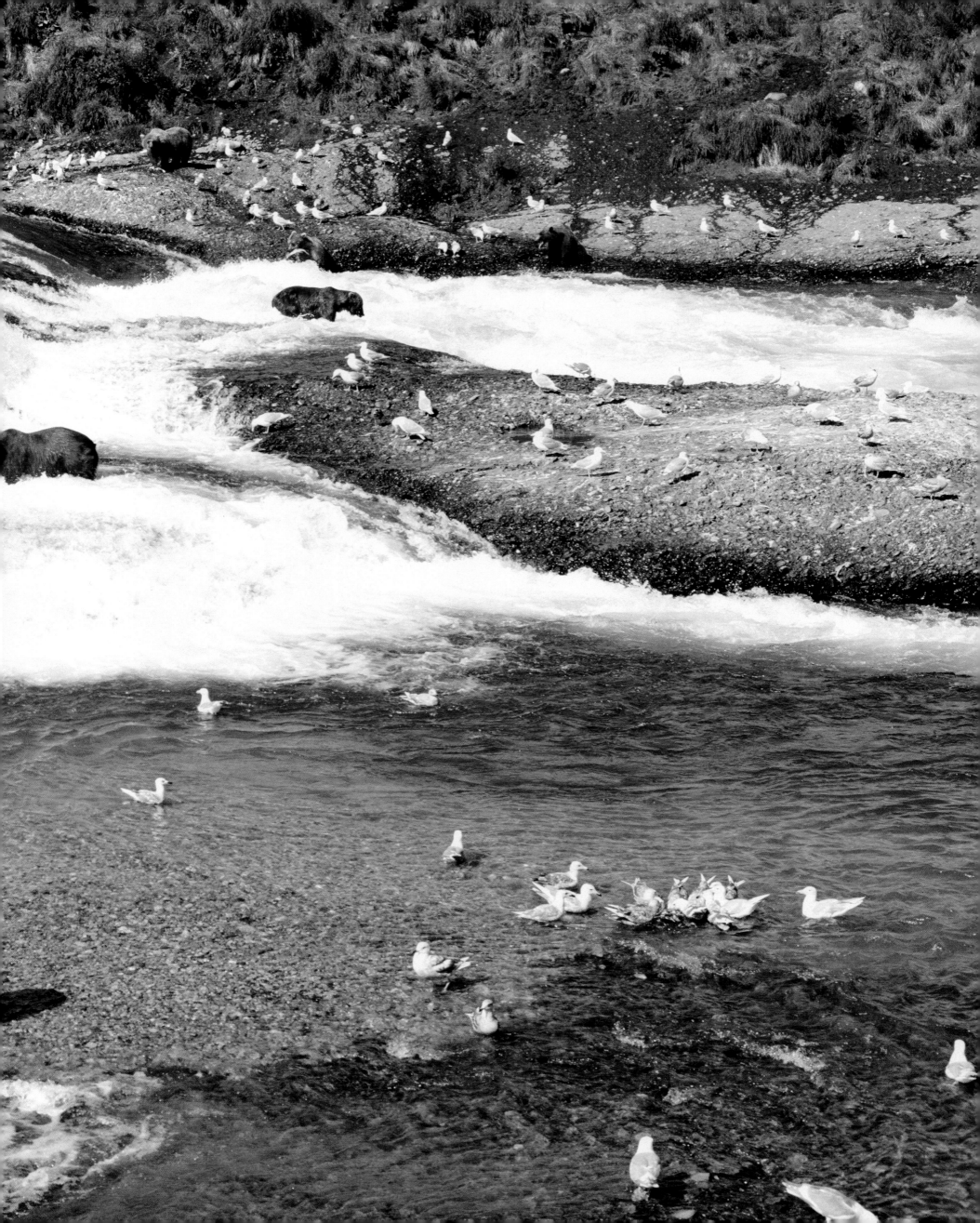

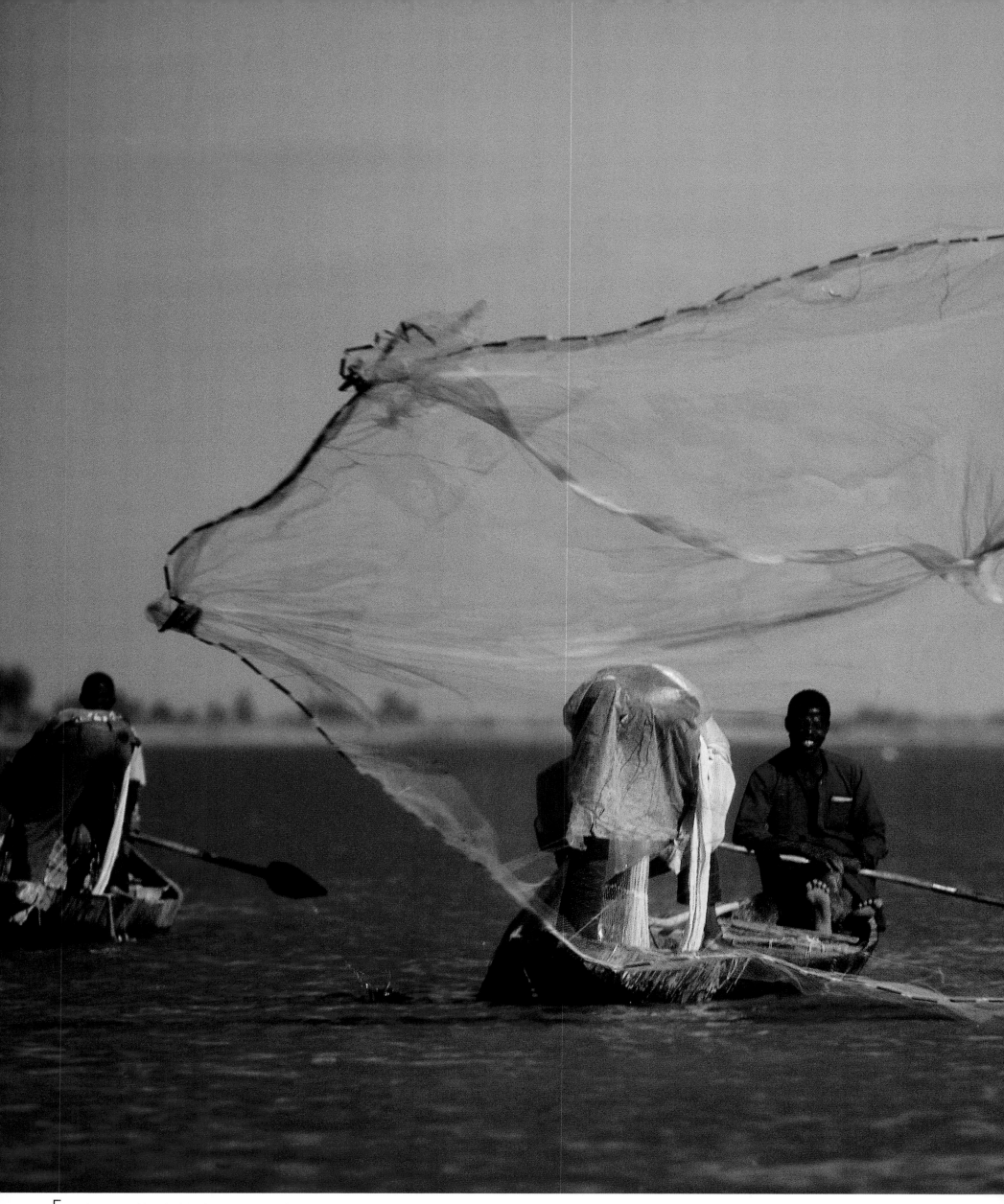

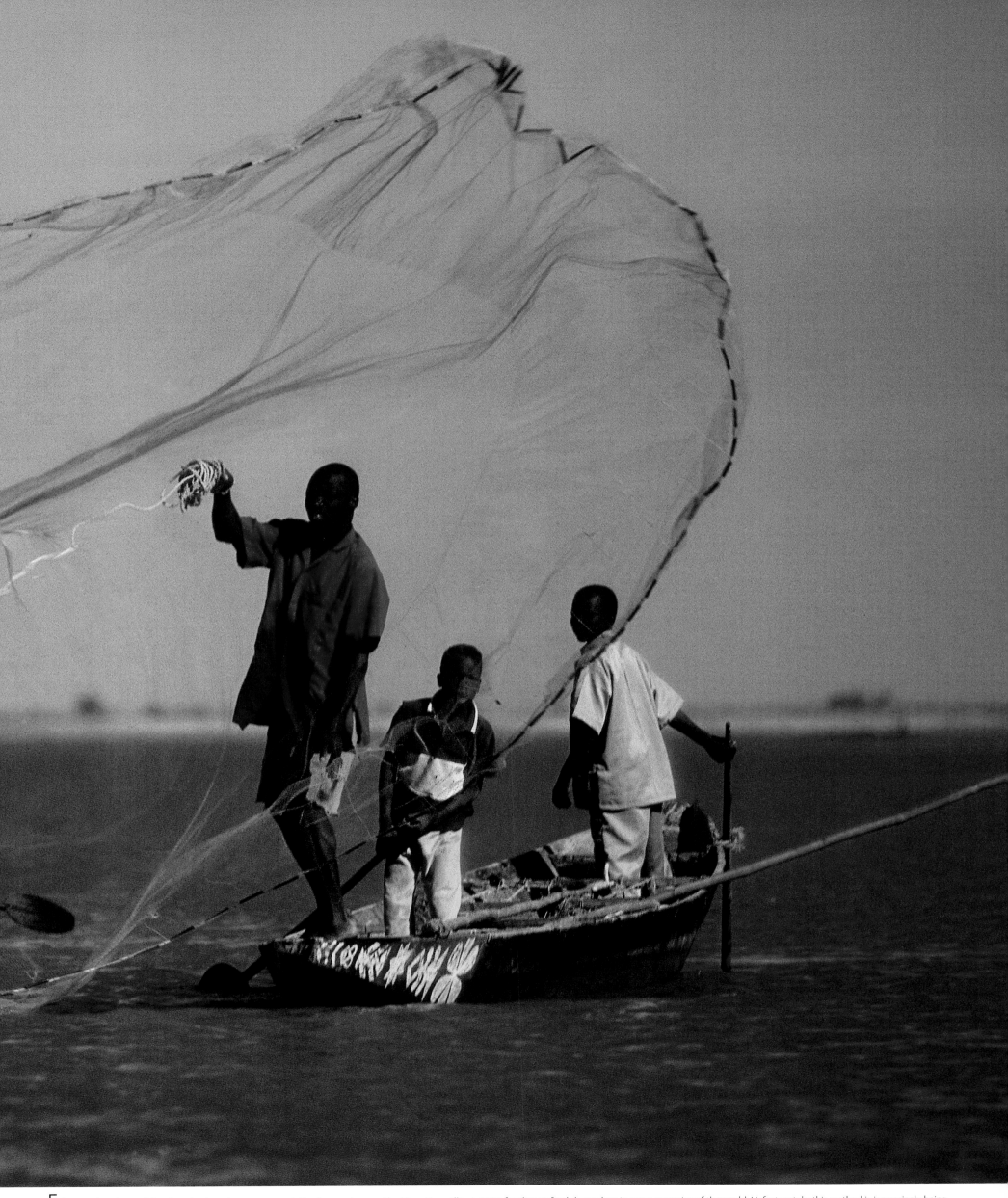

Above: Fishing by traditional methods such as a sweep net, like the one here on the Niger River, allows entire families to feed themselves in many countries of the world. Unfortunately, this method is increasingly being replaced by industrial, intensive fishing, which leads to the complete destruction of some fish species. Moreover, in other continents such as Asia and South America, these "modern" methods, which are less selective, have contributed to the decline in the numbers of river dolphins over the last few decades. These dolphins get tangled in large nets meant for other fish. All these species of freshwater dolphin face extinction.

Climatologists believe that the climate changes now under way as a result of increasing levels of greenhouse gases in the atmosphere could lead to more frequent extreme weather events such as storms, droughts, and floods. France and other European countries have suffered severe floods since the beginning of the 21st century. For example, pictured here is the spring 2001 flood in Picardy and the November 2002 flood in Camargue.

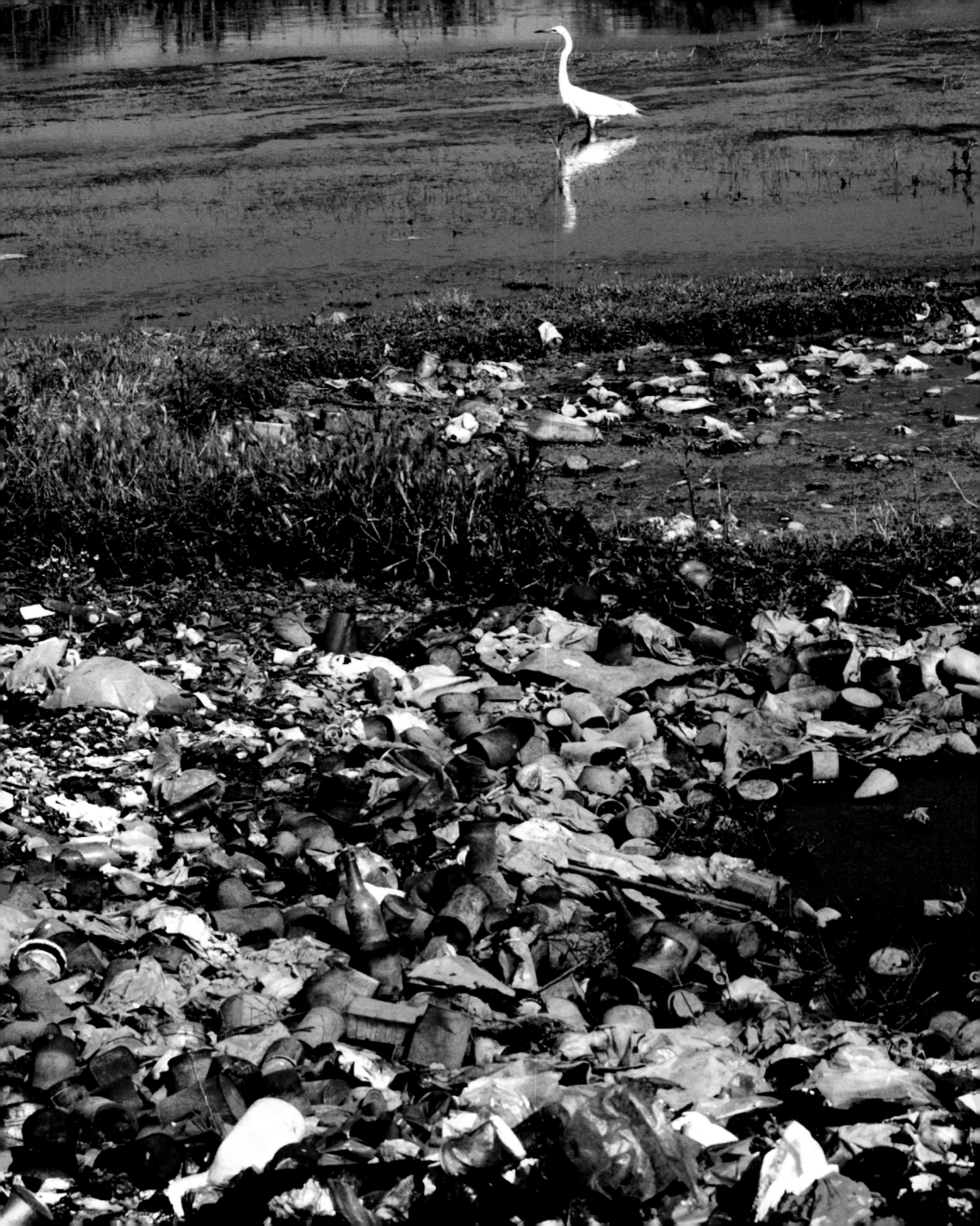

Left: A stone's throw from an open-air garbage dump in Romania's Danube River delta, this egret appears unconcerned as it hunts for fish. However, such insidious pollution, which takes many forms, seriously disturbs the water cycle and contaminates supplies. Here it is all the more regrettable because this is the heart of a national park.

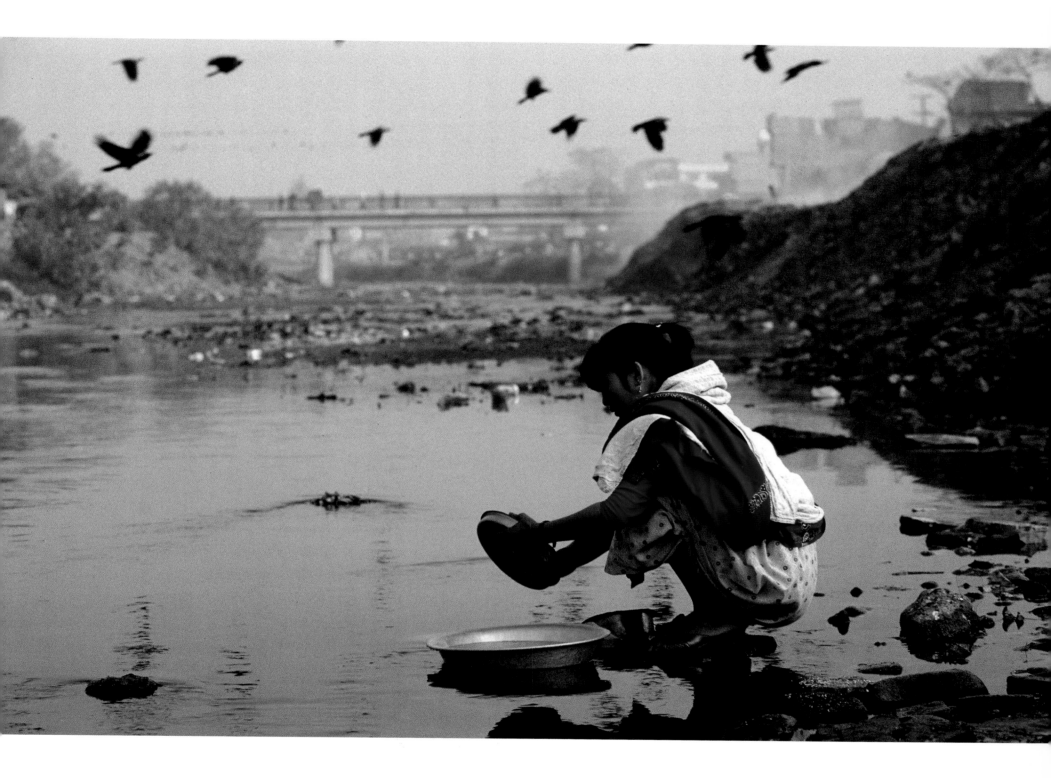

Above: Water is unquestionably one of the biggest environmental challenges of the 21st century, and soon we will have to face it. The issue will not just be whether it is plentiful or drinkable, but whether it is even accessible. Abundant clean water is, and threatens to remain, an unlikely prospect for several billion people on this planet. Here, a woman washes her dishes in a polluted river in Nepal.

Preceding pages: Dam building to generate hydroelectric power considerably alters the conditions in the rivers involved. Sometimes, during the construction process, lands are permanently flooded due to raised water levels. Recently, the building of the world's biggest dam, the Three Gorges Dam on China's Yangtze River, provoked heated international debate. More than 100 towns and villages will be flooded out, and an estimated 1.2 million to 2 million people will need to be relocated. The Chinese government claims that the dam will avoid destruction from future floods. Experts, on the other hand, have pointed out that other similarly sized projects, such as the Aswan Dam in Egypt, have partly failed. All dam building affects biodiversity.

Above: It is said the Loire River cannot be tamed. Like many "untamed" rivers, it is unpredictable. Late spring floods can suddenly submerge its sandy islets, where colonies of birds nest, causing the loss of their eggs and chicks. The river is not navigable everywhere and, during severe droughts, it can sometimes be crossed on foot. It is also dangerous to swim in, due to strong and unpredictable currents.

Right: It is well known that winter floods are a regular occurrence, notably in the lower valleys of the Anjou region. What varies from year to year, however, is the extent of these climatic phenomena. The invasion of plant habitats by water has, over time, allowed a remarkable and diverse flora to become established. In spring, migratory birds including ducks and small waders, such as godwits and lapwings, find the food they need in these flooded meadows to complete their northward return journey.

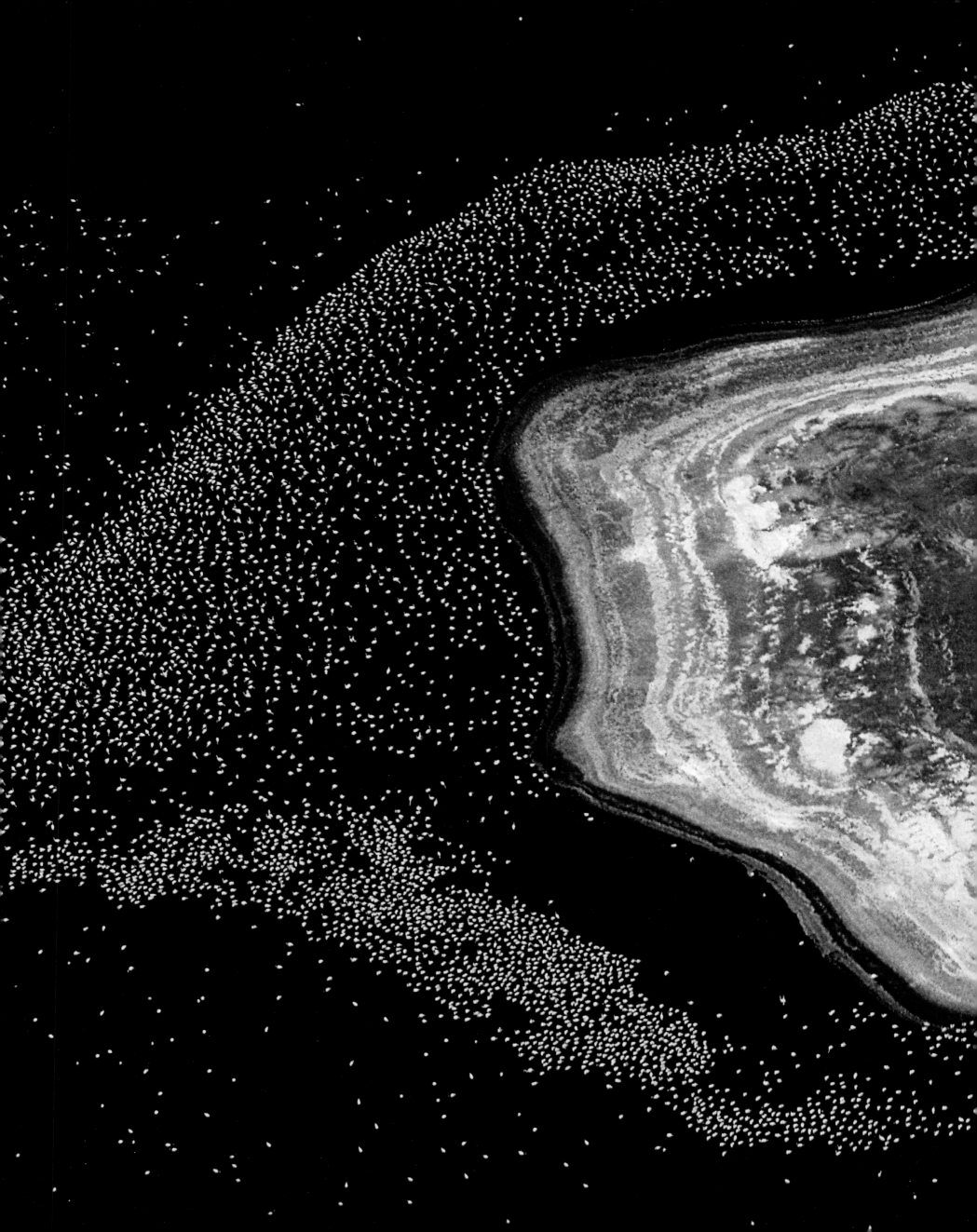

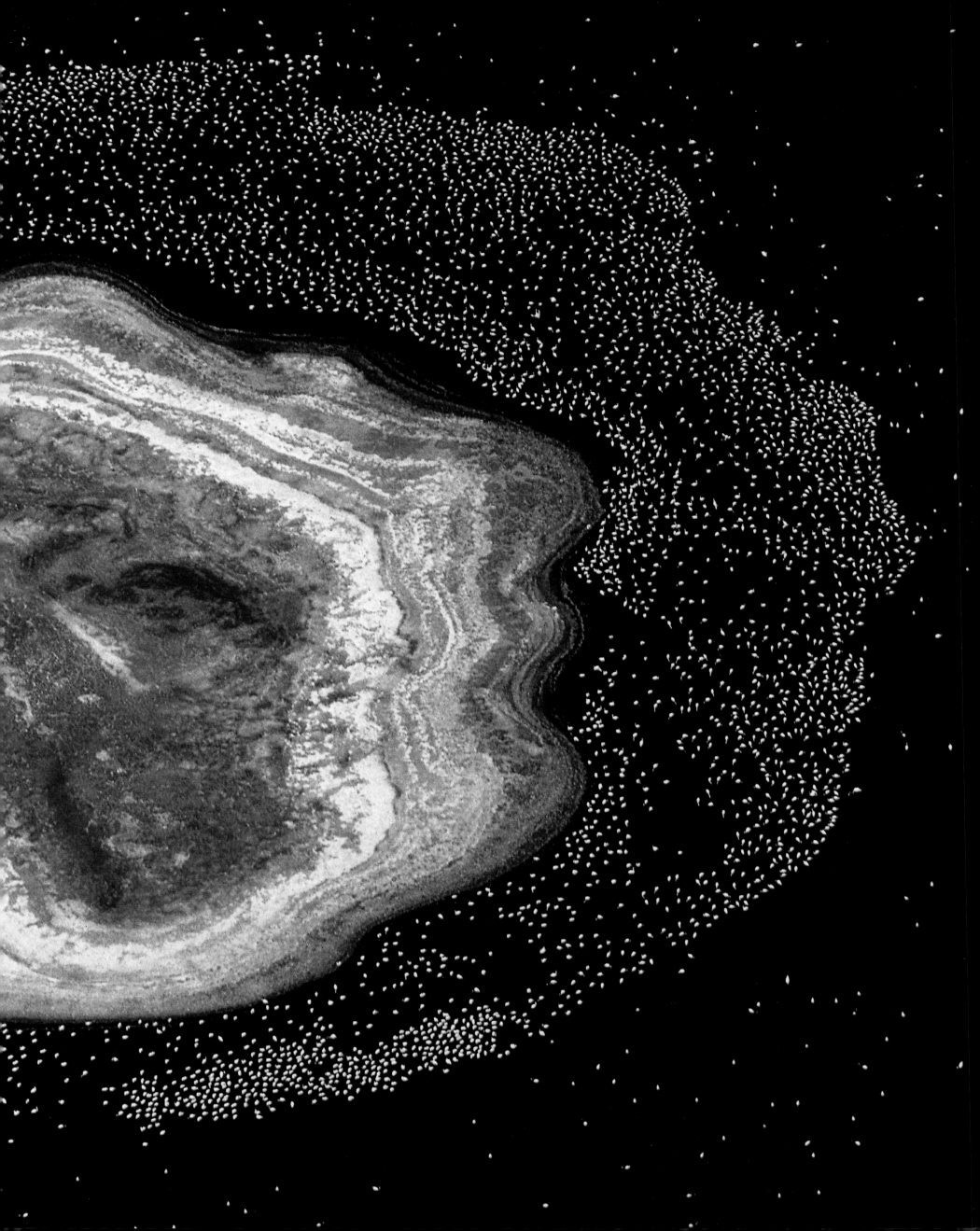

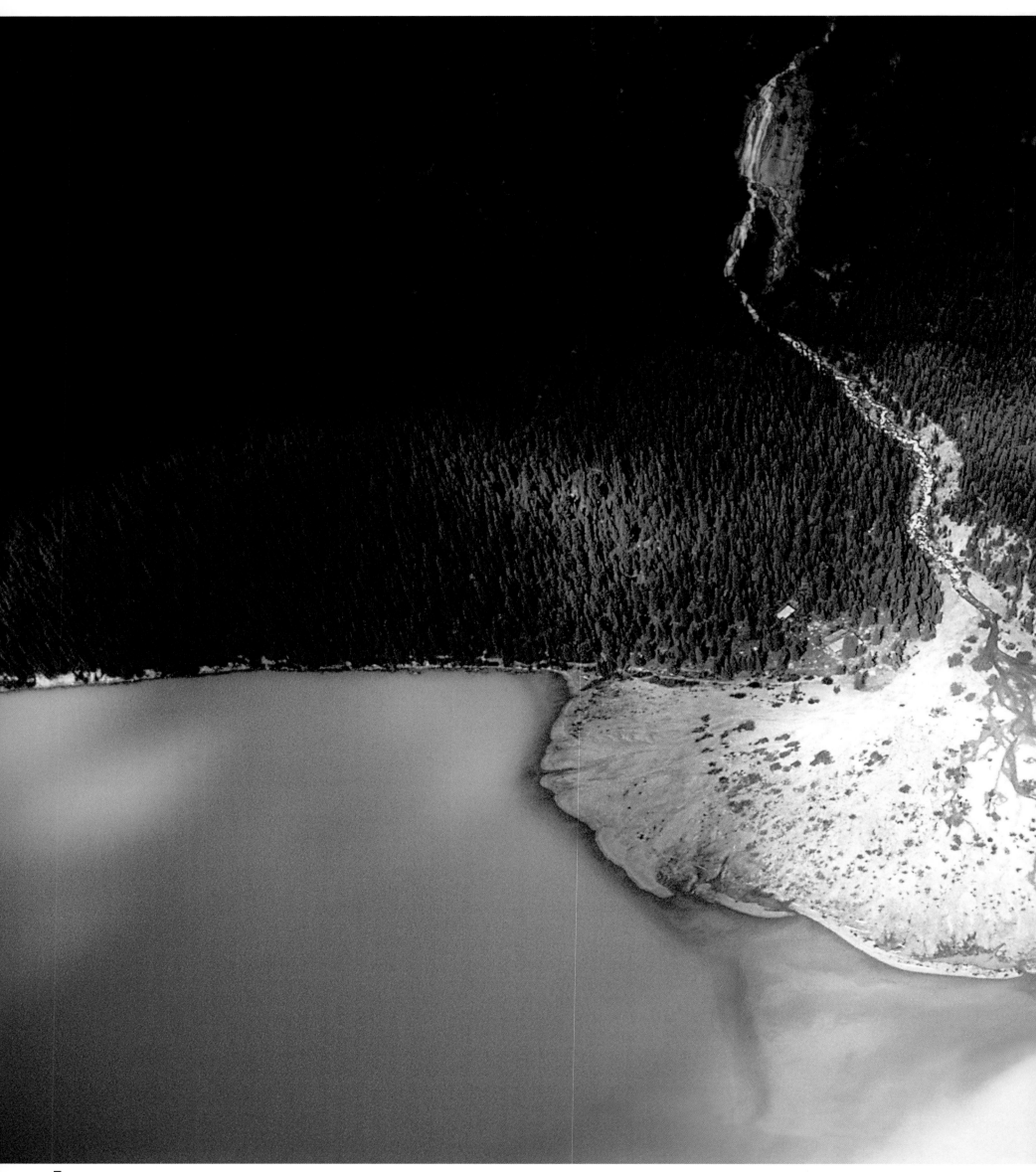

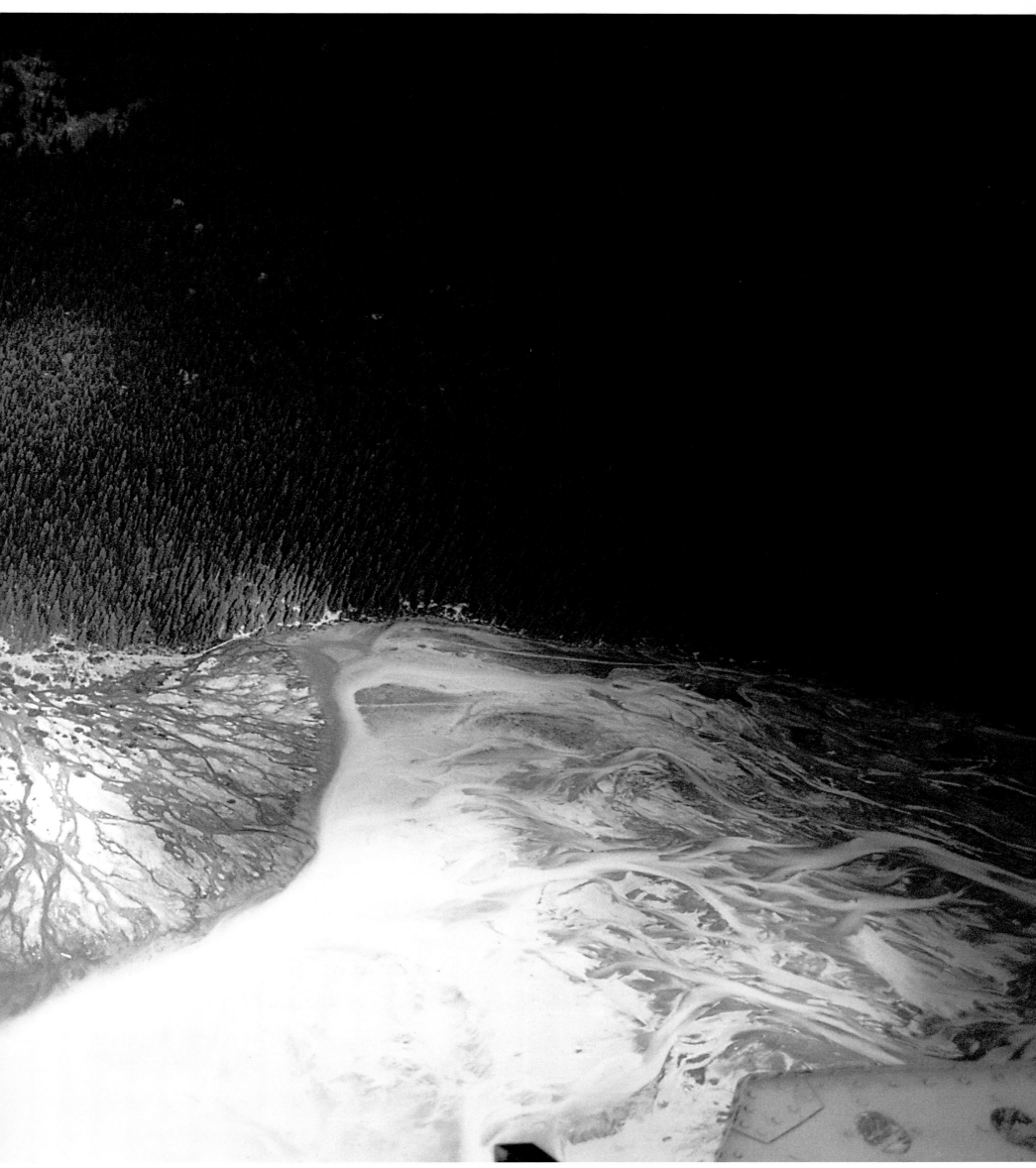

Above: This glacial stream empties into a great lake in Alberta, Canada, and forms a sort of fan at its mouth. It consists of alluvial deposits that the little river has carried from its source. Such mineral and organic material is extremely important: in a sense, it "feeds" the lake into which it is poured. This example clearly illustrates the role water plays in transporting organic material, which is necessary for life.

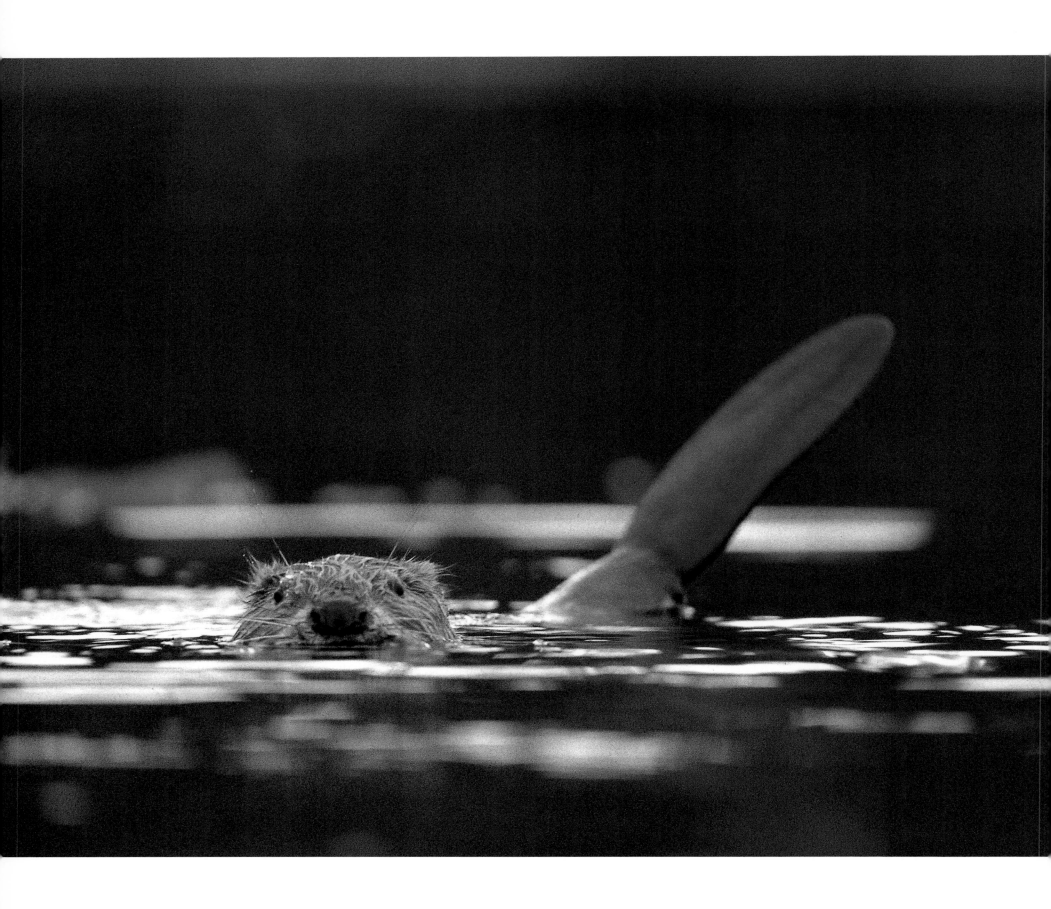

As the sun sets over the river, a beaver emerges from its lodge in search of food. In France, beavers narrowly escaped being wiped out. They were the victims of human destruction, both direct (hunting) and indirect (river management). Conservation organizations worked to bring back beavers, and today they are once again found on some of the country's rivers and streams. Unlike its American cousin, the European beaver is nocturnal.

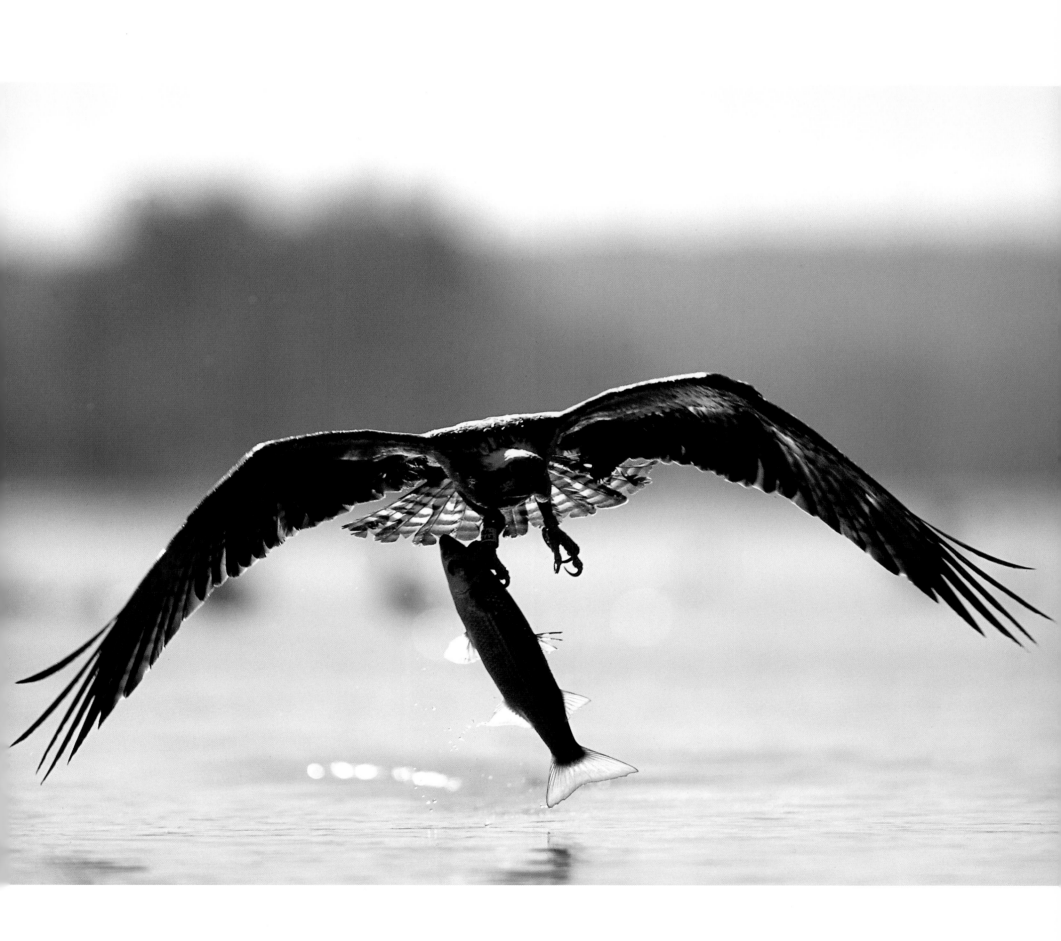

Laden with a good-sized prey, an osprey heads back to its nest, where it is rearing two young. This fish-eating bird almost disappeared from Europe during the 1960s, a victim, like other raptors, of pesticides. Today, thanks to increased protection, its numbers have increased considerably. While previously it had only nested in Corsica, it has now established itself in the center of France.

Right: The shoebill, which according to some authorities is closely related to storks, lives in the remotest papyrus marshes of central and eastern Africa. The species is believed to number between 10,000 and 15,000.

246

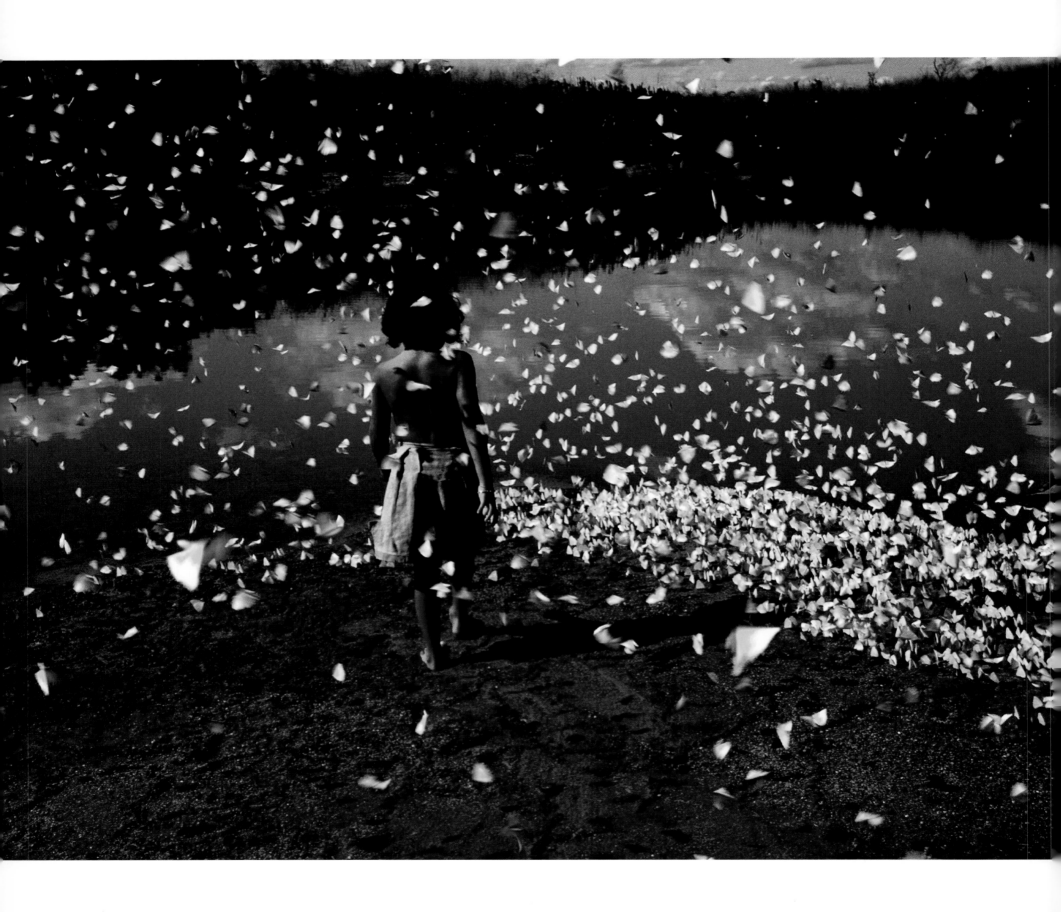

Above: In an instant, the smallest body of water—the tiniest pool—may become an incredible place, teeming with life. Here in the Amazon basin, thousands of butterflies come to quench their thirst.

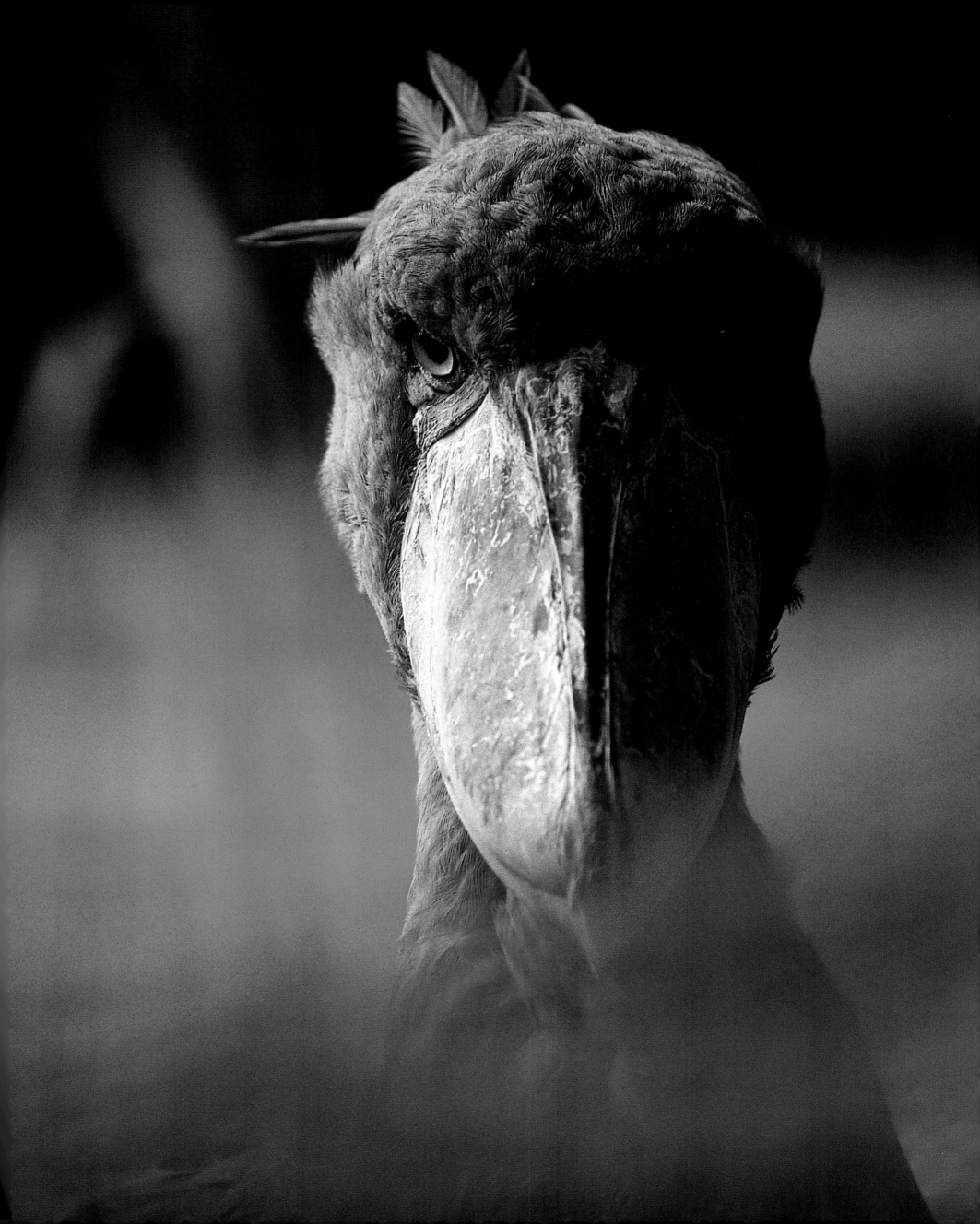

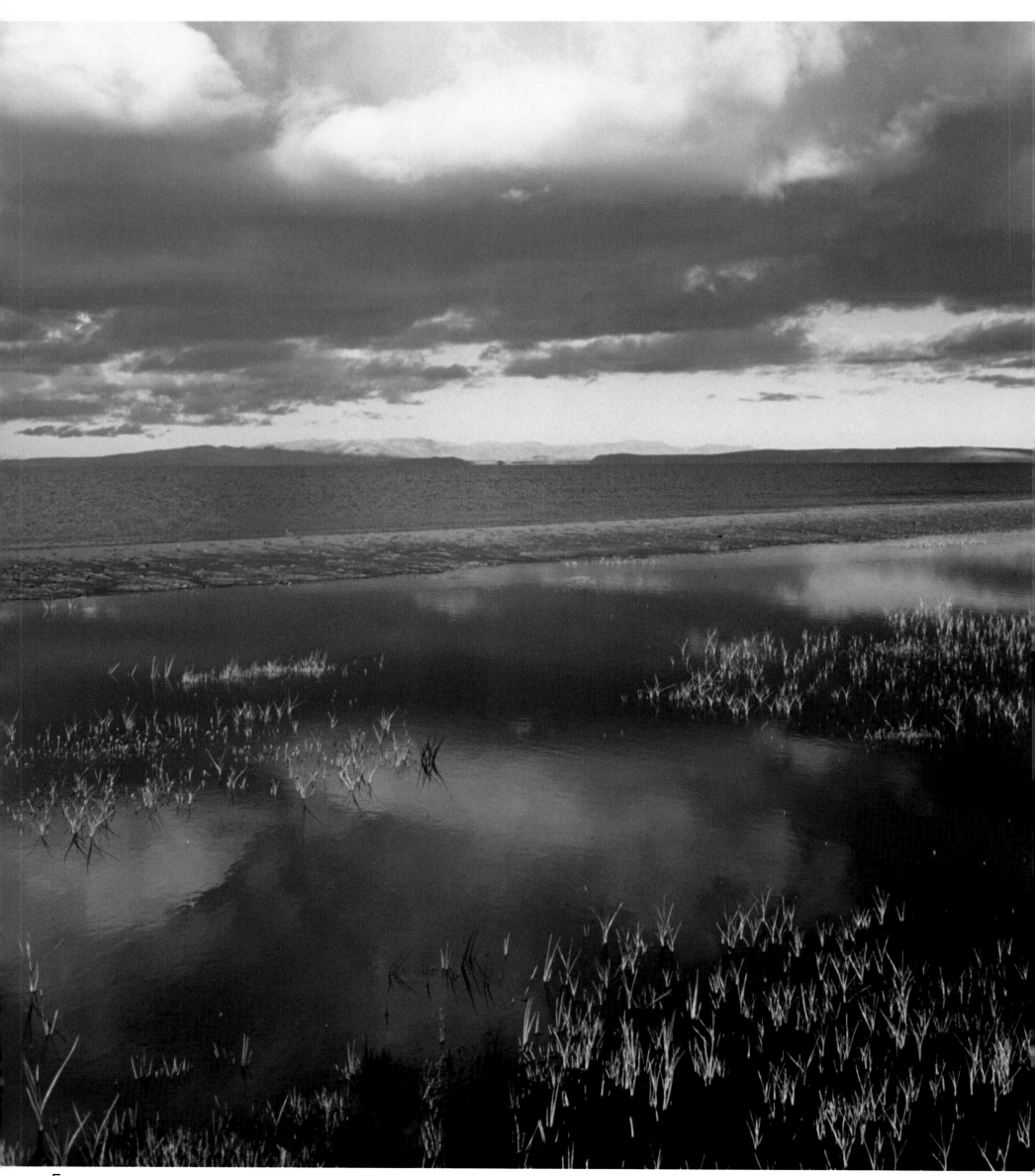

Above: Situated at an altitude of 15,000 feet, Lake Manasovar in western Tibet is the world's highest freshwater lake. Other glacial lakes in the Himalayas are swelling as glaciers melt faster. There is a risk that they might burst their banks, causing disastrous floods downstream.

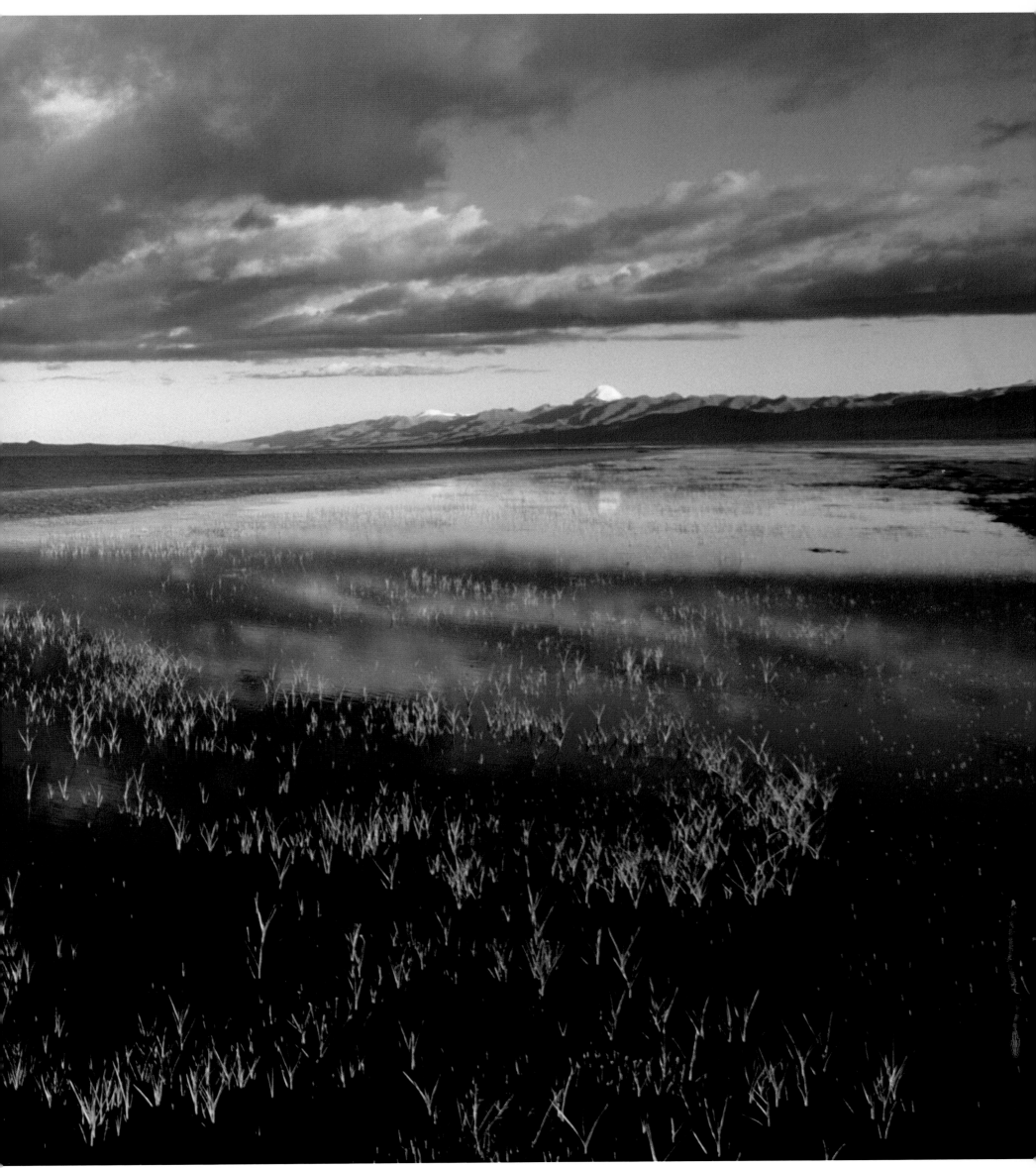

Following pages: Seen from the air, the waters of this river take on a strange color due to mineral salts from nearby volcanoes.

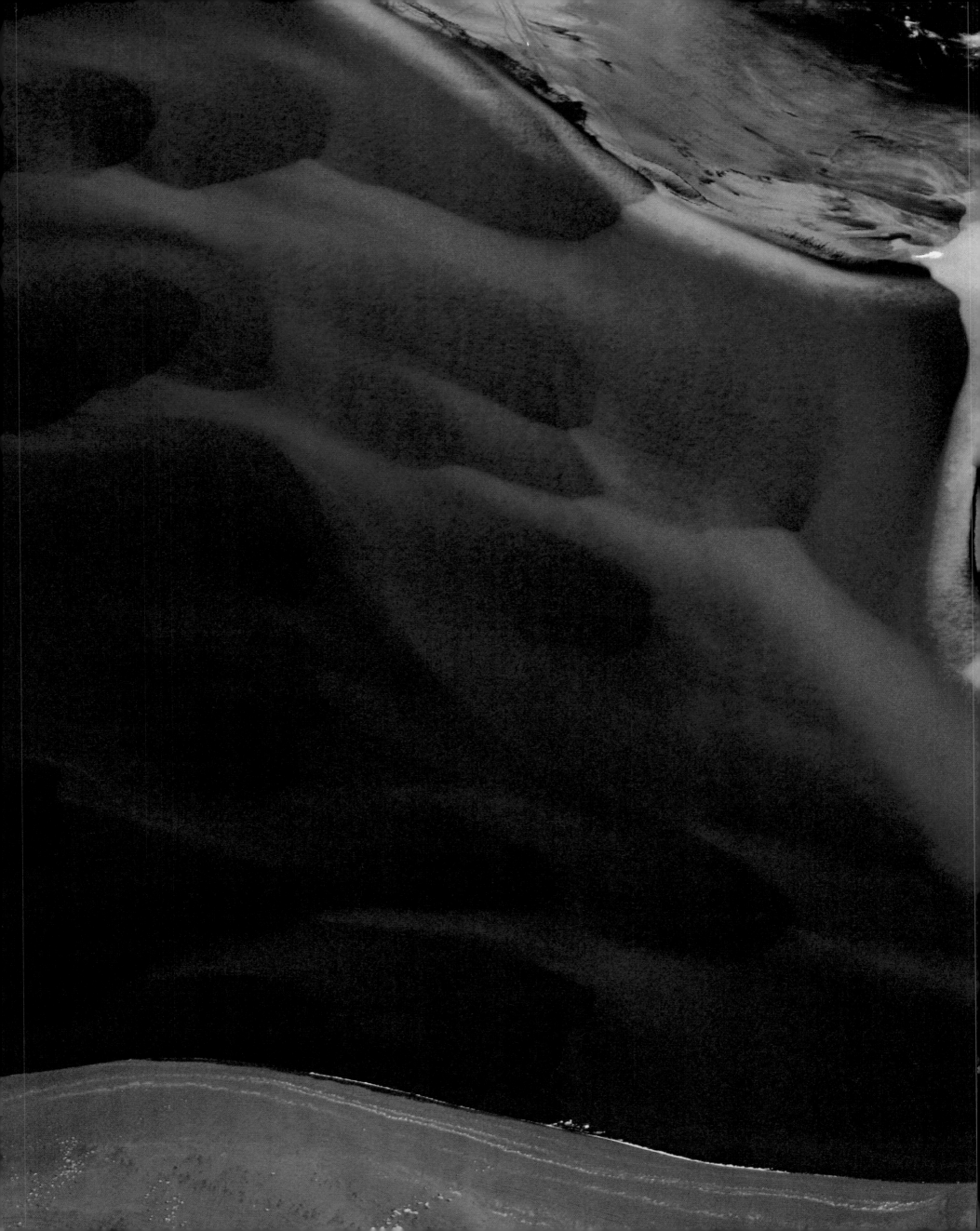

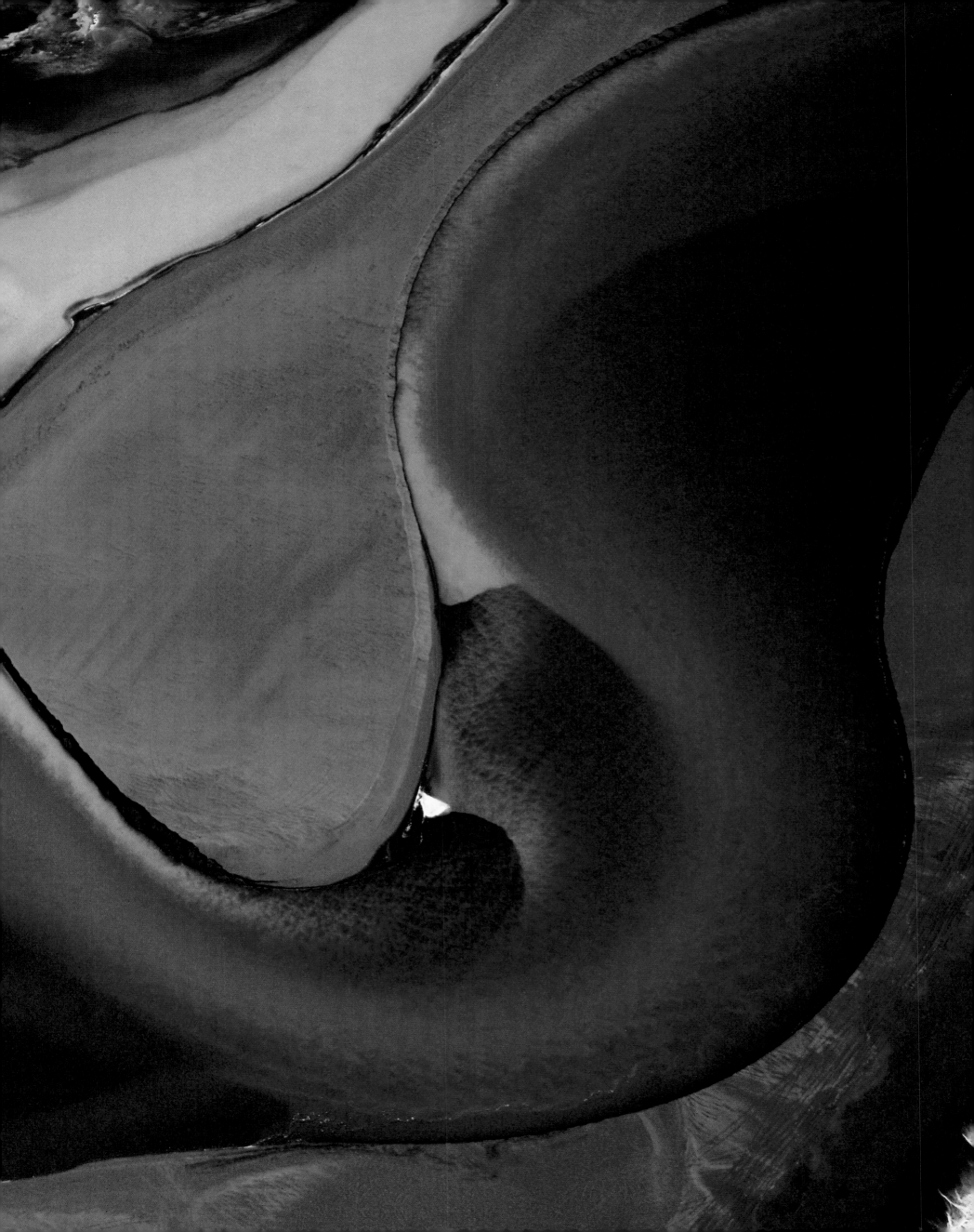

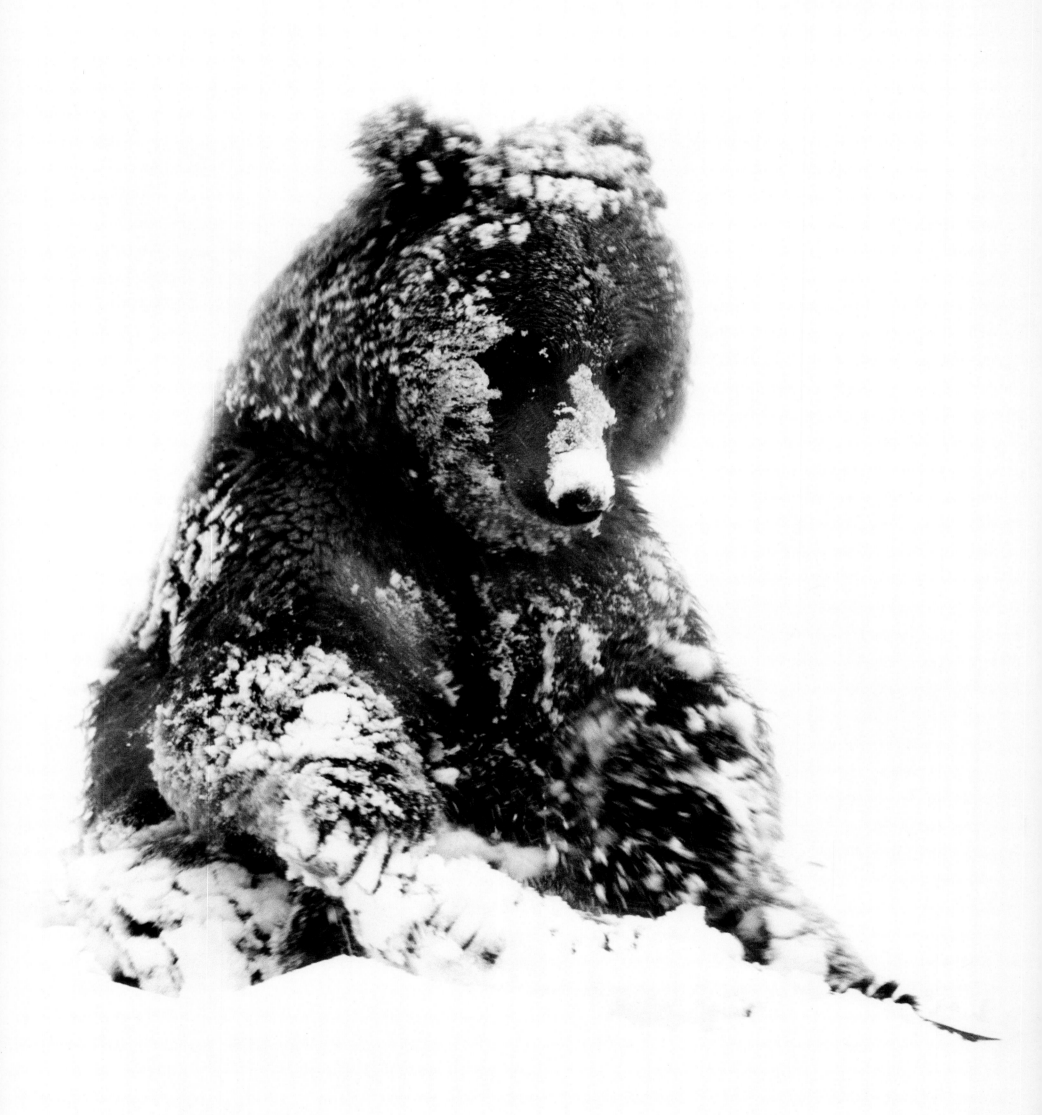

Mountains

A land of vast vertical planes, the imposing majesty of great rocks: mountains are a habitat with which I have a strong bond—not any particular mountain, but mountains in general. With their sheer cliffs, scree, and high plateaus, these great masses command our respect and admiration. They are the earth's memorials and—testifying to its past geological upheavals—silent witnesses to its future.

Left: A young brown bear plays in the snow in Alaska's Katmai National Park and Preserve.

Mountains are living habitats and home to treasures of biodiversity. Each mountain is different, yet the important role played by rocks, the extraordinary challenge of this rugged terrain, and the special, difficult life conditions mean that all mountains belong to the same family of ecosystems. Whether in the lofty Himalaya, the cordillera of the Andes, or the Alps we can only marvel at nature's capacity to adapt to such a rugged environment. The slopes are steep, the soil poor and scanty; as we climb higher toward the summits, the changing climatic conditions force living things to adapt to extreme environments.

At high altitudes there is less oxygen, and the temperature varies sharply between day and night—water supplies are erratic and winds can be violent. Atop a mountain the ultraviolet rays are stronger because the air is clearer and thinner. And yet, although this environment is hostile, life has been established here and has become part of this sublime landscape.

Mountains are home to peculiar life forms. In inhospitable places, to which access is sometimes dangerous, life develops. In the tiniest crack in a rock on the face of a cliff, a seed borne by the wind will begin to grow into a tree. On the scree, plants take the shape of little cushions, thus increasing their surface area to gather more rain and runoff water while tenaciously clinging to the slope. The huddled, stunted vegetation is often sparse. The wind encounters little resistance and, in these highly unfavorable conditions, spiders have given up spinning webs to catch insects: they hunt on the ground instead.

Closer to the equator, where the sun is stronger and there is a higher amount of rainfall, there tends to be more diversity of plants and animals. In general, there is less biodiversity on a mountain that has lower, more variable temperatures. On the other hand, mountains—just like islands and archipelagos—are home to species that adapt to their peculiar conditions. Every localized human population may be specific to a given region and ecosystem and may not communicate with outside areas. Therefore, these plants and animals are especially vulnerable to the destruction of their specific environment, to disease, and to any climatic change.

The plant kingdom contains unparalleled diversity, ranging from mosses to complex flowering plants to giant sequoias. More than 1,000 plant species grow in the Caucasus alpine region. The isolation and ruggedness of these areas have led to the evolution of certain species that are now threatened by overgrazing.

> Mountains are home to peculiar life forms. In inhospitable places, to which access is sometimes dangerous, life develops.

Central and South America are home to some of the greatest diversity of species in existence, from virgin forest to high desert plateau, from temperate forest to the snow-capped summits of the Andes, ranging from the northern Andes to western Ecuador, and central Chile to as far as Patagonia. Absolutely, these environments must be protected. Destruction of or pollution in this region would be disastrous for the waters that feed the Amazon River, its tributaries, and the world's greatest tropical forest.

Although not easily accessible, mountains are areas where humans are encroaching. The amount of vegetation is gradually eliminated to allow for intensive farming, while grazing increases the amount of stress put on mountains. Tourism also damages these wonderful, fragile habitats. How many hikers forget that they are supposed to be humble visitors in these landscapes? When mountains and other open spaces become covered with garbage, it is damaging and dangerous

for the habitat and all living things. And what about those ski runs? They tear through forests, flatten slopes, and lead to the diversion of watercourses, which feed their snow-making machines. All of these human activities in the mountains destroy this habitat, waste resources, and displace living things into the few places that remain undisturbed.

Biodiversity in the high mountains takes shelter in ever-smaller areas, which are hard to reach and to survive in and are farther and farther from each other—veritable islands of life, cut adrift. For example, the Mission blue and the San Bruno elfin butterflies, found in the San Bruno Mountains in California, are rapidly becoming extinct due to the increase in mountain development; they're forced to relocate their habitats as bulldozers clear the land for housing. Gradually but ineluctably, species are driven back and isolated, and the various groups grow smaller and smaller, and farther and farther apart, endangering the species' very survival. These islands of animals and plants are even more vulnerable to predators and natural disasters, which can only become more frequent with the climate change now under way.

> Gradually but ineluctably, species are driven back and isolated, and the various groups grow smaller and smaller, and farther and farther apart, endangering the species' very survival.

Species spread out in the mountains and become unable to mingle (due to lack of passage). As a result, these mountain species, with their specific adaptations, are headed for extinction. This dwindling and isolation of populations is a silent phenomenon. Every day, these islands of survivors are pushed a little closer to their demise, which will be savage and irreversible. For example, in France, bears have been able to find refuge in only a few corners of mountainous regions, where they are endangered.

In North Africa and in Europe, from Spain to the Balkans and Turkey, humans and the fauna and flora of the mountains have had a fruitful relationship for millennia. This relationship, incorporating common sense, nature, and civilizations, has left its mark on the mountains (even today Alpine pastures bear witness to this) through myriad local domestic breeds—another key element of biodiversity. Transhumance by shepherds, and the principal routes it followed, bear witness to the dual nature of this type of livestock farming—simultaneously Mediterranean and of the mountains. These have profoundly influenced ecosystems, and it is perhaps no coincidence that the mountains of the Mediterranean basin are included in one of the 25 world "hot spots" for nature conservation.

Humans have succeeded in domesticating some 40 animal species. Throughout 12,000 years, selective breeding and ecological changes have produced thousands of breeds of these species, which needed only natural shelter and pasture, though certainly they produced lower milk or meat yields. The preservation of this genetic variety is more vital than ever to meet the needs of the future because of climate change and its impact on the ecology of individual regions.

Today, it is not merely a question of preserving the few places that have been spared by the human conquest. We need to encourage the restoration of habitats that have been abandoned by their native flora and fauna and recognize that local knowledge and local practices regarding the use of biodiversity, both wild and domestic, are essential contributions to humanity's world heritage. It is an immense challenge, but it is an essential condition for safeguarding the future of ecosystems and species, as well as our own future. Will we find a way to respect these precious habitats—these extraordinary living things—and be reconciled with nature?

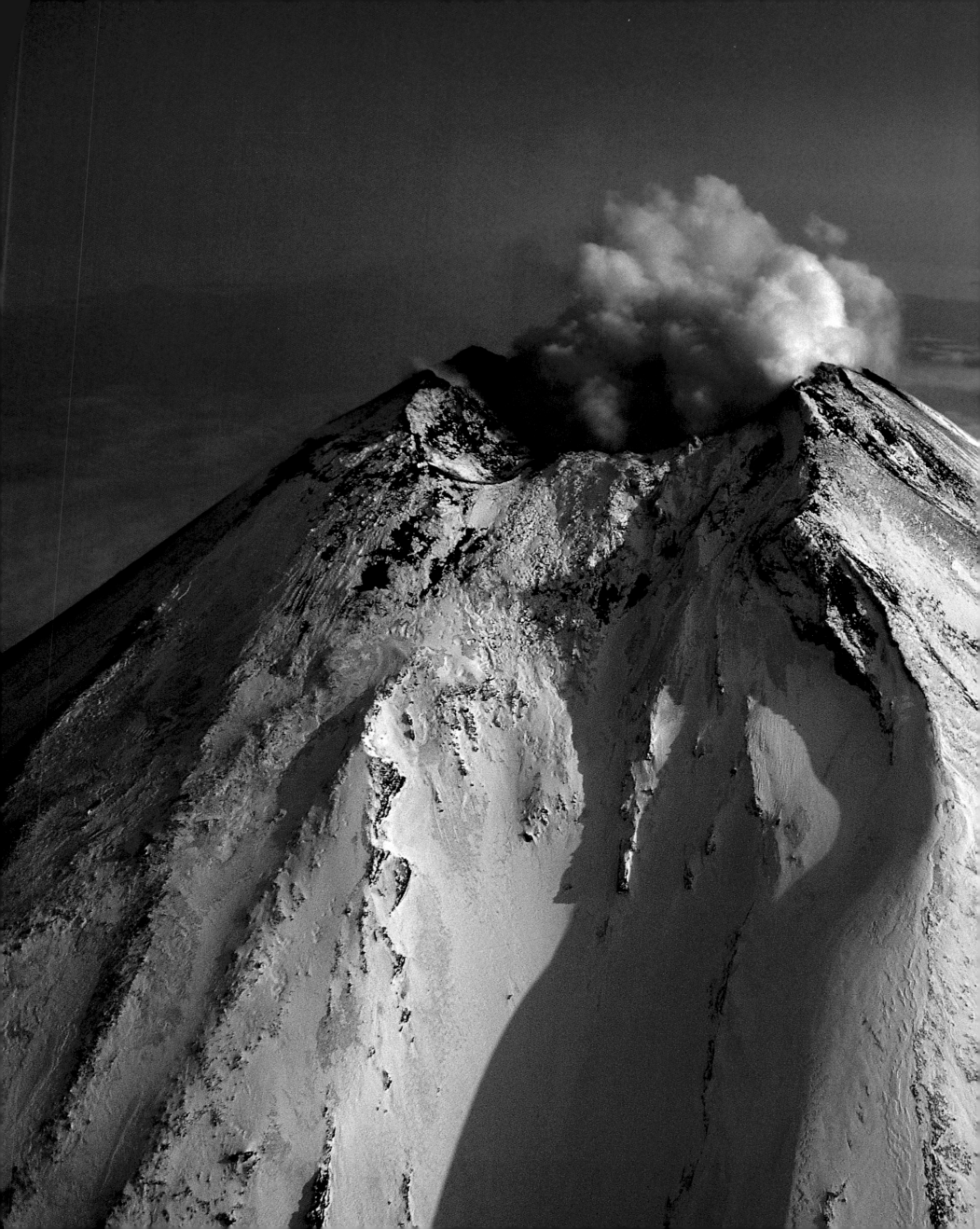

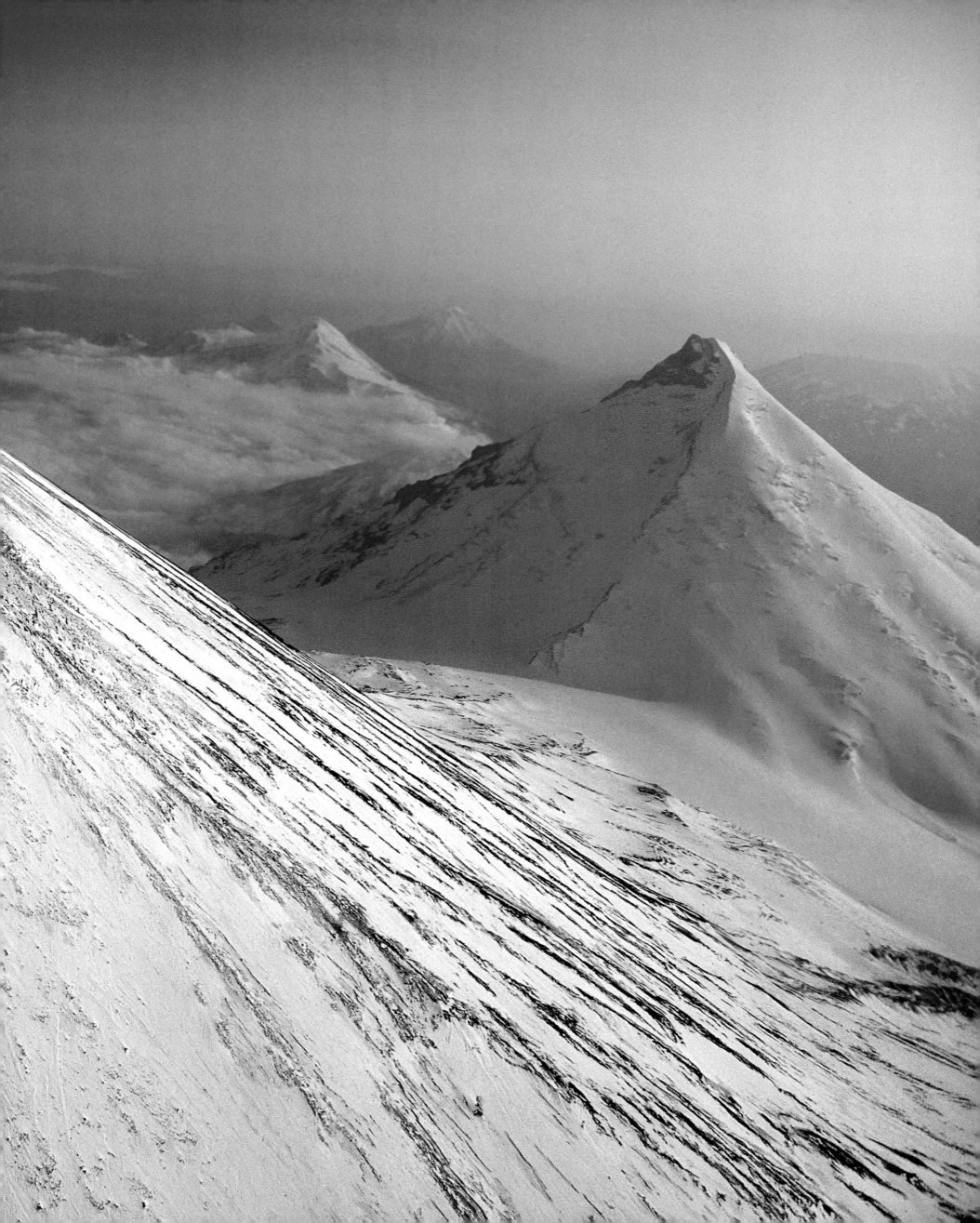

Preceding pages: The volcanic region of Kamchatka, in eastern Siberia, is one of the last great unspoiled mountain regions. This peninsula is home to just 450,000 people, but it contains more than 160 volcanoes, of which 29 are still active. Some peoples, such as the Koryaks, the Itelmens, and the Evens, still raise reindeer in this region.

Above: The high, arid mountains of the Zanskar, in China, are not teeming with biodiversity like other parts of the world. However, the region remains largely unexplored by scientists. Most likely there are species yet unknown to science, notably flowers, lichens, and insects. And it may hold even greater surprises: in 2004 a new species of monkey was discovered in the foothills on the Indian side of the Himalayas.

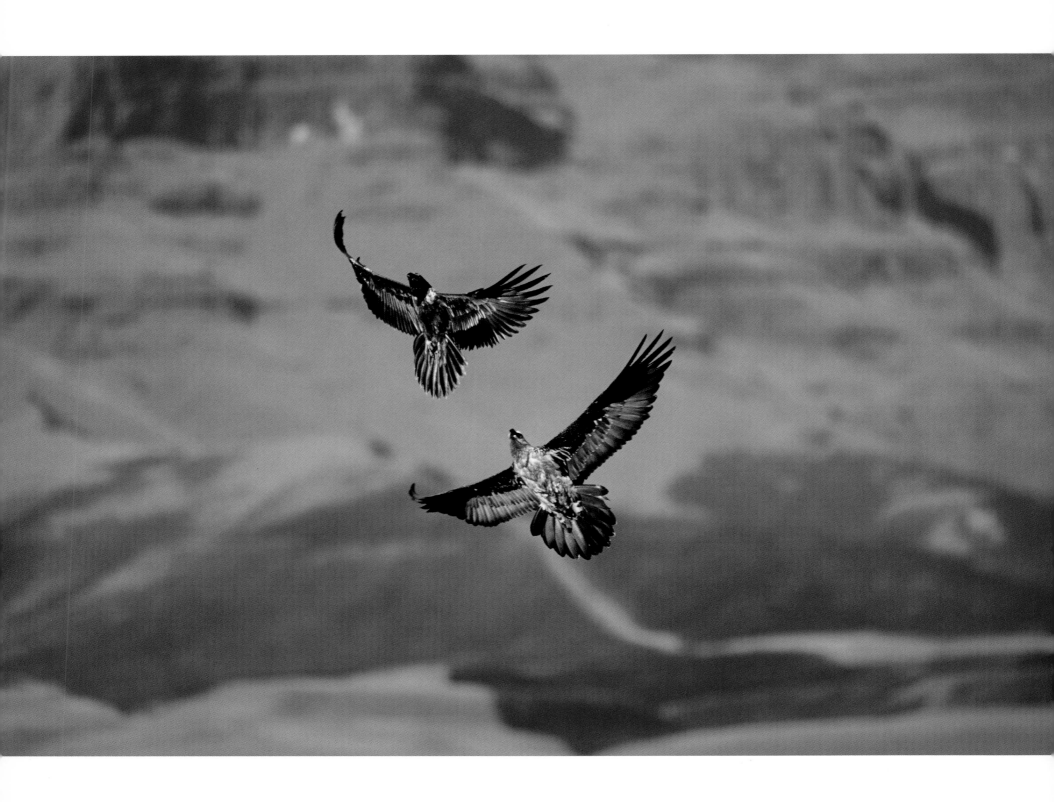

The lammergeier, the most majestic of all vultures, was once found in most of Europe's mountainous areas. During the 20th century it was wiped out in the Alps, though it still found a refuge in other mountain massifs, such as the Pyrenees and the mountains of Corsica and Greece. Thanks to the efforts of conservationists, the species has been reintroduced to the Alps, and this magnificent raptor can now be seen in the skies from Italy to Austria, as well as over the Drakensberg in South Africa, where this adult and young bird were photographed.

Mountain flora is among the most diverse on the planet. The greatest variety is found at medium altitudes. Above 6,500 feet the number of species is smaller, though the plants have adapted to cope with harsh climatic conditions (much in the same way as the plants that grow near the polar regions). These saxifrages, for example, clinging to the rock, grow in places sheltered from the wind, and their nutritional needs are modest.

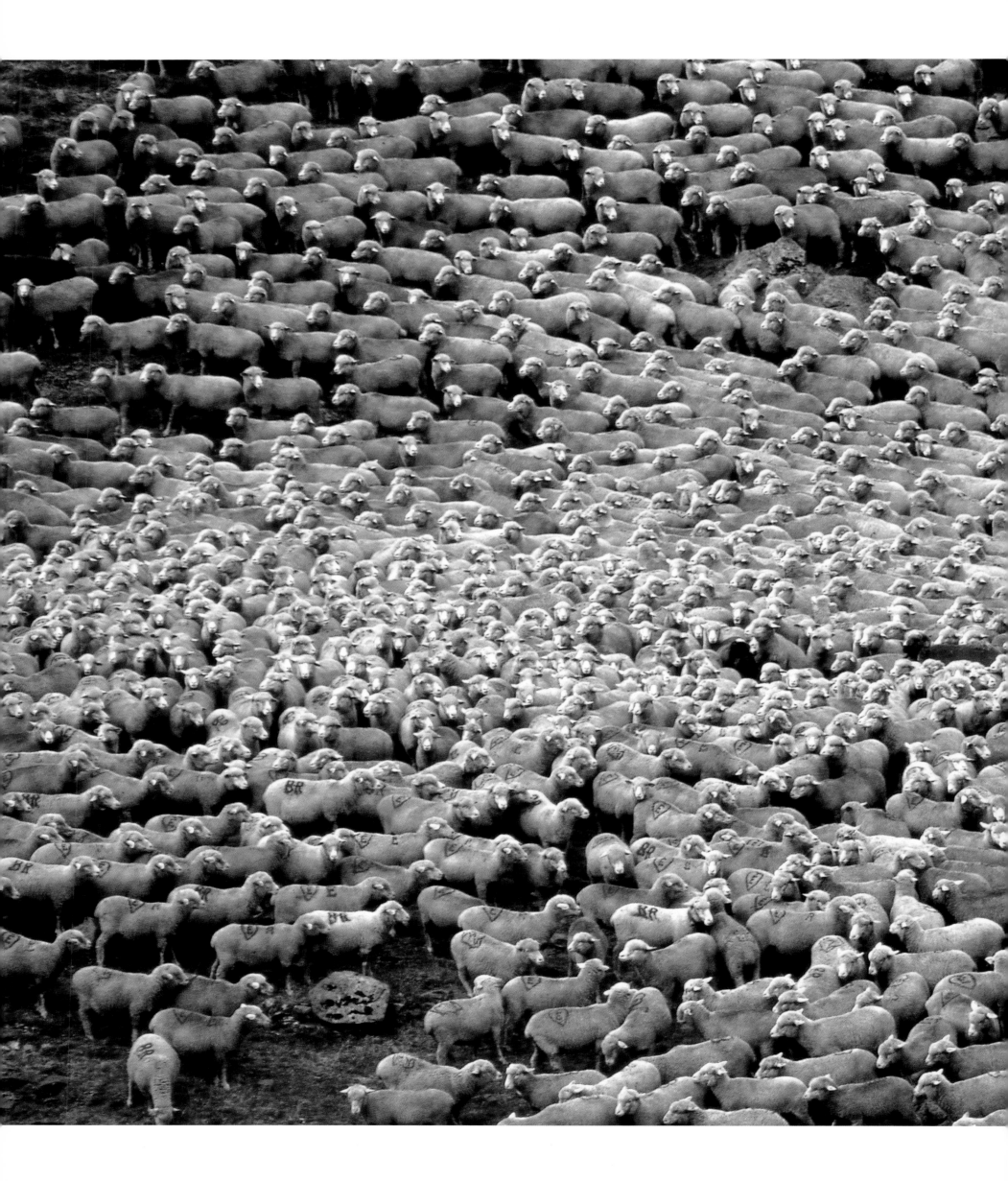

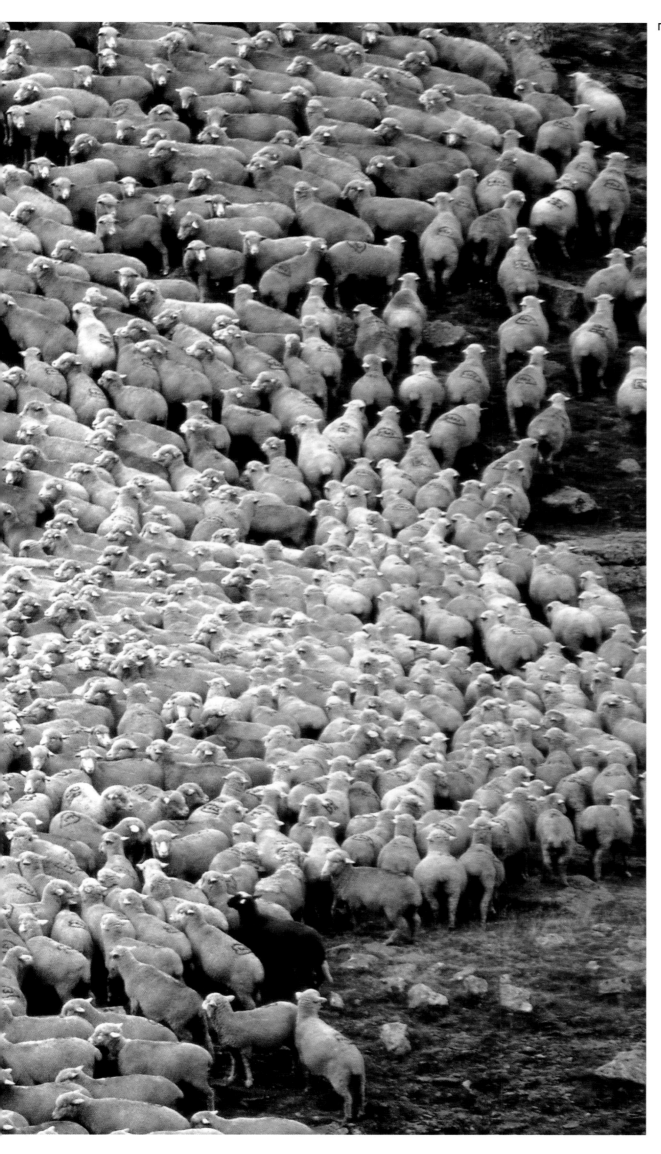

Until the end of the 1970s, transhumance of sheep flocks from the plains to the mountains was a well-established tradition in France. The sheep were driven, via time-honored mountain trails, to summer pastures. There, closely watched by the shepherd and his dogs, the sheep would spend the summer before again descending to the plain in autumn. Today, transhumance is carried out using trucks. The sheep pass the summer at a high altitude, sometimes without people watching over them. In the Pyrenees, the few surviving brown bears sometimes attack such unguarded flocks. Although a flock that is guarded is not completely safe from attack by brown bears, the risk is nevertheless far lower than for an unattended flock.

Above: The giant panda has symbolized nature conservation for decades; it is the emblem of the World Wildlife Fund (WWF). This species, which was discovered during the 19th century by French zoologist Father Armand David, lives in the mountains of Sichuan province in China. Just over 1,000 are left in the wild, where they feed exclusively on bamboo. The Chinese authorities have made admirable efforts to preserve what remains of this population. They have also encouraged captive breeding with the aim of increasing the numbers of animals in the wild.

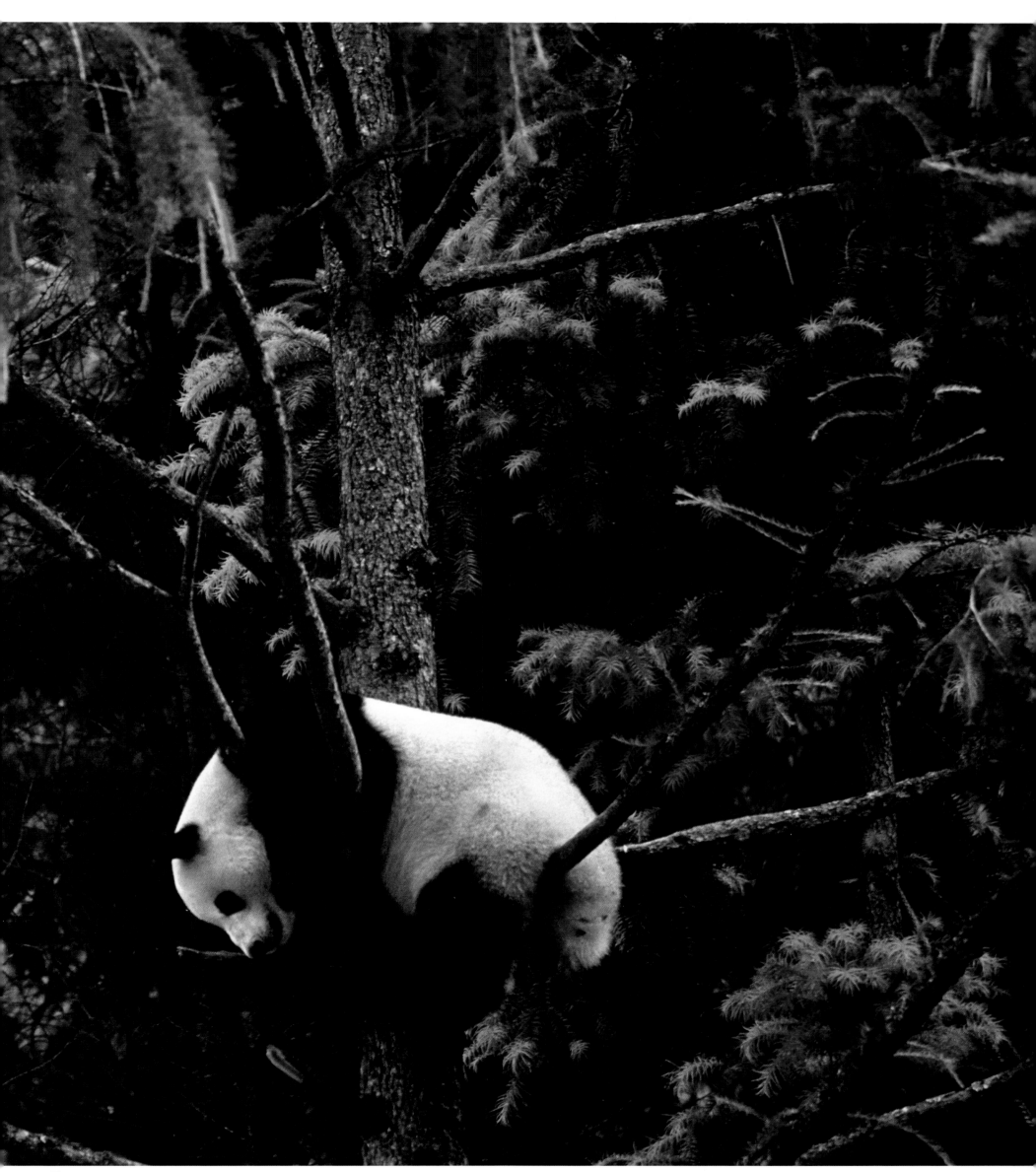

Following pages: The ends of spruce branches will be added to the bedding in the cave or crevice where this brown bear will hibernate, leaving snow to cover up the entrance. Although the brown bear is not a threatened species in Europe as a whole, on a local level the situation varies considerably. The Pyrenean brown bear, numbering no more than a dozen, will not survive much longer without the introduction of new animals, and unless local people share the desire to let it live unmolested.

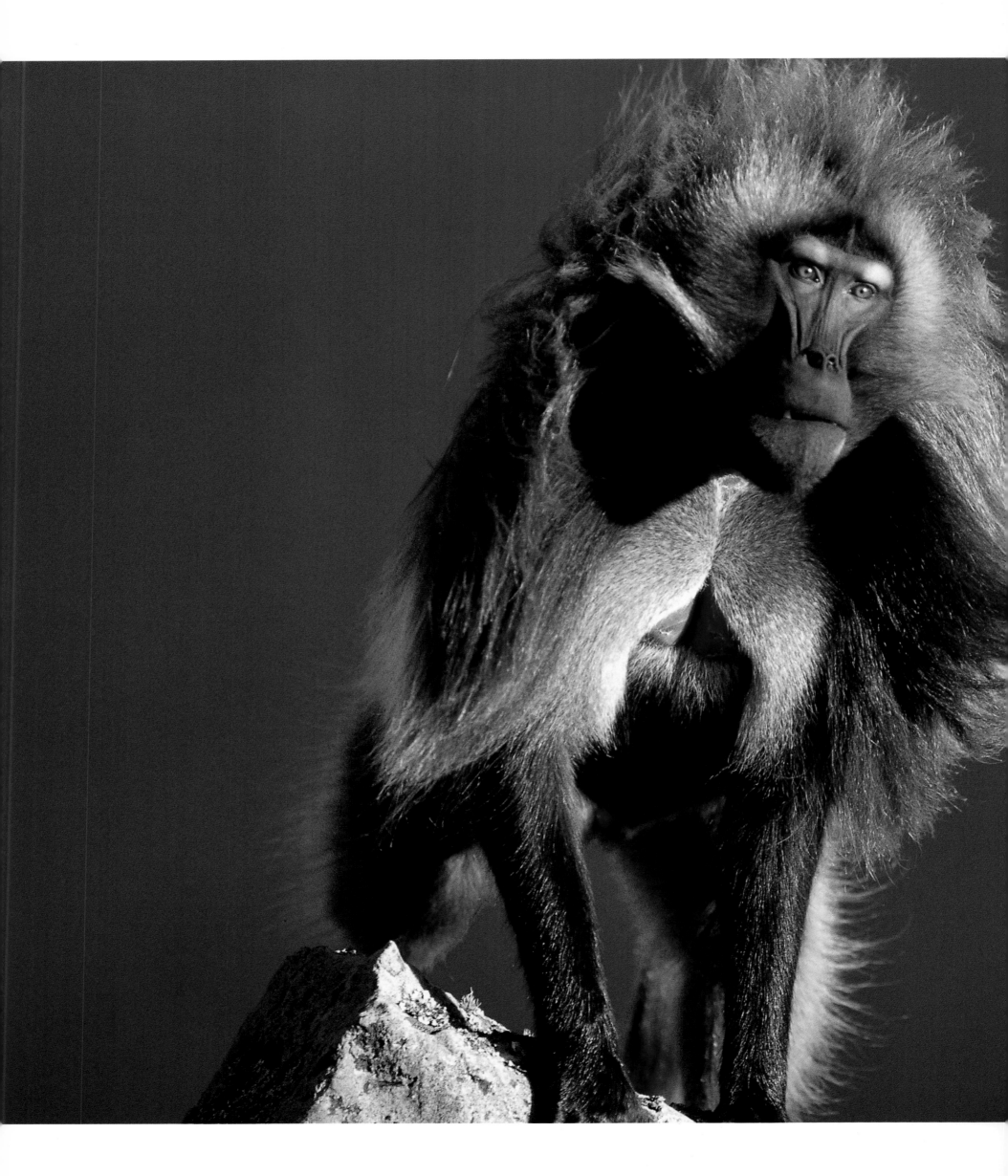

On the high plateaus of Ethiopia, at almost 10,000 feet above sea level, it's surprising to see troops of geladas (a species of baboon) wandering among the goats, sheep, and cattle. These monkeys, closely related to the baboons of the African savannah, feed mostly on roots, bulbs, and other plants. In the evening they return to the rocky escarpments or cliffs where they spend the night in groups.

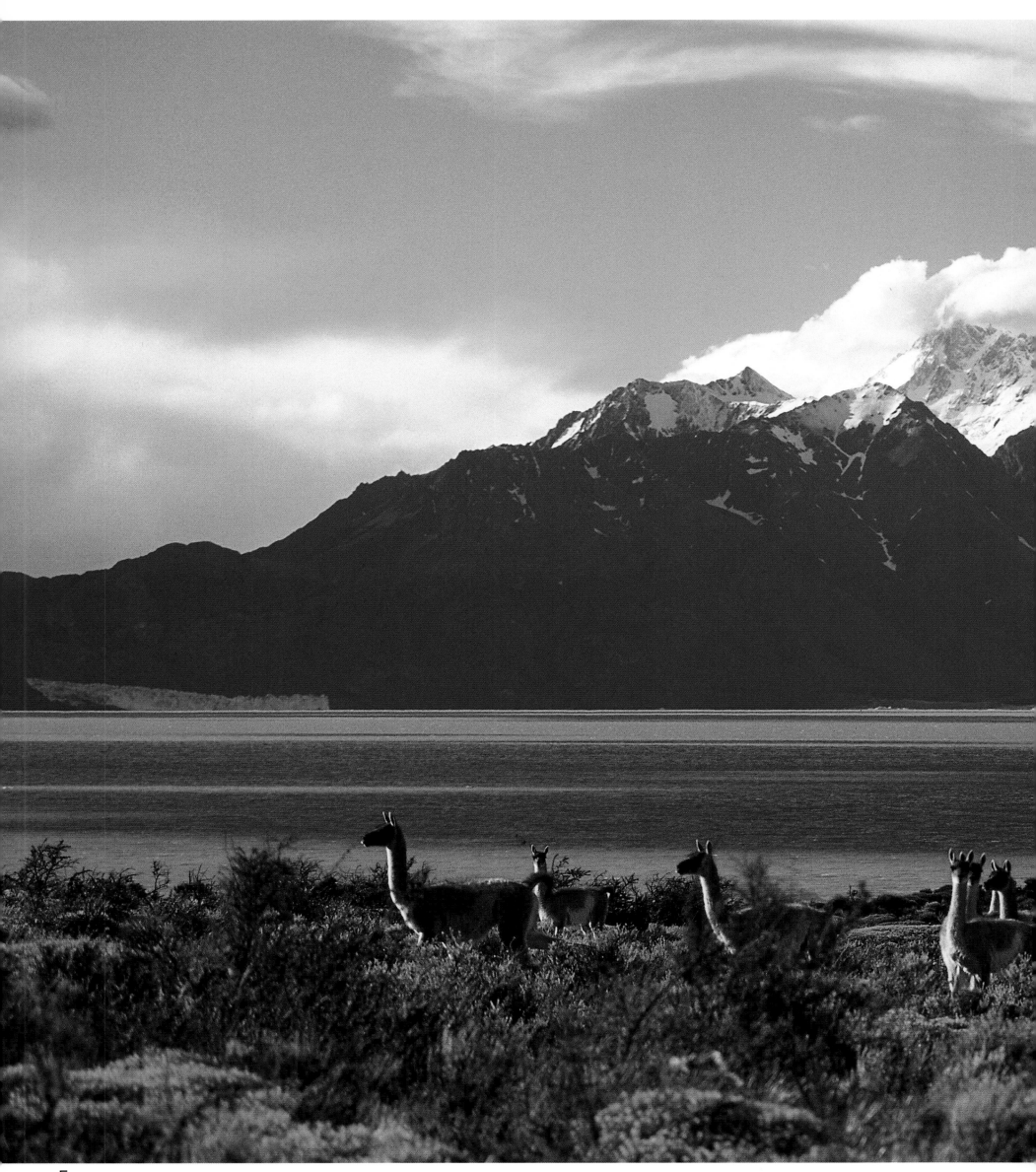

Unlike the llama, the guanaco (a species related to dromedaries and camels) is not domesticated. However, genetic tests have established that it is an ancestor of the llama. This species lives at slightly lower altitudes than the alpaca and vicuña, and also has the southernmost range, reaching as far as the plains and hills of Patagonia. During the past two centuries the guanaco has suffered from hunting (though it is now protected), from changes to its habitat, and from competition with livestock.

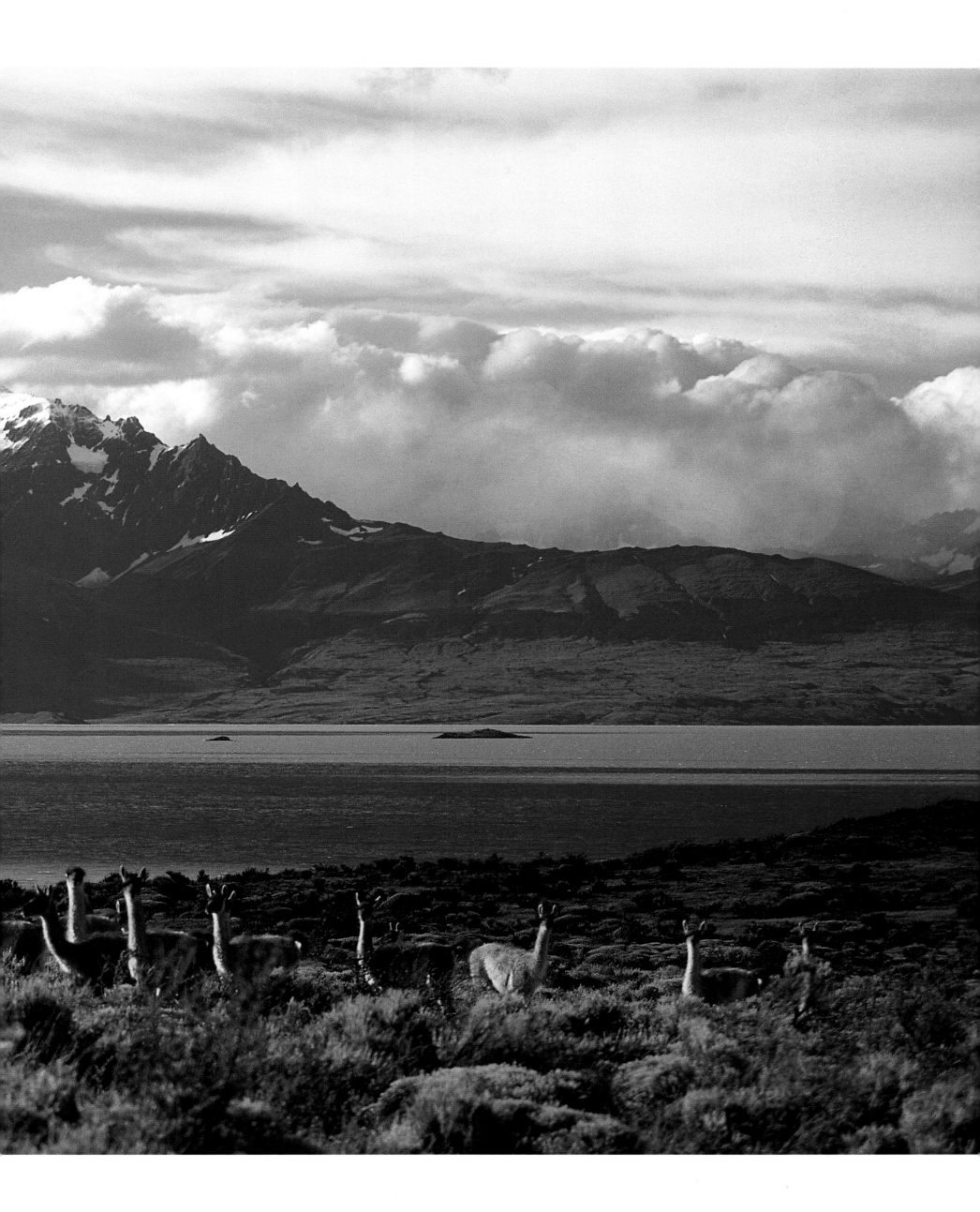

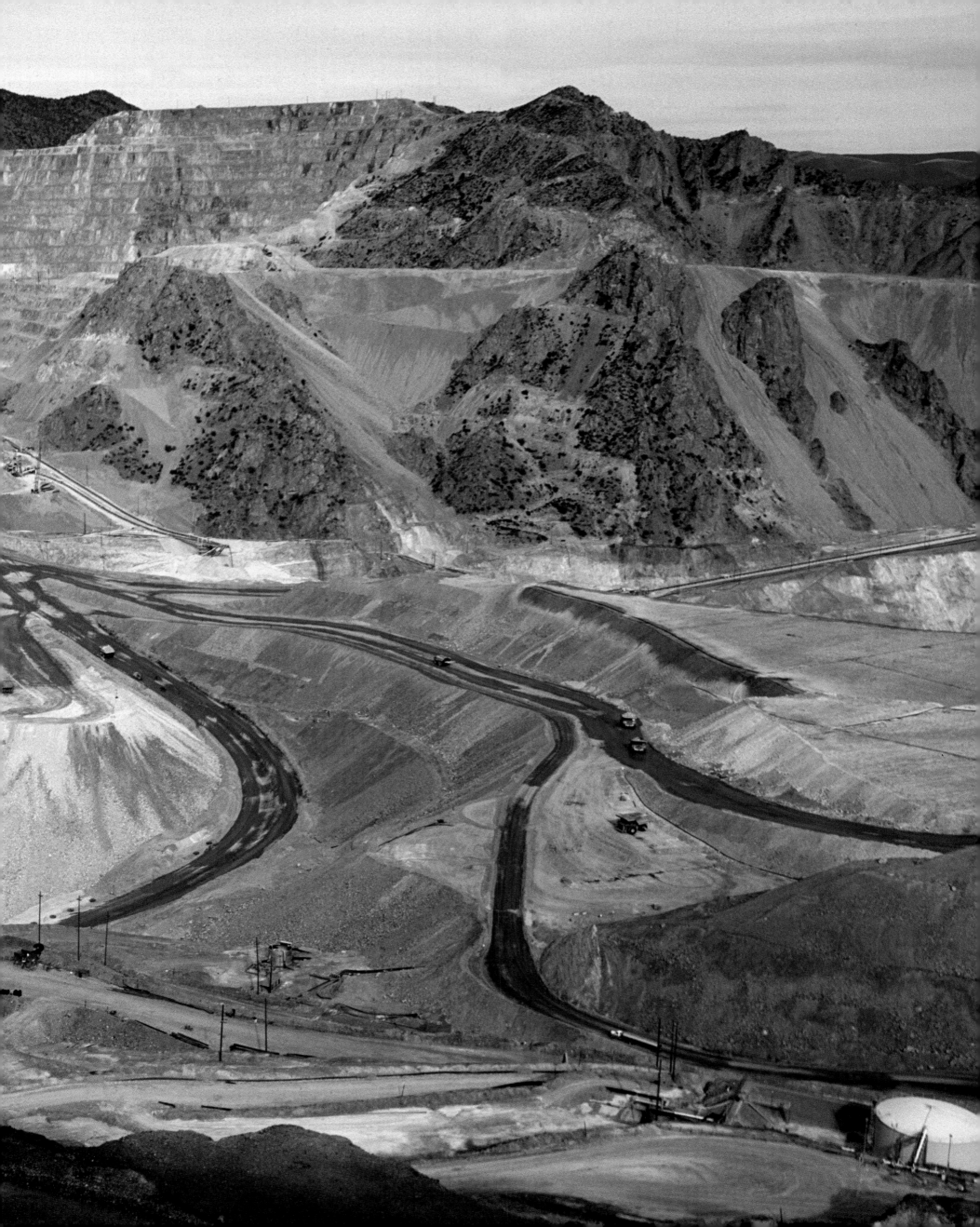

Preceding pages: This opencast copper mine in the Morenci district of Arizona disfigures the landscape. Strong demand for raw materials has led to the disembowelment of forests, rocks, and cliffs, in many mountainous regions with little regard for aestheticism. Apart from the environmental upheaval these activities cause, there has been little understanding of their impact on the landscape. Today efforts are being made to take these problems into account when exploiting mineral resources.

Right: One could be forgiven for thinking this is a public rubbish dump at the foot of the mountains. In fact, it is waste left behind at a base camp on K2, in China; the mountain itself is no longer spared from pollution.

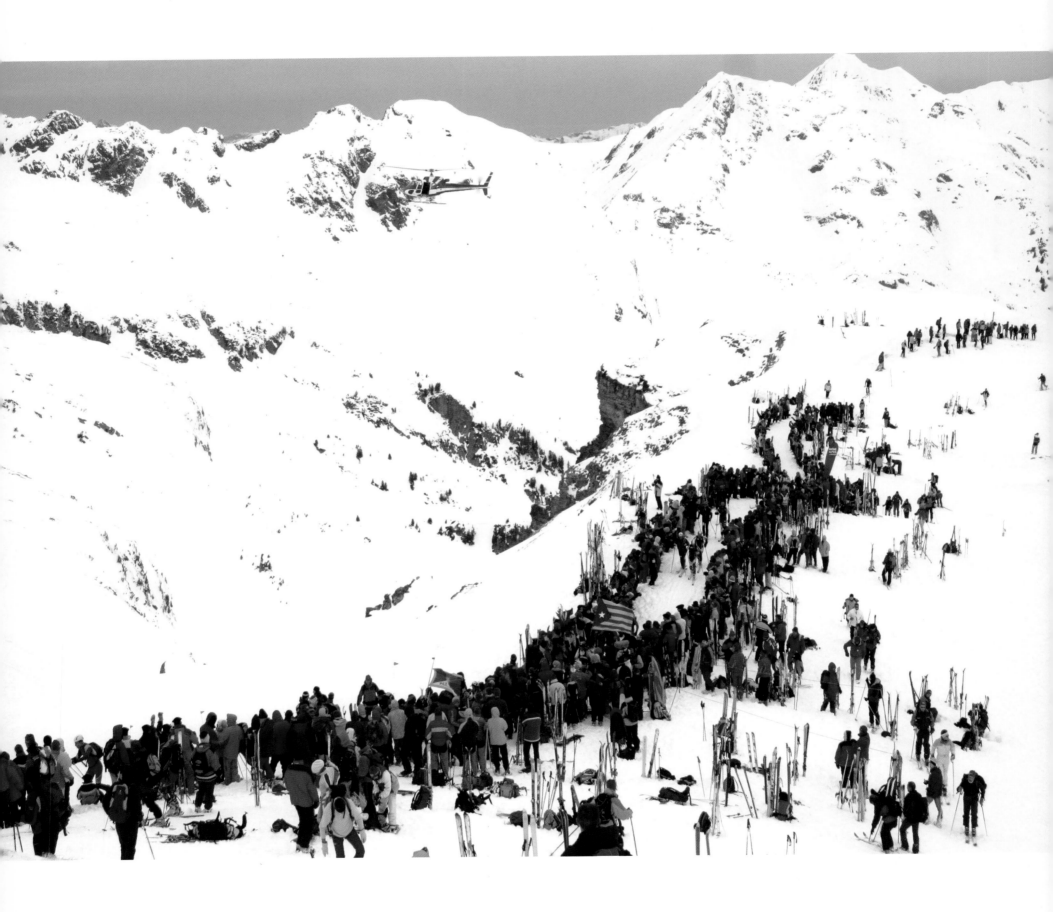

Above: The development of winter sports, chiefly in the mountains of Europe and North America, has profoundly modified mountain ecosystems. Ski runs and lifts cut swaths through the forests, reducing habitat and disturbing even the most timid species.

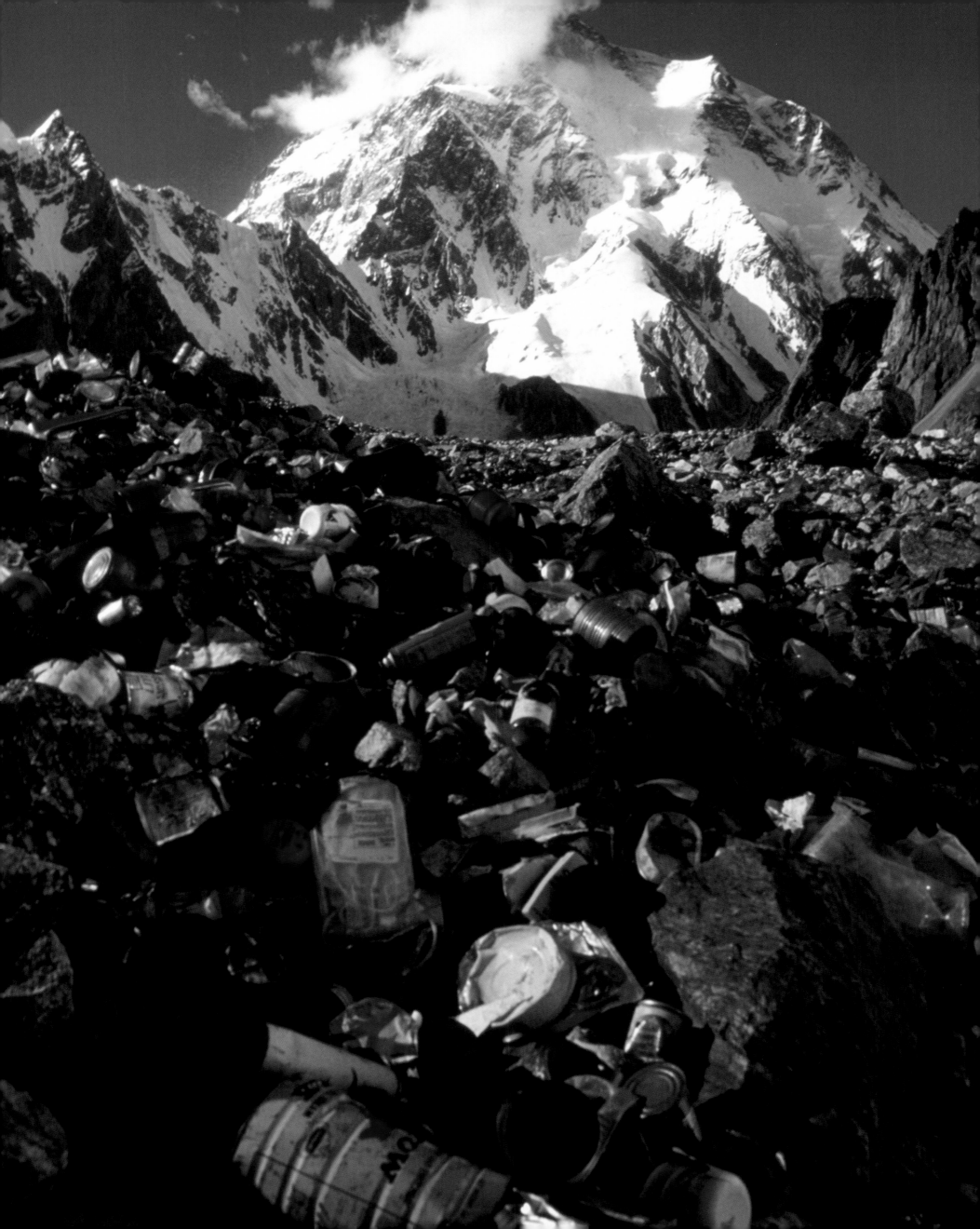

Above: The mountain range that includes Mount McKinley, in Alaska, is still unsullied by human development. Some reasons include the state's low population, its few large cities, and general remoteness. How much longer will this area remain unspoiled?

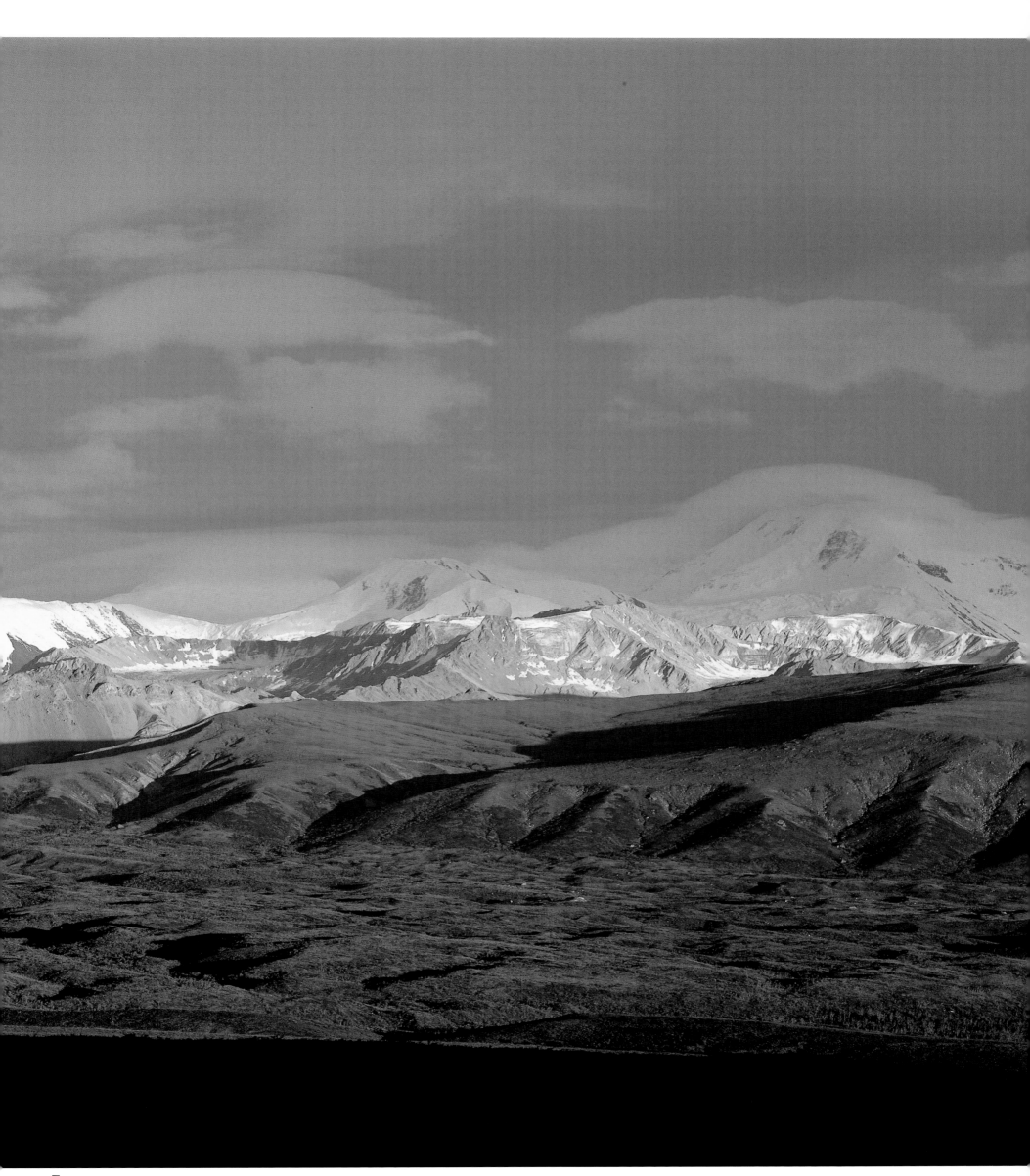

Following pages: Vultures have long been persecuted in Europe. Even though they are strict carrion eaters, they have been accused of carrying off lambs, rabbits, poultry—even children! The griffon vulture is a perfect "natural garbage collector"; it clears mountain pastures of domestic animal carcasses. In France, nature conservation organizations have reintroduced it to its old haunts in the Cévennes Mountains and the Alps; previously it was confined to just the Pyrenees. The success of this operation has been acclaimed worldwide.

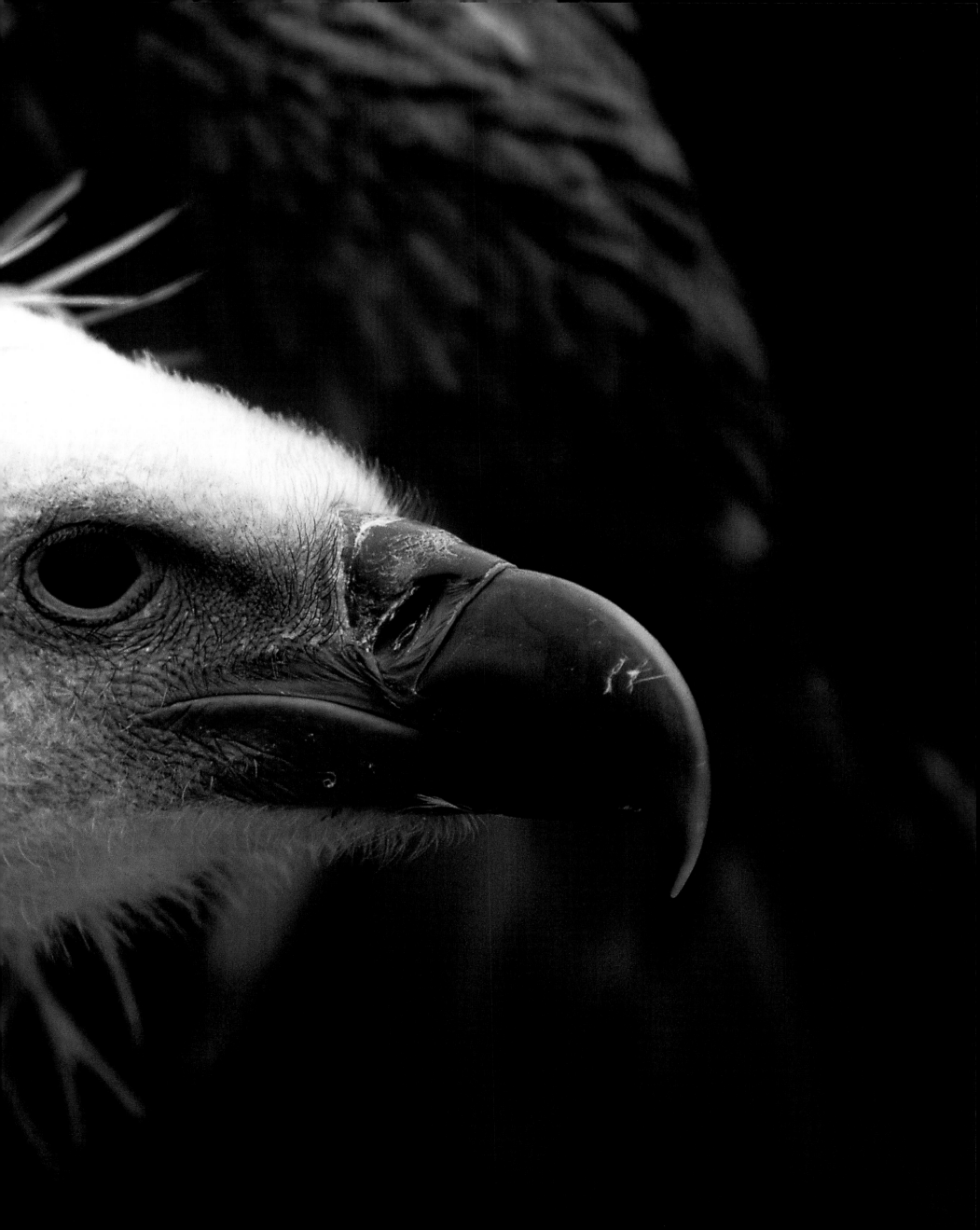

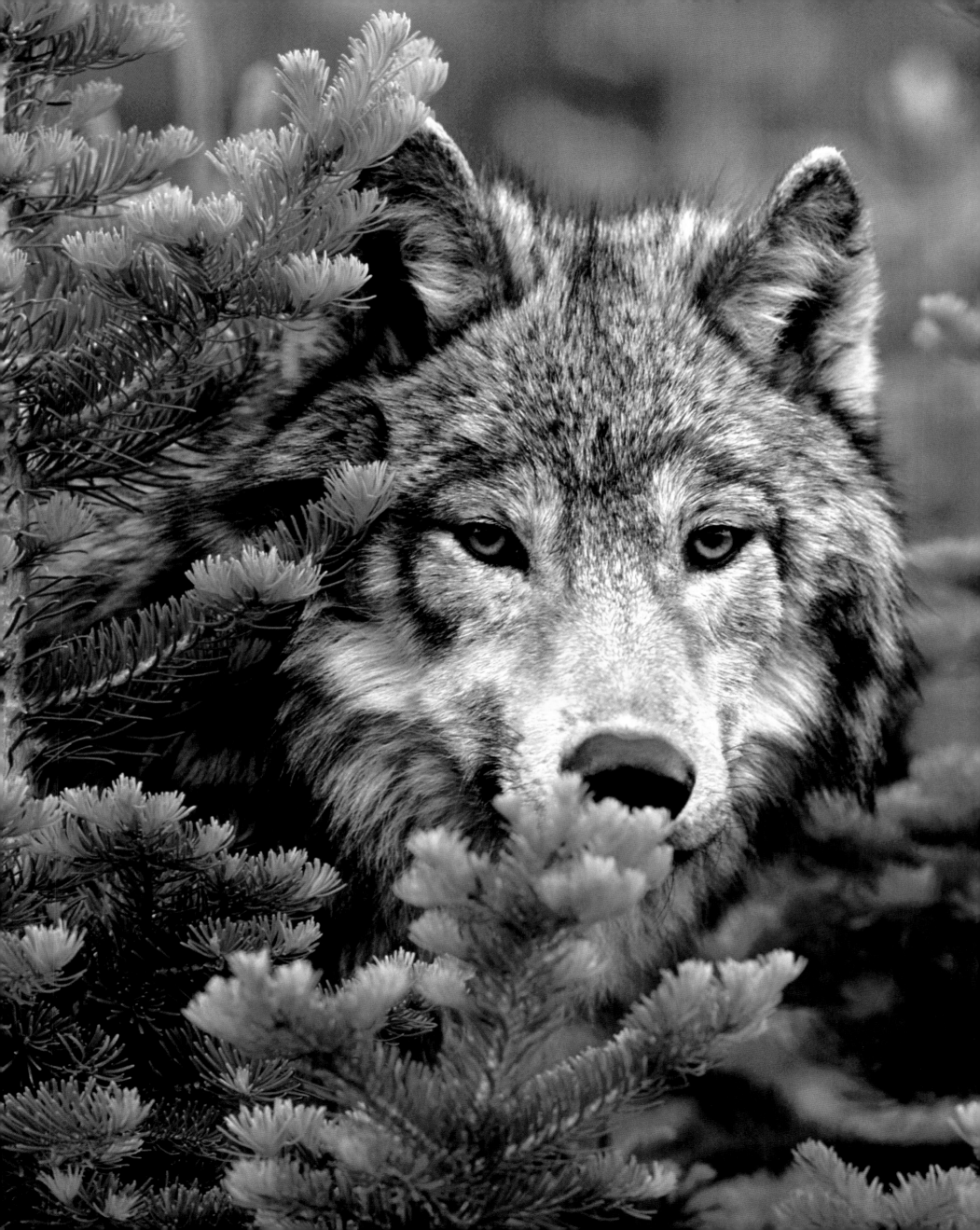

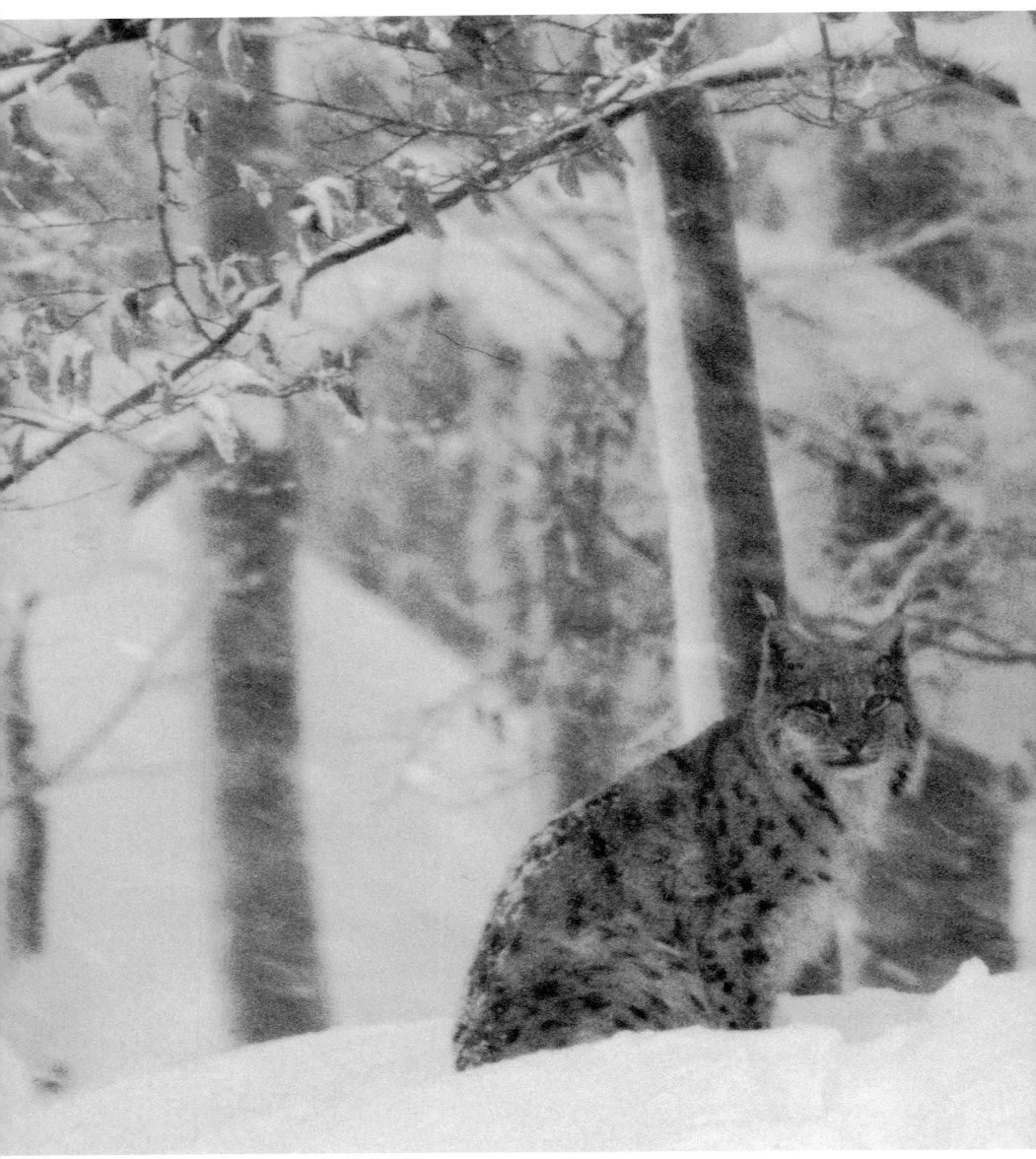

Above: In France and Switzerland, the lynx is making a tentative comeback, notably in the Jura Mountains. However, like other large predators, it suffers from a bad reputation. Even though it is protected, cases of poisoning are regularly reported.

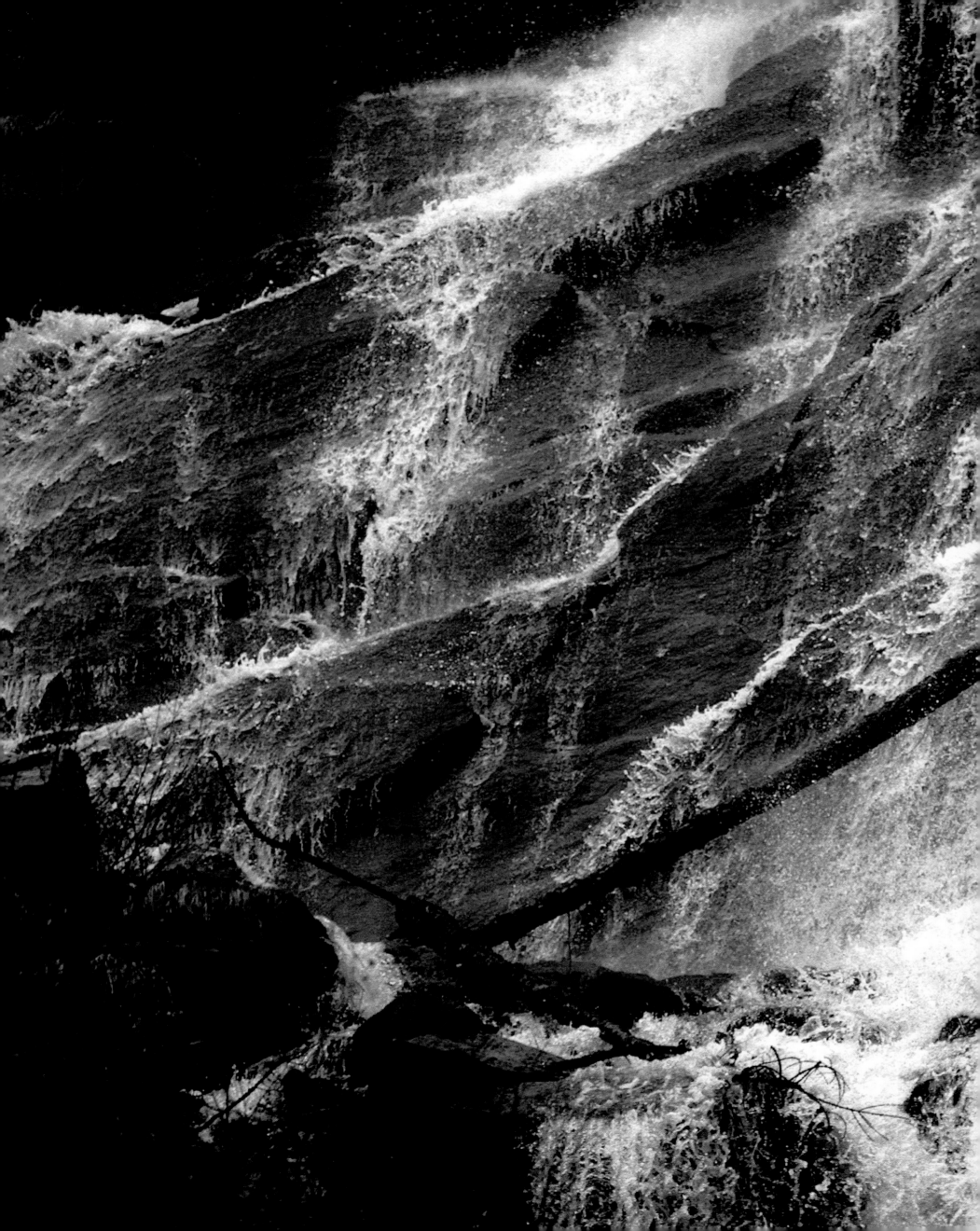

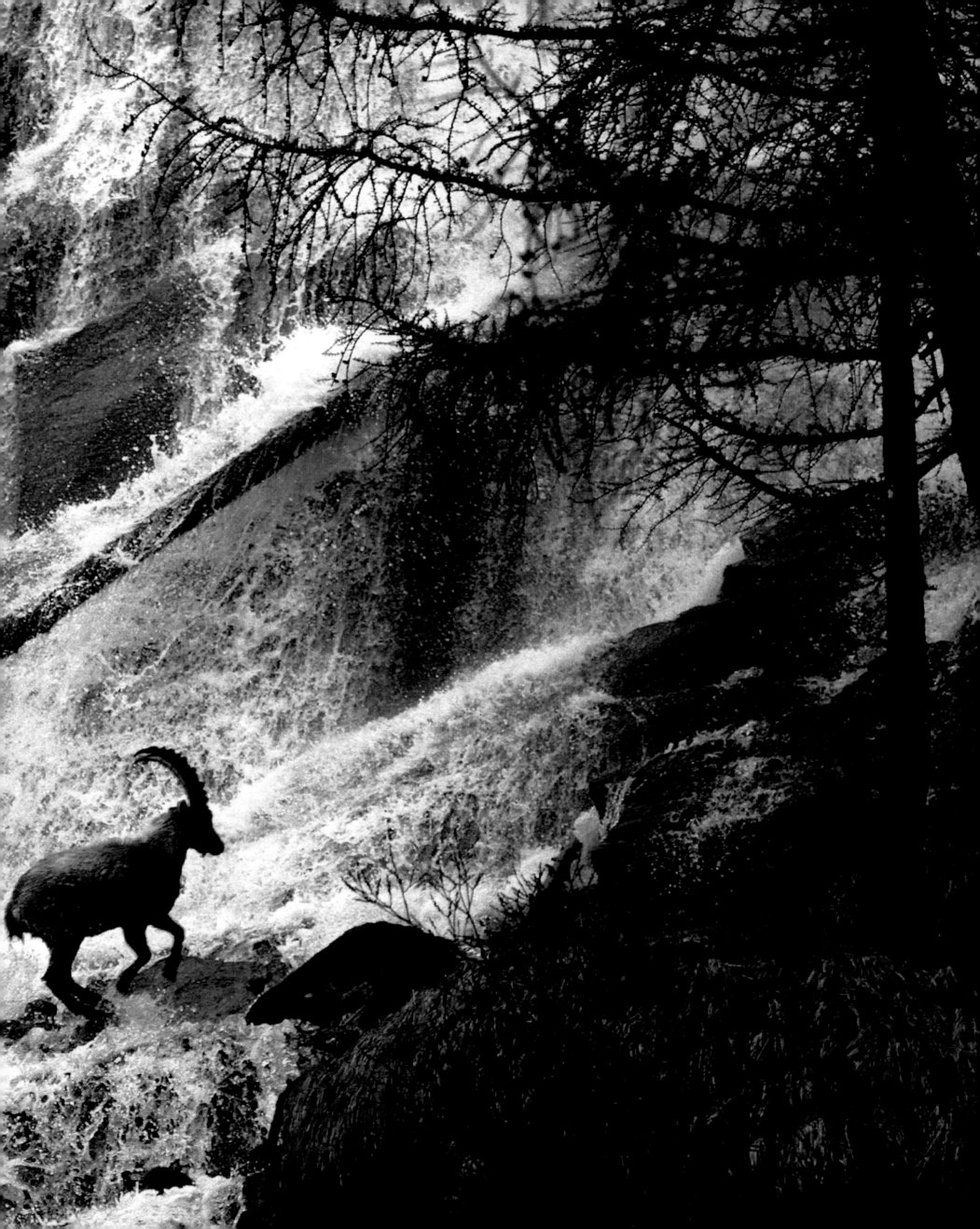

Preceding pages: During the rut, in autumn, male ibexes fight fiercely to compete for the attention of females. These jousts are spectacular rather than life-threatening; the combatant that is unable to continue fighting withdraws from the area, leaving his opponent to court the females. During the rest of the year, the males lead a solitary existence.

Above: Marmots are rodents that live both in high mountain country—like these in the Rocky Mountains of North America—and on the great steppes of central Asia. In Europe, marmot populations are flourishing, and in France the animals, which are originally from the Alps, have been successfully introduced to the Massif Central and the Pyrenees.

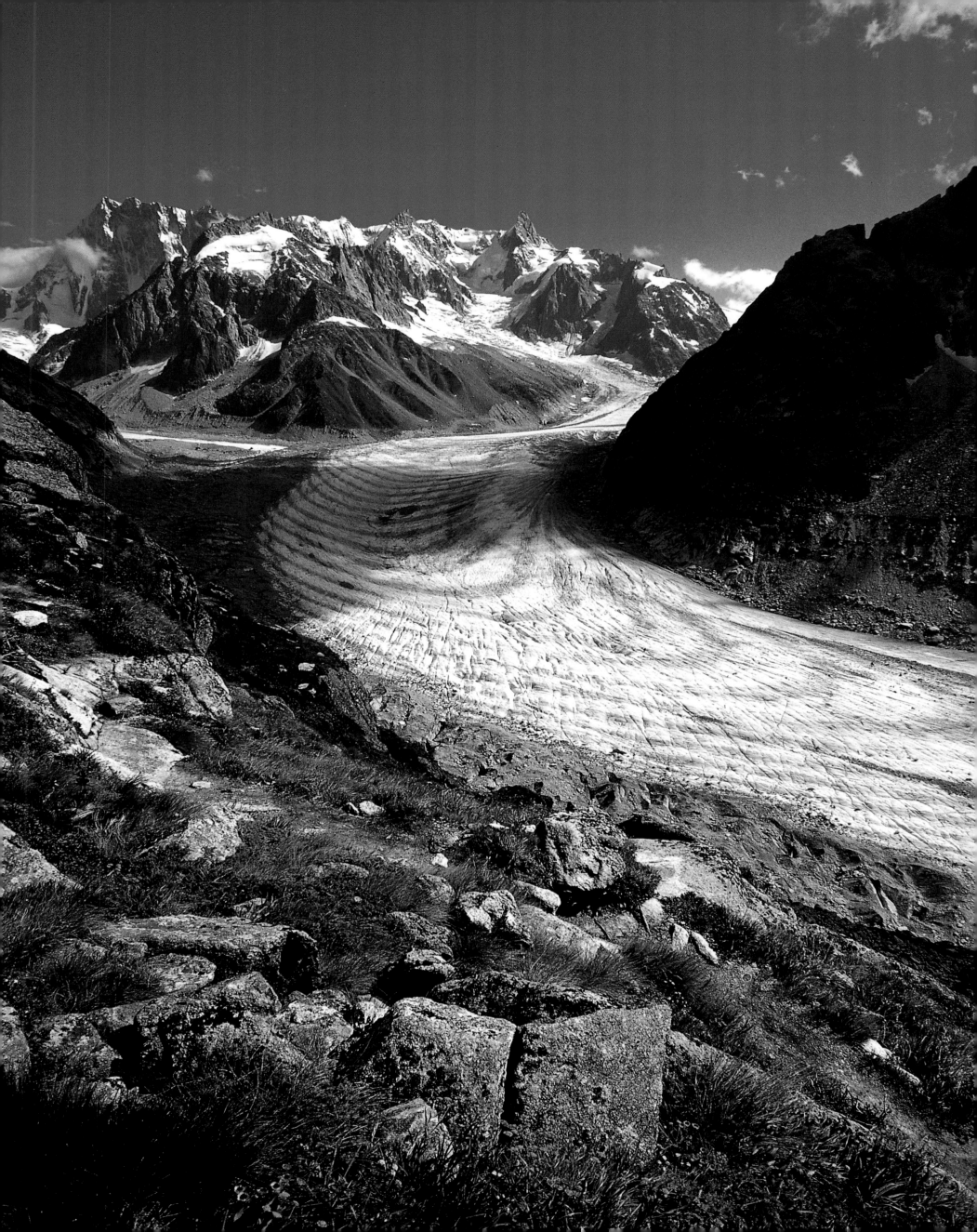

Left: Like many Alpine glaciers, the Mer de Glace, in the Savoy region of France, shrank considerably during the 20th century. It used to be visible from the town of Chamonix, but this is no longer the case. More than four miles long and covering an area of fifteen square miles, it is one of Europe's biggest glaciers. Although glaciers may go through cyclical phases during which they advance and retreat, it is now known that the current climate change is partly responsible for the melting of glaciers.

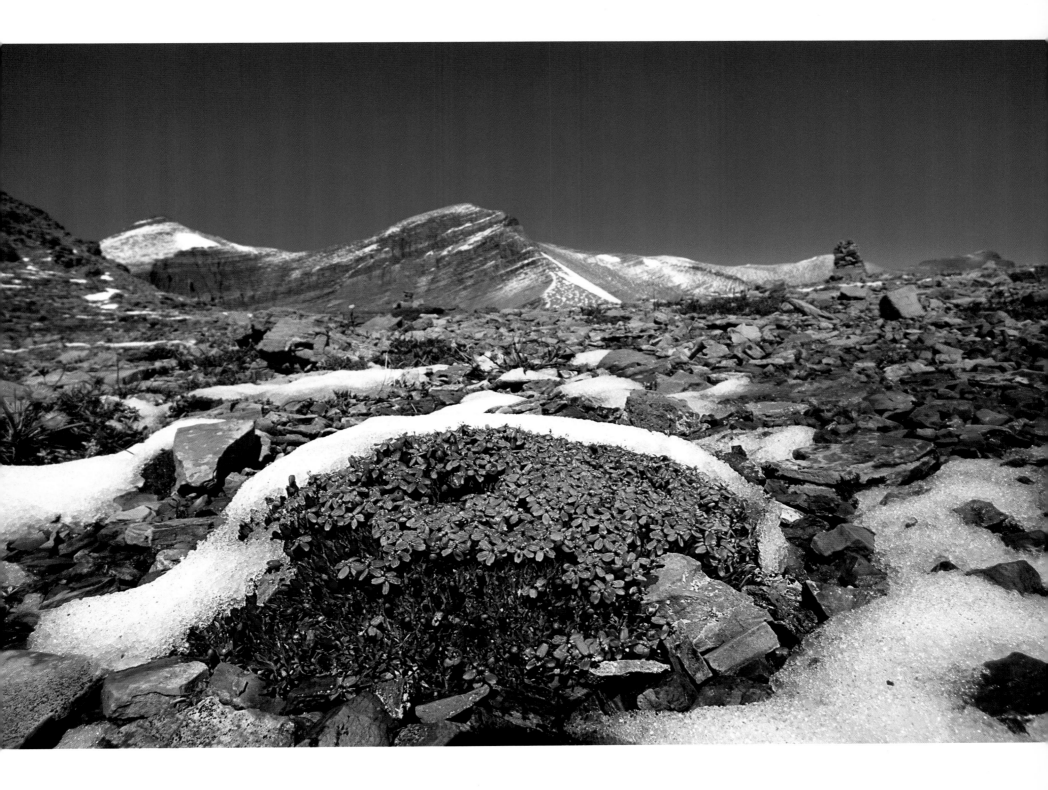

Above: The moss campion is typical of plants capable of enduring severe climatic conditions. It has developed a means of growing in cracks in rock before the snow has melted. The plant accomplishes this due to the cushionlike structure of its leaves and stems, which give it remarkable protection against drying winter winds and minimal exposure to external elements. In summer, the exposed, large surface area of its leaves gives the plant excellent photosynthesis. This species, as well as others related to it, is found in mountain areas, at lower altitudes, and in the tundra, where climatic conditions are very similar.

In steep terrain such as this, where a river flows between cliffs in the mountains of Montenegro, European fauna and flora still live relatively undisturbed. Completely wild country is receding rapidly all over the continent, and tourism now enables people to go virtually anywhere. However, every once in a while, especially in mountainous areas, the decline of agriculture produces a return to "wilderness."

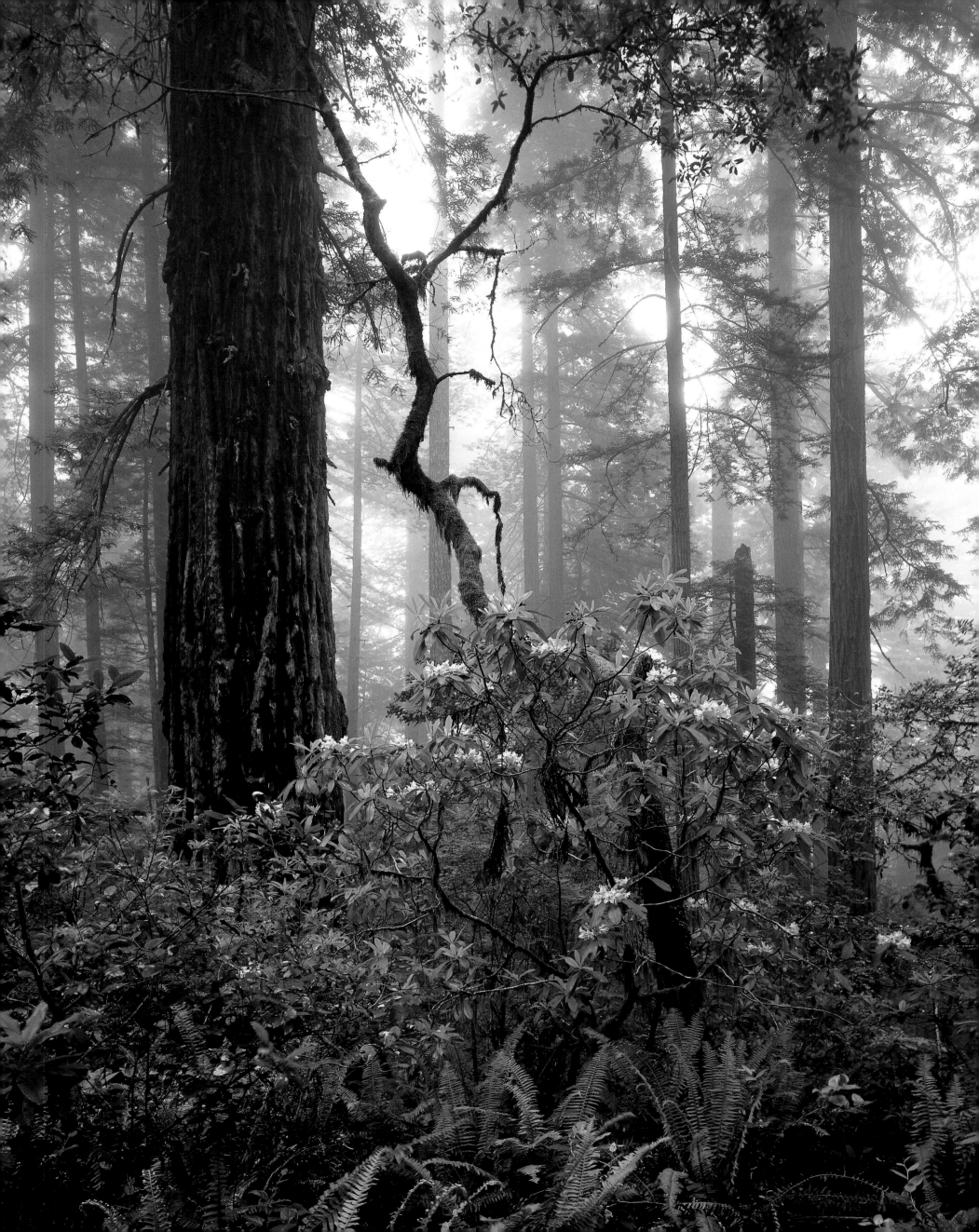

Forests

There are a thousand forests on earth. They differ so much from each other that we might wonder whether they are actually the same habitat. What does the "domesticated" temperate forest of Europe have in common with the riotous forest on the equator? Or a mangrove swamp, this forest "with its feet in the water" that grows on the shores of tropical seas, with the vastness of the taiga, a veritable frozen jungle alternately thick and sparse; or the tundra, a "miniature" forest with its bushes and dwarf shrubs—alder, birch, and willow—that form heathland?

Left: The forests on the Pacific Coast of North America, stretching from Alaska to California, are among the most impressive nontropical forests on the planet. In California, huge sequoias grow in the forests, which are fairly wet environments covered with moss and giant ferns. The sequoias are often shrouded in mist that steals in off the ocean, and the extraordinarily tall trees (some measuring more than 350 feet in height) then disappear into the clouds, as here in Redwood National Park.

This multiplicity of worlds never leaves us cold, even if we may feel more at ease in one world than in another. Being French, I'm well acquainted with the forest of Rambouillet, southeast of Paris. I observed herds of does and listened to the belling of a stag; in short, I experienced moments of total wonder.

Undoubtedly it is difficult for Westerners to experience and immerse themselves in the world of the tropical forest. I am happy to learn and discover things there, but I would not want to live there. One astonishing fact about tropical forests—home to more than three-quarters of known plant and animal species, even though they cover only 7 percent of the planet—is how difficult it is to observe animals there. In spite of their fabulous diversity of life, these tropical forests are cryptic, hiding themselves right in front of our eyes. When walking through the Amazon, you actually hear far more than you see. Sometimes, life suddenly bursts out, as in the "salt pans" of Congo or Gabon, those damp, salty clearings in the forest devoid of trees. It is as if one had taken the lid off the forest. There, astonishing encounters sometimes happen with the local fauna, notably with gorillas.

Forests in temperate regions, in middle latitudes, are home to deciduous trees; forests in more extreme latitudes, known as boreal forests, consist of conifers. These are the most widespread in the world in terms of surface area. They also contain fantastic old-growth forests, where one can feel as remote as if in the depths of the Amazon. In British Columbia, for example, the rain forest is home to large animals such as the grizzly bear and the wolf, whose coat can range from white to jet-black. Forests such as the Bialowieza in Poland (where the European bison still roams) are reminiscent of the habitat that must have covered Europe as recently as 12,000 years ago. The immensity of the taiga goes beyond the bounds of the traveler's imagination. It forms a blanket of forest between 300 and 1,000 miles wide, stretching across America and Eurasia and covering an area equal to about 1.2 times the size of the United States. The tree species most commonly found in the Bialowieza include the spruce, fir, and larch. The ground is carpeted with lichen and bilberry, whose leaves turn red with the first frosts at the end of August. Both the taiga and the tundra have a predominance of ice, as the ground deep below the surface remains frozen all year. In summer, the only part of the ground that thaws is the surface, allowing plants to grow. Below ground the earth is frozen—a legacy of the last ice age. It contains perfectly preserved animals, such as the mammoths discovered in ancient frozen peat bogs in Siberia. Approximately 26 percent of North and Central America's land area is covered with forest according to figures from 2000. This number is sure to decline. In the United States one of the main causes of deforestation is unrestricted cattle grazing.

Forests have met different fates in other parts of the globe. In Western Europe, forests are in fairly good health. Forested areas have returned due in part to a decline of agriculture—a return to the "wild." This has led to the reappearance of large predators such as the lynx and wolf. Deer, too—such as the red deer and roe deer—and wild boar have never been as healthy as they are now. By contrast, North America's old-growth forests have shrunk by almost 90 percent since Europeans set foot on the continent. Elsewhere, boreal forests are doing well. It seems that the climate change under way and the increase in carbon dioxide in the atmosphere are favorable to tree growth, and to the forest's northward expansion at the expense of tundra. This open landscape, where the vegetation is thin, is home to millions of birds; it is gradually retreating as the taiga advance northward. Experts estimate that in certain places the tundra could shrink by half by the end of the century.

The polar regions, the oceans, Latin America, the Galapagos, and Madagascar—while all of these places are causes of concern regarding their respective biodiversities, they are not nearly as critical as tropical forests. They consist chiefly of evergreen trees in areas of high rainfall, of deciduous trees in areas where there are dry seasons, and of scattered trees forming a wooded savannah in arid regions. Everywhere, though, they are disappearing due in part to the chainsaw—from the Amazon to Indonesia, Southeast Asia to the Congo basin, and the forests of Guinea in West Africa.

In spite of their fabulous diversity of life, these tropical forests are cryptic, hiding themselves right in front of our eyes.

Fire, frequently ignited by lightning, is part of the natural cycle of regeneration of these forests. It destroys the forest canopy, allowing light to reach the ground, and enables young trees to grow. But there are other fires, too. Humans cause fires, either deliberately to clear land for agriculture or by accident.

Destruction of the forest makes land vulnerable to erosion and floods, which rapidly remove the soil. In a few years, agriculture will become impossible. Extensive forest cover plays an important role in the climate. When forests are fragmented, the fauna and flora of each fragment are isolated, and species can become locally extinct. Each year, about 54,000 square miles disappear in this way. To give just one example: only 7 percent of the original Mata Atlântica in Brazil—an astonishing Atlantic forest—now remains.

The tropical forest is a prodigious and unequalled reservoir of biodiversity. It is chilling to see how determined we are to eliminate it. How many species are being wiped from the planet, without ever being discovered and studied by scientists? How many people know that a single tree in the Peruvian forest can be home to 600 different species of beetle? If it were to be destroyed, together with the species living on it, how many of those species would be wiped out forever? And do we need to remind ourselves that one out of every four medicines in use today uses a molecule or an active ingredient that comes from tropical forests? The loss of biodiversity also jeopardizes the future of medical science.

> Do we need to remind ourselves that one out of every four medicines in use today uses a molecule or an active ingredient that comes from tropical forests? The loss of biodiversity also jeopardizes the future of medical science.

The forests of Borneo, among the finest tropical rainforests on the planet, have been almost annihilated just in the last 15 years. Sixty percent of this forest area, which is shared by Malaysia and Indonesia, has been devastated. This plunder is sickening. Just to gather a few varieties of valuable wood, all the surrounding forest is destroyed, together with the humus that would allow the soil to recover. I also carry in my memory a pitiful, pathetic image of the consequences of this conveyor-belt destruction: two little orphaned orangutans, driven out of their sheltering forest, clinging to each other and darting a terrified glance toward their mother, who had just been electrocuted on a power line. Just a few years ago, orangutans (whose name means "man of the forest" in Malay) could cross Borneo from north to south without leaving the forest. Today, this is impossible. A few pockets of forest, surrounded by buildings or wasteland, are all that remain.

Finally, when we interfere with living things in tropical forests, we also interfere with the humans who have been living in harmony with them since time immemorial. What will remain, at the end of this century, of the Korowais, who live in huts 150 feet above the ground in Irian Jaya (an area located in the countries of Papua New Guinea and Indonesia)? To escape the mists that envelop the forest, and their enemies as well, they have built their houses in the treetops. Their children and livestock also live up there. What will the future be for these people of the trees, who communicate by whistles? Will they be victims of the voracious appetites (and diseases) of "civilization"?

Now that this civilization has reached all continents, there is hardly an untouched haven left anywhere on earth. Perhaps one may be found in the depths of the Amazon, where a few forest peoples have deliberately remained apart from the dominant culture of their neighbors. There is certainly no guarantee that loggers, gold prospectors, oilmen, or governments will leave them in peace for too long. And yet these forest people, with their culture, values, and vision of the world and its living things, have so much to teach us. They consider the other creatures of the forest as their equals—true fellow-citizens in the most political sense of the word.

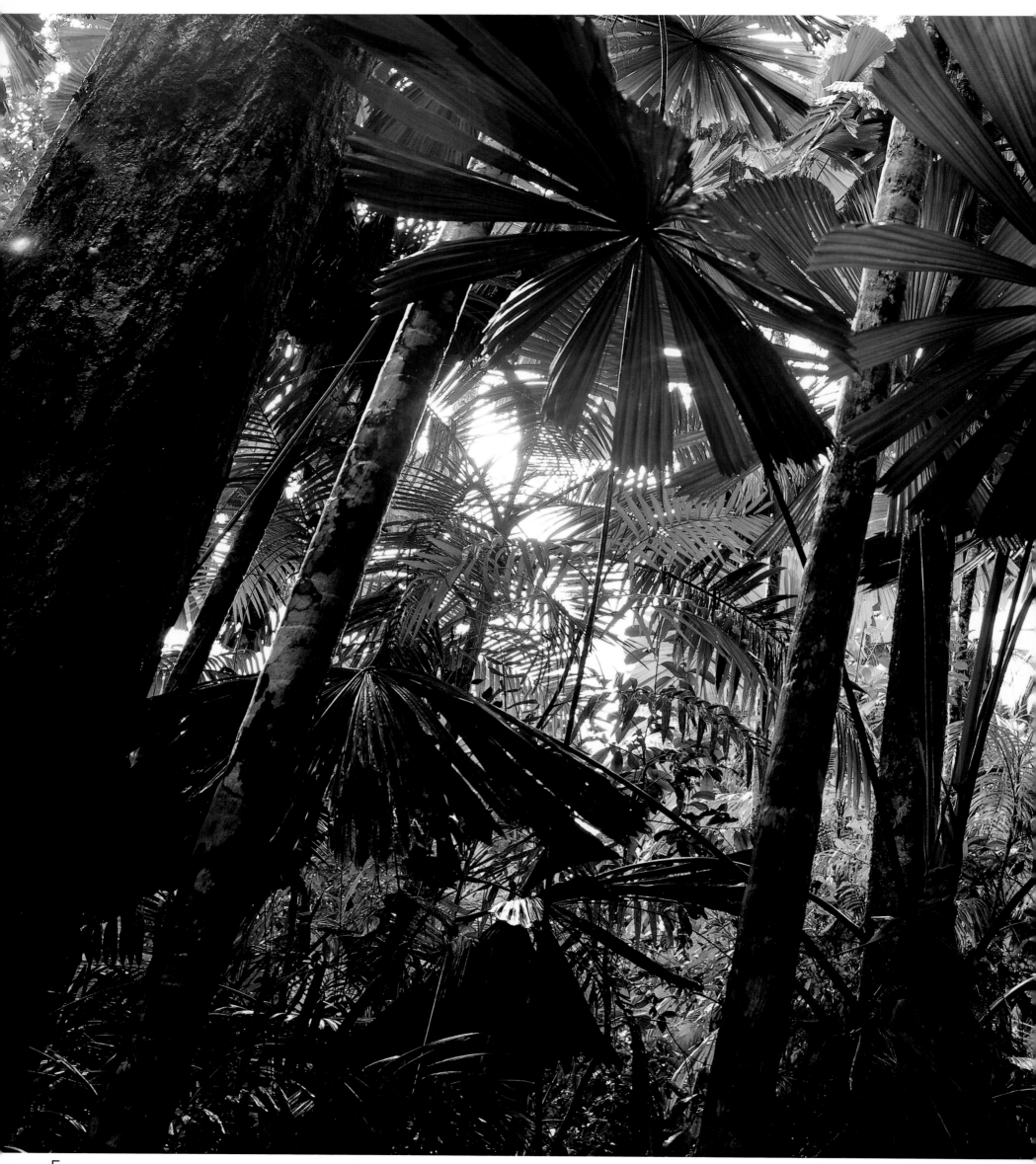

Above: Tropical rain forests contain more tree species than any other habitat. In some parts of the Amazon basin and Southeast Asia, as many as 100 species may grow side by side in about two acres. Here, in Queensland, Australia, palm trees form a thick subcanopy that lets through little light.

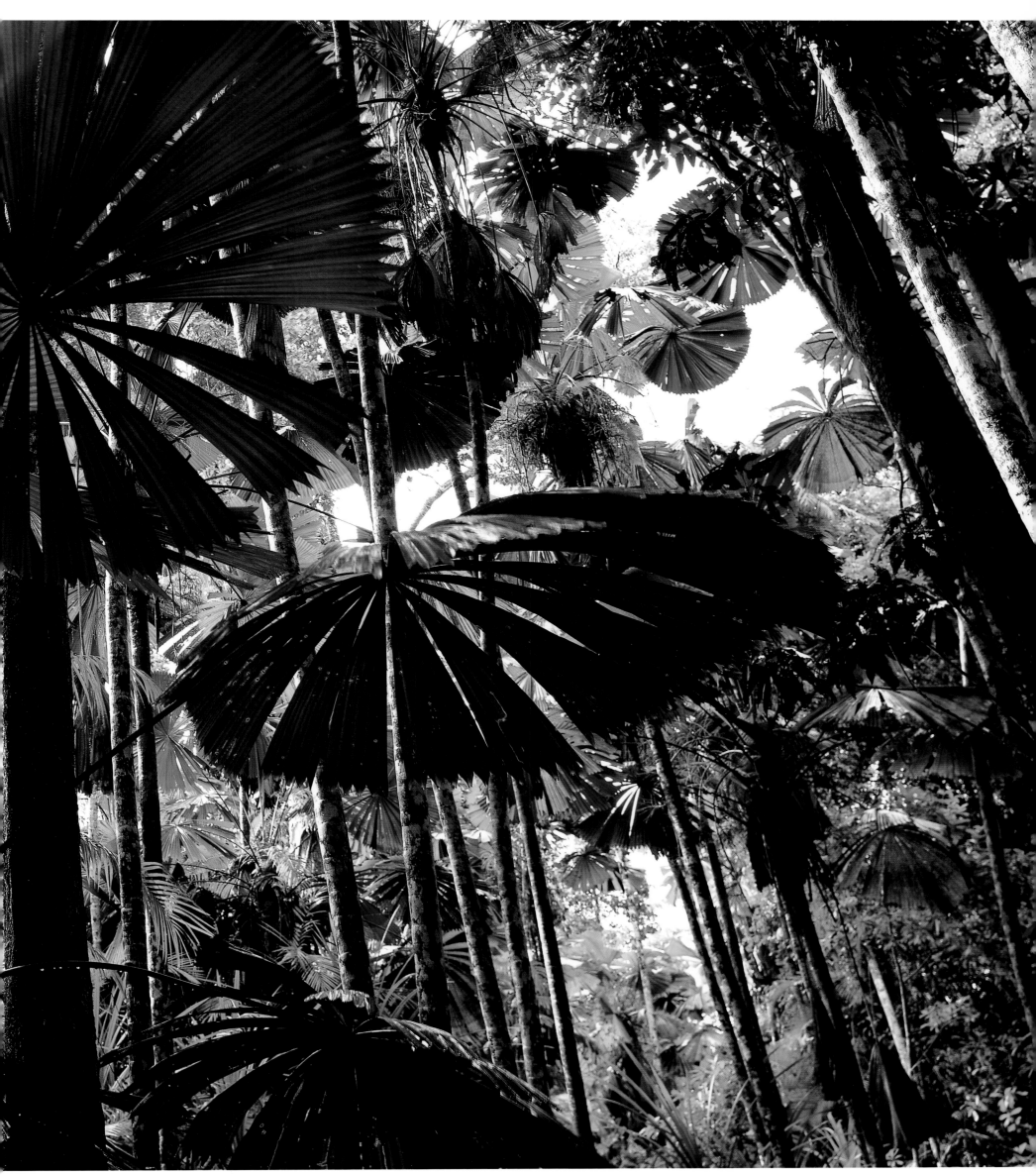

Following pages: From the forest to the savannah, the ancestors of modern man learned how to walk erect and set off to conquer their environment. Today, some humans still live in the forest. In the depths of the Amazon forest, in Gabon and Papua, these forest peoples—sometimes referred to as "first peoples"—have managed to live in harmony with their environment over tens of thousands of years, taking from it only what they need. Now, as other humans arrive, not only is the forest becoming endangered, but all living things in it as well, including the forest peoples themselves.

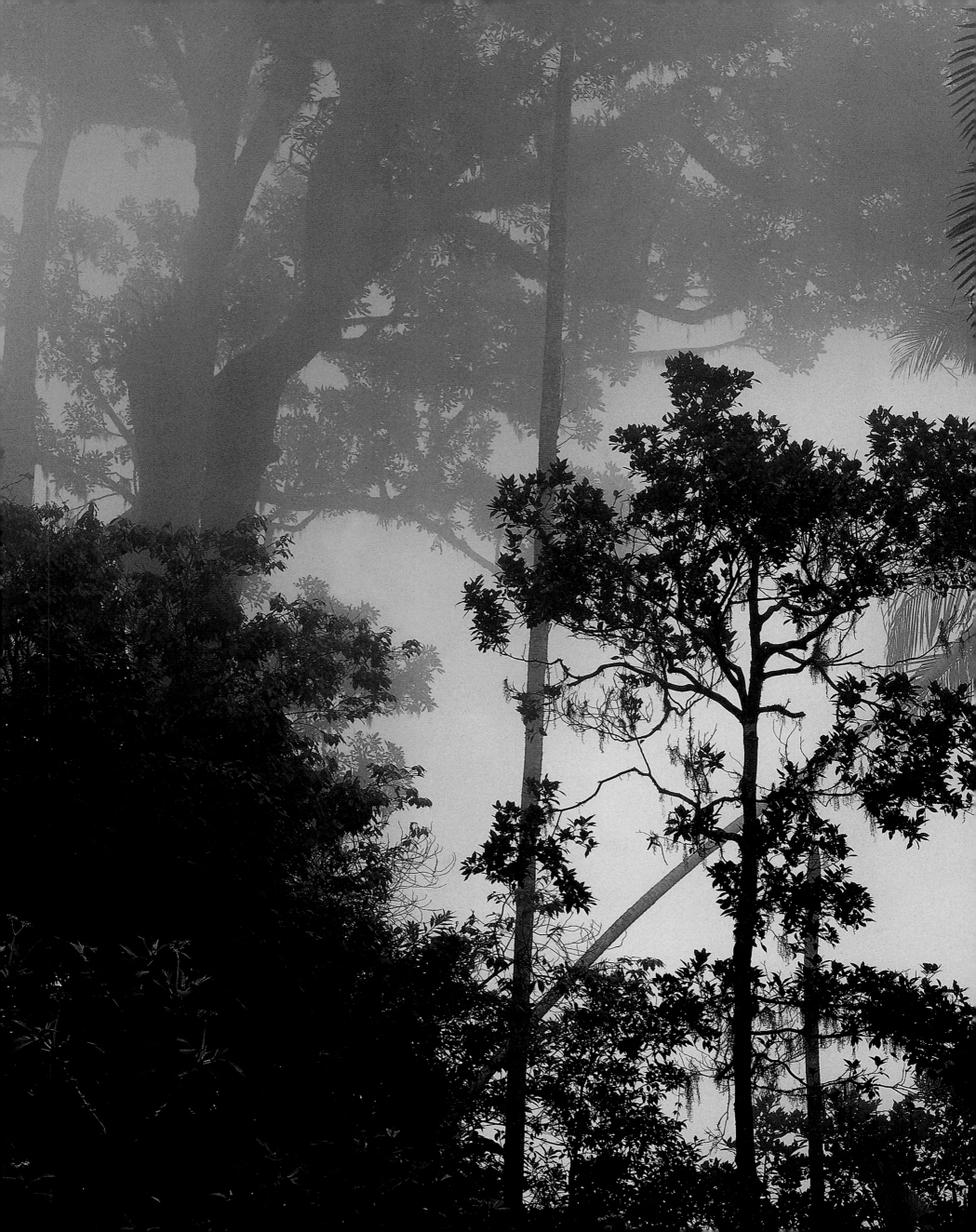

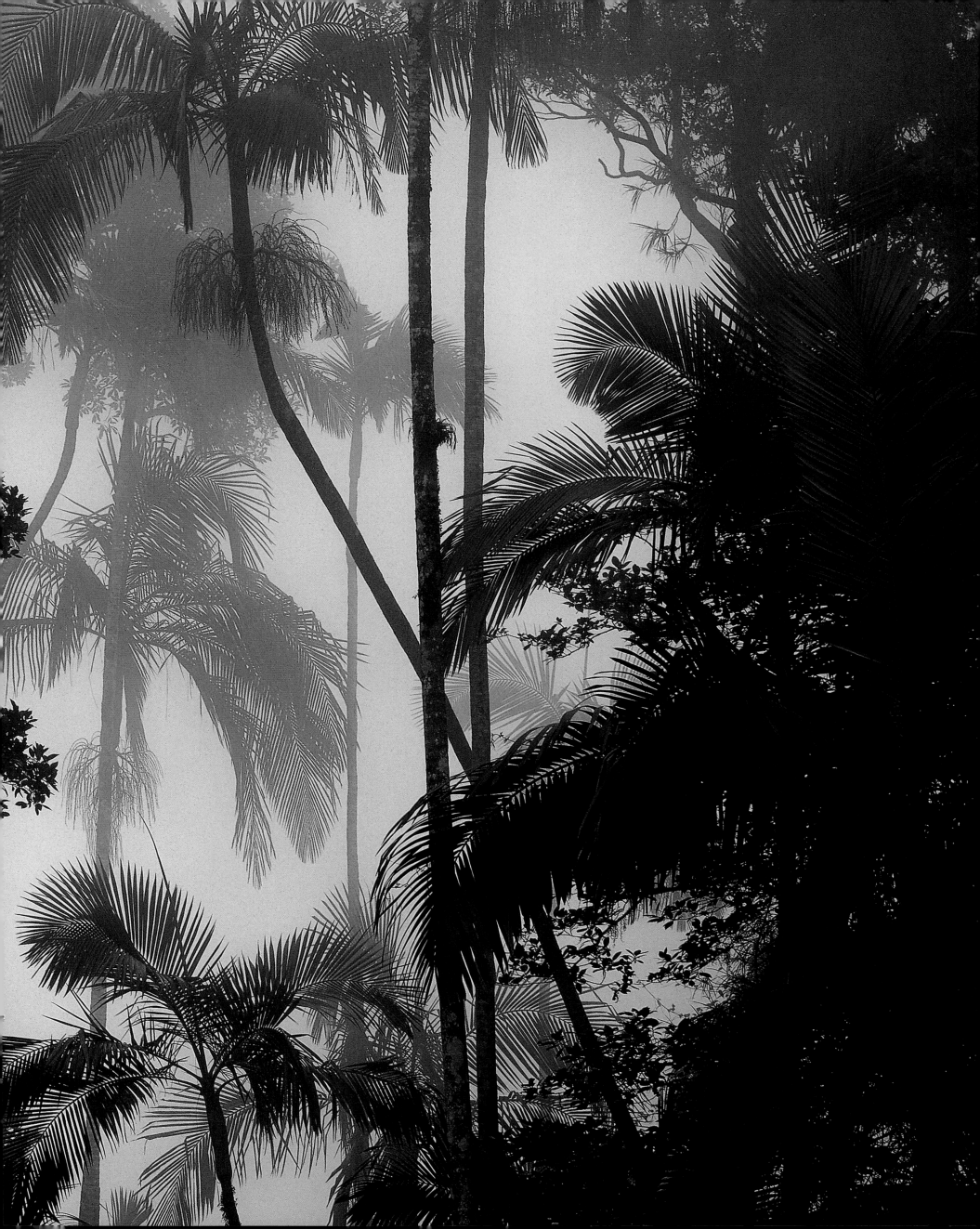

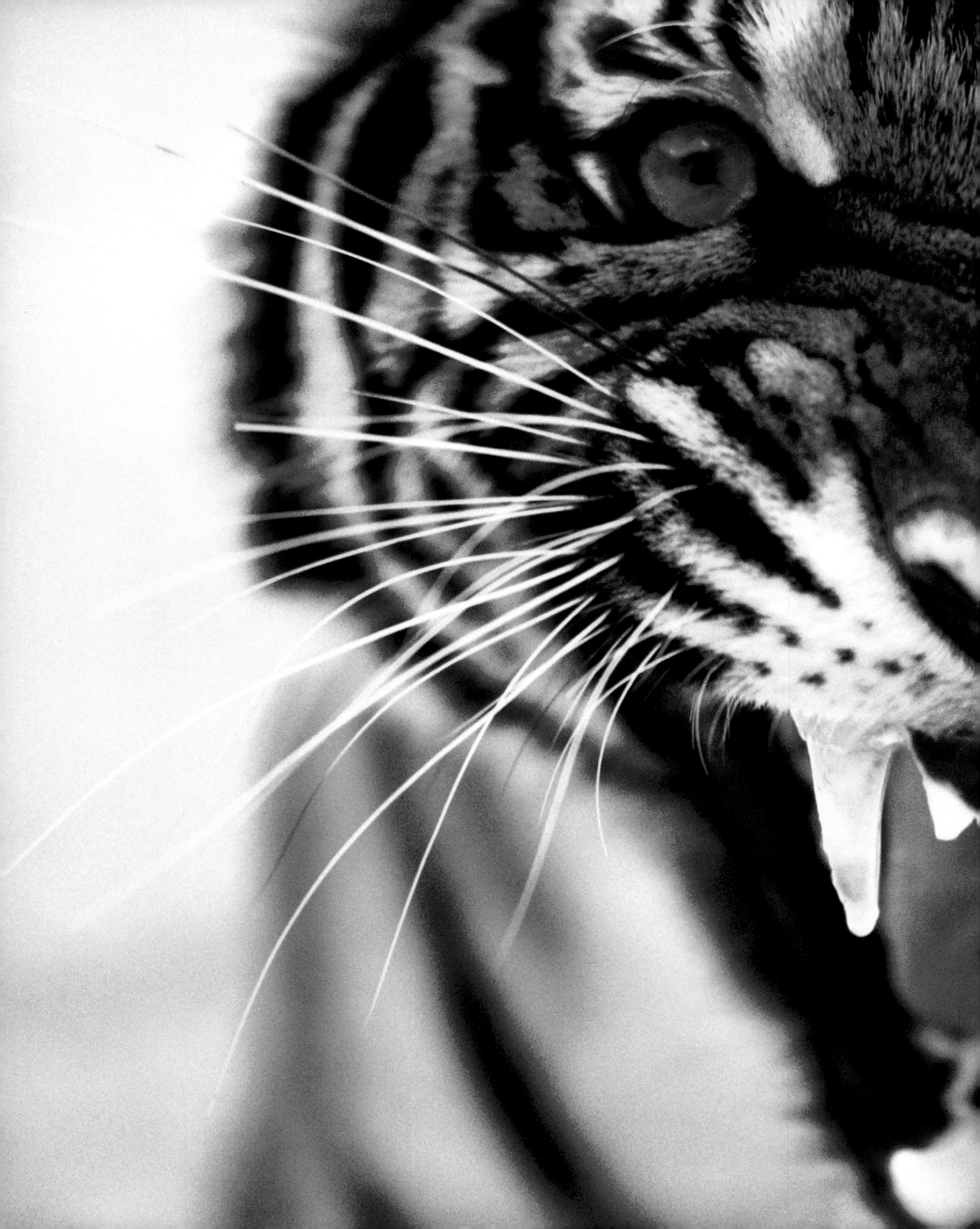

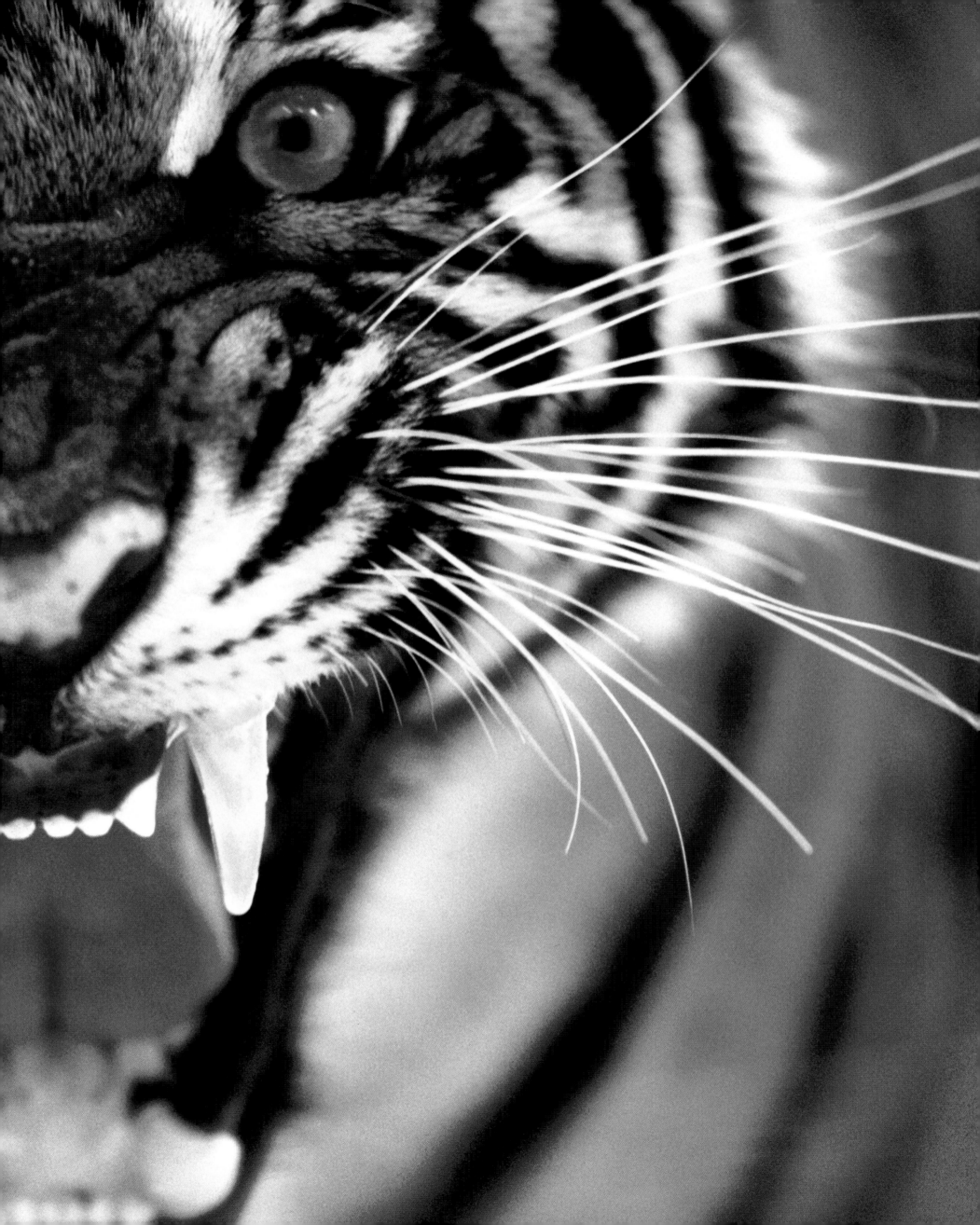

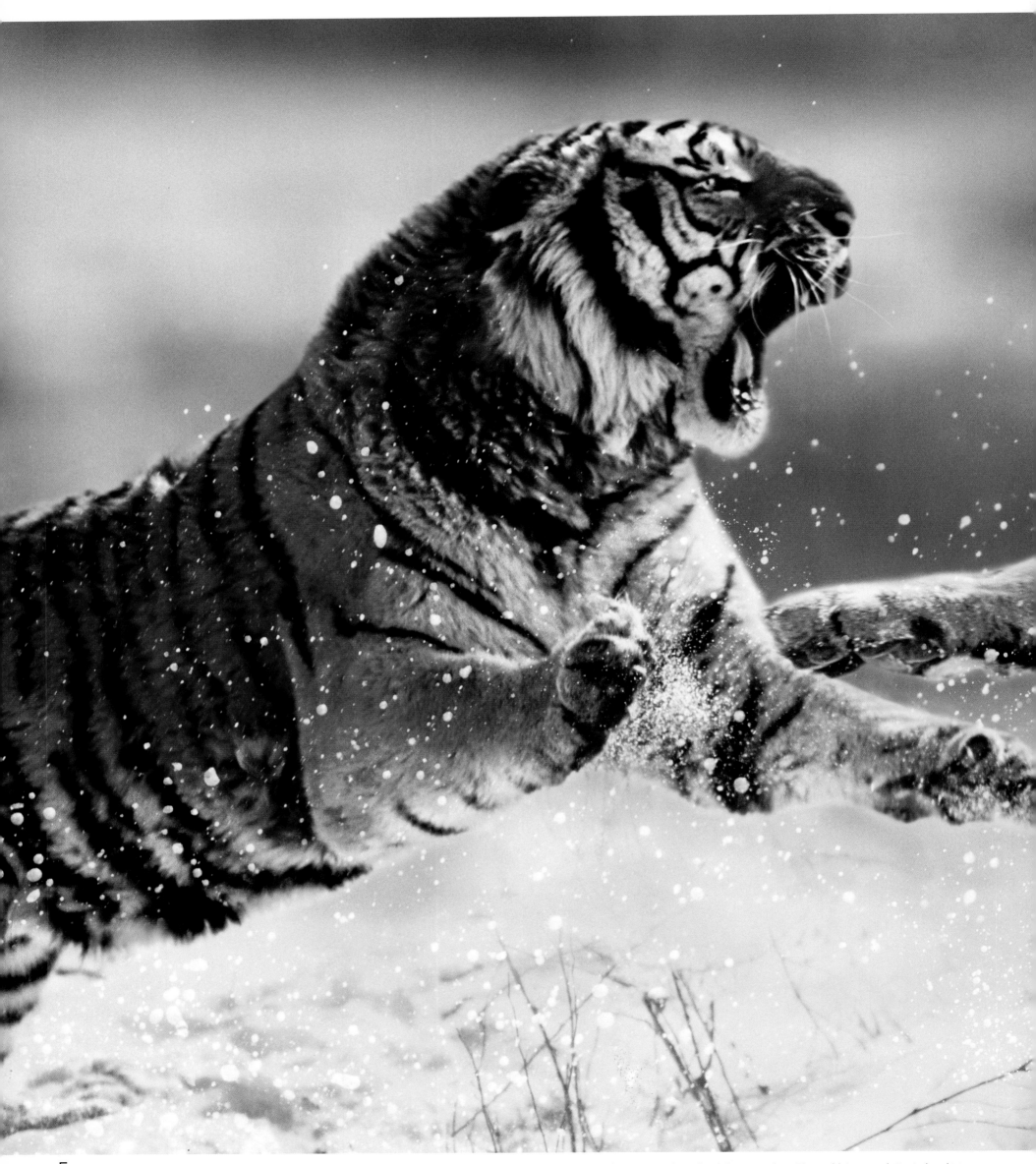

Preceding pages: Every single subspecies of tiger faces extinction today. Of all known subspecies, three—the Caspian, Balinese, and Javan tigers—have already been wiped out. The world tiger population is thought to number between 5,000 and 7,200, but this may be an overestimate. In India, the species' last refuge, only 3,500 remain. At the beginning of the 20th century, the tiger population was estimated at 100,000. In the span of just a century, the number of tigers in the world has fallen by 95 percent.

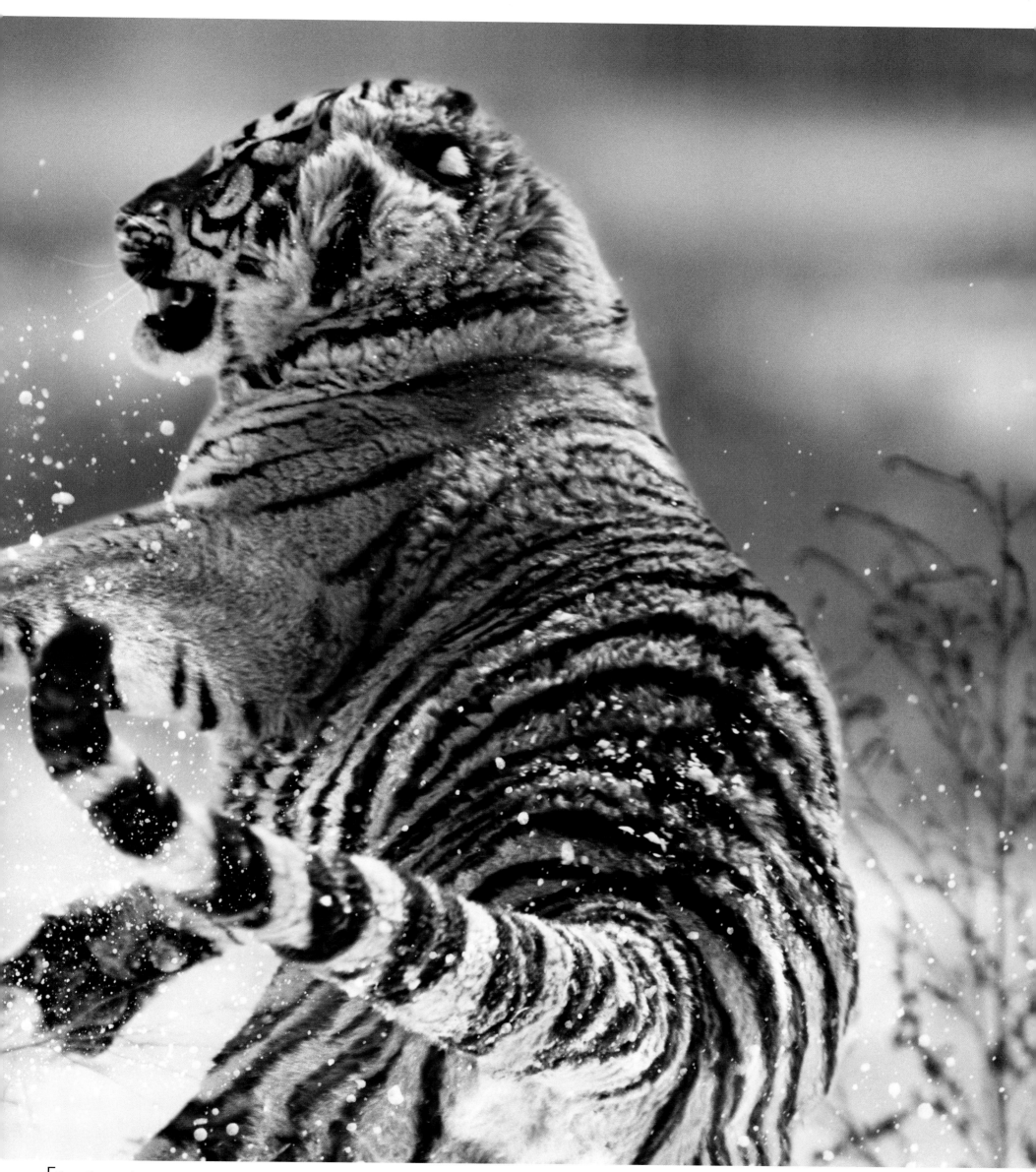

Above: Playing in the snow in the depths of a great forest in southeastern Siberia, these tigers are unaware of their plight. Only about 400 of this subspecies are still living in the wild. Their decline is due not so much to loss of their original habitat as to hunting over a long period of time. Today, clear-cutting is avoided in areas where the species still lives; instead, trees are cut more selectively, to retain the forest clearings that attract the ungulates on which the tiger feeds. Presently, the Siberian tiger population is thought to be stable.

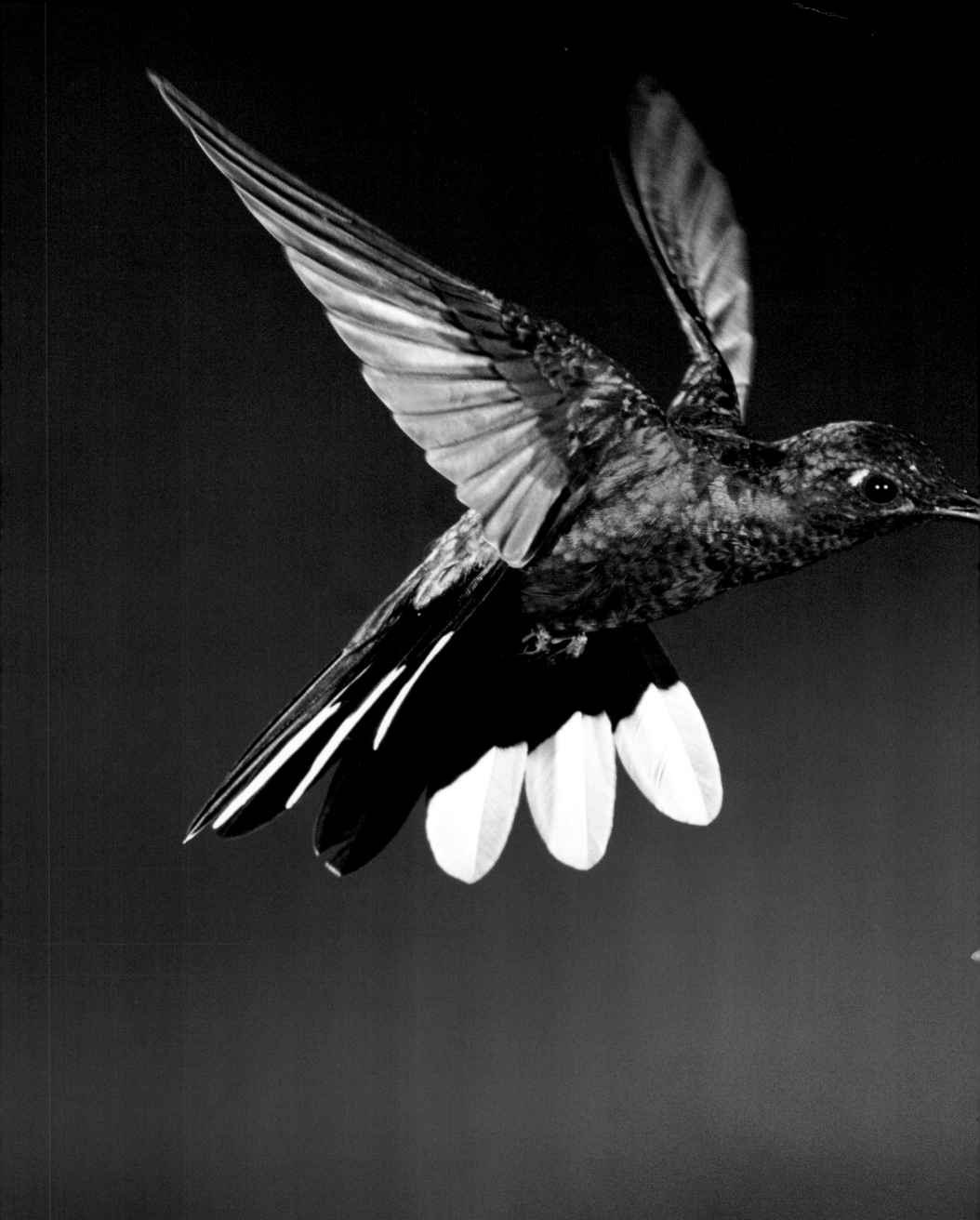

Above: The most remarkable orchids of temperate regions are undoubtedly those of the *Cypripedium* genus—such as this *Cypripedium franchetti,* which is found in China's Yunnan province. In North America, the famous and rare lady's slipper (the name refers to any of several temperate-zone orchids) belongs to the same genus; they are a completely protected species.

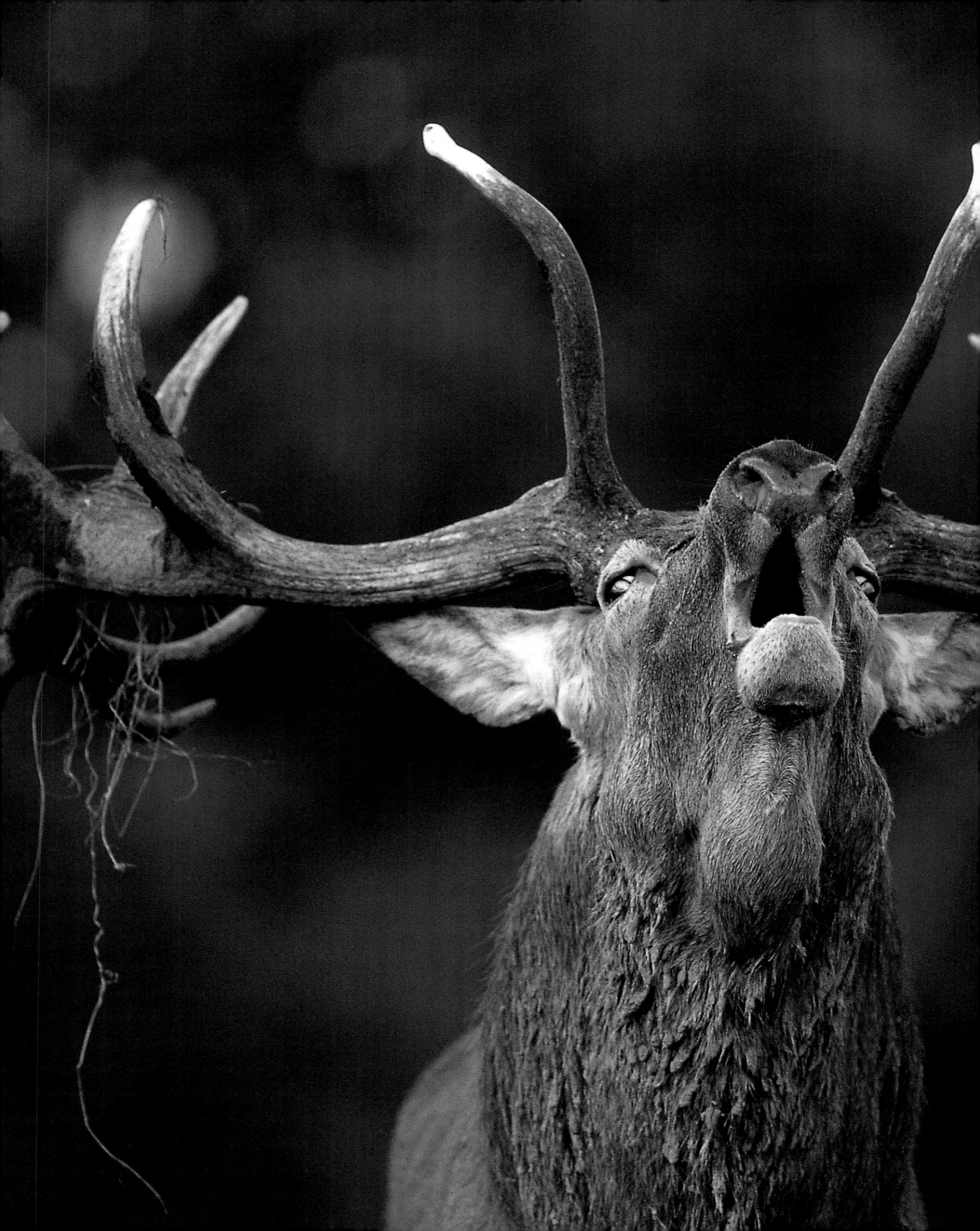

Left: In France, as in several other western European countries, the contraction of agriculture has resulted in an increase in the amount of forest cover. This "return of the forest" is very noticeable in many regions of France, which have not seen this much forest cover since the Middle Ages. Large mammals, such as this deer, benefit from this, especially roe deer and the wild boar; the latter have never been so numerous as they are now.

Above: Planted several centuries ago, pine forest now covers much of France's Mediterranean coastline. This habitat is home only to a low level of animal and plant biodiversity. Moreover, coniferous forest is very vulnerable to fires, which are becoming ever more numerous. The reasons for the increase in fires include the abandonment of farming and herding practices, growing human presence in the summer, and urban development. Droughts, which have become more frequent over recent decades, are also a factor.

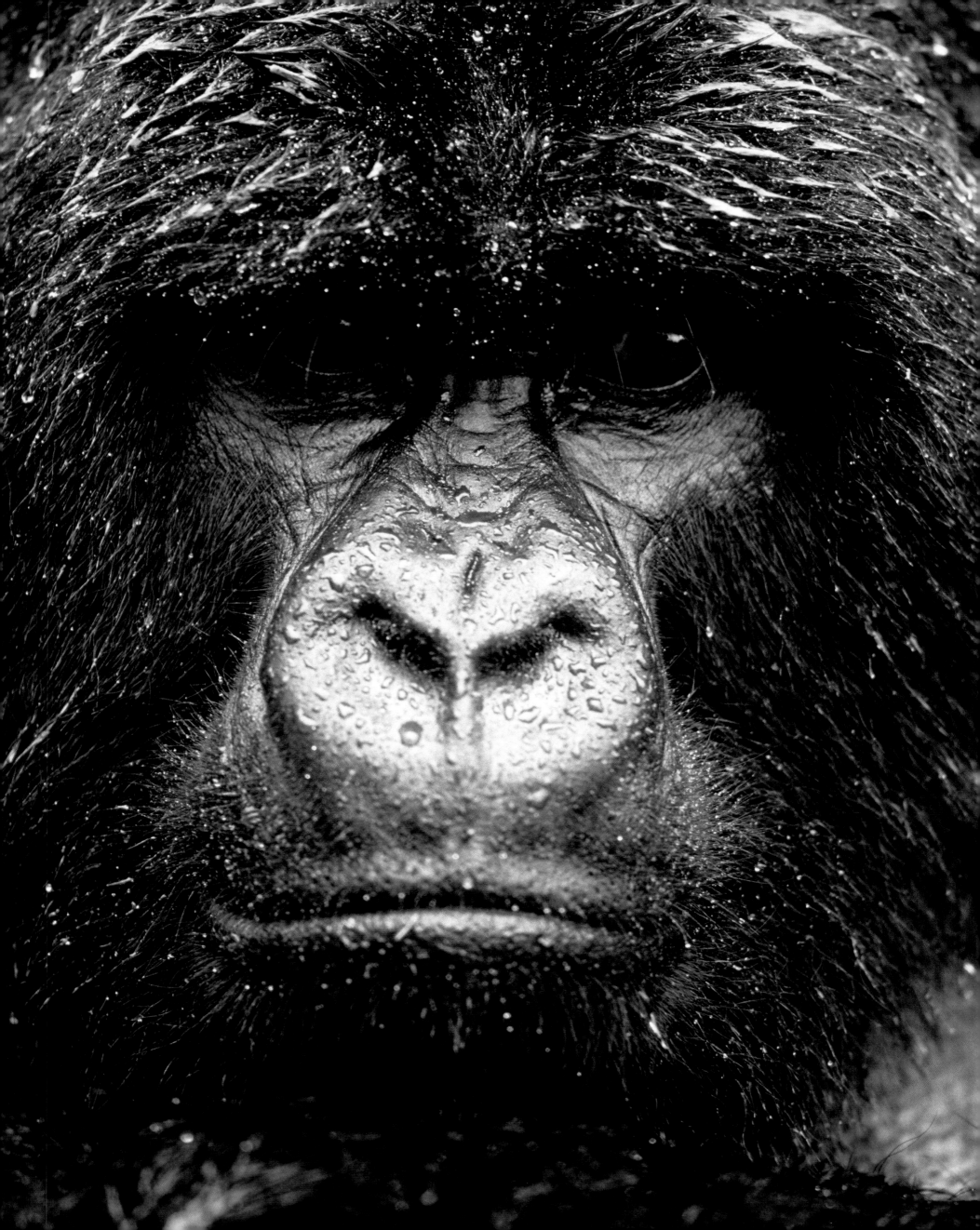

Preceding left-hand page: Here we see a mountain gorilla in the Volcanoes National Park in Rwanda. What has this mild-mannered animal done to deserve endangerment? Nothing. It is simply herbivorous, looks like King Kong, and has unfortunately found itself in the middle of a ruthless civil war.

Preceding right-hand page: An orangutan in Borneo's Sepilok Nature Resort. Its crime? Insisting on living in a tropical forest that is being cleared with the help of bulldozers, chainsaws, and fire, to make way for vast oil palm plantations. A sad future awaits these great apes.

Above: Aye-aye is a unique name, but not as unique as the biology of this lemuroid of the coastal forests of northern Madagascar. This nocturnal distant cousin of the monkey has enormous ears, which it uses to detect the noise made by insect larvae under the bark of trees. The aye-aye then tears off the bark with its incisor teeth, which grow continuously. Using its thin, pointed fingers—the middle one especially—and long claws it extracts the larvae. It is in danger of extinction because of deforestation.

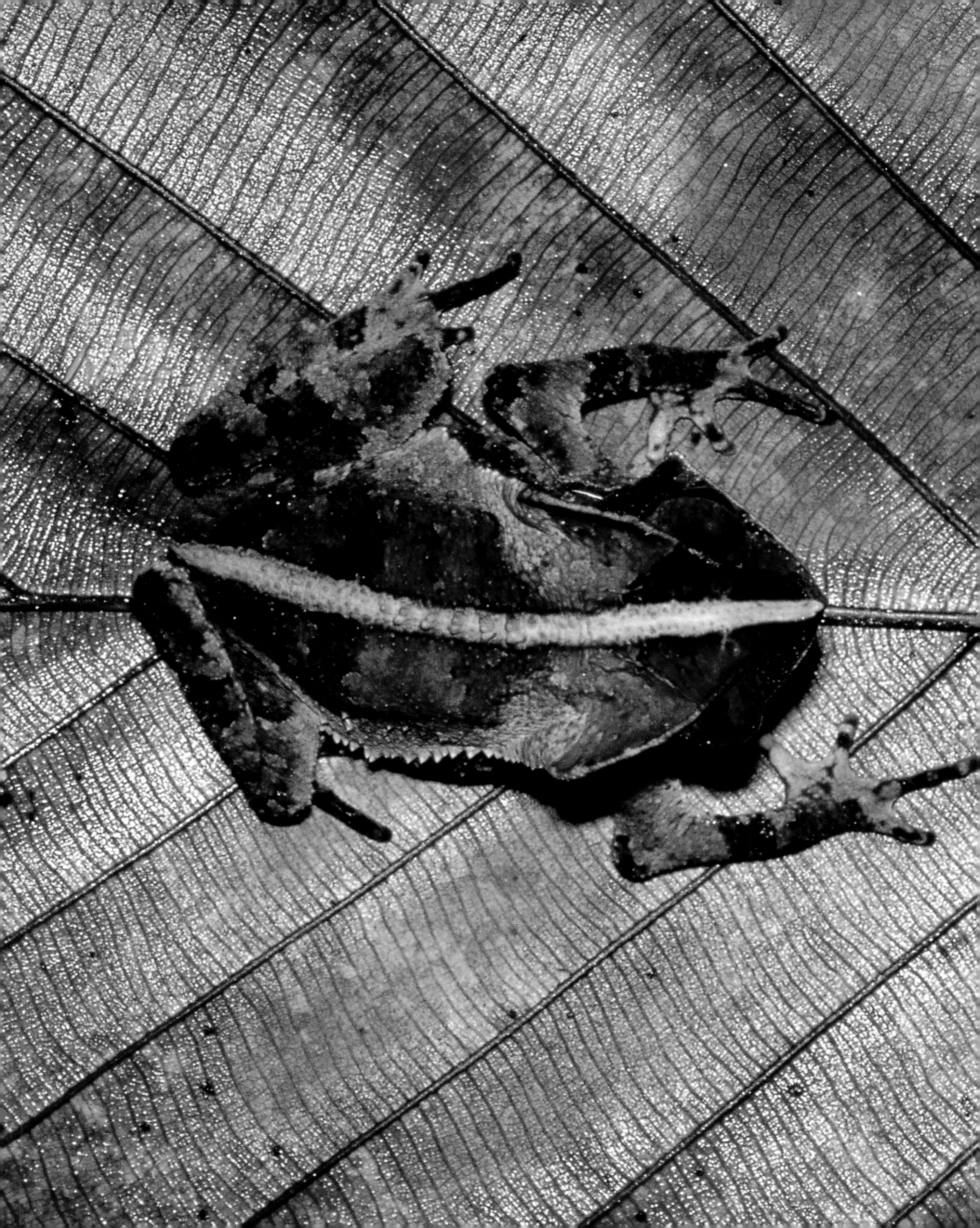

Preceding pages: Little is known about the insect life of tropical forests. There are surely thousands—perhaps tens of thousands—of species yet to be discovered. The world of insects, together with those of plants, bacteria, and fungi, is still largely unexplored, especially in forests. How many species will disappear from the face of the earth before they have been described?

Left: Many species of amphibian are suffering from diseases that are decimating their populations. As a result, scientists around the world have sounded the alarm. Amphibians are in danger of disappearing completely within a short time. It seems that this class of animal, which are both terrestrial and aquatic, is having difficulty adapting to the many changes the earth is undergoing, such as deforestation, pollution, pesticide use, climate change, and the like. They succumb more easily than other groups to infectious agents such as fungi, bacteria, and viruses.

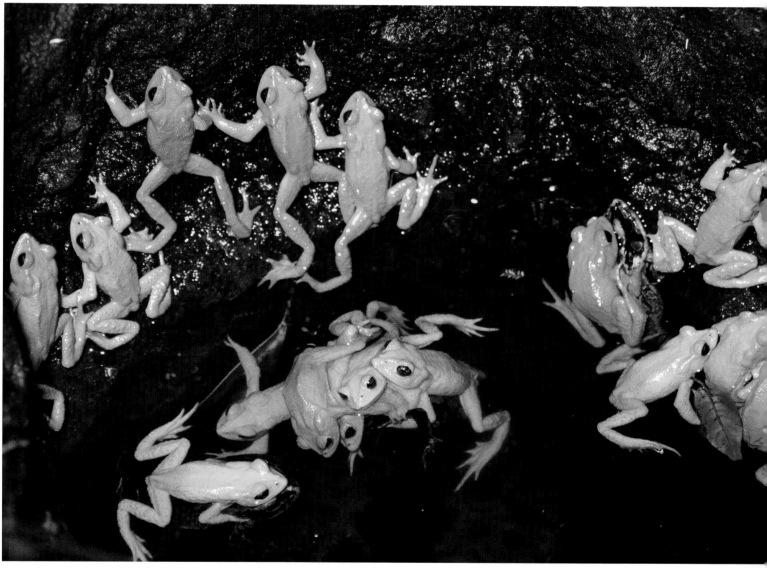

Above: The story of the golden toad is a perfect example of a species suffering from disease. Discovered by scientists in Costa Rica in the 1960s, the species became extinct in 1987. The reasons remain unclear, but it may be that the rise in temperature altered the water balance in the forests of Monteverde, where it lived, by slightly drying out the air. The toads may have become more vulnerable to a pathogenic fungus, which cause a fatal disease.

Right: Scientists do not yet know all forest-dwelling chameleons, which are often small and brightly colored. In Madagascar, for example, there is a large number of species, some no bigger than a fingernail. In recent years, Western countries have prized these chameleons, which have led to an increase in their trafficking.

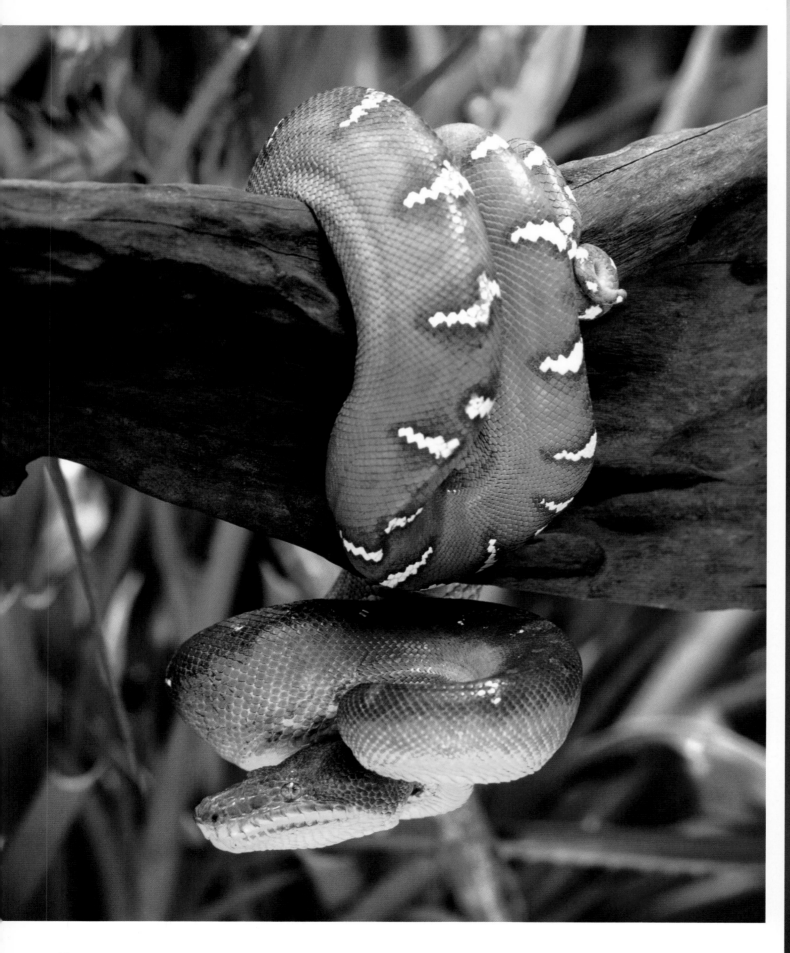

Above: Without a doubt the emerald tree boa is the most beautiful of the large constrictor snakes. It is a close relative of the huge anaconda and is found in the forests of South America. A tree-dwelling species, its skin color allows it to blend in with the surrounding vegetation.

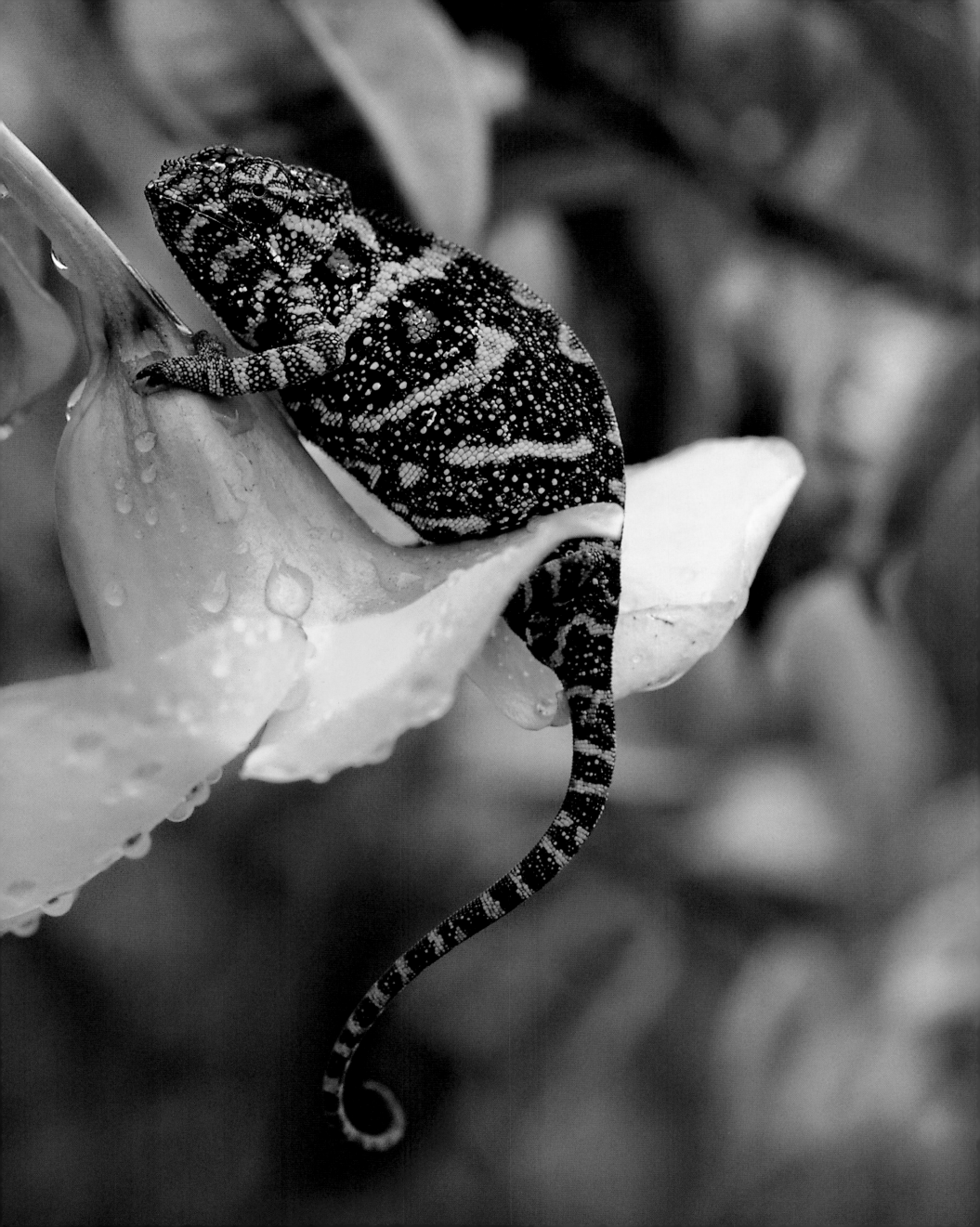

Above: This wintry forest in the Franche-Comté region of France is a veritable reservoir of biodiversity. In such forests a remarkable fauna survives (though now threatened), consisting of relict species that bear witness to a time when forests covered most of what is now France. First and foremost of these is the capercaillie (a type of gouse), which is rapidly heading for extinction. Others are the Eurasian pygmy owl and the three-toed woodpecker, which were present here in large numbers during the Ice Age. The Eurasian lynx has recently made a comeback in eastern France.

Following pages: This flower weighs about 15 pounds and has a diameter of just over one yard. It is the biggest flower on Earth. Rafflesia lives as a parasite on the stems of wild vines in the old-growth forest of Sumatra and Borneo, in Malaysia and Indonesia. Male and female flowers often grow a long distance apart, and it is probably due to the insects and other animals that feed on them that this plant can reproduce. Already rare, rafflesia is further endangered by the massive deforestation in this region of Asia.

Preceding pages: Mangrove forms veritable aquatic forests, buffer zones between land and sea. With their roots in the mud beneath the water, mangrove trees play a fundamental role in protecting the coastline from erosion, while also providing a refuge and spawning ground for fish and many invertebrates. They also help to mitigate the effects of some natural disasters, such as tsunamis.

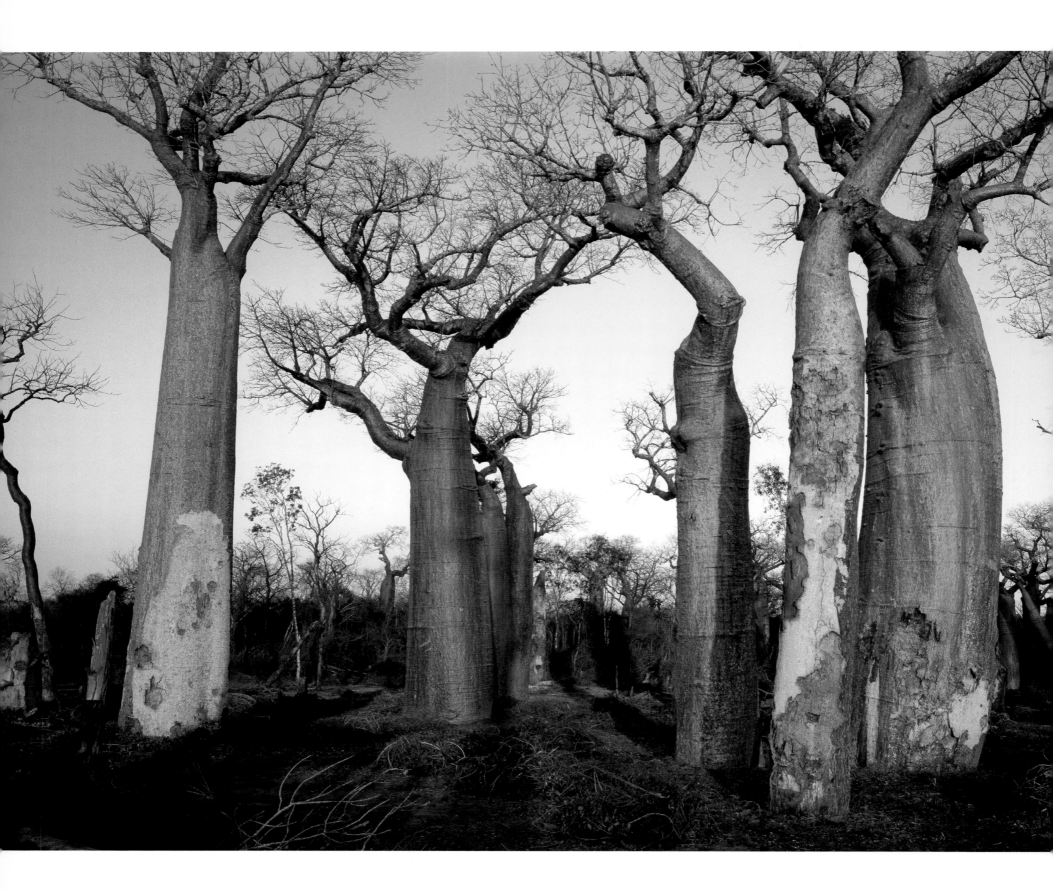

Above: The island of Madagascar is one of the most notable places on the planet for endemic flora and fauna, which is why it is one of the 25 world "hot spots." Although these hot spots account for only 1.4 percent of the world's surface area, they are home to 35 percent of vertebrate species (not including fish) and 44 percent of vascular plants—like the famous baobab pictured here. Madagascar has six species of baobab, whereas just one species is found on the African continent.

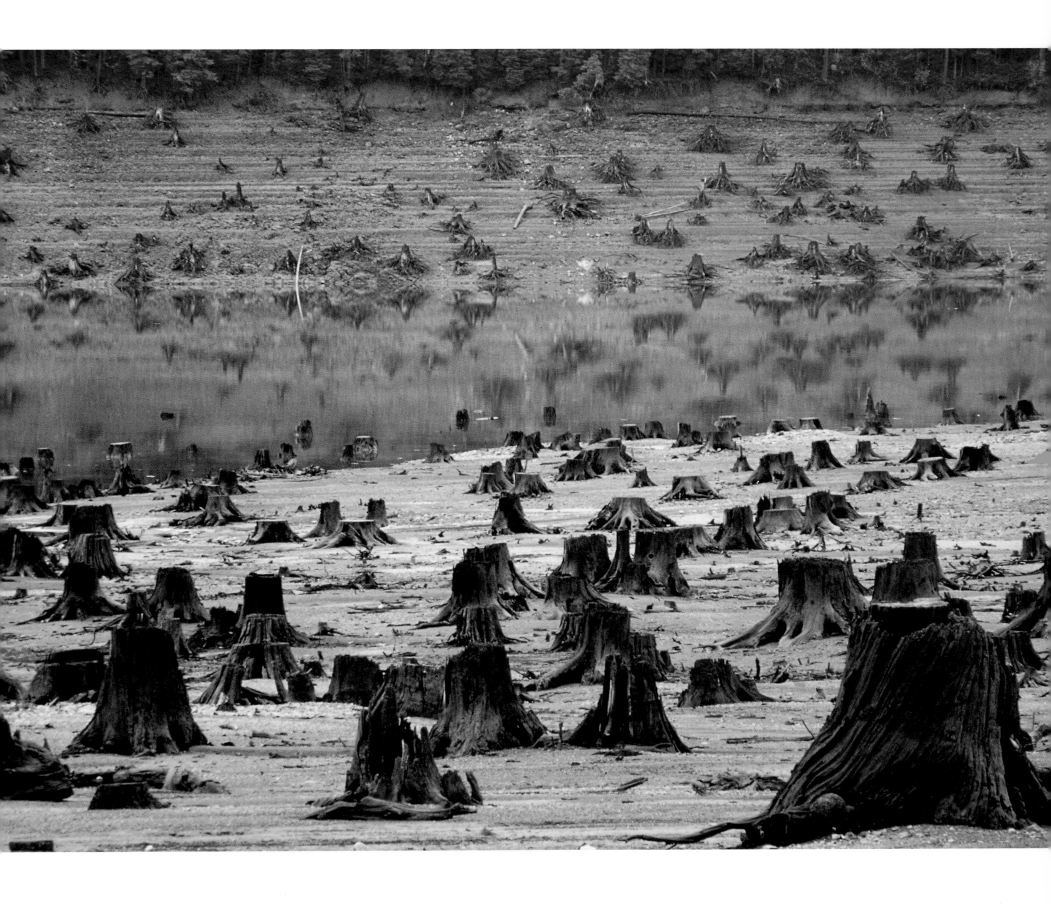

Above: Clear-cutting, pictured here in Oregon, goes against the most basic principles of responsible forestry. Not only does it remove most of the local animal and plant biodiversity, but clear-cutting impoverishes the soil and renders it fragile; it is literally washed clean when the rains carry away its fertile layer.

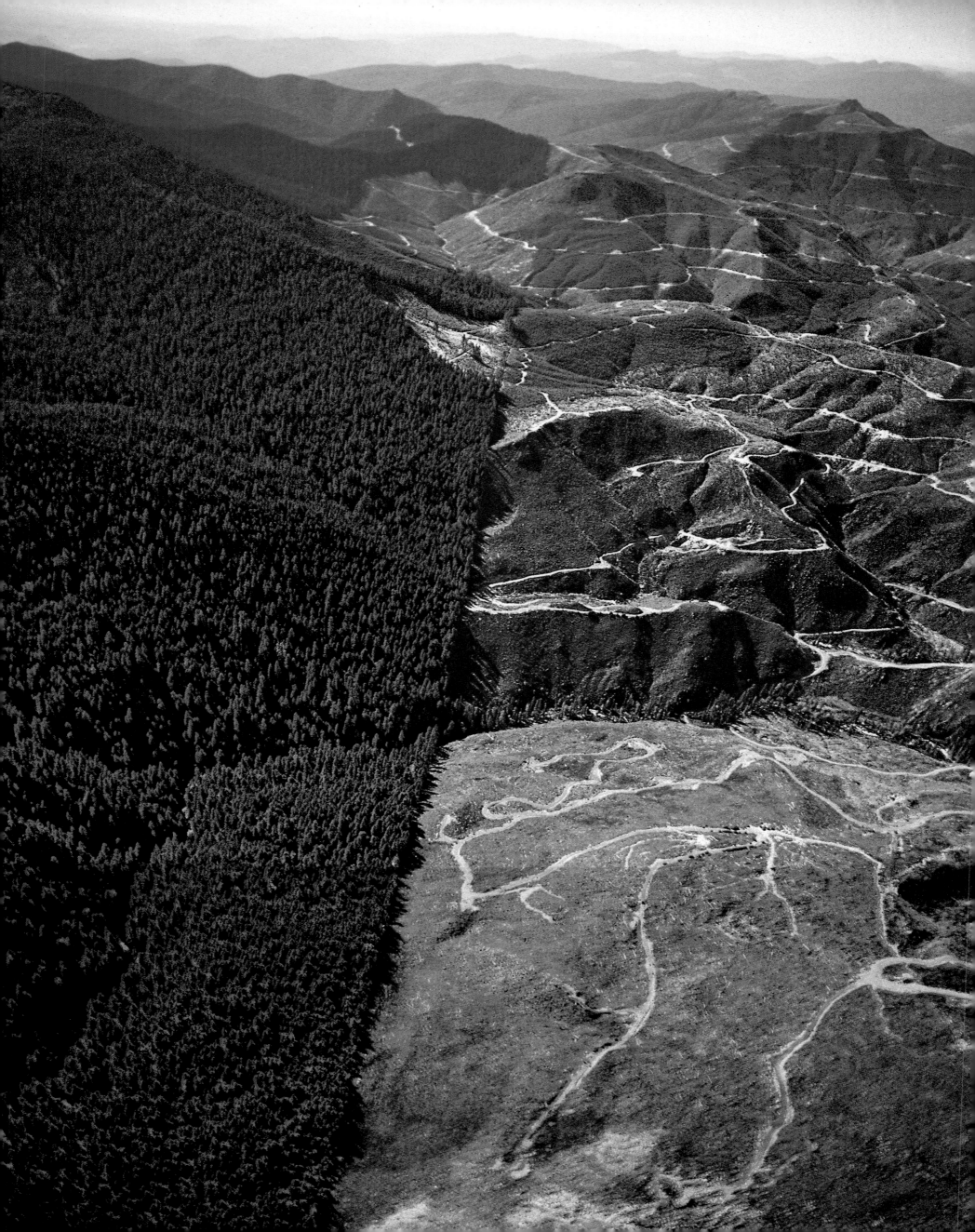

Left: This aerial photograph taken in Washington state clearly shows the appearance of a forest area before and after clear-cutting. In many areas of the world, clear-cutting has led to sometimes-deadly landslides after torrential rains—trees act as a natural buffer to landslides. Some natural disasters, such as the storms that hit Western Europe in December 1999, have less impact on forest biodiversity than this type of clear-cutting.

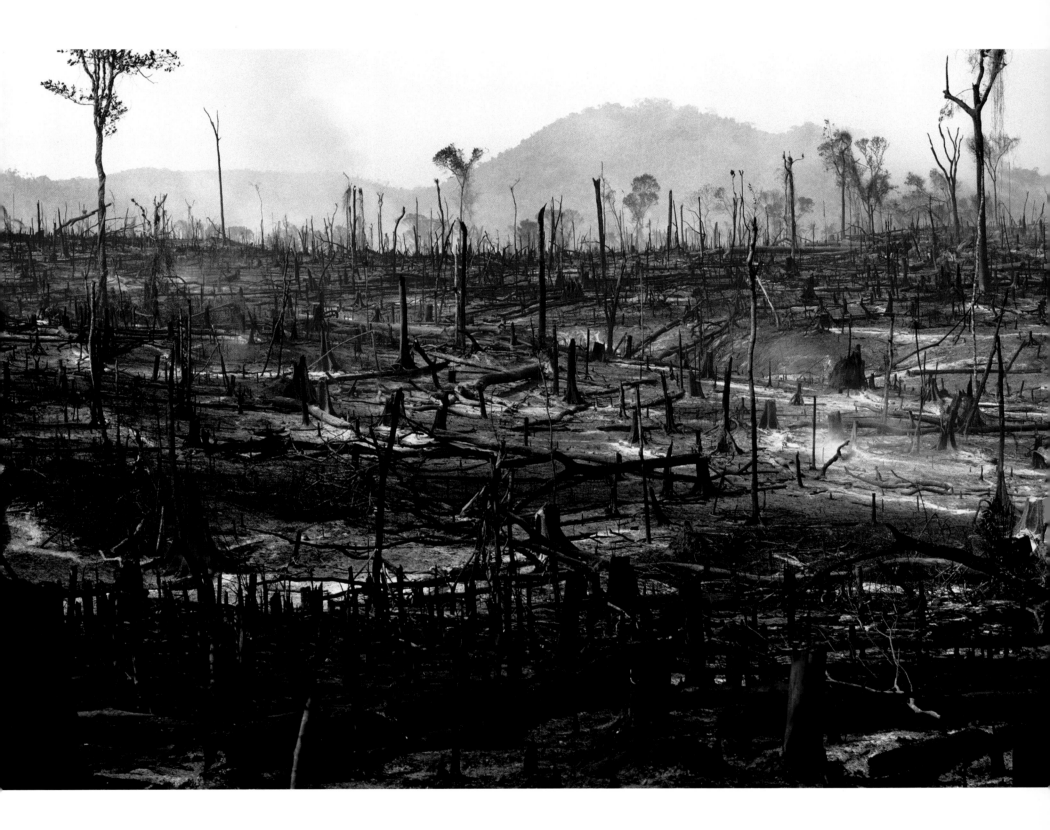

Above: Although slash-and-burn agriculture is traditional among the peoples of the Amazon basin, it is done on a very small scale (close to villages), and in such a way as to allow the old-growth forest time to regenerate. This has nothing in common with the gigantic fires lit by people with the aim of establishing grassland or the intensively farmed soy crops used for animal feed in the Unites States and Europe.

In an effort to be as close to the water as possible, these men have built their huts on floating teak trunks on the edges of the Irrawaddy River in Burma. In developing countries, the trade in tropical wood is threatening highly valuable woods, such as mahogany. In industrialized countries, it is preferable to choose available substitutes for these rare types of wood.

Above: Tinder polypores grow on this old tree trunk in a forest in the Queen Charlotte Islands in Canada's British Columbia province. Fungi play a vitally important role in forest ecosystems, because they break down and recycle organic matter. Tinder polypores, also known as hoof fungi, are more parasitic and attack the living tissue of trees.

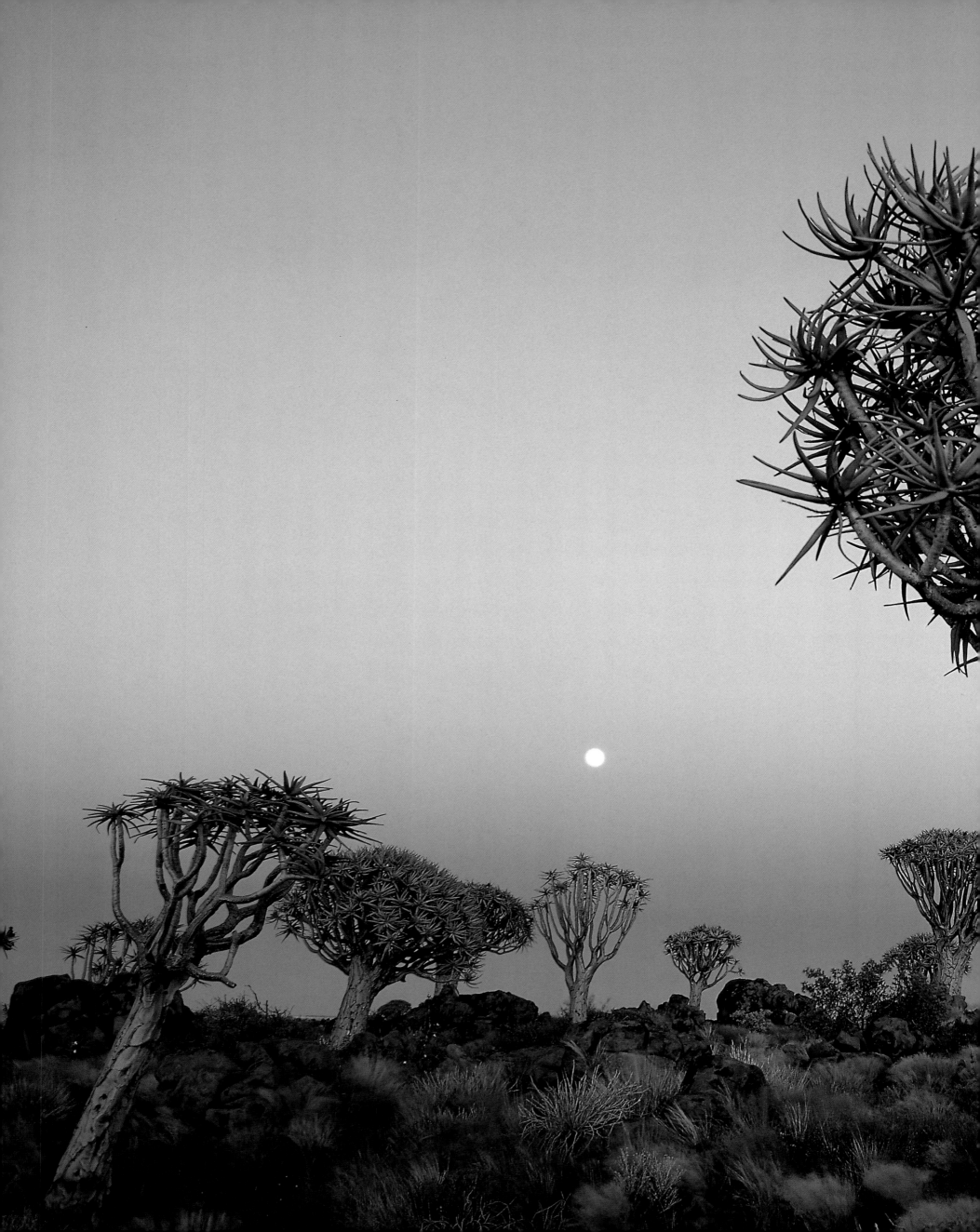

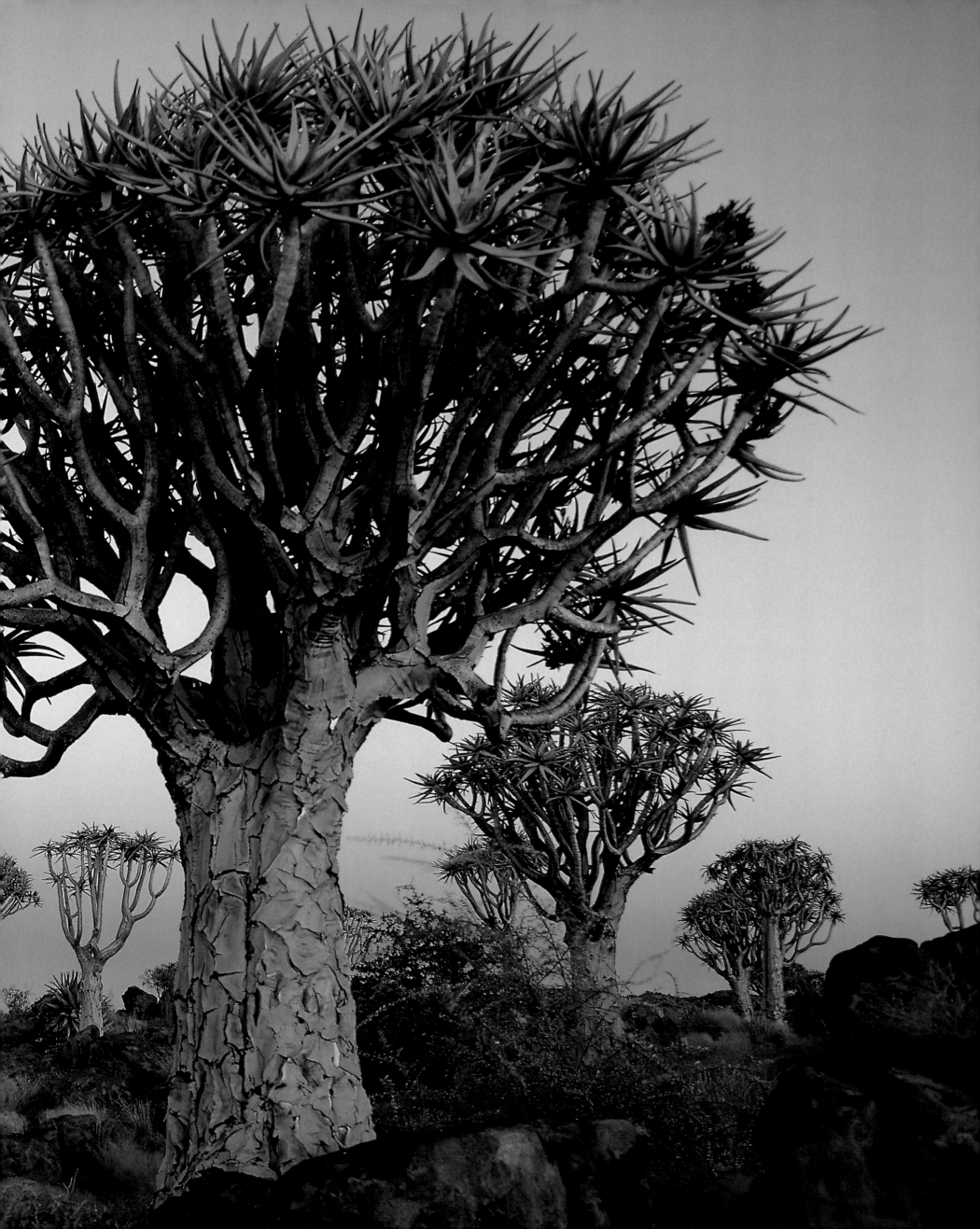

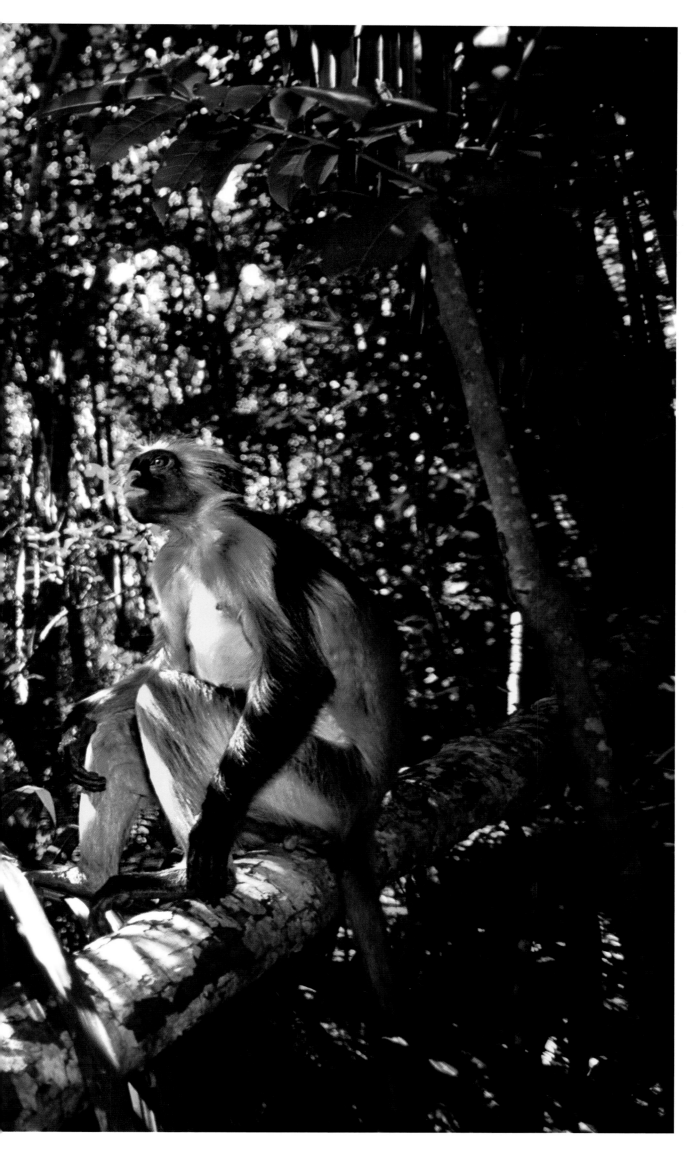

The red colobus monkeys of Zanzibar have developed a curious type of behavior. They are extremely fond of the leaves of a tree that they know will give them a stomach ache. They treat their ailment (so they can continue to enjoy the leaves) exactly as humans: with charcoal. They steal it from those who burn it in the forest.

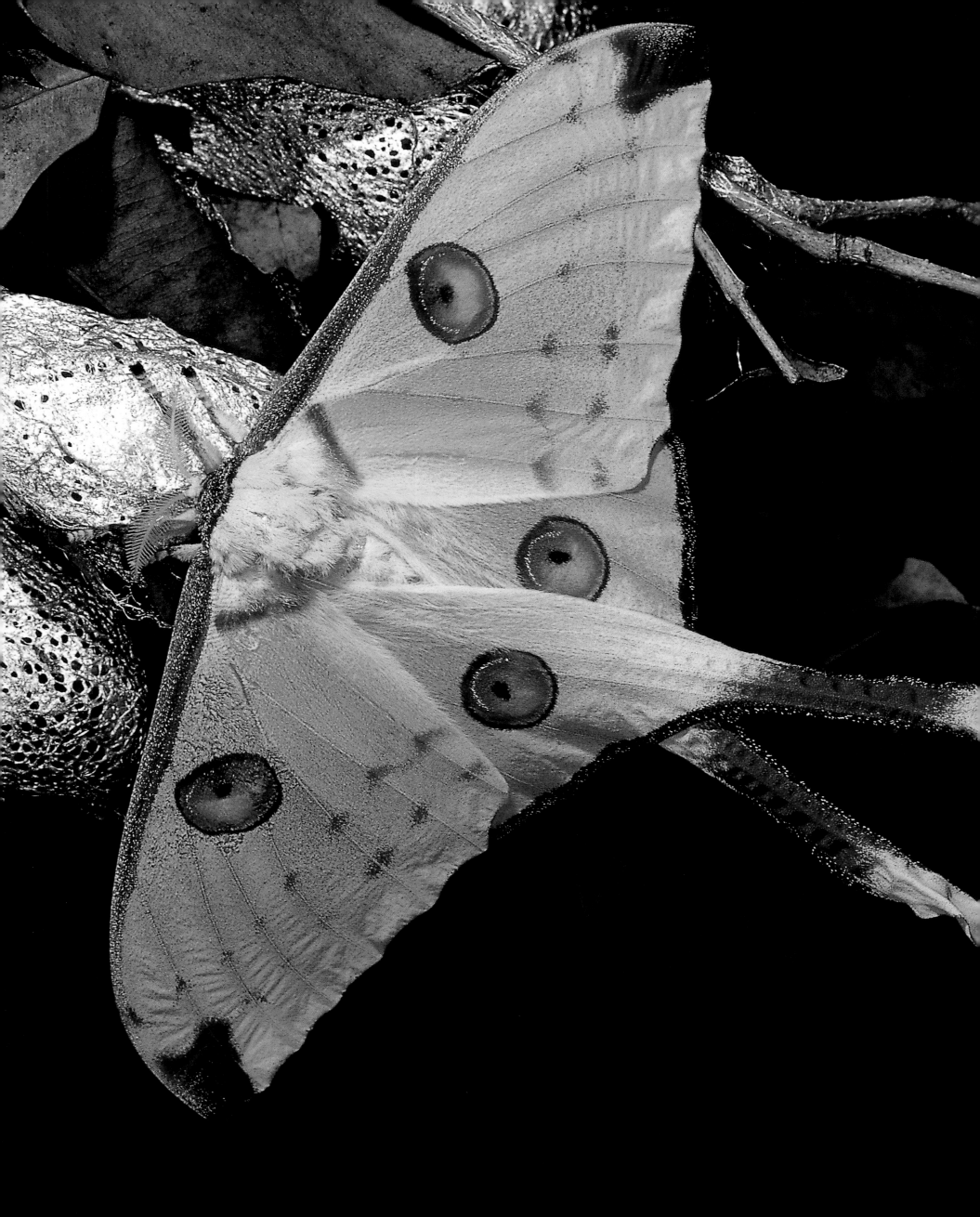

Left: The comet's tail moth (*Argema mittrei*) is found in Madagascar and takes its name from its long hind wings. The adult insects emerge from a large chrysalis, often at night, and give off a strong mushroom odor.

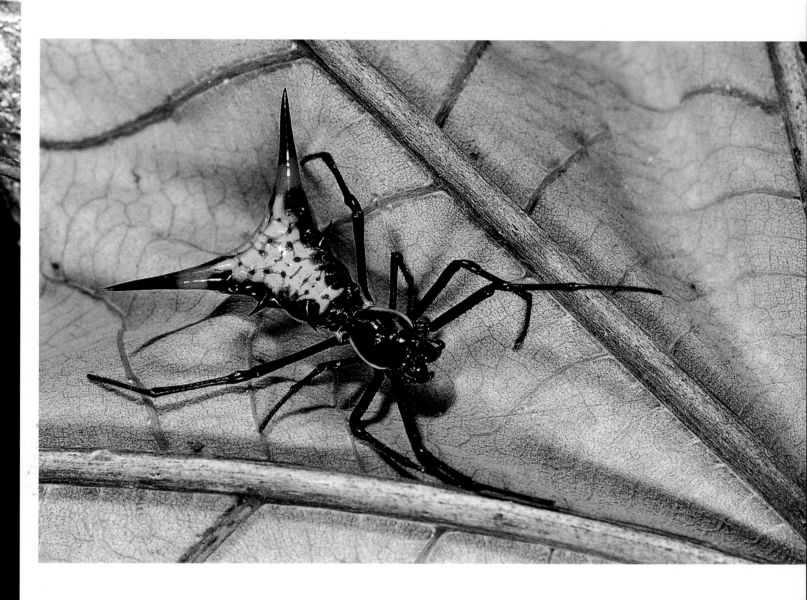

Above: To date, 1.75 million species have been described—more than 1 million of them arthropods (insects, crustaceans, and arachnids). It is possible that just as many remain to be discovered, chiefly in tropical forests. Moreover, there are tens of thousands of specimens in the world's natural history museums, waiting to be described. However, in the absence of trained staff, and especially adequate funding, this work will remain in abeyance.

The orchid family is one of the largest among the world's flora, numbering about 20,000 species and 700 genera. Most of them are found in tropical and equatorial latitudes, like this Madagascan species, and are epiphytes: they can grow only on a living support, which is usually a tree.

Above: This shadow theater of figures advancing along a stem is performed by leafcutter ants, fungus-growing ants of South America. They spend their lives cutting up leaves and hoarding them in cultivation chambers. When the leaves decompose, they form a sort of compost that the ants use to grow a fungus on which they feed. This ingenious system also fertilizes the soil. Each ant can carry up to 10 times its own body weight on each journey.

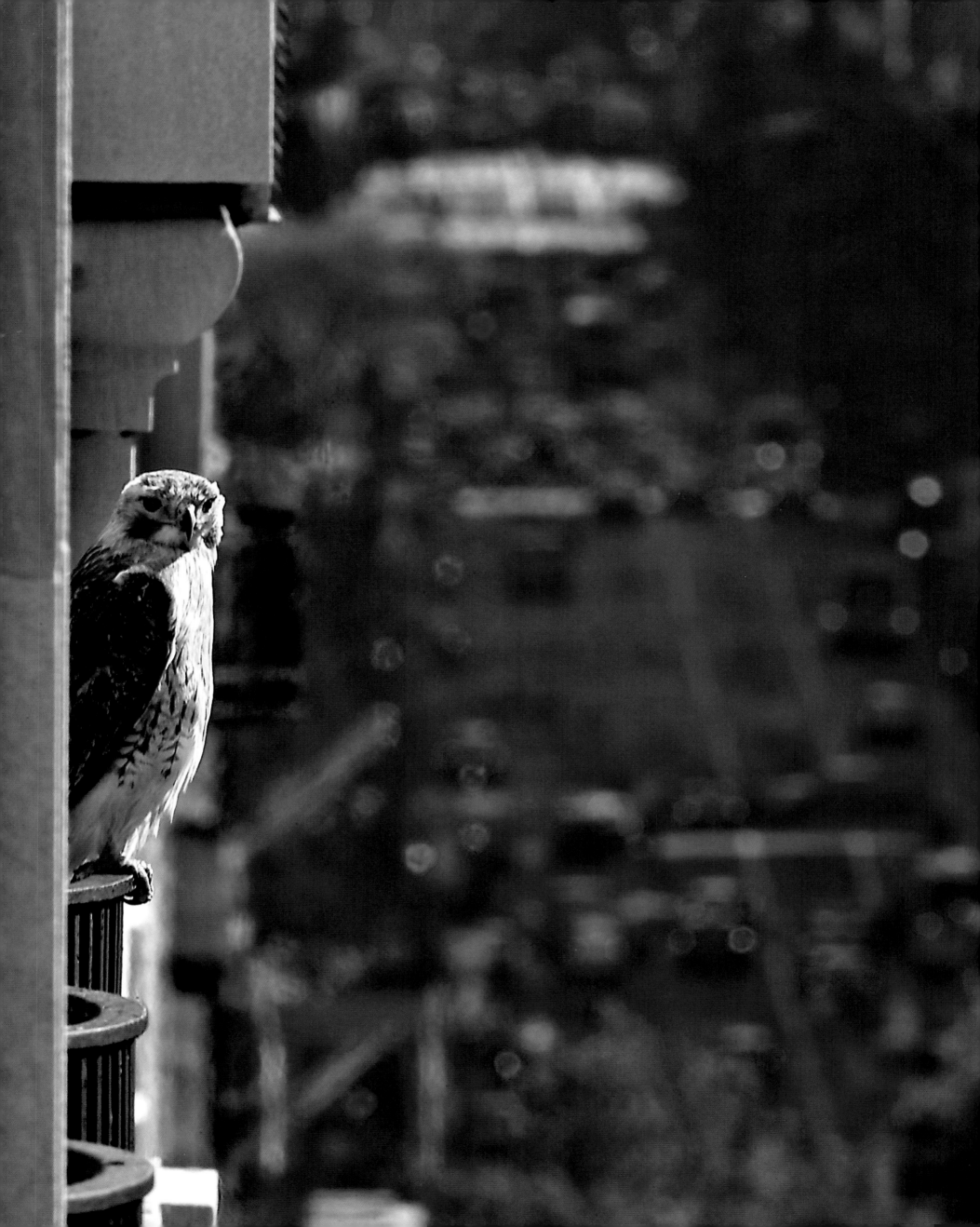

Cities

A long time ago, I fled the clamor of the city. As soon as I had the chance, I settled down as close to nature as possible. I did this to end an isolation that was no doubt paradoxical, but also because in urban societies nature has almost become an abstraction.

Left: First spotted in the early 1990s, a male red-tailed hawk, which would normally have lived in forest, decided to settle in the heart of New York City. Pale Male, as he was named, even succeeded in attracting a female, and the pair built a nest and raised young on the balcony of an apartment building. Eventually it was decided to remove the nest, because the apartment's owners could not use their balcony. However, thousands of New Yorkers and people around the world protested and some demonstrated in front of the building. There are now several Web sites devoted to these two birds, and an artificial nest site has been constructed for Pale Male and his mate. When nature decides to move into the city, it can provoke strongly opposing views among city dwellers.

The city is the most thoroughly artificial ecosystem on earth. Humans have constructed cities and control their operations, yet, even in a city—a world full of concrete, glass, and steel—nature reasserts its rights. That is what is so astonishing: the city is a source of life. A small, modest grass, the plantain, can pierce the asphalt of the sidewalk, while the ailanthus (shrubby trees native to America) can grow in a crack in a wall, as can that pretty purple flower known as Ivy-leaved toadflax (*Cymbalaria muralis*)—to say nothing of the dozens of species of insects, reptiles, amphibians, mammals, and especially birds which, over decades, have ingeniously colonized the city. What an extraordinary lesson on life, on superb adaptation to a habitat that can hardly be described as "natural." In a sense the city is a monument to the ingeniousness of living things. Some cities, such as Vancouver, Perth, and Cape Town, welcome animal life with open arms. Their arteries are broad, and the vast parking lots on their outskirts help keep their centers free of congestion. You can experience the same sensation in their many huge parks and green spaces as you can in a forest; their bird species are the same. In other cities, such as Stockholm, there are many rivers, shorelines, lakes, islands, and ponds, which are home to hundreds of ducks in winter. Even in New York, Central Park is a sort of "green lung" in the heart of the city that attracts many animals. In Paris, at night, the stone marten can be found alongside the tawny owl, while on the city's outskirts the fox prowls once more!

> A small, modest grass, the plantain, can pierce the asphalt of the sidewalk.

One of the greatest threats to biodiversity in the United States is suburban sprawl. According to the Sierra Club and U.S. Census Bureau, the cities of Detroit, Pittsburgh, and Chicago increased their urbanized areas by double-digit percentages from 1970 to 1990, while their population growths for the same time period shrank or only increased slightly. As suburbs expand, more and more natural habitats are destroyed.

Although a few dozen species adapt well to urban environments, others disappear as cities advance to the countryside. The transformation of the landscape due to human activity, and its fragmentation by transportation infrastructure (freeway interchanges, roads), has led to a reordering of the relationships between living things (fauna and flora) and the habitats that make up landscapes. The relationship between the city and its surrounding environment is one of exclusion—of the original landscape, of nature, of living species, and even of lower socioeconomic groups.

The outskirts of cities, which are often more bucolic, are gradually transformed. There are not always enough green spaces in cities. Certain living things found in cities—for example, the house sparrow, which is so dependent upon humans—may be dying out. In some large European cities, such as London, the house sparrow is rapidly vanishing, a victim, no doubt, of pollution and of the disappearance of the insects on which it feeds to its young.

Today more than 60 percent of the world's population lives in cities; rural populations are declining in Western countries. In the process, our essential link with nature and the common destiny we share with all living things is broken. When this happens, we willingly forget Mother Earth's role as a provider of goods and services—industry and technology are mere points on a supply chain that begins with natural resources, renewable or not.

Moreover, we continue to build cities according to criteria that have not changed since the beginning of the 20th century. These criteria are no longer appropriate either to demographics or to the movements of people within the urban area.

The city has become a "stress factory," a succession of ordeals that we endure with varying degrees of passivity. All of this is because large conurbations are no longer on a human scale.

Honoré Mirabeau said, putting it rather bluntly, "Humans are like apples: when you pile them up, they rot." It is high time to change the face of the city and completely reinvent it. We need to reconsider modes of travel within the city and its outskirts and air and noise pollution regulations. We also need to tighten the energy consumption of all vehicles, in the short and medium term. And perhaps we also need to encourage industry and research institutes to come up with different modes of transportation.

Half measures, such as days chosen to be "car-free," are not enough to solve the problem of air pollution. These are mere symbolic gestures—window dressing. What really matters, however, is action. Strategies and policies need to be reinvented so that society does not become paralyzed.

In order to preserve and restore "wildlife corridors"—natural spaces essential to the movement of fauna and flora—we must take an interest in what is known as "ordinary nature." Ordinary nature in cities includes those spaces close to us that most resemble the protected nature outside the city. If everyone takes responsibility to safeguard these corridors, citizens will have an opportunity to take part, in their immediate environment, in concrete action to protect and respect the natural world around them.

At the same time, the flow of people to and within cities must be rethought—we need a revolution. We mustn't wait for the worst to happen before we take action; we need to help our society evolve intelligently. This does not necessarily mean building cities in the countryside, as the film director Sacha Guitry advocated. It does, however, mean devising a city where space is used intelligently, on a human scale, and connected to natural spaces and the surrounding ecosystems.

> ⌐ Despite all the talk and international agreements, more than two billion people have no access to clean water and proper sanitation. ⌐

In 2015, there will be 36 megalopolises with more than 8 million inhabitants in each. Today, 60 percent of the water used for human consumption is pumped to urban areas (of that figure, half is used for irrigating crops in cities, a third for industry, and the remainder for drinking and sanitation). The poorest people bear the heaviest environmental burden. Despite all the talk and international agreements, more than 2 billion people have no access to clean water and proper sanitation. For example, in many sub-Saharan cities, whose populations are growing at almost twice the world average rate, waste is not properly managed; diseases spread when there is no proper sanitation facilities. These diseases, amoebic dysentery, typhoid, diarrhea, and lung illnesses, are truly borne of urban development and are proof that nature and humans are closely linked. As Pierre-Alain Roche of France's water agency asks in his article, "Water: Africa's Vital Element": Could developed countries, which so often preach about the environment, deal with the avalanche of difficulties that now swamp developing ones?

A feral pigeon appears to survey the city from atop the Empire State Building in New York. Here, as in Europe and Asia, the feral pigeon is unquestionably the species most closely linked to the city environment. Descended from the wild rock dove, which lives on cliffs, the feral pigeon has been living close to humans for centuries. Locally it can be a problem, as it may carry certain diseases and foul monuments with its droppings.

Above: This pair of American robins, which have built their nest between the statues of two lovers embracing for all eternity, demonstrate how life reproduces in the animal world—even in the most urban environments.

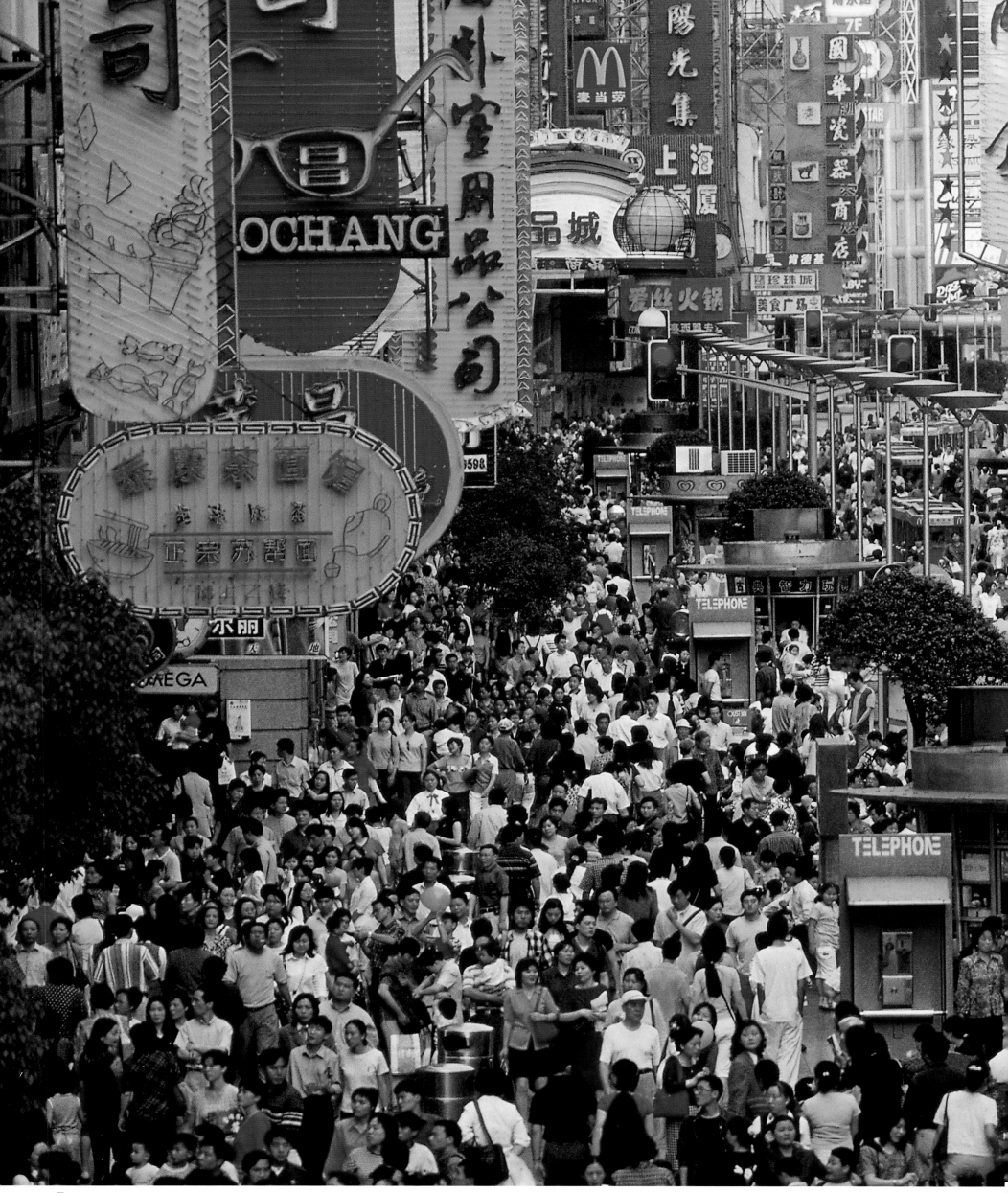

Preceding pages: Whether the traffic light is red or green, this collared dove does not move. It has decided to make its modest nest of twigs in the most unlikely spot in this European city. Originally from Asia Minor, this species spread throughout Europe during the 20th century. Although in its original range now, it was chiefly found in rural areas. In colonizing Europe it has preferred to live mostly close to humans, for reasons that remain a mystery.

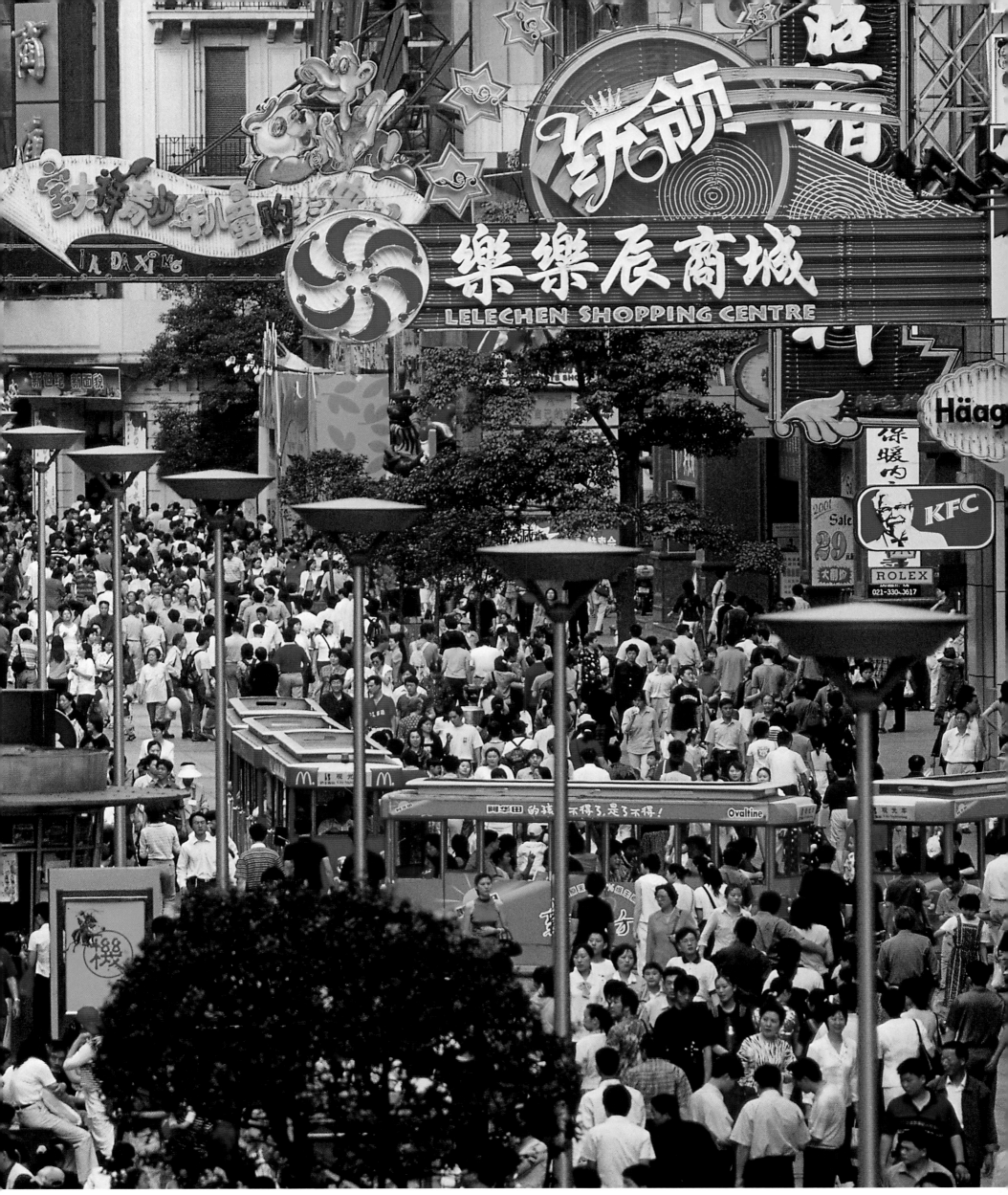

⌐**Above:** People jam a Shanghai street. China is home to a fifth of the world's population, just over 1.3 billion people, and has 353 people per square mile. Some experts, however, forecast that India will catch up and overtake China's population within a few decades.

House martins never nest very far from humans. Most build their nests, generally made of mud, on houses and often in towns: under gutters, eaves, and overhanging balconies. Apart from the use of insecticides, which has reduced the numbers of their prey, these birds suffer from lack of nest-building material and, above all, from destruction of their nests—unfortunately these nests are often removed when buildings are refurbished, even though it's illegal to remove them. The number of house martins in France has fallen by more than 80 percent in less than 15 years.

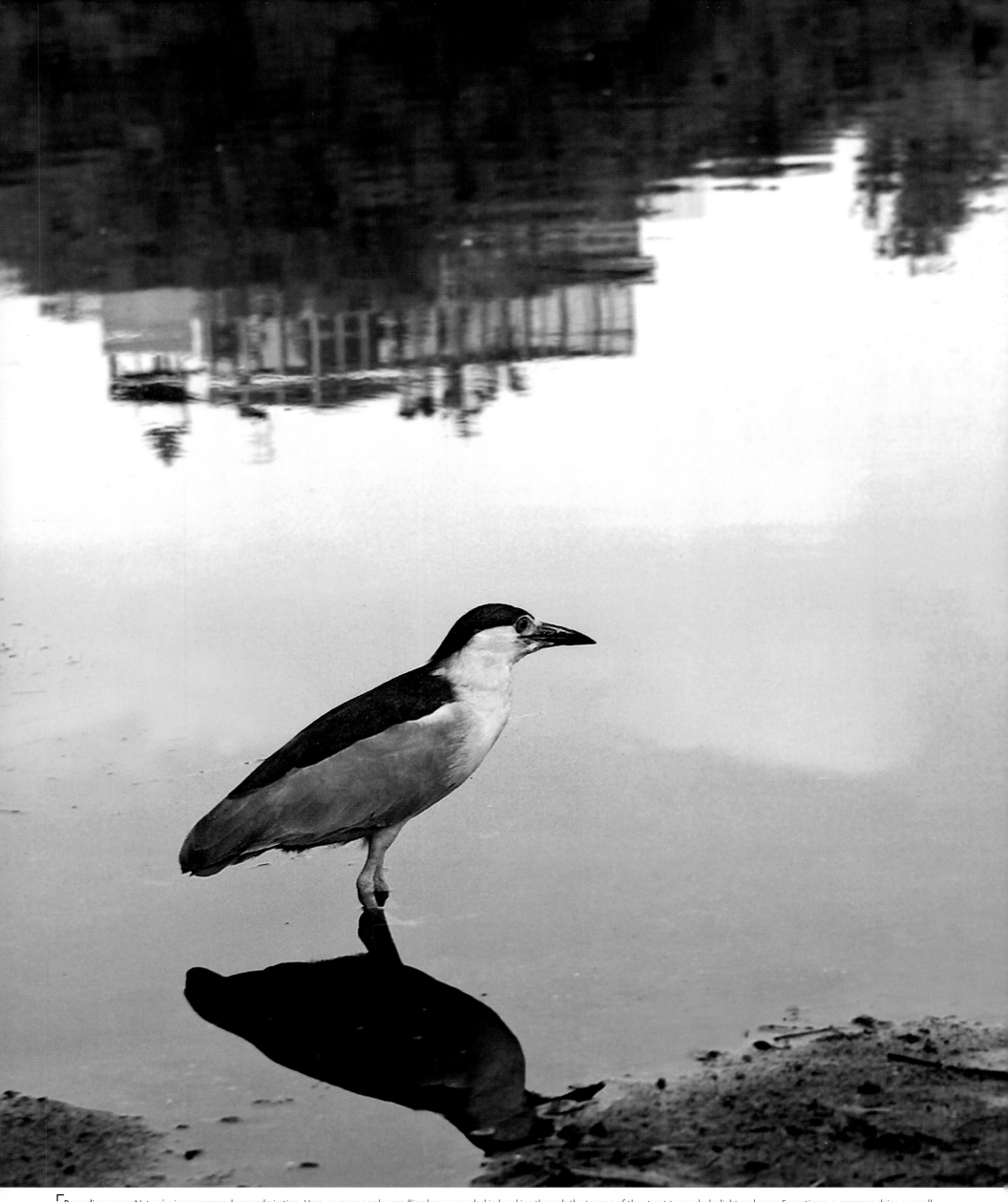

Preceding pages: Nature's vigor commands our admiration. Here, a young poplar seedling has succeeded in breaking through the tarmac of the street to reach daylight and grow. Sometimes, a common daisy or small blade of grass will do the same. To the keen-eyed observer, the gaps in the curb or between paving stones on sidewalks display a whole world of plants that have succeeded in adapting to the constant passage of human feet.

Above: This night heron—one of the smaller heron species—is on the lookout for prey. It appears to be gazing fixedly at the reflection of the skyscrapers in the pond where it has come to fish. Such species, which used to live in very different habitats (marshes or forests), are increasingly moving into cities, sometimes permanently. Large cities offer food and shelter; parks, which are increasingly wild in nature, partly re-create the habitats these species find congenial. Of course, this should not allow us to forget that their natural, wild habitats are being destroyed.

Central Park, in the heart of New York, is truly the green lung of this American megalopolis. More than 150 years old, this 840-acre park is the most famous city park in the United States. It has more than 75 miles of paved roads and paths, and 26,000 trees. A remarkable richness of animal and plant life has developed there, to the delight of naturalists and casual visitors alike—who number 25 million per year.

Of all living things, the rat has the closest commensal relationship with humans. Since the dawn of time the rat has discreetly followed humans everywhere, establishing itself close to them and benefiting from all their activities. Though the rat no longer carries plagues or causes severe epidemics, it is still persona non grata among humans, even though it is a conscientious and efficient rubbish cleaner. If there were no rats in London or Paris, these cities' sewers would be far more of a health risk.

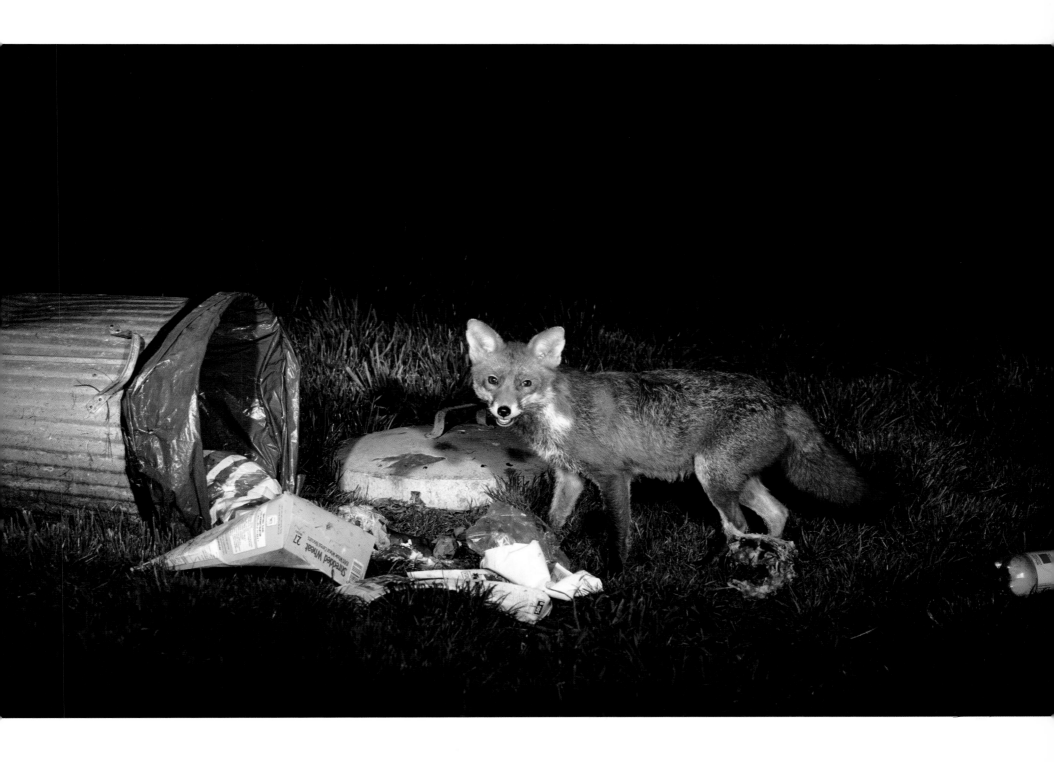

Caught in the act in the middle of the night, this fox has ventured into the heart of the city to seek its food and to go through the garbage. Often persecuted and wrongly regarded as harmful, the fox has been able to adapt perfectly to cities and to take advantage of them—which it does by night, when the chances of encountering humans are low.

People who live in coastal cities in southern latitudes can easily discover the living world of the sea, for some of its inhabitants may venture into harbors or on to beaches. The great white shark may not be welcome when it cruises off certain north Australian cities, but when whales come close inshore, as here, they provide a spectacle that rarely fails to arouse the interest of residents. Sadly, this blue whale was stranded at Punta del Este, Uruguay, where it died.

It takes little to sustain life, as this buddleia, growing directly on a wall by the Seine in Paris, demonstrates. This shrub, also known as the "butterfly bush," originally came from China and was introduced to Europe more than a century ago. It has acclimatized perfectly, colonizing wasteland, gardens, and the smallest crannies where it can find organic matter on which to grow. Plants, perhaps even more than animals, have developed superb ways of adapting in order to survive in an urban environment.

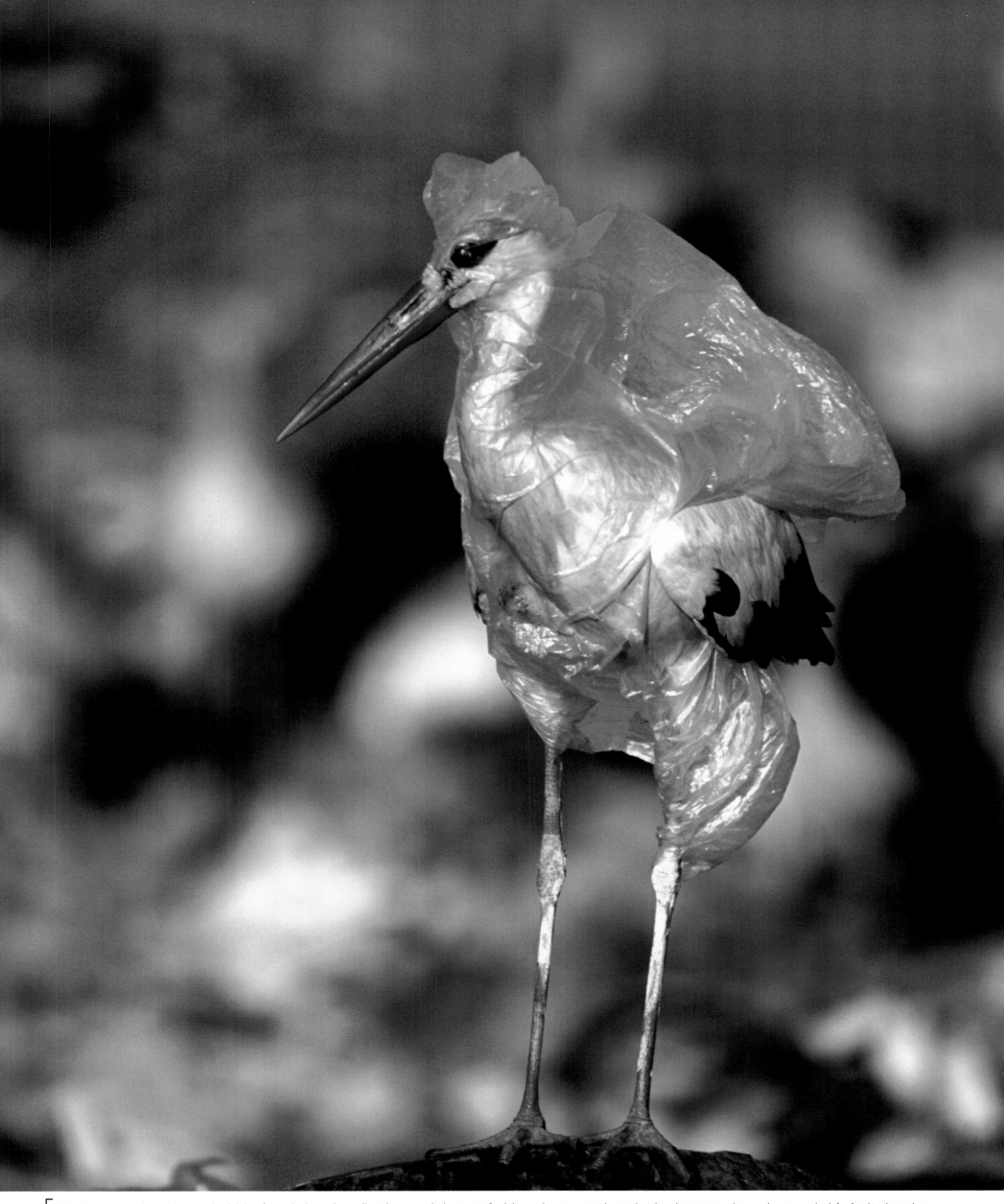

Although open-air garbage dumps are the delight of some birds—such as gulls and raptors, which come to feed there—they are not without risks. Like other species, white storks come to look for food in these places. Sadly, this bird, trapped in a plastic bag in a garbage dump in Spain, has little chance of surviving. There are countless cases, too, of mass bird poisonings in garbage dumps.

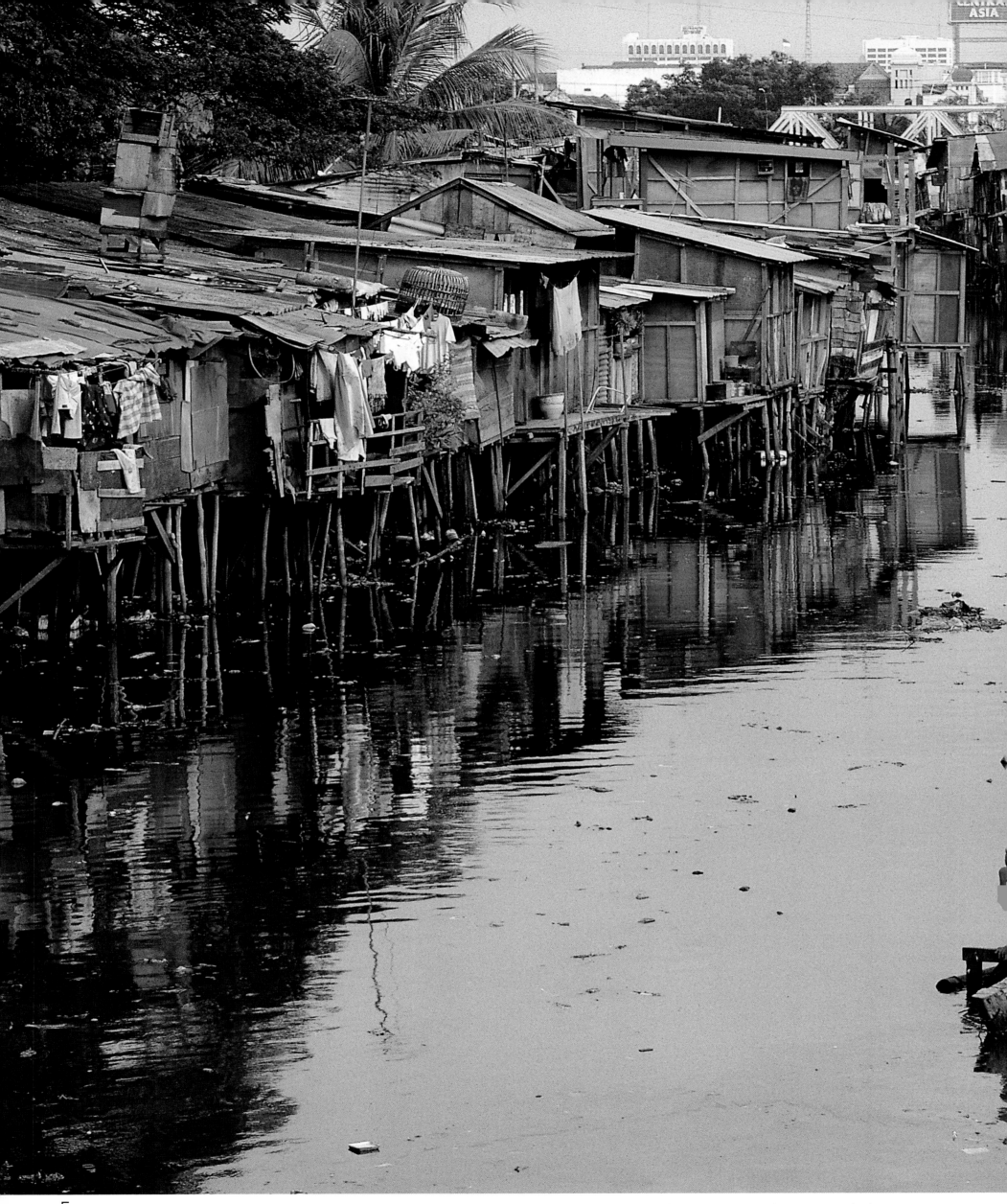

Today it is estimated that almost 60 percent of humanity lives in cities. During the 1950s, 65 percent of the world's population lived in rural areas. This urban migration is much more massive in developing countries, often because farmers cannot cultivate their land in the face of competition by transnational corporations. People mass in slums, which often lack the most basic sanitation, on the outskirts of large cities.

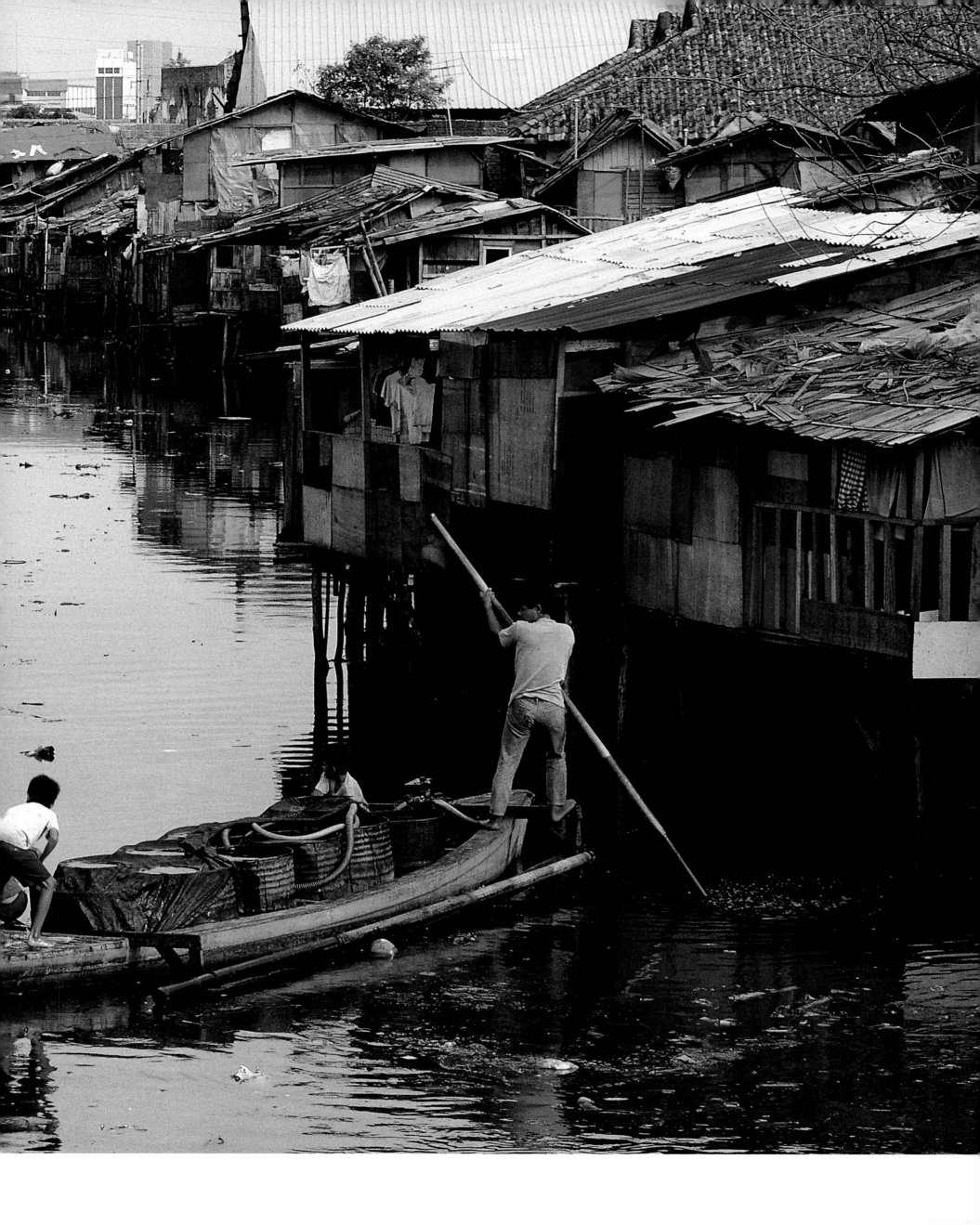

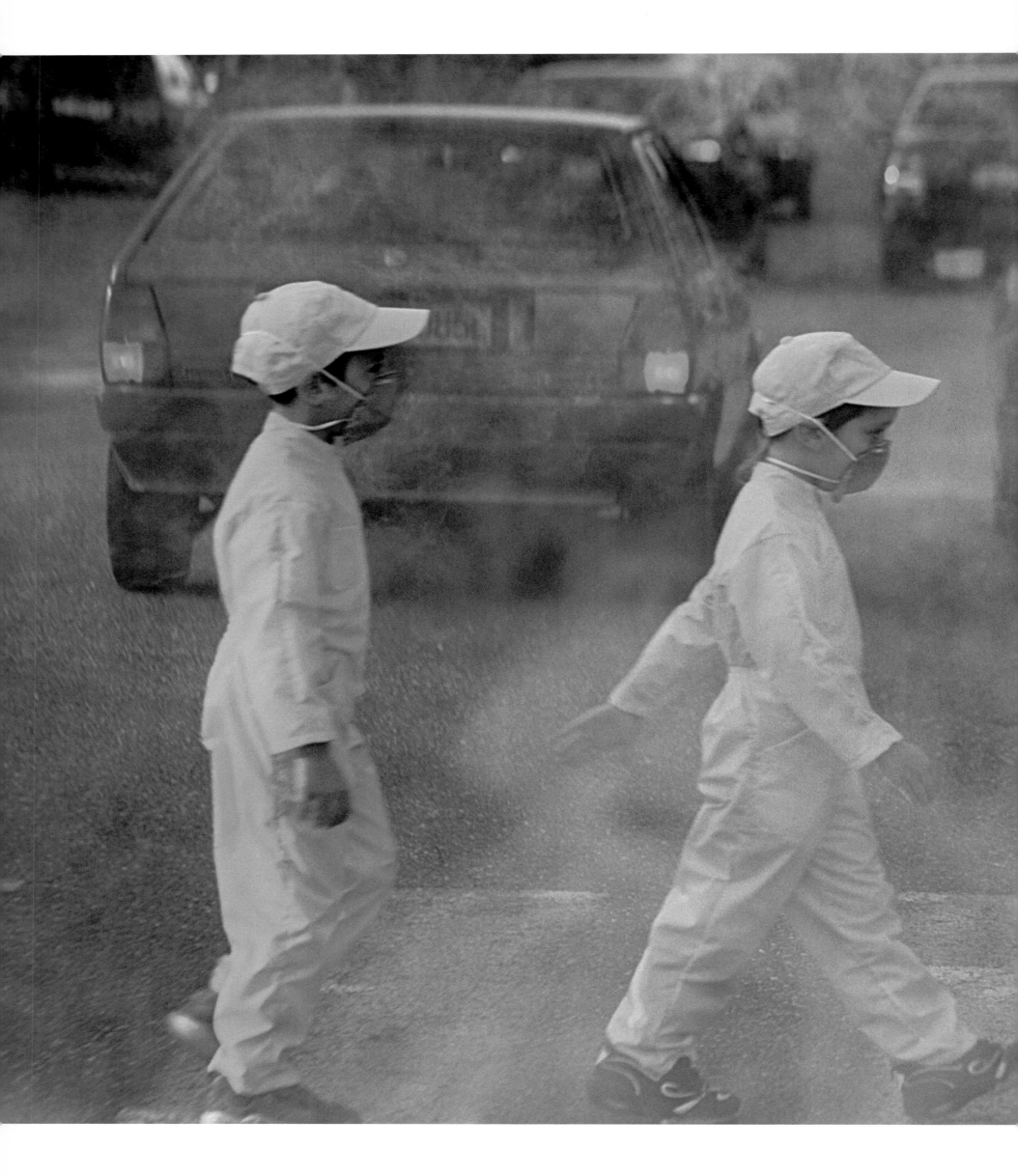

The car has come to occupy a prominent place in the urban environment. Its gas emissions are rendering city air less and less healthy to breathe, as demonstrated by the increase in respiratory and cardiovascular illness in megalopolises. These young children, demonstrating against urban pollution in the streets of Turin, Italy, remind us that it is high time to use other modes of urban transport than the car.

Above and following pages: Even in the concrete universe of the city, humans retain a link with nature. They need elements that remind them of the green of the countryside—even if it is just a plant in the office or a pot of begonias on a balcony. Sometimes, as seen here in the Atocha train station in Madrid and in this Barcelona apartment block (following pages), architects integrate plants in a much more striking way, to give the illusion of a natural setting. In this vein, plant-covered walls have become much more common on the façades of blocks in large cities.

Here, in a poor district of Bombay, clothes hang to dry as far as the eye can see. On the horizon, meanwhile, the chimneys of aging factories belch out their polluting fumes.

Anyone who flies over Ulan Bator will be surprised to see Mongolian yurts side by side with ranks of Soviet-style apartment blocks. It is as if the steppe has invited itself into the city. Many nomads have decided to adopt a settled way of life on the outskirts of the capital, but they have nevertheless retained some of their traditions.

PHOTOGRAPH CREDITS

p. 8 © Alexis Rosenfeld; p. 12–13 © Steve Bloom; p. 14–15 © L'Œil d'Andromède/Laurent Ballesta; p. 16–17 © Bios/Still Pictures/Unep/M. Flores; p. 18–19 © L'Œil d'Andromède/Laurent Ballesta; p. 20 © Fred Bavendam/Minden Pictures/Joël Halioua Editorial Agency; p. 21 © Constantin Petrinos; p. 22 © Chris Newbert/Minden Pictures/Joël Halioua Editorial Agency; p. 23 © Constantin Petrinos; p. 24 © Constantin Petrinos; p. 25 © Constantin Petrinos; p. 26–27 © Alexis Rosenfeld; p. 28–29 © Chris Newbert/Minden Pictures/Joël Halioua Editorial Agency; p. 30–31 © Brigitte Wilms/Minden Pictures/Joël Halioua Editorial Agency; p. 32–33 © Reuters/Maxppp/Miguel Vidal p. 34–35 © L'Œil d'Andromède/Laurent Ballesta; p. 36–37 © Chris Newbert/Minden Pictures/Joël Halioua Editorial Agency; p. 38–39 © Bios/J. J. Alcalay/Marcon; p. 40–41 © Norbert Wu/Minden Pictures/Joël Halioua Editorial Agency; p. 42–43 © Philip Plisson; p. 44–45 © L'Œil d'Andromède/Laurent Ballesta; p. 46–47 © Doc White/Seapics.com/Joël Halioua Editorial Agency; p. 48–49 © Philip Plisson; p. 50 © Constantin Petrinos; p. 51 © Constantin Petrinos; p. 52 © Espen Rekdal/Seapics.com/Joël Halioua Editorial Agency; p. 53 © Flip Nicklin/Minden Pictures/Joël Halioua Editorial Agency; p. 54–55 © Yann Layma; p. 56–57 © Philip Plisson; p. 58 © Olivier Grunewald; p. 62–63 © Olivier Grunewald; p. 64–65 © Bios/Unep/Still Pictures/A. Gloor; p. 66 © Bios/M. & C. Denis-Huot; p. 67 © Michaël & Patricia Fogden/Minden Pictures/Joël Halioua Editorial Agency; p. 68–69 © Michaël & Patricia Fogden/Minden Pictures/Joël Halioua Editorial Agency; p. 70–71 © Frans Lanting/Minden Pictures/Joël Halioua Editorial Agency; p. 72–73 © Philippe Bourseiller; p. 74–75 © Philippe Bourseiller ; p. 76 © Michaël & Patricia Fogden/Minden Pictures/Joël Halioua Editorial Agency; p. 77 © Michaël & Patricia Fogden/Minden Pictures/Joël Halioua Editorial Agency; p. 78–79 © Philippe Bourseiller; p. 80–81 © Olivier Grunewald; p. 82 © Bios/Théo Allofs; p. 83 © Art Wolfe/Joël Halioua Editorial Agency; p. 84–85 © Philippe Bourseiller; p. 86–87 © Philippe Bourseiller; p. 88 © Philippe Bourseiller; p. 89 © Afp Photo/Patrick Hertzog; p. 90–91 © Philippe Bourseiller; p. 92–93 © Olivier Grunewald; p. 94 © Art Wolfe/Joël Halioua Editorial Agency; p. 95 © Bios/Argus/Peter Frischmuth; p. 96–97 © Philippe Bourseiller; p. 98–99 © Philippe Bourseiller; p. 100–1 © Philippe Bourseiller; p. 102 © Bios/Muriel Hazan; p. 103 © Louis Marie Préau; p. 104 © Olivier Grunewald; p. 105 © Philippe Bourseiller; p. 106–7 © Philippe Bourseiller; p. 108–9 © Philippe Bourseiller; p. 110 © Jim Brandenburg/Minden Pictures/Joël Halioua Editorial Agency; p. 114–15 © Yva Momatiuk/John Eastcott/Minden Pictures/Joël Halioua Editorial Agency; p. 116–17 © Art Wolfe/Joël Halioua Editorial Agency; p. 118–19 © Art Wolfe/Joël Halioua Editorial Agency; p. 120–21 © Steve Bloom; p. 122–23 © Steve Bloom; p. 124–25 © Shin Yohino/Minden Pictures/Joël Halioua Editorial Agency; p. 126–27 © Konrad Wothe/Minden Pictures/Joël Halioua Editorial Agency; p. 128–29 © Jim Brandenburg/Minden Pictures/Joël Halioua Editorial Agency; p. 130–31 © Olivier Grunewald; p. 132–33 © Tim Fitzharris/Minden Pictures/Joël Halioua Editorial Agency; p. 134–35 © Philippe Bourseiller; p. 136–37 © Rapho/Hans Silvester; p. 138–39 © Rapho/Hans Silvester; p. 140–41 © Rapho/Hans Silvester; p. 142–43 © Olivier Föllmi; p. 144–45 © Michel Setboun; p. 146–47 © Afp/Hémisphères/Bertrand Gardel; p. 148 © Bios/Rémy Courseaux; p. 149 © Frans Lanting/Minden Pictures/Joël Halioua Editorial Agency; p. 150 © Philippe Bourseiller; p. 151 © Louis Marie Préau; p. 152–53 © Hoa Qui/Explorer/J. P. Lescourret; p. 154–55 © Philippe Bourseiller; p. 156–57 © Olivier Föllmi; p. 158–59 © Philippe Bourseiller; p. 160 © Bios/Peter Arnold/Heacox Kim; p. 164–65 © Michio Hoshino/Minden Pictures/Joël Halioua Editorial Agency; p. 166–167 © Frans Lanting/Minden Pictures/Joël Halioua Editorial Agency; p. 168–69 © Norbert Wu/Minden Pictures/Joël Halioua Editorial Agency; p. 170–171 © Uwpress. com/Amos Nachoum; p. 172–73 © Bios/Phone/Jean Paul Ferrero; p. 174 © National Geographic Image Collection/George F. Mobley; p. 175 © Michio Hoshino/Minden Pictures/Joël Halioua Editorial Agency; p. 176–77 © Art Wolfe/Joël Halioua Editorial Agency; p. 178–79 © National Géographic Image Collection/Bill Curtsinger; p. 180–81 © Michael Quinton/Minden Pictures/Joël Halioua Editorial Agency; p. 182–83 © Foto Natura/Chris Schenk/Minden Pictures/Joël Halioua Editorial Agency; p. 184–85 © Bios/Klein & Hubert; p. 186–87 © Michio Hoshino/Minden Pictures/Joël Halioua Editorial Agency; p. 188 © Tui de Roy/Minden Pictures/Joël Halioua Editorial Agency; p. 189 © Flip Nicken/Minden Pictures/Joël Halioua Editorial Agency; p. 190–191 © Art Wolfe/Joël Halioua Editorial Agency; p. 192 © Jan Van Arkal Foto Natura/Minden Pictures/Joël Halioua Editorial Agency;

PHOTOGRAPH CREDITS

Scientific consultant: Philippe J. Dubois, assisted by

Hélène Leriche and Jean-Jacques Blanchon

Photograph selection: Marie-Christine Petit

Design:

Translated from the French by Simon Jones

Project manager, English-language edition: Magali Veillon

Editor, English-language edition: David Bourgeois

Design coordinator, English-language edition: Shawn Dahl

Cover design, English-language edition: Eric J. Diloné

Production manager, English-language edition: Colin Hough Trapp

Library of Congress Control Number: 2006921506

Printed and bound in Italy

10 9 8 7 6 5 4 3 2 1

HNA ▮▮▮▮▮
harry n. abrams, inc.
a subsidiary of La Martinère Groupe

115 West 18th Street

New York, NY 10011

www.hnabooks.com